BY THE SAME AUTHOR

Industrial Relations: The Boardroom Viewpoint (with Peter Hobday and Eric Foster)

Translations

Baldassare Castiglione, *The Book of the Courtier*
Benvenuto Cellini, *Autobiography*
Michelangelo: Life, Letters and Poetry
Giorgio Vasari, *Lives of the Artists* (two volumes)

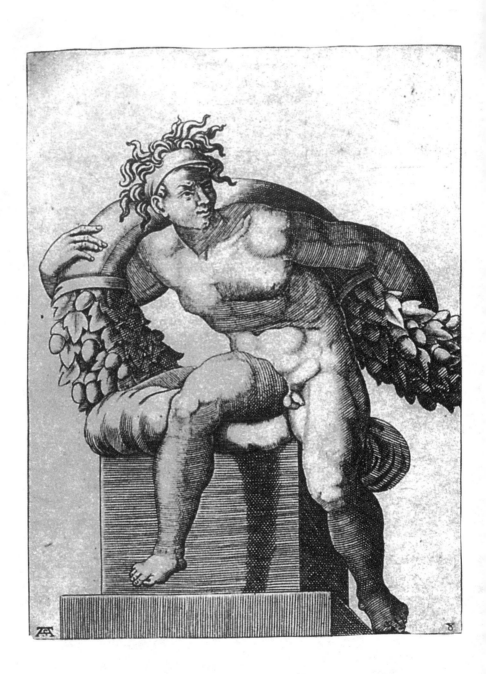

MICHELANGELO

A BIOGRAPHY

George Bull

St. Martin's Griffin
New York

Library of Congress Cataloging-in-Publication Data

Bull, George Anthony.
 Michelangelo : a biography / George Bull.
 p. cm.
 Includes bibliographical references and index.
 ISBN 0-312-18746-7
 1. Michelangelo Buonarroti, 1475–1564.
 2. Artists—Italy—Biography. I. Title.
N6923.B9B83 1997
709′.2—dc20
[B] 96-9923
 CIP

First published in Great Britain by Viking,
a division of Penguin Books Ltd.

First St. Martin's Griffin Edition: August 1998

10 9 8 7 6 5 4 3 2 1

For Dido, with love

Contents

List of Illustrations

Photo Credits

Text illustrations

Reproductions of works by Michelangelo in the Sistine Chapel, 'Adam Sculptor Mantuanus Incidit', *Buonarroti Figurae* (1616)

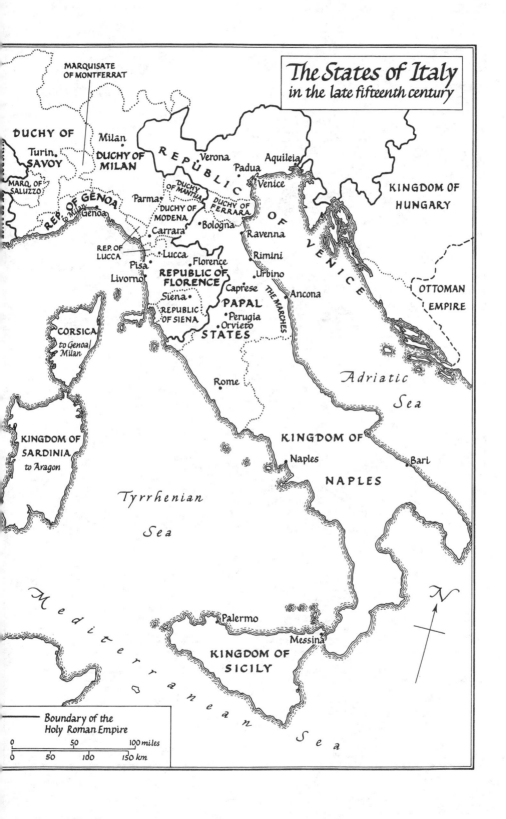

MARQUISATE
OF MONTFERRAT

DUCHY OF
SAVOY
Turin,

MARQ. OF
SALUZZO

REP. OF GENOA

Milan

DUCHY OF
MILAN

to Milan

Genoa

REP. OF
LUCCA

Pisa

Livorno

CORSICA
to Genoa/
Milan

KINGDOM OF
SARDINIA
to Aragon

Parma

DUCHY
OF MANTUA

DUCHY OF
MODENA

Carrara

Lucca

Florence

REPUBLIC OF
FLORENCE

Siena

REPUBLIC
OF SIENA

R E P U B L I C

Verona
Padua

DUCHY OF
FERRARA

Bologna

Ravenna

Rimini

Urbino
Caprese

PAPAL

Perugia
Orvieto

STATES

Aquileia

Venice

O F

V E N I C E

THE MARCHES

Ancona

Rome

The States of Italy
in the late fifteenth century

KINGDOM OF
HUNGARY

OTTOMAN
EMPIRE

Adriatic
Sea

KINGDOM OF

Naples

Bari

NAPLES

Tyrrhenian

Sea

N

Palermo

Messina

KINGDOM OF
SICILY

Mediterranean

Sea

Boundary of the
Holy Roman Empire

| 0 | 50 | 100 miles |
| 0 | 50 | 100 | 150 km |

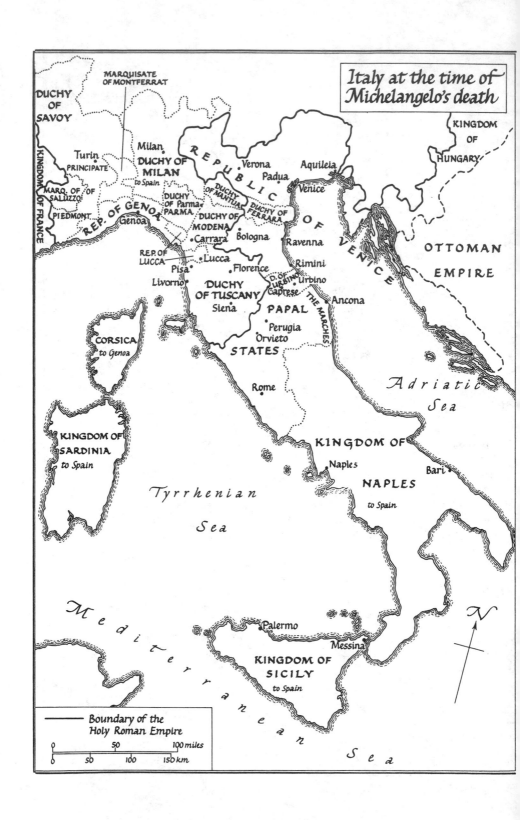

Italy at the time of Michelangelo's death

DUCHY OF SAVOY

MARQUISATE OF MONTFERRAT

KINGDOM OF HUNGARY

Turin
PRINCIPATE

Milan

DUCHY OF MILAN
to Spain

REPUBLIC

Verona
Padua

Aquileia

Venice

OTTOMAN EMPIRE

KINGDOM OF FRANCE

MARQ. OF SALUZZO

PIEDMONT

REP. OF GENOA

Genoa

DUCHY of Parma PARMA

DUCHY OF MANTUA

DUCHY OF FERRARA

OF

Carrara

Bologna

Ravenna

VENICE

DUCHY OF MODENA

REP. OF LUCCA

Pisa

Lucca

Florence

Rimini

D. OF URBINO

Urbino

Livorno

DUCHY OF TUSCANY

Caprese

Ancona

CORSICA
to Genoa

Siena

PAPAL

Perugia
Orvieto

THE MARCHES

STATES

Rome

Adriatic Sea

KINGDOM OF SARDINIA
to Spain

Tyrrhenian Sea

Naples

Bari

KINGDOM OF

NAPLES
to Spain

N

Mediterranean

Palermo

Messina

KINGDOM OF SICILY
to Spain

Sea

———— Boundary of the Holy Roman Empire

0 50 100 miles
0 50 100 150 km

Introduction

Michelangelo's beloved Vittoria Colonna, marchesa of Pescara, during one of their affectionate, ironic conversations in the convent of San Silvestro in Rome, remarked that those who knew him esteemed him more than his works and that those who did not know him esteemed the least part of him, which was his works. Michelangelo was then in his early sixties, had been appointed supreme architect, sculptor and painter of the Vatican, and was at work in the Sistine Chapel on his painting of the *Last Judgement*. This book is a response to Vittoria Colonna's subtle challenge to throw more light on the personality of Michelangelo and the centrality of his genius.

Michelangelo was born on 6 March 1475 and died on 18 February 1564. He grew up in Tuscany and spent most of his life in Rome, where he worked as an artist for seven popes in turn. Nearly ninety when he died, he lived through a period of immense historical change and turbulence in Florence, Italy and Europe, in every field of human endeavour from politics, economics and technology to literature, language and music, religion and art. He was shaped by his age, and in art he was one of the supreme shapers of the age.

The period of Michelangelo's lifetime has been variously characterized as the age of printing, the age of humanism, the Reformation, Counter-Reformation, Catholic Reform, the waning of the Middle Ages, the Renaissance, and the age of discovery. While he worked, often for long stretches in silence, Díaz reached and Vasco da Gama rounded the Cape of Good Hope, Columbus sailed to the west, the Spaniards landed in Brazil, Cortés captured Mexico, the Portuguese landed in Japan. The great changes to which Michelangelo was most alert, and which continually affected his art, were religious and political: the split in Christendom; the fitful passage of the papacy from corrupt worldliness and resurgent classicism to administrative correctness and Christian renewal; and the struggle for European hegemony between Habsburg and Valois, during which Italy, continually threatened and assaulted by the French and the Turks, fell under Spanish domination, and the Republic of Florence succumbed to autocracy.

This was a period of rapid development in technology: movable type to print pamphlets and books; copper engraving enabling prints of popular pictures to be circulated; painting in oils; new musical instruments such as the violin. All these and myriad other interconnected

changes combined to transform the culture of Europe. Cultural innovation and development were exceptionally rapid and intense; painters and sculptors flourished in quattrocento and cinquecento Italy.

Michelangelo is better understood not in the isolation of his towering genius but in the crowded context of the significant changes and continuities of his age. His immediate family was big and troublesome: a father twice widowed, a bevy of in-laws, four brothers (three younger than him), of whom one married and had children. His patrons through his life (Michelangelo was resentful of some patronage, but proud of not being a man to keep a shop) were varied in status and background, and some, from Lorenzo de' Medici and Pope Julius II to Catherine de' Medici and Pope Pius IV, were among his friends. His friends were numerous, drawn from many professions and walks of life, from different age groups, of very varied dispositions. Many of his friendships were highly emotional and fulfilling; at least two, with the well-born Tommaso de' Cavalieri and the noble Vittoria Colonna, were in contrasting ways love affairs, and he loved his servant Urbino like a father.

Michelangelo's longevity, versatile genius and searching practical intellect, curiosity and needs would inevitably have brought him into contact with a great many people. In turn, he felt passionately about the people he met from all strata of society. His relationships were spontaneously warm and natural, full of kindliness and concern, though infused with suspicion, calculation and sometimes even cruelty when his tongue or temper took charge.

The events of Michelangelo's life introduce us to many of the dramatis personae of Renaissance Italy in their incomparable profusion: the long lines of Medici rulers and sovereign popes; the prelates and clerics of the Roman curia and the officials of Florentine government, cardinals, bishops, priests, *condottieri*, courtiers, painters, sculptors and architects, poets, historians, bankers, marble-workers, street singers, villagers and workshop *garzoni*. I have tried to bring them alive partly through Michelangelo's eyes, and to present Michelangelo partly through theirs.

In writing about Michelangelo and his times, I have wanted to use relevant detail to highlight his achievements as an artist, not bury them. In his life he displayed wit, compassion, good sense, humour, intuition and acute intelligence. He was a man of volcanic temperament, convulsive energy, strong sensuality, enormous pride, fierce sensitivity and subversive emotional and intellectual inclination. He was also, always, utterly sane.

Though liking for his work and his reputation have oscillated over the centuries, Michelangelo ranks among the greatest Western practitioners of the three arts of painting, sculpture and architecture. His reputation as an original, skilful, and moving poet is still rising.

A biography of Michelangelo must, of course, record the events of his life to illuminate the context of great works of art. For the significance of particular works of art the reader is best advised to seek the guidance of art historians, to use his own eyes, and to trust his own feelings. Each generation brings to and derives from Michelangelo fresh and stimulating insights into art and the processes of artistic creation. An enormous amount of archival material relevant to Michelangelo and his life and times is being published for the first time (some of it newly translated from the Italian in this book). Moreover, the recent cleaning of Michelangelo's fresco cycles in the Sistine Chapel has demanded a dramatically revised appraisal of his achievements as a colourist as well as a consummate draughtsman. Again, reappraisals of the historical context of Michelangelo's achievements – for example, the view of the so-called Counter-Reformation as parallel to the Lutheran Reformation in its yearning for spiritual renewal rather than simply in stark opposition – put Michelangelo's own religious sensibilities, and much of his work, in a radically altered historical framework. Anyone writing a life of Michelangelo today also has the advantage of being able to discuss his sexual orientation without evasion or embarrassment.

My first glimpses of Michelangelo's works came in 1950, when I visited Florence and Rome for Holy Year. My fascination with him has grown over the years, greatly stimulated by the reading of cascades of other people's scholarly books and papers, and by the concentrated attention needed to translate the classic biographies by his devoted contemporaries Giorgio Vasari and Ascanio Condivi, as well as many of his letters and sonnets, and the opportunity to look quite often at his statues, buildings and paintings. I have above all been helped to complete a long, enjoyable task through the patience, thoughtfulness, knowledge and kindness of the following: Sidney Anglo, Giovanni Aquilecchia, Aideen Archbold, Leonard E. Boyle, Anthony Brook, Jennie Bull, John Bury, Andrew Cameron, Wilfrid Cameron-Curry, Peter Carson, David Cast, Brian Chestle, Cecil Clough, John Cullis, Bob Davenport, Judith Flanders, Giles Gordon, John Hale, Nigel McGilchrist, the late Fabrizio Mancinelli, Nicholas Mann, Philip Mason, Linda Murray, the late Peter Murray, Paolo Nardi, John O'Malley, Frank and Orietta Doria

Pamphilj, Walter Persegati, Peter Porter, Michael Quinlan, Lily Richards, Clare Robertson, Nicolai Rubinstein, Esther Sidwell, Patrick Sweeney, Guido Waldman, Julia Watson and the late J. H. Whitfield.

Select bibliography

Informative and readable biographies of Michelangelo were written while he was living: the *Life* of 1553 by Ascanio Condivi and the 'Life of Michelangelo Buonarroti' in Giorgio Vasari's *Lives* of the artists of 1550 and 1568. Editions of both these works exist in Italian and in translation.

Both Condivi's and Vasari's Lives were published and annotated in Paola Barocchi's monumental five-volume *Giorgio Vasari: La vita de Michelangelo nelle redazioni del 1550 e del 1568* . . . (Milan, 1962). Einaudi have published a convenient two-volume version (Turin, 1991) of the first (1550) edition of the *Lives*.

The sometimes fanciful narratives of Condivi and Vasari colour my reconstruction of Michelangelo's early years, and I have as a rule made use of my own translations of them: with Peter Porter, *Michelangelo: Life, Letters and Poetry* (Oxford, 1987) and from Giorgio Vasari, *Lives of the Artists* (Harmondsworth, 1987).

Among the older numerous lives of Michelangelo which I have found useful and which demand to be read rather than just consulted are Aurelio Gotti's *Vita di Michelangelo* (2 vols., Florence, 1875); Herman Grimm's *Life of Michelangelo*, translated by Fanny Bunnett (2 vols., Boston, 1896); Giovanni Papini's *Vita di Michelangiolo nella vita del suo tempo* (Milan, 1951); R. Duppa's *Life of Michelangelo Buonarroti* (London, 1816); Charles Heath Wilson's *Life and Works of Michelangelo Buonarroti* (London, 1874); J. A. Symonds's *The Life of Michelangelo* (2 vols., London, 1893).

Texts which provide essential documentary material for any life of Michelangelo are Gaetano Milanesi, *Lettere di Michelangelo Buonarroti* (Florence, 1875; Osnabrück, 1976); *The Letters of Michelangelo*, translated, edited and annotated by E. H. Ramsden (2 vols., London, 1963); Paola Barocchi, *Giorgio Vasari, la vita di Michelangelo nelle redazioni del 1550 e del 1568* (5 vols., Milan and Naples, 1962); *Il carteggio di Michelangelo* in five volumes begun by Giovanni Poggi and continued by Paola Barocchi and Renzo Ristori (Florence, 1965–83); *I ricordi di Michelangelo* edited by Lucilla Bardeschi Ciulich and Paola Barocchi (Florence, 1970); *Il carteggio di Michelangelo: Carteggio indiretto* vol. 1, edited by Paola Barocchi, Bramanti and Renzo Ristori (Florence, 1988); *Rime di Michelangelo Buonarroti* edited by E. N. Girardi (Bari, 1960) and (in annotated translation) James M. Saslow's *The Poetry of Michelangelo* (New Haven and London, 1991).

For salient aspects of Michelangelo's art, poetry and character I have both read pleasurably and consulted especially *Michelangelo: A Study in the Nature of Art* by Adrian Stokes (London, 1955); *Michelangelo: A Psychoanalytic Study of his Life and Images* by Robert S. Liebert (New Haven and London, 1983); *Michelangelo* by Herbert von Einem translated by Ronald Taylor (London, 1973); *Michelangelo's Theory of Art* by Robert J. Clements (London, 1963); *Michelangelo and the Language of Art* by David Summers (Princeton, 1981); *The Architecture of Michelangelo* by James S. Ackerman (2 vols., London, 1961); *Michelangelo architetto: La facciata di San Lorenzo e la cupola di San Pietro*, by Henry A. Millon and Craig Hugh Smyth (Milan, 1988); *Michelangelo and his Drawings* by Michael Hirst (New Haven and London, 1988); *Michelangelo's Drawings: The Science of Attribution* by Alexander Perrig, translated by Michael Joyce (New Haven and London, 1991); *Michelangelo: Six Lectures* by Johannes Wilde (Oxford, 1978); *Michelangelo e la controriforma* by Romeo De Maio (Rome, 1981); *Michelangelo's Poetry: Fury of Form* by Glauco Cambon (Princeton, 1985); *Michelangelo's Last Paintings* by Leo Steinberg (London, 1975); *Michelangelo* by Charles de Tolnay (5 vols., Princeton, 1938–60); *Michelangelo Sculptor, Painter, Architect* by Charles de Tolnay, translated by Gaynor Woodhouse (Princeton, 1985), a 'distillation' of de Tolnay's multitudinous studies, which are listed in its select biography.

Many other relevant general and specialist books and articles are cited in my notes and/or listed in the 'Further reading' section.

So to one tomb he gave Night and Day, and to the other Dawn and Evening . . .

GIORGIO VASARI

The sarcophagi are placed against the side walls, and along their lids stretch two great figures, larger than life-size, namely a man and a woman, by which are signified separately Day and Night, and, both together, Time which consumes everything.

ASCANIO CONDIVI

There on that scaffolding reclines
Michael Angelo.
With no more sound than the mice make
His hand moves to and fro.
Like a long-legged fly upon the stream
His mind moves upon silence.

W. B. YEATS

PART ONE

Requiem 1564

1 Obsequies in San Lorenzo

In the early spring of 1564, by the time Michelangelo Buonarroti's corpse, in a coffin and wrapped like a bale of merchandise, arrived from Rome, the three hundred or so excited members of the Accademia del Disegno (Academy of Design) in Florence were well advanced with their plans for the obsequies of the 'head, master and father of us all'. Academicians decorated and furnished the Medici family church of San Lorenzo. They hurriedly produced scores of paintings, plaster figures and furnishings to pay tribute to the divine Michelangelo, back in his own native city at last after decades of self-imposed absence. The aims of this festive funereal display were to publicize the artists and the Academy, to glorify the enhanced status of art itself, and to praise the ruler of Florence and his Medici ancestors for their princely patronage. Michelangelo's corpse was displayed to the curious and the reverent, and then interred in the Franciscan church of Santa Croce.

A few months later, on a hot July afternoon, San Lorenzo was thrown open to the crowds for the requiem mass. The plain, harmonious beauty of the interior's members, serried arches and chapel openings, of the bluish sandstone *pietra serena*, had been darkened and transformed. A huge catafalque loomed in the central nave of the church. On its base, facing the main door, reclined statues of the two river gods of the Arno and the Tiber. Over these, a chiaroscuro picture showed Lorenzo the Magnificent welcoming the young Michelangelo to his renowned garden-school of San Marco; other pictures showed Michelangelo building the famous impregnable fortifications of the hill of San Miniato during the siege of Florence, and Michelangelo being welcomed back by the Medici Pope Clement after the retaking of Florence by Imperial and papal forces.

On the second tier of the catafalque were depicted Michelangelo presenting his stupendous wooden model of the dome of St Peter's in Rome to Pope Pius IV, with a statue of Architecture above; Michelangelo at work on his fresco of the Last Judgement, with a statue of Painting above; Michelangelo with his own works of sculpture, under a recumbent statue of Sculpture; and Michelangelo writing poetry, surrounded by the nine Muses, led by Apollo, who was crowning him with laurel.

From the base of the catafalque rose a pyramid with two oval reliefs, facing the main door and the high altar respectively. Each showed the

portrait head of Michelangelo executed by Santi Buglioni. On top of the pyramid was a sphere, and on it – about sixty feet from the ground – was Zanobi Lastricati's figure of Fame holding Michelangelo's emblem in the form of three intertwined wreaths, and a three-mouthed trumpet.

Black cloth hangings along the chapels throughout the church set off another series of paintings of events attesting to Michelangelo's pre-eminence in life and the hereafter. There were also various representations of Death, among them a skeleton who had thrown his scythe to the ground and was weeping for the loss he had inflicted on mankind. As candles flickered around the catafalque and the altar, the scholar and writer Benedetto Varchi gave an address, crammed with fashionable conceits, eulogizing the works and life of the divine Michelangelo to the immense congregation.

Michelangelo had been a recluse, a scholar and a saint. The obsequies in San Lorenzo were elaborate and magnificent, orchestrated by his loving friends and admirers, from motives of propaganda and policy as well as piety. By mid-August 1564 the decorations for Michelangelo's funeral had been removed to make way for the next memorial service, that of the Holy Roman Emperor Ferdinand.

PART TWO

L'Aurora 1475–1508

2 Birth and upbringing

In a family record book Lodovico di Lionardi Buonarroti Simoni wrote down details of the birth on 6 March 1475 of his second son, using Florentine computation (which dated the beginning of the year from the Incarnation, 25 March, rather than from, as in Rome, the Nativity of Christ):

> I record that on this day the 6th of March 1474 a son was born to me: I gave him the name of Michelangelo, and he was born on Monday morning, before 4 or 5 o'clock, and he was born to me while I was *podestà* of Caprese, and he was born at Caprese: the godfathers were those named below. He was baptised on the 8th day of the same month in the church of San Giovanni at Caprese.

Lodovico appended the names of nine godfathers, the *compari*, present at the christening in the chapel of St John the Baptist. Nine was a large number of *compari*: the contemporary Francesco Guicciardini, born into a grand patrician family in 1483, had only three. Also unusual was the choice of name, Michelangelo, the prince of archangels who weighs human souls on the Day of Judgement.

Lodovico was an anxious, touchy man who liked to put on good appearances. He was thirty-one when Michelangelo was born, and his wife, Francesca, about twenty. They had married in 1472, and their first son, born in 1473, they named Leonardo. In early manhood Lodovico lived in genteel poverty, with an eye diffidently open for the main chance. He was set in the belief that people of good descent should be able to subsist on patronage or rents.

Lodovico's family could trace its descent back to the early years of the twelfth century, but towards the end of the fifteenth century the family was showing signs of having come down in the world. Well known in the Santa Croce district, even as their fortunes declined, the Buonarroti Simoni continued to be privileged citizens, eligible for election to the Signoria, the supreme power of Florence. Although one of the Buonarroti Simoni had been a soldier and another a Dominican friar, dealing in wool and money-changing were the traditional family interests. The twin spurs of money and respectability sustained their pride.

The family had been shamed when Leonardo, Michelangelo's grandfather, failed to find the money for his daughter's dowry in 1449 and

resorted to pledging the house he had on the Piazza dei Peruzzi instead. Lodovico was his son by a second wife, Alessandra di Brunaccio Brunacci. Lodovico was born in 1444 (just a few years before Lorenzo de' Medici), and he was fifteen years old when his father died. He shared his inherited revenues from a farm at the village of Settignano and a little property in Florence with his older brother, Francesco; of their five sisters, one had died in infancy. Married to Cassandra di Cosimo Bartoli, Francesco pursued with scant success a business career like his father's. The household he shared with Lodovico included their mother, Alessandra.

The parents of Lodovico's wife, Francesca, were Neri di Miniato del Sera and Bonda Rucellai. Michelangelo's genius has sometimes been characterized as a kind of miracle, owing nothing traceable to inherited disposition, judging by the lack of evidence of any artistic talent on his father's side. Usually ignored, however, is his Rucellai descent. Giovanni Rucellai – who made a huge fortune from the red dye *oricello*, which gave the family its name – was third cousin to Michelangelo's grand-mother, Bonda, and was a patron of Alberti, who designed the Palazzo Rucellai.

Francesca had brought Lodovico a modest dowry of 416 florins on their marriage in 1472, and in their early married life he sometimes had to pawn their belongings to pay his bills and taxes. His appointment as *podestà* at two little fortified cities, Chiusi and Caprese, in October 1474 meant that Michelangelo was born in one of the remote territories of Florence, in the Val Tiberina.

The office of *podestà* in Florence was founded about the year 1200, when the Commune sought to enhance the impartiality of the adminis-tration of justice by appointing someone from another city to preside over the courts, with authority to convict, pass sentences and execute judgements. The system was extended throughout the domain of the Florentine republic as it expanded (decisively with the acquisition of Pisa in 1406) from the mid fourteenth to the mid fifteenth centuries. A *podestà* originally would be from the noble or knightly class and would carry out military and ceremonial as well as judicial functions, taking charge in wartime of the communal army. In the fifteenth century the *podestà*'s status and rewards varied greatly, depending on the size and importance of the city or even village where he held office and on his opportunity and inclination to milk the system. He might carry the keys of the city gates jangling at his side.

The little family of Buonarroti Simoni spent the first three months of Lodovico's term of office (from October 1474 to March 1475) at Chiusi

in the Casentino and the following three months at the village of Caprese, about seven miles distant. At Caprese, about fifty miles south-east of Florence, Lodovico had his headquarters in a roomy stone building, part town hall, part castle, part farmhouse, which lorded it over the local chapel of St John the Baptist and a scatter of hamlets and farms. It was here that Michelangelo was born.

In early April 1475 Lodovico and Francesca returned with the new baby to Florence, where the family property was provisioned from their farm at Settignano, about three miles to the east of the city. The hills of Settignano, Monte Ceceri and Fiesole, rising from a landscape of vineyards, olive groves and cypresses, had long been exploited for their marble and were intensely farmed and quarried. The sculptors Desiderio (who was skilled in low reliefs and had learned from Donatello) and Bernardo and Antonio Rossellino had been born in Settignano; Antonio lived till 1479. They had produced sculptures of charm and delicacy, a famous sweetness of style like the smiling countryside around Florence, as in Desiderio's *Laughing Boy* or Antonio Rossellino's *Virgin with the Laughing Child*.

At first Michelangelo was brought up in the village by a wet-nurse who was the daughter of a stonecutter and married to one. This fostering may have been because of poor health on the part of Francesca, but for many years Florentines had followed the practice of putting their infant children out to a salaried nurse. Michelangelo was not taken back into the family till he was two or three years old (the date is unknown). By the time he was ten he was living mostly at the family house in Florence. Younger brothers had arrived in regular succession: Buonarroto in 1477, Giovansimone in 1479 and Gismondo in 1481. In 1481 Francesca died, and in 1485 Lodovico remarried, taking home another woman related to a famous family, Lucrezia degli Ubaldini da Gagliano. The new mother brought a dowry of 600 florins.

Michelangelo was an alert, sensitive, intelligent, introspective and quick-tempered boy, prone to sickness, but resilient, with black hair and brown eyes flecked with yellow. In parts brooding and slum-ridden, and wedged alongside the Arno to the south, the Santa Croce quarter, where the Buonarroti family lived, surged with energetic and sharp-witted people. More than elsewhere in Florence, rich and poor were packed closely together, in apartments over artisans' workshops and in tall old houses with courtyards along narrow, shaded streets.

For centuries the quarter had been centre of the wool business, from whose acrimonious class divisions had sprung the fierce but brief

workers' uprising of 1378, the Ciompi revolt. The large piazza in front of the church of Santa Croce itself was used for demonstrations, celebrations and sports from jousting to *calcio*, the Florentine version of football.

The young Michelangelo could attend mass in the vast church, an austere, timber-framed Franciscan foundation, with huge cloisters and a bare stone façade dating from the thirteenth century. Among the family tombs and chapels, monuments and statues with which the enormous interior of the basilica was crammed were Bernardo Rossellino's beautifully modulated monument to Leonardo Bruni (Florence's erstwhile chancellor and historian), Donatello's wooden crucifix, carved in competition with Brunelleschi, and dramatic mural scenes by Giotto and his followers. The only two new chapels to be created for Santa Croce in the fifteenth century were Michelozzo's Medici Chapel and the Pazzi Chapel, built in the 1430s by Brunelleschi.

Michelangelo in boyhood lived through the period of the consolidation and triumph of Medicean power in Florence. Lorenzo de' Medici, the *de facto* ruler, strengthened his political influence through constitutional manipulation and shows of force. Survival of the family influence seemed assured. Piero, Lorenzo's first son (preceded by a daughter and followed by another eight children, of whom three died in infancy), had been born in 1471 and was taught by the scholar Poliziano, as were his brothers Giovanni and Giuliano. He had become the petulant idol of the pro-Medicean populace. After the election of the new pope, Innocent VIII, in 1484, Piero was sent on the official delegation bearing the customary congratulations of the Florentines.

Three years younger than the Medicean prince, Michelangelo was placed by his father about this time in one of the grammar schools which taught Latin to the sons of ambitious Florentine parents. Michelangelo immortalized the name of his teacher, Francesco da Urbino, but learned very little Latin. Francesco da Urbino can probably be given credit for the beginnings of Michelangelo's sense of poetic style and superb defiant penmanship. Michelangelo was soon to be affected by a compulsive urge to draw, copying to equal or surpass the works of others, and obsessed by the ability of painters and sculptors to render human movement and the human form with marvellous verisimilitude in marble, bronze or paint.

While Michelangelo was still with Francesco da Urbino, he came to enjoy a close friendship with a boy several years older called Francesco Granacci (1469–1543), who had worked with Filippino Lippi. Granacci was now a lively and talented apprentice in the workshop of Domenico

Ghirlandaio. The attachment became a fond relationship, fed by Gran-
acci's recognition of Michelangelo's innate genius.

Granacci himself had the talent to develop into a popular and
versatile decorative painter, with a graceful style, in great demand for
carnivals, processions and triumphs. With him, in a way that was
impossible with his three younger brothers and his religiously inclined
older brother, Leonardo, the restless Michelangelo could share excur-
sions, receive recognition from someone older, and respond affection-
ately to generous initiatives. Granacci, who had an easy-going kindly
nature, assisted Domenico Ghirlandaio and his brothers Davide and
Benedetto when the accomplished fresco painter was decorating the
choir of the Dominican church of Santa Maria Novella. Granacci
started to show Michelangelo's drawings, to ask him along to Ghir-
landaio's busy workshop, and to join him in exploring Florence to
discover imitable works of art.

At the workshop, in Ghirlandaio's circle of assistants, boys and
young men, of different grades and backgrounds, Michelangelo for the
first time encountered a multi-layered social world outside the family.
Granacci's timely practical encouragement and Michelangelo's growing
awareness of his vocation disconcerted some of the Buonarroti family,
especially Lodovico. Michelangelo was sometimes punished for his
truancy, and scolded for the very idea of becoming a workshop appren-
tice. Painting and sculpture meant little to Lodovico, and he regarded
the craftsmen who practised them as socially inferior.

The battle of wills was protracted, but the outcome was inevitable.
In the struggle with his father, Michelangelo's granite obduracy and
Granacci's complicity won through. Lodovico had the good sense to
seek and accept knowledgeable advice when he grudgingly agreed that
Michelangelo might train as a designer and painter in the best *bottega* in
Florence. Ghirlandaio was jealous and narrow-visioned, but had influen-
tial connections, and this meant that talented young men working with
him were brought to the notice of the rich and the powerful.

3 The workshop of Ghirlandaio

Domenico Ghirlandaio's family name was Bigordi, as he recorded when he signed his paintings in Santa Maria Novella. The nickname Ghirlandaio came from the attribution to his father, Tommaso di Currado, of the invention of a new kind of ornament, in the form of gold and silver *ghirlandi* or garlands, for girls' hair. Trained as a goldsmith like so many other contemporary painters, the young Ghirlandaio first showed signs of artistic talent when he started drawing people passing by the shop where he worked.

Ghirlandaio was in his mid-thirties when Michelangelo came to his workshop. He had a well-established reputation for being hard-working and expeditious; he was a skilful and willing painter, especially of murals. In Rome he had helped to decorate the huge, bluntly assertive new chapel of Pope Sixtus IV, the Sistine Chapel, built during the previous decade, to the dimensions of the Temple of Solomon. Here he had worked with talented painters from Umbria and Florence, including Perugino, Cosimo Rosselli, Botticelli and later Signorelli.

In 1485, for the banking family of Francesco Sassetti, he decorated a chapel in the Vallombrosan church of Santa Trinita with glowing scenes from the life of St Francis. The frescoes also extolled the virtues of Florence (seen as the new Rome) and the magnificence of the Sassetti's powerful friends, the Medici, who are shown as bystanders in one of the scenes. The altarpiece, a Nativity, dated 1485 in Latin numerals at the top of a Corinthian column and showing the influence of Flemish painting, exemplified Ghirlandaio's mature style in all its harmonious assurance, assimilative skill and dramatic tenderness.

In Florence, Ghirlandaio also contracted to paint the altarpiece for the chapel of the Ospedale degli Innocenti in October 1485, and his resources, disposition and skills made him the inevitable choice by the Tornabuoni for decorating the choir of the church of Santa Maria Novella. The contract was drawn up (before the Sassetti chapel was quite finished) in September 1485, to the 'praise, magnitude, and honour of Almighty God and His glorious Mother, ever Virgin, and of St John, St Dominic and other saints as follows, and the whole host of heaven'.

The contract, between Domenico Ghirlandaio, his brother Davide, and Giovanni Tornabuoni, included the agreement to paint principally

seven episodes of the life of the Virgin on the right-hand chapel wall
and seven more scenes relating to John the Baptist on the left-hand
wall. The contract specifications of scenes and colours (especially as
regards azure and gold) were fairly precise; the selection of 'figures,
buildings, castles, cities, mountains, hills, plains, water, rocks, garments,
animals, birds and beasts' was left to the painters' discretion. Work
on the chapel was to start in May 1486 and be finished in May
1490.

The family business which Michelangelo entered in the spring of
1487, a year after the new frescoes had been started in Santa Maria
Novella, ran an all-male workshop, a typically general-purpose Floren-
tine atelier, where Domenico Ghirlandaio was the driving force. Young
craftsmen were trained on the job, beginning between the ages of about
ten and fourteen, assimilating traditional techniques and familiarizing
themselves with the visual raw material for their design and colouring
work from the workshop's pattern books of nature studies and ancient
motifs, and also from living models. Apprentices seem usually to have
been paid in regularly augmented sums of cash. They would aspire to
running their own workshops in due time. Apprentices also sometimes
served as convenient models, especially as artists in the 1480s came
systematically to utilize drawings after the nude.

The deal made by Michelangelo's father with the Ghirlandaio broth-
ers was entered in the former's record book. It recorded that Lodovico
had apprenticed his son to Domenico and Davide di Tommaso di
Currado 'for the next three years', under the following conditions:

> that the said Michelangelo must stay for the stipulated time with
> the above-named to learn and practise the art of painting, and
> that he should obey their orders, and that the same Domenico and
> Davide should pay him in those three years twenty-four florins of
> full weight: six in the first year, eight in the second year, and ten in
> the third year, to a total of ninety-six lire.

After having apprenticed Michelangelo to the Ghirlandaio brothers,
Lodovico also recorded that on 16 April 1488 Michelangelo had re-
ceived two gold florins and he, his father, twelve lire and twelve soldi
on the boy's account.

Immediately, Michelangelo's association with Ghirlandaio brought
him the opportunity to gain experience of panel painting; later he
acquired the basic techniques of fresco. There was, however, little
rapport between Ghirlandaio and Michelangelo, and there were signs
of jealousy on the part of the former. Michelangelo began to attract

attention to himself in various unorthodox ways. He drew, for example, a pen-and-ink copy of a copper print shown him by Granacci which was from the hand of the German craftsman Martin Schongauer and portrayed the early Christian monk St Anthony being tempted by grotesque devils. Michelangelo was fascinated by the strangely formed demons and monsters assailing the saint, and took pains to ground fantasy on nature by using for his copy the colouring of the scales, fins and eyes of fishes in the local market.

Michelangelo's amazingly retentive memory and sharp eye were soon evident. He filled his notebook with sketches of buildings, landscapes, animals and human figures. His mind and imagination were fed by the many masterpieces in Santa Maria Novella. In the Tornabuoni Chapel, Michelangelo was involved in the first stages of fresco painting, from grinding colours to plastering the walls, preparing the working drawings, or cartoons, and drawing and painting on the wet plaster. Above all, he was thoroughly grounded by Domenico Ghirlandaio in the primary Florentine art of drawing with the pen or brush, in which Ghirlandaio commonly employed cross-hatching, broadly spaced lines and thickened contours.

Michelangelo had few qualms about scrapping his drawings when done, but several of them from this period survive. One, in pen and ink, contains two figures probably copied from Giotto's narrative painting of the Ascension of St John the Evangelist in the Peruzzi Chapel of Santa Croce. Michelangelo studied Giotto's two male robed figures and sketched the main erect figure with more modelled drapery and a firmer stance. With a few lines, he deftly enhanced the sculptural qualities of Giotto's pensive onlooker. Michelangelo was then about fifteen, and had not long been taken up by the most powerful man in Florence, Lorenzo de' Medici – Il Magnifico.

4 Bertoldo di Giovanni: Lorenzo's friend

Having wilfully broken with family tradition to become an apprentice painter, Michelangelo found that the connection with Ghirlandaio placed him in a perfect position to draw attention to his talent among rich Florentines. Ghirlandaio was part of the extended Medicean connection, and it was almost certainly he or Granacci who brought Michelangelo into his first contact with Lorenzo de' Medici not long

after he had begun his apprenticeship. Michelangelo began to see Lorenzo and other members of the Medici family quite often, and was drawn into a wide circle of young Florentine craftsmen of about the same age, including Giovanfrancesco Rustici, Giuliano Bugiardini and the aspiring sculptor Pietro Torrigiano. Michelangelo also came to know for the first time the revered sculptor Bertoldo di Giovanni, the heir and erstwhile pupil of the great Donatello.

Bertoldo, approaching his seventies, was an intimate of Lorenzo, and there has been vague speculation that he was related to Lorenzo by blood. Bertoldo's art was rooted in Florentine traditions. His talent and technique as a sculptor derived chiefly from Donatello, with whom he had loosely collaborated for many years, till the latter's death in 1466. Tied to the Medici, he had been employed chiefly to cast bronze statues, medals and reliefs after the antique, full of motion and drama. To the young men whom he influenced, Bertoldo handed on through his work not only something of the spirit of Donatello, but also the richly rewarding practice, perfected in fifteenth-century Florence, of using – as well as drawings – small models, usually in terracotta or wax, as a basic stage in the creation of sculpture.

Bertoldo was in charge of the Medici collection of works of art, including antiques, in a garden and apartments by the Piazza San Marco, where young craftsmen could go for pleasure and study. It was here, near the great Dominican convent patronized by Cosimo de' Medici, and not far from the Medici Palace on the old Via Larga, that Michelangelo began to practise sculpture, in stone rather than the bronze preferred by Bertoldo, and captured the esteem of Lorenzo de' Medici.

Among the students who frequented the garden, Michelangelo encountered the first overt resentment of his talent and temperament, and provoked an outburst of violence springing partly from soured friendship.

Pietro Torrigiano, three years older than Michelangelo, studied and worked in the gardens, moulding figures in clay under Bertoldo's guidance. When Michelangelo began to do the same, Torrigiano at first befriended him, but soon grew jealous of his skill and the ready favour he found with Lorenzo. Torrigiano was big, handsome and boastful. Michelangelo was quick and scornful.

After a series of squabbles, Torrigiano gave vent to his feelings by assaulting Michelangelo with a blow that broke his nose. The attack took place in the chapel painted by Masaccio in the church of the Carmine, where they customarily went with others to study and draw.

Torrigiano came to boast that Michelangelo would carry his signature all his life. His not unconvincing excuse was that Michelangelo was in the habit of teasing anyone else who was drawing in the chapel and had provoked him intolerably.

Meanwhile, Michelangelo had been given his own room in the Medici Palace, was being paid an allowance of five ducats a day, and received from Lorenzo the special gift of a violet cloak. Lorenzo, perhaps chiefly to please Michelangelo himself, had sought permission for these arrangements from Michelangelo's father, who, after having protested to Granacci that he would not like his son to become a stonemason, now stammered out in Lorenzo's presence that not only his son but his own life and all he owned were at the disposal of Il Magnifico. Later, Lodovico requested from Lorenzo and was granted a post that had fallen vacant in the custom-house. 'I know nothing except how to read and write,' he said. 'I am very suitable for that post.' Lorenzo, having expected him to ask for rather more, remarked, 'You'll always be poor.'

Bertoldo, who had grown almost inseparable from Lorenzo, died in December 1491. Domenico Ghirlandaio died in 1494, leaving his brother Davide and son Ridolfo to continue the family business. And the shadows were beginning to fall on the court of one of the many other influences in these critically formative years: the elusive, complex Lorenzo de' Medici himself.

5 At the court of the Medici

Lorenzo de' Medici's patronage sharpened the social sensibilities and independent spirit of a boy strongly affected by his father's claims of noble descent and disdain for living through craft or trade, which were transmuted into Michelangelo's obsession with his family's status and well-being and rejection of the conventional artist-manager role of keeping shop. The customs and ceremonies of the Medici family provided Michelangelo's continuing informal education.

The Medici family bridged the worlds of finance, politics, letters and fine arts. Lorenzo, like his grandfather Cosimo – *Pater Patriae*, the banker turned politician – loved, studied and even practised architecture. In 1485, for example, a time when he was reading Alberti's architectural treatise, he supervised the design (then commissioned

from Giuliano da Sangallo) of a new church in Prato, Santa Maria delle Carceri. Lorenzo's eye for sculpture was also enlightened, judging by his far-sighted commissions, including Antonio Pollaiuolo's small bronze Hercules and Antaeus.

A discriminating, avid and generous collector of books and student of literature, classical and Tuscan (in which Dante was his star), Lorenzo wrote prolifically all his life. His curiosity ranged from medicine to magic. But his emotions were principally engaged by poetry. The example of his adored and dutiful mother, Lucrezia Tornabuoni, was important, for she encouraged poets such as Luigi Pulci, and also wrote stylish religious verse herself. The many poems attributed to Lorenzo roam uninhibitedly over the libidinous and the sacred, and exemplify the Florentine capacity to embrace extremes in ideas and emotions, as in behaviour.

Words even more than weapons were part of the Medicean political armoury. When he wrote warmly defending the use of Tuscan vernacular for writing his sonnets, Lorenzo remarked that as the language evolved to greater perfection it would, to the delight of good citizens, also enhance and augment the Florentine *imperio*.

Lorenzo de' Medici was nearly forty when he called Michelangelo to live at the Medici Palace. There Michelangelo found a domesticity as intense as, but of course much more varied and cultivated than, the one he had left. After the death of his gentle, obedient wife, Clarice Orsini, in the summer of 1488, Lorenzo, despite pressures of public business, drew closer than ever to his children. By now, two of them, Lucrezia the eldest and Piero the second, were married. Lorenzo's clever, circumspect second son, Giovanni, was some months younger than Michelangelo. Destined by his father for the Church, he had received the tonsure at seven and already, in the spring of 1489, had formally been nominated a cardinal. (The corrupt and incompetent reigning pope, Innocent VIII, prudently wanted to keep this quiet for the time being, but the exultant Lorenzo broadcast the news, and the family's supporters lit bonfires all over Florence.)

Within Michelozzo's stylistically influential Medici Palace, with its huge cornice of travertine, two courtyards, great vaulted cellars, loggias and many fine living and reception rooms, Michelangelo was given his own room and mixed on terms of guarded familiarity with Lorenzo and his family. Michelangelo formed a lasting attachment to Lorenzo. He absorbed the literary and scholarly values both of the head of the family himself and of the select circle of scholars and writers who frequented Lorenzo's villas and houses.

Well established in Lorenzo's entourage of bright and ambitious scholars when Michelangelo came to its periphery were Pico della Mirandola and Francesco Catani da Diacceto, who both exemplified the restless, curious diversity of contemporary philosophy as it sought to revivify Christian tradition with exotic strains of thought. Pico had recently found refuge in Florence when one of his works (*Conclusiones sive theses DCCCC . . .*, or *Nine Hundred Conclusions*) was condemned by the Inquisition. This nobly born, precocious syncretist sought to harmonize the Jewish cabbala with Christian theology, burned five volumes of his own Latin verse in self-dissatisfaction, wrote a book against astrology, and passionately glorified freedom of choice. For Pico, man constituted a microcosm free to find his own place in the universe, to rise or fall.

The priest Marsilio Ficino was the best-known and oldest contemporary Florentine teacher and philosopher. Fair-haired, with furrowed brow, a slight stammer and hunched shoulders, he had hardly ever left Florence after his arrival as a student from Figline in the Val d'Arno except for visits to the Medici villa at Careggi, near which he had been given a farm and dwellings by the Medici. The son of a doctor, and prone to depressions and illnesses, but amiably disposed and sociable, Ficino was already writing philosophy by the time he was twenty-one (in 1454); soon after he began to learn Greek to further his understanding of the works of Plato, his 'father of philosophy'.

Ficino's book learning was prodigious: from Plato (he had finished the first complete translation into Latin of Plato's dialogues by 1469) to books by the followers of Plato in the ancient world and the apocryphal works of Hermes Trismegistus, Zoroaster, Orpheus and Pythagoras, and Christian writers including St Thomas Aquinas. After translating Plato, he wrote a commentary on Plato's *Symposium*, *De amore* (*On Love*), and his own *magnum opus*, *Theologia Platonica de immortalitate animae* (*Platonic Theology concerning the Immortality of the Soul*), which he finished in five years. The friends and followers around him formed a kind of academy of modern learning, the Platonic Academy.

The Academy, in a city whose own university had been ignored by the Medici in favour of the University of Pisa, played a subtle role in the psychological drama of Florentine politics. Ficino's ascription to Cosimo de' Medici of the idea of the Platonic Academy was part of the magnification of the cultural, religious and political eminence of Cosimo which helped Lorenzo de' Medici look to his grandfather as a noble by talent and virtue if not by birth. Platonic sentiment, through Ficino's brilliant mediation, also provided an ideological, ethical and educa-

tional system for young Florentines during a period of increasing Medicean dominance. The Platonic path, with its advocacy of the contemplative life, was the way forward for many Florentines seeking reassuring and unifying answers to social and political tensions.

Several grand concepts at the heart of Ficino's thought appealed in Florence for both aesthetic and ideological reasons. One was that beauty was the way to God. 'The soul, consumed by the divine brilliance which shines in the beauteous man as though in a mirror, is seized unknowingly by that brilliance, and is drawn upward as if by a hook.' But, whether of a girl or a man, the body's beauty was just the shadow of the soul's. And to attain true happiness man must make the ascent by intellect and will through knowledge and love 'from the material of the elements, to immaterial heaven, to the soul without dimension, to the angel world without change, and to God: substance without attribute'.

Ficino began in his lifetime to become something of a model and a legend, for his frugal lifestyle, for his well-ordered feasts, for his restrained fondness for wine, for his conversation and witticisms, for his family piety, and for his many chaste and loving friendships – like those of Socrates, who also used to debate vehemently with young men on the subject of love.

Through his friendship with Lorenzo and Lorenzo's second cousin, Lorenzo di Pierfrancesco, Ficino may have exercised influence on some of Botticelli's paintings. But he had little correspondence with artists of any sort, and little to say directly about painting, sculpture or architecture. For the influence of Ficino on Florentine art we must look to the stimulus he and his friends provided by their portrayal of man as an imitator of the works of divine nature.

Among the scholars and poets of Laurentian Florence, Angelo Poliziano offered Michelangelo the closest practical friendship and inspiration. At the height of his creative powers, not so old as Ficino nor so rarified as Pico, Poliziano had been tutor to Piero and Giovanni de' Medici for a few years from 1475 (till their mother quarrelled with him over their lessons). In 1490 Poliziano with Piero de' Medici was helping reorganize the Medici library, for which Lorenzo was lavishly buying or having copied as many as he could secure of the books it lacked. His access in all senses to great works of learning and literature was unique.

Poliziano's portrait, as done by Ghirlandaio, first in the murals for Santa Trinita and a few years later in those for Santa Maria Novella, shows a man of intense appearance, raven-haired, with a fleshy face, a

craggy nose and a zealot's expression, gesticulating (in the latter paint-
ing) as he converses in an animated group. Poliziano shone as a
philologist, translated ancient Greek into perfect Latin, and wrote good
poetry. As well as achieving great success with his *Giostra* and *Orfeo*, he
turned his pen to minor verse, whose freshness, delicacy and wit seem
spontaneous. He expounded the classics, and through his poems showed
how the images, allegories and myths found in Lucretius and Ovid,
Horace and Tibullus and the Homeric stories could be subtly adapted
to satisfy and delight modern sensibilities.

There were no important sculptors working in Florence during the last
years of Lorenzo de' Medici. Leonardo da Vinci, who claimed compe-
tence in nearly every art and science, was at the court of Milan. In the
Medici Palace there was only Bertoldo, fashioning bronzes, looking
after Lorenzo's antiques and reminiscing about Donatello. The field
was open.

 Among Bertoldo's most spirited works was a bronze relief of horsemen
in battle, based on a Roman sarcophagus at Pisa, showing figures of
horses and soldiers, some mounted and helmeted, others naked and
unhorsed, in a balanced flurry of weapons and limbs. Michelangelo
chose a similar theme for one of his first, astonishing, exercises in
marble relief: a battle of men and centaurs. This dramatic work
contrasted remarkably in theme and composition with another highly
finished shallow marble relief he executed at about the same time,
showing a Madonna seated on steps; he seems to have kept both of
these for himself.*

 The Madonna relief shows a monumental nursing mother, haloed,
elaborately draped, in heroic profile. She is seated on a massive-looking
square block, staring into space; a boy-child is being suckled with head
turned away and his relaxed Herculean back and muscled arm promi-
nently displayed. The outstretched arms of one of three wingless putti
form a cross with the stone baluster as he gathers up a winding-sheet.
Through the powerful mother's large hands and agitated draperies and
the infant's head, shoulder and curling fingers, a circle of energy whirls
round in the centre of the creamy marble. This portentous work thus
combines majestic, almost sepulchral stillness with powerful movement
and life.

 Michelangelo's high-relief carving of the battle of the centaurs also

*Both in the Casa Buonarroti, Florence. The *Madonna of the Stairs* measures
22 inches by $15\frac{3}{4}$ inches, and the *Battle of the Centaurs* $33\frac{1}{4}$ inches by $35\frac{5}{8}$ inches.

combines pulsating energy with a sense of still timelessness. The theme was suggested by Poliziano, who was always ready to encourage and stimulate him. The small, highly polished but unfinished relief shows part of a mêlée of athletic male nudes linked in close embrace, with set faces and sensually expressive bodies. A virtuoso exercise in the portrayal of the lineaments and facets of the human body, the seething composition shows one figure crouching in despair, and an ambivalent figure with arm imperiously raised creates a dynamic circle in the centre of the picture.

In carving the marble, Michelangelo used his claw-chisel to attack the block from different directions as he re-created the shapes in his mind, and so produced a mesh of criss-cross lines like the pen strokes he had been practising as a draughtsman to enhance his shading.

An educated contemporary would have noticed the varied sources on which Michelangelo had drawn so confidently and imaginatively. The Madonna relief followed Donatello in its shallow carving and in the use of small figures on the stairs and leaning over the balustrade; the form of the Virgin echoes the grief-stricken women on the tombs of the ancient Greeks. The struggling male nudes of the battle scene would have brought to mind Antonio Pollaiuolo's bizarre, anatomically didactic engraving of a battle of naked men, and the pulpit sculptures at Pistoia by Giovanni Pisano, as well as Bertoldo's bronze. But the two marble reliefs simultaneously exploited and defied all these traditional presentations, offering a revolutionary artistic programme no one could as yet take up.

Michelangelo's prowess as a sculptor was well-known and attested by 1492. Now in his late teens, he already knew the particular direction of his vocation. He would be a sculptor, and his marble sculptures would express the beauty of the human body and the dutiful love of God. He would look for employment and patronage to the Medici family, which had recognized and fostered his calling.

With the death of Lorenzo de' Medici in 1492, Michelangelo lost his first important protector and patron, and Florence relinquished all hope of peace. The event was fateful for the whole of Italy, which since the Peace of Lodi in 1454 had been kept relatively calm through Lorenzo's diplomatic skills. Nature itself seemed to many Florentines to recognize the momentous character of Lorenzo's passing. A few days before, the lantern of the cathedral had been struck by a thunderbolt from a cloudless sky and split almost in two, causing a hail of falling marble and masonry. Luckily, it had been late at night and not at the

time of the morning mass, when a regular sermon attracted many thousands of people. It was said that Lorenzo, lying ill at his estate of Careggi, was told that the thunderbolt had fallen on the side of the cathedral towards the Medici Palace, and took this as a sure sign of his death.

Three times at least during his life Lorenzo had escaped assassination, always a threat through the family's political exposure. In the end, he succumbed to the effects of gout after an agonizing illness. He left everything in order except the state of Florence. For his favoured son, the plump and purposeful Giovanni, the cardinal, he had written a letter of shrewd fatherly advice. Giovanni was admonished to set a good example to the whole world and collect antiques and scholarly books rather than acquire silk and jewels, and above all to rise early each morning, for this would not only benefit his health but also enable him to arrange and expedite all the business of the day.

Lorenzo had discussed the political future of Florence with his eldest son, Piero, assuring him that the Florentines would recognize him as his successor. Poliziano stayed by him constantly, and he was also visited by Ficino and by Pico della Mirandola, who consoled him with reports on the progress of his wonderful library and on the shipment of manuscripts from Greece.

A dramatic appearance at the villa of Careggi was made by the swarthy Dominican friar Girolamo Savonarola, creating a deathbed scene of rare irony between two men who both possessed and exploited power, but in richly contrasting ways.

Originally from Ferrara, Savonarola had won a formidable reputation as a preacher, theologian and holy man chiefly through his lectures and sermons in Florence. At Lorenzo's request, Savonarola had been appointed lecturer in logic and, in 1491, prior of the Medici's own lovingly endowed convent of San Marco. Through the stark language he used, his hell-fire denunciations of luxurious and sinful living, and his gradual insinuation of the messianic role of Florence, Savonarola had been gaining a mass following among the populace. He had friends in high places, including, as well as Pico della Mirandola, several writers and poets in Lorenzo's circle, such as the poet Girolamo Benivieni and his brother Domenico, who once gently criticized the friar to his face for his bad pronunciation and uncouth gestures. Savonarola's apocalyptic calls to repentance were linked to specific prophecies: that the Church was to be scourged, that it would then be reformed, and that these events would happen soon.

At Lorenzo's death, Savonarola was in the middle of his series of

Lenten sermons in San Lorenzo, the family's parish church, criticizing rulers and their flatterers, prophesying the scourging of Florence and the reprobation of Rome. Just after Lorenzo had received the sacraments, the friar came to his bedside. The encounter was bound to inspire dramatic legends. According to these, when Lorenzo looked up at the cowled figure whose dark grey eyes could emit red flashes and whose thick lips and aquiline nose dominated features of a strength and dignity comparable to his own, he was refused absolution for his sins of pillage, robbery and vengeance unless he manifested great faith in God's redemptive mercy, returned his allegedly ill-gotten gains, and (this being demanded in awesomely resounding tones) restored liberty to the Florentines. Having assented to the first two conditions, on hearing the third Lorenzo turned his face away from Savonarola in despairing defiance.

It is more likely, however, that Lorenzo asked for and received Savonarola's blessing, and was gratified by the visit. Very soon after, he kissed a crucifix, fell back, and died. This was on 8 April 1492. The same night, his body was taken to San Marco, and on the evening of 10 April he was buried in the sacristy of San Lorenzo.

Savonarola, continuing his sermons after Lorenzo's death, had a vision (commemorated in medals by the Della Robbias) of an arm in the heavens clasping a sword inscribed with the words of prophecy, the Lord's terrible, swift sword: *Gladius Domini super terram cito et velociter*. He heard the voice of God calling mankind to repent, and perceived clouds of white-robed angels descending to earth with red crosses and white robes which the wicked refused, and as the sword was turned towards the earth he saw, after thundering and lightning, the world assailed by plague, war and famine.

At the very beginning of 1492 the Moorish capital of Granada was captured by the forces of the newly united Christian monarchy in Spain; after eight hundred years the Muhammadan grip on the Iberian peninsula was at last removed. The news was received with jubilation in Rome.

In July 1492 Pope Innocent died; and a month later the wealthy and ebullient Spanish–Italian Cardinal Borgia, just into his vigorous sixties, was elected his successor. In November the Florentine apothecary and diarist Luca Landucci noted the names of the ambassadors sent to Rome to visit the new pope: Piero de' Medici, the bishop of Arezzo, Pier Filippo Pandolfini, Francesco Valori and Tommaso Minerbetti. 'They went in fine array, especially Piero de' Medici.'

Piero had succeeded without open opposition to the headship of the family and the effective rule of Florence. His brother Cardinal Giovanni came back from Rome to join him. He had to attend to some frictions within the Medici family itself (less manageable after the loss of Lorenzo's controlling hand), the jealousies of two members of the younger branch of the family, Lorenzo and Giovanni, sons of Pierfrancesco.

Michelangelo stayed at his father's house, grieving and inactive for some days after Lorenzo's death. His brothers were all still at home, save for Leonardo, who was in Pisa, where he made his profession as a Dominican friar in July 1492. Michelangelo's relations with his father were helped by Lodovico's satisfaction over his post at the custom-house, which he retained under Piero, and by the continuing favour shown to Michelangelo by the Medici. Piero sent for him sometimes to ask his advice about buying cameos and engraving stones.

But all was changed. Bertoldo was dead, and there was little sign that Piero had the wit or the will to make use of Michelangelo as sculptor or painter. On record as the one work he commissioned from Michelangelo was, startlingly, a snowman. There had been a heavy fall of snow in Florence, and Piero remembered Michelangelo when it came into his mind to want a snowman. Piero then invited him to return to the Medici Palace and have back the room he enjoyed when Lorenzo was living, but it was not to be for long. Michelangelo's snowman disappeared with the thaw. Piero's attitude towards him was amused, ambivalent. He was heard to remark that the two men of the greatest worth in his household were his handsome, athletic Spanish groom and Michelangelo Buonarroti.

6 The French, the friar and
the flight to Bologna

Michelangelo was the oldest and most responsible of the brothers left in Florence when Leonardo joined the Dominicans. After the death of Bertoldo and, a few months later, of Lorenzo de' Medici, on his return home to live with his father and Lodovico's second wife, Lucrezia, and with his three younger brothers, all under sixteen, he had no wish to

belong to a workshop. He was still too young, even if he had the inclination, to start his own. He had a desperate need for a new patron if he were to build on his precocious success as a sculptor.

While he was with his father, struggling to earn money to support himself and to supplement the family's income, Michelangelo could afford to buy only a block of marble which had been left out in the open and was rather weather-beaten. When he finished the piece, which would have taken several months, perhaps a year, it went to the *palazzo* then being built for the rich Strozzi family, second in reputation and influence to the Medici. Filippo Strozzi, who had died in 1491, leaving a very young son, had advised and worked with Lorenzo de' Medici; but, as great patricians, the Strozzi were a restraining influence on Medicean dominance, and in early life Filippo had fiercely opposed the Medici. When he died (and was given a princely funeral), his magnificent palace had been built only to as far as the *campanelle*, the large iron rings for tethering the horses.

Michelangelo's statue, for which he made one or more models, stood about eight feet high and was of the classical hero Hercules, recognized by his club and seen as the symbol of the independence of Florence, the embodiment of the virtue of fortitude.* For inspiration, Michelangelo looked back to antiquity, beyond Donatello's influential nude David, itself another, biblical, symbol of Florence's defiance.

A further stage in Michelangelo's search to understand the organic processes of human bodies was to embark on the dissection of corpses. The Church did not forbid, but was chary of allowing, the dissection of dead bodies. Michelangelo's intensity of purpose and proven talent impressed Niccolò Bichiellini, the prior of Santo Spirito, and he gave Michelangelo access to the dead bodies awaiting burial in the nearby hospital.

The study of human anatomy by dissection was the logical result of the desire to represent the human body, as ancient sculptors were admired for doing, in ways that made it appear truly alive and functioning. Pollaiuolo's copper engraving of naked men in combat encouraged the belief that he had flayed many corpses so as to depict nerves and muscles in their proper form and place. Leonardo da Vinci, in order to achieve anatomical correctness, copied from casts and also went on to use dissection in the 1490s, chiefly impelled by his zest for natural science and his intellectual curiosity. Both practical and

* The Hercules eventually went to France and was then lost.

perfectionist, Michelangelo used dissection to explore beneath the surfaces of the body and so to test his keen observations of the nude against the structural truth.

The prior who gave him the chance to practise dissection, and put some rooms at his disposal, also commissioned from Michelangelo a carving of the crucified Christ. The wooden crucifix was made for the high altar of Santo Spirito. Michelangelo carved the body of Christ slightly over life-size, in poplar, and painted it in polychrome, with trickles of blood running over the faintly olive-complexioned flesh from the pierced side and the drooping head.

In religious art, the Church had long allowed the depiction of Christ on the Cross as a naked man. Michelangelo's languishing Christ was reminiscent of the tender images of the still living woodcarver-turned-sculptor Benedetto da Maiano. But not seen before was the combination of soft and dramatic elements, expressing extreme pathos through anatomically subtle tension and movement in the limbs and torso and deftly portrayed restraint and bitterness in the face.

All the while, since Lorenzo's death, Michelangelo's relations with Piero de' Medici remained sterile, despite Piero's apparent readiness to extend the same kind of patronage as his father. There was no mutual attraction. In any case, as the French king Charles VIII threatened to march into Italy to make good his claim to Naples, and as Savonarola, for Lent 1494, preached in the church of San Lorenzo about the mystical ark in which the people of Florence might hope to find refuge from the inundation from abroad, there was not much hope of a commission from Piero or anyone else.

By August 1494 Charles had assembled an army at the foot of the Alps. After conferring with Lodovico Sforza of Milan, he advanced into Tuscany and attacked the Florentine town of Fivizzano, sacking it savagely. Months later the French army, which had been reinforced by Swiss mercenaries, then moved through the snow against the solid fortress of Sarzana. Its captains might have expected to encounter tough resistance, but, before the attack began, Piero de' Medici, dramatically reversing his anti-French policy, rode under safe conduct to Charles's camp. He meant to achieve a triumph of diplomatic compromise after the style of his father, whose personal initiatives had more that once saved the peace, but he lamely accepted all the king's demands, to the surprise of the French. There were expressions of outrage in Florence, but many, all the same, hoped gratefully that

Charles had been appeased. Piero de' Medici prepared to receive the king of France in the Medici Palace itself.

As the winter approached, the Florentines had waited fearfully for the arrival of the French army, the message of Savonarola's thunderous sermon of 21 September in the cathedral echoing in their ears: 'And behold, I, even I, do bring a flood of waters upon the earth.' Pico della Mirandola, who was in the congregation, shuddered and felt his hair stand up on end as the friar spoke. A few days later his fellow scholar Poliziano, Michelangelo's mentor, died. Soon after, Michelangelo quit Florence.

Michelangelo may have feared incurring guilt by association as the tide of feeling in Florence began to run more and more strongly against the dominant Medici family and Piero's policies. There was nothing extraordinary in Michelangelo's decision to go to Bologna and on to Venice, which was a magnet for the ambitious, the talented and the disaffected. However, as well as apprehension about the régime in Florence, an incident involving Michelangelo, Piero de' Medici and a lute-player known as Cardiere also drove him to run away.

Cardiere confided to Michelangelo a vision in which the dead Lorenzo had appeared to him wearing just a black cloak over his naked body and commanded him to tell Piero that he would soon be permanently driven from his home for his vices. Michelangelo urged Cardiere to tell Piero about this, which he did, after the ghost had made another appearance and boxed his ears for disobeying. Encountering Piero about a mile from Florence as he was returning on horseback from his villa at Careggi, Cardiere explained what he had seen and heard, and was mocked by Piero and his grooms and his young chancellor, Bernardo Dovizi, who plausibly argued that Cardiere must be mad, since if Lorenzo were to appear to anyone it would surely be to his own son. A few days later, with two friends – possibly Granacci and Cardiere – Michelangelo set off.

Venice proved disappointing, perhaps through lack of acceptable work; as Michelangelo was paying his companions' expenses and running out of money, he left with them for Bologna and possibly home. On their arrival at Bologna the three young men were detained because of some infringement of the regulations. They were hauled off to the licence office and fined fifty lire. While they waited, unable to pay, they were seen by a prominent Bolognese citizen (who was politically active on the government's Committee of Sixteen) called Gian Francesco Aldovrandi. Michelangelo especially seems to have

caught his attention. At any rate, after they were free, Aldovrandi asked Michelangelo to stay with him. Aldovrandi was captivated by Michelangelo's Tuscan accent, and his intelligence, and in the evenings liked to listen to him reading aloud, chiefly from the Tuscan writers Dante and Petrarch, sometimes Boccaccio.

Fifty miles to the north of Florence, Bologna enjoyed an autonomous artistic and political tradition. In 1494 it was ruled by Giovanni II, a *condottiere* whose influence in the city was comparable to that hitherto wielded, more subtly, by the Medici family in Florence. Giovanni was fanatical about his horses from Spain and Barbary, the gardens of his arcaded palace, his family's future.

For invaders from the north, the most convenient route south was through the Romagna, to which Bologna's strength could bar the way. Giovanni, whose loyalty was sought by Naples and Florence, France and Milan, played for time till the French forces passed by.

One of Bologna's great living artists, much influenced by the school of Ferrara, was the handsome, sociable goldsmith Francesco Francia, who was in great demand as a medallist and worked beautifully in niello. He was master of the mint of Bologna when Michelangelo arrived, and had begun painting in the 1490s, during his forties.

Michelangelo was more interested in the sculpture to be seen in Bologna, produced mainly by visiting craftsmen, including the sarcophagus of St Dominic, carved by Nicola Pisano and his pupils in the late thirteenth century. The tomb was surmounted by a marble pinnacle carved between 1469 and 1473 by Niccolò dell'Arca, who had died in 1494, leaving the work unfinished. The west door of San Petronio, the huge Dominican church in the main square, was decorated with stone reliefs and statues by Jacopo della Quercia from Siena, a contemporary of Donatello. For Michelangelo, the wealth of sculpture, especially the robust work of della Quercia with its reminders of Donatello's virtuosity and its linear emphasis on muscular bodies, provided new material for absorption and emulation.

When he was showing Michelangelo the church of San Domenico and the unfinished tomb, Aldovrandi asked him whether he would have the courage to undertake the missing statues: two marble figures of saints, Petronius and Proculus, and a second kneeling angel, each about two feet high. Michelangelo agreed; Niccolò dell'Arca's graceful, demure, feminine angel was soon complemented by Michelangelo's, a creamy winged figure with elaborate drapery and a strong, live presence. Above, Michelangelo, again using drapery dramatically, made in the two saints sharply contrasting images of age and youth, both in

arrested movement. The statues demonstrated growing technical mastery of detail and form.

Once Michelangelo had finished the little statues for San Domenico there seemed few prospects for fresh commissions, and a row was brewing between him and a Bolognese sculptor who alleged that the commission for the statues had first been his. With the threat of violence in the air, in the winter of 1495 Michelangelo returned to Florence, where the feuds and violence he had feared as the French were advancing on the city had run their course.

7 The fall of the Medici • Michelangelo in Rome

Piero de' Medici, like Michelangelo, had fled to Bologna and then to Venice in the fateful year 1494, followed by his brothers Giovanni and Giuliano. He was received in Venice reluctantly but respectfully, being given permission, for example, to wear his sword about the city.

In the year from April 1494, when Charles VIII was mustering his army, to the following April, when the Italian states were at last able to proclaim the formation of a league for their own defence, the heads of the Italian powers pursued policies of crafty and cowardly self-interest. The militarily strong Venetians remained watchfully neutral. In Milan, the guileful and determined Lodovico Sforza – Il Moro – helped the French king on his way with counsel and commodities, and exploited the conflict to consolidate his *de facto* control of the duchy's wealthy and extensive territories. Having usurped the position of regent from the mother of Gian Galeazzo Sforza, he took despotic power and subsequently the title when the young duke died.

Manoeuvring to pacify and maintain the papal territories, the new pope, Alexander VI, on the eve of the French expedition against Naples, allied himself with Venice and Milan and alternately affronted and appeased Ferrante, king of Naples. After Ferrante's death, Alfonso of Calabria, his son, was crowned in Naples in May 1494 by Cardinal Juan Borgia, the second of the pope's four children. Alfonso was brutal and vigorous, an intelligent patron of architects and a competent soldier. The preparations he made to forestall the onslaught from the north included the dispatch of ambassadors to Constantinople, to

secure aid from the Turks, and the hiring of several mercenary commanders.

The Italians concentrated their Neapolitan–papal forces on the eastern route through Italy, but the French, perhaps to take advantage of Florentine ambivalence, outflanked them by marching over the Apennines down the western route. Charles entered Rome just after Christmas 1494. In February 1495 Naples was taken by storm after a few hours' fighting, and Charles had himself crowned king of Naples, emperor of the East, and ruler of Jerusalem. However, his rule in Naples was short-lived. An alliance against the French was formed between the Venetians, the pope, the Holy Roman Emperor Maximilian, Lodovico of Milan and King Ferdinand of Spain, who held Sicily and was determined to frustrate French ambitions in Naples. The League of Venice marked not the Italians' rediscovery of the importance of internal unity so much as confirmation of the country's inability to fend for itself against aggression without allies from abroad.

Charles hurriedly withdrew part of his army from Naples in the summer of 1495, and was surrounded near Fornovo by confederate forces under the *condottiere* Francesco Gonzaga of Mantua. The French troops were well outnumbered, wearied from the long march north, and weakened by disease; but they forced their way through the enemy cordon and, after a furious counter-attack, continued their march. The Italians plundered the French baggage train, blamed their failure to pursue the retreating French on rains that flooded the river, and claimed a victory. The marquis Francesco Gonzaga celebrated his dubious triumph by ordering from Andrea Mantegna a glorious oil-painting of the Madonna enthroned, with a portrait of himself bearded and in burnished armour kneeling at her feet.*

The Italian league against the French broke up when King Charles came to terms with Lodovico Sforza and returned home. In Naples, the Aragonese dynasty was re-established, thanks to Spanish power. Florence remained in isolated turmoil, fighting a bitter, protracted war to regain Pisa, which had seized its independence after the arrival of the French in the winter of 1494.

King Charles had been welcomed tumultuously when he entered Florence for the first time on the evening of 17 November and made his headquarters the palace recently vacated by Piero de' Medici. His popularity soon waned. Meanwhile, on 25 November articles of

* Now in the Louvre, Paris.

agreement were signed providing for a generous loan to the king and the return of Pisa and other strongholds to Florence. When Charles left Florence on 28 November, it was said that it was in response to a warning that God willed it so, delivered personally by Savonarola.

The flight of Piero de' Medici led to a frenzy of constitution-making. Political divisions between the supporters of Savonarola (the *frateschi*), the partisans of the Medici, the upper-class opponents of both and the anti-Savonarola republicans were complex and fluid. The most important element in the new constitution as it emerged in December 1494 was the Great Council, set up partly in emulation of Venice and partly as a return to the earlier Florentine practice of popular government.

Whether you were for or against Savonarola was the main political question in Florence after the Great Council was established on the Aristotelian lines he recommended. For a while Savonarola dominated the emotional and political life of the city.

Savonarola imposed a régime of austerity and exaltation. Public games, such as the *palio*, were suspended. There were new laws to suppress immodest dress and conduct, hymns instead of carnival songs, religious processions in place of worldly festivals. Disappointed in the response of laymen and priests to his clamour for reform, Savonarola began to organize his alms-giving processions with boys trained to shame the citizens through their disciplined piety and to sustain visible political support for the increasingly beleaguered prophet.

In two carnivals, great bonfires on the Piazza della Signoria consumed the 'vanities' of Florence. Landucci's diary entry of 27 February 1498 read:

> On the Piazza de' Signori was made a pile of vain objects, such as nude statues, boards for games, heretical books, Morganti, looking-glasses and many other vain things, all very valuable, and reckoned to be worth thousands of florins. The procession of boys was made as the year before: they collected in the four quarters, holding crosses and olive-branches, each quarter drawn up behind its tabernacle, and each quarter went in the afternoon to burn its pile. Some disapproving people caused trouble, throwing dead cats and other rubbish on it; however, the boys set it alight and burned it all.

Savonarola inevitably fell foul of the papacy. Pope Alexander VI, partly pushed by Lodovico Sforza for political reasons, began to move against him in the summer of 1496 with a brief calling him to Rome.

After Savonarola had defied successive papal briefs forbidding him to preach, he was excommunicated in a papal bull published in Florence in June 1497. On 23 May the following year, after the pope had threatened to place Florence under an interdict, Savonarola was tried, tortured, condemned to death and executed by hanging and then burning on the Piazza della Signoria. Charles VIII had died from knocking his head against a low beam in an ill-lit gallery the previous month. He was just twenty-nine. The Florentine republic was now rid of both the prophet and the king.

The period of Savonarola's insecure and uneasy domination of Florence produced a new constitution, and plans to build a great new hall for the Grand Council. But it was a dismal time for practice of the arts. These were years of food shortages, conspiracies and military alarms, recurrent outbursts of plague, and the frightening appearance of a new disease (noted by Landucci as 'French boils') which galloped through the city in 1496: the syphilis carried from Naples and spread throughout Europe by Charles's troops.

Fra Bartolommeo, monk and painter in Savonarola's convent of San Marco, was inspired by Savonarola's religious teaching in several paintings, including an altarpiece commissioned twelve years after the prior's death for the new Hall of the Great Council. The fate of not a few works of art, and artists, was decided by the French invasion. Discerning looters in the expedition of the French king took back examples of Italian art for emulation in France. Donato Bramante, who turned from painting to architecture at the munificent court of Lodovico Sforza, went to Rome to build fountains for Pope Alexander VI only in 1499, when Milan lost its independence to the French. His friend Leonardo da Vinci lost the metal for the great bronze horse he was making for Lodovico in 1494, when it was diverted to Ferrara to make cannons to use against the French, but he also stayed in Milan until 1499. Lodovico's proclaimed 'victory' at Fornovo was depicted by Leonardo in the Castello at Milan. Among portraits done of Charles VIII in Italy was one showing the king as protector of Pisa, by Davide Ghirlandaio. Michelangelo's friend Francesco Granacci later did a small painting of the entry of King Charles into Florence.* But most of the works of art produced as a direct result of the invasion of Italy by the French in 1494 were ephemeral.

* * *

*Now in the Palazzo Medici-Riccardi, Florence.

When Michelangelo came back to Florence from Bologna in the winter of 1495, Charles VIII had just returned to France and the household effects of Piero de' Medici had finally been auctioned in Florence. Michelangelo needed a patron, and there was at least one waiting for him in Florence: a member of the Medici family who, with his brother, had prudently changed his name to Popolano.

Lorenzo di Pierfrancesco de' Medici and his brother Giovanni were the grandsons of the brother of Cosimo de' Medici and were aged respectively thirty-two and twenty-eight in 1495. They had grown up as wards of Lorenzo de' Medici and as intimate members of the extended Medici family, between whose two main branches, none the less, there had often been friction – not least because of Lorenzo's misappropriation of his wards' funds. It was little wonder that they were among Piero's active opponents after the death of Lorenzo.

Michelangelo would have encountered the brothers when he was taken into the household of Lorenzo de' Medici. Lorenzo di Pierfrancesco had been an important patron of Botticelli from at least 1477, when he probably commissioned the mysterious *Primavera* for the villa bought for him at Castello. Botticelli's dramatic drawings to illustrate Dante may also have been started at his behest. A friend of Poliziano, tutored when he was young by Ficino, Lorenzo di Pierfrancesco was now to have a decisive influence on Michelangelo's life and work.

First, he enabled him to continue working as a sculptor, commissioning from him a figure of the young St John the Baptist in marble (now lost), and then becoming involved in the sale in Rome of another marble statue by Michelangelo, a life-size sleeping Cupid. When he was shown the statue, Lorenzo di Pierfrancesco suggested it would fetch a higher price if it were made to look like an antique and then sold in Rome. Michelangelo agreed, and treated the Cupid accordingly. In Rome, it was bought for 200 ducats as an antique by the worldly and luxurious Raffaelle Riario, cardinal of San Giorgio, a nephew of Pope Sixtus IV. In Florence, Michelangelo was paid thirty ducats for his work.

The deception soon came to light, however, and the cardinal sent one of his men to Florence to inquire into the origin of the marble putto. Michelangelo, asked to show the cardinal's young man some of his work, took a quill pen and gracefully sketched a single hand. The upshot was that, armed with a letter of introduction from Lorenzo di Pierfrancesco de' Medici, Michelangelo left Florence to work under the patronage of Cardinal Riario. He arrived in Rome on 25 June 1496.

From Rome, not long after his twenty-first birthday, Michelangelo wrote to Lorenzo di Pierfrancesco in Florence a spirited and dutiful letter invoking the name of Jesus dated 2 July 1496. With the commendation of the 'magnificent' Lorenzo, he had introduced himself to the bankers Paolo Rucellai and Cavalcanti, after being affably received by Cardinal Riario and making a vain attempt to retrieve the Cupid.

> Then on Sunday the cardinal went to his new house, where he asked for me: I met him there and he sought my opinion of the things I had seen. I told him my opinion, thinking them without doubt most beautiful. Then the cardinal asked if I had it in me to undertake some beautiful work myself. I replied that I might not make such splendid works as he possessed, but we would see what I could do. So we have bought a piece of marble suitable for a life-size figure; and I shall start work on Monday.

8 The Borgias and the Bacchus

Rome at the end of the quattrocento was both a cosmopolitan and a semi-rural centre, smouldering like a compost heap with corruption and new life. Surviving ancient structures included the Aurelian walls, the Pantheon, the Forum, the Colosseum, and innumerable arches, baths, temples and theatres. Mingling with these classical remains were countless Christian shrines, convents and churches and, notably, the catácombs and the four great patriarchal basilicas of St Peter, San Paolo fuori le Mura, Santa Maria Maggiore and San Giovanni in Laterano. These glories of papal and pagan Rome were spread in the hollow land between three uninhabited hills enclosing a conglomeration of strongholds, bell-towers, shops and stables, narrow streets and extensive slums, open fields, vineyards and even pasture land, all within the twelve-mile circuit of walls. In many parts, Rome sounded, stank and looked like a pungent, spiralling village rather than the holy city and centre of Christendom. Across the hairpin bend of the Tiber, the city's port and the Vatican complex had created two important suburbs, one teeming with commercial life, the other with political activity. The ancient Roman Capitol or Campidoglio, the historic seat of secular government on the edge of the wilderness, maintained its symbolic value.

Reports of poisonings, debauchery and incest by Alexander VI were

rife in his own time, but based on hearsay and distortion. Nevertheless Rome under the Borgia pope was a city of dreadful violence and moral turpitude in high places. When Sixtus IV died in 1484, Rodrigo Borgia was among the richest and most influential cardinals in Rome. He was versatile, clever, charming, handsome and robust. By the time he was elected pope as Alexander VI in 1492, aged about sixty, living a discreetly unchaste life, he had had several children.

Alexander VI moved early on to impose order in Rome and to assert papal authority in the strategically important Roman Campagna. Piqued by constant obstruction to his initiatives by a group of Italian cardinals, the proud Spanish pope moved to 'internationalize' the Curia. In 1493 he made cardinals of two Frenchmen, a Spaniard, a Pole, and England's John Morton, archbishop of Canterbury, the harsh money-collector and chancellor of King Henry VII of England. At the same time, he raised to the purple his own fearsome son, Cesare Borgia, who at the age of eighteen was three years older than one of the new Italian cardinals, Ippolito d'Este, son of the duke of Ferrara.

Alexander vacillated between forging closer bonds with France or with Naples, vainly tried to resist the invasion of Charles VIII, taking refuge in the stronghold of Castel Sant'Angelo when French troops marched into Rome in December 1494, but dealt with him most astutely; and then in 1495 he played a prominent part in the Italian alliance against the French. He subtly contrived to destroy Savonarola. When his son Juan Borgia, the duke of Gandia, was mysteriously murdered – the corpse found by the Tiber with its throat cut – in a spirit of repentance he set up his reform commission for the Church.

All this was a prelude to the four years of the meteoric rise and fall of the power of the Borgias, from 1498, when the pope tried to play off one great power against another and to establish his ambitious son Cesare, a cardinal no longer, as a secular prince and, with French help, ruler of the Romagna, the most distant and most contumacious of the Papal States. Financed from the revenues of the papacy, including income from the Holy Year of 1500, Cesare Borgia during 1501 completed the conquest of almost all the cities of the Romagna, even threatening Florence; then officially duke of the Romagna, he joined the French in the field in their attack on Naples in the following year.

The figures in the records seem to show that, after the Council of Constance held in 1414–18, the popes gradually recovered from the penury following the Great Schism of the early fifteenth century (1378–1417), when rival popes governed the Catholic Church from Rome (Urban VI) and Avignon (Clement VII). But their expenses also

soared, mostly because of increasing spending for political and military aims (including the long campaigns to crush rebellious *signori* and make good the papacy's territorial claims) and, in Pope Alexander's case especially, financial help to their offspring.

The powerful portrait of Alexander VI by Pinturicchio (who probably left Rome about a year before Michelangelo's arrival) shows the pope praying with strong clasped hands in heavily embroidered and bejewelled vestments. He was then aged sixty-two, and the expression and features of his fleshy beak-nosed face display cleverness, arrogance and introspection.*

Pinturicchio was made responsible for beautifying Castel Sant'Angelo with frescoes narrating the life of the pontiff and containing portraits of his family and friends. The work included grotesques of medallions, foliage and monsters inspired by the recent discovery of the amazing paintings in buried rooms in the Golden House of Nero. These had struck a responsive chord in the imaginations of several artists, including Perugino, Ghirlandaio and Signorelli, and soon began to run riot in artists' pictorial fantasies.

Pope Alexander VI was anxious to improve Rome's fortifications, within and without. As well as commissioning Antonio da Sangallo (the brother of Lorenzo de' Medici's favoured architect, Giuliano) to strengthen Castel Sant'Angelo, he had a tall, crenellated tower built for the Borgia apartments and ordered the completion of the loggia in front of the old basilica of St Peter.

Cardinal Riario's challenge to Michelangelo of July 1496 – was the young man capable of producing some beautiful work himself, like the statues in his new palace? – was taken up immediately, and from the 'marble suitable for a life-size figure' Michelangelo carved a young, plump, nude Bacchus, looking shockingly drunk, reeling but just erect, staring uncertainly at an antique wine-cup, garlanded with vines and letting his leopard-skin fall behind his left thigh, where a curly haired little satyr nibbles furtively at a bunch of grapes. The pagan god in the form of a male nude invites comparisons with antique statues, copies of Greek statues of satyrs to be seen in Rome, but the humour seems to echo that of Poliziano, whose exuberant song about Bacchus in the *Favola di Orfeo* had ended with the drinkers in a state of drunken – or divine – collapse. The circular composition of the piece, the satyr

* In the Borgia apartments in the Vatican.

behind Bacchus and a mask behind the satyr, invited the observer to walk around it till giddy. The Dionysiac spirit of the statue may have displeased the cardinal, for, though commissioned by him, it ended up looking out of place among the antique pieces in the garden of Jacopo Gallo, Michelangelo's banker.*

There were problems over the payment, and by the summer of 1497 Michelangelo was being pressed to return home to his father – whose usual financial problems were compounded this year by the death of his second wife – or at least to say when he could be expected. Michelangelo had been visited by his brother, the Dominican friar, Leonardo, who had for some reason been defrocked and had fled to Rome. Michelangelo gave him a gold ducat and saw him on his way to Florence. The letter telling Lodovico about this, signed 'Michelangelo sculptor in Rome' and dated 1 July 1497, reported that Michelangelo would stay in Rome until he had been 'satisfied and rewarded' for his labours: 'with these high and mighty people, one has to go gently, since they cannot be forced. Still I am absolutely sure that everything will be dealt with quickly this coming week.'

Then Buonarroto, the brother he liked best (and the businessman of the family), arrived in Rome and was staying in a nearby inn, as Michelangelo did not have his own place. Buonarroto had told Michelangelo about a dispute over money between Lodovico and the latter's brother-in-law (a haberdasher), and Michelangelo said he would help financially (though he would have to borrow to do so). If he sometimes sounded irritable when he wrote, he explained, it was because of the emotional stress experienced by people who live away from home. Even if he had to sell himself into slavery, Michelangelo added dramatically, he would send his father whatever he requested. But he, too, had payments to make and burdens to carry:

> I undertook to do a figure for Piero de' Medici and bought the marble: then I never began it, as he never did what he promised: and because of this I am working on my own account, and making a figure to please myself. I bought the piece of marble for five ducats and it was no good, and so I wasted the money: then I bought another piece, another five ducats, and I am working this for my own pleasure.

Michelangelo had with him an apprentice, the first of his many

* Eighty inches high, it is now in the Bargello, Florence.

garzoni, called Piero d'Argenta, with whom Buonarroto formed a warm friendship. It was Piero who wrote to Buonarroto a few months later (on 13 January 1498, from a Rome 'where the snow had settled up to the arse') with the news that Michelangelo had left:

> there has been no letter of his and we have heard nothing about what may have happened. So messer Jacopo and all of us are amazed he has not written one line to us; and therefore I beg you if you have heard anything since his departure you should advise us of his whereabouts and what he is up to, for truly we are hungry for news of him.

After months of frustration in dealing first with Cardinal Riario and then with Piero de' Medici, his former, unsatisfactory patron, Michelangelo found another patron: the French cardinal Jean Bilhères de Lagraulas had resolved to have a *Pietà* carved for his tomb. From the end of November to the end of December 1497 Michelangelo was in Carrara getting the marble for it – this was the reason for his mysterious absence from Rome. On 27 August 1498 a contract was made between the cardinal and Michelangelo. Jacopo Galli, who acted as agent, promised that the statue would be completed within a year, and that it would be the finest marble statue in Rome – such that 'no living artist could better it'.

9 Carrara and the *Pietà*

Cardinal Jean Bilhères de Lagraulas, Abbot of Saint-Denis and bishop of Lombez, had recently been made the French king's envoy to the pope, and was then given the traditionally French titular see of Santa Sabina.

When Charles VIII rode through Italy, the cardinal was to be seen in his train of advisers, entering Rome with the king in arms in December 1494 and accompanying Charles when he arrived at the gates of Rome on his return from the conquest of Naples in June 1495. Of special religious interest to him, and doubtless to King Charles, was the site in the ancient basilica of St Peter dedicated to St Petronilla, the legendary daughter of St Peter and the patroness of the dauphins of France. It was here that the cardinal wanted to place a statue of the dead Christ and his mother, for his own tomb.

Sometime in 1497 the cardinal and Michelangelo had reached an agreement about the commission, and on 18 November Jean Bilhères de Lagraulas wrote to the officials of the little republican city-state of Lucca, lying in Tuscany to the west of Florence, asking them to assist the sculptor in his quest for marble. Following the practice of supplying artists with safe-conduct papers or letters of recommendation, the cardinal announced that:

We have recently agreed with master Michele Angelo di Ludovico Florentine sculptor and bearer of this, that he make for us a marble tombstone [*pietra*], namely a clothed Virgin Mary with a dead Christ naked in her arms, to place in a certain Chapel, which we intend to found in St Peter's in Rome on the site of Santa Petronilla; and on his presently repairing to those parts to excavate and transport here the marbles necessary for such a work, we confidently beg your Lordships out of consideration for us to extend to him every help and favour in this matter, as will be expounded by him at greater length: and this we will reckon as having been done for us ourselves, as it will indeed have been; and we shall not forget this good deed: and if it so happens that we can ever serve your Lordships in practice, you will understand how acceptable and understanding this will be. Farewell.

Lucca had long been a flourishing silk-weaving and building centre, and was convenient for the marble quarries at Carrara, Massa, Pietrasanta, Seravezza and Stazzema. In the valleys of the Apennines, many quarries which had been worked in Roman times were revived during the quattrocento to meet demand for church-building programmes (including the cathedral at Pisa) throughout the region. The largest, finest blocks (especially the brittle, hard-to-work white marbles of Carrara – the *bianchi marmi* known to Dante) were sought after for statues.

Carrara was sited in the foothills of the mountains, near the malaria-ridden coast. It was a busy centre and depot, teeming with quarry-masters and quarrymen, artisans, stonecarvers and sculptors. Oxen, mules, ponies and horses transported the stone along steeply winding roads and paths from the hills down to Carrara and from there to Luna (the old Roman port). It was an awesome locality, with its hills gashed and sliced by excavations and marble slack bleeding down the slopes, with huge rifts and falls between the red-roofed town and the high world of sudden mists and cloud, clear light and thin air.

In November 1497 Michelangelo went to Carrara to search for

marble suitable for the French cardinal's *Pietà*. At length, in a document dated 27 August 1498, he was formally commissioned to create the marble group. The cardinal of Saint-Denis, it was stated, had arranged with Michelangelo, the *statuario fiorentino*, that the latter should make the marble *Pietà* at his own cost. It was to be a draped Virgin Mary, with the dead Christ in her arms, as big as an average-sized man, for the price of 450 gold papal ducats, and to be ready within a year from the day of the start of the work. The cardinal promised to pay 150 gold papal ducats before the work was begun, and then 100 ducats every quarter, with all payments completed in a year, or sooner if the work were to be finished earlier.

Michelangelo did not finish the work (which overlapped with his finishing the statue of Bacchus) when promised but about a year after it was due. By then Cardinal Jean Bilhères de Lagraulas had died. He had just had time to sign the most important artistic commission of the age.*

Though it showed that Michelangelo was still using the drill as well as the chisel, the *Pietà* was technically brilliant. Life studies and dissection had so deepened Michelangelo's understanding of anatomy that to the Bacchus and now still more to the *Pietà* he imparted unprecedented physical verisimilitude and grace. The two figures, one almost naked, the other massively draped, polished and repolished, are inventively composed so as to give grandeur and grace to the northern European iconography of a dead Christ lying across the lap of his mother. Poignancy is imparted through the resignation of the timelessly young mother and the beauty of the son, spent and dead, but physically scarcely violated by the crucifixion.

On Christmas Eve 1499 Pope Alexander VI, in vestments and tiara, was borne along in the pontifical chair under a canopy, holding a lighted candle in one hand and blessing the people with the other, from the Sala del Pappagallo to the basilica of St Peter's. There he gave two or three blows with a hammer to the pilgrims' Golden or Holy Door (invented and carefully constructed for this occasion), which promptly

*The *Pietà*, 69 inches high, was first erected in the chapel of Santa Petronilla in old St Peter's, then, about 1535, moved to the Cappella della Febbre, and in 1626 was taken to its present position in the first chapel of St Peter's on the right. After being vandalized with a hammer in 1972, it is now behind strong glass.

fell to the ground. A new anthem, specially composed, was then sung by the choir while workmen finished demolishing the brickwork in the opening. Halfway along the nave the pope had to rest for a while, and then when he reached the high altar, after the singing of the *Te Deum*, all the cardinals present paid him reverence.

Installed near St Peter's just as preparations for the Holy Year of 1500 were nearing their climax, Michelangelo's *Pietà* ensured that his fame would be spread throughout Christian Europe as the pilgrims returned home. One group of visitors to Rome from Lombardy were admiring the statue when Michelangelo himself happened to be passing by, only to hear one of them tell another that the marble had been carved by 'our Gobbo from Milan' (Cristofero Solari, one of several artists of that family). Michelangelo returned to Santa Petronilla one night, shut himself in the chapel with a light, and carved his name in beautiful ornate Roman lettering in Latin on the band running diagonally between the Virgin's breasts.

Michelangelo's reputation was now established as an all-round artist and talented sculptor eager for work. By the end of 1500, during which he was working hard on the *Pietà*, Michelangelo had agreed to do a painting for the Augustinian friars of Sant'Agostino. The transaction, in which he is described as a sculptor, was recorded in the bank ledgers of Giovanni and Baldassare Balducci. The picture was to be an altar-piece for a new memorial chapel for the dead bishop of Crotone in Calabria, who had long lived in Rome. Michelangelo undertook the work, received the money for it in advance, but never finished it.

The oil-painting showed a rhythmic, powerful grouping: the dead and naked Christ, a bald and bearded Joseph of Arimathea supporting the slender body from the back, Nicodemus on Christ's left and a massive St John on his right taking the strain of the limp corpse as they grasp the winding-cloth, with St Mary Magdalene crouching in the foreground. Christ's mother, Mary, was intended to go in the foreground at the right, with the other Mary behind. The male bearers are monumental, muscular but lightly posed, almost expressionless but physically perfectly beautiful. The panel displayed painterly virtuosity in sculptural form, combining serenity and action.*

* * *

*The *Entombment* is now in the National Gallery, London. For the controversy over this identification, see the note p. 422.

The events leading up to the Holy Year of 1500 violently confirmed the vulnerability of Italy to outside attack and domination. The good-natured, good-looking, debonair and mediocre Louis XII of France, who succeeded his cousin Charles VIII in 1498, played ball with Venice, Florence and the pope, and they with him, each pursuing particular territorial aims for economic and political ends. Louis XII made Cesare Borgia duke of Valence and agreed to his marriage to a French princess (sister of the king of Navarre); the pope agreed to Louis's divorce to enable him to marry the widow of Charles VIII and secure Brittany permanently for France. Louis promised and later gave the Borgias military help to crush the Romagna. Florence asked for his help against Pisa in return for supporting his Italian ambitions (summed up by the title he had assumed of king of Naples, Jerusalem and the two Sicilies and duke of Milan). In alliance with Venice, in September 1499 Louis then seized Milan effortlessly, after Lodovico Sforza had fled to Germany (and the city thereupon lost Bramante and Leonardo da Vinci).

In the Holy Year, Louis had to fight to recapture Milan, which in February had disconcertingly welcomed back Lodovico Sforza when he made a surprise attack with an army of Swiss and Germans. Cesare Borgia lost his French troops and retired to Rome, where he stayed from March till October, before starting to campaign again, to take Pesaro and Rimini, attack Faenza and frighten Florence. The pope tried to win support for a crusade against the Turks, who had been pushing hard against the Venetians in the eastern Mediterranean, but, though this helped Venice to rally, France and Spain had other, more self-interested, engagements: in November they settled a secret treaty to conquer and divide between them the territories of Naples, probably with the tacit though unwilling consent of the pope.

10 Family matters

Many Florentines had felt cause to celebrate in April 1500 when news arrived of the defeat and capture of Lodovico Sforza by the French near Novara, about thirty miles from Milan. Bonfires blazed, guns were fired, and a big picture of Christ was put at the door of the palace of the Signoria, as if to say (Landucci wrote in his diary) that 'we have no other king but Christ'. But the rest of the year brought few other new

occasions to rejoice. Landucci recorded various episodes in Florence's gruelling war with Pisa: Florence's troops strip-searching some women leaving the city scantily clad, and finding them to be carrying messages to the prowling Cesare Borgia; the doubts of Florentine envoys as to whether the French king honestly wished to help them or not; the capture of Corfu and Modone by the Turks; and the flooding of the Arno in September, when Landucci's own fields were spoilt.

The joint Franco-Florentine endeavour against Pisa floundered all year long, and the up-and-coming official Niccolò Machiavelli, having started his public life in Florence in the summer of 1498, returned in January 1501 from France, where he had spent several months as an observant but frustrated ambassador chasing after the court as it moved from place to place, in order to meet and, if he could, pacify the exasperated king.

Letters exchanged between Michelangelo and his father during the time of preparation and celebration of the Holy Year show the intensity of their shared family anxieties.

In February 1500, responding to a letter from Michelangelo accusing him of seeming discontent, Lodovico complained that at the advanced age of fifty-six, with five grown-up sons, he had to do everything for himself, including washing the dishes and baking the bread. So he was happy with God but not with his family. In future he would put himself first and not love others more than himself, as he had done previously. He was angry and incredulous that Michelangelo was winning glory but no gain; he grieved that Michelangelo had been so long in Rome and was still not earning his bread.

In Holy Year, Buonarroto went to Rome, where he saw Michelangelo and presumably his own friend, and Michelangelo's loyal *garzone*, Piero d'Argenta. He left Lodovico living alone in Florence, three years after the death of his second wife, still unemployed, having lost his position at the custom-house when Piero de' Medici fled from Florence. Buonarroto brought back news of Michelangelo's indigent lifestyle and a letter from him for his father.

Lodovico, responding to all this in a remarkable letter dated 19 December 1500, said that he had been glad to hear that Michelangelo was in good health and earning something (he had indeed paid 230 ducats into his bank account in Rome in September). He warned Michelangelo to take good care of his health, since sickness would mean loss of income:

Buonarroto tells me that one of your sides is swollen, which comes from being out of sorts or from fatigue or eating bad, windy food, or from putting up with cold or wet feet. I have had this myself and I am still often troubled when I.eat windy food or suffer from the cold. Our Francesco had it and so did Gismondo. You must guard against all these things, besides it is dangerous for the eardrum, which might burst. So take care. I will now tell you about the remedies that I have found: I went for a few days eating only sops of bread, chicken and egg, and I took by the mouth a little cassia, and I made a poultice of thyme, which I put in a pan with rose oil, and camomile oil, and when the poultice was ready I applied it to the front of my body, and in a few days was well again. However, be careful, as this is dangerous. May Christ keep you from all harm . . .

Then again, importunately, Lodovico urged Michelangelo to come back to Florence, where there would be things for him to do, and to let one of his friends in Rome finish the statues that he had on hand.

The correspondence suggests that Michelangelo's life in Rome was arduous, uncertain and unhappy. However so, it must also have been soured by the moral stench of the bizarre and corrupt Borgia court.

Cesare Borgia, the same age as Michelangelo, was handsome, strong, clever and increasingly sinister. On his way to an audience with his father in the Vatican after his military victories in early 1500, he had around him 'a hundred grooms, each one dressed in a cloak of black velvet with black leather boots and carrying a new halberd in his hands. Don Cesare himself was dressed in a cloak of black velvet reaching to his knees, with a collar of simple and severe design.'

In the July of Holy Year, on steps near the basilica of St Peter's, where the previous Easter 200,000 pilgrims like Buonarroto Buonarroti had received the pope's blessing in the square, Alfonso, duke of Bisceglie, the second husband of the pope's daughter, Lucrezia Borgia, was attacked and almost fatally wounded by armed men. A month later Cesare Borgia's lieutenant, known as Don Michelotto, forced a way into his sickroom and strangled him. This murder, Cesare was to claim, was an act of revenge for a threat by Alfonso to his life.

Alfonso's corpse was carried in procession to St Peter's and deposited in the chapel of Santa Maria della Febbre. A hunchback who had looked after the duke, and the doctors who had attended him, were arrested and then after 'close questioning' released. This, wrote the scrupulous diarist Johann Burchard, master of ceremonies at the papal

court, was because they were innocent, 'and the man who had ordered the deed was well known.'

Near such bloody scenes and fearsome encounters Michelangelo had been carving and polishing the white marble of the *Pietà*. The poem he sent to friends in Florence gives vent to his feelings with regard to Rome about this time:

> Here they make helmets and swords out of chalices,
> and they sell the blood of Christ by handfuls,
> and cross and thorns are lances and shields
> and even Christ all patience loses.
>
> But let him come no more to these city streets,
> for here his blood would flow up to the very stars,
> now that in Rome they sell his skin
> and they have closed the roads to all goodness . . .

Michelangelo now a mature artist, returned to Florence from Rome just after his twenty-sixth birthday, leaving behind an influential circle of appreciative friends.

11 In Florence with Leonardo da Vinci • The giant David

After the turn of the century, Florence experienced not the end of the world, as some millenarists had predicted, but a surge of intellectual renewal – the Republic fought to re-create its constitutional balance and vigour, to restore its territorial authority, and to bring the best artists into its service. By May 1501 Michelangelo had returned to his family, from which he had never really been away, and to his father, living in a rented house in Florence and holding on proudly to the farm in Settignano. He found many of his contemporaries from the workshop of Ghirlandaio and the Medici household reaching confident, creative maturity, like himself; but many faces had gone for ever.

Bertoldo was long since dead; Domenico Ghirlandaio had died in 1494; the influential sculptor Benedetto da Maiano had died in 1497; Botticelli was a spent force, as was Filippino Lippi, though still at work; and Fra Bartolommeo was resting, leaving his painting of the Last Judgement unfinished. Among the thinkers and writers, Poliziano, Pico

della Mirandola and the witty Matteo Franco had all died in 1494, the poet Benivieni had wilted under the influence of Savonarola, and Ficino had died aged sixty-six in 1499.

But in April 1500 Florence had been again turned into an influential cultural and intellectual centre by the reappearance of a single artist of genius – the bizarre, restless Leonardo, back from Milan. Leonardo had entered the service of Lodovico Sforza, probably in 1482. The services he offered to the *de facto* tyrant of that powerful and prosperous military city were engineering – bridge-building, tunnelling and gun manufacture – sculpture in marble, bronze or clay, and painting.

About as formally unschooled as Michelangelo, during his youth and early manhood in Florence Leonardo had developed his own perception of the arts as rational exercises based on discoverable principles in nature. Through the paintings of Masaccio and Giotto and the precepts of Alberti, he had explored the imitation of nature, the creation of illusory space, and the representation of mental and spiritual attitudes through bodily gesture and facial expression. He had worked with Verrocchio, fostering his obsessive skills in portraiture and caricature, and his fascination with the interwined curves of knots and plaits. In 1481 he had painted an Adoration of the Magi, commissioned for the high altar of the monastery of San Donato a Scopeto, just outside Florence.* The picture conveyed rich psychological and religious subtleties of meaning through its blending of light and shade, its strong structures, and the urgent gestures and expressions of its figures. For this beautiful and profound painting, left unfinished, Leonardo did preparatory drawings with bewildering scribbled revisions penned in creative frenzy.

During his incredibly productive years in Milan, Leonardo painted the portrait of (probably) Cecilia Gallerani, Lodovico's mistress, as a lady with an ermine; a richly symbolic and technically very novel altarpiece of the Madonna with Jesus and St John in a rocky grotto; and the stupendous Last Supper for the Dominicans of Santa Maria delle Grazie. Under Lodovico's protection, Leonardo wrote down his ideas about the importance of the visual arts, and especially of painting. Sculpture, Leonardo commented, was dirty, dusty and exhausting, and unfit for gentlemen.

Emotional and mental affinities between Leonardo and Michelangelo, who shared Tuscan wit, ingenuity and ambition, were matched by equally marked disparities and contradictions between

* Now in the Uffizi, Florence.

their characters and convictions. When they first came into contact, Leonardo's vision of a universal science of nature already contrasted with Michelangelo's Platonic philosophy and developing Catholic spirituality. The antagonism between them became evident and well-known. It sprang from the logic of their purposes and pursuits, but seems to have arisen during their earliest encounters from some reaction in Michelangelo's personal chemistry to the older artist.

One of their contemporaries attributed the dislike to a particular event, a chance meeting in the middle of Florence between the self-possessed gentleman-painter and the awkward, sensitive, passionate sculptor. Leonardo was wearing a rose-coloured cloak, just to his knees (in a period when long garments were the fashion), and his curled beard fell to the middle of his breast. With a friend, a painter called Giovanni di Gavina, he was walking past the benches in front of the Palazzo Spini where a group of men were disputing over a passage in Dante. They appealed to Leonardo to explain the lines to them, and just then Michelangelo came by. Leonardo responded to the questioners, 'Michelangelo will explain it to you.' Thinking that he was being ridiculed, Michelangelo said angrily, 'You designed a horse to be cast in bronze and, as you could not cast it, you abandoned it from shame.' And, as Leonardo stood stock still and blushed, Michelangelo added to annoy him, 'And those stupid Milanese believed in you.'

Leonardo had arrived back in Florence via Mantua, Venice and Rome. He based his activities on Florence for several years, but was in and out of the city often, as when in the summer of 1502 he went to serve Cesare Borgia (then in the middle of his third campaign of territorial conquest and at one stage menacing Florence) as 'architect and general engineer'. His absences were apparently prompted by his preference for consultancy work rather than commissioned paintings. During the early years of the new century, however, he did conceive and occasionally, with his helpers, complete numerous compositions, including a rare finished painting, the haunting portrait of the wife of Francesco del Giocondo – Mona Lisa – as well as classically inspired drawings of Neptune and of Leda and the swan.

Following the death of Savonarola, opportunities in Florence for artists and craftsmen had begun to grow steadily brighter. This was partly through the revival of patronage by the rich families who had kept their heads down after the fall of Piero de' Medici and partly through the continuing thirst for political prestige and the desire to enhance the visible signs of the dignity of the Republic. To this end, a grandiose new chamber for the Great Council had been built on to the Palazzo

della Signoria during 1495–8 and was now awaiting its final decoration.

The hall was low, dark and out of square, but magnificently endowed with a huge beamed roof, about eighty feet from wall to wall. Cronaca (Simone del Pollaiuolo) and his team added windows and a wooden gallery round the walls with seats for all the magistrates. The ascent to the hall was up Cronaca's steep staircase, about twelve feet broad, which doubled on itself twice and was adorned with Corinthian capitals and double cornices.

Leonardo may or may not have been consulted about the construction of the chamber in 1494; but he was certainly brought in to advise about the positioning of Michelangelo's giant statue of David, the first important work commissioned from Michelangelo by the Republic after the flight of the Medici; nor was it long, once he and Michelangelo were both available in Florence, before they were thrown in direct competition with each other, in the art where Leonardo held the field.

Michelangelo may have returned to Florence by way of Siena, drawn north not only by Lodovico's insistence but also by the prospect of a commission from Cardinal Francesco Piccolomini to carve fifteen statues in Carrara marble for the Piccolomini Chapel in Siena's richly endowed Cathedral.

This Sienese-born cardinal was the sixty-year-old nephew of Pope Pius II, who had made him a cardinal when he was twenty-two. He was an affable, scholarly man who had been thought of as a possible pope when Innocent VIII and Alexander VI were elected; the latter chose him as one of the members of his abortive commission of reform, and as his legate to Charles VIII when the king invaded Italy.

In June 1501, Piccolomini drew up a contract with Michelangelo. Jacopo Gallo was the sculptor's guarantor. The tone and terms of the deal were strict. Michelangelo guaranteed among other things that the statues would be completed in three years, and done again if not satisfactory, and he was also to finish a statue (of St Francis) left in an uncompleted state by Pietro Torrigiano, his boyhood assailant. The fee would be 500 broad ducats, in instalments, out of which he was to pay for the marble and other costs. (In the event, Michelangelo, perhaps with assistance, finished four of the statues, having in October 1504 renewed the contract with the heirs of Francesco Piccolomini – who reigned as Pius III for just a month in 1503. But he did little more, and left the family convinced he owed them 100 crowns, and with his own conscience troubled.)

* * *

In contrast to the exactitude of the contract for the fifteen statues for Siena, brevity and latitude marked the contract of 16 August 1501 with the Wool Guild and the Operai or overseers of the Duomo, the cathedral of Santa Maria del Fiore in Florence. Michelangelo was to carve a giant male figure to stand on one of the cathedral's high buttresses; he was allowed a vital freedom in carving as perfectly as he could from a block of marble on which work had already been started in a botched exercise by Donatello's assistant Agostino di Duccio about forty years earlier. The work was to be completed within two years from September, for six broad gold florins a month.

An old sculptural programme had envisaged twelve statues of biblical prophets to be placed on high around the east end of the cathedral. The programme had been abandoned at about the time of Donatello's death, and the incomplete marble statue of David – which Antonio Rossellini had been asked unsuccessfully to take an interest in about a decade later – was lying waiting in the workshop of the Duomo.

After preparing his models, Michelangelo began carving the block on 13 September in a specially built wooden shed near the Duomo. He began to work, it was remarked in a marginal note to the deliberations of his employers, with determination and strength. By February 1502 Michelangelo had made such progress that the overseers decided that what was now being called 'the Giant', or 'David', was half finished and he should be paid 400 gold florins, taking in his salary.

As if accomplishing the release of a being perceived within the shallow block of marble, Michelangelo's hammer blows and chiselling gradually revealed the full figure, larger than life, in *contrapposto* stance, of the heroic young David of the Old Testament. The lightly armed youth came into view as if at the very split second of uttermost concentration, pausing with his sling not yet taut but lying slack over his shoulder before it precipitates the stone to fell Goliath. The entire muscular figure, 'open' on one side with the left arm raised, is tense with suppressed physical and spiritual energy, in its strong limbs, its torso rippling with gathering energy, and its determined stare. Because it was to be positioned in a high place, the colossus has huge hands and an oversized head, but otherwise this monumental statue of David exemplified Michelangelo's concept of the finely proportioned, powerful male nude, and his matching of external beauty to spiritual ardour.

The statue of David was a fusion of the many influences on Michelangelo's style. These had been variously assimilated, and ranged from the colossi and heroic gods in literature and stone of the ancient world, to the work of Donatello, Nicola Pisano and Masaccio. The

David reflected his passion for using the disturbingly sensuous male nude to express both the sculptor's own feelings and the supposed emotions of the subject: Michelangelo's will to confront the world and triumph through his art, and David's spirit of courage and fortitude against great odds. The David also may have symbolized for many contemporary citizens of Florence the independence of the small, dangerously divided city-state, even then under threat from more powerful neighbours.

Details on a sheet of preparatory drawings for the David confirm Michelangelo's intimate identification with several aspects of the statue. On the verso of the sheet are written fragments – '*Davicte cholla fromba/e io choll'archo/Michelagniolo*' – which seem to compare the young prophet's sling with the young sculptor's bow-shaped hand drill: as David overcame his Goliath in the flesh with the sling, so Michelangelo would overcome his giant in marble with the bow.*

12 Soderini's Republic: a plethora of patrons

On 14 May 1504 Landucci wrote that the 'marble giant' had been taken out of the Office of Works of the Duomo and that the wall above the door had been broken to let it through. He went on:

> During the night stones were thrown at the giant to injure it, therefore it was necessary to keep watch over it. It went very slowly, being bound in an erect position, and suspended so that it did not touch the ground with its feet. There were immensely strong beams, constructed with great skill; and it took four days to reach the Piazza, arriving there on the 18th at 12 in the morning [8 a.m.]. It was moved along by more than 40 men. Beneath it there were 14 greased beams, which were changed from hand to hand; and they laboured till the 8th July, 1504, to place it on the ringhiera, where the 'Judith' had been, which was now removed and placed inside the palace in the court. The said giant had been made by Michelangelo Buonarroti.

There may have been political reasons why stones were thrown at the statue of David, whose positioning in front of the Palazzo della

* This sheet of study drawings is now in the Louvre, Paris.

Signoria (displacing Donatello's bronze group of Judith and Holofernes, which had come to symbolize the crushing of tyranny) could have affronted opponents of the new republican régime. It may have proved an irresistible target for high-spirited youths or vandals. It may have offended people's sense of decency through its uncompromising nudity, including the carefully carved, curling pubic hair.

The statue had originally been intended for the Duomo, but by January 1503 its location had become an open question, with most of those involved clearly favouring a secular rather than a religious site. To help resolve the problem in traditional Florentine style, the overseers of the Duomo had called a meeting of artists, citizens and architects. Everyone said something briefly, and twenty opinions were recorded, the remainder being thought too brief or repetitive to report. Opinions largely centred on where the statue would look best and be least liable to damage. References to its religious or political significance were notable by their absence or obliqueness.

At least one speaker, Francesco di Domenico (responsible, along with Cronaca, for the Hall of the Great Council), did not see why the location needed to be changed. The statue, he said, had been made with a definite end in view (as all things were): namely, to be placed on the exterior columns of the buttresses round the church. The herald of the Signoria, after careful thought, had decided to recommend that 'such a statue' should go where the Judith was (in front of the Palazzo della Signoria) or in the central courtyard of the palace, where there was a bronze David by Donatello. His chief reasons for recommending this were that the emblems of Florence were the Cross and the lily, and that Judith was an emblem of death, wrongfully showed a woman killing a man, and had brought bad fortune such as the loss of Pisa; also, the David in the courtyard was faulty in the positioning of one of its legs.

Leonardo da Vinci had simply this to say: 'I confirm that it should be in the Loggia, where Giuliano [da Sangallo] has said, on the parapet, where they hang the tapestries on the side of the wall, with decent adornment and in a manner that it does not spoil the ceremonies of the officials.' (A pen-and-ink drawing done by Leonardo about this time shows a fig-leafed figure very like Michelangelo's statue of David, though more concentrated.)

Throughout the discussion, concern was expressed that the statue might suffer in the open from bad weather, and also that it should be located where it could be readily seen by the public. When the statue was finally uncovered, on 8 September 1504, it stood on a pedestal in

front of the palace with the wall close behind.* Its loins had been decently covered by a brass garland of twenty-eight copper leaves. It could indeed now be seen as the determined but decorous guardian of the seat of government of republican Florence.

Between the commissioning of the statue of David in the summer of 1501 and its final unveiling in the early autumn of 1504, some of the gloom and tension had been lifted from Florentine politics. In 1501 there had been growing pressure in Florence for constitutional reform. From a welter of ideas, the front runner was that Florence should appoint a gonfalonier (literally, standard-bearer) for life, to give government more stability and prestige, as the doge was seen to do in Venice. The new office was approved by the Great Council. Selected from a list of over 200 candidates, Piero Soderini defeated two main rivals (in sympathy with the city's *frateschi* and Mediceans respectively) and took up office on 1 November 1502. He was expected to improve the city's finances, win back Pisa, defeat any aggression from outside the Tuscan borders, and glorify Florence.

When Michelangelo was putting the finishing touches to his figure of David in front of the Palazzo della Signoria in 1504, Soderini may well, as the story came to be told, have been fooled into thinking that the statue had been improved through his suggestion that a little more needed doing to the nose, after Michelangelo high up on the scaffolding had tapped lightly with his chisel and let fall some marble dust gathered up in his other hand. Certainly, Soderini sometimes invited mild ridicule as well as welcoming hyperbolic flattery.

In 1502 the gonfalonier was in a powerful position. He was wealthy, well-connected, influential, wily and elusive: a very useful man for artists to know. He had shown himself a cautious, reliable official and diplomat, a patient negotiator, and tenacious. As he had no sons and was over fifty, the odds seemed to be against his being tempted to found a dynasty.

Soderini based his policy for the renewal of Florence on constitutional compromise, financial reform and the French alliance. The year 1502 had been bloody and tumultuous for central Italy as Cesare Borgia's armies marched into the Florentine territory of Val di Chiano and seized the duchy of Urbino. By the following year Cesare had subdued the Romagna and Umbria. Threatened by his ambitions, Italian states to the north,

* A copy stands there today and the original, 16 feet 10½ inches high with base, is in the Accademia, Florence.

including Florence and Siena, hoped for support from the French, but the rising power in Italy was Spain, now dominant in the south, rather than France, and Cesare, whose soldiers were quartered in Umbria and southern Tuscany, looked poised to mount a fourth campaign.

In August 1503 French troops were marching south under the command of Louis de la Trémoille, frustrating Cesare's plans. As they neared Rome, on 12 August, both Pope Alexander and Cesare succumbed to malaria. On 18 August, while Cesare rested enfeebled after the crisis, the pope died. This marked the end of Borgia power, for Cesare's strength snapped with his father's demise. On 20 August the bells were tolled in Florence for the death of the pope; rumours circulated that Cesare had poisoned his father (with a flask of wine) by mistake; and people witnessed the passage of several cardinals riding through Florence in haste for Rome.

The danger from the Borgias receded, but Florence was still threatened, partly now by Venice's greed for buffer territory and recruitment grounds in the Romagna. The state's finances were severely stretched through high military expenditure on the one hand and reluctance or refusal of the Grand Council to vote taxes on the other. Soderini had frequent recourse to *pratiche* – informal meetings of citizens called to advise the Signoria in attempts to explain tax policies and win assent, not very successfully.

In this atmosphere of financial stringency and political suspicion, Michelangelo was intensely active as never before. For many of the contacts and contracts now forthcoming, Soderini provided the introductions and recommendations. Leonardo and Michelangelo were now both in Florence, and the young Raphael of Urbino arrived there, probably in late 1504.

In August 1502 Michelangelo signed a contract for a small bronze figure of David, initially to be cast as a gift from Florence for the former military commander of Charles VIII in Italy, a collector and connoisseur, Pierre de Rohan, maréchal de Gié. Because of Michelangelo's delays, the bronze was eventually cast and polished in 1508 by Benedetto da Rovezzano, an adaptable marble sculptor and architect of the same age as Michelangelo, who was also taken up by Soderini. The recipient was the king's treasurer, as the maréchal had by then fallen from royal favour.*

*The bronze David was dispatched in 1508 and ended up in the hands of the king of France; it has long since been lost.

While still committed to work on the statues for the Piccolomini Chapel, the giant David, and the David in bronze, Michelangelo was also, in April 1503, commissioned by the Operai of the cathedral of Florence and the consuls of the Wool Guild to carve, in white Carrara marble, figures of the twelve Apostles of Jesus Christ (one a year for twelve years) to be placed in the cathedral. Soderini had encouraged the choice of Michelangelo for this very ambitious programme.

Despite the burden of taxation and a decline in the number of wool shops, the Wool Guild, which represented rich investors and manufacturers and had laid the foundations of Florence's industrial prosperity, felt duty bound to provide for the continuing embellishment of the cathedral. In its agreement with Michelangelo it added the inducement of a house and workshop to be built at the guild's expense in the Borgo Pinti, no distance from the Duomo.

In December 1503 Michelangelo received a first payment for yet another work of sculpture, a marble statue of the Madonna and Child, ordered by a Flemish cloth merchant called Mouscron. A second payment was made in October 1504, and, on the instructions of Giovanni Balducci of Rome, the statue was to be shipped to Bruges. Michelangelo showed in the highly polished marble of the deep, full-relief block a seated pensive-looking virgin mother, full of quiet calm, her hand resting lightly on a book, and the chubby Jesus standing as if ready to walk but still safe between the mother's knees and clasping her left hand with his right.*

Though there was no reference to a Madonna in the contract, this charming, classically restrained and dignified statue may originally have been meant for the Piccolomini altar, and work on it may have started as early as 1501 or 1502. At any rate, Pope Pius III, having commissioned the fifteen statues for Siena from Michelangelo when he was Cardinal Piccolomini, died in mid-October 1503, just before the first payment for the marble Madonna on behalf of the Flemish merchant.

In October 1504 a new agreement was made between Michelangelo and the brothers and heirs of Pope Pius III. Drawn up not long after the statue of David had been taken to its site, this stated that four statues had been delivered and paid for, and a further advance was

*The Madonna, 50½ inches high, was completed and sent to Flanders in 1506. It is in the church of Notre-Dame, Bruges.

made of 100 crowns. If, which God forbid, Michelangelo were to fall ill, the agreement added, or if the transport of marble from Carrara was interrupted by the war, then more time would be allowed.

As he was demonstrating his productivity and virtuosity as a marble sculptor, Michelangelo began a religious easel painting, commissioned about 1503–4 by Angelo Doni, an avid and perspicacious collector of antiques and modern paintings and sculptures for his own home. Michelangelo may have accepted the commission chiefly because Doni was a friend, or because he wanted to keep his hand in as an occasional painter.

The tondo, in tempera, gives to the central, spiralling pyramid of the Holy Family in the foreground the appearance of a sculptured block, sharpened by the hard, startlingly bright liturgical colours of blue, red and yellow, within a richly ornamented frame carrying the arms of the Strozzi family, into which Doni was marrying. The painting combines dramatic narrative, theological symbolism and psychological tension. The Holy Family dominant in the foreground suggests a loving yet disturbed relationship between mother, foster-father and the divine child precariously balanced as he is being passed between them. Behind the parapet which thrusts across the painting, a wistful-looking baby St John, curly-haired and well nourished, gazes towards them as if he is both involved and excluded. Beyond the middle ground, before the thinly recorded landscape of hill and stream, can be seen the naked figures of five young men languorously preoccupied, one tugging away part of a long winding-sheet or cloak from two of his companions.

When Doni gave Michelangelo's messenger only the forty ducats he claimed it was worth, Michelangelo returned the money, demanding either the return of the picture or 100 ducats from the poor Doni, who reluctantly offered seventy, and in the end – punished by his friend because of breach of faith – had to pay 140.*

The Holy Family, with its strong emotional charges of love and grief, also provided the theme for two tondi in marble on which Michelangelo worked during 1503–5. As a gift for Taddeo Taddei, a discriminating patron and collector, Michelangelo carved a scene which showed the protective, tender Virgin Mary restraining an upright St John, who looks like a pushy Cupid. St John proffers a bird to the unclothed little Christ, who strains to escape, glancing back at St John from the temporary security of his mother's lap. (In the Christian iconographic

* The tondo, 47¼ inches in diameter, is in the Uffizi, Florence.

tradition, the bird would be read as a goldfinch, a symbol of Christ's Passion.)

Smaller and very different in mood was the tondo of the Madonna and Christ made by Michelangelo for Bartolommeo Pitti. The relief is higher than that of the Taddei tondo; the Virgin's head, wearing a helmet-like headcloth (as in the other roundels), projects above the edge of the circle, and the figure of the child Baptist emerges faintly from the rough, unfinished background. The Christ Child leans as if sulkily on an open book on the lap of the Virgin, who dominates the scene, seated on a block, with a look of sudden, sad revelation.*

Michelangelo usually followed Florentine studio custom in using *garzoni* as models for both his male and his female figures, as in his working sketch for the head of the Madonna in the Doni tondo. (A drawing done for the painting of the Madonna in the altarpiece of the Entombment, however, was done after a young girl.) Among the many drawings of these years he preserved a pen sketch for the Christ Child in the painting for Doni, and a series of tiny drawings and a larger pen study for the marble Madonna sold to the Flemish merchant. As well as the pen, lead-point and black and, rarely, red chalk were used; the paper was sometimes given a coloured ground by Michelangelo himself. As he drew, with strongly hatched pen lines, so did Michelangelo carve, chiefly with the claw-chisel. He left the marble in places perfectly polished, in others still roughly hatched.

Michelangelo was just twenty-six when he returned to Florence in 1501. At one point he had either just completed, begun work on or been commissioned to produce nearly forty statues or paintings, all religious works – of the Virgin Mother and Child, of the Apostles and of David, the warrior-prophet. Nearly all the work was commissioned; one or two items may have been done as gifts. He was given the subject-matter, or chose a theme he knew would be congenial to the recipient of the work. Those who commissioned and paid him were state officials and dignitaries of the Wool Guild and the cathedral, clerics, bankers and merchants: mostly very discerning men with ortho-dox artistic tastes and religious loyalties.

Michelangelo's work reflects both the Christian iconography and also the inherited artistic traditions of his time. The young nude males in the background of the painting of the Holy Family could stand for

*The Taddei Madonna (43 inches in diameter) is in the Royal Academy, London; the Pitti Madonna (33½ inches) in the Bargello, Florence.

representatives of the old pagan order before the new dispensation and the coming of Christ; Michelangelo may have taken the imagery and symbolism from the influential Signorelli. But Michelangelo found himself, in Florence in those early years of the cinquecento, amazingly free to pursue his own ideas in the work he was given. The free hand he was allowed in interpreting the wishes of his patrons was further empowered by the less inhibited, more reflective searching religious mood in Florence after the humiliation and death of Savonarola and by the secular aspirations for Florence's independence.

Payments seem to have been agreed and accepted by Michelangelo very unsystematically. His pride made it difficult for him to bargain. He no doubt accepted less than he thought his work and talent were worth, and this fostered resentment. Notions of how artists should be paid were still developing from calculations based primarily on time and materials to a more subjective recognition of artistic quality and reputation. Michelangelo's 1501 agreement for the giant David provided for 'hire and salary at six broad gold florins a month'. When the David was completed, Michelangelo was apparently paid 400 ducats through the agency of Soderini. The contract for twelve statues of Apostles, made in 1503, provided for the expense of the marble and of journeys to Carrara, for the living of the artist and an assistant, to be met by the Office of Works, and for Michelangelo to be paid in addition two broad gold florins a month for twelve years, and as much more as the Office might think fit. Even with the provision of a house and workshop, these rewards were poor compared, for example, with the payment Michelangelo had received for the *Pietà* in Rome; there was no great financial inducement for him to persevere with the work for the Duomo.

Being close to his father and other relations was a mixed blessing, but Michelangelo had many friends in Florence and in Piero Soderini a father-figure who was beneficent and protective. It was Soderini who initiated or backed the inspired decision to invite Michelangelo to contribute to the decoration of the Great Hall of the Palazzo della Signoria, or, as it was now called, the Palazzo del Popolo. The project was fresco painting, not sculpture, and it threw Michelangelo into direct and dangerous artistic confrontation with his formidable critic and rival Leonardo da Vinci. But the grand scale of the enterprise, its proposed location and its subject-matter were marvellously matched to Michelangelo's artistic development.

13 Battle scenes for the Hall of the Great Council

On 24 April 1500, newly arrived in Florence from Milan, Leonardo da Vinci had drawn fifty gold florins from his deposit at Santa Maria Nuova, one of the hospitals which offered (relatively safe) banking facilities. His father was procurator at the Servite monastery of Santissima Annunziata, and Leonardo and his household lodged there. At the monastery, he could, it was thought, work on the magnificent altarpiece, which was graciously handed over to him by Filippino Lippi, from whom it had been commissioned. Already renowned in Florence, Leonardo had won still more acclaim for his subsequent cartoon on the theme of St Anne and the Holy Family, which, it was later remembered, was visited for two days by streams of people, men and women, young and old, as if they were going to a solemn festival.*

Nothing much had transpired by way of commissions in Florence, despite Leonardo's prestige, and the versatile artist had taken service as an architect and engineer with Cesare Borgia, for whom he produced a brilliantly detailed map of the strategically vital city of Imola. During his stay with Cesare Borgia he had struck up a friendship with Machiavelli. After he returned again to Florence in 1503 – where his notes record his lending money to a miniature-painter, paying Andrea Salai three gold ducats to buy himself a pair of rose-coloured hose, and dissecting an old man who had died a sweet death in Santa Maria Nuova – Leonardo had then worked for the Republic on the abortive schemes to divert the Arno around Pisa – so depriving the Pisans of their 'source of life' – and to make it navigable by canalization between Florence and the sea. Late in November 1504, a few months after his father had died, he had gone to Piombino as a military consultant.

By this time Leonardo had landed a contract from the Signoria in Florence to create a vast war painting for the Hall of the Great Council, already furnished with superbly carved woodwork by Baccio d'Agnolo and Filippino Lippi.

The decoration of the great hall was intended to glorify the state of Florence and its religious and secular aspirations under the current

* This cartoon is now lost.

dispensation of post-Medicean and post-Savonarolean republicanism. Michelangelo's near-contemporary Andrea Sansovino had been commissioned in June 1502 to carve a marble statue of Christ as Saviour (and implicitly as king of Florence) for the loggia of the priors and the gonfalonier, on the east wall. The altarpiece opposite, on the west wall, was to be painted by Filippino Lippi, and was to include St Anne, enemy of tyrants, and the patron saints of Florence, all associated with victories in battle. Leonardo's painting was to show the battle fought at Anghiari, near Arezzo, in 1440, where a Florentine and papal army – assisted miraculously from heaven by the first pope, St Peter himself – had defeated the Milanese.

Leonardo's painting – 23 feet by 57 feet – was to go in the right section of one of the long walls. In October 1503 he was given rooms by the church of Santa Maria Novella, where the Sala del Papa could accommodate the huge cartoon for the fresco. After he had been paid for paper, scaffolding and parts of the work, he apparently began to fall behind, for a new contract in May 1504 (showing Machiavelli as one of the signatories for the Signoria) stated that he must finish the cartoon by the end of February 1505 or else begin to paint on the wall the area of the composition for which the cartoon was ready. Apparently choosing the latter course, Leonardo spent a year sitting on the committee to debate where to place Michelangelo's giant David, arranging some scaffolds for the great hall itself, probably whitewashing some of the wall surface, and visiting Piombino as a consultant.

Michelangelo's paintings and sculptures had already shown clear indications of the influence of Leonardo, whom he influenced in turn. More productive by far than Leonardo, who was a master of procrastination, Michelangelo's painting for the Hall of the Great Council was to show an incident before the battle of Cascina, fought victoriously by Florence against the Pisans in July 1364, when the Florentine troops bathing in the Arno were given a false alarm to teach them preparedness. This would give him a splendid opportunity to demonstrate his skills in depicting nude figures in dramatic action.

The decision to employ Michelangelo had been taken about the time he was finishing the statue of David. In October 1504 sheets of paper to make up his cartoon for the bathers were being glued together. While Leonardo was finalizing his drawing in Santa Maria Novella, Michelangelo worked swiftly on his cartoon in the hospital at Sant'Onofrio. And in February 1505 he received an advance payment for the painting. It seemed that Florence's two most revered and famous artists – there was about a quarter of a century difference in their ages – were

about to paint their frescoes simultaneously in the same awesome public hall, crowded with scaffolding, trestles, tables, vessels for paints and pigments, enormous cartoons and numerous assistants. But when Leonardo began applying his colours, early in June 1505, Michelangelo had left Florence. Even so, in March 1505 the two cartoons were put on show together.

In his representation of the battle of Anghiari, Leonardo judiciously used antique motifs and breathtaking draughtsmanship to create an impression of refined energy in warriors, arms and steeds. He also projected the bestial madness of war in all its horror and fury in the dynamic, swirling mass of fighting men and rearing horses, and hate in all its ferocity in the warriors' screaming faces, as well as unyielding patriotism in his depiction of the brave, close struggle to retain the standard, the *gonfalone*, whose shaft below clashing scimitars is bent by an assailant's violent grasp.

Michelangelo's cartoon was in strong contrast to Leonardo's dense and agitated equestrian battle, though in some drawings for the mural he showed how splendidly he too could draw horses, and, like Leonardo's, his composition pulsates with energy. After drawings for various figures and the compositional drawing itself had been rejected or modified, partly increasing the isolation of some of the figures, Michelangelo's cartoon showed, on a ledge of rock by the river, a group of men in various stages of disarray and readiness, individually perfectly delineated and expressive. (There would have been flanking scenes showing the cavalry preparing for battle and engaging the enemy.) The frozen moment of each man's furiously swift reaction to danger is conveyed through a marvellous variety of attitudes and planes and contours. Struggling to clamber from the water, or to help others, or to begin to dress, or pointing to the action or raising the alarm, the nude figures singly and in composition economically exploit the expressiveness of the human body and the ability of painting to realize sculptural forms.

Among those who studied and memorized the cartoons when they were put on show was Raphael. Living in Florence since 1504, he began under their influence to draw twisting, gesticulating nude warriors. He was also absorbing the monumentality, movement and assurance in the handling of colour and light that Leonardo and Michelangelo demonstrated.

Once the dominant scene of his first cartoon had been achieved, Michelangelo, like Leonardo, seems not really to have wanted to labour on his mural. Had he continued, he would have prepared his

cartoons successively for each section before painting it, as he did his drawings immediately before the next stage of the project. But he stopped work all of a sudden. Leaving Leonardo to continue painting, unchallenged by his presence, Michelangelo abruptly set off to Rome, called into the service of a 'terrible' pope.

The political atmosphere in Florence darkened during 1505, chiefly because of Florence's failure to take Pisa by assault during the summer. The Pisans secured the support of Spanish infantry, the Florentines called off the attack, and Florence's hired troops were disbanded, at Cascina itself. Early in 1506, largely in response to this fiasco, Machiavelli's long-nurtured ideas for a standing army to be raised from the city-state's own subjects, attracting quickening interest through the dismal experiences with mercenaries, were at last implemented. In February, Landucci wrote in his record book:

> There was a muster in the Piazza of 400 recruits whom the gonfalonier had assembled, Florentine peasants, and he gave them each a white waistcoat, a pair of stockings half red and half white, a white cap, shoes, and an iron breastplate, and lances, and to some of them muskets. They were called *bandiere*; and they were given a constable who would lead them, and teach them how to use their arms. They were soldiers, but stopped at their own houses, being obliged to appear when needed.

Michelangelo would have run no risk of being conscripted. The enrolment took place in the countryside, where all males over fifteen capable of bearing arms were listed, the selection then being made as far as possible from the ranks of eighteen- to forty-year-olds. One of the reasons for eschewing conscription in Florence itself and limiting it to the long-suffering peasants was Machiavelli's conviction that Florentines would all insist on taking command or being in the cavalry. Machiavelli travelled round to organize the levy himself.

The reflection of Florence's past glory and new pride in the great military murals commissioned for the Hall of the Great Council was cruelly frustrated. Michelangelo did not even start the painting of the battle of Cascina before leaving to serve the pope, whose favour Soderini desperately needed. Leonardo, after beginning his mural showing the battle of the standard, continued painting till about the end of August 1505, as shown by payments made to him for gesso, linseed oil and colours. Work was then halted because of the bad composition of

the plaster, or *intonaco*, he had put on the wall as a surface to take the painting. (And during this time, in love with geometry, he sought irresistible distraction in pursuing studies on squaring the circle, centres of gravity and the flight of birds, while sketching flying-machines on the sheet of paper given to him with a written description of the battle of Anghiari.) Summoned to Milan in May 1506, at the request of the French governor, Charles d'Amboise, he never resumed the painting for which, Soderini complained, he had received a great deal of money and done very little work.

Michelangelo had received his first payment, 3,000 ducats, and had done even less work. But Soderini could do little if anything except grumble when a representative of the king of France, or the pope himself, wanted to employ one of Florence's artists.

14 Julius II, the warrior pope

The uncorrupted and cultivated Cardinal Piccolomini died in October 1503, ten days after his coronation as Pius III. On 1 November Cardinal Giuliano della Rovere was elected supreme pontiff, after the shortest known conclave ever, and took the name of Julius II. The new pope's sixtieth birthday was in December 1503, a month after his election. Compared with Alexander VI at least, Julius was an abstemious and even chaste pontiff, though he had had three daughters and suffered from syphilis before becoming pope. Coming from the Ligurian coast, he was susceptible to French influence and favoured French connections. In succession to the virile Borgia bull, the pontiff's symbol was now the oak tree, often represented by the imperial golden acorn, standing for the holy oak growing from the staff of Romulus but also the oak of the Cross of Christ's suffering, death and triumph.

Giuliano della Rovere had been wealthy enough to demonstrate ambition and importance by employing artists on a grand scale. He had already shown a passion for building and a need for such grand and immediate satisfaction that he seemed to expect edifices to grow as if by magic. Giuliano da Sangallo, who had won renown working in St Peter's in Rome, worked for him, and so did Donato Bramante. Among painters, della Rovere had patronized Perugino and Pinturicchio.

On 2 November 1503, the day after the papal election, Francesco Guidiccioni, envoy of Ferrara, wrote home from Rome to say that

'People here expect the reign of Julius II to be glorious, genial, and free-handed. The Roman people, usually so addicted to plunder, are behaving so quietly that everyone is in astonishment. We have a pope who will be both loved and feared.'

At first Pope Julius appeared to have little time for building or for the arts. The papal treasury was depleted; Cesare Borgia looked still quite powerful and potentially dangerous; the Republic of Venice was encroaching on territories in the Romagna, including the cities of Rimini and Faenza, which had been subdued by Cesare and tradition-ally were claimed by the papacy; and to the south of Rome, near the river Garigliano, the army of Spain under Gonsalvo de Cordoba prepared for battle against advancing French soldiers. On 28 December the Spaniards won an easy victory, forcing the French to retreat to Gaeta and then capitulate. This ended the three years' war in southern Italy, but not the bloody conflict in Italy between rival powers. In the battle of Garigliano, the wretched Piero de' Medici died unheroically by drowning in the river. The headship of the Medici family passed to his brother Cardinal Giovanni, a more agreeable, able and accommodat-ing man by far.

Having skilfully outmanoeuvred Cesare Borgia, and then seen him flee to Gonsalvo in Naples, and rendered harmless, Julius set out with iron resolve to forge discreet alliances with the baronial families of Rome, Orsini and Colonna; to re-establish and strengthen the Papal States, beginning with the Romagna; and to assert papal authority especially in Bologna and Perugia.

When elected pope, Giuliano della Rovere could hardly wait to put on his new vestments; and then he could hardly wait to exchange them for armour. A strong territorial base was vital in his conception of the papacy. On 26 August 1506, with the moral and muscular support of a bevy of cardinals, the pope rode out of Rome fully armed, at the head of a hastily gathered army composed of five hundred knights and their retainers. Their aim was to reassert papal authority to the north, so offsetting entrenched Spanish power in the south.

On 13 September 1506 Julius triumphantly entered Perugia. He was met by the eight priors, and handed the keys of the city. Through crowded streets and decorated arches, accompanied by twenty cardi-nals, the dukes of Urbino and Mantua and many Roman barons, he went to the cathedral, to hear the *Te Deum* sung by the papal choir, to give a solemn blessing to the people, and to proclaim an indulgence. He stayed about a week in Perugia, so intoxicated with success, it was

reported, that he dreamed of freeing Constantinople and Jerusalem from the unbelievers after bringing order to Italy.

But in Bologna its ruler, Giovanni Bentivoglio, was preparing to resist, trusting 'in the strength of the city, the number of his adherents, his high position, and his stalwart sons'.

15 The genesis of the tomb: fear and fury

In June 1503 Giuliano da Sangallo had been elected head of works for the Palazzo della Signoria in Florence. After the election of Julius II in November, he went to Rome, leaving his brother Antonio working near Florence on fortifications at the great villa of Poggio Imperiale, using Pisan prisoners of war. The star soon to be in the ascendant with Julius was the more brilliant, original and imaginatively grandiose Donato Bramante, Sangallo's exact contemporary.

In 1504 Bramante was called on to carry forward a project first devised by Antonio Pollaiuolo for Pope Innocent VIII: a garden and an immensely long courtyard linking the Vatican offices to the Palazzetto del Belvedere, now converted into a gallery for antique sculptures, following and capping the contemporary fashion among Rome's rich admirers of the antique to display statues in their houses and gardens. Before he was pope, della Rovere had worked zealously to preserve ancient sculptures from ruin and keep them in Rome.

Della Rovere had been archbishop in Bologna during Michelangelo's time there with Aldovrandi, and by the time he became pope the young Florentine's reputation as a monumental, religious sculptor, with talent as a painter, was solidly established and growing. Giuliano da Sangallo, a fellow Florentine and a good committee man and adviser, whose family had traditionally served the Medici, and who had long been friendly with Michelangelo, was probably consulted early on by the pope about Julius's wish to have a tomb built for himself. And the scale and the importance of the work, apart from other considerations of amity and patriotism, would have brought Michelangelo's name to mind.

Michelangelo went to Rome early in 1505, about the time of his

thirtieth birthday, at the request of Julius II, expressly to work on the tomb of the pope. In Rome that spring he produced a range of designs for Julius, at some speed. In April the pope approved one of the drawings for a free-standing monument: Michelangelo's most ambitious commission yet, this huge marble edifice was to include over forty statues and several bronze scenes in low relief, and the huge base would measure 34½ feet long by 23 feet wide, rising to a height at least the same measurement as the width, and surmounted by a cornice and by a platform with two angels supporting a shrine. The payment was to be 10,000 ducats, to be paid over a period of five years. Though Michelangelo was still under contract in Florence, the work was to go ahead without delay, and 1,000 ducats were to be paid to him in Florence through the banker Alamanni Salviati for quarrying marble.

As conceived in 1505, the great tomb was to portray Julius as the munificent patron of learning and the seven liberal arts – grammar, rhetoric, dialectic, arithmetic, geometry, astronomy and music – as well as painting, sculpture and architecture. These were to be represented by projecting statues on square plinths, portrayed as being imprisoned by death along with Julius, between niches for other figures, and in front of various terminal figures to which they would be bound as captives. On the strong cornice, as imposing as the cornice embracing the Palazzo Medici in Florence, would be four large figures, including the prophet Moses. The bier over the central bay would have two figures of angels, one smiling to show the pleasure of heaven at the arrival of the soul of Julius, the other weeping for the sadness of the world at his death. The entrance to the tomb at one end would lead to a marble sarcophagus for the body of the pope.

The tomb would be located in or beside the basilica of St Peter's, which was built over the grave of the first pope, St Peter, and contained the tombs of a succession of popes, including that of Pope Innocent VIII, designed by Antonio Pollaiuolo. Apart from such influential precedents, Michelangelo and Julius II could take inspiration from the long-established Christian use of tombs within churches – bracketed wall-tombs or free-standing tombs which proclaimed the distinction of the dead person by their height and isolation and their relationship to the altar.

From his knowledge of the available sites, Michelangelo reached agreement with Julius that the tomb would be best placed in the choir of St Peter's, the restoration of which had started under Pope Nicholas V (1447–55) but was still unfinished at a height of about six feet. To finish and roof this part of the basilica would cost a hundred thousand

crowns, Michelangelo estimated. 'Let it be two hundred thousand,' Julius exclaimed.

Hardly had he said this than Julius made up his mind to undertake a project of stupendous audacity. The ancient basilica of St Peter's had fallen into serious disrepair and had been neglected since the time of Pope Nicholas. In the course of 1505, by the time the summer was out, Julius had resolved that instead of continuing to restore the old church piecemeal he would rebuild it to an overall design commissioned from a contemporary architect. His determination sprang in part from conversations with Bramante and Sangallo but especially from his dealings with Michelangelo himself.

Michelangelo meanwhile left Rome for Carrara in April 1505 to choose and contract for the marble needed for the tomb. With him he took two assistants and a horse. During his time in the mountains, while Julius was scheming against the Venetians and the Florentines were warring dismally against the Pisans, Michelangelo's fantasies took the form of wanting to create his own memorial, in the manner of the ancient world. One day he noticed a crag overlooking the sea which made him want to carve a colossal figure as a distant landmark for sailors. He dreamed earnestly of carving giant statues from the masses of mountain stone in the quarries themselves.

In Rome, Michelangelo had a big room prepared for working on the figures, with furniture and beds for assistants, in a house not far from the piazza of St Peter's, by the since destroyed church of Santa Caterina. He thought of ways to hurry the project on, by having some of the marble shipped to Florence, where he would pass the summers and avoid Rome's unhealthy atmosphere, the frightening malaria. But mostly the marble shipments would go to the port of Rome at Ripa before being unloaded and carted to the basilica.

Michelangelo spent most of the eight months from April 1505 in Carrara, supervising the quarrying and providing the cutters with rough designs for guidance. Towards the end of the year he travelled along the Riviera to Lavagna, famous for its slate quarries and sandy beaches, and contracted on 12 November with two local owners of boats to have thirty-four tons of marble, with two figures weighing fifteen tons more, transported to Rome, for the price of sixty-two broad ducats in gold. On 10 December he contracted in Carrara for the quarrying of marble from the Polvaccio quarry. In December – about the time the cathedral authorities in Florence decided to let the house they had built for him, as there seemed no hope that they would ever

see the Apostles he had been commissioned to make – he was back in Rome, waiting impatiently for the arrival of the first shipments of marble for the tomb.

A letter survives, dated 31 January 1506, sent care of the custom-house in Florence to Michelangelo's father. Michelangelo had put down some money on a farm at Pozzolatico, and was asking how the purchase (in fact completed a few days earlier) was going. In Rome, his affairs would be satisfactory, but unfortunately after the barge had managed to get through with his marble, despite almost continuous bad weather, and had been unloaded, the river had flooded and submerged it all. Meanwhile 'I talk with the pope keeping him hopeful, so that he won't be vexed with me, and hoping that the weather will clear up, so that I can soon get to work, please God.'

The same letter had instructions for Lodovico, revealing both about Michelangelo's working methods and about his secretiveness. He wanted his father to make a small carefully packed parcel of drawings that he had left in a little pouch in Florence and send them to Rome by carrier, and not to let any damage be done to even the least sheet. Lodovico was to instruct the stonemason Michele (Battaglino da Settig-nano) to store a chest belonging to Michelangelo in a safe place, and then leave for Rome. And he was to move 'that marble Madonna' into the house, and not let anyone see it. (The marble Madonna was soon to be dispatched to Flanders instead of to the cathedral at Siena for which it was arguably first intended: hence the secrecy.) 'I am not sending you any money for these things, because I think it is not much to do,' Michelangelo wrote. But he would be able to send Lodovico some money when his marble arrived.

The touch of anxiety in Michelangelo's reference to the pope was soon amply justified, but for a while it seemed that Julius shared Michelangelo's relief and delight when the marble for the tomb was at last safely delivered. When Michelangelo started work on the marble, the pope even had a movable bridge built to his workroom from the corridor leading from the Vatican to Castel Sant'Angelo so that he could visit and see him at his work in his rooms by Santa Caterina.

Michelangelo's opinion was eagerly sought when on 14 January an ancient marble group was discovered, a Roman copy after a Greek original, showing the agony of the Trojan priest Laocoön as he and his two sons are crushed to death by serpents. Giuliano da Sangallo was summoned by Julius to see the group, and he took Michelangelo, and his own small son, Francesco, with him, peered at the statue, and exclaimed that it was the group Pliny had written about. This powerful

antique sculpture of Laocoön with his sons and the snakes marvellously entwined about them, described by Michelangelo as a miracle of sculpture, which challenged one to understand the mind of its maker rather than imitate his work, was taken to the new courtyard being built for statues on the Belvedere. Its portrayal of encumbrance and failing struggle – in sharp contrast to the uncluttered nakedness of Michelangelo's own statue of David – is reflected in his statues for the pope's tomb.

In April, Michelangelo tore away from Rome and headed for Florence, riding as fast as he could the 130 miles or so to Poggibonsi, in Florentine territory, where he arrived after dark and could rest feeling reasonably safe from pursuit. He wrote to Sangallo from Florence on 2 May, giving the reasons for his flight. His patience had run out, he explained:

on Holy Saturday I heard the pope say, as he was talking at table with a jeweller and with the master of ceremonies, that he did not want to spend another penny on stones, whether the small kind or the large; and this amazed me. And yet before I left I asked him for part of what I needed in order to pursue the work. His Holiness answered that I should return on Monday. And I did return on Monday and Tuesday and Wednesday and Thursday, as he saw himself. Finally, on Friday morning I was sent away, or rather driven out, and the person who sent me packing said that he knew me, but that he was under orders. So when I heard those words that Saturday, and then saw what followed, I fell into deep despair. But by itself that was not entirely the reason for my departure; there was something else again, but I don't want to write about it. Enough then that it made me wonder whether if I stayed in Rome my own tomb would not be finished and ready before the pope's. And that was the reason for my sudden departure.

Now you are writing to me on behalf of the pope; and so you will be reading this to the pope. Then let His Holiness understand that I am disposed more than I ever was to pursue the work; and if he himself is absolutely determined to build the tomb it should not annoy him wherever I do it, so long as at the end of five years as we agree it is put up in St Peter's wherever it pleases him then, and is as beautiful as I've promised it will be; for I am certain that, if it comes to be made, there will be nothing like it in the whole world.

So if His Holiness wishes to proceed, let him make me over the deposit here in Florence, and I'll write to tell him where to send it and I'll bring all the blocks of marble I have on order in Carrara and also those I have there in Rome. Although it meant a big loss for me, I wouldn't care so long as I could do the work here. And I would send the things as I made them one by one, so that His Holiness would be able to enjoy them just as much as if I had stayed in Rome . . .

But I must also tell you this: that it is simply not possible that the work in question could be made for that price in Rome; I'll be able to do it in Florence because of all the many advantages I have here but do not have there. And I'll do it better and more devotedly, because I shall not have so many things to worry about. Meanwhile, my dearest Giuliano, please give me an answer and quickly. That is all.

Michelangelo began this sorrowful letter by mentioning that he knew the pope had taken his departure badly and had agreed to pay a deposit, and had also said he was to return to Rome and not worry. It hinted at another reason for his departure as well as the Pope's rude refusal to see him.

The ever-sensitive matter of money was paramount. That year, the demands on the papacy's financial resources were escalating. On 18 April, the day after Michelangelo left, the eager and nimble pope laid the foundation-stone of the new St Peter's, clambering down into a deep pit while shouting at the crowd to stand back from the edge. The pope was also planning his expedition against Perugia and Bologna, an exercise in bluff and audacity which involved sending into the field only twenty times as many men as cardinals, but still needed heavy financial outlays.

Michelangelo was not a man to keep waiting in the full sight of curious Vatican courtiers and servants, and uncertain how he would pay for the remaining marble from Carrara which was waiting to be unloaded. But there was something else again. Michelangelo's letter to Sangallo implied threatened violence or intrigue or both when he remarked drily that he had wondered whether if he stayed in Rome his own tomb would not be finished and ready before the pope's. The letter was adamant that he wanted to stay in Florence. On his departure from Rome he had told his two servants to sell all the household furniture and follow him with the money.

From about this time, the period of Michelangelo's second sojourn in

Rome, the artists who had come to Rome in rising numbers from other parts of Italy had to vie for the favour of the pope, and the cardinals had begun to fall into discernible rival groups. One coterie seemed to cluster around Bramante, whose favoured position with Julius infuriated Michelangelo's friend Sangallo. Bramante, it was said, had told the pope it would be bad luck to have his tomb prepared while he was still living. The couriers who sped after Michelangelo to Poggibonsi threatened and cajoled him to no avail, but, in response to a written demand for his return, he did write to the pope to say that, as His Holiness wished no longer to continue with the tomb, he considered he had discharged his obligation.

16 The Sistine Chapel • Julius in bronze

In the spring of 1506, now in Florence, Michelangelo was being urged by Soderini to finish his cartoon for the Hall of the Great Council, though the gonfalonier knew that he would have to placate the pope if Julius insisted on the runaway's return to Rome. Michelangelo was now free to press on with the first Apostle statue, of St Matthew, for the Duomo, though he eventually abandoned it unfinished, with the Apostle's angular, anguished, *contrapposto* figure still emerging from the stone.

In Michelangelo's own development as a sculptor and painter, these months in Florence were a vital period, coloured by his rivalry with Leonardo, the admiration of younger men, the approbation of Soderini and the slackening in work pressure, if not emotional tension, while he waited to see what the pope would do. He was competing directly with Leonardo in the huge frescoes, a field where the older man seemed intellectually and practically more comfortable. Leonardo, for example, delegated to teams of assistants very happily. He had also indicated at various times that he regarded painting as being as superior to music, and sculpture, as sight was to hearing.

There was no doubt in Florence about Michelangelo's talent, however, whether as sculptor or painter. During the spring and summer of 1506 his prestige soared among the artists as he completed the central section of his cartoon, showing the consternation of the bathers as the alarm was raised. The figures and composition of the battle scene confirmed his supremacy as a draughtsman; the black chalk drawings

of the nude soldiers, dramatically enhanced through the use of white lead, represented a surge forward of his artistic genius.

As a 'school' for painters and sculptors, Michelangelo's cartoon on display in the Sala del Papa soon rivalled, even superseded, Masaccio's frescoes in the Brancacci Chapel. Leonardo and Raphael both learned from it, as did many others. With Fra Bartolommeo, inspired by Leonardo, painting again in his prime, with Leonardo and Michelangelo competing in their midst, the young artists of Florence saw being created for their emulation work that respected but broke with tradition in an exciting new manner.

On 9 May 1506, a few days after Michelangelo had written his defiant letter to Sangallo explaining his anger with the pope, his banker and friend Giovanni Balducci wrote very affectionately to him from Rome urging him to return to Rome if the pope did what he promised, as he would gain honour and profit from finishing the work he had begun. Then on 10 May a letter was sent to Michelangelo from the master mason Piero Rosselli in Rome, which heightened Michelangelo's suspicions about the role of Bramante in his fracas with Julius:

> I must inform you [Rosselli wrote] that on Saturday evening, the pope being at supper, I showed him some drawings which Bramante and I had to do together. I showed them after he had had supper; he sent for Bramante and said to him, 'Sangallo goes tomorrow to Florence and will bring back with him Michelangelo.' Bramante replied to the pope and said, 'Holy Father, for sure he will not come, for I am intimate with Michelangelo, and he told me that he would not undertake the chapel, although you insisted upon giving him this task, but that he would only attend to the tomb and not to painting.' And he further said, 'Holy Father, I believe that he lacks the heart to do it, for he has not done all that many figures, especially where the figures are high up and foreshortened, which is quite another thing from painting on the ground.' Then the pope replied and said, 'If he does not return, let me bear the blame, for I believe that he will most certainly return.' At that moment I came forward and in the pope's presence I abused Bramante and said what I believed you would have said for me; and in the meantime he did not know what to answer, and seemed to think that he had spoken ill. And I further said, 'Holy Father, he never spoke to Michelangelo, and if that which he has just said

be true, you may take my head; and I believe that he will return for sure when Your Holiness wishes.' And here matters ended. I have nothing more to say. God keep you from evil. If I can do anything, advise me, I will do it willingly. Remember me to Simone del Pollaiuolo.

It seems from this vivid report that the pope had at least mentioned earlier to Michelangelo the possibility of his painting in the Sistine Chapel, and that Julius was sure he would come back into his service. Awaiting the choice of painter was the tremendous project of replacing the existing, traditional ceiling scheme in the Sistine Chapel – a star-studded heaven – with a grander, modern design, appropriate to the new pope's views of the papacy's unique historical and theological role. It is clear that Michelangelo still expected to work on the tomb, however, for he visited Carrara in May, to attend to the marble waiting for him, before returning to Florence to resume drawing the battle scene. He had proved his talent as a painter, as the pope well knew, but he had set his heart on carving the monument with all its massive figures. The pope seemed uncertain how best to employ him, as his own plans multiplied for creating stupendous memorials of his reign. But he would have Michelangelo.

During the summer of 1506 Julius tugged on the thread with a series of papal briefs, directed to the Signoria of Florence. On 28 July, Soderini wrote to his brother Cardinal Francesco Soderini, at the papal court, saying that Michelangelo was frightened and that the cardinal of Pavia, Francesco Alidosi, would have to write to the Signoria confirming that he would be preserved from harm; meanwhile Soderini would try to persuade him to return. Soderini appealed to patriotism. 'You've tried and tested the pope as not even the king of France would dare . . . we don't want to wage war with him over you and put our state at risk.' Michelangelo's resistance was being worn down.

After the cartoon was finished, about the end of August, and after the pope had begun his campaign against Perugia and Bologna, Michelangelo seems to have resolved, or been pressured, to leave fairly soon for the papal court, on its way north from Rome.

Machiavelli about now was on his second mission to the Curia, relieved from his duties with the Florentine militia. He was in his element, at the centre of a political and military whirlwind as it moved relentlessly north from Rome, on its way to Bologna.

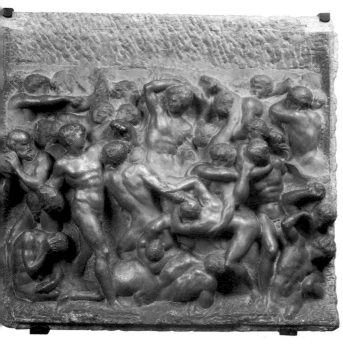

1. *The Battle of the Centaurs*, marble relief by Michelangelo, *c.*1491–2 (Casa Buonarroti, Florence)

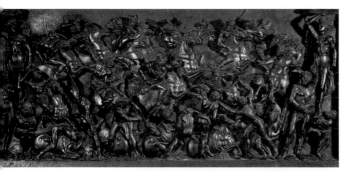

2. *The Battle of the Horsemen*, bronze relief by Bertoldo di Giovanni, *c.*1475 (Museo Nazionale, Bargello, Florence)

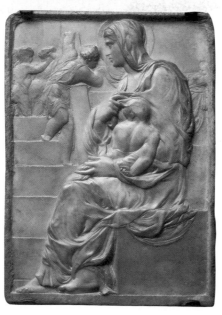

3. *The Madonna of the Stairs*, marble relief by Michelangelo, *c.*1491–2 (Casa Buonarrotti, Florence)

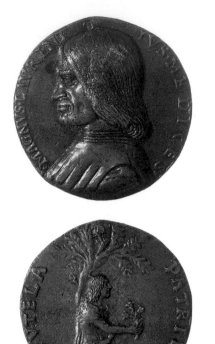

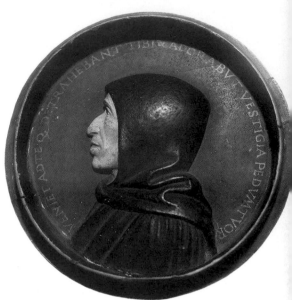

5. *Fra Girolamo Savonarola*, wax model of *intaglio*

4. Bronze portrait medal of *Lorenzo il Magnifico*, with personification of Florence (reverse), by Niccolò di Forzore Spinelli, called Fiorentino

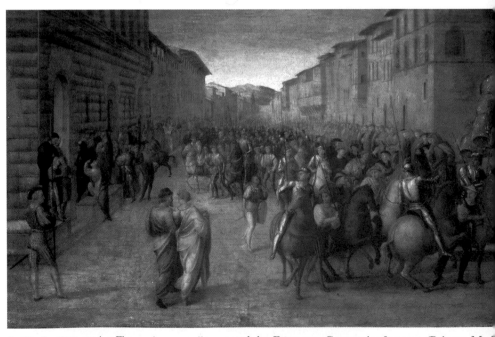

6. *Charles VIII entering Florence in 1494*, oil on panel, by Francesco Granacci, after 1527 (Palazzo Medici Riccardi, Florence)

7. (*Left*) *Sacrifice of Isaac*, by Jacopo della Quercia, *c*.1430–34, from the portal of San Petronio, Bologna

8. (*Below*) *Garden of Antiquities of Jacopo Galli, Rome*, showing Michelangelo's *Bacchus* with one hand severed, to make it appear antique, engraving by Marten van Heemskerck, *c*.1535 (Kupferstichkabinett, Staatliche Museen, Berlin)

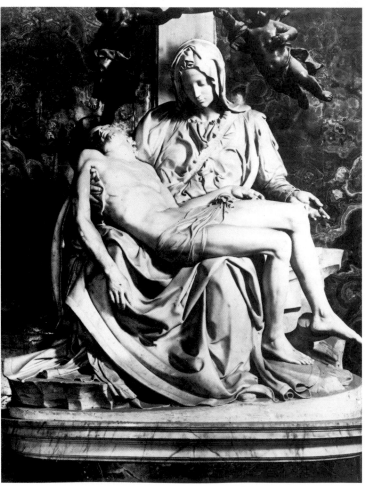

9. (*Above*) *Old St Peter's and the Vatican*, drawing by circle of Heemskerck, *c.*1532–5 (Devonshire Collection, Chatsworth)

10. (*Left*) *Pietà*, marble by Michelangelo, 1497–1500 (St Peter's, Rome)

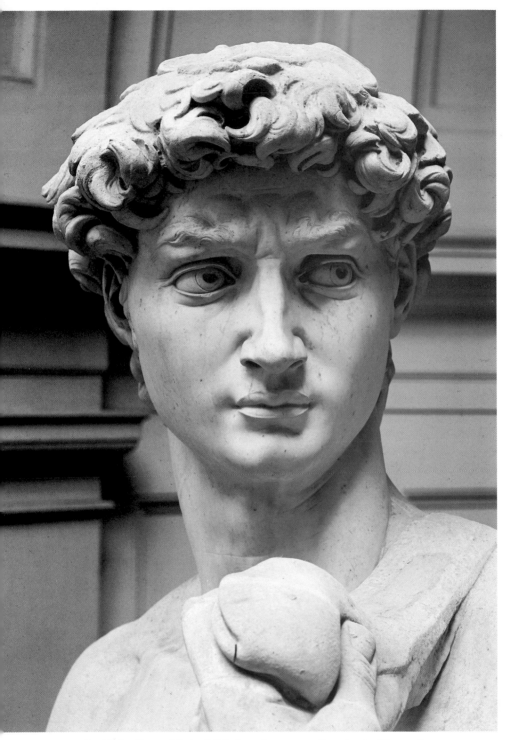

11. *David* (detail), marble by Michelangelo, 1501–4 (Accademia, Florence)

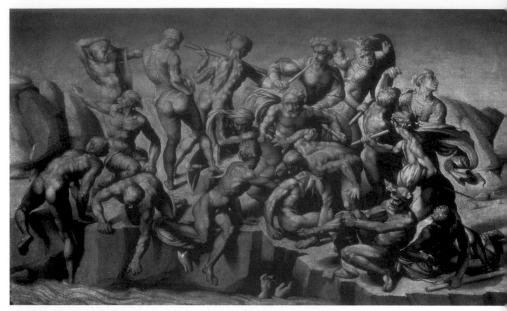

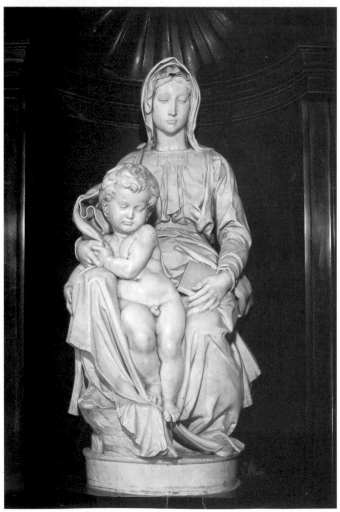

12 (*Above*) *The Battle of Cascina*, grisaille on panel by Aristotile da Sangallo, *c.*1542, after the centre part of Michelangelo's cartoon (Holkham Hall, Norfolk)

13. (*Left*) *The Bruges Madonna*, marble by Michelangelo, 1503– (Notre Dame, Bruges)

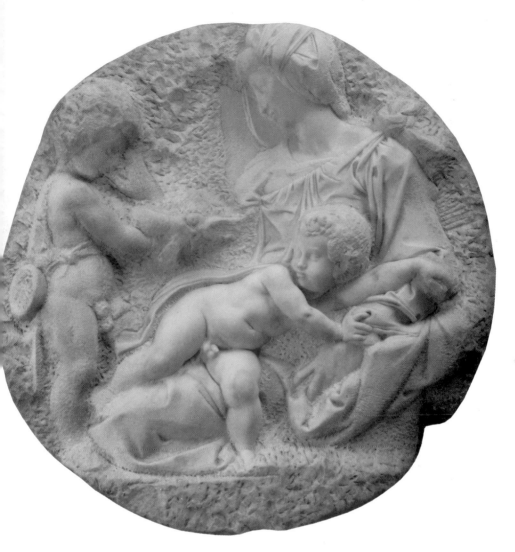

14. *Taddei Tondo*, marble by Michelangelo, 1504–5 (Royal Academy, London)

15. *Laocoön Group*, Roman copy of the Greek, marble, *c.*50 BC, discovered near Rome in 1506 (Vatican Museums, Rome)

16. *Leonardo da Vinci*, woodcut from Vasari's *Lives* 1568

17. *Pope Julius II*, painting by Raphael, 1511–12 (National Gallery, London)

18. *The Brazen Serpent*, black chalk drawing after the Sistine ceiling, by a follower of Michelangelo, late sixteenth century (Devonshire Collection, Chatsworth)

Julius had been busy on the final stage of his campaign against Giovanni Bentivoglio in Bologna. After establishing a new régime in Perugia, the pope had crossed the Apennines to Urbino, where he received the keys of the city on 25 September 1506, and pressed on through foul weather to Cesena, where he issued his first interdict against Bologna on 7 October; in Forlì he excommunicated Bentivoglio and issued his second interdict against the city. Now the French commanders also began to move against Bologna, and the pope hurried, by a mountainous route, to about twenty miles from the city.

Giovanni Bentivoglio faced an onslaught by the pope's army of 2,000 men, under the command of Gianfrancesco Gonzaga, and by a French contingent of 8,000 troops under Charles d'Amboise. Preferring to leave Bologna rather than place himself in the hands of the pope – the only choices open to him – Bentivoglio accepted an offer of asylum from the French king. On 1 November he rode out of Bologna and through the French lines with his sons, grandsons, supporters and friends. At the entreaty of the citizens, the pope bought off the French soldiers and their captains before they could sack the city. On 11 November, the feast of St Martin, Julius made his long, slow processional way to Bologna's basilica of San Petronio for a thanksgiving service.

But it was near the time of reckoning for the recalcitrant Michelangelo. The self-willed artist, a mature man just into his thirties, was summoned to make his peace with the domineering, irascible pope of his father's age, who had a week or so previously achieved a bloodless but brilliant military and political coup against the long-established ruling family of Bologna. On 21 November, Cardinal Alidosi wrote to tell the Signoria that the pope wished Michelangelo to come to Bologna as soon as possible to do some work for him in this city. The letter was conciliatory: Michelangelo was assured that he would be treated honourably. None the less, a carefully worded reply accompanied Michelangelo when he set off to Bologna a week later. Soderini, trying hard to strike the right note, wrote as follows:

> The bearer is the sculptor Michelangelo, sent to please and satisfy His Holiness, our Lord. We certify that he is a splendid young man, and in his profession unequalled in Italy, and perhaps in the whole world. We cannot recommend him too earnestly. His disposition is such that, if spoken to kindly and well treated, he will do everything. It is necessary to show him love and to favour him,

and then he will do works that will astonish all who see them. We inform you that here he has begun work on an historical picture for the public, which will be marvelled at, and also on twelve Apostles, each nine to ten feet high, which will be transcendent works. We repeat that we recommend him with all our good will.

At least Soderini pinpointed Michelangelo's responsiveness to affection as well as the quality of the 'historical picture' for the public domain, and his energy as a sculptor: factors that might count with Julius.

In the early days of December, Michelangelo was seen by some papal servants at a mass in San Petronio, and was asked to accompany them to the pope himself, who was seated at table in the Palace of the Sixteen. It was a dangerous moment. Looking angry, Julius said, 'You were meant to come to find us, but you have waited for us to come to find you.'

Falling to his knees, Michelangelo begged for pardon in a bold voice and explained that being chased away in the manner he was had thrown him into a rage. With his head lowered, Julius was looking about him without saying a word and the tension mounted. Suddenly, making excuses for Michelangelo, one of Cardinal Soderini's monsignori interjected, 'Your Holiness, pay no regard to his error, because he has erred from ignorance. Saving for their art, painters are all just as ignorant.' Seizing on this, Julius thundered that the bishop was abusing Michelangelo, whereas he had not meant to. 'It is you who are ignorant, and you who are an ignorant wretch, not him. Get out of my sight.'

Having found a scapegoat and discharged his anger, Julius called Michelangelo closer, said he forgave him, and told him not to leave Bologna till he had received another commission. This was not long in coming, and not much to Michelangelo's liking. Julius wanted a portrait of himself, a seated figure to be cast in bronze, over fourteen feet high, to go above the central door of San Petronio. Asked what this would cost, Michelangelo gave the estimate of 1,000 ducats, but added that bronze-casting was not his art and he would not do it; but the pope told him to keep trying till he succeeded, 'and we shall give you enough to satisfy you'. Michelangelo might have said that he did not like doing portraits; but he could now hardly refuse.

Pope Julius spent most of his time in Bologna reorganizing the government; replacing the Council of Sixteen with a Senate of forty to be elected from the leading families, but initially appointed by him, and negotiating with the insatiable French the reward for their military

assistance. But during the winter the cracks in their alliance began to widen. On 22 February 1507 Julius left for Rome.

The lack of confidence Michelangelo expressed to the pope in his ability to cast a bronze figure was genuine. When Julius insisted, Michelangelo, knowing he would need skilled help as well as the usual assistance, sent to Florence for two sculptors to come to assist him. These were Lapo d'Antonio di Lapo, who had been working for some years on the Duomo, and Lodovico di Guglielmo Lotti, a bronze-caster who had once been in the workshop of Antonio Pollaiuolo. Both were about ten years older than Michelangelo, and they brought him no joy.

Michelangelo's letter to his brother Buonarroto of 1 February 1507 records his pleasure at the progress being made in their father's purchase of a small farm. He describes a reassuring visit from the pope, who came to the rooms where he was working (the Stanza del Pavaglione, behind the basilica) and watched him for about an hour before leaving him with a blessing, 'having shown himself content with what I am doing'. But then, swiftly changing mood, Michelangelo explodes with anger over the behaviour of his two helpers from Florence. '... on Friday morning, I dismissed Lapo and Lodovico who were here with me. Lapo I sent packing, since he is a sly one and a bad man, who did not meet my needs, though Lodovico is better, and I would have kept him on for two more months; but Lapo, not to be the only one blamed, seduced him so that they both left. I am writing this to you, not because I take any account of them, for they are not worth three farthings between them, but so that, if they come to talk to Lodovico, he may not be bemused.'

His letters to Buonarroto are infused with affectionate allusions to Florentine friends such as Baroncello Baroncelli and, above all, to the loyal Granacci. Deep-seated desires surface in the letters to win back the pope's favour and to perform well in the eyes of his father. But Lapo and Lodovico continue to irk him and provoke detailed, indignant defence of his own behaviour, in immediate, instinctive retaliation against those who impugn his honour or his honesty:

> But their deepest anguish, and especially that wretched Lapo's, was this: that they had given everyone to believe that they were themselves doing this work, or at least they were my collaborators; and it never dawned on them, particularly Lapo, that they were not the masters, till I saw them off. Only then did he realize he was in my service.

Michelangelo, with his faithful Piero d'Argenta (whom he had

employed to prove that Lapo was cheating over some purchases of wax), now had to prepare to cast the huge statue of the pope using his own scarcely tested understanding of the technique. It was about this time that Pope Julius, visiting the workshop to check on Michelangelo's progress, was shown the clay model and was asked what should be placed in the statue's left hand, the right being raised to give a blessing. Would a book seem right? 'Why a book?' Julius reponds. 'Do a sword. I am not a man of letters.' Neither book nor sword but a key was the final choice: the key of St Peter.

When the pope asked teasingly whether the right hand was giving a benediction or a malediction, Michelangelo, well aware that the pope could be at risk from the deposed ruling family or its supporters at any time, said, 'It is warning the people here, Holy Father, to be prudent.'

The modelling and casting of the statue proved to be a mini-epic. Through successive letters in which, very unusually, Michelangelo confided in his family about the technicalities of his work, he gave a running commentary on its rapid initial progress, the crises and delays, and the short-lived triumph. As plague breaks out in Bologna 'of a deadly kind', Michelangelo declares on 26 March that he is hoping to cast his figure within a month. On 20 April, he writes that he has taken on a Frenchman to help with the casting, since the expert he wanted from Florence has failed to arrive because of the plague. That was the Republic's master of ordnance, Bernardino d'Antonio of Milan, who was skilled in making moulds and casts. Meanwhile in a short letter to his brother Giovansimone, chiefly concerned with a promise to set this brother up in a company, Michelangelo says, 'I have finished the wax of my figure. This coming week I shall begin to make the outer mould and I think this will be completed in twenty or twenty-five days. Then I shall give the order for casting, and if it turns out well, I'll be home soon.'

Bernardino arrives from Florence by 26 May, when Michelangelo writes that he is expecting to do the casting about the middle of June. On 20 June he writes again to Buonarroto, '. . . without fail we shall cast it this Saturday.' And then, to Buonarroto on 1 July, 'We have cast my figure but the way it has turned out I am positive I shall have to do it again . . . thank God for this, since I suppose all is for the best.'

What has happened, Michelangelo explains to Buonarroto on 6 July, is that:

Bernardino, through ignorance or through accident, did not melt the material properly. It would take too long to write why: enough

that my figure came out up to the waist; the rest of the material, that is half of the metal, has remained in the furnace, not having melted, so that to extract it I shall have to have the furnace dismantled, and this I am doing, and I shall also have it rebuilt this week; and next week I shall recast the top and finish filling the mould, and I believe that, after the bad start, it will all go well, but not without very painful effort and expense.

Michelangelo tells his brother that he had believed Bernardino so good that he could cast a figure without fire. He is a good master, Michelangelo still thinks, and he had worked *con amore* on the statue of Julius. But now Bernardino cannot look anyone in the face in Bologna, he has been so shamed. Bernardino leaves Bologna on 9 July, after the top part of the statue has been recast and its casing is still hot; Michelangelo writes the next day to say to Buonarroto, 'If he should say anything to you, look at him kindly; and leave it there.'

Then, to Michelangelo's surprise, the more of the figure is uncovered, the better it appears. At the beginning of August he tells Buonarroto that cleaning it up will take about six weeks. At the end of September, for all his hard work with hardly time to eat, as he says, he forecasts that he will finish or nearly so by All Saints Day. Then, however, although working 'day and night', protesting his anxiety to return to Florence, he writes to Buonarroto on 10 November with the news that work on the statue has been successful, though it will not be altogether finished that month. He comments triumphantly, 'I think that some-one's prayers may have helped me and kept me well, for my ever finishing it was against the expectation of the whole of Bologna.'

The colossal seated statue of Julius,* for which some of the metal had come from a bell from the tower of the deposed Bentivoglio and some from a broken gun of the Commune, was put in place over the portal of San Petronio on 21 February 1508, to the applause of a large crowd of people, the sound of pipes and drums, and the ringing of bells. (Michelangelo's exertions had included acting as adviser on moving forward the lower part of the façade and portal of the basilica to create the space for a huge niche to accommodate the bronze figure.) On the pope's orders, Michelangelo had waited several weeks, bored and impatient, after the statue had been finished, till the exact hour and day in late February considered propitious by the astrologers.

* Later destroyed – it was said to have been melted down to make a cannon.

17 *Bologna la grassa*

Completing the statue of Pope Julius brought Michelangelo a renewed sense of defeating adversity single-handed, but little profit (about four and a half ducats after meeting his expenses) and no guarantee of a harmonious relationship with the pope.

The Bolognese goldsmith turned painter Francesco Francia was highly successful and was admired in Bologna especially for his oil-paintings of Madonnas, for a gruesome mural in the Bentivoglio palace showing Judith cutting off the head of Holofernes, and for medals and coins. His painting style lacked personality, however. Being out of sympathy with the man and his art, Michelangelo was all the more sensitive to any slight, and when Francia praised his statue of Julius for its fine casting and material Michelangelo rounded on him and called him a fool. 'I owe as much to Pope Julius who gave me the bronze as you owe to the chemists who gave you the colours for paintings,' he said.

To a Bolognese nobleman who marvelled not at the genius but at the size of the statue of Julius, and fatuously wondered aloud if it were bigger than a pair of oxen, Michelangelo remarked that this would depend on whether they were Florentine or Bolognese oxen, as the Bolognese ones were bigger.

In Bologna, Michelangelo said, he worked day and night for the pope and he thought day and night only of his family. He was always promising them to be back soon in Florence, always guaranteeing financial support, sending his father money from time to time for various purposes, and being exasperated when it was not acknowledged. Michelangelo's blunt letters from Bologna created constant drama out of his mixed feelings of acrimony and affection towards Lodovico, Buonarroto and Giovansimone.

As far as his art was concerned, however, Michelangelo's mood usually exuded anxious resignation as he did exhausting work which brought him pleasure only in its technical accomplishment. In the long hot summer of 1507, he wrote to Buonarroto:

Today I've received a letter from you, telling me that you are all in good health. I'm pleased about this; I am likewise well and I think what I'm doing will succeed. It's true that great efforts are needed; but I am sure that I have no more risks to run nor too

great expenses to incur, as I am obliged only to finish the work where it stands . . . since I have been here, it has rained only once, and is hotter than I believe it could ever have been in the world. The wine is as dear here as there, but as bad as can be, and everything else is likewise, so it's wretched to be here, and like a thousand years till I leave.

Witnessing Pope Julius's victory procession in Bologna, Erasmus, the scholarly Dutch priest, who was then travelling in Italy as a tutor, shrewdly observing, making useful friends, pursuing his polemical literary career, had been struck by the pope's exultation and by the contrast between this triumph and the terrible nature of war. Reluctant to make the statue of Julius, as he had protested, Michelangelo yet had no qualms about its message and his role in producing a massive symbol of power, unambiguously both secular and sacred. He had needed to placate the pope, because of personal ambition and political pressure, but in any case felt no bias against Julius in favour of a city he rather despised.

Though often physically exhausted, Michelangelo did not fully expend his creative energy on the figure of the pope. The fire burning in his heart found some outlet in the welling-up of his impulse to write poetry, fed by his formative experiences with Lorenzo de' Medici and Aldovrandi, and by his intense reading after finishing the Cascina cartoon. A love poem, plaintive and sensual, survives from this period, along with an emotional fragment of verse.

On the back of a letter from Buonarroto dated 24 December 1507, Michelangelo composed or, more likely, made a fair copy from earlier drafting of an elegant and curious sonnet on the charms of a young woman's beauty, using the commonplace conceit of her admirer's envy of the clothing she wears: of her garland for touching her head, the bodice and gold ribbon her breast, the golden thread her cheeks and neck, the girdle, with its knot, her waist. The last tactile line asks what remains for the poet's arms to do: '*Or che farebbon dunche le mie braccia?*' Lightly throughout, the verbs Michelangelo chose – *serra*, *preme*, *tocha*, *stringer* – suggest the delicate pressure of the adornments on the body and the visibility of the body's contours under light embrace.

The poem was partly a derivative exercise, after the style and adopting some of the rhyme words and vocabulary of Poliziano's *Giostra*, but with an added sculptural element in its suggestion of the body's emergence like Venus from the sea.

Did a live young woman inspire Michelangelo's sonnet? Or was it

another representation of the young mother who had so often appeared, sadly and sweetly and abstractedly, in Michelangelo's drawing, painting, in his carvings of the Madonna? The mild sensuality of the sonnet's sestet is duplicated in the words he wrote beside the poem: '*la m'arde e lega e temmi e parm'un zucchero*': 'she burns me and binds and holds me and seems to be a darling'. There seems more passion in this than in the sonnet, which was perhaps an exercise and no more.

In *Bologna la grassa* – rich Bologna, fat Bologna, as a friend described the city to him – Michelangelo grew increasingly eager to return soon to Florence and to Rome. He would be in Rome by Lent, he told Buonarroto in December 1507, and again to Buonarroto, writing in January 1508, 'I shall leave within a fortnight, or be ready to do so. This seems like a thousand years to me, because the way I live here, if you knew what it was like, you would feel sorry for me. Don't write any more to Bologna, unless it is something important, as the delivery of letters is so bad . . .'

PART THREE

Il Giorno 1508–1534

18 Father and sons: family business

Michelangelo craved security. This depended on property and patronage. After shaking the dust of Bologna off his feet, in March 1508 he acquired substantial property in Florence. In May, for Julius, he committed himself to a long-term artistic programme rivalling the projected tomb in its monumental ambition: the painting of the great vault of the Sistine Chapel in the Vatican.

The property consisted of a piece of land with three small adjoining houses, two on Via Ghibellina, where Michelangelo had been living, and one on Via Santa Maria (now Via Michelangelo Buonarroti). The sale was made on 9 March for 1,050 large florins. Now, as well as the family house and farm at Settignano and the farm Michelangelo had bought for investment at Pozzolatico in 1506, the family had a place in the city spacious enough, when converted, for brothers and father to live together in the largest house.

Lodovico's life as widower was a continuing story of financial and family woes. As Buonarroto and Giovansimone had been planning to go into the wool business, in 1507 he had himself registered with the Wool Guild so that they could benefit from the privileges to which the Buonarroti were entitled. In 1508 his brother's widow, Cassandra, sued Lodovico for the recovery of her dowry, for which the farm at Settignano stood pledge. When she won her lawsuit and the distraught Lodovico had to pay out, Michelangelo sent the money needed, as he did so often.

Michelangelo's brother Buonarroto shared some of Michelangelo's traits of character, including perspicacity and ambition, and the ability to charm influential friends. These included members of the Strozzi family, for whom he worked and in whose wool business in Via Porta Rossa he modestly invested (Michelangelo's money) in 1505. But from the beginning Buonarroto's business experiences were dismal.

A new wool company formed by Buonarroto and the Strozzi in 1508 ran its course over five years, but all the while Buonarroto was yearning to have his own family business. This would also involve Giovansimone, who was clearing thirty when Michelangelo came back from Bologna. He was dreamy, simple-minded and highly strung, and Michelangelo was more than fond of him. Giovansimone kept close to the family chiefly through Buonarroto, and when not in the country he lived in

the house in Via Ghibellina. He worked in the Strozzi's *bottega*, and Michelangelo helped him invest a little money in the joint company.

Suddenly, Giovansimone's horizons expanded hugely when he became involved in a commercial venture connected with a ship's journey from Lisbon to India in 1509 (ten years after Vasco da Gama had returned to Portugal after having rounded the Cape and reached India). The next year Giovansimone was thinking that he might himself journey to Lisbon, where there was a thriving Florentine community, and make the voyage to India. This was an audacious plan, in an age when even coastal sea-voyages in sailing-ships were journeys of surprises, fraught with dangers from piracy, storms and rampaging Moors. But Giovansimone stayed at home to attend to the wool business.

Gismondo, the youngest of the brothers, had just turned twenty-seven when the family property was bought in Via Ghibellina. Michelangelo scarcely knew him, but from time to time he was ready to encourage him with kind words or money. This did not go so far as to welcome the proposal (in the summer of 1509) that Gismondo should join him in Rome – 'not that I do not love him as a brother, but because I cannot help him at all'.

While pursuing his tremendous project for Julius in Rome, Michelangelo intermittently hammered his family in Florence with accusations and recriminations over their foolhardiness and bad faith. When exasperated, he would threaten to make a stormy appearance in person.

Against Giovansimone, his anger exploded in the summer heat of Rome in 1509, when, not for the first time, Michelangelo was waiting anxiously for payment from the pope and also being distracted by a trickle of news about the lawsuit brought against Lodovico by his sister-in-law, Cassandra. The precise nature of Giovansimone's bad behaviour – which Lodovico dutifully reported to Michelangelo – is obscure. It provoked from Michelangelo an angry message to his father:

> I have had no worse news these past ten years than on the evening I read [your last letter], because I thought I had arranged matters for them, namely how they might hope to set up a good workshop with my help, as I promised them, and in this hope might apply themselves to becoming proficient and to learning their trade, so as to be able to run the shop when the time came. Now I learn they are doing the contrary, and especially Giovansimone, and so I've come to see that doing people good is no use at all. And if I

had been able to, the day I had your letter, I'd have mounted a horse and by now would have settled everything. But as I can't do this, I am writing him a letter on how things seem to me; and if from now on he does not turn over a new leaf, or rather if he so much as takes a stick from home or does anything at all to displease you, I beg you to let me know about it, because I shall then seek leave from the pope and I shall come there and show him his mistake.

I want you to know for certain that all the hardships I have ever endured have been on your account as much as my own, and what I have bought was intended to be yours as long as you live; had it not been for you, I would not have bought it. So if you would like to let the house and lease the farm, do so as it suits you; then, with the income provided and with what I'll give you, you'll live like a gentleman. And if summer were not on the way, as it is, I would tell you to do it now and come to live here with me. But now is not the right time of year, because you could scarely live here during the summer. I have thought of taking back the money he has for the shop and giving it to Gismondo, and allowing him and Buonarroto to fend for themselves as best they can, while you let those houses and the farm at Pozzolatico and, with the income and the help I'll give you as well, retire to some place that suits you well, and keep someone to look after you either in Florence or outside Florence, and leave that wretch to scratch his arse.

The letter Michelangelo wrote that summer in evident haste to Giovansimone 'on how things seem to me' was so alarming that it may well have pushed Giovansimone into his attempt to leave Florence for Lisbon and the high seas:

Giovansimone – They say that if you treat a good man kindly you make him even better, and if you treat a wicked man so you make him worse. I've tried now for many years with kind words and deeds to lead you back to a decent way of life at peace with your father and the rest of us, and yet you grow worse all the time. I am not telling you you are wicked, but the way you are carrying on you never ever please me, or the others. I could speak volumes about your behaviour, but that would just be adding more to all the other words I've said about it. So let me be brief and just tell you that for sure you have nothing of your own in this world, and your spending money and home expenses are what I give you and have given you for some time, for the love of God. This has been

in the belief that you were my brother just like the others. But now I am certain this is not so. For if you were my brother you would never threaten my father. In fact you're an animal, and I shall treat you like an animal. You should know that if a man sees his father threatened or hurt he is bound to defend him with his life if need be. And that's all there is to it. I tell you that you own not a thing in the world; and if I hear anything more at all about the way you behave I'll ride with the post all the way to Florence to show you your mistake, and teach you to squander all your belongings and to act like a firebrand in the houses and farms you've done nothing to earn. If I come there, I'll show you something that will scald your eyes with tears, and you'll soon know what your pride is worth. I must say this to you once again, that if you will set about doing good and honouring and respecting your father I shall help you as I do the others, and I'll shortly make it possible for you to start a decent shop. If you don't do this I shall get there and settle your affairs in such a way that you will understand just what you are, better than you ever did, and you'll realize just what you've got in this world and you'll know it wherever you go. That's all. Words may fail me, but what I do will be stunning.

Michelangelo in Rome

I can't refrain from writing you another couple of lines; and this is to say that for twelve years now I've been traipsing around Italy, borne all kinds of disgrace, suffered every calamity, lacerated my body with cruel toil, put my own life in danger a thousand times, only to help my family; and now that I've started to raise our house up again a little, just you alone wish to be the one to confound it and ruin in an hour what I've achieved after so many years and through such great toil. And, by the body of Christ, that's the truth! If needs be, I'm ready to confound ten thousand of the likes of you. Now be wise, and do not provoke a man who has other tribulations to endure.

Michelangelo's rage usually subsided quickly; though he never forgot and would brood for ever over a slight, he found it hard to be vindictive. A few months later in 1509, in a letter to Buonarroto warning off Gismondo from coming to Rome, he none the less showed that the breach was repaired with the casual remark that he was glad to hear, apropos of the brothers' business ambitions, that 'Giovansimone is beginning to do well'.

Lodovico – his 'dearest father', his 'most revered father' – often irritated and even enraged Michelangelo when he was working in Rome under Pope Julius. After Michelangelo's discovery that his father had drawn without his permission from his bank account in Florence, hoping to repay the money in good time, Lodovico's response to Michelangelo's explosion of anger was typically and understandably contrite.

Money was always bound to be a sore point with Michelangelo, whose family rows in 1509 and 1510 coincided first with intense painting activity and then with preparations to begin a fresh session of work in the Sistine Chapel, and whose payments from the pope were made erratically: on one occasion, in 1512, only after the pope grew afraid that Michelangelo would not return from a holiday in Florence unless paid an instalment before he went; and again, towards the completion of the work, only after Michelangelo had twice pursued the pope to Bologna, cap in hand.

19 The Creation of the World • The humbling of Venice

Michelangelo went to Rome in the spring of 1508 still not sure what work he would be doing for Julius. He left uncompleted in Florence important works of painting and sculpture, but also in the air was yet another commission from Soderini, the carving of a statue to balance the David on the Piazza della Signoria. Then on 10 May 1508, after long negotiations, Michelangelo wrote:

> I, Michelangelo, sculptor, have this day received from His Holiness our Lord Pope Julius II five hundred papal ducats, paid to me by messer Carlino chamberlain and messer Carlo degli Albizzi, on account of the painting of the vault of the chapel of Pope Sixtus, regarding which today I am starting work, on the conditions and agreements which appear in a deed of writing drawn up by the most reverend monsignor of Pavia.

Pope Julius, or his artistic advisers, perhaps including Bramante, had seen the splendid opportunity to paint the ceiling of the Sistine Chapel with figures and scenes to rival the existing scenes of episodes from the

life of Christ and, on the opposite wall, from the life of Moses executed in fresco by Perugino, Botticelli, Ghirlandaio and others. The project had first been discussed in 1506. Initially Michelangelo sketched ideas for a strong geometrical field of squares, circles and lozenges. This design was modified to increase the size and shape of the framed areas and to add winged figures, and was then transformed into a tremendous scheme to represent the epic story of the Creation and Fall, with prefigurations of the Redemption.

In this architecturally inspired design, the middle, highest, stretch of the vault – strongly contained like an open sky within a painted cornice – was divided into nine segments, alternately larger and smaller, which would present the biblical sequence of the opening chapters of Genesis, from the separation of light from darkness to the centrally placed Creation of Man and lastly the Flood and the drunkenness of Noah. Lower down on the curve of the barrel vault, between painted pillars, twelve sections of simulated wall would show seven Old Testament prophets and five pagan sibyls seated on thrones with attendant genii.

Also under the pictorial cornice, in the spandrels, were to be the ancestors of Christ as summarized in St Matthew's Gospel. Huge corner spandrels at this level would show Old Testament scenes of salvation (the death of Haman, the brazen serpent, Judith and Holofernes, David and Goliath). Over the chapel's windows were to appear more scenes from the ancestry of Christ.

To enhance the spatial and architectural illusion, twenty-four simulated pilasters were to be painted on the surface of the vault, supporting illusionary sculptures of naked children. These would flank the prophets and sibyls, and over them, in the highest part of the vault, the design contained imitation marble blocks seating ten paired male nudes (*ignudi*). These would support fictive bronze medallions showing still more biblical scenes.

This final scheme, allowing for great spontaneity as the work progressed, created a cathedral-like expanse of painted architecture, simulating walls, pilasters, cornice, arches, and materials of marble, bronze and gold, with an opening to the heavens. The aim was not to display convincing illusionistic effects so much as to provide a setting for an abundance of storytelling and for figurative painting aspiring to the dramatic solidity of sculpture.

The preparatory work for the painting of the Sistine vault was carried out in stages lasting till the beginning of 1509. In mid-May 1508, Michelangelo sent to Florence for some best-quality blue pigments from a friar Jacopo at the monastery of the Gesuati, a customary source

of azures. Francesco Granacci had joined Michelangelo in Rome and sent an accompanying letter to the same priest requesting the best possible help. The scaffolding was meant to be put in place in June, but this immediately caused problems, chiefly because the liturgically important chapel had to continue in use while the frescoes were being painted. Bramante, the pope's architect, tried to solve the problem with a hanging scaffold with ropes passing through holes in the ceiling, but this was rejected by Michelangelo. How would the holes be filled in when the ceiling was finished, he asked sarcastically.

Given his head by the pope, who told him in front of Bramante that he should make the scaffold in his own way, Michelangelo adapted previous techniques to devise a structure of scaffolding placed on massive blocks or brackets, projecting outward from the wall just above the cornice under the lunettes. For safety and appearance's sake, the scaffolding was concealed from below by an underflooring. Partly for economy's sake, partly for convenience, this extended to just half the chapel's length. Timber was expensive and used with care, even though Michelangelo had been delighted that by abandoning Bramante's scheme for the scaffolding he had been able to give enough of the leftover ropes to his carpenter to make up a daughter's dowry. Above all, however, this arrangement meant more natural light, to supplement the abundance of artificial illumination, essential for a painter using frequent cross-hatching and contriving to let one thin layer of paint show through another.

Michelangelo set to work in an atmosphere of dust and heat generated by masses of candles to supplement the limited natural light. Often he had to work painfully, standing stretched with his head tilted backwards.

After he had begun to devise ideas for decorating the vault, Michelangelo had sent for assistance from Florence. Never short of willing help, this time he used the devoted Granacci as an intermediary. On 22 July 1508 Granacci reported that he had met the painter Raffaellino, who would journey to Rome at Michelangelo's bidding 'should you be pleased to pay the salary which he has been receiving from Master Pietro Matteo d'Amelia, who he says gave him ten ducats a month'. On 24 July Granacci reported that two of the painters approached, Jacopo l'Indaco and Giuliano Bugiardini, had wanted to be paid in advance, with guarantees. The entertaining Jacopo explained that he sometimes had to fight with agents who asked for more than their employer. Both men were Michelangelo's contemporaries, and Giuliano had been a pupil of Mariotto Albertini, a painter who had

been a partner of Fra Bartolommeo and had then become an innkeeper.

Writing to his brother Buonarroto on 29 July, Michelangelo enclosed a letter from a sculptor, Giovanni Michi, 'who wanted to work with me previously and has written again saying he wants to come. So please go to San Lorenzo where he says he works and try to find him, give him the letter, and seek a definite answer, because I cannot go on alone.'

In August, Michelangelo finalized a contract with the artists he wanted to employ for advances of twenty ducats each, half retainable for their expenses in coming to Rome if they did not find themselves in accord with him. Harassed as he was this summer, he had found time to try to arrange for a young Spanish painter who had met him in Rome to study the cartoon for the *Battle of Cascina* in Florence. But during this preparatory period he lost patience with several of the little band from Florence. In October one of them, Jacopo di Sandro, was abruptly dismissed, and after grumbling about Michelangelo in Rome went back to protest in Florence. 'Turn a deaf ear,' Michelangelo wrote to his father. 'He was utterly in the wrong and I have good cause for complaint. Pretend not to notice him.' About the same time, exasperated, Michelangelo made his feelings about their work clear by shutting himself up in the chapel and refusing to let them in, or see them anywhere else.

From the spring till the autumn, Piero Rosselli and his team had been working on the scaffolding and on scoring the entire ceiling for the *arriccio*, the first coat of plaster, beneath the wet lime plaster which would be applied daily for Michelangelo's brush. Early in September the blue pigment ordered from Florence arrived in Rome. By the end of the year Michelangelo had started enlarging his varied studies in pen and chalk to cartoons, and was ready to transfer outlines of the cartoons to the plaster.

During the winter of 1508–9, beginning in the topmost part of the ceiling above the great door with the story of the Flood (between the smaller scenes about the drunkenness of Noah and his sacrifice), Michelangelo began to work in concentrated bursts. Then, fulfilling Michelangelo's forebodings, after a third or more of the work had been completed disaster struck with the *tramontano*, the fierce north wind: salt efflorescences started to appear in several places as the surface was drying. Giuliano da Sangallo, soon to leave for Florence, was sent by Julius to put his Roman architectural experience to good use and reassured Michelangelo about the nature of the problem as

well as teaching him how to remove the moulds formed on the surface.

In late January 1509 Michelangelo was writing to his father about the difficulty of the work, which was proceeding so fruitlessly that he was not inclined to ask the pope for more money, despite the lapse of time since he had received any. In June Michelangelo reported to Lodovico that he had now received no money from the pope for thirteen months, and would have to borrow if he were to want to go home. He was feeling unwell. One of his other worries was the lack of someone to 'manage' domestically for him. His servant, a stonecutter called Pietro Basso, had fallen sick in the summer of 1508 and returned to Florence to escape the bad Roman air. But he also wrote teasingly and more cheerfully, 'I learn from your last letter that they say in Florence I am dead. This does not matter, because I am still alive . . . I'm concentrating on working as hard as I can.' And by the autumn of 1509 Michelangelo had received another 500 ducats for his work on the Sistine and quickly remitted 350 ducats to Florence for investment.

Julius, since his departure from Bologna and triumphal return to Rome in 1507, had continued to agitate for the return of papal territories from Venetian control. For a while his plans were disrupted by an understanding between the French and Spanish kings, and the disconcerting threat of the Holy Roman Emperor Maximilian to bring an army into Italy and have himself crowned in Rome, a ceremony anticipated when he was proclaimed emperor-elect of Rome in the cathedral of Trent.

Julius persuaded Maximilian to attack Venice, but the Venetians beat back his armies with French help. This provoked the drawing up of a compact known as the League of Cambrai, uniting all those states which had lost territory to Venice or saw the chance of spoils. It contained undertakings to launch a crusade against the Turks and, more realistically, to force Venice to disgorge territory seized on the mainland. The part of the compact meant for publication recorded a treaty of peace between the emperor and the French king which handed the city and territories of Milan over for ever to Louis XII and his heirs. The secret treaty detailed the way in which Venetian-held territories were to be shared out among the signatories.

On 14 May 1509 on the plain of Agnadello in the province of Cremona, Louis XII's army of 40,000 men, including 15,000 heavy cavalry and 8,000 Swiss, inflicted total defeat on the Venetian forces. The reconquest of Pisa after fifteen years – so immensely comforting to

Florence – was a sideshow compared with the manoeuvres of the big European powers as they drove Venice back to the lagoons.

Julius's triumph over the Venetians was marred by the retaking of Padua and by the surprise capture of Gianfrancesco Gonzaga, the marquis of Mantua, one of the allies of the League of Cambrai. The marquis's wife, Isabella d'Este, prayed with her spiritual advisers, consulted her astrologer, and sent to lighten her husband's confinement in Venice a lute-player, his favourite tenor and other court singers, and a copy of her own portrait by the court painter Lorenzo Costa. The pope threw his cap to the ground and cursed St Peter. He was exasperated and frustrated not only by the resilience of the Venetians but also by the sudden shift of power in the Italian peninsula to the French king, and dealings with Venice during the remainder of 1509 were aimed at securing a surrender which would not be too abject or ruinous.

Despite pressing concerns of war and diplomacy, Julius also gave sporadic attention to his artistic projects. From the start of his pontificate artists and craftsmen increasingly settled in Rome. He commissioned two magnificent tombs: one for Cardinal Ascanio Sforza, the other for his own cousin Cardinal Girolamo Basso della Rovere. Following Sangallo, Bramante was now in the ascendant as principal architectural adviser. Working on the Belvedere court and the foundations of the vast new St Peter's, he ran a large workshop and Vatican office, employing at one time or another the foremost Italian architects, Sangallo, Baldassare Peruzzi from Siena, Giulio Romano and Raphael of Urbino.

20 Raphael of Urbino

From the day he arrived in Rome in 1508, Raphael was inevitably drawn into the webs of rivalry and intrigue spun by the Curia's officials and servants. The twenty-six-year-old genius soon became another pole of force in artistic Rome. Julius may have seen his painting of the Entombment at Perugia and marked him down for employment; Bramante may have suggested his name to the Pope as a young and ambitious painter of proven talent, who would be a splendid addition to the team working in the Vatican, which included Perugino, Bramantino and Giovanni Bazzi – Il Sodoma.

* * *

In 1507, finding intolerable the reminders of his hated predecessor Alexander VI in the painting by Pinturicchio of the apartments of the second floor of the Vatican Palace, Julius had determined to move permanently into the floor above and to decorate his own apartments there. In January 1509 Raphael was recorded as receiving 100 ducats for painting in one of the vaulted rooms, intended by Julius for his modest library (later called the Stanza della Segnatura). Raphael expanded and unified the programme while he worked, retained the smaller pictures among those already painted by Sodoma, and depicted scenes suggestive of literature and learning. In four circles on the ceiling were personifications of Theology, Philosophy, Justice and Poetry, with appropriate scenes in the spaces between; the paintings on the walls below include the *Disputa* or *Disputation Concerning the Blessed Sacrament*, and the *School of Athens*. Raphael's pictures were a pictorial encyclopaedia of the intellectual life and heritage of Julius's Rome, full of subtle symbolism, movement and colour.

Raphael's increasingly confident ability to set variedly posed and dignified figures most satisfyingly in mathematically ordered space and his remarkable powers of assimilation and creative imitation were richly illustrated by his work on the ceiling and walls of Julius's apartments. His figure of the hanging Marsyas on the ceiling and of Apollo, for example, derived from an antique sculpture; the executioner in the Judgement of Solomon resembled figures by Leonardo and by Bertoldo, and by the ancient creator of a battle sarcophagus in Pisa.

From Michelangelo, Raphael had taken lessons for the poses of the Christ in his paintings of the Holy Family, and of male nudes in action from the famous battle cartoon. Now in Rome he was essaying large-scale fresco painting with huge narrative scenes including the female nude and the heroic male nude. He was eight years younger than Michelangelo, but, following the death of Giorgione in Venice, and of Botticelli, Signorelli and Perugino in Florence, Raphael was the only artist apart from the ailing and erratic Leonardo who challenged Michelangelo's dominance as a painter. As the scores of preparatory drawings attest, in undertaking a huge fresco as in the Vatican Palace he needed to improvise and change, and he had to learn from others with the experience he lacked – and learn fast. He seized every opportunity to study Michelangelo's astonishing figures in the Sistine, even as his own work was progressing in the pope's apartments.

Raphael was ever opportunistic. Marcantonio Raimondi of Bologna, after working in Venice, had engraved figures in Florence from

Michelangelo's cartoon for the *Battle of Cascina*, but it was with Raphael that he formed a business to print and market engravings. The prints, marked R.S. for Raphael Sanzio and M.R. for Marcantonio, were sold wholesale and retail and widely distributed.

Amorous, in a Rome whose predominance of clerics meant a scarcity of married women but not of courtesans, Raphael depicted women with deeply interested curiosity and sensuality. Full of grace and charm, athletic and erudite, he enjoyed an energy which, unlike Michelangelo's concentrated force, flowed through numerous sophisticated social and artistic channels. His apparently effortlessly painted figures and scenes (carefully studied and prepared) demonstrated especially the qualities of decorum and nonchalance – *decoro* and *sprezzatura* – in the spirit of Castiglione, who arrived in Rome early in 1510 with a group of notables from Urbino.

Michelangelo's prophets and sibyls in the Sistine held Raphael spell-bound, but Michelangelo's uncourtierlike manner and temperament and suspicious insight ruled out friendship. The story went round that Raphael was calling Michelangelo 'the hangman' for his solitariness after Michelangelo had likened him to a police-sergeant with his troop. Yet Michelangelo's family did not hesitate to ask him to entertain visitors to Rome, such as the rich and sociable Lorenzo Strozzi, and expected him to do so. His lack of sociability, Michelangelo explained to Buonarroto (late in 1509, when working flat out), was because he had to put himself before others as he was living in a state of great anxiety and was utterly fatigued. 'I have no friends of any sort and want none. I do not even have time to eat properly.'

21 To the tempo of war

Julius justified his assertion of temporal power over the lands of the Church in Italy by his belief that the Roman pontiff ruled as heir to the Caesars as well as being spiritual successor of the chief of Christ's Apostles. The Catholic faith and worldly aims of Pope Julius found fluent expression in the creations of Sangallo, Bramante, Raphael, and Michelangelo above all.

Michelangelo transformed the details of the commission first mooted in the spring of 1506 and finally given him in May 1508 into inventions

of his own fertile and retentive mind, as the Sistine frescoes now began to show. Empowered to fashion his own universe, re-creating so much of what he had observed and stored since he first opened his eyes on the world, he moved with amazing speed to complete over half of the painting between July 1508, when the scaffolding and *arriccio* were ready, and late July or August 1510, when work stopped just before the pope quit Rome, leaving him bereft of instructions and money.

When Ghirlandaio had adorned the walls of the choir of Santa Maria Novella, he had employed numerous assistants and collaborators, including at least ten painters, among whom, as well as his own brothers and his brother-in-law, Sebastiano Mainardi, were Jacopo l'Indaco, Baldino Baldinelli, Giuliano Bugiardini, Francesco Granacci and Michelangelo. Some of those who had come in 1508 to help Michelangelo were his companions of twenty years before; but, just as his interpretations dominated the designs, so he did most of the brushwork with his own hands.

As he painted, Michelangelo resented watching eyes, even – perhaps especially – the greedy eyes of Julius II. The pope often asked to see the progress made, however: to climb a ladder and be helped on to the platform by Michelangelo himself. By the summer of 1510 Julius's impatience was becoming explosive. But he may then have at last obtained his first view of a great stretch of the ceiling, which Michelangelo as early as July had been preparing to uncover.

In September 1510 Michelangelo wrote to his father, having heard Buonarroto was ill, that he might come to Florence, though this would be costly for him, 'because the 500 ducats I have earned under the agreement are due to me, and as much again which the pope must give me to start the rest of the work. But he has gone away and left me no instructions, and so I find myself without money and do not know what I should do.' The same month, having written to Julius, Michelangelo left for Florence (where he discovered that his father had purloined some of his savings) and then pursued the pope to Bologna. At length, in October 1510, he received a third payment of 500 ducats from the papal datary (most of which he promptly transferred to his account in Florence). After spending Christmas in Florence, he received the second overdue payment, again of 500 ducats, in January 1511, once more having had to press for it. Work on the chapel probably restarted early in 1511.

Michelangelo continued to be tormented by financial problems – his own, the family's and the pope's. In June 1511 (when Julius returned

to Rome) he wrote to tell his father that, after sending money for deposit in Florence, he had left himself eighty ducats, which should last him a few months, and that he had still six months' work to do before he was due to receive more from the pope, and therefore Lodovico should let him have fifty ducats of the money he had promised to repay. He was also troubled by his broken contract for the Piccolomini Chapel, and mentioned that the 100 ducats he had sent to his father for safe-keeping were intended to be kept to repay the cardinal's heirs.

In August, Paris de Grassis, who had succeeded Johann Burchard as papal master of ceremonies in 1506, recorded a significant visit to the Sistine by the pope, for vespers and mass on the vigil and the feast-day of the Assumption of the Virgin, 'for this chapel is consecrated to the Assumption. The pope came to the services either to see the new paintings recently revealed in the chapel or because his devotions led him to.' Michelangelo thankfully recorded a fifth payment for his work, of 400 ducats, in October 1511, after he had visited the Pope.

Julius's war campaigns and the state of the papal treasury had dictated the tempo of Michelangelo's painting. In 1510, after the humbling of Venice, the pope had set about shaping his alliance to chase the French out of Italy, wooing Spain by investing the Spanish king with Naples despite French claims, and securing with the Swiss Federation a treaty which promised that Julius would defend the cantons with spiritual weapons and they the papacy with 6,000 men. King Louis XII attacked several of the pope's valuable spiritual prerogatives, and the pope coordinated plans to defeat the French at several key points in Italy.

As Michelangelo's work in the Sistine had come to a halt in August 1510, Julius went to Ostia to inspect the war fleet (bound for Genoa), and then in rainy weather set out with 400 men for the north. At the end of September he entered Bologna, and immediately fell ill. During this illness, Julius grew a long, white beard – the first seen on a pope for many centuries. He vowed not to shave it off till Louis XII had been chased out of Italy. At the end of December, to his courtiers' astonishment, he said he would join the papal army, before the town of Mirandola, to hasten its attack; and this he did, pushing through the bitter cold, accompanied by a bevy of cardinals and his architect Bramante, having just passed his (probably) sixty-seventh birthday, and looking in the snow like a polar bear.

In April 1511 the French army once more advanced on Bologna. Julius left the city for Ravenna in mid-May, to avoid any danger of capture. The men he left in charge – Cardinal Alidosi and the duke of

Urbino, the pope's nephew Francesco della Rovere – behaved in their different ways ignominiously. Alidosi fled as soon as the supporters of the Bentivogli began to show their hand in the city. On news of the unrest, Franceso della Rovere ordered a retreat. On 23 May 1511 the French under Gian Giacomo Trivulzio seized Bologna and the Bentivogli were restored to government.

In Ravenna, the pope made a dignified but vituperative speech to the cardinals present, attributing the loss of Bologna to cowardice and treachery. His nephew Francesco, who had hardly dared go near the old man when he was storming against his commanders in the camp outside Mirandola, now felt the humiliating lash of his tongue in Ravenna and himself rode away enraged, only to encounter his hated rival Alidosi approaching on a mule. The duke dismounted, rushed to Alidosi's side and struck him on the head with his sword. The cardinal's attendants watched in terrified silence while two of Francesco's men ended Alidosi's life.

Francesco Alidosi – brought up as one of the *famiglia* of Sixtus IV – had been sheltered by the pope, as his obvious favourite, for many years. As the pope's legate in Bologna, he had infamously exploited his position for personal gain. After Alidosi's murder, the pope left Ravenna sobbing behind the drawn curtains of his litter.

In August, Julius suffered a nearly fatal illness during which he removed the interdict he had placed on Ferrara and Bologna, absolved and reinstated the duke of Urbino, and was prepared with the sacraments for death, while rebellious noble families in Rome tried to organize an uprising. By September his remarkable constitution and an unorthodox liberality in the diet he was allowed (especially of peaches and plums) saw him through to convalescence and the resumption of desperate negotiations for an alliance against France. On 4 October 1511 the Holy League was signed. Involving Julius II, Ferdinand of Spain and the Republic of Venice, and providing for the membership of the Holy Roman Emperor and the king of England, it aimed formally at preserving the unity of the Church and the integrity of its patrimony and in effect at securing revenge against the French: 'to liberate Italy from the barbarians'.

During the months of Julius's astounding reversal of fortune, he sat for Raphael to paint his portrait. Completed before March 1512, the powerful nearly life-size portrait* shows Julius radiating intense individu-

* National Gallery, London.

ality. This is the first known independent painted portrait of an unaccom-
panied pope. He seems ravaged with disease as well as recent defeat. The
portrait expressed both the pope's unique character and the universe of
his formidable pretensions: as royal pontiff and priest wearing six rings –
the white diamond, the green emerald and the red ruby respectively
symbolize faith, hope and charity – and as potent head of the della
Rovere, whose proud, massive acorn emblems were highlighted in gold
on the back of the papal chair, framing the pontiff's head.

22 Man in the image of God

During the course of 1510, Michelangelo expressed his mood of exaspera-
tion and weariness in beautiful handwriting like lace:

> This comes of dangling from the ceiling –
> I'm goitered like a Lombard cat
> (or wherever else their throats grow fat) –
> it's my belly that's beyond concealing,
> it hangs beneath my chin like peeling.
> My beard points skyward, I seem a bat
> upon its back, I've breast and splat!
> On my face the paint's congealing.
>
> Loins concertinaed in my gut,
> I drop an arse as counterweight
> and move without the help of eyes.
> Like a skinned martyr I abut
> on air, and, wrinkled, show my fate.
> Bow-like, I strain towards the skies
>
> No wonder then I size
> thing crookedly; I'm on all fours.
> Bent blowpipes send their darts off-course.
>
> Defend my labour's cause,
> good Giovanni, from all strictures:
> I live in hell and paint its pictures.

He addressed the intimate composition to the friend invoked in
the sonnet, Giovanni di Benedetto from Pistoia, an academically well-
respected writer of plays and verse, who exchanged sonnets with

Michelangelo and expressed deep affection for him. At the side of his poem Michelangelo drew a naked figure almost on tiptoe, sketched with a few, short, single lines, with right arm stretched up high in order to execute a figure on the vault. This aching posture left him for a while unable to read a letter without holding it above his head.

Literally translated, what Michelangelo wrote as the last line of this extended sonnet was that he was not in a 'good place' nor was he a painter. This was contradicted by every stroke applied to the Sistine vault; but it rankled that his sculptural work for the tomb of Julius had been blocked, and, as he convinced himself, by the machinations of Bramante and Raphael (who he supposed envied his skill as a sculptor). He came to suspect that these two favourites of the pope even conspired to have the painting of the vault taken away from him when it had been half completed and its radiance revealed.

For about a year and a half, from some time after mid-January 1511 till October 1512, Michelangelo worked for long stretches and bursts of concentrated fury on the uncompleted parts of the Sistine ceiling: he had prepared for this during the period of enforced neglect of the work, not least by making numerous sketches, some of those surviving tiny in pen and bistre ink, some larger studies in black chalk as well, both clothed and nude. Demonstrating endless inventiveness, some may have been drawn by Michelangelo in the Roman streets, directly from life, as in the case of a black chalk study of an old man leaning on a stick and accompanied by a dog.

On the eve of 1 November, All Saints Day 1512, after the scaffolding had been taken down, Paris de Grassis noted in his diary that 'our chapel was opened, the painting being finished'. The first half of the ceiling had in some few places been retouched *a secco* (on the dry plaster) and also a little in gold leaf, but not so the second half, possibly because of the expense of the gold.

The story goes that when the chapel had been seen on All Saints Day by a very satisfied pope himself, 'and admired by all Rome crowding to see it', Julius, to make it seem richer, wished to have it retouched with ultramarine *a secco* and, in one or two places, with gold. Michelangelo, considering the bother that he would have in reassembling the scaffolding properly, replied that what was lacking was nothing of importance. 'It must still be necessary to have it retouched with gold,' replied the pope; and Michelangelo, talking familiarly, as he used to with His Holiness, said, 'I do not see that men should wear gold.' And the pope, 'It will look poor.' Then: 'Those who are painted here', Michelangelo replied, 'were poor themselves.' So he turned the quarrel into a joke,

intentionally or unconsciously echoed some lines of Dante, and ensured that the ceiling remained as it was.

Michelangelo's fertile creative genius transformed the Sistine ceiling into an irregular, occasionally truly illusionistic, yet unified field of brilliant colour and form. He executed the scenes on the vault elaborately, with some initial help from other painters (as in the story of Noah's drunkenness), using cartoons extensively, often reworking in fresco, and doing some work (the medallions of the *ignudi* almost entirely) *a secco*. In contrast he executed the lunettes – the transition zone between his universe and the scenes of earlier painters – very swiftly without cartoons, totally in true fresco, with its successive transparent layers of traditional colours, including white and yellow, green, orange and blue. Sometimes working with candles, he made a world of light.

In the autumn of 1512 the ceiling gave the Romans who crowded in and stared upwards through sixty feet of space, straining their necks, the overpowering visual shock of innumerable figures of extraordinary brightness in tumultuous movement. Michelangelo's profound interpretation of the contemporary canon of religious ideas expresses the duality of his own feelings towards the subject-matter, and also his allusive, often ironic or macabre, humour.

In depicting the Creation of the sun, the moon and the earth, Michelangelo projected God the Father as a double, powerfully foreshortened, monumental figure, moving in opposite directions – first floating massively with outflung arms and four cherubim, then zooming away to make the earth, showing the soles of his feet, bare backside and dishevelled hair. Among the cherubim, one holds up his arm against the light of the moon. In the last scene, depicting the drunkenness of Noah and the sin of Ham, as Shem (or Japheth) looks away anxiously and flings a covering over his sprawling father, his penis flies flaccidly upwards with the speed of his movement. Simultaneously, the three naked sons are portrayed in fidelity to Genesis through Shem and Japheth's clear concern and Ham's finger-pointing derision.

Among the decorative figures of the Sistine vault, all the *ignudi* celebrating the patronage of the della Rovere family break dramatically with the classical conventions through their individuality – one androgynous, detached; another boyish, sportive. Several with their heavy garlands of oak leaves and acorns have almost punning genitals most plainly exposed. The putti caryatids, surprisingly pairing boy and girl, tease, dance or frolic with each other with curious abandonment.

In the interwoven, essentially narrative pictures of the Sistine ceiling, females play vital, often determining and sometimes dominant roles: in

the central and the corner scenes; in the spandrels and lunettes depicting the ancestors of Christ; and as prophetic sibyls, each of the five with her two attendant pairs of putti, usually plainly boy and girl.

Painting domestic scenes for a fresco cycle whose biblical themes were essentially about historical families, and the collective human family, revealed Michelangelo's deep preoccupation as emotively as did portraying the handsome *ignudi*, Julius's acolytes, Michelangelo's celebrations of youth. He portrayed family piety and tenderness movingly in the large painting of the Flood, and in the scenes of the ancestors of Christ, which subtly reflect domestic life in middle-class Florence.

Love between the sexes seems absent in the ceiling, except as implied in the shared shame of the double figures of Adam and Eve, in suggestive carnal proximity under the Tree of Knowledge, and shrinking in dejection as they flee the Garden. From the crook of the arm of the Creator, a young woman, revealing naked shoulders and breasts – the figure of Eve or of the personification of Wisdom, or both – stares directly into the eyes of the awakening Adam. Love of a different, stupendous, sort Michelangelo portrayed sublimely in the scene of the creation of the first man, where the pointing finger of a potent, fatherly God, cushioned by cherubim, has touched the finger of a languidly stirring Adam to transmit the current of spiritual life.

Writhing bodies and contorted faces express the results of sin and the horror of violence: in the story of the Flood, where a naked man is assailed by a woman as he tries to board a sinking craft; in the corner spandrels, where, under the rain of serpents, bodies mingle almost orgiastically; repeatedly in the bronze shields or medallions with their violent narratives; and in the lunettes, where, for example, a dejected figure – it may be of King Rehoboam – is bent over double with his averted head on his knees and his arm hanging listlessly.

In contrast to such virtual personification of emotions, the largest figures painted on the ceiling, the prophets and sibyls, are rather exaltations of character, subtly individualized and energized through expression and posture. The seven prophets and the 'good pagans' – the five sibyls – all inspired to foresee the coming of the Saviour, shine with intellectual grace.

In painting the ceiling, Michelangelo expressed his own state of mind; he painted for the glory of God and for the pleasure of his patron, for the approbation of the papal courtiers and *cognoscenti*, and for his fellow artists.

Michelangelo's Sistine paintings challenged many of the canons of religious art; they expressed the inner restlessness and horrific sense of confinement that made him create so many huge figures fighting against the space in which they were confined, whether the *ignudi* crouching on their socles or the Israelites reeling around the golden serpent. Michelangelo painted a rare still figure on the ceiling – God the Father in the scene of the creation of Eve. All the rest of this universe is in movement, leading to an end that can also be interpreted as a beginning.

Already in 1512 thousands flocked to stare up at the great painting, craning their necks to 'read' the biblical stories from Genesis covering the period before God gave the Law to Moses, the world's creation, the history of Adam, the history of Noah. The Platonists of Michelangelo's time may have discerned on the Sistine vault the poetic story of the tragedy of the human soul created in the image of God and suffering on earth, imprisoned in matter. Artists more certainly were amazed by Michelangelo's bold originality in using the old fresco techniques to produce startling, mould-breaking solutions to the challenges of ceiling decoration, and most appreciative of his triumphs in the skilful use of colour for modelling, the manipulation of perspective and proportion, and the projection of difficult images of the human form.

Michelangelo's Sistine frescoes would come to be experienced as having arrested the development of Florentine painting in its course, in a daunting sweep of violent creativity that sent a generation of painters searching and experimenting in the blaze of his genius. Raphael assimilated what he would and could. Almost immediately a true follower emerged in the person of Sebastiano Luciani (later Sebastiano del Piombo), an ambitious, racy and beguiling painter from Venice who had arrived in Rome in 1511 after working with Giorgione, and had been befriended by Michelangelo after quarrelling with Raphael.

The Sistine frescoes raised Michelangelo's reputation still higher, enhanced the status of artists generally and, again in tandem with Raphael's rival works, heightened the artistic prestige and attraction of Rome. They held the potential to transform the course of the arts.

For Michelangelo's contemporaries, the Sistine paintings constituted the fullest revelation he had yet offered of his creative response to commissions of comprehensive theological significance, of his personality and experience, and of his own religious sensibilities. Religious faith was second nature to Michelangelo in every unguarded utterance. As he had thanked God in the letter to his brother Buonarroto when the

casting of Julius's statue went wrong in Bologna, 'since I suppose all is for the best,' so he advised the same brother against dealing in business with unscrupulous men. 'Avarice is a deadly sin and nothing sinful can succeed.' He had, after all, absorbed Catholic piety and belief almost through his pores, and known what it was to live in Savonarola's Florence.

At one level of religious faith, what unsophisticated believers saw in the scenes Michelangelo painted in the Sistine he saw too: pictures of the Creation of the world, of the Fall of man, and of the Flood, and other stories from the Old Testament. He could also say with them, as Beatrice says to Dante:

> *Avete il vecchio e il nuovo testamento,*
> *e il pastor della Chiesa che vi guida:*
> *questo vi basti a vostro salvamento . . .*

> You have the old and the new testament and
> the pastor of the Church who guides you:
> this is enough for your salvation . . .

To stimulate his imagination, Michelangelo had the Bible in the vernacular – almost certainly the *Biblia vulgare* of Niccolò Malermi, reprinted with new woodcuts in 1493 – literary stimuli from Dante, the preaching of Savonarola, and his own religious and sexual feelings.

No underlying programme for the ceiling survives. But, when Michelangelo was adorning the vault of the Sistine, theological exploration was running at a high, creative level in Rome, taking in the study of the works of Dante and Thomas Aquinas, biblical and Hebrew scholarship, and classical oratory (studied for preaching the word of God). Also current among the theologians of the Roman Curia were messianic interpretations of classical and biblical antiquity which, following St Paul, divided history into three stages: before the Law of Moses, under the Law, and then in the state of grace through Christ's sacrifice. Correspondences were suggested between Adam and Christ, and between Eve and the Church.

In a sermon in 1497 the Spanish cardinal Bernardino Carvajal lauded God as the builder and decorator of a magnificent temple and man as made wonderfully in the image of God. Among the authorities he quoted was Pico della Mirandola, in his often cited *Oration on the Dignity of Man*. Michelangelo's passion for the beauty and power of the human body found no contradiction as yet, in these early years of the century, in the sermons of the priests in Rome.

23 'I toil harder than any man . . .'

A papal bull being prepared at the end of 1512 promised completion of
the new basilica of St Peter's to embody the greatness of the past and
present with splendid proportions surpassing all other churches in the
world. By then the versatile Bramante, destroying the ancient basilica
as he built afresh, had laid the foundations of the new main piers and
built their huge linking arches, though the pace of work had slackened
during the pope's campaigns in 1511, and it was alleged that Julius spent
money collected for St Peter's on arms and men to fight the French.

Meanwhile, whatever else their message and mystery, when they
were finally revealed in 1512 Michelangelo's frescoes in the Sistine
Chapel mingled the sacred and secular in Julius's proud manner, and
proclaimed the unique glory of the Catholic Church. Both Michelangelo
and the pope were living at a high pitch of emotional intensity, yoked
as patron and artist, but distanced from each other in age and position.
Curiously, when the time came, both were uncommunicative about the
completion of the tremendous frescoes on the Sistine ceiling; for neither,
the records suggest, did this represent a fulfilling climax.

Michelangelo had felt near to despair several times after he started
painting the ceiling, especially in mid-1509, when his temper had
snapped for family reasons. About 1511, Michelangelo again sourly
complained about lack of appreciation, this time in a sonnet reproaching
a signor who was like a dried-up fruit tree – namely the della Rovere
pope. He had been a good servant to this exalted man with powerful
sword, he wrote, but his lord had not done for him what he could have
done and had listened to lying and rumour. Yet Michelangelo belonged
to him, the subversive verse runs on, like the sun's rays to the sun.

Michelangelo's pace of work quickened before the impetuosity of the
pope, and in late July 1512 he was writing tersely to Buonarroto, 'I toil
harder than any man who ever was, unwell and with enormous effort;
and yet I have the patience to reach the desired end.' On 21 August he
told Buonarroto:

I have had your letter, and I'm replying briefly for lack of time. As
for my returning there [to Florence], I cannot return, until I finish
the work, which I reckon to finish by the end of September; but
truly the labour is so immense that I cannot say within a fortnight.

Enough to say that I'll be there before All Saints by all means, if I do not die in the meantime. I am hurrying as much as I can, because it seems a thousand years till I'm home.

In October, Michelangelo wrote briefly to his father first about the return of the money Lodovico had improperly drawn, and then about the Sistine paintings:

I have finished the chapel I painted: and the pope was highly satisfied, but the other things have not turned out for me as I thought; for this I blame the times, which are very contrary to our art. I shall not be with you on All Saints, because I do not have the means to do what I wish to do, and also this is not the right time . . .

This letter was signed, as usual, 'Michelangelo sculptor in Rome'.

Increasingly on the mind of the pope, certainly now preoccupying Michelangelo, was the matter of the tomb. Already, at Pentecost 1512, Julius had told Paris de Grassis that he no longer felt strong enough to officiate at official ceremonies. On Christmas Eve, he said that he should be brought the holy oils, since he would not live much longer. Diseased, often severely depressed, during the intervening months Pope Julius had witnessed and partly contrived to raise a whirlwind of change in the Italian north.

24 France's retreat • The Medici's return • The pope's death

The allies of the Holy League launched simultaneous attacks on French positions early in 1512, but at Easter a French victory on the battlefield at Ravenna seemed to reverse fortunes decisively and to open the way for the fall of Rome, the dispossession of the pope and the ejection of the Spaniards from Naples. King Louis XII was resolved to seize the initiative in Italy before France's dispersed forces were assailed by Spaniards marching into Navarre, English landings in Normandy and Brittany, and Swiss invading Milan.

In Florence, reactions to the news were mixed but fearful. Florence had refused to ally with the pope or Spain or yet, despite strong French

pressure, to declare war on them. Landucci wrote thankfully that the armies had shattered each other and neither could harm Florence. But the aftermath of the battle – 10,000 men slain, people said – was appalling and ominous. 'Every day came stories of more cruelties of the French and Spaniards, of how they reviled, and slew, and even sold monks and nuns and every sort of people; of how they stole the silver vessels containing the Host, and relics, without any fear of God or any reverence.'

But only two months after the French victory at Ravenna, Landucci was recording that the French were 'fleeing the country'. Julius's confidence had been restored enough to press on with his plans for a Council of the whole Church in Rome. This fifth Lateran Council, meeting in Julius's own cathedral church, the Lateran Basilica, proved politically an effective counterstroke to the rebel Council at Pisa, which moved to Asti after the battle of Ravenna and then across the Alps on to French soil. Its doctrinal work included preparing the way for a dogmatic assertion of the immortality of the soul 'single for each individual of a multitude of human beings'.

Julius was punctilious in carrying out his religious duties as pontiff – Paris de Grassis recorded his daily masses and ceremonial observances – as well as in fulfilling what he saw as his responsibilities as leader of the Church Militant, from putting down heretics to spreading the Christian faith to the East and to the lands newly reached by the Spaniards and the Portuguese. A reformer in detail, his obsession with papal power and authority blinded him to the signs of the times, which indicated Italy's political enfeeblement and the fragility of Christian unity. In 1512, as Julius exulted in his diplomatic successes, the young Augustinian lecturer Martin Luther was put in charge of the friars' monastery in Wittenberg. He had visited Rome during 1510–11, on the affairs of his order, hoping to save souls by his prayers and penances, and had been scandalized during his stay by crude Roman impieties and irreverences.

In 1512 Pope Julius's embittered struggle against the French brought about the humiliation of Florence and the collapse of the régime. Florence had cautiously refrained from sending soldiers to help the French army before the battle of Ravenna but welcomed what at first looked like a victory. Soderini's government renewed its agreement with France for mutual defence, despite pressures from within and without to switch sides to the Holy League. But in conference in Mantua the League's representatives discussed their new order for Italy which would make Lodovico Sforza's son Massimiliano nominal ruler of Milan and restore the Medici family to Florence.

Negotiations failed. The Florentines refused to depose Soderini. Machiavelli and the gonfalonier were politically and militarily wrong-footed, their concentration of troops outflanked by the Spaniards, who moved swiftly to attack the town of Prato. Once a breach had been made in the walls of this well-garrisoned town, Florence's pikemen and bowmen fled, and Prato was brutally sacked. Marvelling at this collapse, despite the presence of 4,000 defending soldiers, Landucci wrote on 29 August that they had grown 'as timid as mice'. Although there were still several thousand soldiers, foot and horse, under the walls of Florence, the political will of the resisters now snapped.

Patricians who had supported Soderini abandoned him. On 1 September he fled to Siena, and the young Florentine Antonfrancesco degli Albizzi, who had in fact been close to the slow-moving, increasingly unaware Soderini, rode into Florence with, on the crupper of his horse, Giuliano de' Medici, the papal legate in Tuscany. Atrocities were committed on both sides. Even now the Signoria only reluctantly agreed to sanction Soderini's deposition.

On Thursday 16 September 1512, in the afternoon, Giuliano de' Medici with his armed followers – mostly ambitious, violently inclined young men, many distantly related to the Medici – strode into and took possession of the Palazzo della Signoria. In the evening the bell was tolled for summoning a *parlamento* at which were read the articles for a new political system. 'They made a proclamation that anyone wishing to enter the piazza must do so unarmed; nevertheless the piazza was full of armed men, and all the streets and outlets from it were barred with men-at-arms' – Medici supporters.

In this atmosphere of intimidation through a very small proportion of Florentines, the city rejected efforts to establish a balanced patrician constitution and moved towards a system which one family could dominate. With the military imposition of a small *Balía*, an 'authority', with full powers to reform Florence and its constitution, very many Florentines were robbed for the first time of the rights they had enjoyed as members of the Great Council. Soon after, the Medici – absent from the city for twenty years – had their coats of arms repainted on several buildings in Florence, including their palace and the church of the Annunziata, from which Soderini's image in wax was quickly removed. At the end of the year, after Soderini and his brothers had been formally banished, the Hall of the Great Council, so proudly decorated under the Republic, was stripped of its beautiful woodwork.

Tired of strife, the militarily chastened and financially exhausted Florentines settled down with some disgruntlement under a heterogene-

ous government of men on the make, supervised but not completely controlled by the Medici brothers: Cardinal Giovanni closely watching developments from Bologna, Giuliano affably operating on the spot, and their illegitimate cousin, Giulio, keeping an eye on Giuliano and on the new Signoria.

Among the political casualties of the return of the Medici after the family's long exile was Niccolò Machiavelli, long-standing servant of the Republic. He had been quick to offer advice to Cardinal de' Medici (telling him to be cautious in taking back the old alienated estates of the Medici, 'for men feel more grief at the loss of a farm than at the death of father or brother'), but on 7 November 1512, by a decree passed unanimously in the Signoria, he was dismissed from every post he held; a few days later the Signoria ordered that he should be confined within Florentine territory for a year and find sureties for the large sum of 1,000 gold florins. The disgraced secretary was forbidden to cross for a year the threshold of the palace where he had worked so loyally for fourteen years.

Michelangelo, in painting scenes of violence and distress in the Sistine, had imagined rather than experienced the horrors of contemporary war. But as Florence came under increasing threat he grew increasingly nervous – partly over his family's safety, partly over association with the régime of Soderini, one of the pope's hated enemies.

Early in 1512 rumours spread through Rome of possible uprisings and a plot against the pope. Julius briefly left the Vatican Palace for the security of Castel Sant'Angelo. There had been some apprehension in Rome, Michelangelo wrote to his father in February, but things were expected to calm down. Nevertheless, later, when the Florentine territory was threatened, he urged his family to abandon everything and go somewhere safe. Then, hearing news that the Medici had entered Florence, and assuming that the danger from the Spaniards was over, Michelangelo advised his brother to stay put but not to be friendly or familiar with anyone, except God, nor to speak good or ill of anyone, because 'what the outcome will be is unknown'.

Someone in Florence was trying to make mischief for Michelangelo, his father said, in October, as the hold of the Medici was tightening on the city. Michelangelo replied:

> I have never spoken anything against them, unless in the manner that every man has generally spoken, as was so with the affair of Prato, when if the very stones had known how to speak they would

have spoken about it. Afterwards many other things were said here, and, when I heard them, I said, 'If it is true that they are doing so, they are doing wrong; not that I have believed such things, and God grant they be not so.' Also a month ago someone purporting to be my friend spoke to me very ill about their affairs: at which I reproved him and said that they did wrong who spoke so, and that he should speak no more to me about it. So I want Buonarroto to find out quietly whence it was that person heard I had spoken out against the Medici, to see if I can find out where it came from and if it came from one of those who purport to be my friends, so that I can be on my guard.

Michelangelo fought shy of workshop apprentices and assistants in Rome, nor was there a mature new generation of Florentine painters or sculptors pressing on his heels. After he had finished the Sistine Chapel and was waiting for the pope's next word, Michelangelo asked his father to send from Florence 'some boy, a son of poor but good people, who is used to chores, to come and stay with me here to do all the housework, such as shopping and errands where needed; and in his free time, he could learn . . .' At this time Michelangelo found a new friend through the merchant banker and patron of the arts Agostino Chigi, a man in his late forties who had grown immensely wealthy in Rome as tax-farmer for Pope Alexander VI. He helped to finance the election of Pope Julius II, and played a key role in Julius's war plans, negotiating with the Venetian government. When he sailed for Rome soon afterwards, he took with him his newly acquired Venetian mistress and the young artist Sebastiano Luciani.

By November 1512 Michelangelo was preparing drawings for the tomb of the pope, who now wanted a scaled-down though still magnificent version of the original breath-taking project. His thoughts were running ahead to the work on the tomb – he was hoping after finishing the marble delivered to Rome to do the rest in Florence – but he found time to dispatch advice to his family on other matters. These included the purchase with money he had banked in Rome of a 'good property' as an investment in Tuscany, which would provide an income while he was working on the tomb.

He was writing home in early 1513 about negotiations over the house he was renting in Rome, in which he hoped to complete the tomb, and sending advice to his brother Buonarroto not to marry till summer was out. He sent a sardonic letter about the boy he had requested from Florence when his apprentice fell ill: he had arrived 'mounted grandly

on a mule' and the 'little turd' insisted on drawing all night, and had to be looked after though it was he who was supposed to look after Michelangelo. 'I beg you to have him whisked away, because he has irked me so much that I cannot go on . . . Although I sent him away the second day and several other times, he didn't believe it.'

On 19 February 1513 a papal bull was issued concerning the purchase of a house at Macello de' Corvi – Ravens Lane, opposite Santa Maria del Loreto and near Trajan's Forum – in which Michelangelo would make the tomb for Julius, to be placed when finished in the Sistine Chapel itself. Two days later, in the early hours of Monday 21 February, Pope Julius II died, calm and fully conscious to the end. On 6 May 1513 Michelangelo entered into a contract with Julius's executors (his cousin Lionardo Grosso della Rovere, bishop of Agen, and Lorenzo Pucci, the papal datary). The pope's will stated that 10,000 ducats should be allocated to the tomb, but the contract increased this to 16,500. The tomb was to be completed within seven years, and Michelangelo was not to undertake any other work that would hinder the undertaking. Julius's tomb was still to include forty great statues, but instead of being free-standing it was to be attached to the wall.

Michelangelo could now securely, he hoped, practise his intensely felt vocation as a sculptor. Quickly presenting a new wooden model, hiring masters from Florence, preparing to see through the expensive process from sketches, drawings and models to the attack on the stone, he would be paid regularly by Bernardo Bini, as trustee and head cashier of the papal treasury.

Julius's aggressive use of spiritual and worldly weapons in the cause of the papacy had abased the Catholic Church and weakened the Italian states. But he was a good administrator who encouraged talent and stimulated Italian pride. His embattled obduracy and defiance of invaders of Italy, and his seemingly miraculous energy, secured his reputation as a patriot.

Among Julius's many cultural legacies was the endowment, shortly before he died, of the Papal Choir Chapel, the Cappella Giulia, to enhance the liturgical dignity of the Sistine with its own tradition of unaccompanied polyphony. His partially realized aim was, through the charter's calling for twelve adult singers and as many Italian boys, to lessen dependence on French and Spanish musicians.

The work Pope Julius commissioned gave Michelangelo the unique opportunity to experiment with numerous ways to show human bodies in movement; the painter did prodigious exercises for the waiting

sculptor. Michelangelo knew what great cause he had to be loyal to the
memory of Giuliano della Rovere.

25 Leo X: civic splendour, Catholic patronage

In the spring of 1489, about the time that Michelangelo had begun his
fruitful association with Lorenzo de' Medici's sculptor Bertoldo, the
thirteen-year-old Giovanni de' Medici was created cardinal deacon of
Santa Maria in Domenica. The two boys saw something of each other,
but not much. Two years later, Giovanni left Florence for a brief
sojourn in Rome and an appearance among the cardinals of the Sacred
College. His studies in Pisa, his attention to the accumulation and care
of ecclesiastical benefices, and his sporting pursuits allowed no particular
friendship to spring up between the two intelligent young Florentines,
nor had this been likely in view of Giovanni's status. When still young,
Michelangelo had been close to Lorenzo di Pierfrancesco de' Medici, a
member of the family's younger branch, outside the charmed circle. He
had also formed a warm friendship with a Medici from another branch
of the family, Ottaviano.

After a long exile spent on the move in Italy and northern Europe,
when he had been seeking help for his brother Piero, and then in the
service of Julius II, as a shrewd diplomat and an active commander in
the surge of war, Giuliano de' Medici had come home to Florence in
September 1512. After the return of the Medici, Lodovico Buonarroto,
who under Soderini had held the modest office of *podestà* at San
Casciano for a few months in 1510–11, overcame his nervousness and
wrote asking Giuliano de' Medici if he might have back the customs
post he had lost in 1494, in a short letter coming quickly to the point
about the position and its salary: 'ordinary and extraordinary auditor
of the Customs at twelve lire a month'. This was just before Giovanni,
in March 1513, was elected supreme pontiff and head of the Catholic
Church, taking the title of Leo X.

Giovanni, well-travelled but scarcely known abroad save by hearsay,
easy-going and cultivated, though in holy orders was not yet a priest.
After his election he was quickly ordained (on 15 March) and then
made a bishop (on 19 March). The fat, genial new Holy Father was
said to have remarked that since God had given him the papacy he
meant to enjoy it. For the Medici family, his election put into the grasp

of the dominant albeit dependent power in Tuscany the still enormous dual authority of the papacy, spiritual and temporal. Pope Julius had left the papacy spiritually weakened by his reign, but with its territory enlarged, and its financial resources much strengthened.

Once they were back in Florence the Medici poured money into the encouragement of clubs and festivals. Pageants and processions were organized by societies of young Florentine nobles. A scholar of the University of Florence drew up the programme for a Roman-style triumph in 1513, with floats representing respectively boyhood, manhood and old age. Jacopo Pontormo painted the three cars in chiaroscuro, for Giuliano de' Medici, with scenes of the metamorphoses of the gods, and devices stating '*Erimus*', '*Sumus*', '*Fuimus*' – 'We shall be', 'We are', 'We were'.

Not to be outdone, Lorenzo de' Medici went for ideas to the historian Jacopo Nardi, who devised triumphs for six floats. Through the streets of Florence passed a procession of oxen and horses, covered with the skins of wild animals, priests wearing gold hoods, footmen carrying torches like antique candelabra, senators on horseback wearing togas, lictors with fasces and axes, buffaloes disguised as elephants, men-at-arms in gleaming armour, steeds winged like griffins, and six pairs of poets from different regions crowned like Caesar with laurel. The *pièce de résistance* was a huge globe with the figure of a man in rusty armour sprawling lifelessly on top. Dazzled by the multicoloured splendour, the Florentine bystanders saw the back of this figure opening for the emergence of a naked gilded child, to represent the Golden Age restored by Pope Leo's coronation after the Age of Iron. The baker's child who was covered all over in gold paint and paid ten crowns died soon after from the effects.

In April 1513 the new pope created his newly legitimized cousin Giulio archbishop of Florence. Giulio had been monitoring the political performance of Leo's brother Giuliano, as Florence settled down shakily under the political authority of the Medici. The election of a fellow citizen and a much-liked Medici as pope in charge of the rich resources of the Holy See and Papal States raised the hope of more stable times in Tuscany, and of even more beneficial circumstances than in the past for favoured Florentines and Tuscans involved with the court and the administration in Rome.

Machiavelli stayed away from Florence in disgust to write the treatise that came to be called *The Prince*, dedicating it first to Giuliano when

he finished it about the end of 1513. After his frightening experiences of confinement to Florentine territory in 1512 and then imprisonment and torture, Machiavelli had spent most of 1513 at his small country property, high up on the slopes with a distant view of the roofs and towers of Florence. In September he was snaring thrushes. In October he was reading Dante, Petrarch, Tibullus or Ovid as he walked in the woods, and in the afternoon playing dice or cards with the butcher or the miller in the village. In the evenings he returned home, took off his soiled clothes, dressed as if he were in high office again, and returned in imagination to talk politics with great leaders of history such as Hannibal and Moses. In *The Prince*, Machiavelli, fired by bitterness and ambition and drawing on his own reading of history and his own diplomatic experience, commented with fervent astringency on the dire events in Italy and what must be done to regain the country's independence and pride.

Machiavelli was for the time being neglected by the Medici. But many of his precepts were second nature to the ruling family. After 1513, step by step, Pope Leo put the control of Florentine affairs into the hands of his nephew and protégé Lorenzo. The decent, gentlemanly Giuliano (who to Leo's annoyance had shaved off his beard when he returned to Florence, to signify that he eschewed aristocratic ways) chose to pursue his career in Rome, where the pope made him gonfalonier of the papal forces. Early in 1515 Leo sent him to congratulate the new French king, Francis I, on his accession, and while at the French court, in his mid-thirties, he was married to Philiberte of Savoy, aged seventeen. Francis gave Giuliano the title of duke of Nemours.

After a vigorous start, Lorenzo's grip on affairs began to loosen, largely through arrogance and inattention to detail in the management of his relationships with important Florentines and with Rome itself. Popular disgruntlement with the régime was worsened by diplomatic fumbling and political mishaps, as Florence's traditional pro-French inclinations cut across the pope's decision to form an alliance with Spain.

Still resolute, however, Lorenzo intrigued to have himself made captain-general of Florence with a *condotta*, or commander's contract, for three years from June 1515, allowing 35,000 florins annually for his own maintenance and that of 250 men-at-arms. Lorenzo's military initiatives strengthened fears that he was planning to seize signorial power. Meanwhile Francis I had assembled an army in Lyons to enforce the French claim to Milan, now under the Swiss but nominally

ruled by Massimiliano Sforza. The French unexpectedly sped through the Alps by a route over the Col d'Argentière previously held to be impassable. The ensuing battle, at Marignano, on 13–14 September 1515, was recorded by Landucci: 'We hear that the king of France has had an encounter with the Milanese and Swiss troops, and that 20,000 men had been slain.' (The slain were mostly Swiss mercenaries, not Italians.)

King Francis swiftly consolidated his hold in the north of Italy: the doge of Genoa surrendered to him, and Massimiliano Sforza fled from Milan. He made a 'Perpetual Peace' with the Swiss, renewing an earlier agreement that the French king might levy troops among the cantons whenever he needed in return for an annual subsidy. He came to terms with the pope in October 1515, pledging, to Lorenzo de' Medici's great relief, that he would sustain Giuliano and Lorenzo and protect Florence and the Medici family.

The year ended for Florence and the Medici with triumphal displays in an atmosphere of excitement and relief. In the city the prices of oil, corn and wine shot up when it was heard that the pope and the French king were to meet in Florence. Instead they eventually came together in Bologna, partly for reasons of safety; but on 30 November Pope Leo made a splendid military-style entrance into Florence, accompanied by soldiers including the papal guard of mounted bowmen and musketeers and infantry with two-edged axes. After being borne under a baldachin to the cathedral of Santa Maria del Fiore to process to the high altar, Pope Leo proceeded to Santa Maria Novella, behind a band of buglers and fife-players, and having silver coins thrown to the people as he passed them by.

To prepare incomparable and unprecedented displays for the pope's visit to Florence, Landucci wrote, 'several thousand men worked for over a month in advance'. They included, from the 'various trades', carpenters, stone-masons, painters, carters, porters and sawyers. A cost of 70,000 florins or more was incurred, Landucci added, 'all for things of no duration; when a splendid church might have been built to the honour of God and to the glory of the city'.

The projects ranged from lavish decorations for the gate of San Piero Gattolini to a giant figure by Baccio Bandinelli for the Loggia de' Signori – seemingly of bronze, but 'not much appreciated'. As well as Pontormo, other artists recorded as working on the ephemeral decorations for the pope's visit included Giuliano del Tasso, Antonio and Aristotile da Sangallo, Giovanni Battista Rosso, Francesco Granacci,

Andrea del Sarto and Jacopo Sansovino. Andrea del Sarto worked with Sansovino on the temporary wooden façade for the cathedral which so impressed Leo that he regretted, it was said, that it was not the actual façade. Michelangelo's boyhood friend Granacci painted stage scenery and designed a triumphal arch.

Leo went to Bologna to wait for the energetic French king, half his age, in early December. Not only was Bologna safer, but the king had not wanted the expense of making a grand entry into Florence which would have had to emulate that of Charles VIII in 1494. The two leaders stayed for three days in the same palace, putting on a show of mutual respect and great cordiality after Francis had publicly protested his loyalty and apologized for warring against Julius II, 'who would have made a better general than pope'.

The pope had to yield Parma and Piacenza, to enable Francis to keep intact his newly conquered territory of Milan. The king approved Medici domination of Florence, and promised to take any cities of Tuscany under his protection. Not much of all this negotiation was committed to paper. Death and duplicity started to wreck it almost as soon as the festive decorations disappeared from Florence.

About this time, as quietly as the snowman the young Michelangelo had made for Piero de' Medici, the cartoon of the *Battle of Cascina* vanished from history. It was ten years since Michelangelo had gone to live in Rome. Studied avidly by Florence's leading artists, the cartoon also offered inspiration and ideas for the many decorators and craftsmen preparing for Pope Leo's visit. It was divided into sections and strips were cut off as if it were being used in a master's workshop or a draper's store; remnants of the cartoon came to be scattered in different places.

Michelangelo left no trace of anger or interest in this act of destruction. While younger artists in Florence worked on frivolous and ingenious effects to exalt and flatter the Medici pope, Michelangelo in Rome continued with his labour of tormented loyalty, making drawings and models for the tomb of Pope Julius, for which, still determined, he was quarrying marble in Carrara in the autumn of 1516.

26 The Leonine age: bureaucracy and culture

In popular favour, patronage and professional esteem, only Leonardo da Vinci and Raphael rivalled Michelangelo. Among other sculptors, no one stood in his path. Andrea Sansovino, the greatest of them, many years older than Michelangelo and probably first trained by Pollaiuolo, had also been involved with Lorenzo de' Medici. But as Michelangelo was returning to his colossal commitment to Pope Julius, Andrea was commissioned by Pope Leo to execute Bramante's designs for the Holy House at Loreto, a task which kept this strong, intelligent and original sculptor busy for the rest of his working life, supervising his own team of young men.

Moderately talented both as architect and sculptor, Lorenzotto had started out as a bell-founder in Florence. About fifteen years older than Michelangelo, he came nowhere near him in power and the comparatively strong elements in his work were derived from Raphael's designs.

In 1514 Leo appointed Raphael, who had effortlessly, as it seemed, continued to paint portraits and supervise the further decoration of the *stanze* in the Vatican, to be the architect of St Peter's. Bramante had died that year at the age of seventy, after progressing so far with the demolition of the old St Peter's, as his own belvedere partly collapsed, that he was called Maestro Ruinante. A satirist of the time wrote that after death Bramante wanted to demolish heaven and build a better one, with improved access roads.

By about mid-1514 Raphael had just finished decorating a second stanza for Pope Leo, incorporating into his work in what came to be called the Stanza of Heliodorus several images of Leo, who had been crowned pope after Raphael began this fresco.

Raphael was especially favoured by Leo. In July 1514 the young painter wrote to his uncle in Urbino to report that he now had possessions in Rome worth 3,000 ducats, with fifty gold scudi in income, because His Holiness 'has provided me with 300 gold ducats to look after the building of St Peter's, which I shall not lack for as long as I live, and I am sure I shall have much more from others'. After remarks about his quest for a suitable well-endowed wife, Raphael exulted in his latest well-paid post: 'what work is worthier than St Peter's, which is the foremost church in the world?'

Meanwhile his team was starting work on the next *stanza* of the papal apartments, which came to be called the Stanza dell'Incendio, after

one of the evocative, classically inspired scenes which linked Leo through his predecessor Pope Leo IV to St Peter, the first pope.

Raphael was commissioned by the pope to design the cartoons for ten tapestries to be woven in Brussels showing parallel cycles of the lives of St Peter and St Paul. Leo intended these to hang on ceremonial occasions on the lower walls in the Sistine Chapel, where Michelangelo had not long since stopped working. Confrontation was implicit. When Pope Leo left Rome for Florence in late 1515, he took Raphael with him. Raphael's task in Florence was along with others to prepare designs for the façade of San Lorenzo, the Medici family's parish church – a formidable challenge for technical reasons, but all the same a potentially lucrative opportunity for eager architects and draughtsmen.

In contrast, Leonardo da Vinci received little in the way of commissions from the pope, partly through his own fault. Well into his sixties, Leonardo had placed his hopes in the fanciful Giuliano de' Medici, who shared his curiosity and his moodiness. Leo was reported to have said after commissioning an oil-painting from him and hearing that he was already preparing the varnish, 'This man will never do anything. Here he is thinking about finishing the work before he even starts it!' Leonardo's time in Rome seems to have been wretched; he failed to please or even see much of the pope, and suffered from the bad behaviour of two of his workmen, both Germans.

The Rome of Leo X was no right setting for Leonardo's tormented brilliance. For Raphael it provided creature comforts and fame and the perfect cultural milieu for his poetic and classicizing genius. For Michelangelo Leo provided an income and the promise that he could at last work as a sculptor on an immense scale for years to come.

Pope Leo's resourceful economic management, helped by Cardinal Giulio's energies, gave Bramante and Raphael stupendous opportunities. Their response brought into being the greatest achievements of the age of Leo, though the pope favoured literature rather more than the arts of design.

Bureaucracy and culture flourished at his confident and cosmopolitan (mostly clerical) court, to which so many felt called but where not all were chosen. The poet Ariosto had put aside his Homeric *Orlando Furioso* when Leo was crowned and hurried to Rome to reap the harvest of the large promises made to him when Leo had been a guest at Ferrara, only to find that the pope ignored him. The greatest poet of the time secured nothing more than a pontifical privilege, conveyed in

a papal bull paid for at his own expense, securing him the sole right to print his own work. Ariosto kicked his heels a while in Rome, waiting in vain for a demonstration of the generosity and gratitude of Leo, who had once said he was as close to him as to his own brother. He soon wrote to a friend, 'I did indeed kiss the pope's foot, and he made a show of being glad to *hear* me; I do not believe he *saw* me, because, since becoming pope, he no longer uses his spectacles.'

Pope Leo initiated a Medicean hegemony at the papacy, linking new princely governments of Rome and Florence, disposed to favour Florentines before any other Italians unless personal prejudices intervened. Cardinals related to the Medici by blood or marriage, the grandees of the system which provided ever-growing opportunities for making money, were first in line for offices and benefits, heading a swarm of agents, dependants and bankers.

Leo's efforts to enrich Rome's store of learning and literature were neither desultory nor decisive. Early in his reign he appointed the scholar Pietro Bembo as apostolic secretary, and soon after charged him with the establishment of a Greek College in Rome. The printer Aldus Manutius hopefully dedicated to the pope his first edition of Plato's complete works with a fine elegiac poem in Greek by the learned Marcus Musurus, later to be the first professor of the college.

Leo looked indulgently at learning and men of letters, and practised a generally judicious patronage. He revived and encouraged the Accademia Romana. He limited the length of sermons at the papal court, and stressed the rule that no part of them should be 'in praise of the pope'. He responded to exhortations to build and restore churches as acts of piety and public service. He prompted creative studies such as led to Andrea Fulvio's expanded poem on the topography of ancient Rome, the *Antiquaria urbis*, and he urged Raphael to prepare a pictorial reconstruction of the old city. He promoted and conversed familiarly with civilized stylists such as Jacopo Sadoleto and Bembo.

Leo was an organ-lover and lute-player. He loved musical performances, sometimes in the background as when he was playing chess. His culture was finely attuned to the increasing sophistication of a Rome where cardinals were encouraged to live in noble style, with households of over 100 servants, including cooks, craftsmen, silversmiths and musicians, in palaces with libraries and music rooms.

The manipulative creation of cardinals was one of Leo's skills. In September 1513 he made four cardinals, of whom two were close relations (Giulio de' Medici and Innocenzo Cibo) and two were learned friends (Lorenzo Pucci and Bernardo Dovizi). In September 1515 he

made the Englishman Thomas Wolsey a cardinal, but with some reluctance, partly to persuade King Henry VIII to join the alliance against France. In the summer of 1517 he made thirty-one new cardinals, chiefly to pack the Sacred College with his own supporters.

Leo's recorded affability had always concealed latent Medicean ferocity. Destruction of ancient beauty through demolition and eviction was the price paid for his encouragement of new building in Rome as he continued the ambitious programme initiated by Pope Sixtus IV. The point was made in a report of 1519 – attributable to Raphael and Baldassare Castiglione – on the condition of the Roman monuments and ruins.

> Knowledge of so many excellent things has given me the greatest pleasure: on the other hand the greatest grief. For I behold this noble city, which was the queen of the world, so wretchedly wounded as to be almost a corpse . . . The famous works which now more than ever should appear in the flower of their beauty were burned and destroyed by the brutal rage and savage passions of men wicked as the wild beasts. Yet not completely so, for there still remains to us the skeleton of those things, though without their ornament – the bones of the body without the flesh, one might say . . . How many pontiffs, Holy Father, who held the same office as yourself, though without the same knowledge, the same valour and greatness of soul – how many, I say, of these pontiffs have permitted the ruin and defacement of the ancient temples, of statues and arches and other edifices that were the glory of their builders?
> . . . I am bold to ask how much of all this new Rome that we see today, however great, however beautiful, however adorned with palaces and churches and other buildings, has been built with lime made from ancient marbles? Nor can I remember without grief that during the time I have spent in Rome – not yet twelve years – so many beautiful things have been ruined . . . It is the infamy of our time that we have suffered these things.

Raphael's thoughts, Castiglione's style: the message was elaborately worded but clear. To the pope, be generous; to knowledgeable men, accept the challenge of emulating and even improving on the work of the ancients.

May your Holiness, while keeping the example of the ancient

world still alive among us, hasten to equal and to surpass the men of ancient days, as you even now do, by setting up magnificent buildings, by sustaining and encouraging the virtuous, by fostering talent, by rewarding all noble effort – thus sowing fruitful seeds among Christian princes ... And this is truly to be the merciful Shepherd, yes, the greatest Father of the World.

Raphael, none the less, seeking rare-coloured marbles to embellish the chapel of Agostino Chigi in Santa Maria del Popolo, did not scruple to pillage the ancient ruins. Leo himself, who in a brief confirming Raphael's appointment as architect of St Peter's in April 1514 asked for the new basilica to be built as 'magnificently and quickly as possible', was more anxious to preserve ancient inscriptions than the ancient sites whose blocks were suitable for the greatest church in Christendom.

But by the time Leo became pope the interaction in Rome of ancient beauty and contemporary Christian faith had already produced its greatest fruits in building and painting: the visitor to Rome could walk in a morning from the Colosseum past the Pantheon and the Basilica of Constantine to visit the Sistine Chapel and the *stanze* of Raphael.

Like the flecked and spotted porphyry stones which the ancient Romans had shipped from Egypt, or the faked serpentine from Greece, the hard, flawed city of Rome was a mass of colourful contrasts and contradictions, arising from its unique social and physical conditions. Everything was in flux from one pope to the next. The great Roman families, the lesser nobility, the thousands of ordinary Romans and transient outsiders, rich and poor, were packed closely together roughly in the same areas. A competitive meritocracy, Rome above all spawned innumerable services, from prostitution to building, from piety to painting, to meet the needs and desires of its ruling element, the curial clergy, its mixed populace and its pilgrims. It could echo Babylon or Bethlehem, from one street or one day to another.

In sexual attitudes, Rome's sophisticated inhabitants grew more tolerant of sinful behaviour, promiscuity and pornography – or at least showed their tolerance more openly as affluence increased and fascination with the lascivious elements in the rediscovered paintings, poetry and prose of antiquity grew. Franker, more explicit, more ambiguous and darker strains of sexuality began to appear in the courts, especially of the Borgia and Medici popes. The exploration of the grottoes of the Golden House of Nero in the 1490s yielded a mass of antique paintings

inspiring pictorial fantasies, *grotteschi*, winged creatures, monsters, trophies, for bathrooms and loggias, and stimulating sensual and erotic images and ambivalences, as did vernacular versions of the writings of Lucian and Ovid.

Raphael planned to decorate the entrance loggia of Agostino Chigi's villa with the story of Cupid and Psyche as told in Apuleius's ribald Latin novel *The Golden Ass*, possibly with the encouragement of his mistress and the advice of a young adventurer and writer from Arezzo, Pietro Aretino, who joined Chigi's household in Rome about 1516. The pergola was to have a framework (executed by Raphael's assistant Giovanni da Udine) showing fruit, flowers and foliage for each season, and flying birds. A brilliant naturalistic painter, who had been a pupil of Giorgione in Venice and was recommended to Raphael by Castiglione, Giovanni painted over the figure of Mercury a parody of copulation in the form of a bursting fig touched by a priapic pumpkin.

A wild player along with Aretino on the social scene of Rome was the Tuscan Francesco Berni, whose family was poor but well enough connected to Cardinal Bibbiena to bring him to Rome. He was destined for a dull secretarial and clerical career, but he had a brilliant sense of style and huge streak of irreverence. Between Berni and Michelangelo there was an easy familiarity – on paper at least.

27 New house and new friends • The tomb's new design

During 1513 Michelangelo was working by the piazza of St Peter's, not far from where Raphael lived for a time before he bought, for 3,600 ducats, the Palazzo Caprini on the Via Alessandrini in the Borgo (and then, almost immediately, started to design another, yet more princely though practical *palazzo* for the site he owned on the Via Giulia). Raphael's *palazzi* were designed for utility, comfort, conviviality and show. Drawings for the palace on the Via Giulia envisaged two court-yards, many conveniences, including inside lavatories and a bathroom with plumbing for hot and cold water, workshops and the artist-owner's studio on the *piano nobile*. Raphael's patrons, contacts, friends and followers – a large network – were to be assiduously cultivated and entertained.

Michelangelo's relationships were more selective, idiosyncratic and intense. Houses interested him either primarily as family investments or as workplaces. Michelangelo's house in Macello de' Corvi was massive, high-ceilinged, austere, with a garden for chickens, an imposing vestibule and a grand stairway. The building was grand enough to match his status and dignity but was for simple living. It was bought for him at the expense of the family of Pope Julius II, which, three years after the death of Julius, formally put it at his disposal, rent free, for work on the statues for the tomb.

Soon after Leo's enthronement Michelangelo met the septuagenarian painter Luca Signorelli, wandering in Rome where he had arrived hoping, like so many others, to receive favours from the new pope in return for past services. Michelangelo gave him some money. Before Signorelli left the house, Michelangelo grumbled about being too ill to work. He did not forget the old man's reply: 'Have no doubt the angels will come from heaven to take you by the arm and help you.'

For immediate practical help and solace, Michelangelo looked to a variety of supporters and friends nearer to home. For the time being, the della Rovere family remained Michelangelo's most important patrons, but many others were anxious to have work from his hands. Agostino Chigi and Michelangelo kept their distance from each other. Pope Leo was biding his time. Pierfrancesco Borgherini, of the banking family, nearly succeeded in commissioning a picture from Michelangelo while he was working on the tomb, but the commission went to Andrea del Sarto in Florence (who used Michelangelo's design) partly because of Michelangelo's professed reluctance to confuse the nature of his relationship with an agreeable young nobleman. He wrote to Buonarroto, in 1515, that he wanted to serve Borgherini for pleasure and not as a duty, and so did not want to feel obliged to him over money. He would serve him very happily, 'for he is truly a worthy young man, unequalled among the Florentines here'.

In June 1514 Michelangelo had concluded a contract with those Florentines, and others, including the blue-blooded Roman Metello Vari, for a marble statue of a Risen Christ for the church of Santa Maria sopra Minerva.

It was to be 'lifesize, naked, erect, bearing a cross and in an attitude seeming best to Michelangelo', for delivery within four years at most for 200 golden ducats.

Even if it were feasible, Michelangelo did not fancy being accompanied by an escort of admiring painters, in the fashion of Raphael, whenever

he left his house to visit the Vatican, but his friendships during this period were numerous.

Sebastiano, probably after a quarrel with Raphael, transferred his attentions and gave his loyalty to Michelangelo. After the spectacular promise of his oil-paintings, his frescoes for Chigi had not been successful. Sebastiano was an amusing conversationalist, musical and gregarious. Thanks to his Venetian training, he was a proficient, graceful portrait painter and a delicate colourist, absorbed by detail, thus complementing Michelangelo, who shrank from portraiture and knew that many people held Raphael's colouring to be better than his. Michelangelo found him useful. Sebastiano learned eagerly from Raphael and very imaginatively from Michelangelo as their uneven relationship began to develop. His darkly romantic painting of the lamentation of Mary over the dead recumbent Christ – large statuesque figures set against a misty moonlit landscape – which seemed inspired by Giorgione, was based on a drawing by Michelangelo, and in about 1514 marked their first impressive collaboration.*

Later, at Michelangelo's behest, Borgherini commissioned from Sebastiano a fresco painting of Christ's flagellation for his chapel in San Pietro in Montorio; Sebastiano used but transformed a figure drawn by Michelangelo. The pattern of collaboration in which the ambitious younger man depended on but rethought the ideas of the proud older artist, with its potentially explosive emotional content, seemed to sharpen and prolong the duel between Raphael and Michelangelo, even as Michelangelo concentrated on his sculpture.

Michelangelo inevitably formed emotional relationships of varying intensity with his assistants, sometimes long-lasting ties of affection, as with the amusing Piero d'Argenta, who helped him first in Rome, from 1498, and then in Bologna and Rome till 1509. Silvio Falcone from Magliano, after Piero, was dismissed by Michelangelo for behaving badly, but tried hard to keep in Michelangelo's good books. Part general factotum and part apprentice, Pietro, or Piero, Urbano from Pistoia joined Michelangelo's modest household in Rome around 1515, when he was about twenty, and stayed on for several years, treated solicitously by Michelangelo, who would urge him to work hard and draw often. Once, when Pietro was ill at home in Pistoia, Michelangelo sent him his jerkin, hose and riding-cloak and said he would come himself if there were need.

* Now in the Viterbo Museum.

Michelangelo maintained mutually respectful individual relationships with a handful of powerful men in politics and diplomacy, usually with Tuscan affiliations. Among these, Jacopo Salviati, a member of the influential banking family, was married to Pope Leo's sister, Lucrezia de' Medici; his connections and his fondness for Michelangelo made him invaluable to a sculptor on the grand scale who needed professional services and usually looked after his own supplies and shipments.

Bernardo Dovizi da Bibbiena, an influential friend at court, was papal treasurer and a cardinal, and a few years older than Michelangelo. He had been one of the scholars and noble courtiers associated with the court of Urbino, and early in life had entered the orbit of the Medici, following his brother Piero, the private secretary who used to read aloud to Lorenzo de' Medici during his illnesses.

A fond acquaintance ripening into friendship was formed earlier still by Michelangelo with his near contemporary Donato Giannotti, a scholar and political thinker from a family of Florentine goldsmiths.

Michelangelo's male friends and acquaintances, ranging extensively in age and status, provided practical support, amusing companionship, enduring affection. When he was painting the Sistine vault he had written to Buonarroto complaining about his anxiety and tiredness and adding that he had no friends and wanted none. But even though the commitment to build the tomb was tremendous, and again he complained there was not time to eat, he was out and about often, and soon made time for travelling frequently between Rome, Florence, Carrara and Pietrasanta.

The affection he inspired was conveyed uncloyingly in a letter written to him when he was temporarily away from Rome, in 1515, by another Tuscan, Giovanni Gellesi, which also left glimpses of the pleasure-seeking Michelangelo who would rush to hear the improvised singing of the handsome Luigi Pulci outside in the streets on summer evenings in Florence. Gellesi wrote from Rome that Michelangelo's absence had left him feeling orphaned 'in this vast Babylonia' because his company had been so precious, and so at a supper party to which Domenico Buoninsegni had been asked in Michelangelo's place his thoughts would be elsewhere.

Michelangelo is again shown as a good companion, if not a perfect courtier, in a letter of introduction from Argentina Malaspina, the wife of Piero Soderini, to her brother Lorenzo, the marquis of Fosdenone. She asked Lorenzo to do all he could for Michelangelo, who was then travelling to Carrara, and described him as of such good breeding and

character that 'we believe there is no other man like him in Europe today'. If her brother were to invite Michelangelo to stay a few days, he would very much enjoy his company 'since he is well versed in architecture, artillery and fortifications'.

The group of friends attending the supper parties Michelangelo liked included Sebastiano, Giovanni Gellesi, Changiano, Giovanni Spetiale, and Bartolommeo Venazzano. Michelangelo was amused by the relaxing company of unsophisticated good-hearted men such as the painter Jacopo (called by the Florentines l'Indaco or Indigo, to distinguish him from all the other Jacopos) who had tried to help on the first stages of the Sistine. Jacopo was a joker, and when Michelangelo once wanted a rest from his chatter he sent him to buy some figs and locked the door against him on his return, Jacopo spread figs and fig leaves angrily over the entrance, sulked for months, but then made it up. Michelangelo needed and liked solitude, but there was nothing lonely about his life in Rome.

At times of stress, none the less, Michelangelo could react to provocation with a fury going far beyond shutting someone out. In concentrating on the tomb, Michelangelo was honouring the memory of Pope Julius, expressing his love of incarnate beauty, and executing an important work in sculpture. But the preparation, with all this entailed in drawing, modelling and planning, while wondering what was agitating the mind of the pope, made him edgy with friends and family. The summer heat, too, was likely to have added to his vehemence when he burst out in exasperation, writing to Buonarroto at the end of July 1513, 'you have never known me and you do not know me. May God forgive you! For he has given me the grace to bear what I bear, and indeed have borne, so that you might be helped. But you will know it when you do not have me.'

All the same, Michelangelo went on to offer a big advance of money for Buonarroto to purchase a shop about this time. 'I do not want any of your profits, but I want to be assured that at the end of ten years, if I am alive, you will undertake to return me these 1,000 ducats in money or in kind, if I should want them back . . . This will be a curb on you, so that you do not waste them.'

Another cause for irritation was the difficulty of securing supplies of good marble – a problem worsened when the Republic of Florence began to exploit deposits within Tuscan territory at the expense of Carrara, which had always dominated the market. (In May 1515 the Republic, needing marble particularly for completing the Duomo,

acquired from the Commune of Seravezza the sole right of quarrying marbles in the region of Monte Altissimo and Monte Ceresola.)

In July 1515 Michelangelo told Buonarroto he did not know what to do about the marble he needed; he did not want to go to Carrara himself, and he distrusted others he might send – 'like that scoundrelly little Bernardo, who cost me 100 ducats last time he was here, and went around gossiping and grumbling about me all over Rome.' In August, wondering whether the road for marble from Seravezza was yet open, he was making models and preparations.

He would manage to obtain the marble he wanted in one way or another, he told Buonarroto, but he needed to add, in September, that he could not take on another sculptor, Benedetto di Bartolommeo, as he had no marble to work. He decided to write to Antonio da Massa, the chancellor to the marquis of Carrara, as he was conscious of being suspected in Carrara of supporting the intended diversion of Florentine purchases to the rival quarries of Pietrasanta. Not mentioned at all in surviving letters was Michelangelo's substantial work for the tomb, during 1515–16, on two huge marble statues of heroic young men and of the prophet Moses. His assistants from Florence had been working chiefly on the grotesque ornaments for the front of the bottom storey, while Michelangelo, fusing Christian and classical elements, worked, often in solitude, on the spiritually and physically powerful figures of the captive nudes and of the dominant Moses.

Between the promise and the performance the gap was widening, despite Michelangelo's physical force and furious energy. In 1513 the design for the tomb had been changed to express several more traditional Christian rather than Roman concepts compared with the first composition, pleasing to Pope Julius, of a free-standing mausoleum containing a burial temple. A statue of the Madonna would now crown the whole edifice. The main features of the lower level were to stay the same, including allegorical fettered or captive figures to be placed in front of herm-pilasters and, on the base in front of the tabernacles, allegorical statues of victorious Virtues. But the contract of 6 May 1513 with Julius's heirs now promised completion within seven years of a three-tiered wall-tomb with forty figures, for the increased sum of 16,500 ducats.

The contract, translated by a notary for Michelangelo from the Latin into Italian, attests to the freedom he could demand and the status he had acquired as painter and sculptor. He was to follow the drawing or model, or the *figura*, of the proposed tomb, or thereabouts.

The statues for the tomb must be as perfect as his judgement and conscience could make them, so far as he valued his honour and fame. He was to work only on the tomb so long as any part of it remained unfinished during those seven years.

As he and his helpers began executing the work, almost at once Michelangelo again increased the scale of the structure, making it wider, more massive and more architecturally imposing than his model and description had suggested.

Early on, Michelangelo had translated first thoughts into pen sketches for a cornice binding the lower level of the tomb and for several dynamic figures, bound or captive, in varied complicated poses, also meant for the base. Surely and swiftly executed, the sketches showed him yet again enthusiastically exploring the expressive possibilities of male nudes.

One of the three statues to emerge from its block of marble by the summer of 1516 showed a perfectly finished, handsome, youthful figure, eyes closed, sensuously struggling in a loose halter as if out of sleep or bondage, languid but athletic. Another, not quite completed, cheekbones still cross-hatched, showed a more thickly built, more masculine figure, standing *contrapposto*, his arms bound behind him. Carved in the marble of each statue were uncompleted simian images, references to art's imitation or aping of nature. Of the four larger-than-life figures which were to surmount the tomb's lower block, about twelve feet above the ground, Michelangelo by mid-1516 had carved the Old Testament prophet Moses as an imperious, seated figure. The prophet glares angrily to his left; the luxuriant beard cascades above his huge naked knee, and the right hand rests on the two tablets of stone. Again, in this older man, Michelangelo portrayed an ideal but naturalistically articulated palpable body, terrible in repose.*

Later, when it was in place, Roman Jews for a while flocked to admire the statue of the prophet of the Ten Commandments and the Exodus from Egypt to the Promised Land: Christian onlookers compared him to the dead Pope Julius, the armed but enlightened leader of the papacy. Like Michelangelo's statue of David, the radiant, lightly clad figure of Moses seems portrayed in a momentary stillness preceding decisive action.

*The statues of the bound youths are now in the Louvre, Paris. Sometimes called the *Dying Captive* and the *Heroic Captive*, they are respectively 90½ inches and 85 inches high. The Moses is 100 inches high.

Michelangelo worked on the statues with still undiminished physical power and delicacy, realizing fully in the vigorous male nudes his innate feeling for plastic, tactile values. In the verse he was writing about this time, concrete images of touching and binding enlivened his abstract Petrarchan evocations of tears or death. Though 'bound and confined, yet I am free and loose'. From the ruck of flesh and muscular tension, the statues he carved as he reached and passed the age of forty (already referring to himself as an old man) soared to new spiritual grandeur, like the Sistine *ignudi* before them. The rough original block was never lost to view in the polished image.

In June 1515 Michelangelo wrote to Buonarroto about the serious attempt he was making that summer to finish the work on the tomb as soon as possible, because 'I think I then have to be in the pope's service'. In August, he was writing about making a great effort, after models had been made, to finish the tomb, with many helpers, in two or three years.

Hearing that his father had been dangerously ill, Michelangelo wrote to Buonarroto from Carrara in November 1516 that if he, Lodovico, had a relapse, he should receive the sacraments, and have his wishes concerning measures to help save his soul, and should want for nothing for the needs of his body 'because I have never exerted myself except for him, to help him in his needs before he dies'. It would have been very inconvenient for him to rush home, he added, but he would do so at once if his father were in serious danger 'even if I had to die with him'.

Michelangelo had been arranging for marble for the tomb. But his expectations that he would be requested to work on an important project for Pope Leo were now on the point of being fulfilled. He left no indication that this at the time dismayed him. How could he not welcome the grand patronage of a living pope? Could he not complete the tomb and also satisfy Leo's sudden demands? In all his creative ambitions, Michelangelo's impulse was to invest the largest possible frame. The work on offer from the pope was irresistible.

With his rather disjointed message of filial concern to Buonarroto in November 1516 Michelangelo sent a letter to be handed to 'Stefano, the saddler' for sending to Rome care of the Borgherini – promptly, 'as it concerns serious matters'. The 'serious matters' must certainly have meant his own work and the change in direction that had led, in July 1516, to the renegotiation of his ill-fated contract for the tomb, now to be completed on a far smaller scale. The initiative for this came from the worried heirs of Julius II, Cardinals Aginensis and Santiquattro, and

sprang partly from the chilling of their relationship with Pope Leo. In the spring of 1516, Leo ejected Pope Julius's nephew Francesco Maria della Rovere from the duchy of Urbino and made his own nephew Lorenzo de' Medici absentee duke of Urbino. Pope Leo seemed unlikely to maintain an indifferent attitude to Michelangelo's absorption by the colossal della Rovere enterprise. The cardinals also seemed to sense that Michelangelo could not possibly finish the tomb as envisaged in the 1513 contract in the time allotted.

The summary Italian version of the new, 1516, contract began by announcing that Michelangelo, *scultore fiorentino*, undertook to make the marble wall-tomb of Pope Julius for his executors for 16,500 gold ducats. There would be two niches on each of the faces, resting on a plinth running all the way round with adornments of pilasters, architrave, frieze and cornice, 'as seen from a small wooden model'. There were now to be four tabernacle figures plus four pairs of flanking figures. Above these would be four seated figures, the effigy of the pope and two angels, and a further four seated figures. Finally, surmounting the whole, would be the Madonna and Child, making twenty-four statues in all. There would also be three narrative scenes in bronze or marble.

> And I bind myself to finish this tomb all at my own expense for the payment mentioned above, executing it in such manner as shall appear in the contract, in seven years; and if any part of the said tomb shall remain unfinished after seven years, there shall be allowed to me by the said executors as much time as possible to do what remains, [my] not being able to do anything else.

Despite this massive commitment, in January 1518, only a year and a half later, and after several months of plot and negotiation, Michelangelo signed an eight-year contract to design, build and decorate for the pope and the Medici family a huge façade for the church of San Lorenzo in Florence. Would he sink under the weight of it? Michelangelo's avuncular friend Lionardo di Compagno (Lionardo Sellaio), a Florentine working for the Borgherini family in Rome as a postmaster, felt that he must remind and nag him about his duty to hurry on with his work for the tomb of Pope Julius. By the end of 1518 Michelangelo was feeling these exhortations 'like so many knife-thrusts' as he looked forward to erecting twenty statues at a time in his new workshop in Florence, in a high state of mingled euphoria and despair.

28 Leo in Florence: the *entrata*; the façade

Buonarroto had been very active in his own way in Florence, turning dreams of commercial success with Michelangelo's help into modest performance. Now nearly thirty-eight, he was admitted to the Wool Guild of Florence in February 1515, and soon after with his brothers Giovansimone and Gismondo he opened a shop in the street of the Palagio del Podestà. They had borrowed 1,000 ducats from Michelangelo in 1514 and were hoping for more.

Buonarroto wrote a long lively report on the pope's *entrata* or grand entrance into Florence late in December 1515, addressed to '*Domino Michelagniolo di Lodovico Simoni scultore in Roma*'.

> . . . our Holy Father entered Florence on the 30th, St Andrew's day; and his entrance was greeted with a great show of devotion, a great clamour of people shouting '*Palle*' [the Medici emblem], so loud that the world seemed to spin round. Well, he entered Florence magnificently with all his court in train and attended by many of Florence's citizens, and with everything in good order. Among the rest, there were an assortment of young men, among the best of the city, all wearing livery with doublets of violet satin, fashioned alike, holding golden staves and preceding the pope's throne. It was beautiful to see. Before the pope came his escort of guards, and then his grooms who were carrying him under a rich canopy of brocade borne by cardinals, and about his throne came the Signoria. There was no respite even once for three days from the sounds of bells and firing. There was also a beautiful show of big triumphal arches, with a good ten of them in several places, and of an obelisk at the end of the bridge of Santa Trinita, and the façade of Santa Maria del Fiore also looked good. As these were festivities, the poor in turn have received alms and a great deal of money was being thrown all the time from the door of the Hall of the Pope.

To mark the visit of the pope, Buonarroto, like other members of the Signoria, received the title of count palatine and the right to bear the Medici *palle* and the fleur-de-lis on his coat of arms.

While in Florence, Pope Leo was observed to shed some tears at the sepulchre of his father in the church of San Lorenzo, built with the

money of his greatgrandfather Cosimo to Brunelleschi's designs. Despite its lavish interior, the façade of San Lorenzo was still unfinished, a vast rough expanse of dark rubble, left so partly because of the difficulty of matching the low aisles and high nave with a proper, uniform classical system. The immense scale of the impending commission to complete this tempted scores of artists to submit their ideas, including the elder Antonio da Sangallo, Giuliano da Sangallo, Andrea and Jacopo Sansovino, and Raphael. Now, imagining a beautiful façade for San Lorenzo as a great theatrical framework full of statues and reliefs – perhaps like the decorative work in his honour he had just seen on the Duomo – the thoughts of the pope turned to Michelangelo.

Once he had been told to involve himself, Michelangelo would by nature expect to be in charge of the whole enterprise and, as *capomaestro*, to see to architectural design as well as sculptural adornment, but he was soon caught up in a confused struggle of wills. At first the pope, discussing the project with his cousin Cardinal Giulio de' Medici, thought that Michelangelo and Giuliano di Baccio d'Agnolo might do the work together.

Baccio d'Agnolo was a versatile, erratic craftsman, then in his midfifties, who had studied building in Rome, ran a much frequented workshop in Florence, and had executed some of the triumphal arches for Leo's entrance into Florence. Michelangelo knew him well from his own boyhood days and thought little of him. However, it was from Baccio, in October 1516, that Michelangelo received a letter written by Domenico Buoninsegni, treasurer for Cardinal Giulio, whom the cardinal and the pope were using as their Roman agent. Buoninsegni said that both of them, Leo and Giulio, were ready to come to an agreement with Baccio and Michelangelo about the façade. A large sum of money had been put aside for the project; it only remained for the two artists to talk to His Holiness in person. There was a whiff of intrigue in the suggestion that if this meeting were to be arranged before the papal court returned to Rome a certain 'friend' (probably Jacopo Sansovino, who was also after the work) would not be able to block it.

Not much of this pleased Michelangelo. In November the same year Buoninsegni, exasperated, was writing to Michelangelo to complain about the way he, Michelangelo, had kept changing his mind, ever since he and Baccio had told him in Florence that they wanted to do the façade. 'And now from your last letter I see you have again decided not to come, and I am equally determined not to be bothered ever again by these matters, since I only end up ashamed and rather embarrassed.'

The flurry of correspondence continued during the winter of 1516. Baccio would not go to Rome by himself and Michelangelo would not go with him, chiefly through his anger at being told that the pope wanted to share the work on the façade between him and Baccio, while yet giving him all the statues to do himself or to farm out to others of his choice. Michelangelo expostulated that he would have accepted the commission, but only if he had been put in sole charge. Then, suddenly, after several months of manoeuvre and recrimination, in December Michelangelo was called to Rome from Carrara, where he had been quarrying marble for the tomb. He saw first the cardinal and next the pope, who then commissioned him verbally to undertake the façade, on whose design he had been working quite intently. Money was to be available and a workshop for working the marble was to be opened in Florence. Several days after seeing the Medici, Michelangelo rode to Florence and went almost at once to see Baccio d'Agnolo, giving him the drawing he had shown to the pope and asking him to make a wooden model.

But, in his most brusque and dismissive vein, on 20 March 1517 Michelangelo was writing to Buoninsegni from Florence with the news that he had seen the model and found that it was just a child's toy. In December 1517 Michelangelo sent his assistant Pietro Urbano to Rome with a wooden model made by another Florentine craftsman, after his own clay model, for which he did the figures in wax. He heard from Buoninsegni at the beginning of January 1518 that the cardinal and the pope were delighted with this.

When he rejected Baccio's model, even after changes had been made, it was not from cussedness: Michelangelo was already working on a totally different approach. But he wanted for the time being to keep this to himself. The design Michelangelo had in mind incorporated an imaginative leap from façade as veneer to façade as self-contained three-dimensional structure, three storeys in height throughout.

The last of Michelangelo's surviving drawings for the façade shows an outer narthex or antechamber with space for statues on the side façades and, at the front, six huge statues on each of the three storeys. The exuberance and grandeur of the design, posing the question of how Michelangelo's mature sculptural dynamism would maintain equilibrium with his developing architectural strength, had been expressed verbally when he wrote to Buoninsegni on 2 May 1517. He said it would take too long to explain why he had not sent him the model he had promised, but he was sending a small one in clay, crinkled like a wafer, to show he was not just a dreamer. Then he added the resounding

declaration that he felt able to 'execute this work of the façade of San Lorenzo, so as to make it in architecture and sculpture the mirror of all Italy'. But the pope and the cardinal must decide soon whether they wanted him to do it or not.

Much of the anxiety to have the work commissioned quickly on contract or some other satisfactory way, and to have it completely his responsibility, was financial and practical, Michelangelo then explained. He had experienced the nuisance of being told to secure blocks of marble, handing out money, quarrying, and then getting blocks of the wrong size or defective. Michelangelo added, either facetiously or gloomily or both, that as he was now an old man (he had recently turned forty-two) it did not seem worth while his wasting time in such ways to save the pope just two or three hundred ducats on marble, and because he was being harassed about the tomb 'I must come to agreement no matter what'.

According to his calculations, Michelangelo told Buoninsegni, the cost of the façade as he intended to do it including everything ('the pope would not have to trouble himself further about anything') could not be under 35,000 gold ducats, and for this he would undertake to execute it in six years.

Settled just under a year after this pleading, dated 19 January 1518, the detailed agreement for the construction and adornment of the façade of San Lorenzo stipulated that Michelangelo, applying himself continuously, should complete the façade in eight years, for the price of 40,000 gold ducats.

The façade was to follow the wooden model with wax figures which he had sent from Florence in December. Michelangelo was to have free accommodation near the church of San Lorenzo. The pope agreed that, to begin and bring the work to completion, Michelangelo should be paid up to 5,000 gold ducats a year, with 4,000 on account so that he could start quarrying the marble. The work itemized in the document included eight fluted marble columns rising to the first cornice and framing the three doors of the church and a total of twenty-two statues, of which the six on the storey over the door were to be over life-size seated figures in bronze (made possible as Michelangelo had unified the mezzanine into a single level); and seven marble scenes in low relief, five square panels and two round.

The agreement was a highly personal deal between Pope Leo and Michelangelo. It stated, for example, that Michelangelo was undertaking to execute the statues and scenes in his own hand, and was at

liberty to seek help as he pleased in ways he considered would well serve and satisfy His Holiness within the time allotted, and that if the work was interrupted through illnesses, wars or other blows of fortune Michelangelo in everything put himself in the pope's hands.

The pope and Michelangelo had previously agreed on the saints to be honoured on the façade. The first four statues at the base were to be St Lawrence (Lorenzo), St John (Giovanni) the Baptist, St Peter (Piero) the Apostle and St Paul; seated above these the cardinal – always consulting the pope – wanted St Luke, St John the Evangelist, St Matthew and St Mark; and at the top would be St Cosmas and St Damian, to be indicated as doctors, 'since they were doctors'. And so the two Medici saints were to tower over the façade.

Michelangelo's anxieties about the tomb and the façade were meanwhile compounded by a furious, protracted dispute over where he should buy the marble for San Lorenzo. Pope Leo and Cardinal Giulio de' Medici were insisting that he should use the new quarries at Pietrasanta, in Florentine territory to the south of Carrara near Viareggio. Tuscan marble suppliers in Pietrasanta were now challenging the monopoly of the marquis of Carrara. To transport the marble wanted for the Duomo, the overseers had planned roads which were already under way when Michelangelo was commissioned to do the façade of San Lorenzo.

Michelangelo, however, had been using marble from Carrara since 1498. In January 1517 he reluctantly went from Carrara to Pietrasanta to survey the terrain and study the quality of the marble. He reported boldly to the pope that the marble was difficult to work, unsuitable for the purpose, and would be awkward and costly to transport through the mountains and over the marshy plain to the coast. On Monday 2 February 1517 Cardinal Giulio wrote saying that, as the marble quarries and works on Pietrasanta were well run, amply stocked and easily accessible, 'the marbles should be taken from Pietrasanta and from nowhere else, for the above-written reasons, and most of all because it is also understood that they will be less expensive than those of Carrara ... because if you do otherwise, it will be against the will of His Holiness and ourselves, and we shall have cause to complain of you greatly.'

However, the road-building for Pietrasanta was still in progress, and a contract of 12 February 1517 recorded that Michelangelo, when going about his business in Carrara, had been shown an ancient marble quarry by its owner, Lionardo of Cagione, with whom he had agreed to form a company to share the expense and profit, both employing the

same number of men in the quarry. The loosely worded agreement stipulated that the company would stay in being until Michelangelo had been furnished with the marbles he needed for the façade. But when he wrote on 20 March to tell Buoninsegni his poor opinion of Baccio's model for the façade, he also reported that he had ended the partnership, 'for good reasons'. The 'good reasons' may have been pressure from Rome; Michelangelo felt the phrase said enough. When the contract for the façade came to be finalized in January 1518, it stated that the façade was to be made of fine white marble from Carrara or Pietrasanta, as judged better for the work. Finally, either because the pope willed it or because he felt let down and boxed in by the Carrarese, or for both reasons, Michelangelo decided to quarry in Pietrasanta for the marble for San Lorenzo.

In Carrara, consequently, from being well regarded Michelangelo became reviled, most hurtfully by the marquis. As he became more alert to the possible advantages of seeking marble from Pietrasanta, he realized that he would have to provide the skills and experience needed to make the quarries accessible and productive. Suddenly all his concentration was focused on Pietrasanta.

In the summer of 1517, Michelangelo's family in Florence found it hard to keep track of him. Lodovico (who had made a swift recovery after seeming at death's door in the winter of 1516) found Michelangelo in June much consoled by the progress being made on preparatory work for the façade, but the stress began to take its toll. Michelangelo was commiserating with Lodovico and Buonarroto over their health in July; in the autumn, they were worrying about him. On 23 September, Gismondo reported to Buonarroto that Michelangelo had been very ill. He had not told Buonarroto before, to avoid upsetting him unnecessarily; but now Michelangelo was better and the fever had left him, though he was still very weak.

In the spring of 1518 Michelangelo was writing to Buoninsegni and to his brother Buonarroto in Florence about his efforts to open up the quarries in the mountains of Seravezza and Pietrasanta. He found he could have the marble blocks wanted for Rome transported easily from Carrara to the coast at Seravezza, but the different location of the marble he needed for his own statues meant widening the road, and in one part building a new one, and cutting into the mountains. Michelangelo sought authority to supervise all the road-building; he would not cheat, he declared, and moreover he knew where the best marble was. After a journey to Genoa to arrange for barges to load his

marble at Avenza – where he found that the Carrarese had bribed the barge-masters to frustrate him – early in April 1518 Michelangelo went to Pisa to find a barge-master who would cooperate with him. He then returned to Pietrasanta, only to find the marble-cutters he had brought from Florence, costing him the earth, were ignorant about quarrying and marble. However, in July he was expecting deliveries of marble for the work at San Lorenzo and buying a site in Florence for his workshop. At last, as he wrote in mid-September 1518 from Seravezza to Berto da Filicaia, a key official at the cathedral's Office of Works who was well disposed towards him, the road was as good as finished. There were only a few outcrops of rock to cut through, and a few spots to be levelled with pickaxes. He knew the marsh was nearly filled in, as the last time he was there people were still working on this task 'as badly as they could'.

'Concerning the marble, I have the quarried column down safely on the river bed, fifty braccia [about 100 feet] from the road. It has been a harder task than I reckoned, to sling it down; something went wrong when it was slung so one man broke his neck and died at once, and my own life was put at risk.'

The quarry site, Michelangelo remarked, was very rugged. The men were inexperienced in the work they were doing. A great deal of patience would be needed for some months, till the mountains were tamed and the men had been trained.

As winter approached it would rain constantly in the mountains and work would become impossible. Michelangelo, who was also anxious to discuss Buonarroto's plans to buy a farm near Fiesole and a house in the city near Santa Maria del Carmine, returned to Florence. There, perversely, the lack of rain (to fill the Arno and float the boats) meant a lack of wood to roof his workshop. ('And I don't believe it will ever rain again, unless it will be to do me some harm', he commented.) The dry weather, as he grumbled when writing to his friend Lionardo Sellaio in Rome, was holding up shipments of Carrara marble from Pisa, where an already loaded boat was waiting and four more had been commissioned. 'I am more discontented than anyone in the world.'

As he told his friend, he had also recently been reproached by Metello Vari for the delay over the statue of the Risen Christ, commissioned over three years previously, in 1514. The pressures and delays were tormenting him; all against his will, he was seeming to be a cheat.

Buoninsegni wrote late in 1518 that Michelangelo 'would do well' to commission marbles for San Lorenzo. 'I have already commissioned them three times and been deceived over all three,' Michelangelo wrote

back at around the end of the year. 'And so I have thrown away some hundreds of ducats, and have had to stay there sometimes and set to work myself, and to show them the lines of the marble and the things that are damaging and the marbles which are bad, as well as even how to quarry, for I am skilled in such matters.'

The spring of 1519 brought its fresh chapter of delays and another accident in the mountains of Seravezza, when an iron fastening broke and a fine column of marble fell and shattered, nearly killing Michelangelo and several others. Again, Michelangelo noted that he was the victim of bad, dishonest workmanship. But he supposed he must be patient, he told Urbano, whom he had been keeping busy in Florence preparing to pay boatmen and cartwrights, buying rope and rubble, training the vines of the workshop in the Via Mozza and also – if he were taking notice of Michelangelo's list of instructions – going to confession. Michelangelo was then planning to be in Florence at Easter to begin work. But, after he returned there, in May the Carrarese working in Pietrasanta failed on their contract to supply marble for eight figures for San Lorenzo.

In the summer of 1519 (following a visit to Rome) Michelangelo was again in Pietrasanta and writing to arrange another shipment of marble. He nearly lost his Urbano that autumn, for he had fallen dangerously ill on a visit to make some payments in Carrara. (Michelangelo noted in his records that his own journey to Carrara, the doctor and medicines, having Urbano carried to Seravezza, and leaving him with ten ducats all came to thirty-three and a half ducats.)

Michelangelo's need to occupy the whole ground had a bruising effect on the several other sculptors who had hoped to win or share in the commission for the façade of San Lorenzo. Prominent among them was Jacopo Sansovino, ten years younger, born in the same district of Florence, versatile, ambitious and successful, both admiring and envious of Michelangelo. He took his name from his master, Andrea Sansovino, Michelangelo's near contemporary. The story came to be told of Jacopo, as an example of his ruthless dedication as a sculptor, that, to model a perfect Bacchus, he had his assistant, Pippo, pose in the nude for hours at a time, in the depths of winter. The experience apparently made Pippo deranged, and until his death a few years later he would often be seen around Florence posing on rooftops and wrapped round with cloth as if he were a clay model, striking attitudes as a prophet, an Apostle or a soldier.

Sansovino was assuring the pope's advisers early in 1517 that the

marble of Pietrasanta was excellent, abundant and more accessible than had been thought, at a time when Michelangelo was suspected of delaying its exploitation because he wanted to stay with Carrara. Sansovino still regarded himself as sharing the enterprise of the façade with Michelangelo and others.

In February he had written affectionately and respectfully to Michelangelo in Carrara about a block of marble he wanted and about going to stay with him. Then, disregarded and enraged, he wrote from Florence at the end of June 1517 beginning with some provocative praising of Baccio Bandinelli, and continuing:

> Not having been able to talk to you before your departure, I have decided to let you know my opinion of you . . . I tell you that the pope, the cardinal and Jacopo Salviati are men who when they say yes, it is a contract in black and white, so true are they and not what you say. But you measure them with your own yardstick, for with you there are neither contracts nor good faith, and all the time you say no or yes as it suits and profits you. Know that the pope promised me the reliefs [*storie*] and Jacopo also; and they are men who will keep their word. And I for my part have done as much for you as I could, for your profit and honour. But I had not yet seen that you never do any good to anyone: and that, beginning with me, it would be like wishing water would not make anyone wet. I have reason for saying this, as we have often conversed, and may the time be cursed when you ever said good of anyone in the world. Go with God. That's all.

Suddenly, in his *ricordi* of 10 March 1520, Michelangelo refers to the cancellation of the commission to build the façade, which he had promised at the start would, with God's help, be 'the most beautiful work in Italy'. He carefully set down what had happened: he noted the payments made for the façade and added that now 'Pope Leo, perhaps to have the aforesaid façade of San Lorenzo done sooner' had freed him from the agreement, with all the money received accounted for by the work done at Pietrasanta and the marble quarried and blocked out there. He was left at liberty and freed from the obligation of rendering an account to anyone.

What had happened, Michelangelo regarded as a gross insult – *vitupero grandissimo* – aggravated by the pope's failure to explain why the work was taken from him. He said this, in a mood of tense restraint, obsessed as always with the need to set the record, especially the

figures, straight, in a letter probably to a notary in Florence, written soon after the anticlimax. A couple of pages summed up the tragedy of three wasted years.

When I was in Carrara, for my own business, namely for marble to take to Rome for the tomb of Pope Julius, in 1516, Pope Leo sent for me concerning the façade of San Lorenzo that he wished to construct in Florence. So on 5 December I left Carrara and went to Rome, and there I made a design for this façade, whereupon the said Pope Leo commissioned me to have marble quarried for this work at Carrara. Then when I returned from Rome to Carrara, the last day of that December, Pope Leo sent me, for quarrying marble for this work, through the hands of Jacopo Salviati 1,000 ducats, which were brought to me by one of his servants called Bentivolgio ... I undertook the said façade on contract, as appears from the written agreement with His Holiness which I have; and as in order to serve His Holiness I had to transport to Florence the marble which I had had brought to Rome for the tomb of Pope Julius, which I have, and then after the marble had been worked to bring it back to Rome, he promised to indemnify me for all these expenses, that is to say the dues and the freight, which is an expense of about 800 ducats, although the agreement does not say so.

And on the 6th day of February 1517 I returned from Rome to Florence, and as I had undertaken on contract the aforesaid façade of San Lorenzo, all at my expense, and as the said Pope Leo had to pay me in Florence 4,000 ducats, on account of the said work, as appears in the written agreement, on about the 25th I had from Jacopo Salviati 800 ducats therefore, and I made a receipt and went to Carrara. But as they had not fulfilled the contracts and orders made previously for marble for the said work, and as the Carraresi wished to block me, I went to quarry the said marble at Seravezza, a mountain by Pietrasanta in Florentine territory; and once I had blocked out six columns, each eleven and a half braccia, and many other marbles, and had begun the workings that are seen there today, on 20 March 1519 I went to Florence for money to transport the said marble; and on 26 March 1519 the Cardinal de' Medici had me paid for the said work on behalf of Pope Leo, through the Gaddi in Florence, 500 ducats, for which I gave a receipt. Then in the same period the cardinal at the pope's behest told me not to proceed further with the

aforementioned work, because they said they wished to relieve me of the trouble of transporting the marbles, and they wished to give me them in Florence themselves, and to make a covenant; and this is how the matter stands today.

Now during this period the commissioners of Santa Maria del Fiore sent a certain number of stonecutters to Pietrasanta, or rather Seravezza, to occupy the workings and take from me the marbles I had quarried for the façade of San Lorenzo, in order to make the paving of Santa Maria del Fiore, while the Pope still wished to proceed with the façade of San Lorenzo; and the Cardinal de' Medici having allocated the marbles for the said façade to all others save me, and having given to those who have taken over the transport my workings at Seravezza, without accounting with me, I was very aggrieved, because neither the cardinal nor the commissioners were able to intervene in my affairs until I had ended my agreement with the pope; and the said work of San Lorenzo having been dropped in agreement with the pope, and the expenses paid and the monies received accounted for, the said workings and the equipment would of necessity have fallen either to His Holiness or to me; and one party or the other afterwards could have done with it whatever he wished.

Now regarding this matter the cardinal has told me that I should account for the monies received and the expenses incurred, and that he wishes to free me, so that he can, for the Office of Works and for himself, take the marbles he wants from the aforesaid workings at Seravezza.

I have therefore accounted for 2,300 ducats in the ways and at the times herein declared, and I have also accounted for having spent 1,800 ducats. And of these, about 250 were spent in consideration of the freight up the Arno of marbles for the tomb of Pope Julius, which I transported to work here so as to serve Pope Leo, then to transport to Rome, as was said; all the other money to the said sum of 1,800 as said, I have accounted for as spent on the said work of San Lorenzo, not charging to Pope Leo the transportation to Rome of the marble worked for the tomb of Pope Julius; which would be more than 500 ducats. Nor am I charging him for the wooden model for the said façade, which I sent to Rome; nor am I putting to his account the period of three years that I have lost over this; nor am I putting to his account that I have been ruined over the said work of San Lorenzo; nor am I putting to his account the gross insult of having brought me here to do the said

work, and then taking it from me; and I still do not know why. Nor do I charge to his account my house in Rome that I have left, including marble, furniture and completed work, which has deteriorated to the amount of over 500 ducats. Without charging all the aforesaid things, I do not have left in hand, of the 2,300 ducats, other than 500 ducats.

Now we are agreed: Pope Leo takes over the workings as opened up, with the said marbles that have been quarried, and I the money left in hand, and I am left free; and am proposing to have a brief drawn up, that the pope will sign . . .

29 Money, mortality, and the Medici tombs

From the start of his pontificate, Leo's expenses had risen continuously and income had remained erratic. Both were huge. The Vatican's swollen body of clerical bureaucrats, enlarged to make more money, was itself costing ever more: salaries were taking at least a quarter of ordinary papal income. Leo's household, or *famiglia* – the largest court in Rome, as befitted the city's bishop and the head of the Church, ranging from cardinals to gardeners, and rich in scholars and Florentines – numbered about 700, costing about 40,000 gold florins a year.

The rebuilding of St Peter's, first promised by Pope Nicholas V advised by Leon Battista Alberti, had been vigorously pushed forward by Julius II, chiefly in response to Michelangelo's programme for the pope's stupendous tomb. Julius had employed Bramante, with his scheme for a completely new church (in the form of a Greek cross), to demolish obstructive parts of the old church and raise four central piers for a huge dome. By 1514, just after Leo's enthronement, nearly 71,000 ducats had been spent. Employing successively Bramante's fellow countryman and possibly distant kinsman Raphael, with a salary of 300 gold crowns, and then Baldassare Peruzzi as his main architects, Leo had the foundations for a new church extended and the columns strengthened. He kept up the momentum to make St Peter's worthy of the new Rome, the new Jerusalem, and delighted in architectural innovation within the papal palace as well as new buildings, roads, bridges and palaces throughout the city.

Inclined to the politics of astute passivity, for most of his reign Leo escaped serious warring incursions by the great powers of the time. But military expenditure on local wars in Italy became burdensome, flaring

up early in 1517 when Francesco della Rovere recaptured Urbino from Lorenzo de' Medici. The pope also wanted money for a crusade against the Turks. He had grown increasingly alarmed by the conquests of the aggressive Turkish ruler, Selim, who, after occupying Syria and Egypt, seemed to be menacing either Hungary or Italy itself, but the danger from the Turks receded when Selim died in 1520.

At the start of his reign, in 1513, Leo made the fatal decision to maintain the use of 'indulgences' to raise revenue for building St Peter's, and in successive stages he widened their application. Crisis point was reached with the circulation of Luther's attacking theses in November 1517, just a few months after the dissolution of the Lateran Council. During the four years that Michelangelo was fruitlessly organizing supplies of marble for the family church of the Medici, a squabble involving in particular two religious orders, the Augustinians and the Dominicans, came to convulse a Germany tense with rebellious feeling, and the protest against papal authority grew irreversible.

To raise money speedily, Pope Leo 'sold' about two thousand posts in the Curia for capital sums repaid by fees to the office-holders. In 1520 Luther echoed widespread disquiet and anger when he lambasted the 'swarm of parasites in Rome' all 'boasting that they belong to the pope . . . lying in wait for the endowment and benefices of Germany as the wolves lie in wait for the sheep'. Again and again, financial opportunism powerfully affected the pope's ecclesiastic or political decisions.

Leo did not have for Michelangelo as a person or an artist the warm feeling he showed Raphael, whose personality and style were more serene. When Raphael died, on Good Friday, 6 April 1520, the pope was reported to have sunk into 'measureless grief'.

Raphael's triple portrait of Leo with the cardinals Giulio de' Medici and Luigi de' Rossi showed the artist's effortless rapport with the Florentine pope, painted with plump face and truculent look, wearing gold and silk, and sitting in a chair adorned with the Medici emblem, the *palle*. The picture was on show at the wedding celebrations of Leo's nephew Lorenzo de' Medici, duke of Urbino, in September 1518, when Michelangelo was brooding and lonely in the rain at Seravezza. Michelangelo did not readily do portraits of popes.

Sebastiano, Michelangelo's closest non-Florentine friend in Rome, tried to reassure him about Leo's goodwill, especially following the bitter disappointment over the façade. Sebastiano also sought, soon after Raphael's death, to secure some of the decorating of the Vatican

apartments for himself and Michelangelo, who was in fact not inter-
ested. Sebastiano told the pontiff that, with Michelangelo's help, he
could work miracles. 'I do not doubt this, as you have all learned from
him,' Leo said. 'Look at the works of Raphael, who when he saw
Michelangelo's works at once abandoned Perugino's style and ap-
proached as near he could to Michelangelo's. But he is terrible, as you
see; one cannot deal with him.'

Terribile was the pope's word, indicating someone awesome, a man
to be feared. Sebastiano replied that Michelangelo's *terribilità* did not
harm anyone, but because of his love for the great and important works
he was doing he seemed terrible.

Sebastiano again reported on Leo's attitude when he wrote to
Michelangelo, a few weeks later, to announce that he had told the pope
that as Cardinal Aginensis had suddenly passed away (on 27 Septem-
ber) Michelangelo could make a 'digression' from his work on the tomb
of Julius to work for His Holiness in Rome. The pope had demurred –
partly, he explained to Sebastiano, because it was whispered that the
cardinal had been poisoned; 'and so Our Signore will not get embroiled
with anything to do with the cardinal, to avoid rumours among the
crowds'. All the same, Sebastiano urged Michelangelo to come to
Rome, where he would obtain all he wished 'because I know in what
regard the pope holds you, and when he talks about you it is as if he
were speaking of a brother almost with tears in his eyes; for he has told
me that you were brought up together, and he made it clear he knows
and loves you, but you frighten everyone, even popes'.

Michelangelo was not flattered. Early in November, Sebastiano tried
to mollify him in a letter referring to some dispute over payment for the
statue of the Risen Christ, still not finished, and in some alarm mention-
ing allegations that it had been worked not by Michelangelo but by his
assistant Urbano. 'As for this *terribilità* you object about, I myself do
not regard you as terrible . . . except for your art, and your being the
greatest master that ever was.'

Michelangelo's unapproachability or terribleness may have been one
reason for Leo using him at a distance from Rome, but not for ending
the contract for the façade. On the contrary, concern for Michelangelo
and his art may have led the pope, his influential cousin Giulio and his
advisers to decide that it was wrong to let him continue with the
exhausting, protracted and dangerous labour involved in the organiza-
tion and execution of the façade. Moreover, even nearer to Leo's heart
loomed a new project to commemorate and glorify the Medici.

Leo was then, like Michelangelo, forty-five. His brother, Giuliano,

duke of Nemours, had died in 1516, leaving an illegitimate son, Ippolito. His nephew Lorenzo, created duke of Urbino by Leo's command, had died in 1519, leaving only a daughter, Caterina. The deaths of these two princes stripped Leo of his chief hope: of securing, through them, permanent secular honour and power for the family. There was now only one member of the immediate family who could govern Florence, Cardinal Giulio de' Medici.

Before the autumn of 1520 Leo and Giulio had decided to commemorate Giuliano and Lorenzo and the other two truly renowned relations, Lorenzo the Magnificent and his brother Giuliano, with tombs housed in a new chapel to be built on the north transept of San Lorenzo. What was at first a fairly restricted commission to Michelangelo may have been partly to compensate him for disappointment over the façade. Just as likely, the near certainty of his involvement was one of the factors for ending his commission to do the façade.

Another, murky, reason for this decision points to some kind of conspiracy. It became hearsay among Michelangelo's friends that Domenico Buoninsegni had tried to persuade him to defraud the pope through the accounts he kept for San Lorenzo, and that when Michelangelo refused Buoninsegni managed to get the façade abandoned and work on the sacristy brought forward. For sure, Buoninsegni and Bernardo Niccolini (treasurer to the archbishop of Florence) continually appeared to be working against Michelangelo behind the scenes, motivated by personal animosity.

Quite simply, too, there was a limit to what the pope could afford. Leo's flagging enthusiasm for the façade and his reticence over the reasons for taking the work away from Michelangelo must have owed something, and perhaps almost everything, to this unmentionable weakness.

30 Tuscan politics • Family affrays

Michelangelo had a strong sense of self-preservation and often withdrew emotionally, or physically fled, from social or political violence. Frequently, too, in the suspicious atmosphere and dangerous political circumstances of Medicean Rome and Florence, different members of his family cautioned each other to make discretion the better part of valour. In 1512 when the Medici family were restored to Florence and

the city received the triumphant Cardinal Giovanni, Michelangelo had advised Buonarroto to leave Florence for somewhere safe. A few days later he had added, 'speak neither good nor ill of anyone, as no one knows what the outcome of events will be; attend just to your own affairs'.

Buonarroto was long used to receiving fatherly reproof, advice and correction from Michelangelo about everything from property to politics. After Louis XII had died at the beginning of 1515, Buonarroto told Michelangelo that this meant that Italy was now out of danger, and seized the chance to mock at his brother's fears for the future, and his weakness 'for friars and silly stories'. When he reminded Buonarroto of this in the autumn – referring implicitly to the election of Francis I and his aggressive claim on Milan – Michelangelo wrote sarcastically, 'So you see that the king is not dead; and it would have been much better for us if you had run your affairs my way several years ago.' He added injunctions to Buonarroto not to buy a shop, because of the uncertain times, to preserve his capital, and to look to the good of his soul.

Michelangelo remained on guard, for himself and for the family, as the Medici hold on Florence remained precarious into the 1520s and exiles including Piero Soderini still hoped for a revival in their political fortunes. Pope Leo X had successfully yoked Florence to Rome, but after the death of Lorenzo de' Medici the régime had to rely on the pope's client cardinals to supervise the city, and it still feared a *coup d'état*.

By the time Michelangelo had left Rome to work in Florence and Carrara, Buonarroto had married again, following the death of his first wife, Cassandra, some while previously. He was now thirty-nine. This time, as he recorded happily, he had chosen a 'noble' woman, Bartolommea Ghezzo della Casa. Michelangelo had wanted the marriage delayed, and Buonarroto knew his brother was 'none too happy' over the match, which he thought would be a burden on the family.

On 19 February 1517 Buonarroto had written to Michelangelo in Carrara asking his speedy advice whether to go to Castel Focognano as *podestà*; it was a good post of its kind, he said, bearing in mind that there was little business around in Florence. On 1 May Buonarroto wrote telling his father about his reception that morning in Castel Focognano, where he had now taken up the office of *podestà*. He quickly took against Castel Focognano and its inhabitants, who were all '*sbanditi*' and who were soon making difficulties for him by refusing to hand over

the official books, statutes and purses unless he followed custom and lived in the town itself, instead of at nearby Rassina.

Buonarroto's letters to his father, his brothers and his wife increasingly reflected the panic he shared with others near the borders of Tuscany as the dispute between the pope and the duchy of Urbino escalated, and they revealed fretful concerns over the family business, his own health and comfort, and the irksome behaviour of his wife. They show Lodovico cantankerous and obtuse as ever; Gismondo and Giovansimone still striving ineptly to make profits; Bartolommea torn between pleasure and duty, spirited and sensitive; her mother, Mona Piera; and a cluster of women acquaintances and relations, including Mona Lucrezia, Mona Francesca and Mona Maria. During the spring and summer of 1517 Buonarroto sent them all signals of affection, exasperation and despair.

Buonarroto's incessant grumbling irritated his father. Lodovico thought he would stop writing to him, as whatever he said upset him. He conceded that the local people might have bad blood, but Buonarroto didn't have to share a bed with them.

In a letter late that May, an outpouring of truncated and mangled words, Bartolommea thanked her husband for the cheese and the hare that had been killed and the others, and would he send another, as one of the young hares had died? She had had some French chestnuts prepared for him, and she would send more oranges when he had finished those brought to him by Gismondo. She was sorry to hear that his leg was painful. But first of all she needed to defend herself: 'I'll be as patient as you want me to be. You say it seems to you I take little heed of you, and it seems to me you are less kind to me: but as you will. You ask me to pray to God for you, and this is by bounden duty; then you say that I never advised you if I was pregnant or not: and I couldn't know till now; and now I tell you that I'm not.'

Bartolommea, like her mother, often relied on the apparently not very reliable but amusing Tedaldo della Casa, her brother, who became a close friend of Giovansimone Buonarroti, to write her letters for her. His efforts seem to have been exceptionally bad: Buonarroto commented that he should learn to write.

Despite his new temporary earnings, Buonarroto worried constantly about money, and was ready – to Lodovico's horror – to borrow to meet needs that arose in Florence during the summer, when at one time he was urging Lodovico to sell their mule. He grumbled to Bartolommea about a crushing tax of fifty florins, a punishment for their sins. She let him know that she felt she had never been able to confide in him or to

tell him anything without everyone in the house hearing about it. Lodovico urged him to stop thinking so much – just honour God and keep well, and be like the women of his household, whose bottoms were growing so fat they would need a barber's chair to sit in.

In July 1517 Gismondo finally cleared the brothers' shop of what belonged to them, handing back the keys to a surprised Andrea Niccolini, who had been expecting rent to be paid for at least a few weeks more. But business was bad in Florence, and getting worse. Buonarroto told his wife he was not happy about her attitude to joining him in Castel Focognano. Did she want to or did she not? He wanted her to, but it was up to her; and her mother could come too, though he could not provide her with an animal to ride. Bartolommea could come by mid-August if it were not too hot. At the beginning of August, however, Buonarroto had to jettison the idea. He suddenly had more pressing matters to absorb him, as threats to his safety revived overnight.

In May 1517 Francesco Maria della Rovere, duke of Urbino, vengeful against the pope – who had ousted him and given the duchy to his nephew Lorenzo de' Medici – had struck towards Città di Castello and Tuscany. In July he was back in Urbino to give armed protection to the peasants during harvest time. He then advanced towards Florentine territory during late July and August, launching bold attacks on Borgo San Sepolcro, Anghiari and Pieve Santo Stefano, and terrorizing the subjects and citizens of Florence through raids into the Casentino, the mountain-ringed valley some twenty-five miles from the city.

Political unrest in Florence was nearing a climax during August from fear of a military attack on the city. Mercenaries were brought in, and citizens of doubtful loyalty to the Medici were banished to their country homes or even further afield within Florence's dominions.

At Castel Focognano, Buonarroto was on the dangerous edge of the Florentine territory. Early in August, in a letter to Gismondo, he recounted that at night many fires had been started in the country around, since 'these outlaws' had burned the enemies' fodder, just as a few nights previously they had destroyed a couple of vineyards, savaging crops instead of men and demanding ransoms on pain of death.

Buonarroto had thought he was safe where he was, he wrote to Bartolommea in mid-August. Then came the reports that the enemy had penetrated the Casentino, followed by an all-night alarm, and people were evacuating Poppi and Bibbiena and other castle towns to

head either for Florence or for strongholds in the mountains. Buonarroto intended to do the same, he wrote, but he would have to wait for some pack animals.

Buonarroto wrote again on 25 August, not from Rassina but from Pontenano, with the news that there had been skirmishes at Pieve Santo Stefano and all the Casentino had taken to flight, leaving him deserted by beast and man. The soldiers had set fire to all the vale of Caprese. He had managed to secure animals to remove some of his belongings, and then, after hostile soldiers had thrust to within four or five miles, feeling he might well be captured, he had moved eight miles to the stronghold of Pontenano, high up in the mountains. Life there was dismally uncomfortable, Buonarroto told Gismondo; the place was choked with refugees and their possessions. But, as he understood troops were on their way from Florence, he hoped not to be there too long. Attacks meanwhile were being reported at Anghiari and Borgo, but luckily the enemy had no artillery.

Buonarroto escaped any baptism of fire. The pope, that same month, secured the withdrawal of Spanish troop support for Francesco Maria della Rovere, who then retired to Mantua with his guns, the great library of his predecessor, Federigo of Montefeltro, and Leo's enforced agreement to pay the arrears owed his soldiers, which came to over 100,000 ducats.

As the war of Urbino spluttered out ignominiously, Buonarroto returned to his duties as *podestà*, and for a while stayed at Castel Focognano. Once more his angry and suspicious fellings towards his wife were simmering. Letters from Buonarroto to Bartolommea sent during his last few weeks away from home were heavy with complaint. When he wrote on 28 September protesting that he always did all he could to please her and urging her to show Michelangelo patiently that she bore love towards him, 'to both him and me', he complained that all the local people were so busy with the chestnuts and the wine that he had no help. Perhaps Bartolommea would have to find a servant for him, he went on plaintively on 12 October: 'but I am frightened as you want someone young that you may nourish a serpent in your bosom; though I would like this, since a man can use a young woman to serve him in bed as well, unlike the old ones'. Buonarroto's last words to Bartolommea written from Castel Focognano were that he understood Michelangelo had recovered from the fever that seemed to have been afflicting him and had gone to the country.

Two years later, in 1519, Bartolommea had her first child, a daughter christened Francesca. A few days after the birth Buonarroto wrote to

Lodovico, who was in Settignano, 'although she may have been born female, one must take what God gives. At least she is a beautiful baby with all her limbs.'

31 The new sacristy • The Risen Christ • The pride of the Buonarroti

The Savonarolean echo in the lament made by Buonarroto to his wife in his letter of 28 September 1517 – 'I think God does nothing by chance, but that all the adversities and tribulations of this world come through our sins' – presaged the mood in Florence during the decade of political instability after the death of Lorenzo de' Medici in 1519 had left the city with no immediate member of the Medici family to govern it.

Still walking the streets of Florence and taking part in its administration were the *piagnoni*, or snivellers – the followers of the martyred Savonarola, who opposed the adherents of the Medici. Their sense of doom and calls for repentance expressed a general mood of apprehension that had been deepened by the manifest weakness and disunity of Italian states during the war of Urbino. The very records of Florence seem to dry up. Among the intellectuals of the city, many hankered after princely rule as a way to restore Florence's integrity. The pragmatists included Machiavelli, despite his republican ideals, and Francesco Guicciardini, despite his aristocratic predilections.

In this shadowy atmosphere, Michelangelo lived physically exhausted from his exertions in procuring marble for the ill-fated façade of San Lorenzo. He was still bearing the dual burden of emotional guilt and legal and financial obligation renewed through the 1516 agreement with the pope's heirs over the tomb of Julius II. In the spring of 1520, when his contract for the façade of San Lorenzo was scrapped, the work on the tomb of Julius was no further on than it had been in 1516, though he was legally obliged to finish it in 1522. The massive statues, the unfinished Moses and the two young male nudes still stayed walled up in Macello de' Corvi.

Michelangelo's usual expansive fury now drove him to push on with the figures for the tomb, so many still remaining, but at the same time he was manoeuvring to be put in charge of yet another huge building project. Older members of the Medici family had been buried in Florence in Brunelleschi's sacristy at the end of the south transept of

San Lorenzo. Following the death of Giuliano in 1516, Lorenzo de' Medici's death in 1519 served to crystallize the idea of adding a new sacristy to the north transept, reproducing and balancing Brunelleschi's. Instead of a triumphal façade for the church there would be a mausoleum for the mortal remains of the Medici and also a great library for the Medici collection of books and antique statues: the consummation of the dreams of Lorenzo the Magnificent.

The new sacristy would contain as well as the tombs of Giuliano and Lorenzo, respectively Pope Leo's younger brother and nephew, those of the two *magnifici*: his uncle Giuliano and his father, Lorenzo the Magnificent. Cardinal Giulio de' Medici, now in effect controlling the government of Florence, was in charge of the scheme. Conscientiously, he thought to commission some of the work from Michelangelo: designs for the tombs, some of the statues. Cautiously, he did not put him in charge.

A staunch Medici partisan, the sub-prior of San Lorenzo and canon of both San Lorenzo and Santa Maria del Fiore, Giovanni Battista Figiovanni had been appointed *provveditore* for the fabric of the new sacristy in March 1520. As *provveditore*, the loyal, scrupulous, far from humourless Figiovanni – 'Figi' – farmed out and supervised the work and signed receipts, while, to begin with, Bernardo Niccolini, treasurer to the archbishop, under the control of the banker Jacopo Salviati, managed the money.

Figiovanni was soon dealing with the two leading master masons of Florence, to have the work started in November. By the end of April 1521 the architecture of the chapel up to the architrave was in place. Michelangelo's involvement at this stage is unclear.

While Pope Leo lived, and used his services, Michelangelo was protected from the impatience of Pope Julius's executors; but he became increasingly stressed by his desire to mastermind the new sacristy and his consciousness of the relentless approach of 1522, when the current contract for the tomb of Julius would expire.

Ambition to do the new funereal work for San Lorenzo grew powerfully in Michelangelo during 1521, a year of stress for him personally and of war in Italy. A series of emotional crises, culminating in the death of the pope, resulted in a terrible outburst against his father. Now forty-six (against his father's seventy-seven years), he began increasingly to affect to think of himself as an old man. None the less, in April 1521, he again travelled with undiminished energy around Carrara (where he had first gone for marble in 1498), paying the stonecutter

Scipione a salary and receiving some expenses in advance from Domenico Buoninsegni.

Late that same month, for an outlay of 100 gold ducats, Michelangelo was guaranteed by the stonecutters the production of about 200 loads (*carrate*) of marbles, to the number and measurements and quality he stipulated, within eighteen months. The agreement, dated 22 April, specified three figures from these marbles, and more if possible, and likewise from the rest of the marble as many squared off blocks as possible, with the supplier arranging for shipping by boat. The loosely worded guarantee stated that the Cardinal de' Medici had given Michelangelo the production (*opera*) of the marble for the sacristy of San Lorenzo. A brief receipt for fifty gold ducats from two other stonecutters, dated 23 April, again referred to the supply of marbles as specified, to be about 100 *carrate*, and especially to include 'a seated figure of Our Lady as drawn'.

At first Michelangelo had in mind that the new sacristy would very closely follow Brunelleschi's old sacristy, and that it would encompass a free-standing mausoleum in the centre of the chapel. The decision to have wall-tombs instead, made during 1521, pointed to a different architectural design and stimulated a transformation of Brunelleschi's ideas well beyond the early concepts of the cardinal and the pope.

In the early cinquecento a specialist architectural profession, the clearly distinguished architect as such, hardly yet existed. But Michelangelo's mastery of architectural forms had been exercised and developed since he had devised the painted framework of the Sistine Chapel, made the designs for the tomb of Pope Julius, and planned the façade of San Lorenzo. In Michelangelo's first wholly architectural work, of about 1515, a window of marble adorning an exterior wall of a chapel in Castel Sant'Angelo showed several significant departures from the conventions of Vitruvius, but was plainly the work of a designer versed in architectural norms and confident enough to modify them. Michelangelo's authority in the architectural branch of the arts of design was recognized; even so, the Medici had wished him to have Baccio d'Agnolo as his collaborator in the façade, before they were foiled; and in 1521 they were hesitant to give him much more than an agreement that he should arrange for the marble for the new sacristy.

When Michelangelo returned to Florence after he had been in Carrara ordering marble for what he called 'the cardinal's tombs', he

was, as he recalled events later on, asked by Cardinal Giulio de' Medici
to resolve how best to make the tombs quickly. He eagerly offered his
services either on contract for a salary or for nothing at all, but he was
rejected. When the cardinal, as Michelangelo claimed, took the matter
up again, Michelangelo offered to make wooden models to the size the
tombs would be, and showed that this would be speedy and cost little;
but again nothing happened. In September 1521, hearing that the
cardinal was leaving Florence on the pope's diplomatic business (to
repair a rift between the hired Imperial commanders ranged against
the French in Lombardy), Michelangelo hurried to see him 'because I
wanted to serve him'.

At this meeting, according to Michelangelo, Giulio de' Medici told him
to hurry up the marble and find men so that something was done,
without asking him further; and it was even said that, if the cardinal
lived, Michelangelo would also do the façade. Domenico Buoninsegni
was meant to arrange all the finances needed, the cardinal had said;
but when Michelangelo wrote an account of his conversation with the
cardinal (keeping a copy and having it witnessed) Buoninsegni went to
see him and denied all knowledge of any commission. After the cardi-
nal's return, Figiovanni sent for Michelangelo, who went along expect-
ing that the cardinal wanted to discuss the tombs, only to be told, 'We
want some good piece of work for these tombs, that's to say something
from your hand.' And he did not, Michelangelo later reported, 'say
that he wished me to do them. I left, and said I would return to speak
with him when the marble was there.'

As it had been envisaged by the Medici, the mausoleum in the new
sacristy would contain a chapel with an altar and the four wall-tombs.
The vastness of the project – sacristy, mausoleum, chapel, tombs –
guaranteed tremendous scope for Michelangelo. He had fretted during
the summer and autumn of 1521 over what his role in the great
enterprise would be. Other worries, as always, crowded in – about
unfinished work, about his family, about his health.

All of Michelangelo's work possessed sculptural qualities, from his verse
and drawings to his frescoes and architecture. But for a long period in
his thirties, when he was adorning the Sistine ceiling, his only directly
sculptural activity was the elaboration of a drawing for the statue Piero
Soderini wanted to place on the Piazza della Signoria, as a complement
to the figure of David. When Michelangelo returned to the art for
which he professed most passion, during the early years of Pope Leo, he
concentrated on statues for the tomb of Pope Julius, but he also found

time to carve the statue commissioned by Metello and Mario Vari and Bernardo Cencio, canon of St Peter's.

The Risen Christ for the church of Santa Maria sopra Minerva was to be a 'lifesize nude, standing, bearing a cross, in the attitude Michelangelo will think best', said the contract. When he did a pen study for this figure, over a chalk underdrawing, about the time the contract was signed in June 1514, he drew using the same cross-hatching technique, learned from Ghirlandaio, as for studies of soldiers a decade previously – a demonstration of strong consistency in his penmanship. But after the marble had been worked on it was found to be flawed with black veins, and was thrown aside.

In 1518 another block for the statue of Christ had been rough-shaped and sent by Michelangelo as part of a shipment from Carrara after he had been chivvied by Vari to fulfil the agreement. But only in March 1521 did Michelangelo finally move to complete the commission, when he sent Pietro Urbano to Rome to finish off the work and put the figure of Christ on its pedestal. What happened then was vividly recorded by Michelangelo's closest artist friend in Rome, Sebastiano Luciani.

In September 1521 Sebastiano wrote to tell him – though 'it's not my business to speak ill of anyone' – how badly he had been let down by Pietro:

> First, you sent him to Rome with the figure to finish it and put it in place . . . But I must let you know that all he has worked on is completely disfigured, and especially he has shortened the right foot, where it's manifest the toes have been mutilated; and he has cut short the fingers of the hands, especially that holding the cross, the right one, so that Frizzi says they look as if they have been made by a confectioner: they do not look made of marble, but as if they had been fashioned by pastry-cooks, they are so clumsy. I do not understand about this, not knowing how marble is worked, but I assure you that to me the fingers seem mutilated. I also tell you how it is manifest that he has so executed the beard that I think my little boy would have shown more discretion, since he seems to have used a knife without a point to chisel the hairs – though it will be easy to remedy this. He has mutilated one of the nostrils, and if he had spoilt any more of the nose, only God could have mended it.

Michelangelo had taken care of and been very fond of Pietro Urbano, who had invariably written to him as 'dear to me as a father'. Sebastiano

now told him in the same indignant letter that Pietro, who deluded himself about his talent, not only would utterly ruin the statue if it were left with him, but was generally behaving disgracefully. Giovanni da Reggio, the painter (who had earlier spread the story that Urbano had sculpted the statue of Christ all himself), had to no one's surprise reported that Pietro had fled the court and disappeared; moreover he was chasing after whores and wanted to have them all, and was mincing in velvet shoes around Rome, Sebastiano had heard, and would surely come to a bad end.

When Sebastiano wrote with his complaints, Michelangelo had already arranged to have the statue finished by Federigo Frizzi, with the consent of Metello Vari, and, it seemed, to his honest satisfaction. (At any rate, when Michelangelo offered to embark on another such figure, to fulfil the commission, Vari, who had in safe keeping for Michelangelo a colt Pietro had chosen for his master and tried to sell for himself, quickly insisted that what had now been done could hardly be bettered.)

Michelangelo had carved a completely naked Christ after the Resurrection, a thoroughly human-looking Jesus, neither athlete nor hero but with great sweetness and serenity of features. The statue, reminiscent of the naked figure of the good thief bearing the cross in Bellini's painting, and Mantegna's drawing of the descent of Christ into limbo, marks an edging forward in experimental sculpture, with its rhythmic twisting form meant to be seen in a niche from a single viewpoint.* It was put in place on 27 December 1521. Vari put the unfinished marble of the first version in his garden.

Urbano was dismissed by Michelangelo when he turned up in Florence; he then made his way to Naples, from where Michelangelo had news of him, probably for the last time, in a letter from Vittorio Ghiberti a few weeks later. Urbano, Ghiberti wrote, had been to see him and, from what he said, seemed disposed to do well. He had begun to carve a statue of St Sebastian in Ghiberti's house, and when he had made some money, Urbano had said, he would go to Spain.

Michelangelo's growing disillusionment with Urbano had been adding to his misery during 1521, when he suddenly had a furious row with his father caused by Lodovico's public airing of grievances against

* The statue of the Risen Christ is in the Dominican church of Santa Maria sopra Minerva, wearing a bronze loincloth, and standing 82 inches high. For the good thief holding a cross: Bellini's *Descent into Limbo*. Bristol Museums and Art Gallery, and Mantegna's *Descent into Limbo*, pen on vellum, Bibliothèque de l'Ecole Nationale Supérieure des Beaux-Arts, Paris.

him. Michelangelo writing from Florence to Lodovico in Settignano, after so many letters, so many absences, addressed him in his usual way, as 'dearest father', but went on:

I was amazed at your behaviour the other day, when I did not find you at home; and now hearing that you are complaining about me, and say that I have driven you out, I'm still more amazed; for I am certain that never, from the day I was born till now, was it ever in my mind to do anything either great or small that might be against you, and at all times, all the hardships which I have endured, I have endured for your sake.

Love and resentment of his long-dependent father and the brothers he had helped were intermingled with Michelangelo's pride not in the immediate family but in the abstract house – *la casa* – about whose ancient lineage his feelings had recently been strangely stirred.

Michelangelo's father was very conscious of his status in Florentine society, seeing himself as one of the respectable citizen class, living on investments but not averse to business, occasionally pursuing public office, owning a farm or two. Though he broke the mould of class as a painter and sculptor, Michelangelo himself was 'drawn' as one of the governing priors of Florence; however he was disbarred from taking office, since his brother Buonarroto had been drawn previously for membership of one of the three main offices, the Committee of Sixteen.

Manifestly the Buonarroti were not among the old noble citizen families of Florence, the *uomini da bene* or the *grandi*, such as the Medici and the Strozzi, who had clambered to high fortune outside the feudal network. But, like many families before and since, they had inherited the belief that their family was blue-blooded. It derived, they imagined, from one of the old families of counts, marquises and dukes of the *contado* (the countryside of the city-state) and the outlying and neighbouring territories. Of this, Michelangelo was convinced.

His belief had been confirmed by a letter he had received in October 1520, from Count Alessandro da Canossa. Michelangelo had written to the count to introduce his friend the painter Giovanni da Reggio. Alessandro addressed him in return as a kinsman, *Parente honorando*. He and his brother Alberto urged Michelangelo to regard what was theirs as his. It might comfort Michelangelo, the count wrote, sometime or other to come to know '*la vostra casa*'. The letter ended with the postscript 'Seeking in our ancient records I have found a messer Simone da Canossa to have been *podestà* of Florence.'

The letter had been addressed to 'my much loved and honoured kinsman messer Michelangelo de Canossa worthy sculptor, in Rome'. It seems to have caused Michelangelo to have built several kinds of castle in the air. When Giovanni da Reggio was writing to him later in October, saying that the pope and all Michelangelo's friends wanted him to return to Rome, he mentioned, 'the business of the castle that we spoke about', adding that he had written about the revenue it earned to his companion Bernardino Zacchetti, another painter familiar to Michelangelo, who was to make enquiries.

Neither castles nor counts comforted Michelangelo during 1521.

One agreeable event that year was the invitation in October to stand as godfather to the newly born son of Niccolò Soderini, the nephew of the former gonfalonier of Florence, Piero Soderini, whose brother Cardinal Francesco Soderini was under constant and justified suspicion of plotting the overthrow of the Medici in Florence.

In the middle of December 1521, in Rome, Frizzi was asking to finish Michelangelo's statue of Christ in the house in Macello de' Corvi which was being looked after by Lionardo Sellaio. The Florentine sculptor Baccio Bandinelli, now in his thirties and aspiring to rival Michelangelo, was working on a copy of the *Laocoön* in the Belvedere, to be sent to King Francis, and had just produced a huge model resembling the Arch of Septimius Severus with 142 figures, all to be cast in bronze.

After mentioning such items of news in his letter to Michelangelo of 14 December 1521, Lionardo added mysteriously that he had nothing more to say 'save to remind you not to go about at night and to abandon practices harmful to mind and body – so that they may not harm the soul'. Michelangelo's reply reassured him, for when he wrote a few weeks later he said cheerfully, 'Of all the news you give me, one piece surpasses the rest, and this is your being cured of a malady [*malatia*] from which few recover; and yet I am not surprised, because few are like you. This is pleasing news. Persevere.'

Consolation of a kind for Urbano's betrayal of Michelangelo's trust and the disagreements with his father appeared about this time in the shape of Gherardo Perini, a young man from a banking family, whom he picked out for attention among a group of shared friends in Florence. Disaster soon struck from another quarter, however: the death of Pope Leo.

32 Leo's politics • Luther •
Condottieri of the pen

Leo was forty-six. His sudden death on 1 December 1521 started rumours that he had been poisoned; but his rapid decline seems to have been caused by a chill that easily devastated his corpulent catarrh-ridden frame. He had taken to his bed with fitful shivering after returning in triumph to Rome from his hunting villa at Magliana, on the lower Tiber. Here he had exultantly heard the news that Milan, held and ruled harshly by the French since 1515, had fallen to the papal Imperial army. (It was given a puppet government headed by the young Francesco Maria Sforza.)

The alliances that had created this force went back to May 1521, when, after vacillating between France and the Empire, Leo had made a pact uniting 'Christendom's two real heads' in order to purify it from error, establish universal peace, fight the infidel and introduce a 'better state of things throughout'.

The pope was after the territories of Parma, Piacenza and Ferrara, and the Medici's guaranteed domination of Tuscany. Just before he died, he heard that, following the taking of Piacenza, Parma was his. In Florence, left under Cardinal Giulio's hand since the death of Lorenzo in 1519, Medici rule was still insecure.

The other 'real' head of Christendom was the Habsburg Charles V, ruler of Burgundy, the Netherlands and Spain, elected emperor in succession to Maximilian in 1519. He was after the humiliation of France and control of the wealthy and strategically vital cities of Milan and Genoa.

Leo's serpentine political policies had been devised primarily to strengthen the power of the papacy and the hold of the Medici family on Florence. In both aims he achieved temporary success, striking decisively in 1520, for example, against the little despots of the marches of Ancona and Umbria. But the small triumphs obscured his inability to strengthen the Italian states singly or in combination against foreign threat and intrusion.

The surge of religious rebellion in Germany against papal teaching and authority had also been pushing the pope into dependence on the new emperor. Leo had not been blind to the need for reform. In 1513 he was seen as a beacon of hope by many of the Catholic faithful who

were calling for better supervision of bishops, better training of priests, regular convening of general Councils and synods, revision of canon law, the translation of the Bible into the vernacular, the simplification of the liturgy and the eradication of superstition.

In 1517 the fifth Lateran Council, summoned defensively by Julius II and continued under Leo, at times a cockpit of clerical rivalries, approved two bulls setting forth Leo's ecclesiastical settlement with France. Of these, *Pastor aeternus*, recording the surrender of the French king's right to make key clerical appointments, also reaffirmed the divinely established authority of the papacy, the sovereign see of the Roman Church. Also, in 1517, Luther presented his ninety-seven theses on man's justification, followed by his ninety-five theses on the power of indulgences, and these soon appeared in printed editions. The authority of the papacy was then challenged, and its power in Germany sapped at startling speed.

The new pope and the new emperor were, however, united in their zeal for orthodoxy. The papal bull *Exsurge Domine* in June 1520 commanded Luther to recant. In April 1521, on the initiative of Charles, he was condemned by edict of a portion of the Reichstag. In May, in the Edict of Worms, the emperor placed Luther under 'ban and double ban', enjoining that he should be denied shelter, food and support, seized and overpowered when possible, and sent to him under tightest security. Luther's rival reformer, Erasmus, who had once looked to Leo to restore Christian piety, true learning and the lasting concord of Christendom, expressed his belief that 'the Luther tragedy' was at an end: 'would it had never appeared on the stage'. In September, the pope received in Rome a magnificently bound copy of the polemic against Luther by the English king, Henry VIII, on whom Leo in October conferred the title 'Defender of the Faith'.

It was too late, if it had ever been possible, to counter in Germany the soaring popularity of Luther's message: that the organization of the Catholic Church was flawed and corrupt, and that its teaching on human salvation was theologically wrong. These two critical thrusts – though not original – quickly convinced many thousands of receptive listeners that their souls could be saved from damnation at the Last Judgement without the intervention of the Roman Church and its sacraments as channels of grace, and that they need no longer bear with the gross imperfections of the Roman Church for the sake of its ministry.

As Leo was approaching death, the noble Basque soldier Ignatius Loyola, convalescing at home after being wounded in battle, was

reading in translation stories of the saints and the life of Christ by a German Carthusian, Ludolph of Saxony. These were leading him to his profound spiritual experience of a dark night of the soul and sudden illumination by grace.

As patron of the arts, Pope Leo had wisely appointed Raphael and Giuliano (followed by Antonio) da Sangallo to supervise the building of St Peter's, demonstrating an interest that partly sprang from his concern for proper ceremonial and liturgical practices. He also enabled the Florentine *nazione*, the community in Rome, to commission the building of its own church of San Giovanni to replace an oratory on a plot of land between Via Giulia and the Tiber. And, above all, he proved himself as a caring and illustrious patron of music. In the great Sistine Chapel, Leo employed thirty-one well-paid singers – more than ever recorded previously – and for his personal service at banquets or on hunts he kept a group of up to sixteen singers and instrumentalists.

Pope Leo's motives in encouraging musical performances ranged from his regard for beautiful ceremonial to his urge to glorify the Medici family, as well as God, through public display. This transferred to a great court the tradition of the Medici house, which had long sponsored music at the cathedral in Florence, and encouraged spectacles with music on popular civic or dynastic occasions.

Florentine painters and decorators remembered Leo gratefully for commissions for public displays at the time of his coronation and on his visit to the city in 1515, and for employment in private embellishments – as when he arranged through his brother Cardinal Giulio for the adornment with stucco and paintings of the Medici palace and villa at Poggio a Caiano, on which Franciabigio and Pontormo set to work with Andrea del Sarto.

The tolerance and aestheticism of the Medici pope, the conjunction of Roman and Tuscan traditions, and new ideas from outside Italy had also created a hothouse for all kinds of writing in Latin and Tuscan. Often the same writers, frequently in holy orders, penned ribald or reverent, obscene or devotional writings, depending on demand and circumstances. This was the reverse side of the coin of decorum. During the period of the foreign invasions of Italy, the new writing marked a shift towards the experimental. As well as exercises in Petrarchan pastoral verse, there were scurrilous political lampoons and fantastic priapic *capitoli*, burlesque poems using Dante's favoured *terza rima* verse form. Pietro Aretino's first poetic efforts, which he combined

with painting, recalled the lyrical verse of earlier Petrarchan poets. But when Pope Leo died Aretino wrote satirical verses, streaming with poison, to support the candidature of his patron, Cardinal Giulio de' Medici, for the papacy.

33 Pope Adrian and the pasquinades •
The prudent Perini

When the Sacred College of Cardinals entered into conclave on 27 December, among the thirty-nine mostly Italian cardinals taking part eighteen considered themselves candidates.

Pope Leo had scarcely left in the papal treasury enough money for an appropriate funeral. The informed observer Baldassare Castiglione commented that 'the Holy Spirit is expected to descend from heaven, but, to my mind, seems just to have left Rome'. As tension mounted in the early days of January, the cardinals immured in the Sistine were put on short rations of one course a day, and then threatened with a diet of bread and water. In Florence, opponents of the Medici had long been dreaming of French support for some kind of coup. Immediately on the news of Leo's death, which took about fourteen hours to arrive by special courier, prominent suspects were put in detention.

Because of the emperor's preferences, but also because he had a reputation for learning and goodness, on 9 January 1522 the cardinal of Tortosa, Adrian Florensz Dedal, from Utrecht, was (in his absence) elected supreme pontiff, taking the title of Adrian VI.

Adrian had been appointed a tutor by the emperor Maximilian to the young Charles V and had worked as a university teacher versed in canon law; he had acted as regent in Spain alongside the redoubtable Cardinal Ximenes. He had been inquisitor for Aragón and Navarre, and then for Castile and León, entrusted for his zeal and prudence with the task of ferreting out heretics. Abstemious and stocky, honest, devout and, by comparison with recent popes, to contemporary eyes very dull, Adrian acted as if time were on his side. As he journeyed to Rome he rehearsed his programme, which would include checking and chastizing Luther, stopping abuses in the Curia's administration, and organizing common European resistance to the incursions of the Turks.

* * *

Pietro Aretino used the interregnum to make his mark as a dangerous polemical writer and publicist. He seized on the traditional device for public literary proclamation – affixing verses to the antique statue called *Pasquino*, in the Piazza Navona, and the statue called *Marforio*, recently excavated in the Campus Martius – and transformed it into a vehicle for crudely satirical propaganda and abuse. He pitched his style and content to make his own name rather than to help his frustrated patron, Cardinal Giulio, though the Medici cardinal was the only one he did not attack.

One of Aretino's pasquinades observed that it was not surprising it was taking a long time to choose a pope, for none among the cardinals was worthy of Peter's mantle. One was a womanizer and one chased boys; one gourmand liked titbits, the other was a glutton for 'peaches'; one spied for Spain, and another for France ... Not surprisingly, Aretino fled Rome after the election of Pope Adrian, first seeking refuge in Florence, in the household of Cardinal Giulio, who while trying to keep the city tranquil and secure was soon working hard to ensure that the College of Cardinals would be more pro-Medici by the time of the next papal election.

Francesco Berni greeted Adrian's election with a *capitolo* protesting that he never spoke ill of anyone but he had to deplore the gloomy advent of the Flemish pope. There was a general dispersal of artists on the election of Adrian, less from fear of his strictness than in the expectation of stinginess.

By the time Adrian arrived in Rome, late in August 1522, the city had been stricken by plague. Castiglione, who remained for a while as ambassador of the duke of Mantua, had described vividly in letters to the duke's mother, Isabella Gonzaga, the brooding atmosphere and events in Rome while Adrian was still in Spain. Turkish marauders had sailed up the Tiber, plundered Corneto, and seized several men and women; the plague made terrible inroads, though sparing the nobility, and perhaps forty thousand people had left Rome. Children, bare to the waist, walked in procession, beating their breasts and praying to God for mercy.

Adrian's economic policies were aimed at reducing debt and cutting spending, sequestrating the houses of dead court officials, and, as at least he intended, ending the sale of offices: all calculated to depress the Italian financiers, who were replaced in the Vatican by Germans and began to leave even before the artists. Work on the Florentines' church

was halted. Decoration of the largest of the state rooms in the Vatican, the Sala di Constantino, carried on by Raphael's *garzoni*, was suspended. The cultural chill was intensified by Adrian's suspicion of pagan 'idols', such as the *Laocoön* in the Belvedere, which he closed to visitors, and the report that he wanted to live in a small house with a modest garden rather than the Vatican Palace. Cardinal Sadoleto, secretary to Leo X, was one of the scholars who glumly left Rome; his letters, Adrian remarked disapprovingly, were 'those of a poet'. The pope did have his portrait done by Sebastiano, and he had it in mind to continue the work on St Peter's, though this was foiled by political problems. But building continued on several projects, including the Palazzetto Farnese for the French prelate Thomas le Roy.

Adrian's bookish mind was drawn to the grand abstractions of peace, reform and crusade – issues for whose resolution, however, he lacked both the necessary will-power and the means. One of his significant religious, but also in effect, if not in intention, political, acts was the canonization of the austere and formidable Florentine Archbishop Antonino. On familiar terms with Cosimo de' Medici, Antonino had been none the less in some fashion a spiritual ancestor of Savonarola, harsh in his behaviour and his beliefs, which included the tolerance of slavery if the slave were pagan when captured. The process for declaring Antonino a saint in heaven was welcomed by the Medici supporters in Florence even though it served the purpose of and helped to benefit their enemies, the friars of San Marco.

In Florence, the plague in 1522 put another temporary stop to much of the work which artists had been able to find after the death of Pope Leo. Pontormo, for example, retired three miles from Florence to the Certosa del Galluzzo, where he began some frescoes, strangely pale and simplified, and influenced by his study of Dürer, reflecting his own emotional intensity and general unease and urge for change.

Michelangelo's mood during the early months of 1522 was depressed and restless. The death of Pope Leo had removed one of the very few patrons whose Medicean time-scale and resources might match his own vision. Moreover, it removed his protection against the demands of the della Rovere heirs of Pope Julius for fulfilment of the 1516 contract for the tomb, due to be completed on 6 May 1522. He wrote at the beginning of the year to Giovan Francesco Fattucci, a chaplain at Santa Maria del Fiore who when in Rome acted for him over the tomb; his letter concluded, 'At twenty-three hours and each one seems a year.' It was signed 'Your most faithful sculptor in Via Mozza near the

corner', and here he drew a little millstone, which could have signified both the distress he was under and the name of the spot.

He found some solace, about now, from his new friendship with Gherardo Perini; when Michelangelo wrote to him, he signed with a large M enclosed with strokes for two angels' wings and his own emblem of three intersecting circles, perhaps representing three crowns or garlands for the three arts, and reminiscent of Lorenzo the Magnificent's three rings. Perini returned the good wishes of all their friends, especially Fattucci and the goldsmith and sculptor Giovanni di Baldassare, known as Piloto, whose company Michelangelo enjoyed on social jaunts. (Piloto was also a friend of Benvenuto Cellini, born in Florence in 1500, now aged twenty-two and back in Florence after his first two-year stay in Rome working at his craft and studying Michelangelo's paintings in the Sistine and Raphael's in Agostino Chigi's house.)

Michelangelo's friendship with Gherardo Perini continued at least during 1522, till about the time Antonio Mini entered his service, and left as evidence of its emotional significance the spontaneous gift of three sheets of black chalk drawings, marking a new departure in Michelangelo's use of this medium. The first sheet has at the bottom in Michelangelo's own writing 'Gherardo I have not been able to come today', and the second has Perini's name written at the top with Michelangelo's personal emblem in the lower-right corner. Among the drawings, all done in very soft chalk, the wary-looking, helmeted woman looks back in time to a drawing of Mantegna's day and hints at an interest in antique mythology. The heads range from summary sketches to finely finished, intensely characterized studies.*

On another, quite different, drawing – of a putto urinating into a cup – Michelangelo wrote, under a line from Petrarch, 'Please do not make me draw this evening because Perini is not here.'

Michelangelo's many friendships and relationships at this time existed in very different, sometimes overlapping, worlds. Perini went along with Piloto and Fattucci; Michelangelo's jealous moral guardian Lionardo Sellaio writing from Rome would always want to be remembered to Carlo (Michelangelo's eager and faithful new servant), but not to Perini. Writing from Venice to Michelangelo (in April 1522), Giovanni da Udine told him how welcome he would be if he came for a few days

* Described as the *Three Heads*, the *Fury* and *Venus, Mars and Cupid* (the last also called the *Zenobia*), the drawings are in the Uffizi collection.

to Venice, sent Michelangelo news about troop movements, and asked to be remembered to the Cardinal de' Medici and to Piloto.

Relations on his mother's side coupled Fattucci with Michelangelo when they pressed him to stay by .them in the countryside near Dicomano in the valley of the Mugello. *'Caro e delito chonsang[u]ineo,'* Neri del Sera wrote to him in August 1523, 'come accompanied and mounted and accept gratis bed and board, wine and fodder.' 'Bring either Giovan Francesco or someone to your liking,' Donato del Sera had urged the month before, reporting the availability of a dwelling with bedroom, living-space, stable and cellar, with a barrel of good wine. Another relation, Matteo Buonarroti, writing from Rome to Michelangelo as 'my dearest brother' in July 1520, was possibly the son of Lucrezia, Lodovico's second wife.

Michelangelo's loyal friend and helper Bartolommeo Angiolini, a writer of madrigals and sonnets, mentioned Sebastiano, Giovanni da Reggio and Giovanni da Udine when he wrote in September 1521. Federigo Frizzi, writing to Michelangelo in 1522 for advice on where to find the best marble of Pietrasanta, sent greetings to the sculptor Baccio.

In July 1522 Gherardo Perini plaintively wrote to Michelangelo saying that nothing in the world would give him more pleasure than for Michelangelo to visit him, and begging him not to forget him. He signed the letter 'as a son to you'. His second surviving letter to Michelangelo, dated 19 July 1522, said that he had no other wish than a letter from Michelangelo, which would make him feel as if he were with him. He was joyless where he was, without any news. 'And I have turned to you as I have more faith in you than in all others.'

Some lines of verse written by Michelangelo on the back of the letter from Giovanni da Udine, using the imagery of surrounding sea, mountain and flaming sword, refer to someone who has robbed him of his intellect and taken away his reason and will not let him return to the mountain. Was this a literary exercise? Was there someone who had had on him the effect he anguishedly described? Perini was the cause of Michelangelo's first documented 'presentation' drawings. Whatever happened between them, he may also have inspired this verse. About the time Perini faded from his life, Michelangelo formed another warm but different, and professional, kind of relationship with the sixteen-year-old Antonio Mini – engaged as an assistant, anxious to be a pupil, and soon growing into an indispensable helpmate and companion.

34 'if I work one day, I need to rest for four'

Few letters by Michelangelo survive from the months of Adrian's pontificate, and probably he wrote relatively few. His *ricordi* show only a payment to the director of Santa Maria Nuova made through Gismondo and Buonarroto for a little house that had been taken on by Michelangelo in 1514. Most of the time he stayed in Florence. He turned down an opportunity to visit Bologna and arbitrate over the choice of design for the front of the church of San Petronio, where he had worked himself so many years ago.

With his father, nearing his eighties in Settignano, Michelangelo continued to find cause for grievance. In June 1523 he wrote about the invested dowry of Lodovico's second wife, who had been dead for over a quarter of a century, expostulating that he would be glad to be extricated from this 'great labyrinth'. In the same month Michelangelo's (last extant) follow-up letter to the old man, beginning not now 'Most reverend father' but simply 'Lodovico', announced:

I am not replying to your letter, except to the matters I think necessary; I treat the rest with scorn. You say that you cannot draw your payments from the Monte [where the dowry's capital was invested] because I have had the capital put in my name. This is not true, and I must respond to you on this, so that you may know that you have been deceived by someone you trusted, who perhaps has drawn it and made use of it himself, and gives you to understand this for his own advantage. I have not registered it in my name, nor could I, even if I wished: but it is indeed true that . . . the notary . . . took me to the Monte and had me lay out fifteen grossoni and caused a clause to be added that no one could dispose of it [the capital] while you lived: and you are the beneficiary while you live, as the contract states, and as you know . . .

If I annoy you by living, you have found the way to remedy this, and you will inherit the key to the treasure which you say I have; and you will do well: for all Florence knows that you were a rich man and that I have always robbed you, and have deserved punishment: you will be much praised! Shout and say about me what you wish, but do not write to me any more, because you do not let me work as I still must to make good what you have had

from me for the last twenty-five years. I did not wish to say this to you; yet I cannot but say it. Take care of yourself and beware of those whom you must beware; for a man dies only once, and does not return to redo what has been done wrongly. You have delayed till death even in something like this! May God help you. Michelangelo.

Just a few weeks later, in July 1523, Michelangelo's feelings of passive endurance surfaced in a brief letter responding to a renewed request that he should paint something for the wealthy Venetian cardinal Domenico Grimani. He himself had suggested a small picture; the reminder came from Rome, both from his friend Bartolommeo Angiolini and in a letter from the cardinal himself, delighted by Michelangelo's having promised to gratify him, though he knew he had little time for the work in view of his 'other obligations'. Michelangelo told Angiolini he wanted to serve the cardinal, who had surprised him by writing about such a little matter and in such haste, and would endeavour the best he could and when he could. If this was a put-down, it was most courteous, but it ended dejectedly: 'I have a great obligation, and I am old and ill disposed, so if I work one day, I need to rest for four. Therefore I do not trust myself to make definite promises. I shall endeavour my very best every way to serve, and to show you I recognize the love you bear me.'

The cardinal, who had fallen dangerously ill during the recent conclave, died in August. He might not have received the painting he wanted so desperately even had he lived.

Michelangelo's sense of age and fatigue in the summer of 1523, when he was forty-eight, may have sprung partly from feeling directionless and missing the strong stimulus of a powerful, demanding patron, and partly from sheer physical tiredness, compounded by anxiety caused by the demands of the heirs of Pope Julius II, who were now bearing down on him oppressively.

Francesco Maria della Rovere had re-established power over the whole duchy of Urbino soon after Pope Leo's death. Pope Adrian received him favourably in Rome and granted him the investiture of his duchy in the spring of 1523. About the same time, Julius's heirs prepared a *motu proprio* for the pope, ordering Michelangelo to fulfil his obligations over the tomb. Negotiations then started between the Florentine Lorenzo Pucci, now Cardinal Santiquattro, acting for the duke, and Jacopo Bartolommeo della Rovere, brother of Cardinal Aginensis, on

one side, and Giovan Francesco Fattucci, for Michelangelo, on the other.

What tormented Michelangelo especially were the differences and disputes over his financial obligations to Julius's heirs; long since, the irresistible grandeur of the project of the tomb had been overtaken by the concept of the San Lorenzo façade and the new Medicean project for the sacristy and library. A few months after the 1516 contract for the tomb had expired in May 1522, Michelangelo had received a comforting message from Jacopo Salviati in Rome assuring him that his friends would leave nothing undone to serve his interests.

Salviati's supportive letter, of 18 November 1522, ended with the remark that Michelangelo should keep well and keep working. When and on what he worked during the years immediately following the cancellation of the commission for the façade of San Lorenzo is obscure. But his labour included at least the beginnings of several huge statues meant for Julius's tomb and blocked out in Florence for transport to Macello de' Corvi in Rome to await further work and completion.

After the recommissioning of the pope's memorial as a wall-tomb in 1513, Michelangelo had seen to the architecture of the front of the lower storey and had nearly finished the two 'captives'. His awakening fascination with classical architecture was then absorbed by the project for the façade of San Lorenzo. For this, his final design of May 1517, with its novel side elevations of the width of one bay, was a copy on a huge scale of the previous year's project for the tomb; this had marked a decisive transition in Michelangelo's obsession with his obligation to Julius II, which then lost its hold on his imagination and his allegiance, but not his conscience.

Four massive blocks roughly hewn in Florence Michelangelo came to abandon, mute monuments to his powerful sculptural techniques and protracted struggle verging on panic to complete the tomb. A drawing from life in red chalk done before 1520, with hanging arm and reclined head, anticipates figures in deep blocks on a notably larger scale than the earlier statues of youthful struggling figures. Still emerging from the marble were four more so-called *prigioni* or captives: a limp, youngish Titan, one arm over his drooping head; a giant-like Atlas, with arms raised to a massive overhang of stone; a bearded man, again with arm over head and a strap loosening over his knees; a seemingly awakening figure looking to one side, with tilted head, right leg crossing the left, and hugely extended in clear frontal position. As times of the day, they

could have been meant respectively for Dawn and Day, Dusk and Night.*

The giants show, frozen at an early moment, the product of Michelangelo's stonecutting technique with trimming hammer, occasionally a heavy punch, and also the claw-chisels, all used to push ever on, never out of control, around and into the depths of the marble. The forms of these strong nude male load-bearers emerged frontally or laterally as he had imagined them from all their aspects. He would uncover first the highest reliefs over the entire surface, and then work gradually into the deeper planes. The *prigioni*, like Michelangelo's St Matthew, seem to fight hopelessly to free themselves from the rock within which the artist's mind conceived them.

Michelangelo was continually diverted from his intermittent work on these eloquent figures. In June 1523 Baldassare Castiglione brought from Rome to Mantua a model from Michelangelo's design of a beautiful villa. The same year, the Genoese started negotiations and allocated money for a colossal statue of their great admiral and political leader Andrea Doria, which they wanted to be by Michelangelo.

Pope Adrian died in September 1523; as he was prepared for burial the Romans garlanded the house of his physician, who was hailed as a deliverer of the country – the nine Muses, the wits said, were all rejoicing.

This pope, born before his time, had failed in his honest hopes of uniting Christian powers against the Turks, cleansing the bureaucracy in Rome, and arresting the tide of Lutheranism. He had vainly tried to remain neutral in the contentions between Francis I and Charles V. He had, by his inept policies, added fuel to the blazing rivalry between the king and the emperor, young men in their twenties, both thirsty for prestige and power, both staggeringly creative, energetic and competitive, both generous patrons of the arts.

Set to restore French dominion in Milan, in the autumn of 1523 Francis sent an army into Lombardy under Bonnivet, the high admiral. The French besieged Milan, defended by Imperial forces under Prospero Colonna, who had seized it from the French in April 1523. On the eve of the election of the new pope in mid-November, Bonnivet's troops retired to winter quarters. The two young monarchs and the emperor's

*The drawing is in the École des Beaux-Arts, Paris. The four giant statues, between 8 feet 6¾ inches and 9 feet 1½ inches high, are in the Accademia in Florence.

kinsman, Henry VIII of England, whose invading army had been devastating large tracts of France, waited in angry frustration to wage war among themselves.

The innocent Pope Adrian had also exacerbated the rift in the Christian Church. At the meeting of the Reichstag in Nuremberg in 1522–3 his legate Francesco Chieregati had insisted that the Edict of Worms be enforced against Luther, demanding the suppression of Luther's utterances against official doctrine though promising reform of disciplinary lapses in the Church. The estates of the Reichstag claimed that to suppress Luther would provoke popular rebellion and look like defending the faults of the Church. Adrian's professed readiness to reform the Church foundered on Luther's intransigency, the cardinals' resistance, his allies' indifference and the inadequacy of the Church itself.

35 Michelangelo, Raphael, Leonardo: Giovio's judgement

In January 1519 Gabriello Paccagli wrote from Paris to Michelangelo 'in Rome or wherever you may be' to report that he had overheard talk about him between Cardinal Santa Maria in Portico (Bernardo Dovizi da Bibbiena) and King Francis:

> the king spoke of you so graciously and lovingly that it seemed incredible to me, and he showed he was wholly certain of your talents, coming to say, that in this regard he has no greater desire than to have some, no matter how small, work of yours . . . I have to tell you this, that the pope sent, by the hand of Raphael, a panel painting of Our Lady with five other figures, and another large panel of St Michael, and subsequently he sent a picture of the wife of the viceroy of Naples.

Castiglione completed *The Book of the Courtier* in 1516–18, after he had come to know Michelangelo in Rome. In it he included discussion on the rival merits of sculpture and painting in which, though putting painting first, Count Lodovico Canossa, the cultured Veronese nobleman and diplomat, made bishop of Bayeux in 1516, praised Michelangelo's excellence as a sculptor. Pietro Bembo, in his *Prose della*

volgar lingua, which he began writing at the court of Urbino, discoursing on language and the nature of beauty, cited Michelangelo and Raphael as artists whose different styles would have been approved by Antiquity.

Paolo Giovio, a writer who had started life as a doctor and became a bishop, included Michelangelo in the collection of brief lives of eminent people that he was writing. This was Michelangelo in his mid to late forties:

> Both in painting and in sculpture in marble the Tuscan Michelangelo Buonarroti has approached – in his established fame and by common consent – so closely to the position of the ancient artists that able men in both these arts frankly award the palm to him. He was summoned by Julius II to the Sistine Chapel in the Vatican and offered a huge sum of money and there completed in a short time an immense work, a testimony to his mastery of his art. Of necessity he had to paint lying on his back, but he was able to paint certain figures so that they appear far away and almost hidden by the play of light in recession, such as the body of Holofernes in the tent; while others, such as the crucified Haman, are brought forward by the effects of light and shade in such relief that even the most skilled artists are astonished to find themselves perceiving as solid bodies what are no more than painted forms.
>
> Among the most important figures is one of an old man, in the middle of the ceiling, who is represented in the act of flying through the air delineated with such symmetry that if one looks from different parts of the chapel the eye is deceived into believing the figure has moved and changed its gesture.
>
> He attained also to great fame in the different field of sculpture when he carved a marble figure of Cupid which he buried in the ground for a time and then dug up, so that the small damages and discolorations caused by this treatment allowed him to pass it off as an antique, and he sold it for a high price through an intermediary to Cardinal Riario. Even more felicitous was the way in which he drew from a block of abandoned marble the figure of the Giant [that is, the David] menacing with his sling, which may be seen at the entrance to the Palazzo della Signoria in Florence. He was commissioned to make a tomb for Pope Julius II, and, having received many thousand gold pieces, he made for it various very large statues which were so much admired that it was said that no

one since the Ancients had carved marble with more skill or speed than he, or painted with more harmony and skill.

But in contradiction to so great a genius his nature was so rough and uncouth that his domestic habits were incredibly squalid, and deprived posterity of any pupils who might have succeeded him. Even though he was besought by princes he would never undertake to teach anyone or even allow them to stand watching him at work.

Giovio's biographies of Raphael and of Leonardo da Vinci – 'friendly, brilliant, generous and extraordinarily handsome' – were short and restrained. He felt warmest towards his friend and exact contemporary Raphael, who – 'in third place as painter' – with his marvellous sweetness and assimilative talent and the 'particular beauty that we call grace' succeeded in what alone was lacking to Michelangelo, the ability 'to join to expertly designed pictures the luminous and resistant embellishments of oil colours'. Writing of Raphael, Giovio also singled out his disciples Giovanni Francesco Penni and Giulio Romano, as well as Sebastiano, and from Venice, Titian, Lorenzo Costa and Sodoma ('acting so madly, painting so calmly') and Giovanni Dosso.

Ariosto in Canto xxxiii of *Orlando Furioso* (published in 1516) thought worthy of mention among living or recently dead artists Leonardo and Mantegna, Battista and Dosso Dossi, Giovanni Bellini, Sebastiano, Titian (outshining Raphael), and the one who equally in sculpture and colouring seemed more than mortal, rather a divine angel: '*Michel, più che mortale, Angelo divino.*' After the deaths of Raphael and Leonardo, Michelangelo was unassailable as the best of living artists. As such, he would inevitably be at the command of the Medici.

36 Clement VII's demands · Michelangelo's apologia

Cardinal Giulio de' Medici was elected pope at the age of forty-four on 19 November 1523. His first cousin, Giovanni, Pope Leo X, had promoted him and relied on him. Pope Adrian had providentially called him to Rome to be his chief adviser. He was therefore securely positioned for the Conclave when it met on 1 October, and, though at the outset opposed bitterly by a score of Italian cardinals, he was

supported by the influence of the emperor and, in the event, by the acquiescence of the king of France.

Giulio was by then well versed in the exercise of power and patronage. He was in his mid-forties, intellectually curious and seemingly in the best of health, tall for a Florentine, of good physique and, as lord of Florence, 'very rich', according to the Venetian envoy Marco Foscari, who also noted his large eyes and slight squint.

Among his political allies, no doubt genuinely even on the part of those who would flatter him anyway, the new pope, Clement VII, aroused great hopes. The duke of Sessa, the Spanish ambassador, wrote to the emperor that Pope Clement would be entirely Charles's creature. Castiglione, sent by the marquis of Mantua to offer congratulations, reported after his first audience with Pope Clement that Rome was very joyful, and, despite hunger among the people, that everyone was coming back. 'The pope has not failed to make excellent appointments, and he will have a suitable household.' He followed his usual ways, gave audiences continually, was most benevolent, and kept his previous kind and genial feelings under his new robes. 'What his policy will be, no one yet knows.'

Bembo felt sure that the Muses would return to Rome under the wing of a Medici pope. Reassuringly for scholars, Clement graciously appointed the erudite Latinist Jacopo Sadoleto as his secretary. Machiavelli, who had been commissioned in 1520 to write a history of Florence by Giulio de' Medici and had responded to his request in 1519 for advice on how best to govern Florence with his ambivalent discourse on republican power, could feel far more secure in finishing the book. His history seemed now more than ever a way forward to princely favour, and even fortune, as he set down in the eighth chapter his account of the triumphs and legacy of Pope Clement's ancestor Lorenzo the Magnificent, who had been among so many other things 'a generous patron to learned men'. Francesco Guicciardini was more grandly favoured by the new pope than Machiavelli could ever hope to be; he was soon recalled from governing Modena and Reggio and sent to be president of the Romagna, with no increase in salary 'but with very large extra payments'.

On behalf of a friend who was related to the Medici, another younger Florentine and acquaintance of Machiavelli, Donato Giannotti, one of the *grandi*, penned a congratulatory epistle to Pope Clement before the end of 1523:

To Pope Clement VII on behalf of a friend.

If anyone were to ask me, Holy Father, how overjoyed I am that you in particular of so many outstanding men have been raised to this supreme pinnacle of human distinction, I could not express it at all easily in words. For although no people has failed to greet your pontificate with the most joyful acclaim, still the reason for each people's joy is different. For all others indeed rejoice for this reason especially, that they see they have as pontiff a man than whom nobody is considered more suited to restoring a Christian state . . . And although I realize that you brought honour to the house of Medici during another's pontificate, it is now scarcely credible how much I judge that all our family owes to your goodness. For you have brought to it much renown and standing, that it is vaunted with highest praise all over the world and is held worthy to enjoy for ever the first rank of human distinction . . . The voice of all mankind is one: you are the only man whose virtue can bring help to a world now weary with so many disasters.

Consequently it is no wonder that all are bathed in utmost joy at your pontificate; and in order to avow this to Your Holiness by the presence, they are hurrying to Rome to embrace, caress, kiss your blessed feet. I indeed, for my part, as soon as the great news reached me, decided to hasten at once to adore the presence of Your Holiness. But soon, realizing that nothing could please you if it were not distinguished and perfected by the highest virtue, seeing that it had been by relying on your own virtue that you had attained so great a pinnacle of human authority, I changed my mind and thought to act far more acceptably to Your Holiness if I paid attention to studying the sacred laws without interruption . . . In the meantime, supreme pontiff, live and fare well.

In Florence, Pope Clement's election was celebrated with a procession and an amnesty for prisoners. The atmosphere was tense. The embassy sent to congratulate the pope was told that he would send to Florence the two Medici boys just into their teens, Ippolito (the bastard son of Giuliano, who had died in 1516) and Alessandro (the illegitimate son of Lorenzo, who had died in 1519), of whom it was alleged·that his true father was Pope Clement and his mother a mulatto.

In May 1524 Silvio Passerini, cardinal of Cortona, one of Clement's close collaborators, travelled to Florence, where he was to assert papal

authority, act as special legate in Tuscany, and tutor Ippolito and Alessandro when they arrived, training the former for office and leadership of the family's divided supporters.

On his way north, at Arezzo, Cardinal Passerini had been asked by a local potter, Antonio Vasari, to hear his precocious son Giorgio recite some of Virgil's *Aeneid*. Impressed, the cardinal successfully urged Antonio to send the clever boy to Florence, where soon afterwards Giorgio was studying alongside Ippolito and Alessandro, and then pursuing his vocation as a painter under Andrea del Sarto, learning from the sets made for Machiavelli's play *Mandragola* by Andrea and Bastiano da Sangallo, and responding in awe to the work of Michelangelo.

Among the new pope's varied ambitions was the determination to monopolize the service of Italy's foremost artist, the slightly older Michelangelo, familiar to him since childhood. After learning the result of the election, Michelangelo, when writing about marble supplies to the stonecutter Domenico di Giovanni Bertino Fancelli (Topolino), remarked that his friend would have heard that 'Medici has been made pope: and so it seems to me the whole world will be rejoicing; and so I reckon that here, in regard to our art, many things are possible.' Michelangelo addressed Topolino as *maestro*, rather teasingly, as this older craftsman had pretensions to be a sculptor: his shipments from Carrara invariably contained several figures he had roughed out himself, for Michelangelo to see, and to Michelangelo's great amusement.

Michelangelo stayed in Florence, rather than in Rome near the court; he had many friends in Rome, including the faithful Sebastiano Luciani, to act as his eyes and ears. But Pope Clement wanted to bind Michelangelo for good. He was to work on the planned memorials of the Medici both as builder and as sculptor. It seemed sensible for the pope's peace of mind and for his own well-being that Michelangelo should take minor orders and so obtain income from a benefice. Michelangelo was briefly in Rome before the end of 1523; letters exchanged between him and Fattucci then made it clear that he rejected the idea of taking orders but would consider a salary or stipend, though he had reservations.

Fattucci in a letter of 13 January 1524 joked about the figure Michelangelo had proposed – fifteen ducats a month – as ridiculously low; it was probably deliberately so. Fattucci commented that he had wanted to ensure that Michelangelo would always be independent, even in old age or infirmity, and that Jacopo Salviati (acting as banker for the pope) had arranged for his agent in Florence, Giovanni Spina,

to have Michelangelo paid fifty ducats a month and all that was needed for the expense of the work. Moreover 'for the library which is to be made, or façade, or other work at the expense of our Lord, he desires that all should pass through your hands.' The reference to the façade is surprising. The library promised years of work (already under way) in addition to the tombs for the new sacristy, for which models had recently been made. 'The bearer of this letter', Michelangelo had written to Spina on 7 January 1524, 'will be Antonio di Bernardi Mini, who is with me. Will you pay him fifteen ducats in gold on account of the models for the tombs of the sacristy of San Lorenzo, which I am doing for Pope Clement?'

The pope, Fattucci and Salviati went on trying hard to please and pin down Michelangelo, who was also offered a house in Florence, near San Lorenzo, rent-free, with expenses. But the weight of his obligations over the unfinished tomb of Julius II was growing more oppressive than ever. The financial threat now seemed terrifying. So as to seem less committed or provocative to the heirs of Julius, Michelangelo refused to draw the salary or live in the house arranged by Fattucci. Michelangelo had expressed his exasperation, indignation and fears in a letter to Fattucci in December 1523 – almost a little *apologia pro vita sua* in which, as he nears his half-century, the artist recalled how he had felt as a young man pitched against a masterful pontiff, and fighting for his integrity:

> In your letter you enquire how things stand between me and Pope Julius. I tell you that if I could ask for what I am owed along with interest I think I'd have something coming to me rather than having to pay out. For when he sent for me to Florence, which was I believe in the second year of his pontificate, I had undertaken to do half of the Council Hall of Florence, that's to say painting it; and I had 3,000 ducats for this. And the cartoon was already done, as all Florence knows; so I felt the money was already half earned. And for the twelve Apostles that I still had to do for Santa Maria del Fiore, one was already roughly hewn . . .
>
> Then Pope Julius took me away, and neither for one nor the other did I get anything. So now I was in Rome with Pope Julius and had been commissioned to make his tomb, which would absorb 1,000 ducats worth of marble; and he had this paid to me and sent me to Carrara on account of it. And there I spent eight months having the blocks roughly shaped, and for the most part

transported to the piazza of St Peter's, with some remaining at Ripa. Then, after I had finally paid the freight charges for the marble and come to the end of the money I had received for the work, I furnished the house I had on the piazza of St Peter's with my own household goods and beds, relying on my hopes of doing the tomb; and, to work with me, I called from Florence for some assistants, some of whom are still living in wait; and I paid them from my own money. At this time Pope Julius changed his mind and no longer wanted to do it; and in ignorance of this I went to him to ask for money, and I was chased from the room.

Enraged by this, I left Rome at once; what I had in my house came to grief; and the marble blocks I had brought to Rome were left lying on the piazza of St Peter's till the election of Pope Leo. So on one side and the other everything was ruined. Among the matters I can prove, there were taken from me, from Ripa, by Agostino Chigi, two pieces of marble of nine feet each, which had cost me over fifty gold ducats . . .

Then when Pope Julius first went to Bologna, I was forced to go there with a rope round my neck to ask his pardon; and he ordered me to make his statue in bronze, seated and about fourteen feet high; and when he asked me what it would cost, I replied that I thought I could cast it for 1,000 ducats, but that this was not my branch of art and I did not want to commit myself. He replied, 'Go, start work, and cast it as many times as may be needed, and you will be given enough to make you happy.' To be brief, I cast it twice, and at the end of the two years I spent there I found I had 4½ ducats left. I had no more during this time; and all the outlay I incurred in these two years was included in the 1,000 ducats I had said would be needed to cast the statue; and these were paid to me in stages by messer Antonio Maria da Legniano, of Bologna.

The statue was set up on the façade of San Petronio; and then after his return to Rome Pope Julius still did not want me to make his tomb but put me to painting the vault of the Sistine, in a deal worth 3,000 ducats. The first design for this work was for twelve Apostles in the lunettes, and for the usual ornamentation in the remaining space.

After the work was started, I thought it was turning out poorly; and so I told the pope that if only the Apostles were done and nothing else I thought it would succeed very poorly. He asked me why; and I said, 'Because they themselves were poor men.' Then

he gave me a fresh commission to do what I wanted; he would make me content, and I was to paint as far as the scenes below.

When the vault was almost finished, the pope returned to Bologna; so I went there twice for the money that was due but received nothing and lost all that time, till he returned to Rome. Back in Rome, I started to make cartoons for the work I had to do, namely for the heads and faces all around the Sistine Chapel; and hoping to have the money to finish the work, I could never obtain any at all. And when one day I complained to messer Bernardo da Bibbiena and to Atalante [one of the superintendents of the fabric of St Peter's] that I could no longer stay in Rome and would have to take to my heels, messer Bernardo told Atalante to remind him to ensure I was given some money no matter what. And he had me given 2,000 Camera ducats; and it is these along with the first 1,000 for the marble which they are putting to my account for the tomb; but I reckon I should have had more for all the time lost and the works I made. Also out of that money, as Messer Bernardo and Atalante had acted to save me, I gave the former 100 and the latter fifty ducats.

Then came the death of Pope Julius; and in due time, at the start of Leo's reign, Aginense, wanting to have the tomb made larger, creating a bigger work than the design I had made earlier, drew up another contract. And when I was unwilling to put into the account for the tomb the 3,000 ducats I had already received, since I showed I was due far more, Aginense told me that I was a cheat.

Neither Michelangelo's expostulations nor Clement's self-interested sympathy could resolve the issue of the tomb. Julius's executors threatened to sue Michelangelo; he showed a readiness to compromise, pleading that he was not able to finish the tomb, through old age or bodily ailment. He suggested to Giovanni Spina that the pope let it be known he wished him, Michelangelo, to pay back what he had received for its completion. He would not just capitulate, but he was weary enough to concede. 'As soon as what I have to return is clarified, I shall review what I have: I shall sell all, and I'll arrange this so that I make restitution and then I'll be able to think about the pope's business and my work for him; for as things are now, I do not live my life, let alone work.' Friends in Rome, including Lionardo Sellaio and Jacopo Salviati, persuaded Michelangelo not to settle in this manner, however, and so the threats and arguments continued. Michelangelo was insisting that

he would not continue the work unless the remaining 8,000 scudi of the 16,500 ducats total payment for the tomb were deposited; the family would part with no more.

At length negotiations began on a new contract. Michelangelo recorded, in the summer of 1525, that the tomb was more than half finished, and four of the six figures mentioned in the impending contract were done and waiting in his house in Macello de' Corvi.

One of his letters to Fattucci in October the same year was full of pathos. He mentioned his poverty. He said he would do the statues himself for a tomb for Julius which would be like the tomb of Pius II in St Peter's.* He would always continue to work for Pope Clement with such feeble strength as he possessed as an old man, but only if the campaign of spite against him stopped. (This was apparently a reference to the taunts by Domenico Buoninsegni and Baccio Bandinelli over Michelangelo's wish to carve a Hercules slaying Cacus from a piece of marble Clement had given to Bandinelli, who was boasting that he would do a figure to surpass Michelangelo's statue of David.) He was alone with his worries, and these occupied him more than his sculpture.

The verse Michelangelo was writing in the early 1520s – on backs of letters, on sheets of drawings and sketches, new and old – included some bizarre stanzas on an ugly, tormenting woman, with teeth as white as turnips and hair like a leek, whose mouth, like his own, Michelangelo wrote, resembles a bog filled with beans, whose breasts are like two water melons in a bag, and whom he would chase after if he were still youthful.

A kind of song or frottola, echoing the gloomy Florentine processional chants of Savonarola's time and earlier, records that in time we all die, and the sun leaves nothing to live on. Joy and grief ail us, and our words and wits; and our ancient lineages are shadows in the sun, smoke in the wind.

In January 1524, again writing to Fattucci from Florence, Michelangelo acknowledged the request from 'His Holiness our Lord' that he should design the library planned by Clement to house the Medici family's rare collection of manuscripts and books, and agreed to talk about the proposal to the miniaturist and architect Stefano Lunetti, 'although it is not my profession'.

* Now in Sant'Andrea della Valle.

37 The library, the dovecote and the carving of the tombs

The commission to create a great library building for San Lorenzo was given to Michelangelo about the beginning of 1524. To the role of master mason, Michelangelo brought his love and knowledge of building materials, especially marble; his understanding of traditional and classical principles employed to perfection in the works of Michelozzo, Brunelleschi and Bramante; and his profound sculptural power and vision. In an age of emergent specialization in the fine arts, Michelangelo had been approached for an architectural design (for the gallery for the Duomo in Florence) when he was in his early thirties. Consulting him about the façade for San Lorenzo, Pope Leo had wanted him to work with the well-tried Baccio d'Agnolo as if not quite convinced of his mastery of safe construction. But Michelangelo's sculpture and painting – from the early Madonna carved with a seemingly monumental flight of steps, through the multitudinous spaces of the Sistine ceiling to the successive projects for the tomb of Pope Julius – had shown him responding to the challenges of his commissions with increasingly bold and dynamic architectural ideas.

The constraints of the library commission were severe. It had to be built for a practical purpose – to house volumes which had grown from a collection of manuscripts which had been acquired by Cosimo il Vecchio, enriched by Lorenzo, taken to Rome in 1508 and greatly augmented by Giovanni de' Medici, and returned to Florence by Pope Clement – and it had to enhance the existing grand complex of Dominican monastery and church. In his workshop, Michelangelo studiously drew his site plan in red chalk, describing in detail the first-floor level of the complex and sketching two possible positions for the library. Pope Clement in Rome received a fresh version of this plan during January 1524.

Initially the building work was to have been done by Stefano Lunetti, who had begun his career as an illuminator in the service of the Medici; but after Michelangelo had been asked to furnish a design for the fabric he very soon assumed responsibility for the entire project, including the library furnishings.

When Michelangelo wrote to Fattucci in January 1524, acknowledging the message that Pope Clement wished him to build the library, but sounding very uncertain about possibilities, he defended his efforts to fulfil his obligations over the tomb of Pope Julius. This was also the time of his preoccupation with the conception, design and modelling of the massive architectural sculptures for the Medici Chapel.

Marble to make a figure representing Night had been ordered in April 1521, and was being worked on in the spring of 1524. Michelangelo's scrupulously kept records for this period re-create a busy, clamorous world of servants and *garzoni*, functionaries and clerks, day labourers, stonecutters and craftsmen. In March 1524 he listed the days worked at San Lorenzo by stonemasons: six days for Bastiano, called Bargiacha; six days for Michele, called el Chastello; six days for Giovanni della Bella; and so on up to thirteen names in all. The *ricordi* of payments and receipts for these years cover services rendered at San Lorenzo, wire for models for the statues, benches, nails, hammers, axes, candles to use in the sacristy during bad weather, gold leaf, and dirty washing.

Disputes and accidents on the site added to Michelangelo's innumerable distractions. Among the financial records for the spring of 1524 was a payment for treatment given to Bargiacha, who had fallen from the sacristy vault. In a letter to Piero Gondi dated January 1524, Michelangelo had burst out angrily over the performance of Stefano Lunetti, who was supervising work inside the sacristy. Michelangelo was most revealing about the fearsome pace he set for those working with him, and more so for himself:

> up to now I have not put him [Stefano] in charge, though if I were not able to be there myself I would have found no one else to put there; I have done everything for his benefit and not for my own gain but for his, as now too. What I am doing I am doing for his benefit, as I gave him an undertaking about this and cannot drop it ... And if I have driven him on lately more than usual I've done so because I am more than usually pressured myself; but I simply must find out if he can, and if he wishes, and if he knows how to serve me, so I can think what to do.

Michelangelo's initial expressed reluctance to undertake the library work sprang partly from the slow progress being made on securing marble for the Medici tombs. He wrote a politely worded but sarcastic letter of complaint directly to Pope Clement, saying that, mad and bad as he was, he was certain that if he had been allowed to work

unhindered all the marble needed would have been by then delivered to Florence. Now he could see the work on the statues would take its time, and he begged His Holiness not to put men over him in his own art but to trust him. Then His Holiness 'will see what I shall do and the account I shall make of myself to him'. Meanwhile, he announced, Stefano Lunetti had finished and uncovered the lantern of the new sacristy.

Andrea Sansovino, who had often been considered initially for work which the younger Michelangelo then took, was among the many contemporaries whose respect for him was powerful and unfeigned. After working in Rome, Andrea settled in Loreto, where in 1513 he was put in charge of the marble-cladding and decoration of the Holy House (reputed to have been miraculously flown by angels in stages from Palestine in the thirteenth century). Andrea's letter to Michelangelo on 1 January 1524 left a warm impression of the familiarity between himself and the pope, and between each of them and Michelangelo.

> I said to him that I had told you that my desire was to return to my country, and that if my service on these works [in Florence] were acceptable to you I would with gladness serve you faithfully in all the things you might command, and this is because I have always loved you. To these words his Holiness replied that you had spoken well of me to him, and that it would please him greatly if I might come together with you over this matter.

Everything he could do to please Michelangelo, he would happily do, Sansovino concluded. Sansovino's anxiety to return to Florence clearly in part accounted for his fulsome approach. His letter also expressed affection and admiration for Michelangelo. But nothing came of his offer.

At this time Michelangelo was himself writing to the pope (using the respectful third-person singular) to express his irritation over not being given a free hand as he moved to a fresh stage of the work in San Lorenzo. His friends' letters bear witness to Michelangelo's touchiness and the pope's careful manoeuvring to cope with it.

Michelangelo's worries over the unfinished tomb of Pope Julius were accompanied by constant friction with those who were involved first, from 1520, with building the new chapel for San Lorenzo and then, from 1524, on the tombs (for which he had made full-scale wooden

models). In March 1524 Fattucci wrote from Rome to tell Michelangelo that Figiovanni was reporting in detail on what he found unsatisfactory in the work Michelangelo was doing. By mid-September, Figiovanni had been replaced as overseer by Michelangelo's loyal Baccio Bigio, but the running battle with Figiovanni continued. In April 1526 Michelangelo's irritation with Figiovanni, who had alleged in Rome that Michelangelo was building the Medici library like a dovecote, surfaced in a hilarious letter to Fattucci.

Pope Clement's expressed wish for Michelangelo to build a colossus, using blocks for its construction, prompted Michelangelo to fantasize mockingly about an eighty-foot-high giant to be put at the corner of the loggia of the Medici garden.

> This colossus [he wrote to Fattucci in December 1525] does not suit the corner, because it would take up too much of the road.
>
> However, on the other corner, where the barber's shop is, it would, in my view, turn out much better, because the piazza is in front and so it would not cause so much trouble with the street. And then, because perhaps removing the shop wouldn't be tolerated, thanks to the income it provides, I've come to think that the figure could be sitting down, and that the seat could be made so high that if the work were made hollow inside, which could conveniently be done using blocks, the barber's shop could go underneath, and so the rent would not be lost. And in order that the shop may, as now, have somewhere for the smoke to escape, I am thinking of giving the statue a horn of plenty in its hand, all hollow, to serve as a chimney. Then if I have the statue's head hollowed out, like the other members, I also think I can derive some benefit from that, because there is on the piazza here a huckster [i.e. Figiovanni], a great friend of mine, who has told me privately that he would make a fine dovecote inside it. Another idea has occurred to me that would be even better, but it would be necessary to make the figure very much bigger; yet it could be done, seeing that towers are made up of blocks. This is that the head should serve as the bell-tower for San Lorenzo, which badly needs one. And then, with the bells flying round inside and the sound coming out through the mouth, the colossus would appear to be howling for mercy, and especially on feast days, when the bells ring out more often and the peals are louder.

Michelangelo had another dig at Figiovanni when on 17 June 1526

he wrote to Fattucci about the progress of his work, which Figiovanni
had said was lackadaisical:

> Next week I shall have the figures that have been roughed out in
> the sacristy covered up, because I want to leave the sacristy free
> for those marble-cutters, and I want them to start to do the other
> tomb opposite the one already built and which is in place and
> ready, or nearly so. And while they're building it I thought the
> vault might be made, and I imagined that with enough people it
> might be done in two or three months; but I'm no expert in
> this . . .
>
> As for the vestibule, this week four columns have been built and
> one was built previously. The tabernacles are a little behind; but
> in twelve months from now I believe it will be furnished. The floor
> might be started now, but the linden wood is not yet ready; they
> will hurry on the seasoning as much as possible.
>
> I am working as hard as I can, and within fifteen days I shall
> make a start on the other Captain; then of the important things I
> shall have still to do only the four rivers. The four figures on the
> sarcophagi, the four figures on the ground which are the rivers, the
> two Captains, and Our Lady to go in the tomb at the head of the
> chapel, are the figures I will make with my own hands; and six of
> these have been started . . .
>
> Remember me to Giovanni Spina, and beg him to write a note
> to Figiovanni and ask him not to remove the carters to send them
> to Pescia, because we'll be left without stone. And also beg him
> not to charm the stonecutters there to make them fond of him, by
> saying, 'Those people feel nothing for you, the way they make you
> work till sunset, now that the nights are short.' We need eyes
> everywhere to keep even one of them at work, and even he's been
> spoilt by that person being too complaisant. But patience! God
> forbid I should be upset by what doesn't upset him.

Michelangelo was now starting to carve the images of Lorenzo, duke of
Urbino, for the west wall of the chapel, and Giuliano, duke of Nemours,
for the east (the 'Captains'); the symbolical figures for the sarcophagi,
representing Day and Night, and Dawn and Dusk; the Madonna and
Child; and figures of the Medici family's patron saints. Waiting to
house them was the new sacristy, a miracle of innovatory design. All
were shaped first in Michelangelo's mind, and then in the form of
constantly modified drawings and clay models.

For the cupola that he raised over the chapel, Michelangelo had designed a curious lantern with large windows, free-standing columns and a ball made by the goldsmith Piloto. The lantern was an affirmation of difference but it could not, Michelangelo said when challenged, though different, be better than Brunelleschi's existing dome for the church. Inside the chapel, Michelangelo's emphatically vertical design created an integrated structure ascending strongly like a symbolic resurrection. The oblong foundations sustained a huge square mortuary chapel, with a square chancel, or altar base, and side chambers which acknowledged those of Brunelleschi's old sacristy. All four walls were adorned with the order applied by Brunelleschi on his altar wall.

With a flash of wit, Michelangelo added a second order over the first, and included in the lunettes windows tapering disconcertingly towards the drumless dome, which was modelled on the Pantheon.

Michelangelo experimented on paper with several ingenious possibilities, including a free-standing, centrally sited monument, for the four tombs of Lorenzo the Magnificent and his brother Giuliano – the *Magnifici* – and of Giuliano, duke of Nemours, and Lorenzo, duke of Urbino. He later planned to have two sarcophagi decorating each wall and then to add a double tomb for the Medici popes, Leo X and Clement himself, with the already envisaged figure of the Madonna. The sacristy was intended to be viewed from the altar under the entrance arch of the chancel. At its most ambitious, it was to have four seated figures of the Medici to left and right, the papal tomb, with the Medici patron saints Cosmas and Damian interceding with Mary and the infant Christ, and allegorical, classically inspired statues of Time, the underworld and the elements.

In the end, the tomb for Leo and Clement and the tombs for the *Magnifici* were abandoned, and two separate tombs for the dukes, with four river-gods as well as four recumbent figures of Dawn and Dusk, Night and Day, were planned to adorn the side-walls, with the Madonna and saints, facing the altar. The richly plastic marble tombs would be framed by pilasters of grey-greenish *pietra serena*; on either side would be simple doors with marble tabernacles above, repeated eight times round the chapel.

From the beginning, Pope Clement had taken a close interest in Michelangelo's ideas for both the library and the sacristy. According to a letter from Fattucci dated 3 April 1524, Clement was saying that Michelangelo should erect the library where he wished, over the rooms on the side of the old sacristy. He was to send the design showing

exactly where the staircase was to be, so that it would be well understood. The pope wanted vaulting rather than beams over the living-rooms under the library – 'lest some drunkard, as can happen with priests, start a fire in the room, spreading to the library. And above [he] would like a beautiful ceiling, but would wish to get away from the cofferings like those which are here the *squadrimenti* in the Vatican, which displease him'; rather he asked for some novel idea – *qualche fantasia nuova*. Two studios were wanted to house some special books – *libri secreti* – and Michelangelo was to place a window at the head of the library between the two studios, and two others on each side of the door. Lastly, the pope was guardedly telling Michelangelo to devise a beautiful passage (*andamento*); and 'for now design the stairway the way you see it, to ascend those twelve feet [*sei braccia*] you wrote about the other time.' As for the houses in the way towards the Via della Stufa, Clement would have them pulled down.

Towards the end of 1525 the pope was again in touch with Michelangelo about the library, and still following in fine detail the progress of the works at San Lorenzo, despite his preoccupations with politics and war, and the tightening grip of the Imperialists on Italy. Having just passed on Clement's half promise, half threat to visit Florence in about a year or eighteen months to see Michelangelo's work, Fattucci wrote on 29 November 1525 about the entrance room to the library and Clement's fears that Michelangelo's suggestions for round skylights in the ceiling would necessitate employing two friars to do nothing but clean off the dust.

Michelangelo then learned from Clement's secretary, Pietro Maolo Marzi, writing two days before Christmas 1525, that Clement had received his letter of 7 December with his (latest) design for the library, and was only just responding, 'having till now been occupied with important matters'. Clement had liked Michelangelo's ideas, though he wondered about raising the walls four feet to light the vestibule from the sides, as this would entail taking down part of the roof already up and altering the beams, which could endanger the fabric. However, His Beatitude had confidence in Michelangelo's affection, talent and greater knowledge.

The pope's patience, however, was being tested. To Marzi's letter, Clement added a postscript in his own hand:

You know [*Tu sai*] that popes do not live long; and our desire to see, or at least to hear about, the finishing of the chapel with the sepulchres of our relations, and also the library, could not be

greater. So we commend to you both the one and the other project; and meanwhile we will (as you have said) exercise good patience, praying God to set your heart to pushing on with them both. Have no fear you will lack either works or reward while we live. And receive God's blessing and ours.

About a hundred men were working on the library by mid-1525, in addition to the constant dozen or so marble-workers for the new sacristy. Agreement could not always be reached. Michelangelo had laughed Clement's proposal for a colossus out of court (though Marzi wrote that the pope had not been joking and wanted the colossus if there were time, to bring everything to perfection). Progress on the upper part of the vestibule to the library was stalled for a while after the decision had been taken to raise its walls and already-finished roof, so as to take the round windows the pope wanted instead of dust-gathering skylights.

At last, by mid-June 1526, however, Michelangelo could reflect thankfully that six of the statues for the new sacristy were done and that a start could soon be made on decorating its vault. He also felt he could promise Fattucci (partly to refute Figiovanni's accusations about his dilatoriness) that the library's vestibule would be finished in about four months.

The unadorned library had first been planned by Michelangelo on the utilitarian lines of Michelozzo's library for San Marco, as a narrow three-aisled room on the upper level of a two-storey building. Michelangelo had rejected the chosen first site on the piazza of San Lorenzo on the grounds that the view of the church should be left clear, and he used a buttress system on the exterior of the new building to avoid thickening the supporting walls of the old structure. This kept the library walls thin and created a bay system which decided the interior articulation and the placing of the windows. The resultant structure governed the form of the ceiling, with its decorative partitions appearing to be set in a framework of beams and seemingly supported by the wall pilasters.

Placing the windows of the reading-room close together and as low down as possible, for more light to the desks, which were designed to be flush to the wall, Michelangelo produced a calm and elegant room. The walls, with their delicate membering, emerge like insubstantial screens between the pilasters, which express the exterior buttresses of the wall. The entrance door developed from a heavy, modelled design

into a framework of thin layers. But, in contrast to the reading-room, the vestibule has heavier sculptural emphasis and, for structural reasons, a higher ceiling, which gives it a startling verticality.

As Michelangelo's imagination responded to the pope's demands and the contingencies of site and function, he ingeniously disregarded accepted rules for the use of old forms. His strangest innovation was to recess the great columns, the main support of the roof, behind the wall surface, rather than have them projecting forward, as would be expected. The vestibule's design was a triumph for Michelangelo's vision and architectural sleight of hand.

The painting of the vault of the new sacristy was under discussion during the spring and summer of 1526, along with the inscription for the door Michelangelo had designed for the library. Clement asked Paolo Giovio to write several inscriptions from which he could choose. He also informed Michelangelo, who had himself sent him an inscription, that he would be sending Giovanni da Udine to work under his instructions, and Michelangelo said that Giovanni could come whenever he wished.

Giovanni, renowned for his fashionable animal paintings, witty drawings of fruit and flowers, and small strange figures in stucco after the antique, planned to start work in Florence in September, bringing his own *garzone*, after he had finished the decorating he was doing in the papal apartments. He was too late. By the autumn, the whole of Italy was in arms.

38 Collaborating with Sebastiano •
Sansovino and Michelangelo reconciled •
Art, liberty and licence in Cellini's Rome

From the early autumn of 1526, as the relations of Pope Julius were intensifying their legal pressure on him, Michelangelo struggled in torment to interpret confusing signals coming from Rome about his programme of work.

Under financial and military pressure, Clement through Fattucci had instructed him in July to spread one month's spending on the library over three, but to spend what he wished on the tombs for the chapel. In October Michelangelo was thanked for saving money on

marble-cutters and told to stop work on the library ceiling, but to continue spending as needed on the chapel and its statues. He pressed Fattucci to find out what the pope's wishes really were. He had seen the work being slowed down in Florence, Michelangelo told Fattucci in November, and he saw that spending was being cut back publicly and realized that the house rented for him in San Lorenzo and his salary were costly. Could he not be allowed to turn to the work for Pope Julius, either in Florence or Rome? Surely haunted by past misunderstandings and accusations, he asked that the pope's wishes should be clarified in writing so that he could obey all the better and could also, one day, if necessary, justify himself with Fattucci's letters. 'If I hardly know how to write what you will understand, do not be surprised, because my mind has gone entirely.'

Fattucci's last words about the work, written to Michelangelo just before Christmas 1526, were that 'Figi' (Figiovanni) was going around accusing him of slacking, but had been dismissed by the pope as a brute who should do less babbling. Meanwhile, Michelangelo should do things his way.

Michelangelo's work on the new sacristy and library of San Lorenzo had been almost unremitting since 1520, as he approached his fifties, conceiving and executing massive structures and some few statues of great serenity, originality and power. He lived close to his family, though his father spent most of this time irritably at Settignano, and he enjoyed convivial company in a Florence shaken by social and political uncertainties and where emotions seemed often stretched to snapping-point. Other people's company at times was too overwhelming for Michelangelo, but in May 1525 he accepted an invitation to have supper with a Florentine dignitary, Cuio Dini, and some other gentlemen, and this, he remarked, lifted his depression or his madness ('mio pazzo') a little. He appreciated the meal and better still the discussions.

Michelangelo's relationship with Sebastiano in Rome remained intimate and creative while he was working at San Lorenzo. Like several other talented painters active in Rome, and notably the recently arrived Parmigianino, Sebastiano seemed to be changing important elements in his style, consciously acknowledging Raphael, while moving to calmer presentation, cooler colours, and enlarged forms, as in a Madonna and Child, the *Madonna del Velo*,* for Pope Clement.

But Sebastiano was still the supreme example of Michelangelo's

* *The Holy Family*, Narodni Gallery, Prague.

occasional willingness to collaborate with another artist. By 1525, he had been the intimate colleague of Michelangelo for about twelve years, during which Michelangelo had shared closely in the initial stages of several of Sebastiano's best paintings. Springing partly from Michelangelo's need to counter the threat he saw from Raphael and his followers after he had finished the Sistine ceiling, the collaboration had flowered magnificently in Sebastiano's *Pietà* for the church of San Francesco in Viterbo; then in the decoration for the banker Pierfrancesco Borgherini of the chapel in San Pietro in Montorio in Rome, whose main feature was a flagellation of Christ; and in the great altarpiece of the raising of Lazarus* painted in flagrant rivalry with Raphael. This last had been commissioned by Cardinal Giulio de' Medici for his archiepiscopal church at Narbonne, and may have been suggested to the cardinal by Michelangelo.

The details of Michelangelo's collaboration with Sebastiano included supplying the figure composition and cartoon for the *Pietà*; discussing the 'programme' for the Borgherini chapel; a vital drawing of Christ for the scene of the flagellation; and a group of three drawings relating to Lazarus and the figures around him as he comes from the tomb.

The demand for Sebastiano's work ensured a line of classical continuity in Roman painting from the high period of Raphael's and Michelangelo's commissions. He found new directions for himself with his series of startling portraits. His painting of a man† (probably Anton Francesco degli Albizzi) finished in 1525 – its style influenced by Michelangelo and in turn influencing Pontormo – with its cool colours, dramatic and massively realized characterization, like other of Sebastiano's portraits in the mid-1520s, triumphantly demonstrated his emergence as one of the foremost living portrait painters.

Sebastiano's portrait of Clement VII‡ was painted in 1526, at the time when the pope was desperately bending all his diplomatic and military resources to resist the demands of the emperor. Sebastiano depicted the half-turned shadowed face of the pontiff, with strong jawline and nose, to provide a subtle evocation of Clement's disdain, sensitivity and suspiciousness.

In Pope Clement's Rome there were, however, several highly talented painters who were more intent on *grazia* and illusion than on grandeur

* Now in the National Gallery, London.
† Museum of Fine Arts, Boston.
‡ Capodimonte, Naples.

and truth; they were affected by the *terribilità* of the Sistine ceiling, but followed more closely the path indicated by Raphael.

Baldassare Peruzzi from Agostino Chigi's circle in Siena and Giulio Romano, Antonio da Sangallo, originally a woodworker, and Jacopo Sansovino, the sculptor, were all practising architecture in Rome at the beginning of Clement's pontificate. Just before Pope Leo's death, Peruzzi had succeeded Raphael as head of works for St Peter's. His main architectural and decorative work in Rome, a graceful villa for Chigi, had been completed. Under Pope Clement, from 1524 he was engaged on a huge monument to Pope Adrian VI for Santa Maria dell'Anima, the recently built church of the German–Dutch community in Rome.

Giulio Romano, the youngest of this group, immediately after the death of his master Raphael, executed two paintings with prominent architectural features for the church of Santa Maria dell'Anima and for the church of Santo Stefano in Genoa.*

Hardworking, consistently competent and judicious, drawn into the Roman building business by his uncles, Antonio da Sangallo had been helpmate and draughtsman to Bramante. His main patron in the 1520s was Cardinal Alessandro Farnese, though he shared responsibility for the (slow) progress of and change of direction in the work on St Peter's following the death of Raphael, and Pope Clement used him on several architectural projects.

Jacopo Sansovino had sought collaboration with Michelangelo but had been rejected. After competing for the façade of San Lorenzo, he stayed in Rome from 1518, well distanced from Michelangelo and, being also favoured by Cardinal Giulio de' Medici, apparently well placed to pursue a career taking him from mainly sculpture towards architectural design. His continuing sculptural work showed Michelangelo's influence, notwithstanding the rift. Sansovino won the commission for the design of the enormously ambitious Florentine church of San Giovanni in Rome, despite competition with Raphael, Peruzzi and Antonio da Sangallo. In 1521 he became friendly with Sebastiano, who helped reconcile him with Michelangelo in 1525.

Pope Clement had little money to spare for great projects in Rome, as he schemed and manoeuvred to maintain a strong stance from a position dangerously weakened by the defeat and capture of King

* The first is still in Santa Maria dell'Anima; the latter is now in the Villa Lante, Rome.

Francis at the battle of Pavia in February 1525. The progress on St Peter's was desultory; most of all, Clement wanted Michelangelo to hurry on with the tombs and the library for San Lorenzo.

Under Clement the borders between artistic liberty and artistic licence shifted unpredictably. Giulio Romano, friend and portraitist of Castiglione, collaborated with Marcantonio Raimondi, the prolific engraver of Raphael's works, on a profitable series of indecent prints. Giulio did the sixteen or so drawings of sexual coupling between a man and a woman, and Marcantonio engraved them. They turned up, it was later recalled, in places one would least have expected.

Pietro Aretino wrote sonnets to accompany the engravings. According to his own account, addressed to his friend Battista Zatti, a surgeon:

> I took a fancy to see the figures ... And because poets and sculptors both ancient and modern are sometimes in the habit of diverting themselves by writing or carving lascivious things, as we see for example in the Chigi Palace from the marble satyr attempting to violate a boy, I dashed off the sonnets that you see underneath them. And I dedicate the lust they commemorate to you to spite the hypocrites, since I reject the furtive attitude and filthy custom which forbid the eyes what delights them most.
>
> What harm is there in seeing a man mount a woman? Should the beasts be more free than us? It would seem to me that the tool Nature gave us to preserve the race should be worn as a pendant round one's neck or as a medal in one's hat, since it's the spring which feeds all the rivers of humankind and the ambrosia the world drinks on high-days and holidays.
>
> It has made you, and you are one of the best physicians. It has made me, and I'm as good as gold.

As a result of the ensuing scandal, Giulio Romano fled to Mantua, where he designed the frescoes in the Palazzo del Tè; Aretino also left Rome, but he had returned by November 1524; Marcantonio Raimondi was imprisoned, but was soon released. He was highly valued, for his engravings disseminated knowledge of the works of the painters, especially Raphael, throughout Europe.

La Cortigiana, Aretino's first prose comedy about the ways of the court, written early in 1525, cut a brutal swathe through the contemporary public life of Rome before homing in on the horrors of courtiership. His mental baggage included first-hand knowledge of the seamy side of

the papal court. Rome at this time was turbulent, dissolute and dangerous.

The young Benvenuto Cellini also found rich pickings for his talents in the Rome of Clement VII after he had returned there from Florence in November 1523. He studied, copied in wax, or drew the antiquities of Rome and the paintings of Michelangelo and Raphael in the Sistine and at Chigi's palace. He sold some of his vases to the famous surgeon Giacomo Berengario, who claimed to be able to cure the French pox (which Cellini saw was very fond of rich priests) and who decamped to Ferrara with the advance payments from his patients (who grew still more unwell) and with Cellini's vases, which he passed off as antiques.

The audacious Rosso Fiorentino also arrived in Rome from Florence in 1523, not just to study but to compete with the followers of Raphael. He was soon painting biblical frescoes in Santa Maria della Pace, and quarrelling with Antonio da Sangallo who had secured him the work, later writing to Michelangelo an embarrassed letter defending himself against allegations of arrogantly criticizing the frescoes on the Sistine ceiling, whose challenge had thrown him into emotional turmoil.

Instead of the return of mythical Medici profusion, Rome under Pope Clement experienced an extended period of frustrated aspirations and unfulfilled projects. There was certainly less ready money than in the days of Pope Julius and Bramante for the pope to spend on buildings and painting. Raphael's beautiful classical villa of loggia, courtyards, garden, ponds and Vitruvian theatre, begun about 1516 for Cardinal Giulio de' Medici on the slopes of Monte Mario, remained unfinished long after Giulio became Pope Clement. Giulio Romano may have contributed to the design of this project, but his last work in Rome was probably the decoration of Clement's bathroom in Castel Sant'Angelo, before he left for Mantua in 1524.

39 New ways in Florence: anguish and opportunities

On his arrival in 1522 in Florence, in flight with the goldsmith Piloto from the plague in Rome, the painter Perino del Vaga remarked on the divergence in styles between the followers of Raphael in Rome, himself included, and the more independent painters in Florence, aware of their own great Florentine heritage from Giotto to Masaccio and the young Michelangelo, as well as of the stupendous accomplishments in the papal apartments and the Sistine Chapel.

The arrival of Perino del Vaga stimulated discussion on recent developments in the arts, particularly painting. The debate, probably over months and years, centred on recent paintings in Florence and Rome and on how the present matched up to the past. From the time of Dante, connections and contrasts between Rome and Florence had been intellectually and artistically fruitful, enriched by Florence's sense of business and beauty and Rome's place as the spiritual hub of Christianity. The links were tighter still under the Medici popes, but Florence and Rome though geographically close were not so similar or so near to each other as to prevent big divergences.

Masaccio's paintings in the Brancacci Chapel of the Carmine were cited as evidence of mastery, all the more miraculous since he had had only Giotto to emulate. Perino del Vaga, standing by these very frescoes, argued that modern painting was as graceful and vigorous as that of Florence's past, and even more beautiful, and that he could demonstrate this with his own brush.

A great change was beginning to come over the art of painting in Florence, and the debate associated with Perino reflected contemporary awareness above all of the perfection so demonstrably attained by the recently deceased Leonardo and Raphael and the still living Michelangelo. Who could improve on his representations of monumental human figures?

While Michelangelo was exploring his own architectural and sculptural imagination in the successive projects for the complex of San Lorenzo, his younger contemporaries in Florence were increasingly breaking with convention, seeking to escape the direct comparison with recently created masterpieces in Florence and Rome. The behaviour and the

work of Pontormo and Rosso Fiorentino, for example, grew more unconventional and bizarre. Their paintings showed constant inventiveness, brilliant colouring and sometimes deep serenity, as in Pontormo's religiously profound fresco cycle in the Certosa del Galluzzo. During the tense years of the 1520s, the artistic experimentation and gamy behaviour of artists in Florence grew absurd, almost hysterical.

The sculptor Giovan Francesco Rustici, who was a little older than Michelangelo and had learned in Verrocchio's workshop, from della Robbia and Leonardo da Vinci, was nobly born, generous, simple-seeming yet a shrewd and sensitive man. He is best remembered both for his dramatically characterized figures for the Baptistery – over the payment of which he disputed for years – and for his grand eccentricities. He doted on animals and kept an eagle and a beautifully spoken raven. Guests at his table would draw their legs back sharply when scratched by the quills of his porcupine, before going to view the pet serpents or grass snakes he kept in place of fish in his pond. He used to scare his apprentices with his conjuring, which seemed like magic.

During the 1520s Rustici ran a club called The Cauldron, which met in his rooms. His gastronomic apotheosis was a banquet inside what looked like an enormous decorated cooking-pot lit from the handle over the top. Immersed in the boiling water, as it were, the members and guests were served successive courses from the branches of a tree in the middle which rose up and then descended below, where musicians were playing.

To his feast, Rustici himself brought two succulent capons wrapped in pastry dressed to represent Ulysses roasting his father to rejuvenate him. Andrea del Sarto brought a church like the church of San Giovanni but raised on edible columns and made from mounds of jelly, big sausages, Parmesan cheese, pastry, sugar and marzipan, with a choir of roast thrushes, pigeons (as basses) and larks (as sopranos). A painter named Spillo presented a fat goose meant to be a tinker for the cauldron. Domenico Puligo, a beautiful colourist from Ghirlandaio's workshop and an amorous painter of Madonnas and portraits, brought a sucking-pig as the girl to clean the cauldron. The goldsmith Cristofero Robetta brought a calf's head fashioned into an anvil with tools to keep the cauldron in good shape.

Another club of the time, to which Rustici belonged, was called The Trowel. Taking off the old guilds or *arti*, the club divided its membership into the greater and lesser sections and it celebrated every St Andrew's Day with a special banquet. At one feast, arranged by Giuliano Bugiardini and Rustici, the members dressed up as masons and labour-

ers, with hammers and trowels or (lesser members) hods and a trowel. They were shown a plan, and then labourers carried in the materials for the foundation: lasagne and cream cheese for mortar, spices and pepper mixed with cheese for sand, sweets and cake slices for gravel. After eating their meal, which began with a huge column stuffed with veal, chicken and tripe, they heard the sound of a mock thunderstorm, downed tools, and went home.

These extravagant festive gatherings, which combined classical and Christian allusions, went to the edge of Florentine propriety. Their importance was indicated by varied and widening circles of membership. The Trowel, founded when the Medici returned to Florence, had as its twenty-four initial members several men from noble families (including Francesco and Domenico Rucellai, and Girolamo del Giocondo); in the 'greater' membership were chiefly musicians and painters (including Bugiardini, Granacci and Rustici), in the 'lesser' − as supporters or associates − a group of tradesmen, heralds of the Signoria, and well-known comedians. Strengthening the social and political undercurrents of The Trowel in particular was the subsequent membership of politically influential Florentines, including Giovanni de' Medici.

The club shifted direction after a few years in the face of criticism of its members' self-indulgence and extravagance. The moment of truth was an event when members arriving at their usual meeting-place by Santa Maria Nuova found it painted to look like a hospital and inside some of their waggish friends dressed like paupers who reproached them for all the money they had wasted. Finally, over a good dinner, their patron St Andrew (also a patron saint of the sick) exhorted them to stop being profligate with money and keep themselves out of hospital by limiting their big feasts to one a year.

In the everyday life of Florence, a city of sexual opportunism, Giuliano Brancacci strolls out one warm evening, about the year 1514, to pick up a 'bird' and finds a boy − a 'young thrush' − instead, plucks his feathers and bags him, and tells him his name is Filippo da Casavecchia; but the boy turns the tables on Brancacci the next day, when he sends for the money he was promised. On 14 January 1523 Benvenuto Cellini is fined twelve bushels of flour for having, in company with Giovanni di Ser Matteo Rigoli, committed indecent acts to the injury of Domenico di Ser Giuliano da Ripa. In April 1524 Michelangelo's relation Tedaldo della Casa writes that there has just been an extraordinary to-do on St Mark's Day in the Campanile, when a boy had been buggered by four

men. His father had complained to the magistrates, and one man had been seized and condemned and looked like being beheaded.

From Rome on 3 November 1524 the wide-eyed Tedaldo wrote an equally arresting letter to Buonarroto Buonarroti to say that he had arrived safely and that all was well, 'and I have been in St Peter's and I have seen the chapel of your Michelangelo, and it is a beautiful chapel; and I have seen a good part of Rome and it pleases me very much'.

After the death of Fra Bartolommeo in 1517, the most highly regarded painter in Florence was Andrea del Sarto. He influenced many other painters, including his contemporary Franciabigio, Rosso, Pontormo, Francesco Salviati and Giorgio Vasari. His sensitive classical paintings nearly always have a sense of warm humanity. Childless himself, he painted children beautifully.

Rosso Fiorentino's panel painting of the dead Christ between earthy angels (for Bishop Leonardo Tornabuoni of Borgo San Sepolcro) was challengingly ambivalent in style and subject-matter. By Christ's big, sagging, naked body, in the light also falling on its athletic chest and belly and long extended thighs, only the casual-seeming presence of the instruments of his suffering and death relate his corpse to the Crucifixion rather than to the pagan world.

Jacopo Pontormo stayed in Florence expressing his own poetic fury and developing his own amazing style of painting through numerous altarpieces, religious frescoes and portraits. The faces Pontormo painted stare at the world with tremendous inner power. His several portraits of the Medici beautifully captured their subjects' emotional tautness and intensity.*

From about 1525, when he was just into his thirties, Pontormo became fixed in the orbit of Michelangelo's genius. In the Capponi Chapel at Santa Felicita, he painted frescoes on the walls and vaults and, for the altarpiece, a Deposition.† This refers through the dead Christ both to the historical Crucifixion and entombment and to the real

* Portrait of Cosimo il Vecchio in the Uffizi and of Alessandro at Lucca. His Ottaviano is lost.

† The vault of the Capponi Chapel was destroyed in the eighteenth century. The altarpiece of the Deposition, an Annunciation and a (damaged) Evangelists survive, as does a picture of the Madonna, executed later and still possessed by the Capponi family.

presence of the body of Christ on the altar. The ten tearfully distraught tightly linked figures afloat in space, including the two Marys and a nearly naked youth crouching on tiptoe (and, at the edge, the pale bearded face of the painter himself), form a powerful, swirling pattern like a mandorla of significant luminous colours and dramatic outlines.

In this strange poignant painting of desolation but not despair, Michelangelo could see the distant influence of the figure of Christ he sculpted in Rome, and of the nude athletes he painted for the Sistine, and of the Sistine's palette of bright, clear colours which conveyed relief almost without shadows. Its violations of the expected were the accomplishments of an artist whom he had encouraged to paint from his drawings (a Christ appearing to Mary Magdalene, a nude Venus) and who was inspired, resolute and striving to outpace him.

40 'the times are contrary to my art'

Michelangelo's paintings tended to be sculptural. His poetry put into words what he could not conceive perfectly in marble, but it was also like his marble sculpture in its hardness and depth. Berni said that he wrote 'things, not words'.

Michelangelo touched on the emotional ravages of rejection and of time in an incomplete sonnet, drafted on the back of a letter dated 20 April 1521 written to him in Carrara from Stefano Lunetti. The lines are packed with traditional and Petrarchan conceits: a heart is cruel and pitiless and all sweetness outside but bitter within; time acts as a scythe, and human lives are gathered like hay. 'Fidelity is brief and beauty does not last' − 'La fede è corta e la beltà non dura . . .'

The sentiments in some of the poems from this period may refer to Gherardo Perini's invasion of Michelangelo's life. In an incomplete poem of six-line stanzas, beginning with a confession of fault and suffused with a sense of sin, fresh images appear − of Michelangelo passing like an old serpent through a narrow place, shedding his old armour, stripping and shielding his soul anew. This poem and others that may be from the 1520s are above all about love and its power to bind.

In two quatrains written on a sheet of accounts, Michelangelo began with an unusual reference to place:

> It was here that my love took my heart in his pity,
> and further on my life . . .
> It was here that his love promised help with his beautiful
> eyes, which then withdrew it.
>
> It was here that he bound me, there he set me loose;
> here I wept for myself, and with infinite grief
> from this rock I saw him leave,
> he who took me from myself and wanted me not.

About the end of 1526, Michelangelo told Giovanni Spina that, as the pen was bolder than the tongue, he was writing now what he had lacked courage to say by word of mouth.

> This is as follows: that having seen, as I said, that the times are contrary to my art, I do not know if I have any hope of further salary. If I were certain of not having it any longer, I should not cease on that account from working and doing all I could for the pope, but I would not go on keeping open house, in view of the obligation you know I am under, as I have somewhere far less expensive to go; and you would also be relieved of the burden of rent. But if my salary is to continue I shall stay here as I am and strive to fulfil my obligations. So I beg you to tell me what you intend to do, so that I can think about my own affairs, and I'll be obliged to you. I shall see you again at the festival in Santa Maria del Fiore.

Michelangelo's lament that the times were unfavourable to his art repeats what he had written to his father fourteen years previously, in October 1512 after he had finished painting the Sistine ceiling and the Medici family had been forcibly restored to Florence. The same mood of uncertainty verging on despair about his work as a sculptor proved far more justified in 1526, as papal politics foundered and military violence increased.

Francis I and Emperor Charles V had been at war since 1521. Francis was captured at Pavia in 1525 and sent as a prisoner to Spain. He was set free in 1526 on condition that he renounced all claims to Italian territory, but after crossing the river Bidassoa, and mounting his horse, Francis exclaimed, 'I am king again.' This meant chiefly that he felt he was free to renege on the promises he had made.

On 22 May, a treaty was signed at Cognac between King Francis, and Pope Clement, Venice (under Doge Andrea Gritti) and Francesco Maria Sforza, the puppet duke of Milan; they wanted the emperor to recognize Francesco Sforza as duke of Milan and release his hostages, the French king's two sons. France wanted Italian territory. King Francis felt bound to pursue his inherited rights to Milan and Naples, and to avenge his recent martial humiliations. But, even with allies in Italy, the French forces could not prevail against the Imperial troops, either at Pavia in 1525 or in Lombardy in 1526. In Milan, occupied by Spanish troops, Sforza, claiming to be loyal to the emperor, held out in the citadel against the emperor's generals, waiting vainly for the arrival of the forces of the pope's new league, under the feeble command of Francesco della Rovere, duke of Urbino.

In July 1526, unable to resist further, Sforza abandoned the citadel after the allies of the League had retreated. Among them, serving the French with fifty lances, fifty men at arms, and a hundred light horsemen, was an indignant Giovanni dalle Bande Nere, son of Giovanni de' Medici and Caterina Sforza, who refused to withdraw like the others under cover of night. The bravery of his black-uniformed soldiers was legendary; they had proved their worth at Pavia, despite defeat. (There was a scurrilous story that Machiavelli, trying to illustrate a point, spent two hours under a burning sun trying to arrange the foot-soldiers in the order prescribed in his books. Impatient for dinner, Giovanni asked Machiavelli to withdraw and then himself had the troops drawn up in good order through a few commands and drum beats in the twinkling of an eye.)

In the autumn, Pope Clement's failing confidence was shattered. First he received the shocking news of the utter defeat of the Hungarian army by the Turks at Mohács and the killing of the Hungarian king, Lajos II. Soon after, Cardinal Pompeo Colonna, more *condottiere* than cleric, vented his family's ancient antipathy to centralizing popes and his personal spleen against Clement by marching a few thousand soldiers into Rome. The pope took refuge in Castel Sant'Angelo, and the city's palaces (including the Vatican) were looted by marauders who were not everywhere unwelcome.

Early that winter, Clement moved to take his revenge on the Colonna, with the encouragement of King Francis, who said he would come in person at the head of his troops to defend the Apostolic See. But Clement's ferocious onslaughts against the strongholds of the

Colonna in the Campagna warned the emperor to prepare for war in Lombardy.

The staunch Imperialist the Prince of Mindelheim, Georg von Frundsberg, leader of the Landsknechts – loosely, the followers of Luther – now proceeded from the southern Tyrol with a handful of captains and over 10,000 troops through an unguarded pass in the Alps to Mantua. Then, after a brush with troops commanded by the duke of Urbino and Giovanni delle Bande Nere, he advanced into the territory of Piacenza to wait for the army of the constable of Bourbon, which was moving down from Milan.

In the last weeks of 1526 Pope Clement learned of the accession to the Imperialists of the duke of Ferrara, whose support – provisions and consent – was vital to Frundsberg's safe passage; of the unopposed arrival of an Imperial fleet under Charles de Lannoy at Gaeta to the south; and of the death of Giovanni delle Bande Nere on the last day of November after he had been shot in a skirmish with the Landsknechts.

Giovanni dalle Bande Nere (de' Medici) left a seven-year-old boy, Cosimo, as his heir. Cosimo's mother was Maria Salviati, granddaughter of Lorenzo the Magnificent. In her palace on the Corso in Florence, Maria received condolences and alarming offers from the duke of Urbino and from Giovanni's fellow captains to look after her son's immediate future. Towards the end of 1526 Cosimo left with his aged tutor, Pietro Riccio, first for the family villa at Castello, then for the safety of Venice and voluntary exile.

In Florence the news of the death of Giovanni delle Bande Nere killed what feeble hope there had been of successful resistance to the Imperialists. Many families sent money as well as sons to safety in Venice. Many nobles demanded the public distribution of weapons, especially to the restless, well-born, single men in their twenties. Resentment surged against the Medici and the pope.

As the patched-up truce between the emperor and the pope and his allies hung in shreds, the Signoria of Florence, alarmed at the inadequacy of its naked defences, sent Machiavelli to the camp of Clement's lieutenant-general, Francesco Guicciardini, at Modena. Guicciardini told his friend that the forces of the League were so scattered that even in extremities he could march no more than six or seven thousand of the papal infantry to help the city. Florence must do the best it could.

Florence was governed chiefly by the inept Silvio Passerini, cardinal of Cortona, through packed committees on behalf of the pope and the

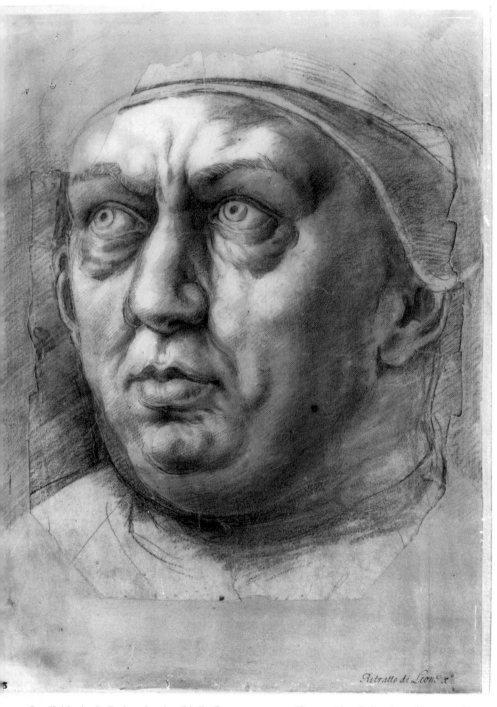

19. *Leo X*, black chalk drawing by Giulio Romano, *c*.1515 (Devonshire Collection, Chatsworth)

20. (*Above*) Raphael, woodcut from Vasari's *Lives*, 1568

22. (*Below*) Sketch for the Julius Tomb project, pen drawing (lower half of sheet) by Michelangelo, *c.*1505 (?) (Gabinetto Disegni e Stampe, Florence)

21. Gilt bronze portrait medal of *Donato Bramante*, with an allegor of Architecture seated before the façade proposed by Bramante for St Peter's (*reverse*), by Cristofor Caradosso Foppa (British Museum Attributed as a self-portrait to Bramante in *The Currency of Fame* ed. Stephen K. Scher, London, 19

VITA DI RAFFAELLO DA VRB. PIT. ARCHITETTO.

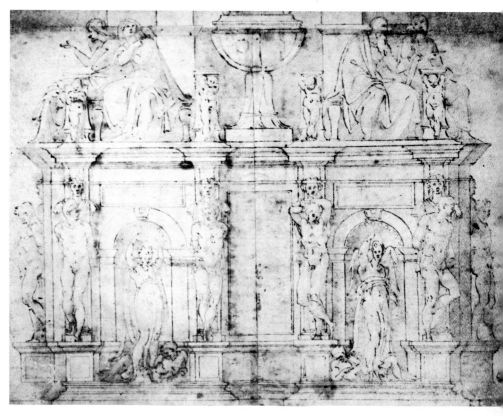

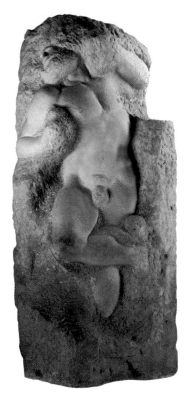

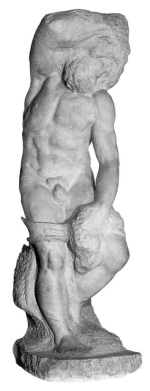

23. *Awakening Captive*, marble by Michelangelo, 1520–34 (Accademia, Florence)

24. *Bearded Captive*, marble by Michelangelo, 1520–34 (Accademia, Florence)

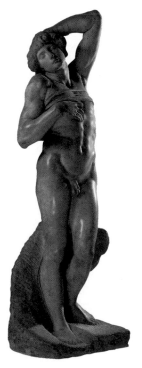

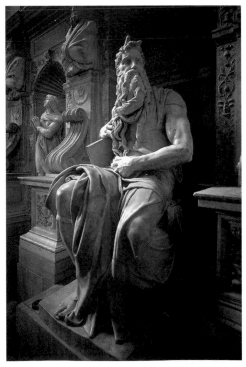

25. *Dying Slave*, marble by Michelangelo, 1513–16 (Louvre, Paris)

26. *Moses*, marble by Michelangelo, 1513–16 (San Pietro in Vincoli, Rome)

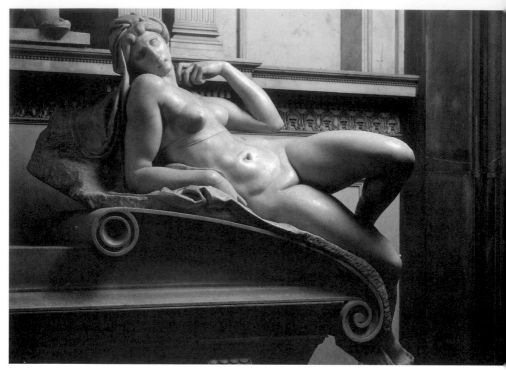

27. *Dawn* (*Aurora*), detail from the tomb of Lorenzo de' Medici, marble by Michelangelo, 1524–31 (Medici Chapel, San Lorenzo, Florence)

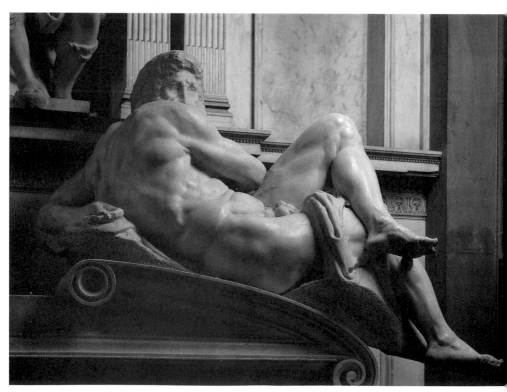

28. *Day* (*Giorno*), detail from the tomb of Giuliano de' Medici, marble by Michelangelo, c.1526–34 (Medici Chapel, San Lorenzo, Florence)

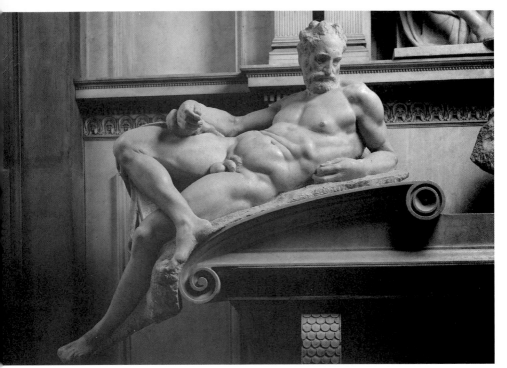

Dusk (*Crepuscolo*), detail from the tomb of Lorenzo de' Medici, marble by Michelangelo, *c*.1526–34
(Medici Chapel, San Lorenzo, Florence)

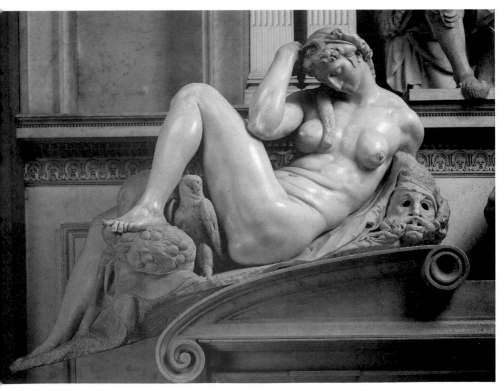

Night (*Notte*), detail from the tomb of Giuliano de' Medici, marble by Michelangelo, *c*.1526–32
(Medici Chapel, San Lorenzo, Florence)

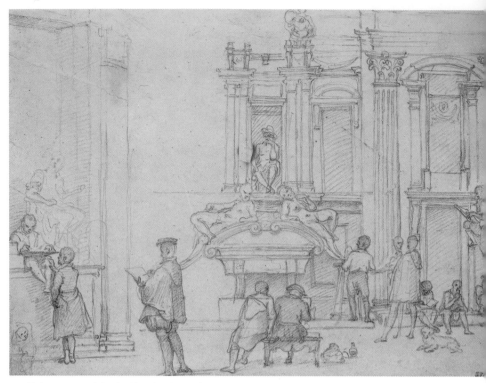

31. *Painters at work in the New Sacristy, The Medici Chapel, San Lorenzo*, black chalk and pen drawing by Federico Zuccaro (1540/43–1609) (Louvre, Paris)

32. Wooden model of the façade (never realized) for San Lorenzo, probably executed by Pietro Urbano to Michelangelo's final design, *c.*1517 (Casa Buonarroti, Florence)

33. *Andrea Quaretesi*, portrait in black chalk by Michelangelo, *c*.1532 (British Museum, London)

34. *Pope Clement VII*, oil on canvas by Sebastiano del Piombo, 1526 (Museo di Capodimonte, Naples)

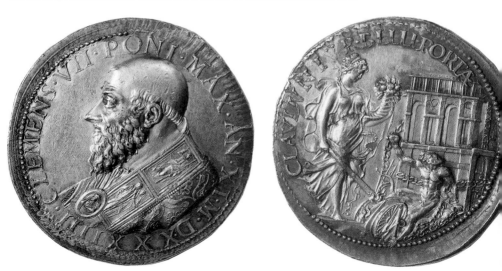

35. Portrait medal of *Clement VII*, showing Peace with cornucopia and flaming torch burning the weapons of war (reverse), by Benvenuto Cellini, 1534 (Museo Nazionale, Bargello, Florence)

Medici family. The Medici lords in Florence, Ippolito and Alessandro, were still teenagers.

The Florentines' nervous discontent with the regime and its policies grew more threatening as their safety as well as their pockets became increasingly affected. After years of financial drain, at the end of 1526 the physical danger was now mounting towards a climax.

41 Family fortunes: rancour and reconciliation

Nothing ran smoothly for Michelangelo in 1526. Among the minor irritations was that he needed to find a new personal servant. In August 1525 he had engaged a Niccolò from Pescia, at a salary of four and a half lire a month. For some reason he dismissed him in December 1526, and several days later he took on a Mona Chiara from the Casentino as a maid, at nine florins, or thirty-six lire, a year.

Following Clement's self-interested but well-meant attempts to satisfy him with a decent financial arrangement, after Michelangelo's brief visit to Rome in 1523, Michelangelo had agreed in the summer of 1524 to take possession of Casa di Macciagnini, the house offered to him at San Lorenzo, and to be paid the arrears of his salary, 400 ducats, which he received the following October. Even so, his sense of divided responsibilities and obligations – to the dead Pope Julius and to the live Pope Clement – continued to make him fret over what he was earning and what he might owe.

In October 1525, writing to Fattucci about all the work he still had to do for San Lorenzo and for the tomb, he had added that he had not drawn his salary for a year and was fighting against poverty. In November 1526, when he wrote to Fattucci saying he was in great turmoil over the suit against him by Pope Julius's relations and was aware that public spending was being curtailed, he offered to have his own expenses cut back. In December 1526 he offered to give up the house in Florence.

The family property in Via Ghibellina, in the parish of San Pier Maggiore, had played its silent part in the domestic drama of Michelangelo's life since about the time of his thirty-fourth birthday, in 1509. In 1523 Michelangelo had made a valiant effort to sort out the

financial entanglements of his father, his brothers and himself, and to end their recriminations. He wanted partly to safeguard his own financial position, partly to ease the remaining years of his father, now wanting to return to Florence after his earlier insistence on staying in the country alone.

Far from achieving family harmony, the legal agreement they had drawn up in 1523 caused renewed rancour, especially between Michelangelo and his father. Both felt betrayed. The two letters from Michelangelo written in June 1523, immediately following the confused Lodovico's (missing) letter of complaint to him, blazed with hurt and fury, from the sarcastic opening words of the first – 'Such good news in your letter this morning' – to the final 'God help you!' of the second.

Michelangelo made renewed attempts at reconciliation, even suggesting the possible annulment of the agreement. Explanatory letters to Lodovico from his brother-in-law Raffaello Ubaldini, who had been involved in the arbitration, showed Michelangelo's deep concern to hold the family together. But he failed to prevent Buonarroto with wife and children moving away from the house in Via Ghibellina to a rented house in the Santa Croce quarter, where Giovansimone also stayed when he was in Florence. The house in Via Ghibellina was left to Michelangelo and Gismondo. Lodovico stayed where he had been living for some while, in Settignano.

After the outbursts in 1523, the Buonarroti Simoni family soon resumed its normal course of emotionally fraught but fond and frequent exchanges. At least from the autumn of 1526, Michelangelo was sending his father grain, wine, poultry and sweets. He also recorded sending Antonio Mini to his brother Buonarroto in January 1526 with the money for a length of fine cloth for a robe. About two years before, Buonarroto and Giovansimone had stopped running their shop and Buonarroto had become a minor investor, in effect an employee, in another enterprise in the wool trade. By the end of 1526 the prospects for him and this business were bleak, especially with the disruption of Florence's commerce. Giovansimone meanwhile stayed close to Buonarroto and his wife Bartolommea and her family, which he liked to visit in the Mugello. He still seemed to be regarded with special fondness by Michelangelo, whose religious and poetic inclinations he shared.

Michelangelo's more responsible, slower, youngest brother, Gismondo, served as *podestà* of Mangona for six months until April 1526. Just before Gismondo received his 500 florins from the 1523 settlement, Lodovico had commented in a letter to Buonarroto written in January

1525 that he felt sorry for Gismondo, who was frightened and did not know where to go. 'He says that Michelangelo is treating him badly. Consequently I am very melancholy.' In the same letter from Settignano, Lodovico mentioned the child he was looking after – and said to be spoiling – and insisted he did not want to send her back to Buonarroto in Florence. This was the daughter of Buonarroto and Bartolommea, Francesca, now six years old, whose brother, Lionardo, had been born in April 1522. Another boy, Simone, followed in 1526.

One of Buonarroto's Florentine friends in Spain, Bartolommeo Cisti, wrote to him in January 1526 about business and family matters and mentioned the marriage of the emperor Charles V (to Isabella of Portugal) and his hopes that the agreed marriage of the king of France with the emperor's sister Eleanor would ensure peace. 'Pray God this may be so, for, if we have peace between these two princes, it can also spread throughout Christendom.' By the end of 1526 peace was a hopeless cause. Florence waited for war. Everyone was in danger.

42 Dangerous choices • The sack of Rome • The siege of Florence

At the beginning of 1527 the sounds of work died away at San Lorenzo. Michelangelo eyed the unfinished, unadorned library; the shell of the new chapel with the tomb of (probably) Giuliano, duke of Nemours, just assembled; the nearly finished statue of one of his 'Captains'; the four figures representing Night and Day, Dawn and Dusk, emerging still from the stone. He continued to work on the marbles for the sacristy when and as he could, but the political situation was alarming. He faced dangerous choices. Pope or Republic? Family or friends? Service or survival? Defiance or flight?

The mainly Lutheran soldiers mustered by Frundsberg had marched into Italy fired with hatred for the Roman Church and heady with the notion of killing the pope and destroying the power of the papacy. Frundsberg wore round his neck a gold chain with which, he said, he would strangle the pope. In February 1527 the German Landsknechts, marauding and pillaging as they went, joined forces with the Spanish

troops commanded by the duke of Bourbon near Piacenza, about 150 miles north-west of Florence, beyond the Apennines but south of the Po.

Terrifying reports poured into Florence during March 1527: the duke of Urbino, promising assistance, held well back from the front; the League's army under Guicciardini stayed irresolutely encamped near Reggio, and the Imperialists pushed south, ravaging Bolognese territory *en route*. Frundsberg suffered a stroke after trying to quell a mutiny among his troops, and the tragic duke of Bourbon, Frundsberg's ally, though centre-stage, was now powerless over his half-starved, ragged, unpaid army. The captain-general of the Spanish troops (the marquis of Vasto), professing loyalty to the emperor's orders, left for Ferrara; Bourbon was left alone to discipline his army as best he could.

On 25 April the army of the League moved south to Incisa, to block an attack on Florence; the duke of Bourbon had been borne along with the surge of his army and was now at San Giovanni, about thirty miles from Florence. Futile attempts were made to buy off the duke of Bourbon. On 26 April the two young Medici, with attendant cardinals and a large escort of troops, rode out of Florence to meet the duke of Urbino, who had at last moved south with his Venetian army. An affray between soldiers and citizens and the cry that the Medici had run away were the immediate causes of an uprising in Florence on the same day. The Signoria was compelled to restore the 1512 constitution and sentence the Medici to exile.

For several days all was in suspense, even after the cardinals returned with Ippolito de' Medici and the duke of Urbino, but thanks to Guicciardini, who had returned to Florence with Machiavelli and what troops he commanded after leaving garrisons behind him, the rebels were pacified without any storming of the Palazzo della Signoria. It was, however, besieged for several days, during which the anti-Medicean occupiers hurled down a bench which hit the raised arm of Michelangelo's statue of David and broke it into three pieces. (The young Giorgio Vasari and his friend Francesco de' Rossi emerged a few days later to salvage the broken pieces and store them away safely.)

The Medici were back in Florence after a bloodless, aborted coup, seemingly more entrenched in the city than before.

With the duke of Bourbon in Tuscany, Clement was fearful for Florence but relieved for himself and for Rome. He thought of raising troops to attack the territory of Siena and so pin the Imperialists down. He was consoled by reports that the duke of Bourbon's forces were hamstrung by lack of money and supplies and would at least have to turn aside to recuperate near Siena.

The news reached Florence that, on 26 April, the duke of Bourbon

had departed from the country around Arezzo with all his army, without its modest artillery and its baggage-train, and had headed towards Rome. No one quite knew why. Perhaps the emperor had contemplated a crushing defeat of the pope all along, knowing also that Bourbon's troops would have to be paid with booty.

Early in May it was learned in Florence that the duke of Bourbon had been covering up to twenty miles a day through the central plains, sacking towns that resisted. On Sunday 5 May his army reached the summit of Monte Mario before crossing the fields towards the Vatican Hill and pitching camp outside the walls as the sun set. He attacked the city on 6 May; on 7 May Rome was sacked. After a few tense days of silence and confusion, the emperor Charles V heard the news in Valladolid, and smiled.

Rome was filled with artists, but not one of them left even a sketch of the terrifying sack of the city, which went on in full spate for about a week and intermittently for months. The Florentines pieced the shocking story together as the posts and refugees arrived, while some of them exulted in the apparent fulfilment of Savonarola's prophecies and prepared for the inevitable revolution in government.

The attacking Spaniards and Germans were helped by rain and fog as they approached the Borgo and the Vatican at dawn and scaled the walls. During the main assault at Porta Santo Spirito the duke of Bourbon, riding before his troops, was killed by a shot from a harquebus. But within a couple of hours his troops were rushing through the Borgo, and the pope, his white robes covered up, had fled from the Vatican along the recently constructed open passage to Castel Sant'Angelo, a secure refuge behind its bastion and moat.

By nightfall the city proper had been breached from Trastevere by the undefended Ponte Sisto. Positions were taken up on the Piazza Navona by the Spaniards and on the Campo dei Fiori by the Germans. But, soon after, the troops broke away and massive looting started. The sacrilegious Germans and savage Spaniards, it was told in Florence, had run wild in search of booty from the rich stores of cardinals, courtiers and merchants, respecting nobody and nothing, however sacred. Prelates had been mounted on asses and mules in their vestments and tormented, tortured to death or held for ransom, mocked and reviled. Women, including nuns, had been seized and raped. Churches had been vandalized and despoiled. Whole libraries had perished, and papal manuscripts had been used as litter for horses. After the ravening hordes of soldiers had done their worst, the peasants had come in for the pickings among the corpses, the fires and the ruins.

The Florentine eyewitness Benvenuto Cellini thought it was his shot that had killed the duke of Bourbon. The occasion and its heightened circumstances etched themselves on his memory: the first glimpse through the fog from the walls of the Campo Santo of Bourbon's army; the wild confusion he saw after firing towards the thickest part of the enemy and hitting their great leader; the sad spectacle of a Florentine bombardier staring from battlements at the sight of his house being sacked and his wife and children outraged; and the conflagration of all Rome.

During the month that the castle was besieged and he was actively engaged on the guns, Cellini secretly melted down the gold settings of tiaras and jewels from the Apostolic Camera and sewed the gems in the linings of the clothes of Pope Clement and his French groom, Cavalierino. Then he escaped to rejoice with his father in Florence, with a servant and a splendid horse.

For other craftsmen and artists, as for numerous scholars and prelates, the fall and sack of Rome had very different consequences: captivity, flight or death. Giovanni da Udine left Rome for his home city after being robbed and beaten. The Croatian illuminator known in Rome as Giulio Clovio, a passionate student of Michelangelo's work, after being wretchedly treated by the Spaniards hastened to Mantua, where he joined the regular flagellants of the monastery of San Ruffino. Jacopo Sansovino left hoping to reach France via Florence and Venice (which kept him), leaving important projects behind in Rome.

Parmigianino had a narrow escape from a band of Germans, who were amazed that he had carried on working on a painting of St Jerome, oblivious to them as they marched in. They accepted his pen and some drawings as ransom.

The engraver Marcantonio Raimondi was impoverished through the ransom he had to pay the Spaniards, lost one of his most beautiful engravings to the Germans, and left Rome for good. Perino del Vaga fell into a deep depression after being chased from place to place and then forced to pay ransom, and soon after, leaving his wife in Rome, fled to Genoa.

The Aretine painter Giovan Lappoli fled from the violence with his friend and patron the papal secretary Paolo Valdambrini, but was taken captive. Valdambrini was killed. Lappoli made his escape from Rome with some other prisoners, stripped down to his shirt, and reached Arezzo a nervous wreck.

Rosso Fiorentino was humiliated when the Germans tore off his clothes and made him, barefooted and bareheaded, empty a cheesemon-

ger's shop of all its stock. The Tuscan painter Vincenzo da San Gimignano, a beautiful colourist who had been befriended by Raphael, left Rome so depressed by the carnage and was then so disturbed by his changed circumstances that he lost his talent and peace of mind, and killed himself. Two prolific painters – Polidoro and Maturino – so fond of each other that they had come to share everything, after resolving to live and die together like brothers, were cruelly separated. Maturino the Florentine was so weakened during his flight from Rome that he succumbed to the plague. Polidoro of Caravaggio went to Naples, where he won very few commissions and nearly starved to death; but eventually he found employment in Messina.

Michelangelo's Sebastiano lived through the sack and its aftermath, loyally sticking close to the pope and witnessing with horror the indignities he endured. Antonio da Sangallo the Younger, employed by Pope Clement before 1527 to strengthen the fortifications of the Papal States, did soon return after the sack to begin a vast programme of military engineering for the resurgent papacy. But the artistic colony that had flourished in Rome during Clement's pontificate was largely dispersed. Rome's loss was France's, Genoa's and, above all, Venice's gain.

Beautiful stained-glass windows in the Vatican planned by Bramante and made by French craftsmen were broken during the sack and the lead was taken for bullets. Most of the looting was for easily transportable and disposable precious objects and cloths, for gold, jewellery and gems. Much of the plunder was marketed in the city itself, and the despoliation turned into a vast commercial and financial operation. No work of art seemed safe from vandalism or looting by Germans, Spaniards or native Italians. The most outrageous deal was mounted by Isabella d'Este, who was in Rome during the sack and sent her son, Ferrante Gonzaga, one of the Imperial commanders, 500 crowns to buy the Sistine tapestries woven from Raphael's cartoons. This was for safekeeping, she said; the tapestries would be returned on reimbursement.

This humbling of Rome was the culmination of bloody assaults and the sacking of other cities in Italy, not infrequently by Italians themselves, almost continuously over some fifty years since the early 1470s. Atrocities had been inflicted by the armies of Florence, Naples and the Turks in Volterra and the territories of Friuli and Puglia, and after 1494 by the French, the Spaniards, and the Venetians, whose highlights of horror were executed in Florence's Fivizzano and in Ravenna, Prato, Brescia, Fabriano, Como, Genoa, Pavia, Milan and Cremona.

Machiavelli, over a decade before the sack of Rome, in his passionate appeal at the end of the last chapter of *The Prince* for the liberation of Italy from the barbarians, had described the country as 'more enslaved than the Hebrews, more oppressed than the Persians, more widely scattered than the Athenians; leaderless, lawless, crushed, despoiled, torn, overrun'. The sack of Rome, after which no bells were rung in the city for nearly a year, brought a brutal end to the myth (shared by Venice and Florence) of its almost sacred immunity as the spiritual centre of Christendom and heir of the Roman Empire. The awfulness of the sack was taken by many to be a warning from God.

On 7 June 1527 Pope Clement's garrison marched out from the Castel Sant'Angelo and the pope was left captive, to treat for peace and negotiate his ransom. He could not look to Florence for help. On 16 May the government of the Medici had been overthrown, and the domination of priests and putti (as a Florentine noble described Clement's regime) ended in bathos. Cardinal Passerini insisted on honourable terms. He rode away abjectly with his two Medici nephews to Lucca, where he showed a flicker of resistance, but in vain. The new Republic adopted the constitution of 1494 as fixed in 1502 and corrected in 1512.

Michelangelo's horrified apprehension of the brutality of war had been attested at its deepest level in the marble battle scene he carved when a youth, which he never let out of his possession, and in the scenes of flight and violence depicted on the Sistine ceiling. War had struck at him as an artist, in his purse and his pride: under Julius in 1510, when the pope left Rome to do battle and his payments stopped; under Leo in 1520, when the agreement for the façade was scrapped probably for lack of funds and from military demands; and now in 1526–7 under Clement, as he tried to carry on with his work for the Medici Chapel while the Republic of Florence readied itself for the shock to come.

The Medici princes and Cardinal Passerini were escorted from Florence by Filippo Strozzi, and the insignia of the Medici were defaced or destroyed. The city now expected dissension and revolt in the dominions, and it took heavy bribes, for example, to persuade the castellan at Pisa to surrender the fortress. The pope might be powerless but he would look for revenge, and pro-Medici sentiment remained strong.

The rich families' dreams of an aristocratic, Venetian-style constitution soon evaporated, and the mass of citizens – 'the people' – took control in stages, beginning with the early restoration of the Great Council and the Council of Eighty. Niccolò Capponi was elected

gonfalonier for a year. The still pervasive influence of Savonarola on popular government was seen early on in measures such as the law to ban Jewish moneylenders and expel Jews; the law, in February 1528, declaring Christ the 'sole and true lord and king' of the Republic; the new law in December 1528 against sodomy and blasphemy; and the culminating theocratic legislation of June 1529, whose preface linked 'free and popular government' with the judgement of Holy Scripture.

In Rome, after a summer darkened by plague and famine and a terrible second sacking of the city by the Germans in November 1527, Pope Clement and his chosen cardinals settled the long-debated terms for a treaty with the representatives of the emperor. The agreements, finalized in December, stated that Clement was to be restored to his spiritual and temporal rights on condition that (while remaining neutral) he advanced the peace of Christendom and convoked a general council for the reform of the Church, the uprooting of Lutheran teaching, and the pursuance of the war against the Turks.

After his seven months of humiliating confinement, Pope Clement resumed his diplomatic activity from Orvieto, the traditional and beautiful refuge of the popes, which he had entered by night.

One of the visitors to Clement's court in exile was the painter Sebastiano. Another was the agent Dr William Knight, sent to Rome from England by Henry VIII about his 'secret matter': the wish for a dispensation to marry the unnamed Anne Boleyn and, almost as an aside, for annulment of the king's marriage with the emperor's aunt, Catherine of Aragon.

For a while it seemed that, despite the fury of the Imperial storm in Italy, Pope Clement could still stand up and choose his allies. It was amazing and unprecedented, Guicciardini reflected, for a pope to be held captive, lose Rome, and have his state subject to the power of others; and within a few months be restored to liberty, regain his occupied state, and then in a very short time be restored to his pristine greatness.

Pope Clement sensed opportunities again. In February 1528 Francis tardily sent Odet de Foix, vicomte de Lautrec, the great survivor from the battle of Ravenna, over the Alps with an army which moved fast through Lombardy and crossed the boundaries of Naples, drawing the Germans away from Rome. The Genoese admiral Andrea Doria, allied with the French, destroyed the Imperial fleet off Salerno, only − while Clement hesitated and bargained over the terms on which he would join the alliance against the emperor − to betray the French and join

the Imperialists, seizing Genoa. Meanwhile Lautrec died of the plague during his siege of Naples, and the French force dispersed. The pope, by the end of 1528, had settled once more for neutrality, as the treaty with the Imperialists had said he must.

In April 1529 the man who had been discreetly dealing with the pope from Florence, the cautious gonfalonier Niccolò Capponi, was deposed and replaced by the more populist Francesco Carducci. Policies of revenge on the Medici and their supporters, including ruthless moves against enemies of the government and insults to the pope, which had been pursued since the early months of Capponi's period of office, suddenly intensified. Ambassadors were sent to Pope Clement from Florence in September 1529, but there was no will to negotiate.

The terms proposed for a treaty between the emperor and the pope in Barcelona in June 1529 bound Clement to crown the emperor and invest him with the kingdom of Naples, and the emperor to restore the Medici to Florence, reinstate the pope in the four towns taken by Ferrara and Venice, and (but this did not happen) dispossess Duke Alfonso of Ferrara of his duchy. Milan was restored to the Sforza claimant. The king of France had made a separate peace with the emperor at Cambrai in August. Foreign intervention in Italy was not yet at an end, but its effects were being limited.

On 5 November 1529 the emperor met Pope Clement waiting enthroned outside the porch of San Petronio in Bologna. Outwardly, the pope possessed the greater dignity, as he graciously received the emperor. It suited Charles V that they should seem the best of friends and allies: a second Leo III, a second Charlemagne.

Several weeks of hard negotiation ensued, but Charles's bargaining strength was enormous. His Imperial power and the pope's spiritual authority were both resisted by increasingly vocal and rebellious Lutheran princes and cities in Germany, where Catholic–Protestant confrontation could easily lead to war. In October the Turks had raised their seige of Vienna, but they might return in greater strength in the spring. Among the Italian states neither the papacy nor Venice could now seriously impede the emperor's dispositions for an Italy where the forces of his chief rival, the king of France, had been once again defeated or dispersed.

On the first day of 1530, an alliance of peace between pope and emperor was signed in the cathedral of Bologna; the allies included the emperor's brother, Ferdinand, king of Hungary and Bohemia, along

with Milan, Mantua, Savoy, Monferrato, Urbino, Siena, Lucca and Venice.

Charles and the pope settled the affairs of Milan, where Francesco Sforza was restored as duke, and of Ferrara, where Duke Alfonso stayed. Venice won peace, and ceded Ravenna and Cervia to the pope. Only Florence was excluded from the general peace in Italy.

Agreement reached, Charles was crowned as emperor by Pope Clement at the high altar of San Petronio in 1530, on 24 February − the feast day of St Matthias, his birthday, the day he had taken the king of France prisoner, and the day he had taken up the symbols of imperial dignity.

The bizarre *rapprochement* between Charles V and Clement VII was imbued with artistic as well as political and religious ironies. Pedro Machuca, who had studied the works of Raphael and Michelangelo in Rome, began the emperor's great palace of Granada with its round colonnaded courtyard like the Colosseum. Ippolito de' Medici invited Titian to Bologna, where he did his first portrait of the emperor, shown wearing full armour while being crowned king of Lombardy. While Titian was painting, the Ferrarese sculptor Alfonso Lombardi, who had asked if he could carry his paints, surreptitiously modelled the emperor's head in stucco and later very profitably translated it into a marble bust at the request of Charles, who had noticed what he was doing.

Giorgio Vasari, who found Alfonso a very conceited man, loaded with jewellery and self-regard, was also in Bologna during the coronation festivities of the emperor, looking for work, but apparently finding none. Hating war as he did, he had left Florence in the autumn of 1529 and carefully avoided his own home in Arezzo. Florence had come under siege, and the garrison of republican Florence in Arezzo had been driven from the citadel.

43 Buonarroto's death • Florence fortified • Michelangelo in command

During the three years between the sack of Rome and the coronation of the emperor in Bologna, the uneasy atmosphere in Italy's cities intensified as the rulers prepared to do homage to Christendom's most powerful monarch. The bloodletting in Rome and the humbling of the pope seemed to portend further disasters.

Benvenuto Cellini had arrived home in Florence to find that thousands were dying from the plague. Suddenly, in the summer of 1529, he was enlisted to fight in the defence of the city. The Medici leaders had been expelled in 1527, but the emperor had agreed to help the pope restore Medici rule there. The expedition sent against Florence was led by the prince of Orange, who had succeeded Bourbon in command of the army which had sacked Rome. In October the army was encamped two miles south of Florence, at Piano di Ripoli.

Meanwhile, Machiavelli's urging that Florence must form a popular militia had borne fruit, and several thousands of young men of citizen class were formed into city guards. Cellini, a spirited twenty-nine-year-old, joined the company of the young nobles of Florence. But he soon returned to Rome, at the pope's request, slipping secretly away, fearful that the authorities might learn that he had been receiving letters from Rome.

There was an atmosphere of fear and suspicion in Florence; the young were defacing images of the pope, and people leaving the city without permission were sentenced to death in their absence.

Michelangelo's brother Buonarroto Buonarroti died of the plague at Settignano on 2 July 1528. He had been the best loved and closest of the Buonarroti brothers to Michelangelo, and he died in Michelangelo's arms. The wool shop he part owned and ran in Via Porta Rossa had closed because of the slump in business and he had planned to move to Rovezzano with his family, leasing a farm from Michelangelo. He left his wife, Bartolommea, with their two sons, Lionardo and Simone, and their daughter, Francesca. Michelangelo looked after the funeral expenses and the return of Bartolommea's dowry. He kept the six-year-old Lionardo in his own house for several months, and then sent him to

stay with Lodovico, who also took charge of the younger brother, Simone. Francesca, not yet nine, he gave into the care of the nuns of the convent of Boldrone.

In March 1528, while he was at Orvieto, Pope Clement had authorized a payment of 500 ducats to Michelangelo to continue work on the tombs at San Lorenzo. But for a while it seemed as if the new republican regime in Florence would now keep him employed as a sculptor of public works. Bandinelli had left in Florence an unfinished block of Hercules and Cacus. It was proposed that Michelangelo – described in the commission as a beloved citizen unique in both painting and sculpture – should use it to carve a statue of two joined figures to adorn the city. Michelangelo's suggestion was a figure of Samson defeating two Philistines. The same block had eluded him once before, when it had been excavated for the façade of San Lorenzo, and he himself had proposed carving from it the figures of Hercules slaying Cacus to stand beside his giant David on the piazza. Domenico Buoninsegni had later persuaded Clement to give it to Bandinelli, to encourage competition. (The threat of going to Bandinelli rather than Michelangelo, it was said in Florence, explained why the block had fallen into the Arno *en route* from Carrara.)

But whatever work Michelangelo may have done on the block by 1529, he then had to abandon it. In April 1529 Florence's Council of Nine – the *Nove della Milizia* on which Michelangelo was already serving – put him in charge of the city's fortifications and his appointment was confirmed a few days later by the newly established war committee, the *Dieci della Guerra*.

The new Republic under Niccolò Capponi had started to think seriously about Florence's fortifications only after it had struggled to put the state's finances in order and realized the fury of the pope and the feebleness of France's support. But controversies over what was to be done had smouldered for years. The mountains, many people thought, were Florence's true defence. The invasion of Charles VIII of France in 1495 with powerful artillery, and, more recently, the emperor's success in seizing and holding on to Milan, showed how obsolete this notion of defence had become.

Pope Clement, seeing Florence partly as a line of defence for Rome, had asked Machiavelli with the soldier-count Pietro Navarro to organize an inspection of the walls of Florence. This took place in March 1526. Machiavelli's report recommended stretches of new walls inside the city and opposed fortifying the hill of San Miniato, even though this would

mean abandoning the San Miniato district to the enemy. Clement pondered Machiavelli's advice and listened to him, but put his trusted architect Antonio da Sangallo alongside him to continue the supervision of the works.

Though no more was heard of the project to enclose all the hills beyond the Arno, the pope authorized the fortifications of San Miniato and Giramonte – to the dismay of Machiavelli, who thought the technical problems too great and also feared that the making of such a huge *fortezza* could play into the hands of a tyrant. In early 1527 stonemasons had started to cut down all Florence's old towers along the walls, as being likely to hinder defence against an attacking army, before strengthening the circuit walls with earth spurs, fortifications and gun embrasures.

During 1528 the new government of Florence had asked Michelangelo and the architect Sebastiano Serlio, called from Ferrara, to make studies of the city's existing defences and to tender advice. As the arguments grew more heated, Michelangelo came out with a vehement plea for the fortification of San Miniato – provoking strong opposition from Capponi. After Serlio returned to Ferrara in January 1529, Michelangelo, now the dominant expert, joined the *Nove della Milizia*. As procurator-general, in April 1529 he was given his head to implement his ideas for a massive single work of fortification: the great bastion of San Miniato.

Bastions had developed as the modern alternative to the tower, which the advent of heavy siege artillery was making obsolete. Michelangelo's drawings for permanent bastions, created when the system was in an early experimental stage, were probably done in 1528. They showed strange starlike forms with curves and claws, and seemed primarily planned to ensure flexible defensive strength.

Michelangelo had been determined to be in charge of Florence's fortifications, and now in 1529 he felt utterly self-confident as his enthusiasm was boosted by the stamp of official approval. He was republican by instinct and conviction. But he was politically suspect. He was even then still working on the arrogant projects of the Medici at San Lorenzo to commemorate and exalt the pope's family. Nearly all his working life he had been close to and patronized by members of the Medici family.

In the same month that Michelangelo was officially made procurator-general in command of the fortifications, the Committee of Ten hired 5,000 foot-soldiers under the *condottiere* Malatesta Baglioni, lord of Perugia, whose anti-Medicean credentials seemed absolutely

solid. Pope Leo had ordered the beheading of Malatesta's ferociously tyrannical father, Gianpaolo, ruler of Perugia, after luring him to come as his vassal for discussions in Rome. There was immediately bad blood between Malatesta Baglioni and Michelangelo Buonarroti.

During 1529, Michelangelo concentrated his energies on San Miniato. In July he held consultations with the defenders of Pisa after visiting the fortifications in Livorno, and in August, on the instructions of the Ten, he was in Ferrara to inspect the famous fortified walls encompassing that city. He was formally introduced as Florence's 'highly esteemed and celebrated' envoy by the Florentine spokesman at the court of Duke Alfonso d'Este, whose son was in the military service of Florence. Michelangelo was taken round Ferrara by the duke himself, and they discussed fortifications and munitions as well as the duke's collection of paintings and ancestral portraits. All the while, however, Michelangelo suspected that his visit to Ferrara, like other suggested fact-finding missions, had been engineered to frustrate him. While he was away in Ferrara, he swore, the works he had supervised in Florence were pulled down.

Michelangelo's anger and doubts grew as intense as the fury with which he set about the task of the fortification of San Miniato. The project was a race against time. Around the hill of San Miniato, rising high over Florence and commanding a broad sweep of countryside to the south-east beyond the Arno, he was throwing a circle of huge earthworks to support the artillery needed to halt the enemy and bombard its siegeworks. Under intense mental pressure, during 1529 he was having to move from the rapid refinement of innovative designs to the rigours of hasty on-site construction. As when he road-built and quarried for San Lorenzo, he was immersed in detailed management, from subcontracting to supervision. 'I give notice to your Lordship of the assignment of the first ditch above the road which goes to San Miniato,' began a memorandum he received, dated 17 June 1529, which ended, 'Provided that your Lordship supplies the tools for excavating, that is six mattocks, eight shovels, two iron levers and two iron mallets . . .'

Assisted by his elderly collaborator at San Lorenzo, Stefano Lunetti, who translated his ideas into drawings and models, Michelangelo was served by a bevy of paid master craftsmen and by smiths, masons and woodworkers, as well as large squads of unskilled men, forced labour from Florence or the villages, chiefly used to dig and move earth, rewarded with supplies of bread and wine, and sweating through many nights by the light of flaming torches.

San Miniato's dips and slopes became busy worksites teeming with Michelangelo's troops of men engaged in shortening the lines of earlier Medici defences but still taking in the tall campanile of the church and monastery as an essential lookout point; raising two cleverly modified bastions with high artillery platforms; and building bastioned curtain walls with ditches up the hillsides to bring the new fort within Florence's old perimeter of defence. For speed, the materials Michelangelo used for the ramparts were interwoven branches of oak and chestnut, at the base, and heavily packed earth mixed with straw, faced with unbaked bricks of tow and dung – better than stone to absorb the shock of missiles. Timber and stone were needed for strengthening parts of the bastions and parapets. As the strongpoints went up, the surrounding land was thick with ox-drawn carts loaded with stone and lime, great beams dragged at the end of ropes, big casks and barrels and tubs spilling over with oil and water. The production process culminated in the siting of guns on the walls and the stockpiling of munitions nearby against the onslaught of an advancing enemy.

Michelangelo's immediate enemies, however, were within the walls of his own city. His reluctant visit to Ferrara and the regard shown him by the duke contrasted with the threatening atmosphere in Florence. About this time Michelangelo was, fruitlessly, asking permission to leave Florence to go to France. The idea of flight grew in his mind.

Because of the restored ancient alliance of pope and emperor, Florence now became the target of the Spanish and German troops under the command of Philibert de Châlons, prince of Orange. In September 1529 Florence's desperate last-chance negotiations with Clement foundered; the city was under seige.

Late in September, on the evening of the 21st, Michelangelo left Florence secretly, without a word to his friends, suddenly deserting the bastions for a meal at home, using his authority to have a gate opened before riding to Venice. His motive was fear for his life, and his intention was to seek refuge in France. This, at least, is how he explained his actions to Giovanni Battista della Palla, from Lucca, an enemy of the Medici who was protected by Francis I and employed by him to buy works of art in Italy.

He had left Florence, Michelangelo wrote to della Palla in a letter dated October 1529, to go to France, but had learned that the route through German territory was dangerous and so was waiting to accompany della Palla when he went there. He had left Florence totally unprepared. It was not as if he had been frightened to see the end of the war, he assured him:

but then on Tuesday morning, on the 21st of September, someone came out from the San Niccolò gate, where I was at the bastions, and whispered in my ear that I should stay no longer if I wished to save my life; and then he came home with me, and dined there, and had horses brought for me, and never left my side till I quit Florence, claiming that this was for my good. Whether God or the devil, who he was I don't know.

Michelangelo had earlier reported to the Signoria rumours of betrayal he had heard were circulating among the soldiers, only to be accused of being timid and suspicious, especially by the gonfalonier, Francesco Carducci. Michelangelo had grown increasingly fearful that Malatesta Baglione would betray the city. He had become more edgy still when Malatesta left his allocated artillery at the bastion unguarded and one of the captains, Mario Orsini, remarked to him that the Baglione family had always been traitors and Malatesta would now betray Florence.

Michelangelo left for Venice with his own little escort, including his familiar assistant Antonio Mini, the sculptor and goldsmith Piloto, and Rinaldo Corsini, of Florence. Corsini went with them only part of the way before turning back. He and Michelangelo were among the thirteen leading Florentines or Medici supporters who on 30 September were all declared rebels for having left Florence without licence and for having failed to return. They would be absolved if they came back by 6 October.

In Florence during 19–25 October 1529 Francesco Granacci prepared a little inventory of the household items Michelangelo had stored away when he fled to Venice, leaving his servant Caterina in charge: quantities of grain, salt, clothing, silver forks and spoons, barley, plates and bowls, wine, a mattress and a pillow. He also noted what was sold or spent on Michelangelo's behalf, and this included on 22 October a payment to the stonecutter Sebastiano di Francesco Balena to seek Michelangelo out in Venice.

'Dearest father', Gismondo Buonarroti wrote from Florence to his father Lodovico at Castelfranco di Sotto, in the Valdarno, on 21 August 1529:

> It is said that the troops of the emperor have turned towards Milan; it is said here by some that the troops of the pope have moved from Rome to come here, and there are also some who say that the pope's affairs have gone cold because he has not given any money to his soldiers. However, then, I am telling you nothing I know for sure, but just the chatter.

Lodovico, serving the state again in his eighties, had accepted the post of *podestà* at Castelfranco di Sotto, where he had arrived in July, perhaps pushed by the family chiefly because of the chance this offered to get him and his fatherless grandsons out of the turmoil of Florence, though at first he was too anxious and frightened to move. On 20 September, Gismondo, now the chief recipient of Lodovico's frets and complaints, wrote to tell his father that, wanting to visit him to give advice, he would have to ask permission from the Eight. The citizens were confined to Florence and could not go to the country without permission. He had some wine and other things to worry about, and was growing desperate. So, if things were disagreeable for Lodovico where he was, he must be patient, as he would be worse off in Florence. Then, at the end of September, Gismondo – still anxious about his barrel of wine in the country – wrote to Lodovico to say that he could not see him, as all the passes were guarded. He had taken courage, and if there were a battle he wanted to die on the city's walls. Lodovico had been lucky to be made *podestà*, for he would have died of grief at the cruel spectacle in Florence of men dead from fatigue.

44 Under siege • The picture of Leda • The statue of Victory

In a letter dated 29 October 1529 (written, he said, with his boots on and his foot in the stirrup as he set out on the journey back to Florence after waiting for Michelangelo in vain), Giovanni Battista della Palla called on Michelangelo to return to save the besieged city, his friends and his honour. His mood now reflected still more the defiant spirit of exultant patriotism seizing many in Florence, where the followers of Savonarola were reporting glimpses of angels flying to defend the city with flaming swords, even as the prince of Orange quartered his army, strengthened with artillery from Siena, on the hills of Montini, del Gallo and Giramonte, to face the fortifications of San Miniato.

Michelangelo was also warned by his friend in this letter (in case he had not begun to return) that the goods of those who had fled with him and were still contumacious were being sold, and that if he did not come within the month covered by a safe conduct that had been obtained for him the same would happen to his property (which had so far been immune).

On 9 November, Michelangelo was on his way back to Florence and lodging in Ferrara. He was travelling in the company of Antonio Francesco degli Albizzi, a long-time opponent of the Medici, and Antonio Francesco's wife and children. Their illness seems to have caused the delay.

Almost as soon as he arrived in Florence, just before or on 23 November, Michelangelo set to work again on the defences of San Miniato, notably by repairing damage done to the campanile. As if to redeem his reputation after his less than glorious flight, he was credited with an ingenious decision to use bales of wool and stout mattresses suspended by ropes to protect the vital campanile from heavy cannon.

At any rate, Michelangelo was restored to his post as supervisor of the fortifications of the Republic. During his absence, Francesco da Sangallo had been named governor-general of the fortifications. His work in fulfilling parts of Michelangelo's plans was overshadowed by the drastic decision to help the defence by demolishing the suburbs and destroying the trees for a mile or more around the city, a brutal Machiavellian stratagem. This meant wiping out the city outside the city – the ruination of villas, houses, shops, churches, monasteries, gardens, orchards and vineyards, many of which constituted or contained precious works of art.

Michelangelo had no hand in this terrible exercise but was back in Florence in good time to take part in the final phase of the bombardment and defence of San Miniato. Again he assumed a heroic stature as the organizing genius of the defence of Florence; Antonio da Sangallo and the reluctant Baldassare Peruzzi were the equivalent artist-engineers in the Imperial camp.

Another renowned Florentine, Francesco Guicciardini, was with the pope in Bologna. His fine villa at Santa Margherita provided lodging for the prince of Orange. At the end of October 1529 two of the prince of Orange's cannon, aimed at the tower of San Miniato, exploded. Another cannon was brought up. The bombardment was continued in vain. Preparations for assault on Florence and counter-plans for defence turned into prolonged siege and skirmishes. After an attempt to escalade the walls on 11 November, the prince of Orange dug in and waited for reinforcements from Lombardy. Florentine harquebusiers and cavalry (there were 8,000 foot-soldiers in the city) made incursions into the increasingly anarchic countryside.

In the new year, the agreement reached between the emperor and the pope in Bologna freed more Imperial soldiers for the onslaught

against Florence. Four thousand German foot-soldiers, 2,500 Spanish foot-soldiers and 800 Italians, and over 300 light horse, with 25 artillery pieces were reported to be joining the campaign. The siege ground on into the spring and summer of 1530 and attracted mercenaries and marauders from the rest of Italy. Then nearby Empoli with its vital stores fell to the Imperialists, and the Florentines began to starve.

Deaths from disease and hunger finally peaked at nearly two hundred a day; food supplies from the ravaged countryside had dwindled, rationing and price controls had been ordained, and the poorest Florentines had only rats and cats for meat.

Michelangelo, despite being busy at the guns, began to fulfil his promise to the duke of Ferrara to finish a painting of Leda (a variation on his figure of Night for the Medici tombs) with the swan and the egg from which Castor and Pollux were born – a decorously lascivious theme after a Roman relief panel, or perhaps taken by Michelangelo from an ancient onyx cameo owned by Lorenzo de' Medici and then Pope Clement. About the time of the siege he also worked on the model for the statue of Samson and the Philistines that he was proposing to carve from the ill-fated block of marble left by Bandinelli.

During these months of continuous intellectual and physical exertion, fear, flight and return, Michelangelo completed a powerfully disturbing group probably for one of the niches for Pope Julius's tomb. Once again he created a larger than life-size male nude, this time with handsome, expressionless features, elongated twisting body, and powerful left leg bent to kneel on a baleful, bearded victim abjectly sprawling belly down and face pointed forward, like a trussed and defeated gladiator. The young man wears a garland of oak leaves. Carved to be viewed from the front, the tall, rippling, flamelike figure of the victor has his right arm from shoulder-blade to curving fingers set squarely across the half-turned chest, almost parallel to the front surface of the original block. The thrusts of limbs and torso left and right create a tense balance. The marble is mostly finished to perfection, but left criss-crossed with ridges and grooves on face and neck.*

The submissive face of the old man looks a little like Michelangelo's own, and also, with its thick beard and curled hair, not unlike the face

* Now in the Salone dei Cinquecento, Palazzo Vecchio, Florence. The name *Victory* was first given to this group by Vasari, after Michelangelo's death.

on the statue representing Day. The group, kept by Michelangelo in the Via Mozza, seems to belong to the family of ponderous figures done in the 1520s and to the same iconographical group as shown in one of Michelangelo's studies for San Lorenzo. Like the unfinished captives for the tomb of Julius – for which the statue may well have been intended – and the times of the day for San Lorenzo, the statue bears messages of defeat and defiance, submission and assertion.

In Rome in May 1530 Pope Clement was back in the Vatican, still appeasing the emperor (and still thinking that somehow, subtly, he might not always need to). Guicciardini had been officially exiled from Florence in March and his property confiscated. The city was moving bravely to defeat. His fellow Florentines, Guicciardini wrote in his *ricordi*, had defended their walls against the enemy 'for seven months when one would not have expected them to resist even seven days'. No one would be astonished if they gained the victory, though everyone had thought they were lost. 'This obstinacy sprang largely from their faith in the prophecy of Fra Girolamo [Savonarola] of Ferrara, that they could not perish.'

From mid-June, as plague sapped the strength of the Florentines still more, all initiative passed to the combined Imperial forces. The Imperialists overran and brutally sacked Volterra, robbing Florence of a possible supply line and forward operational base. The Florentines desperately summoned Francesco Ferrucci to march from Pisa and by a circuitous route join his forces with those in the city.

In the mountains to the north above Pistoia, near Gavinana, halfway between Pisa and Florence, on 3 August Ferrucci's outnumbered Florentine forces retreated after a brave battle. The prince of Orange died after rushing forward in the first charge like a plain soldier. Ferrucci was captured and then murdered.

On 10 August four Florentine emissaries agreed terms with the commander Ferrante Gonzaga (the third son of Federico, marquis of Mantua, and of Isabella d'Este), a hard professional soldier who had guarded the bridge of Sant'Angelo when the sack of Rome began. After the immediate payment of 80,000 ducats for withdrawal of the army, Florence and the pope were to declare within three months the form of the city's government; all outrages and abuses committed against the pope, his friends and servitors would be pardoned; until the emperor's declaration arrived, Malatesta Baglioni was to stay in charge of the city, with 2,000 foot-soldiers.

The rush of events was overwhelming. Baglione was determined to

quit. The need for money and orderly government was urgent. Bartolom-meo Valori or Baccio, the pope's apostolic commissioner, pursued the old ritual of convoking the people for a *parlamento* in the piazza, and this – the lines of papal troops made sure that it consisted of Medici supporters – approved the calling of a *Balía* of twelve citizens (including Ottaviano de' Medici) which abolished the Great Council and restored the pre-1527 form of government.

The new government of Florence launched a campaign of torture, incarceration and banishment, while Pope Clement eased his conscience with the argument that pardoning outrages against himself did not mean cancelling wrongs committed against the Republic. Six men were beheaded, including the former gonfalonier Carducci; Michelangelo's friend from Lucca, Giovanni Battista della Palla, died in prison, after poisoning himself, it was said. The killings and persecutions were intensified despite the return of the supposedly civilized Francesco Guicciardini on 24 September to reorganize the administration for Pope Clement. Guicciardini proved merciless. The Florentines called him Ser Cerrettieri, after the Messer Cerrettieri (Bisdomini) who had been the executioner of a trecento tyrant in Florence, the duke of Athens; Pope Clement they called *Papa Che-mente* – the liar.

45 In hiding

Before the collapse of the resistance of Florence, Michelangelo had discreetly gone into hiding. The harshness of the new régime confirmed his prudence. Despite his Medici attachments since boyhood, he had been on the war committees of the upstart régime, and had worked on the defences of the city against pope and emperor.

Michelangelo's future was clouded, and his life was again in danger. He was now fifty-five, physically still immensely strong, but ailing, disillusioned, emotionally battered and frightened. But he had all his wits about him, for his own and his family's sake, just as he had when he fled to Venice with 12,000 gold florins, and wrote to della Palla the kind of justificatory letter that could be handed round. This time he went to the safe house of a friend in Florence, just before all the rooms and chests, and even the chimney and the privy, of his own house were thoroughly searched.

The pope's ambitious Florentine commissioner, Bartolommeo Valori,

had been charged to clap into the Bargello prison the known enemies of the Medici, and the court had gone after Michelangelo directly. More alarming, Valori had given orders for Michelangelo to be killed to the pope's agent Alessandro Corsini, who had been reviled as a traitor to the Republic of Florence in 1530, but reappeared after peace was made with the pope, and in October was among the 136 citizens elected to the Council of Two Hundred. He was set to make himself infamous as the assassin of Michelangelo. There may have been a motive of revenge, for Michelangelo was believed to have dissected the corpse of a very handsome young Corsini, to his family's outrage, in the time of Soderini at the beginning of the century. It was Rinaldo Corsini who had surreptitiously instigated Michelangelo's flight, warning him that in hours rather than days the city would be in the power of the Medici.

Behind these rumours and the threat from Corsini was the reality of the pope's resentment of Michelangelo's service for the Republic during the siege and the hatred for him felt by Alessandro de' Medici. This hate was somehow engendered in Florence before Alessandro's expulsion with Ippolito in 1527. Now, after the surrender, Michelangelo had every reason to fear Alessandro and his agents, even before the Medici prince came back in person.

Giovanni Battista Figiovanni saved Michelangelo's life. 'Figi' – who had got in Michelangelo's hair when he was overseer of works at the San Lorenzo chapel – had never been able to forget the great, for him the holy, enterprise at San Lorenzo or to put aside his devotion to its fulfilment. It was in Figiovanni's house that Michelangelo may have hidden for several days from his enemies during the late summer of 1530.

Seen from Figiovanni's viewpoint, Michelangelo had always been one to try the patience of Job. It had been to the loyal priest, not to Michelangelo, that Cardinal Giulio de' Medici had first confided his dream of a library and a new sacristy at San Lorenzo. Michelangelo had always seemed to lack respect for 'Figi' – even for the pope, Figiovanni thought – and for Jacopo Salviati, who dealt with Michelangelo through Giovanni Spina. The pope had dismissed Figiovanni from the project after Michelangelo said that otherwise he would quit. When the work was suspended because of revolution, pestilence, siege and war, Figiovanni had assured the pope that he was still guarding the site. When Michelangelo had fled to save his personal fortune, Figiovanni had protected the fabric of San Lorenzo against harm. And, when Bartolommeo Valori sought to have Michelangelo killed, Figiovanni, in his own words, 'saved him from death and saved his property for him'.

During the siege and its aftermath, Michelangelo's fears and frustrations flexed his creative activities and defiance. The images in some of the verse he was writing reflected changes taking place in the depths of his thoughts and feelings. The month and year of the composition cannot be pinpointed, but it was probably during the siege of Florence that Michelangelo wrote in a *canzone* (*Oilmè, oilmè ch'i' son tradito*) lamenting his spiritually wasted years, '*Or che'l tempo la scorza cangia e muda* . . .' – 'Now that time changes and casts off the slough, death and my soul are still contesting with each other, the one and the other, for my [final] state.'

Michelangelo must have hoped fervently for the pardon, if not the forgiveness, of Pope Clement. He heard that he would be safe and the pope had said he could go free, so before the end of 1530 he went back to his work at San Lorenzo. By Christmas the pope had ordered Figiovanni, once more the overseer, to treat Michelangelo well and restore his allowance of fifty crowns a month. In November 1531, Clement, mindful of Michelangelo's health, ordered him under pain of excommunication to put aside all work except the Medici tombs. A few weeks previously, Giovan Battista Mini, Antonio's uncle, writing to the pope's man Valori, had remarked that Michelangelo, who was being cared for by Antonio and Bugiardini, seemed to him very extenuated and shrunken in body and that unless a remedy were found he reckoned he would not live long: 'for he works much, eats little and badly, and sleeps less; and for a month now he has been made an invalid by catarrh, headaches and dizziness'.

The restless intensity of the architectural work at San Lorenzo from its inception had been registered in the mass of drawings, mostly in black chalk and charcoal on the side-walls of the altar chapel. Among the great tangle of huge drawings and small sketches waiting for Michelangelo, the first to have been done were the full-scale ruled drawings of the inner and outer windows of the reading-room of the library, as guides for the masons. Distinctively by Michelangelo himself, several overlapping designs contain strong evidence of his dynamically creative working processes – as, for example, in the making of a double volute, for which the instruction changes as it were in the motion of a hand from a concave volute to one with a downward convex curve at its ends. Here, it is supposed, was a study for the lids of the wall-tombs of the sacristy.

As well as the work at San Lorenzo, Michelangelo's unfinished business after the siege included the Leda he had promised the duke of Ferrara. Alfonso, whose quick wit was matched by an evil temper, was

not a man to cross. Nor was Michelangelo. The duke, on hearing that the painting was ready, sent one of his courtiers to Florence to enquire about it. He was apparently worried for its safety in a Florence still in turmoil after the capitulation. Michelangelo made the gentleman from Ferrara welcome, and showed him the delicate erotic tempera painting of Leda coupling with the swan and Castor and Pollux born from the egg. The courtier made a remark to the effect that it seemed just a trifle. Michelangelo asked him pointedly what his own art was. The courtier retorted sarcastically that he was just a dealer. Then in that case, Michelangelo said, he had just made a bad deal for his master, and he sent him away with a flea in his ear.

When Antonio Mini left Michelangelo in November 1531 after nearly nine years' fond service, he took with him a batch of his master's drawings – perhaps more than anyone else had ever had from him. Among Mini's treasure trove was the painting meant for the duke of Ferrara, and the cartoon for it, given to him by Michelangelo. It was to help pay for his two sisters' dowries and his journey to France, it came to be said, though clearly he was meant to sell the Leda to the king, and make a profit for the artist.

46 Fra Sebastiano •
The third contract for the tomb

Michelangelo was again, almost as soon as he returned to his work at San Lorenzo, being harassed over the tomb of Pope Julius. The agent making overtures to Michelangelo on behalf of Francesco Maria della Rovere, duke of Urbino, was initially the not unfriendly painter Giro-lamo Genga, a man of Michelangelo's own age, close to the duke.

'He is a worthy man and shows himself to be fond of you,' Sebastiano Luciani wrote to Michelangelo on 29 April 1531, after he had met Genga at Pesaro. Sebastiano told Genga that good progress had been made on the tomb, but that 8,000 ducats were needed, and could not be found from anyone. Genga had replied that the duke would provide them, but feared losing his money and the work, and was very angry. Genga asked whether the work could not be in some way cut back to please both parties. Sebastiano had told him, 'He must speak with you. Dear friend, everything is up to you.'

Sebastiano had begun the same letter by saying how upset he was that Michelangelo's last letter to him had already been opened when he received it. Michelangelo had only a little previously begun to renew contacts with those of his friends left in Rome. He was uncertain of the mood of Rome and the present temper of the pope. Suspicion lingered like the plague. Michelangelo had used one of his amusing, familiar friends, the painter Domenico Menichella, to find out from Sebastiano how matters stood. Now in this long letter of 29 April Sebastiano earnestly reassured him. Michelangelo was not to fear coming to Rome, he said: all that was needed was a letter from him to 'the friend'. Michelangelo would soon see how much fruit this would bear, because Sebastiano knew the regard this friend had for him. If Michelangelo were to make a figure for him with his own hand in his own way, nothing would more suit Michelangelo's purpose, 'because he loves you, he knows you, and he adores your things and enjoys them as much as any man has ever done'. The friend spoke of Michelangelo so honourably and with such love and affection that a father would not say as much of his own son. Sometimes, to be sure, he had grieved over some gossip told him during the siege of Florence. But also, 'He shrugged his shoulders and said, "Michelangelo is wrong; I never did him harm."' Sebastiano also informed Michelangelo that the 'head' or portrait of Clement that he wanted – for Michelangelo's old friend Giuliano Bugiardini – was not yet ready.

Sebastiano had returned to Rome from Orvieto in the spring of 1529, a few months before the pope, and was painting again by the middle of 1530. He was Michelangelo's best intermediary with Clement, and the best go-between for fresh negotiations over the tomb of Pope Julius. Pope Clement's regard for Sebastiano was underlined when he granted him the office of the Piombo in the autumn of 1531, acknowledging his talent as the foremost painter in the shrunken art world of Rome. The Piombo – the Office of the Papal Privy Seal, where leaden seals were fixed to papal bulls – brought prestige and income, and could go to a layman. Cellini had asked the pope if he could have it, but, as Cellini recalled, Clement told him if he did, since the office brought in over 800 crowns, 'he would spend all his time scratching his belly'. When Cellini stormed out, Sebastiano – henceforth to be Sebastiano del Piombo – stepped forward and was appointed instead.

During 1531 Sebastiano began painting a series of portraits of Pope Clement. But, despite his partiality to the Venetian, Clement commissioned nothing substantial from him: all the money the pope had to

spare went on completing the works at San Lorenzo. This was his priority after the Apostolic Palace and the Holy House at Loreto. So Sebastiano's usefulness to the pope, ironically, was now chiefly through his role as Michelangelo's negotiator over Pope Julius's tomb and as the facilitator of his and Michelangelo's reconciliation.

On 16 June 1531 Sebastiano wrote that Clement wanted to favour and help Michelangelo in regard to the matter of the tomb of Pope Julius, which in truth would give Michelangelo back twenty-five years of his life. Clement had told Sebastiano that whatever was to be negotiated with the duke of Urbino's agents must be all and exactly what Michelangelo wanted.

Sebastiano was finding some time for his own work, still developing brilliantly and experimentally. Apologizing again for not sending Michelangelo the pope's 'head', he revealed when writing on 22 July that he had painted one portrait of Clement on canvas and that the pope wanted another same, but on a stone support (*sopra una pietra*). As soon as it was copied, he would send it to Michelangelo. In return, although Michelangelo kept his distance in Florence, Sebastiano still looked to his old ally for support in matters of practice as well as morale. He was still, for example, requesting and receiving composition drawings from Michelangelo, though the full tide of their collaboration had ebbed.

A long, newsy letter from Sebastiano to Michelangelo around the middle of November 1531 ('Pope Clement has made me *piombatore*', it erupted) revealed how perilously emotional the negotiations with the duke of Urbino's agents still were. As matters then stood, Sebastiano disclosed, the duke of Urbino wanted Michelangelo to complete the work as agreed after the death of Pope Julius, but he could not afford to pay the additional money wanted by Michelangelo and so wished Michelangelo to prepare a fresh design, which the amount already paid would cover. The duke's agent Girolamo Ostacoli had accused Michelangelo of wanting to sell a house which was not his, keep the money, and cut back and finish the work in his own way. After Ostacoli had told Sebastiano the duke wanted another drawing, 'I boldly told [him] you were not the man to submit trial designs or models or suchlike trifles.'

Tempers had been frayed all round again by 5 December, when Sebastiano wrote expressing his, and the pope's, dismay over Michelangelo's own latest outburst.

'Bear with me patiently,' Michelangelo had begun in his exasperated letter to Sebastiano, written a while previously, and 'think that it must

be more glorious to resuscitate the dead than to make lifelike statues.' He had thought hard about Julius's tomb and decided that there were two possible courses: to do it, or to give the money to the duke's people to do themselves. The first would not please the pope, who wanted Michelangelo to work for him, so it must be the second. Michelangelo would supply the drawings and models and the marbles already worked, with the addition of 2,000 ducats. 'I think a beautiful sepulchre could be made; and there are some young men who could do it better than me.' Michelangelo could put down 1,000 gold ducats immediately and somehow the other thousand later, 'provided they resolve on something that pleases the pope'. And, having mentioned the vexed subject of money, Michelangelo added that he could not do more because the 3,000 ducats he had carried to Venice had become fifty when he had returned to Florence, and the Commune took about 1,500 ducats in a forced loan.

Anxiety over money, various bodily ailments and unceasing work were compounding Michelangelo's resentments. After Antonio Mini had written informing Valori that Michelangelo had finished the second of the female statues, representing the Dawn, in the San Lorenzo sacristy, in the damp, in the cold of winter, and was sleeping badly (though he was healthy, and there were remedies for his ills), on 21 November Clement issued the brief forbidding Michelangelo to do any work other than for him on the tombs at San Lorenzo, though Cardinal Salviati was expecting a picture he had been promised, and Cardinal Cybo was about to request a drawing or model for his tomb.

Before the end of 1531, Sebastiano told Michelangelo that the pope thought a settlement about the tomb might be won sooner if he himself came to Rome, and Michelangelo made ready to do so. The duke's conciliatory ambassador, however, was called away to Pesaro. Talks started again only in April 1532, when Sebastiano sent Michelangelo a thousand-word letter of explanation and advice:

> My very dear friend, Girolamo Rucellai has arrived from Florence and told me of your well-being, and said that you only await a letter from me to begin the journey on the way to Rome, and I am very surprised, since if I remember rightly, many days ago, I believe in the week before Holy Week, I wrote you a letter in which I related everything to you and advised you that the ambassador of the duke of Urbino had returned to Rome; but I believe, from Girolamo's words, that you have not received it. So

once more I must repeat to you that the ambassador has told me that he must write to you, and that he awaits you with the greatest desire; indeed he said to me, 'Provided Michelangelo wishes to send what he has done in Florence for the sepulchre, to send it to Rome, all that Michelangelo wants will be done.' My dear friend, do not be dismayed by this, for it is up to you to send what you want as you please; but, knowing your mind as I do, I did not have enough courage to reveal what you intend to them, because I fear that their knowing your sentiments [*fantasia*] in this matter would so fire their imaginations with hitherto undreamed of ideas that they could hardly ever be disabused of them . . . But if you will adhere to my written advice, through your words and the promises you give to make designs and models, you may well satisfy them for what they fed you so long ago. You will then do everything as you wish, and they will wipe out the contract and you will get out of this wretched business. And, moreover, remember that you have a pope who is favourable and propitious and loves you as much as his own self. While you enjoy good fortune, learn to recognize it, since a pope could come along who perhaps would want to view matters differently, and would perhaps be more favourable to the opposite party than this one is. You may well say, 'If the pope chose, he could free me completely.' I answer you that he could not do so with honour, for many reasons that you know better than I do; and whoever gives you to understand otherwise does not wish you well and is just giving you talk. I am sad at heart that just with my pen I cannot explain to you what I am thinking: if I could converse with you for half an hour, perhaps you would understand my mind another way.

But, my dear friend, it seems to me that, to escape from your great servitude and from all these dangers and vexations, you would do best to give them all those stones and figures made for this work and have it finished by someone else and so get out of this entanglement as best you can, because at present you have lawful cause to be able to refuse to continue, inasmuch as the pope wants you to work just for him; under shield of this you can arrange the matter with them so that they will be content. As the weather changes, however, so they also may change, and you might wish to do things that would not please them, yet meanwhile your glory and honour do not depend on these figures which you have made, nor on this work; all the world will know that what is done from now on will not have been by your hand, and you will

bear no responsibility whatever for it, come what may, as you are too well known, and you are resplendent like the sun. Neither honour nor glory can be taken from you; just consider who you are, and think that no one is making war on you except yourself . . .

I think for sure that you laugh at my letters, and I seem to see you doing so: but I on the other hand give up and despair of the world, since with just a few words you could succeed in your aim and escape from all this vexation.

Girolamo [Rucellai] has told me that, if you want to come, you should give him notice, and he will go to bring you from Florence and accompany you to Rome and will return with you to Florence . . . Christ keep you well. This coming week I shall send you the head of the pope. I have finished it; it needs only to be varnished.

5 April 1532, in Rome

After this, Michelangelo's fraught dealings over the tomb of Pope Julius quickened pace. Sebastiano in agitation – the letter was signed off 'in a hurry' – wrote again to Michelangelo the very next day, 6 April 1532. The gist was that Michelangelo should find a master of whom he approved to finish the monument, and promise to favour him with drawings and models, so that the duke and his agents would be happy to scrap the contract hanging round his neck. From Florence he could send what pleased him; no one would check, Sebastiano said. What mattered was that the work had his feel to it – '*un pocco del vostro odore*'. 'And,' Sebastiano finished emotionally, 'if I seem to you to have taken the sword in my hand for you, do not wonder at it, for I would put at risk my own life, and my poor son, all I have, for love of you, and God knows this is so.'

Michelangelo reached Rome before this letter arrived in Florence. He stayed three weeks in Rome – not in his own house, which was in a bad condition through neglect and damage done during the sack of Rome, but at the Belvedere, with Benvenuto della Volpaia, who held office there and seems to some extent to have taken the place of Michelangelo's old friend Lionardo Sellaio.

Under pressure from the pope, and anxious to see the fruits of his concern for the tomb of his kinsman Pope Julius, the duke of Urbino instructed his ambassador to go gently with Michelangelo. Pope Clement's desire was still to help free Michelangelo of distractions from the work at San Lorenzo.

* * *

The pontiff's own serious distractions from the great work being for-warded by Michelangelo in Florence in 1532 included mulling over the doubtful agreements he had just reached with the emperor in a second meeting in Bologna; planning a Medici alliance with the king of France through the marriage of his niece, Catherine de' Medici, to Francis's second son; and waiting angrily for submissive gestures from England, whose Parliament had just been enacting measures to facilitate King Henry VIII's divorce and remarriage. None the less, on 29 April, when a third contract was witnessed between Michelangelo and the heirs of Pope Julius II, Clement saw the signing in his own rooms. The small group included Felice della Rovere, Sebastiano del Piombo and the duke of Urbino's ambassador, Giovan Maria della Porta.

Even in his torment at Orvieto, exiled from Rome, the pope had been minded to write to Michelangelo when he was working against him on the fortifications, pleading that he should not neglect San Lorenzo. No one recorded what passed between them when they encountered each other in the Apostolic Palace. Michelangelo saw a bearded old man, wasted, showing signs of serious illness from a diseased liver, blind in one eye: the old 'friend' who still loved him and understood him, so Sebastiano had said.

Pope Clement ordered Michelangelo to return to Florence the same day, and he left Rome immediately after the signing. On 30 April the ambassador wrote to Urbino saying that the contract, which was to be ratified by the duke within two months, was such as to satisfy the whole of Rome. The city was full of praise for the care the duke had shown. Michelangelo had promised to send him a new design and to deliver six statues, all from his own hand, and these would be worth the world and truly incomparable. The rest of the work would be under the 'care and discipline' of Michelangelo, and would be finished in three years. The tomb could not be erected in St Peter's and would be better placed in San Pietro in Vincoli – the titular seat of Sixtus IV, the church of Julius – than in Santa Maria del Popolo (the duke's preference), which Michelangelo had said had neither a suitable spot nor the right light.

At last agreement had been reached, but the project of the tomb of Pope Julius still continued to create its peculiar atmosphere of uncer-tainty and tension in the relationships of those it concerned. On 10 May 1532, when he wrote again about the tomb to the duke, the accommodating Giovan Maria della Porta felt the need to say that, with regard to the ratification of the agreement, perhaps his Lordship would write Michelangelo a line in his own hand praising his resolution to attend to the tomb, exhorting him to finish it, in the kindly phrases

that were appropriate, 'inasmuch as it has been said to me that this man will shift to being so much more tractable [or 'sweeter' – '*indolcirse*' was the ambassador's word] when he recognizes your good disposition towards him, that he will be set to work miracles'.

In this same letter, della Porta mentioned that Michelangelo had not been able to provide the stipulated design for the duke before he left Rome, as he first needed to see the statues in Rome that had been buried when the river was in flood, and also those in Florence, to know how best to arrange everything.

None the less, Michelangelo, under the contract which was duly ratified by the duke in June, was now committed to executing a smaller version of the tomb within three years, delivering the six blocked-out figures to be finished by his own hand, visiting Rome, as the pope had agreed, for at least two months each year to supervise the work, and contributing 2,000 ducats of his own money. Part of this sum was represented by the value of the house and marbles in the Macello de' Corvi. If Michelangelo failed to fulfil the terms of the contract, it would be held null and void and he would be again held liable under the agreement of 1516. Even with assistants, Michelangelo knew that the work to be done by his own hand would need more than the time allocated for his visits to Rome.

When Michelangelo resumed work at San Lorenzo, at the pope's behest he employed a small band of trusted helpers both for the sculptures for the sacristy (Tribolo, who then fell sick, Raffaello da Montelupo and his assistant Giovanni Angelo Montorsoli) and for the carpentry and stucco work for the library (Battista del Tasso, il Carota and Giovanni da Udine among others). Michelangelo began the completion of the timeless, ideal figures of the dead Lorenzo and Giuliano de' Medici, and of the ambivalent, erotic female forms representing Dawn and Night, in the melancholy flesh. For Night (alone among the phases of the day) he carved attributes: the moon, the star in the diadem, the owl, the poppy and the mask.

47 Alessandro and Ippolito

After his return from hiding and restoration to the pope's favour, Michelangelo remained in fear for his own safety. It was Alessandro de' Medici who now embodied the menacing power of the Medici. Michelangelo feared the sudden affront or assault even as he worked at San Lorenzo in obedience to Pope Clement and saw every day the symbolic statue he had made to honour the memory of Lorenzo, duke of Urbino, who was Alessandro's putative father – unless, as was often said, Alessandro was the son of Clement himself. This was chiefly why, it was believed, he was the pope's choice to run Florence, albeit with some constitutional constraints, in the dynastic interest. Alessandro was a powerful, arrogant figure, just into his early twenties, sexually voracious, drawn to intrigue, alien in looks, and sometimes displaying deep human curiosity about people. Pontormo, who had painted him aged twelve (for Ottaviano de' Medici) with long oval face, questioning expression, and thick sensual lips, did his portrait again as an adult, as well as being commissioned by him (to no result) to continue his frescoes at Poggio a Caiano. Alessandro's connoisseurship, however, ran chiefly to medals, coats of arms, bronzes and armour.

Clement secured the promise of Alessandro's marriage to Margaret, illegitimate daughter of the emperor, and subsequently Alessandro's title of duke of Florence (the first ever) when in April 1532 he succeeded in having the Medici designated as hereditary rulers of the city.

Ippolito de' Medici, a little older than Alessandro, less obnoxious, but wilder if anything, had seemed to Clement to be more suited to being a cardinal than to being put in command of Florence. His imaginative direct patronage of painting and poetry tended to encourage lustiness and mildly pornographic eroticism. The cardinal's protégé Vasari pleased him with a picture of a lecherous satyr lustfully eyeing a naked Venus with the three Graces from his hiding-place in the bushes. Vasari was then commissioned by Ippolito to paint a kind of bacchanal showing satyrs fighting with fauns, nymphs and children.

Pope Clement in July 1532 sent Ippolito, the cardinal-deacon, out of political range of Florence to the emperor and King Ferdinand, as legate to Hungary, and his mysterious mission (with a command of 300 musketeers) coincided with the arrival of Sultan Suleiman and his Turkish forces on the frontier of Austria. The sultan found stiffer resistance than he had expected and in the autumn he retreated, while

Andrea Doria was defeating the Ottoman fleet in the Ionian sea. Ippolito's part in his commission was fairly inglorious, and at one point the emperor even had him placed under arrest for presumption. Ippolito then settled in Bologna, living lavishly and writing poetry (including a translation into Italian blank verse of the second book of Virgil's *Aeneid*). He was on the spot when emperor and pope conferred in Bologna a second time, with his memories of Hungary still fresh. This was how he came to be immortalized by Titian as a gay hussar.

Titian had executed two paintings of the emperor after his triumphant progress to Bologna at the end of 1532, one showing Charles in armour, the other in festive costume.* After this, the great imperial patron and collector would never sit for anyone else, it was said. Then Titian painted the glowing picture of Ippolito de' Medici, bearded, wearing the red cap and brightly coloured peacock-feather plumes of a gold-buttoned Magyar, with hands resting on a scimitar and a big mace. Later he did another portrait of the cardinal in armour.†

In 1534, to promulgate the new, overt, statements of the Medici about the signorial, dynastic nature of their régime, Vasari painted four scenes from the life of Julius Caesar, in the Medici Palace, and Ottaviano de' Medici commissioned him to paint portraits first of Lorenzo the Magnificent, as he could be imagined, and then of Duke Alessandro. Vasari showed the duke flatteringly in full profile, long-nosed, clean-shaven and curly-haired, on a seat with images of bound prisoners, and with ingenious background detail of a stretch of the walls and the most significant buildings of Florence.‡ Ironically, the pose of this painted, aggressive, steel-clad prince was, in a rare kind of transposition, taken from Michelangelo's sculpted Giuliano de' Medici, duke of Nemours, rotated on its axis to the profile position.

Titian's paintings of Ippolito had proclaimed the politically impotent, vain cardinal's personal fantasies of power as a fighting soldier. Vasari's painting of Alessandro (in the ornamental part 'my own invention', Vasari wrote to Ottaviano de' Medici) was a powerful political statement about the régime. To Ottaviano, 'who had the key to Duke Alessandro's heart', Vasari wrote:

* The first portrait is in the Prado; the second is lost.
† The Magyar portrait is in the Palazzo Pitti, Galleria Palatina; the Ippolito in armour is not identifiable.
‡ Uffizi, Florence.

I have now finished the portrait of our duke; and on behalf of His Excellency, I have sent it to your house . . .

The shining bright armour at the back of the duke is made to resemble a mirror: because the prince should set such an example that the people may be able to see, as in a glass, the actions of his life. I have clad him in full armour, all except the hands and feet, to signify that for the love he bears his country he is always prepared against every dissension either public or private. The sitting attitude implies his having taken possession of the throne; and in his right hand he holds the baton of dominion in gold to support or command princes or generals.

On his right (alluding to times past) are the ruins of buildings and broken columns, representing the siege of the city in 1530; and from an opening in the wall you see a man looking out with a countenance expressive of the restored peace, and with the sky above him now perfectly serene. The seat on which the duke sits is round, with neither beginning nor ending, to show that his reign is perpetual.

The trunks of three bodies serve as feet to the seat: the number three being the perfect number. These bodies represent the people who are guided according to the will of him who holds authority over them, so they have neither hands nor feet. The termination of these figures is the paw of a lion, part of the animal which is the emblem of the city. There is also a mask tied with fillets, and this is meant to signify the fickleness of these unstable people, who are bound together and pressed down by a fortress erected by his grateful subjects to show the love they bore His Excellency.

The red cloth under the seat signifies the blood that was spilt in the suppression of those who conspired against the grandeur of the most illustrious house of Medici . . . The dry trunk of a laurel-tree, that shoots out a straight branch bearing fresh leaves, represents the house of Medici almost decayed, but now in the person of the duke likely to be increased by a plentiful- offspring to perpetuate his name. The duke's helmet burning in the fire is to imply the lasting peace which proceeds from the duke, who by his good government renders his people rich, tranquil and happy.

Building the huge Fortezza da Basso – the fortress mentioned by Vasari – was in part a reflection of the new régime's concern to strengthen the defences of Florence against external attack; but an equally strong and

obvious motive was Pope Clement's obsession with means to sustain the Medici power. Just when and with what pressure Duke Alessandro approached Michelangelo for his services in planning the Fortezza is unclear. What was remembered was that after the return of the Medici to Florence, as he was reaching agreement with the duke of Urbino over the tomb of Pope Julius to begin to-ing and fro-ing between Florence and Rome, Michelangelo 'knew the ill will that Duke Alessandro bore him and was very fearful'; and that why he knew Duke Alessandro was no friend of his was because 'one day when the duke had given him to understand through Alessandro Vitelli that he should select the best site for the castle and citadel of Florence, he had replied that he would only go there if he were ordered to do so by Pope Clement'.

Whatever the approaches made to Michelangelo, nothing could come of them. On 10 March 1534 Alessandro wrote asking Antonio da Sangallo the Younger to come to Florence as soon as he could, to advise and serve him 'in connection with a certain project of mine'. By 16 May the decision had been taken to build the citadel at Porta a Faenza, which was exposed to attacks from an army advancing down the Arno valley or across the plain but was also nearest of all the city's gates to the Medici Palace. At remarkable speed, the basic construction and first garrisoning of the fortress were accomplished by December 1535.

Several events were loosening Michelangelo's bonds with Florence, even as he kept his distance from his friend the pope. Deaths and departures were prominent among them. In Michelangelo's immediate family, Buonarroto's death from the plague in 1528 had moved him profoundly. His last brief letters to his brother, from Florence to Settignano in the autumn of 1527, had mentioned a paid, temporary state office he was going to turn down but thought Buonarroto – whose latest business partnership had done badly – might want instead. He had told Buonarroto that in any case, because of the plague, he did not want him to return to Florence, or even to handle his letters.

Lodovico died at Settignano in 1531, at the age of about eighty-seven, after his return from the comparative safety of Pisa during the siege of Florence. Michelangelo paid twenty-five ducats for the body to be brought to Florence for interment in the church of Santa Croce. He hugged his sorrow to himself. He wrote a long unfinished *capitolo* (about seventy lines) yoking the deaths of Buonarroto and Lodovico, which, he said, had affected him as a loving brother and a dutiful son. He found the imagery for his grief partly in his arts: memory still painted his

brother for him and sculpted the living image of his father in his heart. *Amore* he thus associated with painting and his brother; duty with sculpture and his father. In July 1534 Michelangelo was writing to Giovansimone to say that he had a young man in prospect for Ceca (Buonarroto's daughter, Francesca). 'If you know him I would be glad to learn what you think of him, before I do anything further; and you can send to tell me through Mona Margerita.'

Michelangelo was affected by the departure of Antonio Mini loaded with his gifts in November 1531. He had grown very dependent on Mini's services as a general factotum and faithful friend since he began trying to teach him and sending him on errands. Mini had been with him when he fled to Venice during the siege of Florence. Until his departure for Lyons, Mini's name was appearing regularly among the intimate domestic items of Michelangelo's *ricordi*.

The new contract for Pope Julius's tomb brought no respite. Michelangelo had to find 2,000 ducats to contribute to the cost of finishing the tomb, but it was not a good time for selling assets for cash; and, as he wrote in mid-1532 to his young banking friend Andrea Quaratesi, 'As I have to pay 2,000 ducats because of my business in Rome, which with certain other things will be 3,000, I've wanted, so as not to go naked, to sell houses and possessions, and realize about half the right price: but I haven't and cannot. So I think it will be better to wait than sell for nothing.'

When he wrote to Quaratesi, he was brooding over the way the contract had been finalized the month before. He suspected trickery. He became increasingly 'sure that after he had left the Apostolic Palace and Rome at the pope's request, without the contract being read over properly while Clement was still present, the ambassador Giovan Maria della Porta had told the notary to add 1,000 ducats more to what Michelangelo was supposed to pay, and had then included the house he inhabited in the contract. Rather than owing Pope Julius's heirs money, when he looked back at his dealings over the tomb and all his labour and did his sums he was sure that they owed money to him.

About a year later, in the summer of 1533, Sebastiano del Piombo mentioned to Pope Clement another of Michelangelo's financial vexations: how to recover the money owed him by the Signoria of Florence, including a loan made to the Republic during the siege. Apparently seething with fury – it was hardly permissible for him to write down the words the pope used, Sebastiano told Michelangelo – Pope Clement

impetuously dictated a letter for the Florentine ambassador to send to Duke Alessandro, ordering immediate restitution.

This would hardly have endeared Michelangelo to the duke, but it helped restore some of the old familiarity between Michelangelo and the pope, 'the good and holy master' whom Sebastiano assured Michelangelo he now knew 'down to the ground'. Michelangelo seemed more relaxed about money and his relationship with the pope by the autumn of 1533, when he finished a four-month period of working for him at San Lorenzo. In October he wrote to Figiovanni in Rome that he now wanted to raise all the money he could to hurry on his work there, and so could he now have two months' salary owing him from Clement 'and I shall donate the other two months to the pope'.

PART FOUR

Il Crepuscolo 1534–1560

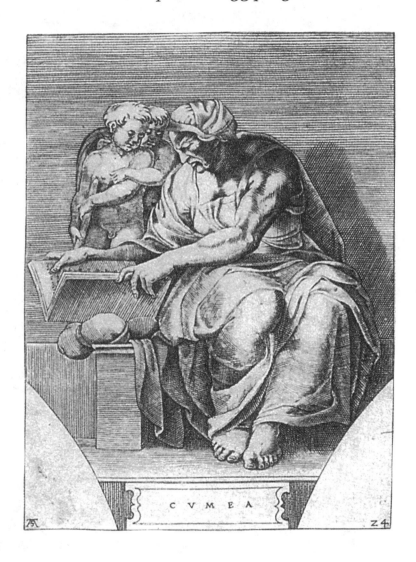

CVMEA

48 Quaratesi, Febo, Mini

There were always shafts of light penetrating Michelangelo's dark periods: from his art, communicating his intense satisfactions of sublime achievement in its own terms, and from his wealth of friendships and affections. In the course of 1532 a new friendship took him to a pitch of happiness he had not thought possible. 'On the happy day for me of the first of January,' he dated a letter at the beginning of 1533 to the young nobleman Tommaso de' Cavalieri he had met in Rome.

A good few men resented Michelangelo almost on first sight (Torrigiano who broke his nose; Bandinelli who schemed jealously against him). He in turn easily took against people, or more often went off them, after taking offence over an apparent slight or feeling let down or professionally threatened. His disappointments included patrons, relations, rivals and some erstwhile friends and collaborators. But he was not a hater. On the contrary, his relationships with men of all ages very often took the form of a variety of positive attractions – ranging from ephemeral infatuations to amused affection, loyal devotion and passionate love. In return, he stimulated many different kinds of affection, with varying elements of awe and self-advantage. During the early 1530s, when he began to divide his time between Florence and Rome, the stream of cogent letters from Sebastiano del Piombo to his *carissimo compare*, the services performed by Benvenuto della Volpaia for his *honorando e charo Michelagnolo* and the untroubled closeness of Mini to *Michelangniolo mio* attested to his unfailing ability to arouse other people's instincts of kindliness and concern.

Letters, often of artless flattery, invariably followed a parting. Silvio Cosini of Fiesole wrote 'a couple of lines' after he had been for two years in Genoa, saying that 'all the credit and favour I now enjoy I possess only through having been in your service'. Writing again to Michelangelo a week later (13 April 1532), Cosini, whose letters were carried by a friar of San Marco, repeated his offer to serve Michelangelo: 'whenever you may need to make use of me in the things you think I might be good for, let me know, since after just one line written by you I'd be ready to abandon every project I'm on'.

A particular assumption about Michelangelo's known kindliness and concern for young men and need for apprentices earned a very urbane rebuff for his old friend Tribolo, who had wanted to be a go-between in finding Michelangelo an assistant:

I could not answer you definitely yesterday evening on the Canto de' Bischeri, as I intended to, as the man on whose behalf you spoke to me was present [the father of the boy], and as perhaps you had given him some hope of what he wanted from me I feared to shame you. And though I burned to do so several times, I did not say exactly what I would have said to you alone. But now let me make you understand this: and it is that for a good reason I cannot take on any boy [*garzone*], and especially not a foreigner, as he is a foreigner. So I said to you that I was not about to do anything for two or three months, so that he could make his decision – that is to say, so that your friend should not leave his son here, hoping on account of me. And he did not understand, but replied that if I saw him I would chase him not just into the house but into bed. I tell you I deny myself this consolation and I do not want to take it from him. So will you dismiss him for me, and I reckon you will know what to do and how, so that he will go away content.

One of the young men whom Michelangelo honoured, and in a sense pursued, at this time was the thoughtful-looking Andrea, son of the banker Riniero Quaratesi. One of his very rare portrait studies was of Andrea, soon after the end of the siege of Florence. The portrait, drawn in black chalk, shows a man in his late teens or early twenties, neatly dressed, rather soulful, perhaps grieving. Letters from Andrea to Michelangelo – 'loved by me as a father' – conveyed simple trust and affection.

Michelangelo's fondness for Andrea Quaratesi, closing the nearly forty-year gap between them, appeared again in the concern he showed, during his visit to Rome in the winter of 1532–3, when he learned that Andrea was ill. He asked another friend, Giovanni Norchiati, one of the canons of San Lorenzo, a willing intermediary, to see how he was. Norchiati replied that Andrea sent Michelangelo all his greetings, 'and it seems a thousand years to him till you come back here'. In contrast to the fond but matter-of-fact relationship with Quaratesi, gently running its course, Michelangelo's relations with a still younger Florentine, Febo di Poggio, plunged him into guilt and anguish. The short, rather surreptitious, but evidently talked about friendship left its bitter-sweet traces in verses and drawings by Michelangelo and in letters exchanged in 1534–5. Michelangelo's earnest, conciliatory note to Febo, written in Florence in September 1534, made the dramatic announcement that he was leaving the city never to return. It clearly followed

some kind of quarrel. It was discreetly unsigned, and it began curtly:

> Febo – Although you bear me very great hatred, I do not know why, I do not believe surely for the love I bear you, but because of the words of others, which you should not believe, having tested me; I cannot but write to tell you this, however. I leave tomorrow morning, and I go to Pescia to find Cardinal Cesis and messer Baldassare; I shall go with them to Pisa; then to Rome: and shall not return here any more: and I must have you understand that as long as I live, wherever I shall be, I shall always be as much at your service, loyally and lovingly, as any other friend you have in the world.
>
> I pray God that he may open your eyes through some other way, so that you may understand that he who desires your good more than his own well-being knows how to love and not to hate like an enemy.

Febo di Poggio was an irresistible name for word play and visual punning. Phoebus the Roman Apollo. Phoebus of the Hill. The sun-god and the slope. Michelangelo wrote a sonnet to say that when Phoebus was setting all the hill on fire, his feathers had been wings for him, and the hill a stairway. Febo had been a lamp for his feet, and death had seemed wonderful: '*Le penne mi furn' ale e 'l poggio scale, Febo lucerna a' piè*'.

The sonnet lacked both passion and remorse. An incomplete sonnet also punning on the name of Febo di Poggio suggested some relief on Michelangelo's part over his release from the friendship.

Febo called on Michelangelo the day after he had received his letter, and found him gone. Michelangelo wrote again. This time, early in 1535, Febo replied, signing himself 'as a son to you':

> Now I am in Florence, and when you left you said to me that if I had need of anything I should ask that friend of yours, and because M. Vincenzo isn't here now I find I'm needy of money both to clothe myself and also to go to the Monte, to see those people in combat, as M. Vincenzo is there. Meantime I went to find the one at the bank, and he said to me that he had no orders whatever from you, but that someone was leaving tonight and that an answer would come within five days and so if you give him your orders he will not fail. So I beg you then to be content to provide for me and help me with whatever you think and don't fail to reply.

One other young Florentine, writing to Michelangelo before the end

of 1534, revealed how devastating the withdrawal of his attention could seem: an effusive, stylish letter from 'your dear Simon', who had almost, he said, lost his senses through grief, ended with the promise that the unknown and allegedly abandoned friend would suffer anything for Michelangelo, provided his friendship were restored.

Michelangelo's verses on Febo read like exercises rather than passionately felt and perfected literary discourses. They were written as the poetry from his pen – at least what ·has survived – was increasing amazingly in volume, variety and resonance. This torrent of composition coincided with his intense activities at San Lorenzo and in Rome. He wrote some memorable lines; he revealed new strange depths of his imagination as he experimented with epigrams, sonnets and stanzas in *ottava rima*, still echoing the images and language of Petrarch, Lorenzo de' Medici and Poliziano.

On the back of a letter from Figiovanni dated 23 November 1532, Michelangelo wrote a sonnet (*Forse perché d'altrui pietà mi vegna*) striking a fresh note of sorrow for sin, and the search for salvation, employing a vocabulary of justification and predestination, and ending with the lament of someone 'so near to death and so far from God'. In a – for him – exceptional Virgilian eulogy of country life, over 100 lines in *ottava rima*, he pressed into service about this time the perennial themes and images of rural bliss.

In further stanzas seeming to begin in the middle of things – 'A giant is there too, so high ...' – Michelangelo returned to both real and nightmarish images of hugeness that had always fascinated him from childhood: the mountains of Tuscany and Carrara, where he had wanted to sculpt a figure to be seen from the sea; his own *gigante* in the piazza; the ridiculous colossus proposed by Pope Clement; Dante's giants at the side of the harlot (the papacy of Clement V) in purgatory. Michelangelo's giant crushes cities with the sole of his foot, and builds towers to reach the heavens he cannot see, as his single prying eye is on his heel. His unseeing head is among the stars; his hairy legs, levelling mountains on the ground, cover two days' journeying at a step. The mountains to him are like grains of sand; huge and monstrous forms live in his legs' thick foliage; a whale to him would seem like a fly; and he is sad and tearful only when the wind blows smoke or a wisp of straw or dust into his one eye. Michelangelo's giant has for company a large old woman, slow and lazy, to nurse and suckle him, a pallid, yellow figure of caves and shadows, with a heart of stone and iron arms, who hates others yet does not love herself, who thrusts the sea and

mountains into her belly. The seven offspring of the giant and his hag roam the earth, searching from one pole to the other, snaring and warring only against the just. Each has a thousand heads.

> For them, the eternal abyss opens and closes,
> such prey do they take from the world's great throng;
> and steadily, steadily their members embrace us,
> as ivy takes a wall stone by stone.

> *L'etterno abisso per lor s'apre e serra*
> *tal preda fan nell'universo stuolo;*
> *e lor membra ci prendon passo passo,*
> *come edera fa el mur fra sasso e sasso.*

Michelangelo's composition brought him relief and, at the time, a new kind of pleasure and recognition, another shaft of light. His prolific writing of verse in the 1530s coincided with the growing popularity in court circles of the madrigals of composers such as Philippe Verdelot and Jacques Arcadelt, now circulating in manuscript. Sebastiano del Piombo wrote to Michelangelo from Rome in the summer of 1533, chiefly to say how delighted Pope Clement was at the progress of the work at San Lorenzo after hearing that Fra Giovanni Montorsoli had been put to work on the figure of Duke Giuliano – 'three times he answered me ... you were to do things your way ... Moreover,' Sebastiano added, 'I am sending you the tune (*canto*) of your madrigals, which will not displease you: one is by messer Constanzo Festa, the other by Concilion, and I have also given two copies to messer Tommaso, who sends his greetings a thousand times.'

Constanzo Festa, a Tuscan in the pope's service, was one of the rare Italian-born composers of the madrigals then winning favour as modern musical entertainment in Rome. Johannes Consilium (Sebastiano's 'Concilion' in his letter), or Jean Conseil, had begun his musical career in Italy as one of three boys sent by Louis XII as a musical gift to mark the election of Leo X.

Michelangelo was anxious to reward whoever composed the music, 'so that I seem as little ignorant and ungrateful as possible'. The madrigals were performed in Florence on the initiative of Fattucci, who had told Michelangelo the settings were splendid. 'The words were not deserving of them,' Michelangelo added. In a letter to Sebastiano, he concluded with a sudden burst of emotion, 'You have given a copy of those madrigals to messer Tommaso, for which I am obliged, and I beg you, if you see him, to commend me to him a thousand times; and

when you write to me say something about him to put me in mind of him, for if he went out of my mind I believe I should immediately fall dead.'

Italy's ambivalent attitude towards the French – for Florentines, both pillagers and protectors – was affected by the knowledge that they were admirers of Italian art and artefacts, willing and wealthy enough in courtly circles to support migrant craftsmen and artists, even to ennoble them. When Mini went to France, it was in search of fortune and perhaps a modest fame as a modest painter. There were Florentines settled in the main cities and towns – notably Lyons, a great commercial and financial centre – and turbulent Paris. From the time he was crowned, using agents including Aretino and della Palla, King Francis had begun to accumulate antiquities and modern Italian works of art: Titians, Raphaels and at length, his heart's desire, something by Michelangelo in the form of the statue of Hercules procured by della Palla from Strozzi in 1529.

Rosso Fiorentino and Francesco Primaticcio were beautifying the royal palace at Fontainebleau. The king's erotic taste as they formed and gratified it ran to nude Michelangelesque depictions, with Rosso's distinctive assertiveness, of sensuous naked pagan divinities; to painting combined with stucco, as Primaticcio had been taught to do it, displaying sphinxes, satyrs, fruit swags, and languid, elongated classical figures. Among the lesser lights of Florence, Giovan Francesco Rustici, who had left Florence after the expulsion of the Medici in 1527, was living on an allowance from King Francis, who wanted him to cast a huge bronze horse to carry his effigy.

Michelangelo was now the luminous centre of the galaxy of artists in Italy, but the French court seemed to provide the more brilliant patronage. Following a quarrel with his uncle, Giovan Battista, over a love affair, Antonio Mini had set out, accompanied by a *garzone* called Benedetto del Bene, with a light heart and full of hope. From Piacenza, where he arrived at the beginning of December 1531, he wrote telling Michelangelo how happy he was over his adventure 'to go to find the king'. From what certain Florentines who had been at the king's court had told him, 'the painter Rosso has become a grand master of money'; Giovan Rustici was flourishing.

Just before Christmas 1531, Mini wrote to Michelangelo to announce his safe arrival, despite the freezing weather and the snow, in Lyons, where 'Francesco Tedaldi, brother of Papi Tedaldi, threw a great party for me and provided me with everything I needed.' In February 1532 Francesco Tedaldi wrote to tell Michelangelo that he had found some

cheap rooms for 'your Antonio and Benedetto del Bene'. After the Leda
– in which he came to have a half share – had arrived, he would see
them on their way with letters of recommendation and a prayer.
Meanwhile, Antonio and Benedetto del Bene were starting to paint
another Leda. Towards the end of February, Antonio Mini wrote a
rambling letter assuring Michelangelo that he was not using up capital,
not gobbling everything up before it was cooked. He and Benedetto
had given such an account of themselves that they were being constantly
asked by one person for a Leda, by another for a work in their own
style. By March 1532 Mini was sounding less sure of himself, even
though he was being asked to draw cartoons of the Leda and would sell
them to whoever paid best: 'Oh just think, when I am in Paris, what a
novelty such pictures will be. There they print mostly landscapes.'

In February 1533 Rustici acknowledged Michelangelo's request that
he should help and advise Mini, and responded that he had approached
the king, who wished Mini to paint a picture for him and would order
a piece of marble for him to do a figure. For love of Michelangelo, who
had done so much for him, and for the sake of Mini's excellent
qualities, Rustici would do all he could. Mini, he added ominously, was
too open and trusting, and had been despoiled of many of the beautiful
drawings Michelangelo had given him.

Eventually the unfortunate Mini's store of Michelangelo's drawings
and cartoons disappeared in the market – some through the hands of
Rustici – and Mini died in Paris in 1533, robbed of his two erotic
paintings of Leda and the swan, cut off from his friends and family, out
of reach of any possible help from his uncle Giovan Battista in Florence
and his 'more than a father', Michelangelo, in Rome.

49 Bugiardini's portrait • Berni's praise

In his verse and his letters, Michelangelo sometimes portrayed himself
as old, exhausted and ugly, though he had always attracted intense
friendship and love as well as reverence and respect. He drew many
people of all ages to him, and he held them in a magnetic field of
powerful personality. How his looks had changed during the years
of his maturity in Florence (the 1520s and early 1530s, the time of some of
his most overtly sentimental friendships with star-struck young men)
can be surmised from possible self-portraits of the younger man in the

Sistine frescoes, from the defeated, sprawling, middle-aged man of the Victory group, and from a portrait of him by Giuliano Bugiardini.

Michelangelo endured sitting for a portrait, an unlikely position for him, because of his old, fond indulgence towards Bugiardini and his fascination with the vagaries of Bugiardini's conversation. The commission came from Ottaviano de' Medici, whose choice of painter was shrewd. Bugiardini appealed to Michelangelo for his oddities, and was not without reputation in Florence in the 1530s. He was used as a competent restorer of Uccello's battle scenes. Michelangelo had helped him with his commission to copy one of the portraits of Pope Clement by Sebastiano.

Michelangelo found the experience of being painted by him hilarious. Shown the portrait after a couple of hours, he burst out laughing and pointed out that one of his eyes had been painted in the temple. After some puzzled study, while Michelangelo sat down again sideways, Bugiardini said he was sure he had painted what he saw. So then Michelangelo let him continue, with the ambiguous remark that it must be a defect of nature. When copying Michelangelo's statue of Night, which had an owl among its attributes, Bugiardini saw fit to add a lantern, a candle, a nightcap, pillows, bats and other reminders of darkness, so that Michelangelo nearly choked from laughing.

As he neared sixty, Michelangelo showed lined cheeks and a furrowed brow, with pronounced thought lines running down his forehead to his broken, pointed nose. The hair on his head was still dark and thick, with flecks of grey, the beard sparse and forked, the eyebrows quite full, tl.e eyes dark and flecked. The expression on his face as he watched someone intent on watching him (Bugiardini, brush in hand) reflected sharp intelligence, amused interest, kindness, pent-up energy, and the presence of a fertile controlling mind. Despite the toll on his health through physical exertion and emotional turmoil during the siege and after, Michelangelo's sinewy, muscular frame was still fit for furious effort, and his spirit was directly responsive to emotional and mental challenge.

He had never lacked unassailable confidence in his ability as a sculptor or, despite protestations to the contrary, as a painter. By the early years of the 1530s, nowhere outside Venice was there any rival to his pre-eminence in either field. The pope would like to monopolize him. His work was sought by the king of France, by princes of the Church and *signori* of the courts, and even by merchants who thought they could persuade and afford him. His public renown through the statue of David and the *Pietà* and the Sistine ceiling in Rome was immeasurable.

* * *

When Castiglione's *The Book of the Courtier* had been published in Venice in 1528, the 'most important personages' to whom the author sent presentation copies (the pope, the emperor and the king of France were on his list) and the several hundred people who bought it read that in the opinion of Count Lodovico Canossa, delivered when Julius was pope, the outstanding painters of the age were Leonardo da Vinci, Mantegna, Raphael, Michelangelo and Giorgio da Castelfranco (Giorgione). And, in the debate about the rival merits of painting and sculpture, Castiglione had reported the count, who thought painting the nobler art, as saying that none the less he did recognize the excellence shown by Michelangelo and other sculptors.

Acknowledgement of Michelangelo's unique stature had begun to surface during the 1520s not in the writings of the historians, Latinists and scholarly poets such as Molza and Bembo, the admirer of Raphael, but in the often coded and dangerous verse and letters of practitioners in the vernacular who had become active in the Rome of Pope Leo, including notably Pietro Aretino and Francesco Berni.

Berni portrayed himself in one of his own poems: with his thin legs, big nose and blue eyes, almost hidden by a huge beard, he was, he said, a great lover and great hater, a friend of princes, peasants and artisans, a man with a talent to amuse. In 1533 he wrote a poem in praise of Michelangelo, calculated to appeal to its subject's sense of humour and sense of importance: here Michelangelo, '*il divino*', was compared with their beloved Plato – though, whereas Plato used words, Michelangelo 'says things' – and lightly, lovingly flattered. Michelangelo replied delightedly to Berni's flattery, using Sebastiano as a cloak, in a *capitolo* stuffed with burlesque images – 'I showed your letter to the greatest Medic of our ills and he laughed so much that his nose split his eyeglasses in two parts' – and erudite allusions and in-jokes.

50 Tommaso de' Cavalieri

In about 1530 Michelangelo had replaced Mini with another assistant, Francesco d'Amadore, called Urbino, who was about eighteen. Very soon he came to be trusted by Michelangelo as much as if not more than Mini had ever been.

Another profound attachment began early in Michelangelo's first prolonged visit to Rome since the end of the siege of Florence, when he

was introduced to and captivated by the nobly born young Roman, Tommaso de' Cavalieri. Cavalieri was then, in the late autumn of 1532, probably about twenty-three. Remarkably handsome, intelligent, cultivated and talented, he was well connected and admired in Roman society. During the sack of Rome he had been a refugee in the palace of Cardinal Andrea della Valle.

Michelangelo made no effort to hide his spontaneous, compelling affection for him from Tommaso himself or from friends. Immediately after they met, he rushed to write to him. He penned three drafts of his second letter. In the longest and first version, written at the end of December 1532, Michelangelo began awkwardly and grandiloquently:

> Inconsiderately, messer Tommaso my most dear lord, I was moved to write to Your Lordship, not in response to any letter of yours that I had received, but as the first to move, as if I had thought, as it were, to cross dry-shod just a little stream, or rather from its shallow water plainly a ford. But, after leaving the bank, I found not a little stream but the ocean with billowing waves that appeared before me; so much so that, not to be completely submerged by them, had I been able, I would gladly have returned to the bank from which I first came. But, since I am now so far, I shall steel myself to go forward courageously: and if I have not the skill to navigate through the waves of the sea of your brilliant mind [*valoroso ingegno*] you will excuse me and will neither disdain the disparities between me and you, nor desire from me what I do not have; since he who is alone in everything can have companions in nothing. So, Your Lordship, light of our century, unique in the world, you cannot be content with the work of anyone else, as nothing is like or equal to you. And yet if any of my things, which I promise and hope to do, should please you, I will attribute this more to its fortune than its goodness; and if I ever have the assurance of pleasing Your Lordship, as I said, in anything, my present time, along with all that is to come for me, I will give to you. And I shall deeply grieve not being able to have the past again, so as to serve you for longer than just in the future, which will be short, because I am too old. There is no more for me to say. Read the heart and not the letter, for 'the pen cannot encompass fond feelings'.

I have to excuse myself for having in my first letter shown such baffled amazement at your rare talent, and so I do, because I have

since realized how great was my error; for it is as much to be wondered at that God performs miracles as it is that Rome produces men who are divine. And to this the whole world bears witness.

Michelangelo quoted one line of Petrarch directly in this letter – '*la pena al buon voler non può gir presso*' – from a *canzone* of desperate love, replete with the kind of phrases about fountains of tears and crystal waters that Berni mocked, but very sonorous and beautiful. Cavalieri would recognize echoes of Dante as well, but not the echoes of Michelangelo's own past verses, now pressed into service to win the regard of a well-born and finely mannered young man. Meanwhile Cavalieri had responded to Michelangelo's first letter, and so in a third draft, dated 1 January 1533, Michelangelo, clearly relieved, substituted a few still respectful lines in rather less high style, referring obliquely to things he was giving Tommaso.

The first few lines of Cavalieri's letter, of 1 January 1533, which had nearly crossed with Michelangelo's, throw light on one vital aspect of Michelangelo's response to their encounter: the glimpses of a talent for design in this young man of great physical beauty. Michelangelo, Tommaso began, had sent him a welcome letter he had not dared hope for:

> I do truly think, rather I am certain, that the cause of the affection you bear for me is this, that since you are full of virtuosity, or better say virtue itself, you are forced to love those who are its followers and who love it, among whom am I – and in this, to the best of my powers, I do not cede to many. I truly promise you that for this you will receive an equal and perhaps greater exchange, since I never bore love for a man more than for you, nor ever did I desire friendship more than yours; and if in nothing else, at least in this I have excellent judgement.

Michelangelo would soon see the effects of this, Cavalieri promised. Fortune – contrary only in this – had made him unwell, but within a few days he would be well enough to repay his debt by visiting Michelangelo, if it pleased him. 'In the meanwhile I shall take pleasure for at least two hours of the day in contemplating two of your drawings which Pier Antonio [Cecchini] has brought me, which the more I gaze at them, the more they please me.'

Michelangelo wrote beneath one of his drawings, sent soon after their friendship began, 'Messer Tommaso, if this sketch does not please you,

say so to Urbino in time for me to do another tomorrow evening, as I promised you; and if it pleases you and you wish me to finish it, send it back to me'. The sketch, done in black chalk, showed Phaeton with his chariot and four marvellously drawn horses falling headlong from the sky, where a handsome figure bestride an eagle is hurling a thunderbolt, while Phaeton's sisters, shown naked with a swan and river-god below, are about to be transformed into poplars.*

When he wrote to him from Florence, where he had returned in the spring of 1533, Michelangelo's words of still more intense affection confirmed that Tommaso also had experienced the deepening of their first mutual interest into strong attachment:

> I could now as easily forget your name as the food on which I live; rather I could sooner forget the food on which I live, which unhappily nourishes only the body, as your name, which nourishes the body and the soul, filling them both with such sweetness that while my memory of you lasts I am unable to feel either weariness [*noia*] or fear of death. Think if the eye were playing its part, in what state I would find myself.

The last few lines of this letter – there were several versions – fused quasi-religious sentiment with Michelangelo's declarations of love, and linked Tommaso's name with the expectation of '*eterna salute*' – eternal health, eternal salvation. In August, Tommaso wrote to Michelangelo, 'indeed I am sure that you cannot forget me . . . please come back soon and let me out of prison, for I am avoiding bad company [*mal pratiche*] . . . and I want only you.'

Michelangelo's infatuation with Cavalieri was from the beginning idealized in their practical collaboration as eminent artist and emulative apprentice. Michelangelo brought *virtù* to the engagement; Cavalieri, *ingegno*. Emotionally very physical and fatherly on Michelangelo's part, deeply filial and responsive on the part of Cavalieri, the relationship was tense with the complicity of shared unspoken understanding of its true nature. It caused an explosion of creativity, propelling Tommaso to the drawing-board and forcing Michelangelo to produce a remarkable series of verses and designs of brilliant originality. Through poems and drawings his buried emotions and struggling ideas would be instantly materialized and rapidly perfected for retention or presentation as finished works.

* The finished drawing is at Windsor.

During 1533 (when Michelangelo began to feel while in Florence that he was an exile from Rome) he kept in touch with Tommaso partly through Bartolommeo Angiolini, who handed on or dispatched their letters.

Constantly that year when writing to Michelangelo his friends in Rome mentioned Tommaso. 'He loves you no less than you love him,' Angiolini remarked in July in a letter packed with gossip and news about the pope's crying out because of the pain of gout, the tunes Sebastiano was sending for Michelangelo's madrigals, and his own wish to be a poet like Michelangelo so long as when he came to it he was cooking sausage and liver. Again, in August 1533, when sending news of the ripening of Michelangelo's grapes, the thieving magpies and the pope's plans to travel to meet the king of France in Nice, Angiolini insisted that Tommaso 'had no other desire in the world than for you to return, for he says that when he is with you he knows he is happy, through having all he desires in this world'.

When writing to Michelangelo in August, Sebastiano too, in a letter otherwise about the business of the pope, brought in the news that during his recent illness 'Messer Tommaso in his kindness came to visit me often when I was in bed. And so too did messer Bartolommeo Angiolini.' And Angiolini, writing to Michelangelo on 6 September, reported that, after making a copy, he had given the sonnet sent by Michelangelo to 'our messer Tommaso', who realized how much God had favoured him through the friendship he enjoyed with so gifted a man.

Michelangelo's gifts to Cavalieri during 1533–4 were prodigious. Before Michelangelo left for Florence in June 1533 Tommaso had sent him his own sketch of the fall of Phaeton, which he had felt bound to do again after seeing Michelangelo's. Early in September, sending his thanks for a sonnet from Michelangelo, Tommaso mentioned that he had finished his drawing of Phaeton and that the pope and Cardinal Ippolito de' Medici had seen it. The cardinal had also wanted to see all Michelangelo's drawings, and had found them so pleasing that he wished to have the Tityus and the Ganymede done in crystal.

Among the drawings already given to Tommaso was a bust in black chalk used by Tommaso in his efforts at self-portraiture, and this in turn moved Michelangelo to draw an ideal head of Cavalieri in ancient costume. Then early in November, from Florence, Michelangelo sent Tommaso his final drawing of Ganymede, transported and transfixed by the great eagle.

In black chalk or red chalk, characterized by nudity and violence,

Michelangelo's powerful drawings for Cavalieri showed beautiful, cory-bantic scenes of pagan sacrifice, violation, torture and assault: the Rape of Ganymede; the giant Tityus bound in Tartarus, sprawling under the big bird of prey that will devour his liver; Phaeton and his chariot with sprawling horses hurtling to earth; a bacchanal of thirty children, in clusters blowing the flames under a pot, straining to carry dead deer, exposing a naked, drunken man, one peeing into a goblet, and one resting his bottom on the hooved legs of a ravaged female satyr.

The composition of purpose-made drawings to be presented to a friend or client was rare, but the practice went back at least to Leonardo da Vinci, who had once made a drawing of Neptune for his dear Antonio Segni. In their invention, allusiveness and detailed perfection, however, Michelangelo's drawings for Cavalieri were un-precedented.

The Ganymede, sent after Michelangelo had savoured Cavalieri's pleasure over receiving a pair of drawings, might have suggested a declaration of love by an older man for a younger; but the declaration came the other way round if Cavalieri had first drawn the rape of Ganymede and Michelangelo's version was by way of being a lesson in design.

The finished drawing of the punishment of Tityus refers to the myth of the semi-divine giant eternally tortured for trying to rape his half-sister Artemis, the frigid daughter of Zeus, and so may have reflected Michelangelo's feelings about the dangers of lust. The fall of Phaeton when Phoebus allowed his beautiful son to drive the chariot of the sun was an allegory of nemesis following hubris, or pride before a fall. Michelangelo may have been thinking of the falling Phaeton on a Roman sarcophagus known in his time, as well as his own passions.

Michelangelo's tutoring of Cavalieri may also have included a draw-ing of the Risen Christ, in response to Cavalieri's own efforts to portray this subject, after Michelangelo's Christ in Limbo (a design for which Sebastiano del Piombo thanked him in the summer of 1532).

There survived numerous precedents for the children's bacchanal, including abandoned-looking putti on Roman sarcophagi and Don-atello's *Cantoria* in the Duomo at Florence with wildly dancing children, symbols of orgiastic abandon. Michelangelo's lovingly detailed, stippled drawing is replete with realizations of shameless erotic gratification by boy children flouting adult conventions. For Cavalieri, Michelangelo unin-hibitedly opened an enclosed, unmonitored part of the busy playground of his mind.

Another magisterial gift to Cavalieri showed nine left-handed archers rushing hopelessly towards their target, as their fire is stoked by wingless putti, while a little Eros sleeps by his quiverful of arrows and a satyr wanders alone with his bow, in an allegory of the futility of human passions without love. The scene of the archers was derived from the well-known classical stucco in the rediscovered Golden House of Nero, of six naked figures shooting at a target in front of a herm.

Michelangelo's burst of creative fury of drawing in response to Cavalieri showed scenes of naked human bodies in dramatic action. There were no landscapes or still lifes, and only the exceptional portrait or two. His drawings sprang overwhelmingly from his repertoire of remembered classical images transformed and vivified through his skill and emotion. Even at his pace, these drawings needed weeks of work.

Possibly for Cavalieri, Michelangelo sketched in black chalk a rich allegorical scene which complemented the story of the archers perpetually failing to reach their goal. It showed a tomb-like box, opened at the side to reveal the kind of grimacing masks he so liked to depict, supporting at its edge a sprawling, naked young man, hands on a great ball, being awakened by a trumpeting angel, or Eros, or figure of Fame, swooping with spread wings from the sky. In the background, small-scale groups of mostly male nudes seem to represent the seven deadly sins as they bludgeon, fornicate, tear with their hands, hold up a big bag of cash.

Something portentous happened to make Michelangelo suddenly stop producing drawings for Cavalieri about the end of October 1533. By then he had begun the fine sequence of sonnets addressed to Cavalieri, which beautifully and agonizingly fused the physical and idealistic elements in his love. Like the drawings – but more directly, since their purpose was declaratory rather than didactic – they disclosed Michelangelo's troubled self-image and his tremendous longing to identify with Cavalieri.

Michelangelo wrote poetry, including the sonnets for Tommaso, for its own sake. He also had publication in mind, although he was aware of the risk he was running of derision or condemnation. On the reverse of a sheet of architectural diagrams, in a sonnet about Tommaso's beauty and its reflection of the beauty of the soul and so of God, he attacked the evil, cruel and stupid mob or rabble which foisted its degrading feelings on to others, and he proclaimed its failure to diminish his love, trust and unblemished desire – 'l'onesto desio'.

It was not only the mob he had to fear. Emotions stirred by excessive love of an older for a younger man were acknowledged and defused by

his educated contemporaries through innuendo or humour. Aretino's comedy *The Stablemaster*, published in 1533, had as its plot the practical joke played on a lover of boys in the service of the court of Mantua, who is tricked into believing that the duke is forcing him to take a bride, who turns out during the 'wedding' to be a young man. In Castiglione's *The Book of the Courtier* (in a chapter about good jokes) when the tutor Beroaldo said he had to visit Bologna on three counts, it was thought very witty for the great scholar Iacopo Sadoleto to remark that he meant Count Lodovico, Count Ercole and the count of Pepoli – 'who had been pupils of Beroaldo and were very handsome youths'.

The same *The Book of the Courtier*, when reference is made to the intimate but chaste relationship between Alcibiades and Socrates, puts into the mouth of Cesare Gonzaga the snide remark that 'it was a strange place and time – in bed and by night – to contemplate that pure beauty which Socrates is said to have loved without any improper desire'.

The climax of Castiglione's book is a paean for human love which begins with physical attraction and ascends to the sacred love of the Almighty, in which we find 'a most happy end to our desires, true rest from our labours, a sure remedy for our miseries, a wholesome medicine for our infirmities, a most safe harbour from the raging storms of the tempestuous sea of this life'. Discussion then centres on whether women are as capable as men of this divine love. From such a philosophy, from Plato and Ficino and Bembo, Michelangelo derived the concepts to legitimize and idealize his consuming love for Tommaso.

This world of metaphysical rapture was well distanced from the public arena; in the Italian states the penalties set for sodomy were cruelly severe. None the less, in his sonnets for Cavalieri Michelangelo expressed in vivid concrete terms all the intense sensuality and physical ardour of his love. Set alongside the bold uncanonical iconography of his drawings for Cavalieri, his poems were exceptionally revelatory, mould-breaking and defiant.

In one of the several autographed drafts of an early sonnet for Tommaso, written while he was in Rome in 1533, Michelangelo recorded his desire to embrace for ever 'the breast and neck of my lord' as he called for Time and its hours and the day and the sun in its ancient circuit to stay their course. In the summer of the same year, now in Florence, he wrote a sonnet about his sense of loss and the onset, since he had seen his *signor*, of 'a bitter sweetness, a yes and no that moves me: and this must surely have been your eyes'.

Written probably in 1534, the verses in which Michelangelo contemp-

tuously mentioned the 'stupid mob' continued the conflation of divine and human love, the register of his mood shifting like a needle to Cavalieri's magnetic presence and the expression of his alternating hope and despair. He came to look on Tommaso as the material from which he drew out what was sympathetic to himself, in the ways – following their own propensities – in which a sculptor draws out what is hidden in the stone and the writer with pen and ink finds his high, low or mediocre style. He saw Cavalieri as the sun which 'warmed the earth but heatless sailed the skies'; he saw him as the life-restoring phoenix.

Michelangelo in these sonnets portrays and exposes himself as the old man who would run to Cavalieri like a stag or lynx or a leopard if he could; as a soul transformed by Tommaso just as iron is forged by a smith in the fire; as a lame creature sharing another's strong wings; as the moon which is invisible till revealed by the sun.

One sonnet to Cavalieri early on expressed the revelation of their friendship's meaning in Michelangelo's own driving language but Ficino's Platonic imagery and Petrarch's insistences:

> *S'un casto amor, s'una pietà superna . . .*

> If one chaste love, if one God-given piety,
> if one same fortune by two lovers dared,
> if one the grief but two the pain it shared,
> if one will rules two hearts whose souls agree,
> if bodies doubled set one spirit free
> and both to heaven rise on quick wings paired;
> if love's fire in two self-same souls has flared
> from one thrust of one dart's trajectory;
> if loving one another they spurn self
> by mutual pleasure, zest and certain aim
> which speeds them both to where they want to go:
> if this were true a thousandfold, its wealth
> would be a hundredth of the love I claim
> is ours, which disdain only could bring low.

One of the last sonnets in the sequence ended with a pun on Cavalieri's name in lines demanding the happiness for which Michelangelo yearned, even if this meant being vanquished and bound, of being naked and alone in the arms of a knight.

> *A che più debb'i' omai l'intensa voglia . . .*

> Why should I still indulge my deep desire

and let it seek release in tears and sleep,
if heaven, which touches souls its love to teach,
will late or never quench the very fire?
Why whip my heart to act when it would tire
to death? For at my final moment's reach
these lights, my eyes, would its sweet sleep beseech,
knowing all joy must sink as grief climbs higher.
If then the blows of love which so obsess
me may not be evaded, who may own
that feeling space between my dark and bright?
If I must be defeated to be blessed,
don't marvel that one, naked and alone,
should prove a prisoner of an armoured knight.

And one most powerful, prophetic, tormented religious sonnet erupted into the sequence of the early 1530s like an active volcano:

Vorrei voler, Signor, quel ch'io non voglio . . .

I wish to want, Lord, what eludes my will:
between your passion and my heart a block
of ice deflects your fire, and makes a mock
of everything I write with perjured quill.
I love you with my lips, then groan that still
your love can't reach my heart, nor will it knock
and force the door, that joys of all kinds flock
about my heart, your purpose to fulfil.
Dissolve that block, my lord, tear down the wall
whose thickness keeps me from the piercing light
of your sweet presence, no longer seen on earth.
Be like a bridegroom, let your brightness fall
upon a yearning soul which at your sight
is warmed at heart, having from you its birth.

This time the *signor* to whom Michelangelo was pleading was the Lord God, revealing Michelangelo's deepening religious consciousness and the incipient tension between even sublimated human love and Christian abandon to God. The sonnet was perfectly structured and developed, showing his mastery of his own novel images, rhythms, vocabulary and syntax. (Coincidentally, Michelangelo's handwriting in his letters to Cavalieri at the time showed a most discernible gain in clarity, spacing, classical beauty.)

Falling in love with Tommaso de' Cavalieri had utterly changed the

course of Michelangelo's life. The sequence of sonnets for Cavalieri set out the programme for a chaste ascent to perfect love. The sonnet to the Lord prophetically announced the alternative programme of Michelangelo's soul waiting like a bride and demanding that the Lord should rend the veil and break down the wall obstructing divine grace: '*Squarcia'l vel tu, Signor, rompi quel muro . . .*'

51 The purposes of the pope • San Lorenzo

Michelangelo's friends in Rome thoughtfully kept him in touch with the pope's intentions during 1533. Clement was preparing to meet the king of France, following their agreement that the houses of Valois and Medici should be bound together through the marriage of the fourteen-year-old Catherine de' Medici, daughter of the dead Lorenzo, duke of Urbino, to Francis's second son, Henri, duke of Orleans. One of the successive postponements of their meeting during the summer was caused by the news that the king of England's marriage with Catherine of Aragon had been declared void and his marriage with Anne Boleyn valid by the recently created archbishop of Canterbury, Thomas Cranmer, and that Anne had been crowned as queen. In July, Pope Clement pronounced the marriage null and void, but decided to keep his full excommunication of Henry in suspense till the autumn.

Clement still kept a jealous eye on Michelangelo's work in Florence. Delighted with its progress, he had given a stream of instructions concerning the library at San Lorenzo: the seats were all to be of plain walnut, never mind the few extra florins, so long as they compared with the works of the magnificent Cosimo. Giovanni da Udine was to be told that the vault should not be so white but should compare with the vault of the Villa Madama and, above all, he should use long-lasting colours and shun those likely to fade, such as *azuri de Magnia* and *verdi azuri* (Prussian blues and green-blue oxides). The vault of the lantern Michelangelo should decorate as he wished.

A letter of July 1533, from Sebastiano, contained what appears to have been the news of Pope Clement's resolve to use Michelangelo to create a new great work of art in Rome: 'to make a contract with you for something such as you never dreamed of . . . These words were not

just talk between us. His Holiness has charged me to report them to you, on his behalf, and note well, they are words of great importance.'

When would they meet to discuss it? Michelangelo was burning to spend all the time he could in Rome. The pope was anxious to please him. Eventually Clement announced that he would see Michelangelo on his way to visit the king of France. The pope would leave Rome in mid-August, Sebastiano was at last able to report on 2 August: he would go overland to La Spezia, 'and His Holiness wishes to come to stay with you two or three days in Florence, and then follow the court, and this gives me great joy. And because, going overland, I have need of the mule, I beg you, if it is not inconvenient, send it to me as soon as you can.'

Among the flurry of letters from Rome to Michelangelo in Florence at the beginning of August was an elegant and respectful dispatch on behalf of the pope from his Florentine secretary, Gian Francesco Bini. The pope's instructions were to the effect that Michelangelo should stay in Florence to do what needed his presence, but later he should take someone from Rome to whom he could delegate work in Florence.

Halfway through August there was still no decision about the departure from Rome. Before telling Michelangelo about the ripening of his figs, on 23 August, Angiolini mentioned still more dithering by the pope, some saying he would be going to Marseilles, others to Fréjus or Grasse. On 6 September Angiolini had firmer news. He reported that, though there was some doubt because of the desire to wait till it rained, the pope was said for sure to be leaving on the following Tuesday.

Pope Clement, leaving Cardinal del Monte in a disgruntled Rome as his legate, journeyed through Sienese lands to Pisa, where the bad weather kept him till early October. He avoided Florence, and sailed from Livorno to Villafranca with nine accompanying cardinals in a gold-brocaded galley escorted by French vessels and ships of the Knights of St John. The mission was joined by Catherine de' Medici, and the fleet then sailed to Marseilles, where the pope made his state entry on 12 October and the king on 13 October, and where the marriage, at which Clement officiated, took place on 28 October. After splendid festivities – during which Cardinal Ippolito de' Medici was seen dressed more lavishly than the king – the pope and Francis engaged in secret negotiations. The pope left for La Spezia and Rome on 12 November, after having pleaded in vain with Francis to be reconciled with the emperor and having agreed to the postponement of the proposed Council of the Church, as well as to another delay over the excommuni-

cation of King Henry VIII. He also (it was later alleged) acquiesced in an alliance between the king of France and the Turks and Protestants against the emperor.

On 28 August, not long before Pope Clement (and Sebastiano) had set out on the journey to Marseilles, Michelangelo was sent an extraordinary request from Cardinal Santiquattro, a skilled and erudite diplomat, who was clearly ready to chance his luck. Writing from his episcopal villa of Igno, he asked if he would spend a couple of hours with him – no more – to design a stone bridge and a church:

> I am sending you a mount: and if there's anything else you will need, Raphaello Nasi will provide it all; and if you wish to bring a mason with you, to follow your ideas better, this Raphaello will look after whatever may be needed. This time I happen to be asking you for a favour: another time, you will be asking me, once twice or three times, and you will realize I love you like a brother.

But already Michelangelo had his mind on a more tremendous commission.

Pope Clement kept his word and met Michelangelo on 22 September 1533, not in Florence but at San Miniato al Tedesco, in the valley of the lower Arno, near Empoli, and within easy riding distance of Pisa, where the pope was headed on his way to Marseilles. Michelangelo made a note of the occasion. 'In 1533. I record that today on the 22 of September I went to San Miniato al Tedesco to speak to Pope Clement who was going to Nice; and on this day Fra Sebastiano del Piombo left me his horse.'

Michelangelo and Clement presumably talked about the undertaking to exploit Michelangelo's talent on a grand scale in Rome. The pope's wish for Michelangelo to work for him in Rome followed Michelangelo's first meeting with Tommaso de' Cavalieri in 1532 but became a firm commitment only after Clement had uttered 'words of great importance' to Sebastiano in the summer of 1533. In March 1534 it was reported in diplomatic correspondence that the pope had 'disposed' Michelangelo to paint a scene of a 'resurrection' over the altar in the Sistine Chapel.

There was little by then to keep Michelangelo in Florence; everything to draw him to Rome, once he felt sure of work on a grand scale from a great patron. The pope may indeed have been partly responding to Michelangelo's pressure on him, springing from his longing to be well away from Duke Alessandro and near to Tommaso de' Cavalieri and rid of the underfinanced project of San Lorenzo. Certainly, this time he

left no record of complaint that painting was not his profession, although he once again felt a renewed tension between the new challenge from a living pope and the old obligation to the memory and heirs of Pope Julius.

Compositional sketches in Florence, London and Windsor transport one back to the period of sudden, newly aroused creativity when Michelangelo was responding to the idea of painting the general resurrection of the dead and scenes of judgement, hell and heaven.

First thoughts were to show the Last Judgement in the traditional place for the subject, on the entrance wall. Its pendant, the fall of rebel angels, would be depicted over the altar, opposite, in accord with the existing narrative sequence of the wall and ceiling frescoes. One of Michelangelo's first sketches at this early stage showed, in a traditional composition, loosely linked groupings of the dead arising from graves; above them in a crescent the blessed ascend, Christ with his arm raised in judgement by a beseeching Mary, with the Apostles to his left; and below again, beneath trumpeting angels, is the turmoil of the damned.

After brooding over various possibilities during the winter of 1533–4, Clement finally decided that the painting of the Last Judgement would be done on the altar wall.

Michelangelo reached Rome on 23 September 1534. His brother Buonarroto had been dead six years, his father three. He left behind his surviving brothers, Giovansimone and Gismondo, both now in their mid-fifties, both still unmarried, and neither nearly as close to him as Buonarroto had been. He also left his nephew Lionardo, in his mid-teens, and his niece Francesca, who was under fifteen and lodged in a convent. Both were now legally in the care of Giovansimone and Gismondo. His other nephew, Simone, had died in 1530. Of Michelangelo's household, Antonio Mini – his place taken by Urbino – had died in France; Mona Margherita da Pratiglione, an old family servant, whom he had promised his father to look after, he entrusted to the care of Gismondo.

Michelangelo carried the emotional burden of his family concerns and responsibilities to Rome. His relations with Giovansimone and Gismondo were as loyal and tetchy as ever. Immediately after the end of the siege of Florence, when all three brothers had been unwell and Lodovico had just died, he complained to Fattucci that he had done more for his brothers than he had ever done for himself, and that in return they had done nothing but speak ill of him throughout the city. But, after moving to Rome, Michelangelo was still ready to help

Giovansimone financially, from affection and for the sake of the family. Gismondo, even just to go to Florence, now rarely strayed from Settignano, where he was living with Lionardo and Margherita.

Michelangelo's other ties and friendships in Florence had mostly worn thin or had been broken by the war and the siege, and the change of régime. He may rarely have attended the traditional social meetings and professional discussions of artists and their interested friends which blossomed into the exclusive festive societies of the last decade of the old Republic, but he was familiar with those involved and, as well as particular friendships with young Florentines, he enjoyed many wide-ranging social and professional relationships. Among these, time and retribution had taken their toll. Giovanni Battista della Palla, for example, had poisoned himself, after being incarcerated at Pisa following the return of the Medici.

The kind of younger artists patronized by Duke Alessandro in Florence, like the duke himself, left Michelangelo uninterested or repelled. Pontormo – survivor of the three very talented painters who had started the decoration of Poggio a Caiano – was the brilliant exception; and between 1531 and 1533 Michelangelo nominated him to execute from his cartoons two paintings: one a *Noli me tangere*, Christ's meeting with Mary Magdalene after the Crucifixion, the other a scene of a nude Venus being kissed by Cupid. The artists used for portraiture by Duke Alessandro also included the younger Giorgio Vasari and the inventive, accomplished, and icily elegant Agnolo Bronzino, Pontormo's star pupil, who shared his fascination with Michelangelo.

Michelangelo was still working in Florence on his marble statue of Giuliano de' Medici for San Lorenzo after he had met Tommaso de' Cavalieri in Rome and had drawn the young man's portrait. The features and the expression of the statue shone with the individuality of his living model, of the Cavalieri waiting for him in Rome. Compared with those of Giuliano, the looks of Lorenzo on the matching ducal figure were abstract and characterless.

For the mass of work still to be completed at San Lorenzo, the funding from pope Clement and Michelangelo's enthusiasm ran out at about the same time. The half-abandoned structure from which Michelangelo sped away in 1534 was all the same a richly variegated architectural and sculptural triumph.

Installed in their niches in the massive, cool interior of San Lorenzo's silent domed chapel were the graceful polished figures of the younger Medici princes, Lorenzo and Giuliano, in pseudo-Roman armour, revealing their powerful limbs and torsos. Lorenzo's expressionless downward-looking face is shadowed by a zoomorphic helmet with a

lion's mask; a bat's head terminates the end of the money-box under his elbow; Giuliano's scant armour is decorated with fantastic simulated masks, and he holds across his thighs the baton of a commander, perhaps a captain of the Church. His developed pectorals and general muscle definition make him look like a body-builder.

Ready for the sarcophagus under Lorenzo's niche were the polished male and ambiguously female figures respectively of Evening and Dawn; and, for the sarcophagus under Giuliano's niche, the semi-recumbent images of Night and Day, female and male, both heavily muscled, mournful, generative and erotic, with the night owl below the former's bent leg and with mountainous back and shoulders on the latter, whose face was left symbolically unfinished.

None of the statues of the times of the day was ever completely finished. Having since about 1530 neglected and largely delegated the work for the funerary chapel Michelangelo left it suddenly suspended, as if time had stopped. Only in his imagination did he complete his original grand design for the chapel, in which the union of the three arts was closed with a series of frescoes.

Partly finished statues lay around the site, and the Madonna and Child waited in Michelangelo's studio, in the house rented for him in Via Mozza, as did the four colossal figures that had been intended for Pope Julius's tomb. The bodies of the two Medici dukes were not yet in their sarcophagi.

Work on the vestibule and reading-room of the magnificent library for San Lorenzo had stopped when funds dried up in 1526. During 1533–4, after the pope had pressed Michelangelo to have the staircase and decorations completed, carpenters and masons were busy on site. But when Michelangelo left Florence all work stopped on his final plans. These stipulated a reading-room full of light entered from a sculptural vestibule, with the two united not under a single roof but through the dynamic experience of tension and relief.

52 Florentines in Rome •
The death of Pope Clement

In Rome, Michelangelo found no more serious rivalry waiting for him than he had encountered in Florence. Following the dispersal of 1527,

the city was only just beginning to attract a fresh inflow of artistic talent. After arriving to study in Rome in 1531, for example, Vasari's friend Francesco de' Rossi (called Cecchino Salviati after his early patron Cardinal Giovanni Salviati, a nephew of Leo X) had been securing commissions from Florentine residents in Rome and creating his own manner of clever decorative painting and convincing portraiture.

Benvenuto Cellini had settled back in Rome and was as hyperactive as ever. He had managed to quarrel dangerously with Cardinal Salviati, to catch, and cure himself of, the 'French disease', and to flee from Rome after being accused of murder; he returned to find that the case had been dropped thanks to Cardinal Ippolito de' Medici's intercession.

Meanwhile Michelangelo's closest professional friend in Rome, Sebastiano del Piombo, having done four revealing portraits of Pope Clement since 1530, had shown his support for Michelangelo by painting Cardinal Salviati (whom Michelangelo had offered to portray) in a Michelangelesque style at a time when Salviati's goodwill towards Michelangelo was important in the negotiations over the tomb of Julius II. Waiting to welcome Michelangelo in Rome, the faithful Sebastiano formed part of a circle of men of letters patronized by Cardinal Ippolito de' Medici. The cardinal was a magnet for Florentines in Rome, especially the formidable *fuorusciti* – exiles who were hostile to Duke Alessandro and waiting hopefully for the death of Pope Clement who, along with the Imperial soldiers, was the main support of the Florentine regime.

However, during the years 1532–5, when Michelangelo was regularly spending some of the year in Florence and some in Rome, the bad feelings about the tomb of Pope Julius, far from being remedied by the sweetness of the duke of Urbino, grew still more poisonous. Scant progress had been made on this work since the third contract was signed in April 1532, and it was due to expire in 1535. Michelangelo still had to deliver six statues executed by his own hand. Complaints from the heirs of Julius II were unceasing. He might, Michelangelo thought, find time to make some solid progress on the tomb between arriving in Rome and starting to work fully on the altar fresco for the Sistine; otherwise it seemed the bitterness and guilt would stay with him all the days of his life.

Pope Clement died, aged fifty-six, on 25 September 1534, two days after Michelangelo arrived in Rome. The cause was some form of gastric disease. Some people thought His Holiness had been poisoned

when journeying from Marseilles: by the French or the Florentines, it was alleged in Rome. Clement bequeathed Florence to Alessandro and his other possessions to Ippolito. If Alessandro was his son, the irony was bitter.

Michelangelo had known Clement since boyhood. They understood each other's strengths and weaknesses. Clement, erratically, always at a distance, had provided the substantial funds and kept up the pressures essential to the fulfilment of Michelangelo's huge architectural and sculptural projects. His willingness to spend to immortalize the house of Medici had fed Michelangelo's hunger for commissions on a huge scale.

After the sack of Rome, Clement had encouraged a renewal of artistic activity by commissioning new building and sculptures for the cathedral, and for the Holy House and the Apostolic Palace at Loreto; and then he re-employed Michelangelo at San Lorenzo. Much of his and his court's patronage had been of luxurious works for visual and tactile pleasure, adornment and propaganda, for giving or for religious ceremonies, ranging from gold roses and swords of honour to crystals, bronzes and coinage. Clement had been temperate in eating, coarse in humour, sensitive to music, and eclectically appreciative of craftsmen and artists, eagerly wanting to seek out the talented woman sculptor Properzia de' Rossi, for example (famous, *inter alia*, for carving the Passion of Christ on a peach-stone), after he had crowned the emperor at Bologna.

When Benvenuto Cellini visited Clement shortly before his death, the fifty-six-year-old pontiff – enfeebled, in pain, and scarcely able to see – felt with his fingers the dies and the medals he had commissioned, and sighed deeply.

Clement left Florence less free and the papacy poorer and less powerful than he had found them. In Florence, he had determined in 1532, never again would the spirit of conciliation and tolerance be allowed to threaten the power of the prince; but the ruler of Florence in 1534 was the acquiescent pawn of a far greater power. Clement's diplomacy left the Papal States as intact as when he began to govern them – save for territories seized back by Venice in 1527 – but he had shamed and reduced the papacy to such an extent that it was only just able to continue spasmodically the old game of trying to play one enemy against another in an Italy whose rulers had formed an alliance of un-equals united in varying degrees of submission to the emperor Charles V.

Berni wrote a sonnet on Pope Clement which flailed his pontificate as one of ifs and buts, noes and yesses, doubt and discourse and useless guesses:

Un papato composto di rispetti,
di considerazioni e di discorsi,
di più, di poi, di ma, di sì, di forsi,
di pur, di assai parole senza effetti . . .

Clement's reluctance to accept the emperor's dominance in Italy, his ignorance of Germany, and his overestimation of the power of France had bedevilled his unremitting efforts as supreme pontiff to unite the Christian rulers against the Turk and to stop the spread of Protestantism in Germany and further north.

Under Leo X, Giulio de' Medici had been made cardinal protector of England; not long before Clement's death, the English Church broke with Rome. Clement's refusal to summon a general Council had reflected his inadequate support for religious reform.

Michelangelo had welcomed Cardinal Giulio's election as pope with moderate enthusiasm. Pope Clement's death left alive no other Medici with whom Michelangelo had close bonds stretching back to boyhood. Only three years had divided them in age.

53 The Farnese pope

Alessandro Farnese, dean of the Sacred College, elected Pope Paul III in 1534, was seven years older than Michelangelo. He was the outstanding candidate among cardinals whose choice was not this time dictated by either king or emperor. Clement had recommended him as the right successor. As an Italian 'neutral' in the conflict between the adherents of Charles V and those of Francis I, Farnese benefited from the mood of chastened exhaustion at the end of Clement's troubled reign. His election on 12 October was so sure and so speedy that even before the result was announced the Roman mob was ready to do the traditional plundering of his palace.

Alessandro Farnese came from a rich and powerful family of lately ennobled *condottieri* of the Papal States. His pretty sister, married to Orsino Orsini, from another powerful Roman baronial clan, had been the mistress of Cardinal Rodrigo Borgia, later Pope Alexander VI. His suavity, his intelligence and his learning marked him out for success. Julius II had befriended and promoted him and legitimized his two sons, Pier Luigi and Paolo (born about 1503–5 and followed by a daughter, Costanza, and a third son, Ranuccio, all conceived when he

was in his early thirties, before he was ordained in 1519). Leo X showered him with benefices.

When at last he became pope by acclamation, Farnese was the oldest cardinal as well as the wealthiest, and had proved himself a wise and tactful diplomat; he was naturally popular in Rome and of high repute outside Italy. Moreover, he had given evidence both of personal reform (or at least prudence in ending as early as 1513 his liaison with the mistress by whom he had had his four children) and of sympathy for the growing surge of active discontent within the Catholic Church with its inherited corruptions and accretions. He had five grandchildren when elected pope. In early manhood he had joined academies devoted to classical studies, and consorted with members of the scholarly families making their careers in the Curia. Like similarly minded bishops such as Marcello Cervini and Gian Matteo Giberti, Farnese had embarked on diocesan reform, and pressed for the summoning of a Council to deal with the perils of Lutheranism, the Turk, heresies and other threats to Christendom and Christian unity.

Farnese was far-sighted and self-willed, and sometimes wildly fanciful and extravagant. When he had been imprisoned by Pope Innocent VIII for forging a papal brief, he had been let down by ropes in a basket from a balcony of Castel Sant'Angelo and ridden to the safety of his family. His friend Castiglione long remembered the feast that Cardinal Farnese laid on, soon after the accession of Pope Leo, with one course solely of peacocks. He loved fine wines and rich food. Disturbingly, he allowed his protective wall against undue outside influence by friends or advisers to be broken down by relations, and in particular by Pier Luigi, whom he loved passionately, and indulged, and for whom he had great plans.

Arms rather than arts, utility rather than beauty, Latin poetry and antiquities rather than new paintings and sculptures were the foundations of Farnese's rich culture. Among the new pope's earliest measures relevant to the arts was his appointment, in November 1534, of the erudite Roman and canon of St Peter's Giovanale de' Manetti as curator of classical monuments in Rome – a difficult post under a pope keen on new construction. He also almost immediately called on Antonio da Sangallo to enlarge and refashion his family palace. He sent for Benvenuto Cellini, whom he had commissioned to carry on making the dies for the papal coinage. He made up his mind what he wanted to do about Michelangelo.

* * *

Michelangelo was now living in his house in Macello de' Corvi, a substantial property on several storeys, with vegetable garden, wells and two cottages in the grounds. Bought by the della Rovere family, its ownership was unhappily still in dispute, but it gave him the space he needed for a few servants, for storing or working on huge marbles, for retreat into his world of poetry and imagination.

When Michelangelo visited the pope in response to his summons, he saw and heard a tired-looking old man, slow-spoken but voluble, with flushed complexion and penetrating eyes, long aquiline nose and full greyish-white beard, a worldly, highly intelligent prelate, deliberate and dangerous. It seems that he pleaded before Pope Paul his duty to fulfil his contract with the duke of Urbino for Julius's tomb. This irritated and angered the choleric new pope, who poured out his disappointment and fury. Had he not waited thirty years to satisfy his wish to have Michelangelo's services? Where was the contract Michelangelo cited? He would tear it to shreds. He was determined to have his way.

Having for so long a time hungered for Michelangelo's services, the pope directed him to finish the fresco paintings in the Sistine, urging him to implement his agreement with Pope Clement to paint a great scene of the resurrection of the dead and the second coming of Christ. But now the painting would be for the glory of the Church – now striving to renew and reform itself – rather than for the bitter admonitory motives of the Medici pope, who had originally wanted also a painting of the fall of the rebel angels.

Shaken by the pope's outburst, Michelangelo then thought – or let it be known that he thought – of fleeing from Rome and settling in Genoa. Here his friend the bishop of Aleria (an appointee of Pope Julius) had an abbey where he could work on the tomb, not so far from the marble of Carrara. Or he might go to live in Urbino for its peacefulness, where he would be welcomed for Julius's sake, and where indeed one of his men had already been sent by him before Pope Clement's death to buy a house and land.

Then again, Michelangelo seems to have reflected prudently, the pope would not live for ever, and perhaps he could please him somehow and still appease his own conscience. Also perhaps mindful that he would not live for ever, Pope Paul decided to pay court to Michelangelo in Michelangelo's own house, where he one day arrived with an escort of about ten cardinals, including Ercole Gonzaga, cardinal of Mantua. The pope saw the cartoon and drawings Michelangelo had made for the Sistine, and a collection of statues, including those made for Julius's

tomb. When they saw the figure of Moses, Ercole Gonzaga remarked that this alone was enough to honour the tomb of Pope Julius.

What Michelangelo had already done for the chapel, the pope thought stupendous. Again Farnese adjured Michelangelo to work for him. Again Michelangelo demurred. Then, by all accounts, the new pope, in the face of Michelangelo's obduracy, said that he would arrange for the duke of Urbino to be content with three statues from Michelangelo's hand and for the rest to be given to others to do. And this may well have been what Michelangelo wanted. In due course, at any rate, the way was clear for Michelangelo to work for Pope Paul, and to rise under him to a position of high income and status, safe and secure, in a Rome full of friends and admirers and Florentines. He embarked on a period of greater tranquillity than he had known for years.

Reluctantly, the duke of Urbino started negotiating for a fresh agreement that would be acceptable to the pope. Michelangelo probably found time to work secretly in figures for the tomb, but Pope Paul soon bound him to his service by designating him supreme architect, sculptor and painter of the Apostolic Palace in a brief dated 1 September 1535. To remunerate him for the picture of the Last Judgement, which had already been started, he was promised 1,200 gold crowns annually for life – half from revenues of the ferry above Piacenza, on the river Po, and half in cash.

54 Sebastiano, Aretino and the *Last Judgement*

The preparation of the wall for his fresco of the Last Judgement was completed by April 1536, but it had caused Michelangelo to quarrel angrily with his devoted Sebastiano. Perhaps it was inevitable that Michelangelo's relationship with Sebastiano would be strained when they came to see more of each other; according to Cellini, Sebastiano liked to talk disparagingly of Michelangelo in front of others. But the storm burst after Sebastiano, who liked experimentation, had persuaded the pope that the Last Judgement should be painted in oils and had the wall prepared for this technique.

Michelangelo relapsed into aggrieved silence and time passed. For several months he did nothing. When pressed, he exclaimed that he

would paint only in fresco and that oil-painting was a woman's art or the slack and slothful technique of someone like Fra Sebastiano. Eventually Michelangelo stripped the wall of Sebastiano's *incrostatura*.

By now, Michelangelo's melancholy, exemplified so darkly in the female statues of Night and Dawn in San Lorenzo, had scored him deeply. The wishes of the Curia's theologians and Pope Paul III – who had shared with Pope Clement the outrage of seeing Rome sacked by Imperial troops, and were acutely conscious of the need for renewal of the Church through reform – also contributed to the genesis of the *Last Judgement*. So too did Michelangelo's rich stock of images from his own inventions and from the works of Signorelli and Dante, and from the Bible.

The cartoon for the *Last Judgement* was finished in September 1535. In front of the structural wall, a new wall with a slight overhang against dust was built from special bricks, leaving space for ventilation. By January 1536 the top coat of mortar mixed with resin, ordered by Sebastiano, had been removed, and by mid-April a fresh ground of lime mortar had been applied as Michelangelo instructed. Michelangelo began work on the blank surface, 66 feet by 33 feet, during April–May 1536, over a year and a half after his arrival in Rome. Tommaso de' Cavalieri had been close to Michelangelo while he was completing his preparatory drawings, some of which were perfected from his first drafts. The only helper to grind Michelangelo's colours and apply the plaster ground for painting when needed was Urbino.

Scaffolding was still in place for painting the top half of the wall when Michelangelo received a letter from Pietro Aretino, dated 15 September 1537, warm with praise, exuberantly constructing what he imagined the world would soon be able to admire.

Now who would not be terrified to apply his brush to so awesome a subject? I see Antichrist in the midst of the rabble, with an appearance only conceivable by you. I see terror on the faces of all the living, I see the signs of the impending extinction of the sun, the moon and the stars. I see, as it were breathing their last, the elements of fire, air, earth and water. I see Nature standing there to one side, full of terror, shrunken and barren in the decrepitude of old age. I see Time, withered and trembling, who is near to his end and seated upon a dry tree-trunk. And while I hear the trumpets of the angels setting all hearts astir, I see Life and Death in fearsome confusion, as the former exerts himself to the utmost in

an effort to raise the dead, while the latter goes about striking down the living. I see Hope and Despair guiding the ranks of the good and the throng of evil-doers. I see the amphitheatre of the clouds illuminated by the rays which stream from the pure fires of heaven and on which Christ sits enthroned among his legions, encircled by splendours and terrors. I see his countenance refulgent with brightness, and as it blazes with flames of sweet and terrible light it fills the children of good with joy and those of evil with fear.

Then I see the guardians of the infernal pit, who are dreadful to behold and who to the glory of the martyrs and the saints are taunting all the Caesars and Alexanders, who may have conquered the world but did not therefore conquer themselves . . .

I see the lights of Paradise and the furnaces of the abyss which pierce the shadows cast on the vault of the empyrean; and my thoughts on seeing this vision of the ruin of Doomsday prompt me to exclaim, 'If we are in fear and trembling on contemplating the work of Buonarroti, how much more will we fear and tremble when we are being judged by the One who must judge us?'

Michelangelo expeditiously responded with a cautious, good-natured letter, addressed to the Magnificent Messer Pietro Aretino in Venice, lord and brother, saying that he should by all means break his resolution to visit Rome 'just to see the painting I am doing', and adding killingly:

In receiving your letter I knew both joy and grief together; I greatly rejoiced as it came from you as you are uniquely talented among us all; but I also grieved very much, because I have completed a large part of the composition [*istoria*] and so I cannot use what you have imagined in the work, though it is such that if the Day of Judgement had happened, and you had seen it in person, your words could not have represented it better.

55 Luigi del Riccio and Vittoria Colonna

Aretino's fulsome intrusion came not long after Michelangelo had embarked on an odyssey of friendship with two newcomers into his life, a shrewd, talented and well-connected man of business and a formidable, nobly born woman.

He had met Luigi del Riccio near the time he began the *Last Judgement* and a few years later he had come to know him well enough to choose him as his man of business following the death of Bartolommeo Angiolini in December 1540. Vittoria Colonna he first met in 1536, about the same time, and was very soon fond enough of her to embrace her too, as he had embraced Tommaso de' Cavalieri, in his poetry and his private reflection.

Del Riccio was from a noble Florentine family and worked as an agent of Roberto Strozzi in Rome, where he ran the Strozzi–Ulvieri bank and had many friends among the Florentine *nazione*, including the exiles. The most brilliant of these was the intensely political writer and secretary Donato Giannotti, who had been involved in anti-Medicean republicanism. In years of wandering he had plotted, written plays, studied Dante, and composed a stirring discourse on his design for a mixed constitution for Florence, the *Repubblica fiorentina*.

From the spring of 1536, Vittoria Colonna had begun to spend longer periods than before in Rome, living at San Silvestro (in Capite), a convent connected with the Colonna for centuries past. Born in 1490 at Marino, an ancient castle of the Colonna family in the Alban hills, Vittoria had been engaged at five to the Spanish *condottiere* and noble-man Ferrante Francesco d'Avalos, marquis of Pescara, married at nineteen, and widowed at thirty-five, in November 1525. A daring, resourceful, madly ambitious and unscrupulous commander, suspected of treachery, Ferrante, who had been badly wounded during a brilliant campaign at the battle of Pavia, left his marchesa childless. In her loneliness, she had collected cultured friends in high places and in literary and scholarly circles: Castiglione, the immortalizer of the court of her uncle, Guidobaldo da Montefeltro, duke of Urbino; Jacopo Sadoleto and Pietro Bembo, when they were secretaries to Leo X; Gian Matteo Giberti, head of the papal secretaries; the poets Giovanni Guidiccioni and Francesco Maria Molza; her cousin Cardinal Pompeo Colonna, who before he died in 1532 dedicated to her his Aristotelian *Apologia mulierum* (*Women's Apologia*), which argued that women should share in public offices and magistracies, and ended with praise for the great deeds of Vittoria's dead husband and the shining goodness of his widow.

Vittoria Colonna had lived mostly in Ischia after Ferrante's death, which she mourned in refreshingly personal verse, of the kind she had been writing since childhood. Her life began to swing between the two poles of contemplation – religious meditation and prayer – and

charitable activities, stimulated in due course by the suffering she saw during and after the sack of Rome.

Vittoria's brothers had wished her to remarry, but she never would. In 1536 she visited Rome with her brother Ascanio and his wife, Giovanna of Aragon, and her own adopted son the marquis of Vasto. There, later the same year, she was honoured with a magnificent reception by Pope Paul and a visit from none other than the emperor, in Rome on the momentous business of the reform of the Church and the peace and unity of Christendom. Vittoria's own religious inclinations were now expressing themselves particularly through an appetite for the sermons of the renowned Capuchin priest Bernardino Ochino, whom she met and assisted in Rome. In 1538 she followed him from city to city as he preached to the court of Ferrara and then in Florence and Pisa, before (through her intercession) moving on to Venice.

Vittoria had intended to make a pilgrimage to the Holy Land, but at Pope Paul's request she returned to Rome. Her status, her spirit of enquiry and her devoutness ensured the continuing growth of her already very catholic circle of correspondents and friends.

Vittoria Colonna knew how to flatter intelligent men without condescension. After she had spent a winter at Marino reading the manuscript of Castiglione's *The Book of the Courtier*, she wrote to tell him that, used as she was to thinking that a man writing in Latin had the same advantage over other authors as craftsmen working in gold had over other men working in copper, she had yet found that Castiglione's modern Italian 'has so rare a majesty that its charm need not yield to that of any Latin works in prose'.

Vittoria's poems had become well-known by the time Michelangelo first met her, and some of her *canzoniere* were published (not with her consent) in 1538. As poets, they were united in making use of Platonic imagery to express particular love, and especially the concept of the winged soul returning to the source of its happiness in heaven. Death too, not unnaturally, pervaded Vittoria's early sonnets, as it came to pervade Michelangelo's thoughts. As she moved from mourning and Platonic conceits to mysticism and new kinds of sacrificial imagery, Vittoria echoed and influenced Michelangelo's poetic expression as well as his religious development.

Michelangelo's relationship with Vittoria Colonna showed respect, humour and delicacy veiling strong contradictory feelings which broke though from the deepest levels. His affection for her inspired several beautiful, ambivalent madrigals and gave him bonds of religious sympathy with clerical scholars and bishops committed in varying degrees to

change within the Church. This was threatening as well as liberating at a time when the theological battle-lines were becoming more definite. Michelangelo expressed his deep personal attraction to the middle-aged Vittoria in poetry while he was still putting his emotions about the young Tommaso de' Cavalieri into sonnets of intense thought and feeling.

56 San Silvestro: time in suspense

A contemporary account, Francisco de Holanda's *Da pintura antigua*, describes Michelangelo conversing about art with friends in the beautiful convent of San Silvestro, so caught up with them and their preoccupations that time seemed to stand still.

San Silvestro al Quirinale, popularly known as San Silvestro at Monte Cavallo, included its own house, offices and gardens as well as a refectory, dormitories and a cloister, and was surrounded by the villas of rich men and cardinals.

One Sunday in 1538 – when the painting of the *Last Judgement* was well advanced – Vittoria Colonna was in the church of San Silvestro listening, with the scholar Lattanzio Tolomei, to a reading from the epistles of St Paul. They were joined by a young Portuguese painter, Francisco de Holanda, who had been sent to Rome by his king to study. Knowing the friendship Francisco had struck up with Michelangelo (to whom he had been introduced by Tolomei), the marchesa instructed one of her servants to go to Michelangelo's house and tell him that she and Tolomei hoped that he would join them. Michelangelo arrived sooner than they had expected. He had been already on his way towards them, walking to the baths by the Esquiline Way, with his beloved Urbino.

Vittoria Colonna asked Michelangelo's advice about the nunnery the pope had given her permission to build on the brow of Monte Cavallo, by the ruined portico from where Nero was supposed to have once seen all Rome aflame. Could some of the old structures be adapted to her purpose?

The broken portico might be used as a campanile, Michelangelo said, responding very seriously and then promising to do a drawing for her. The marchesa praised his generosity, his discretion, and his wisdom in not painting for all the princes who asked him to. This caused

Michelangelo to criticize people who alleged that eminent painters were eccentric and their manners uncouth. Painters were not unsociable because of pride, he said – not at all – but because they did not want to waste time away from painting in idle conversation. Even His Holiness the pope, Michelangelo remarked, wearied him when, for example, he asked rather harshly why Michelangelo did not come to see him. He had told the pope that he served him better by working for him at home than by standing in front of him all day.

Those who were reticent because of their work or because they had been born with a dislike of ceremony and dissimulation, Michelangelo went on, should surely be tolerated and be allowed to eschew idle chatter or else speak their minds frankly (as he did, sometimes casually putting on his old felt hat when he was with the pope). An artist who was not his own man and did not keep his reserve could never be better than the people of mediocre common talent to be found, without need of a lantern, in all the world's market-places.

After praising the perception by artists that the best pursuits in this life were good work and a good name, Tolomei recalled the emperor Maximilian saying that he as ruler could make a duke or a count but God alone could when he wished make an excellent painter; and for this reason, he added, the emperor had once pardoned a painter who had deserved to die.

Speaking with deliberation, Michelangelo commented that Flemish painting affected devout people such as friars and nuns more than Italian painting, not because of its excellence but because of their goodness. The Flemings crammed their landscapes with figures, and by trying to do too much they distracted the viewer. Good painting was found in Italy, and it endeavoured to emulate the perfection of God and to satisfy the intellect. An Italian apprentice, even if with little talent, painted better than a master from another country. Even as fine a non-Italian painter as Dürer could not paint convincingly in the Italian manner. Italian painting did not belong to any one country, but had been in Italy since ancient times and might well end in it.

Francisco, after Michelangelo had fallen silent, tried to provoke him into saying more. Painting was done well in Italy and badly elsewhere for many reasons, he said. Francisco thought Italians inherited talent, studied hard, and aimed at perfection. Italians lived in a country which was the mother of all knowledge and full of great works from the past. Unlike other peoples, the Italians honoured painters and talented men, and it was in Italy alone that one painter, Michelangelo, had been called divine.

Vittoria courteously interposed that goodness and talent, none the less, were the same everywhere; and Francisco praised Portugal and especially its king, who had converted distant barbarian countries to the Faith, was feared in the East and throughout Mauritania, was a patron of the fine arts, and had sent Francisco to see Italy, its civilization and Michelangelo.

Tolomei at this point came back into the discussion and made a lengthy disquisition on the claims of painting to be patronized by intelligent people as it was by emperors, kings, philosophers, popes, cardinals and prelates and by great rulers of the past from Alexander the Great to the Caesars, who loved painting, paid generously for it, and even engaged in it themselves. And painting was a great teacher, Vittoria Colonna continued in turn, affecting the emotions, representing holy images, recording great scenes of history, leaving memorials of the present time, and, through portraiture, giving additional years of life to the dead and consolation to the living.

As the marchesa almost wept at this thought, Tolomei quoted Pythagoras to the effect that men were similar to the everlasting God only in learning, painting and music. Michelangelo rounded off the discussion by observing drily that if the Portuguese were to see the beauty of the painting in Italy they would surely esteem it greatly, but they could hardly appreciate what they had never seen. Then he rose to his feet to retire, as did the marchesa. Francisco quickly asked if they could meet the following day in the same place, and with Michelangelo present.

The meeting planned for the following day was postponed, as both Vittoria and Michelangelo were too busy, but another was arranged for a week later, again on a Sunday. Francisco was a little late in arriving and was gently scolded. He started their discourse by asking Michelangelo to say what were the famous works in Italy that those from the kingdom of Portugal ('which you here call Spain') should see and esteem.

This was not a question that Michelangelo would normally care to answer. He was always sparing in praise, though totally assured when he commended a work of art or an artist, such as Ghiberti's doors for the Baptistery in Florence or the promise shown by the young Pontormo. In his eagerness, Francisco prompted Michelangelo, running through the places he himself had visited in Italy and some of the masterpieces he had seen. He had travelled to Rome in 1538 by way of Genoa, and must have greatly admired Perino del Vaga's dramatic frescoes. Still fresh in his memory and likely to be of special interest to his king were

the Medici palaces he had visited in Tuscany and the ducal palace at Urbino. In response, Michelangelo paid tribute to the many private patrons all over Italy and to the artistically aware cities of Siena, Florence, Urbino, Mantua – for the duke's palace – and Padua, among others, and the paintings of Giovanni da Udine, Mantegna, Parmigianino, Dosso Dossi, Pierino del Vaga, and the *cavaliere* Titian, whose Venice was a good picture in itself.

The marchesa, thinking the summary was coming to an end, looked at Francisco and suggested that Michelangelo might well deliberately not draw attention to Rome, the mother of painting, so as not to speak of his own work. She meant, she said, the great frescoed vault with its histories of how God created the world, and its sibyls and other figures, and all the work in the Sistine Michelangelo had not yet completed. And in Rome there was all Raphael's great painting, which would have ranked first had Michelangelo's not been undertaken. As well as Raphael's painting for Chigi's palace and various churches in Rome, there was Sebastiano's famous rival picture of the raising of Lazarus in San Pietro in Montorio. In Rome there were also wonderful palace façades painted by Baldassare Peruzzi and by Maturino and Polidoro. As well as the adornments of cardinals' homes inside Rome there were notable works outside the city, including Pope Clement's Vigna de' Medici under Monte Mario, with its works by Raphael and Giulio Romano, not least the giant fresco of the one-eyed Cyclops Polyphemus, whose feet were shown being measured by satyrs with shepherds' crooks.

And also, interjected Francisco, the marchesa was not to forget the chapel of the Medici in Florence, where the image of Night sleeping over the bird of night had pleased him most, though the figure of Dawn was also richly presented. Francisco felt he must also mention, though it was not in Italy, the picture of a beautiful woman that he had seen in Avignon;* and he was reminded of the St Sebastian he would have seen in Narbonne and, by Michelangelo, of the innumerable palaces and paintings of the king of France, as at Fontainebleau and at the Palace of Madrid, built by Francis to commemorate his captivity in Spain.

Very adroitly, Tolomei then tried to draw Michelangelo out on one of the great topics of debate among artists and connoisseurs: the rival merits of the arts. Francisco had mentioned Michelangelo's marble tomb, he said, but this could scarcely be called painting. Francisco was

*Raphael designed and Giulio Romano began this – never completed – villa, now Villa Madama, for Giulio de' Medici, later Pope Clement.

bold enough to launch into his own disquisition on the pre-eminence of drawing or design done for painting, and the evidence from history which recorded that Phidias and Praxiteles were called painters but were assuredly marble sculptors, and – asking Michelangelo's permission – he cited as one of the first of the famous modern sculptors of Italy the great Donatello, who, when teaching his pupils, said he gave them the whole art of sculpture in the single word 'draw'.

Treading carefully, Francisco then appealed to Michelangelo's own practice. Michelangelo's basic art, he suggested, was not sculpture, though he did marble sculptures better even than he painted with the brush on a panel and had told Francisco that he found sculpting in stone less difficult than painting in colours. Behind all sculpture was the power and virtue of drawing.

After Francisco had brought to the aid of his argument the work of Bandinelli (whom he had been to see and who could not paint in oils, he noticed), and Raphael and Peruzzi, Michelangelo supported him by saying to Tolomei that the painter should not only be well versed in the liberal arts, and in sciences such as architecture and sculpture, but also in all the other manual crafts, and could if he so wished surpass the specialist masters themselves. Using the word 'painting' as synonymous with 'drawing', Michelangelo developed the argument for its determining role by appealing to personal experience and shared observations that it was used in all human activities: in creating all sorts of forms, in dress and adornment, in building and erecting decorated edifices and houses, in navigating the seas, in fighting and dividing the spoils, in all matters of life and death. This was apart from all the handicrafts and arts, of which, Michelangelo continued, painting was the main fount, from which sprang the rivers of sculpture and architecture, the brooks of the mechanical trades, and the stagnant waters of pointless exercises such as cutting out with scissors. He looked back to the great flood of old when painting overflowed its banks and established its universal dominion, as could be seen in the multitude of works left by the Romans, in their triumphs and buildings, and even in the elegance of their coins and in their writings. A draughtsman, or painter, could master other arts and crafts, but only he could be master of his own.

Tolomei happily seized on the thought that letters were a part of painting too. Had not Quintilian said that the orator should not only be a draughtsman in arranging his words of rhetoric but also know how to sketch with his own hand? In the time of Demosthenes, writing had been called by a word meaning drawings; and the hieroglyphics of the Egyptians were painted beasts and birds.

He then enthusiastically compared poetry, above all, to painting, and recalled how Virgil, then prince of poets, had dreamed and meditated how to paint in words the vases of Alcimedon, the tempest of Aeolus, the port of Carthage, the burning of Troy, the gates of hell and its monsters, the souls of passing Acheron, the Elysian fields, the torments of the wicked, the arms of Vulcan, and the spoils and trophies and fates of noble men. In the whole of Virgil, Tolomei commented very felicitously, you would not find anything but the handiwork of a Michelangelo. He then brought into play as painters in words the ancient writers Lucan, Ovid, Statius, Lucretius, Tibullus, Catullus, Propertius and Martial. They called painting 'dumb poetry', he cleverly concluded.

Francisco protested that surely poetry was the more dumb. Challenged by Vittoria Colonna to prove this, the young Portuguese, after some gallantry and a mention of the lateness of the hour, displayed all his wit and Virgilian erudition in a long poetic exposition of painting's eloquence, its verisimilitude, its instantaneousness, its dramatic appeal to all classes of mankind and all nations, and its emotional power. Let Calliope, the muse of poetry, be the judge, he said.

Vittoria joked that the young man had done so well for his beloved painting that she might divorce Michelangelo and go back with Francisco to Portugal. Michelangelo said smilingly that she had done so already. Francisco wondered whether painting would be welcomed in Portugal – if rejected, she might drown herself and have to be mourned like Lycidas. Then the marchesa said they would take up the question the following Sunday, and rose to her feet.

The third discussion took place a fortnight later, despite falling on the Sunday of the festival chariot races in the style of the ancient Romans round the Piazza Navona and the improvised celebrations of the marriage of Ottavio Farnese, Pier Luigi's thirteen-year-old son (the pope's grandson), to Margaret of Austria, natural daughter of the emperor and widow of Alessandro de' Medici, who had been murdered in 1537. The couple were ill-suited and their marriage was miserable from the start, but it was celebrated with a banquet and illuminations and other festivities, including races between horses and buffaloes and the slaughter of the bulls.

Francisco de Holanda watched a procession of local mayors and a hundred citizens' sons on horseback dressed like ancient Romans, with bevies of foot-soldiers, descending from the Capitol. He admired the gonfalonier of Rome, Giulio Cesarino, as he passed by on a horse caparisoned with black brocade and a coat of arms in white. Then he

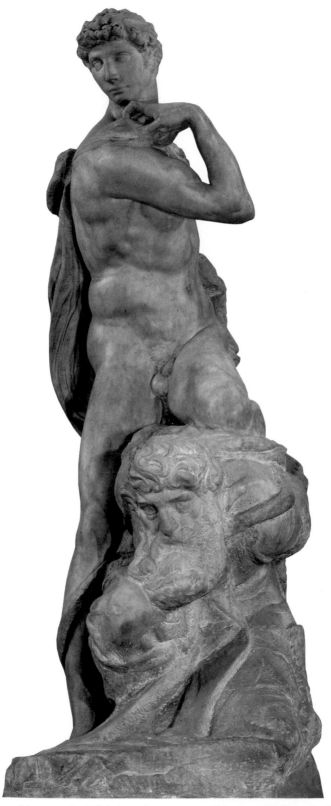

36. *Victory*, marble group by Michelangelo, *c.*1525–33 (Palazzo della Signoria, Florence)

37. Vestibule staircase of the Laurentian Library by Michelangelo, completed 1559 by Bartolomeo Ammanati and Giorgio Vasari (San Lorenzo, Florence)

38. Reading room of the Laurentian Library by Michelangelo, c.1524–34 (San Lorenzo, Florence)

40. *Self-Portrait Medal* by Francesco da Sangallo, 1551 (Metropolitan Museum of Art, New York)

39. *The Siege of Florence*, 1529, fresco by Giorgio Vasari (Palazzo Vecchio, Florence)

41. *Sebastiano del Piombo*, woodcut from Vasari's *Lives*, 1568

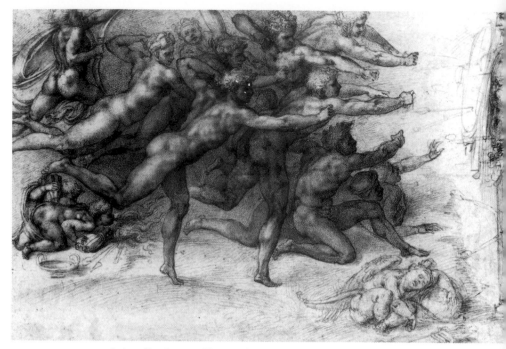

42. *Archers Shooting at a Herm*, red chalk drawing by Michelangelo, *c.*1533
(Royal Library, Windsor Castle)

43. Courtyard of the Palazzo Farnese, by Antonio da Sangallo the Younger and Michelangelo,
completed *c.*1547 (Rome)

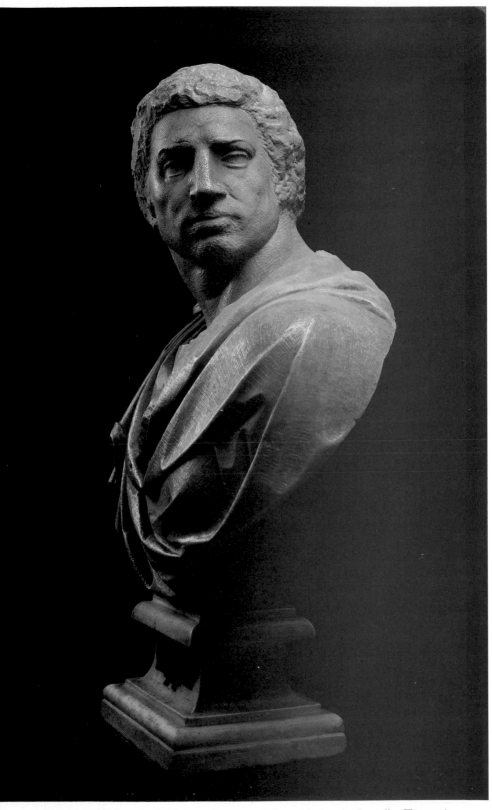

44. *Brutus*, marble bust by Michelangelo, *c.*1540 (Museo Nazionale, Bargello, Florence)

45. *The Dream of Human Life*, black chalk drawing by Michelangelo, *c.*1533 (Courtauld Institute of Ar

46. (*Above*) *A Bacchanal of Children*, red chalk drawing by Michelangelo, *c.*1533 (Royal Library, Windsor Castle)

47. (*Left*) *Vestibule of Michelangelo's House in Macel de' Corvi, Rome*, etching from *I monumenti più interessanti di Roma*, by Luigi Rossini, Rome, 1818

48. *The Risen Christ*, black chalk drawing by Michelangelo, *c.*1533 (Royal Library, Windsor Castle)

turned his horse towards Monte Cavallo and meditated on the wonders of the past, feeling he existed there rather than in the present.

He arrived at San Silvestro along with a courtier of the marchesa, Diego Zapata, scion of one of the oldest families of Madrid, whom he had met on the way. There he found Tolomei, Michelangelo and the anti-Lutheran preacher Fra Ambrogio Caterino, relaxing in the garden under some laurel-trees by a stream. Behind them was an ivy-covered wall; in front, a wide prospect of the city of Rome.

Zapata apologized for the marchesa's absence and passed on her hope that they would continue their noble discourse on painting, which he would report back to her. Francisco recalled they had been talking about whether painting would be useless in time of war, and added that the marchesa would want them to continue this theme. Michelangelo laughed at Francisco's acceptance that Vittoria had as much power over them absent as present, and began with the challenging question, What was more advantageous to the conduct and waging of war and of more use in sieges and assaults than painting?

Making a rare, almost unique, personal apologia, confirming the importance he (like Leonardo) attached to his capabilities as a military engineer, Michelangelo recalled that it was through his work and skill that the besieged Florentines had mounted a strong defence of their city, and that his fortification had disconcerted and destroyed so many of the enemy, and Castilian soldiers had been blown to pieces.

Painting, Michelangelo elaborated, was therefore not only useful but essential in war: in the past for catapults and battering-rams; now for cannons and harquebuses, fortresses, bastions, mines, trenches, bridges, ladders, for marshalling troops, and even for the design of banners and standards, for the devices on shields and helmets, for coats of arms, crests and medals. And drawing was of immense use in war for demonstrating distances and for displaying the positions of distant places and the shapes of mountains and harbours.

After maintaining the need for field maps in aggressive warfare and citing Alexander the Great, Julius Caesar and Pompey as either patrons or practitioners of painting, or both, Michelangelo asked rhetorically, What country warmed by the sun was more bellicose and saw more war and routs and sieges than Italy, and in what country was painting more esteemed?

As Michelangelo fell silent, Diego Zapata joked that he, Michelangelo, had given arms to Francisco's beloved lady, painting, but had disarmed the emperor Charles, and had forgotten that those he was with were supporters of the emperor and more Colonna than Orsini.

Would Michelangelo now show the worth of painting in peacetime?

After commenting on how republics and kingdoms patronized paint-ing in different ways and how painting and architecture could be used in times of peace to immortalize the achievements of war, Michelangelo recalled that when Augustus Caesar closed the iron doors of the Temple of Janus he opened the doors of gold of treasures of the empire and then paid as much for a figure in painting as he would have given a regiment of soldiers in a month; peace was then desirable to encourage princes to enhance their own state and their glory, to benefit themselves spiritually, and to enjoy contemplating peaceful things.

Remarking on the attitudes in Spain and Portugal towards rewards for painters, Michelangelo advised Francisco to live in Italy or France, where talent was acknowledged and great painting highly esteemed. Pope Paul, for example, treated him better than he asked, and paid Urbino for grinding his colours as well as giving him meals in the papal palace. But how is painting to be valued, asked Francisco, after protest-ing that he lived only to serve his King João and had been born and hoped to die in Portugal.

Valuations should be made by those who could distinguish good from bad painting, Michelangelo said, and they should relate to the excellence of the work, not to the time spent on it.

After Michelangelo had referred to notorious instances when painters had destroyed their work rather than accept an insulting payment, Zapata suddenly asked him why in Rome painters had depicted so many grotesques: monsters and beasts, some with women's faces and with fishes' tails, others with the legs of beasts but the features of men.

Michelangelo replied at length and in all seriousness. This kind of painters' licence was right and reasonable, he argued, and the commen-tators were wrong who said that the lyric poet Horace condemned painters in the verses '*Pictoribus atque poetis/Quidlibet audendi semper fuit aequa potestas/Scimus et hanc veniam petimusque damusque vicissim*' ('Poets and painters have always shared a like power of daring anything – we know that, and between us we both seek and grant that licence in turn' *De Arte Poetica*). Rather he had said they were at liberty to do what they dared. And painters had always had this insight and power.

Great painters would never do anything whose falsity was not true; they would not paint a man's hand with ten fingers, or the face of a child like an old man's, or an eye or an ear half an inch out of its proper place. But a painter, in order to observe what was proper to the time and place, using grotesques, might alter parts of the limbs, which would otherwise be graceless and indeed quite false. As instances,

Michelangelo mentioned converting a griffin or deer into a dolphin down below, or into any shape at the top that the painter fancied – wings in place of arms, say. The transformed limb of the lion or horse or bird would be perfect of its kind, and might be called well invented and monstrous rather than false. Sometimes, rather than show the usual, albeit admirable, figure of a man or an animal, it was reasonable to paint a monstrosity for the sake of variation, visual enjoyment, and surprise. So sometimes human desires had seized the licence to eschew buildings with columns, windows and doors for others with the imaginative falsity of the grotesque, whose columns showed little creatures at the top of flower-stalks, architraves and cornices made of branches of myrtle, and doorways of reed and so on. These seemed impossible and senseless, but might be superb if done by someone who understood.

Michelangelo's quotation suggested the divine fury as well as the poetic licence of Horace. Rarely had he so explicitly preached what he practised himself so consistently: the right to be daring in his art. Francisco, as he bowed to Michelangelo's argument, carefully added the need for decorum and propriety: King David should not be dragged from his prayers, and the right place for Pan playing his pipes or a woman with the tail of a fish was a fountain or garden. If this were remembered, then skilfully executed grotesques were fine in their place – and better, for example, than a certain painting in which the hare had to be labelled to distinguish it from the hound pursuing it.

Francisco had unwittingly defused Michelangelo's praise of bold nonconformity, and may well have missed the irony in the response at this point, as Michelangelo commented on the exalted nature of decorum, and on how badly painters who were not painters observed it, and how attentively a great painter regarded it. When Tolomei chimed in that he could not abide one special indiscretion of bad painters, which was to paint without due consideration and devoutness in churches, Michelangelo moved the discussion smoothly forward and on.

He again spoke at some length, linking the successful painting of holy images with the moral goodness of the painter, and even the inspiration of the Holy Spirit. He gave as an example the head of the Saviour in San Giovanni in Laterano (the silver-coloured miraculous picture of Christ).

Francisco revealed that he had himself copied this sacred painting of Christ to send to the queen of Portugal. Tolomei marvelled at this, as to his knowledge neither popes nor the brothers of San Giovanni in Laterano had ever allowed the holy picture to be copied. Michelangelo added admiringly that Francisco had painted the picture using oils for the first time in his life; and then he repeated his conviction that drawing or

design was the fount and body of painting and sculpture and archi-
tecture, and the root of all sciences. One who succeeded in being able
to draw well possessed great treasure, being able to make figures higher
than any tower, in colours or carved from the block, to find no wall
that did not seem circumscribed and small to his soaring imagination,
to be able to paint in fresco in the old manner of Italy, to paint sweetly
in oils, and also to achieve perfection on a scrap of parchment.

At its most excellent, Michelangelo continued, as daylight was fading,
painting was the imitation of the works of God – a human figure, or a
wild animal or bird of the air – and it must be executed not with gold
or silver or even beautiful tints, but simply with pen or pencil, or with a
brush in black and white. Anyone who could draw well and merely did
a hand or foot, he said, could paint well whatever he wished. A painter
had only to make a simple outline, he added, echoing the story of
Giotto's O, and he would be known by it – as Apelles, merely by the
straight lines he drew, had distinguished himself from Protogenes.

Asked by Francisco whether it were better to paint quickly or slowly,
Michelangelo gave the obvious answer: that the quick painter deserved
the more praise if he painted no worse than the slow. But what
mattered, he assured Francisco, from the heart (and as indeed his own
practice bore out), was that a work done well with toil and sweat
should appear to have been executed almost effortlessly.

Michelangelo allowed Francisco the last word, asking what he consid-
ered best among the many different kinds of painting. Francisco duti-
fully listed for their different but excellent styles Polidoro da Caravaggio
and the Sienese Baldassare Peruzzi in Rome; Perino del Vaga and
Giulio Romano in Mantua; the Florentine Maturino and Parmigianino;
Titian, who was softer in style than Leonardo da Vinci; Raphael,
whose softness differed from that of Sebastiano del Piombo; and
Michelangelo, whose work was like no one else's, just as his own small
talent, Francisco said, was dissimilar from all others.

Night had fallen while Francisco was talking, and the little group
dispersed. Francisco had been privileged to hear Michelangelo talk,
eagerly but conventionally, as a Florentine, about the importance of the
arts and the primacy of design. He had expressed less commonplace
views on Flemish pictures, on grotesques, on the nature of painting, on
rapidity of execution, and on the appearances of spontaneity and of
effortlessness – Castiglione's *sprezzatura*, the noble courtier's nonchalance.

Francisco had also seen the mutually respectful, tender relationship
between Michelangelo and Vittoria Colonna, and had sensed, as they
relaxed and talked in the beautiful atmosphere of the convent garden,

the ever-deepening religious sensibility of Michelangelo, on this occasion at his most benign. It was about this time that Michelangelo wrote one of his most lyrical poems, 'O notte, o dolce tempo, benché nero . . .':

O dark yet lovely night, the gentlest time,
you seal with peace the work of every hand
and only those who praise you understand
the good; who honour you know the sublime.
Our trailing thoughts you trim and clip like rhyme;
your moist shade sheds a quietness on the land
and then you raise me in my dreams to stand
in hoped-for heaven where my soul would climb.
O shadow of our death, who takes from life
the wretchedness of both heart and mind,
the last and healing salve of wounded flesh,
you mend our bodies torn by Fortune's knife,
you dry our tears; in you deep rest we find,
our anger calmed, our tiredness refreshed.

57 'your beauty makes me happy'

Michelangelo showed humour and tenderness in his feelings for Vittoria Colonna and, for the first time, found someone to whom he could extend a kind of gallantry. Having come to know him well by the time Francisco de Holanda recorded their discussions, she knew how to manage him beautifully, as the observant Francisco reported. The surviving letters of the many they exchanged showed her pleasure in giving him presents, including a little altarpiece and a painted crucifix.

Vittoria had been sent a sketch of a crucifix by Michelangelo, and he had then secretly worked on a finished drawing with which to surprise her when she returned the sketch. Meanwhile, however, she had told Tommaso de' Cavalieri of changes she wanted made to the design, including the addition of two lamenting angels. This provoked an indignant note from Michelangelo, sent to her within a year or so of their conversation in San Silvestro with the design with which he had wanted to amaze her: 'I did something secretly as a surprise. And my plan was spoilt . . .'

The marchesa tactfully wrote as if uncertain whether it was really Michelangelo who had gone to so much trouble, saying she would not

want to return the drawing if this were so, and wondering if he would execute it as a painting, or discuss with her who should do so. Certainly the figure of Christ, she commented, was so beautiful, so alive and so perfectly executed that it crucified in her mind all other pictures she had ever seen. 'I have examined it carefully in the light, and with a lens and mirror, and I never saw anything more perfect.'

Michelangelo did not share Vittoria's predilection for superfluous angels. The marchesa, none the less, still wanted the painting done, and was excited enough to ask Michelangelo to send the design to her for a while, though it was not finished, as she wanted to show it to some of the courtiers of the cardinal of Mantua; if he were not at work, would he come round at his leisure to talk to her, she added. Further letters thanked Michelangelo for paintings of a *Pietà* and a Christ with the woman of Samaria.

It was probably for Vittoria also that at this time Michelangelo wrote a madrigal – '*A l'alta tuo lucente dïadema*' – with the imagery of a towering but, it seemed, abiding presence to which he could ascend only through her condescension.

> To your resplendent beauty's diadem
> no one may hope to rise, O Lady,
> except by long and steep ascent – the way
> on high is by your gentle courtesy.
> My strength is failing me, I spend
> my breath halfway – I fall, I stray,
> and yet your beauty makes me happy
> and nothing else can please my heart
> in love with everything sublime
> but that, descending here to me
> on earth, you are not set apart.
> It comforts me meantime,
> foreseeing your disdain, that this my crime
> pardons in you the bringing of such light
> down so closely from your hated height.

58 Painting the Apocalypse

The Roman-born Pope Paul began his reign in a mood of hope and triumph, perceiving himself as experienced in politics. He was fearfully

mindful, of course, of the shame of the sack of Rome, but was more concerned to look forward and to grapple with current and future challenges.

Among these was the need to raise money. Venetian calculations showed that in 1536 papal revenue from sources including saleable offices, Roman customs, the provinces of Rome, salt and cattle taxes and the Tolfa alum mines were apparently running at half the amount accruing to Pope Clement a decade previously. Yet the need to rebuild the papacy's prestige and influence was imperative, and while pursuing family interests (two grandsons were made cardinals in 1534) Paul also moved to raise the political and spiritual standing of Rome. He would, he promised the Sacred College, strive hard for peace and religious reform.

By not renewing Clement's league with the emperor, Pope Paul temporarily quietened the French and helped Charles V play his favoured role of Christendom's crusader against Islam: in particular against the corsair chief called Barbarossa, who had captured Tunis in 1534. The emperor's armada of Spanish and papal forces took the enemy's arsenal, the fortress of Goletta, near Tunis, and, after an uprising of 20,000 Christian slaves, Tunis itself in the summer of 1535. But by the autumn Barbarossa was again striking from the sea: Venice and France (secretly allied to Barbarossa) were opposing the pope's call for a crusade against Constantinople and urging him to realize the threat to himself and the Church of an over-mighty emperor. In the summer of 1536 the French and the Imperialists again began to war against each other.

By then Pope Paul had made extensive but futile efforts to rally both Catholic and Protestant princes and kings behind his programme for a Council of the Church. ('We, through the Holy Spirit, are certain of all things and have no need in truth of any Council,' Luther told the pope's emissary, Cardinal Vergerio.) In Rome itself, circumspect but decisive, Paul pushed forward with the appointment of reforming commissions of cardinals and new regulations to improve the morals and discipline of the clergy. In the early winter of 1536, when Michelangelo was at work in the Sistine on his new fresco, three members of the pope's commission of reform, Jacopo Sadoleto, Gianpietro Caraffa and Reginald Pole, were given cardinals' red hats. The choices exemplified the high seriousness of the pope's reforming zeal. The Ferrarese Sadoleto had led a priestly life beyond reproach besides shining as a writer of Ciceronian grace, and as a thinker and diplomat. Caraffa was to be one of the few who dared express disapproval of the extravagant carnival celebrations of 1539, surpassing those which had

so captivated Francisco de Holanda with their ancient splendour. Pole, grandson of the duke of Clarence, had finally turned away from his own country when Henry VIII, after assuming supremacy over the Church in England, executed Thomas More and John Fisher; Pole was fired by the apocalyptic belief that the now excommunicated Tudor king was a precursor of the Antichrist. Vittoria Colonna was one of Pole's closest friends in Italy.

The commission's memorandum exhorted the head of the Church to avoid all venal practices, denounced abuses and scandals connected with holy orders, and reminded the pope of his duties as bishop of Rome. The pope – who was not pleased when the advice was leaked and printed – was told in blunt language:

> You have taken the name of Paul. We hope that you will imitate his charity. He was chosen as an instrument to carry the name of Christ to the heathen; you, we hope, have been chosen to revive in our hearts and deeds the name of Christ long since forgotten among the heathen and by us the clergy, to heal our sickness, to unite Christ's sheep again in one fold, and to avert from our heads the wrath and already threatening vengeance of God.

Michelangelo, in the febrile atmosphere before the Council, conceived for the wall of the Sistine an Apocalypse or revelation of the end of the world to register the hopes and fears of Pauline Rome, but also to break free of its limits of space and time. He disregarded all other notions of decorum for his own sense of the fitness of painting human bodies in the grand manner, with all possible movements and attitudes. Showing his mastery of design, he wished to demonstrate the relevance of the emotional and spiritual expressiveness of the body to the troubled nature and uncertain destiny of mankind.

The turbulences and contrarieties of Michelangelo's own state of mind filled his imagination with innumerable varieties of gesture, form and expression, embodied in hundreds of figures in the void between heaven and hell at the end of time. His imagined unclothed or scarcely clothed figures, from the skeletal to the sublime, showed the extremes of pain and terror and, less noticeably, the pleasures of human affection, charity and beauty. In a society inured to gross birth-to-death physical suffering, inflicted by God or man – plague, rape, murder, torture – Michelangelo saw no point in portraying the shedding of blood or the penetration of bodies to express as he wanted the full range of human emotion.

Michelangelo's design involved the removal of Perugino's altarpiece and the obliteration of two of his own lunettes so that the new fresco could cover the entire wall. This made a deliberately unframed surface space on which to construct a new pictorial reality unified by neither a single space nor a fixed viewpoint. Having long mastered the laws of perspective, he could now transcend them.

A compositional drawing shows the sudden pounce of Michelangelo's mind on transforming the lower part of the picture – traditionally used to show the dead being resurrected and the saved being separated from the damned – so as to show the dynamic ascent of the saved into heaven and the descent of the damned into hell. Where there had been a door in an earlier sketch (done when a *Last Judgement* on the entrance wall was to face a Fall of the Rebel Angels on the altar wall), Michelangelo now drew a cave through which (as living mortals through the associated doorway) the lost souls might continue their journey. And in the same black chalk drawing Michelangelo now showed single little figures of the newly resurrected to left and right on the plain of resurrection.* His early decision to place the figure of Christ at the centre of the main design, with a multitude of figures spiralling around him, like planets around a sun, lent his elaborate design cosmic significance.

After preliminary work, Michelangelo waited till the freezing weather ended to start painting, but as early as February 1537, impatient as his predecessors, Pope Paul visited the Sistine to see what progress was being made. Michelangelo painted from the top down over 215 square yards of wall space in fresco, and used natural ultramarine (necessarily applied *a secco*) for the huge area of sky.

There were tragicomic encounters and near disasters. The story went round that on one occasion when Pope Paul was in the Sistine with his scrupulous master of ceremonies Biagio da Cesena, the latter, asked for his opinion, said portentously that it was very improper to have so many nudes exposing their shameful parts in such a place of honour that it seemed a work not for the chapel of a pope but rather for one of the stews or inns of Rome. Michelangelo took a speedy revenge by depicting Biagio as Minos, painting him from memory with the ears of an ass and with a thick serpent wound about him and fastening its mouth on his penis. When Biagio expostulated, the pope, it was said, commented that he could have helped if Michelangelo

* Partial sketch for the *Last Judgement* with subsidiary sketches, male torso; Windsor Castle, Royal Library no. 12776r.

had depicted him in purgatory, but in hell there was no redemption.

About this time, Michelangelo fell from the scaffolding and injured one of his legs, and then refused any medical treatment. A well-known Florentine doctor and friend of Michelangelo, Bartolommeo (Baccio) Rontini, persisted in trying to seek him out at home and eventually, after gaining entry and going from room to room, found him in desperate straits. Rontini nursed him and stayed with him till he had recovered.

59 Honouring the emperor

While Michelangelo had been painting eschatological scenes under his luminous ceiling frescoes, other artists had done the honours for the emperor Charles V during his triumphal visit to Rome in April 1536. Piloto, with Francesco di Maso Masini, both from Tuscany, had executed statues of the emperors over the door of the Vatican Palace. (Michelangelo's erstwhile companion in Florence, Piloto died from wounds after an affray the following winter.) Antonio da Sangallo, an old friend of the Farnese pope, made a magnificent wooden triumphal arch at the palace of San Marco, with Corinthian columns chased in silver, figures of the emperors, and scenes of Charles's own deeds.

In Florence, for the *entrata* of the emperor on 29 April 1536, Giorgio Vasari (now studying architecture, as he had seen Duke Alessandro was keen on fortifications) made a banner of crimson cloth with the arms of the Medici and the emperor and a border of 40,000 gold leaves. Tribolo did four giant statues: of Hercules, of the river Bagrada (the Mejerda) and the river Rhine, and of Peace with an olive branch and flaming torch.

While in Rome, the emperor paid a visit to Vittoria Colonna, as well as to the wives of Ascanio Colonna (Vittoria's brother) and Pier Luigi Farnese. He visited the churches and monuments, making the pilgrim's traditional round of the seven churches on Holy Saturday. Before the pope, his cardinals and ambassadors to Rome, he delivered an impassioned speech in Spanish, challenging and listing the wrong-doings of the king of France, who had invaded Savoy, seized Turin, and was again claiming the reversion of Milan. The frustrated French envoys wondered if he were seeking a duel with King Francis. The emperor,

physically far less robust than his rival, said this would be so only if peace proved impossible. The emperor's soldiers, Spaniards and Germans, left Rome peaceably – just under ten years after the sack of the city. A date had been fixed for the Council. Pope Paul had promised to stay neutral in the event of war between France and the Empire.

From that summer, however, the war continued for most of the years Michelangelo was in the Sistine, during which (in February 1538), as the French had feared, a new Holy League against the Turks was signed in the Vatican between Charles V, Ferdinand I of Hungary and Bohemia (the younger brother of Charles), Venice and Pope Paul. No pope could, like Atlas, stop the heavens from falling by holding them up on his head and hands. The momentum for political and religious change was too powerful to check or to control.

During the bleak winter of 1538–9 children begged and corpses rotted in the streets of Rome; the companions or so-called 'reformed priests' of Ignatius of Loyola, with Pope Paul's encouragement, changed their mission from being pilgrims to Jerusalem to succouring the poor of Rome. It was this same winter that the pope's grandson, Ottavio Farnese, married the emperor's daughter, the widowed Margaret of Austria, and that Francisco de Holanda especially observed the festivities.

In September 1538 the forces of the League under Andrea Doria were routed at sea by Barbarossa. In October 1540 Venice, ignominiously surrendering territory and paying a war indemnity of 300,000 ducats, made peace with the Turks.

The reform of the Church, the growing turmoil in the Papal States, and the advancement of his own family were now the preoccupations of Pope Paul.

Open rebellion by Perugia was crushed in mid-1540, when, in funereal garments with ropes round their necks, over a score of Perugians threw themselves before the pope in front of St Peter's and begged for mercy. The pope then moved against the petty ruler Ascanio Colonna, Vittoria's brother, who had refused payment of taxes for the war against the Turks, refused to pay an increase in the much hated papal salt tax, prevented grain reaching Rome, raided cattle, and generally acted as a contumacious and dangerous vassal. After savage campaigning all the Colonna castles round Rome were seized, the family was dispossessed of all its states, and Ascanio was exiled to Naples. Locally, at any rate, by the end of 1541 the pope had energetically and decisively secured the dominance of the papacy.

Vittoria Colonna, having tried but failed to achieve a peaceful settlement, had retired to the papal city of Orvieto (where she was spied upon for Pope Paul by the governor) to live with nuns, write poems, correspond widely and read Cardinal Contarini's *Epistola de justicatione*. She stayed in Rome for a few months in 1541, before leaving to live in Viterbo, a day's journey away, where, with Cardinal Pole, she created a centre of the *spirituali* who sought within the Church and the Curia to heighten religious awareness and personal holiness.

Being among Vittoria Colonna's friends put Michelangelo in the perilous company of the reforming Catholics agonizing over the content of their faith but faithful, for the most part, to the office of the pope. Keenly watched by the inquisitors (whose functions in Rome were revived when the pope established the Holy Office in 1542), and suspected by some doctrinally rigid cardinals of covert Lutheranism, for varied reasons – ranging from pious sympathy to diplomatic opportunism – the *spirituali* for the time being were protected by the pontiff himself.

60 The blessed, the saved, the damned

When the *Last Judgement* was unveiled, on 31 October 1541, the painting shone like glass set with precious stones. The bright colours of the Sistine ceiling were now counterpointed by the radiant delicate blue of the sky painted over the altar, where the wall seemed to have dissolved into space, and by the flesh-tints and the ancient Naples yellow and brown, green and madder of the figures and draperies.

In the middle below, on a cloud, between an obese figure of utter despair seeing through one uncovered eye the full horror of sin and being tugged down by demons, and a bending muscular youth raising up two of the resurrected by the rosary of prayer, angels of the Apocalypse with puffed cheeks blast their trumpets to raise the dead, while two among them show respectively the book of life with the names of the saved and the tome for the recording of sins.

Directly beneath, extending to the right, Charon raises his oar to thump the personified sins being dragged with chattering teeth, weeping and blaspheming, from his tilted boat. To the left, shrouded or skeletal figures murmur and exclaim as they are reclothed in flesh and hauled or wafted aloft from the plain of dry bones.

All kinds of sounds float down like leaves, a fall of the noise of lamentation and self-reproach, and the intake of breath, as around the dominant image of Christ some of the resurrected embrace before their journey and the self-absorbed martyrs turn inwards to see and hear the judgement of Jesus – both St Paul's heavenly high priest and exalted Lord, and St Matthew's Messiah of love and sympathy, but also now the image of a beautiful Greek god, flanked intimately by the Virgin looking down and away with holding arms.

Above, the sprawling, reeling, nude and wingless angels with the instruments of the Passion of Christ exclaim and remonstrate among themselves as they battle against rushing winds with the Cross and the column, and the crown of thorns, lance, nails and sponge. Below, the grotesque fiends snarl at the entrance to hell, where a male nude with raised arms is silhouetted against the fires.

The painting shows how well Michelangelo solved the problems he faced, how abundant was his invention, how great his achievement: the quotations from previous painters he wanted to live in his work but make his own; the effortless-looking effects of all his labour; the sheer mass of over four hundred figures in movement; the impression of endless depth; the powerful rush of movement up and down; the subtle correspondences between matched figures and groups; the use of modulated colour tones as well as contours to create an alternating tempo of action and repose.

When the fresco of the *Last Judgement* was finished, Michelangelo was sixty-six. His age, and the lapse of time since he last painted a vast mural, made his energy, skill and assurance all the more amazing. He used broadly drawn cartoons and did most of the painting himself. Many of the heads were generalized, blocked out rather than detailed portraiture, and he threw his energies into subtle modelling, startling aerial perspectives, and the use of graduated focus to create depth. The poise and calm associated with earlier Florentine painting yielded to Roman gravity and monumental motion. The repose and athleticism of the figures on the ceiling gave way to heavy muscularity and violent gesture. But Michelangelo still refined every detail in the expressive faces as well as the gestures of the fleshy figures, all intensely alive.

There were also lewd jokes and visual puns for close friends and enemies and for the *cognoscenti*. Michelangelo has done the portrait of his own ugly face (as he thinks it) in the flayed human skin held up by St Bartholomew in the line of the gaze of the all-powerful Christ. Who would notice the likeness of the body of Christ to Hercules and of the grave countenance of Christ to the handsome features of the Apollo

Belvedere – and also that the athletic, kneeling, unwounded St Sebastian, poised like a bowman with his arrows in hand, looked like Tommaso de' Cavalieri? The features of Aretino (a bald Aretino) are imposed on the bulky body of St Bartholomew; the face of the devoted Urbino, as an apprehensive St James, looks over his shoulder. A line can be traced from the top of the Cross, in the left-hand lunette, through the crown of thorns and the sacred wound, grazing the flaying knife (one of the tokens of redemptive martyrdom), intersecting the face of Michelangelo and finally coming to rest at the figure of Minos/Baccio.

Michelangelo thought of his own sins and prayers for salvation, and of Christian teaching on the four last things: death, hell and heaven, and the Last Judgement, which he has painted and which is still to come.

61 The school for artists •
'Art for a brothel'

Pope Paul looked at the *Last Judgement* through the eyes not of an artist or a theologian (though he was a shrewd scholar in the old tradition of Medicean enlightenment) but of a greedy princely patron who had secured what he wanted: the services of the most famous artist of all Italy.

Michelangelo was at home with the Tuscan community of rich bankers and merchants and craftsmen, and with artists and booksellers, rather than with courtiers, but Pope Paul held him in high affection and regard. It was rumoured that the pope even held his peace, from fondness for Michelangelo and so as not to upset him, when Michelangelo would not put Paul's coat of arms with the fresco of the Last Judgement. So long as Pope Paul lived, Michelangelo's painting was safe. And Michelangelo himself was more than safe; for even while he was still at work on the Last Judgement, Pope Paul commissioned him to paint two more great scenes in fresco, of the conversion of St Paul and the crucifixion of St Peter, for the Pauline Chapel, newly built by the pope's friend the military engineer and architect Antonio da Sangallo. Michelangelo's position since 1535 as supreme architect, painter and sculptor of the Vatican Palace seemed unassailable.

Michelangelo's friends did their best to make sure of this when they saw

the hotly controversial iconography of the *Last Judgement*, viewed publicly for the first time on Christmas Day 1541 after its first uncovering in October. Friendly fellow artists and knowledgeable critics, praising the amazing foreshortenings, perfect contours and harmoniously blended colouring, encouraged the simplified popular view of the *Last Judgement* as the portrayal of the wrath of Christ on the last day, the *dies irae*.

The painting was meant to strike terror and contrition into all who beheld it. This was the emphasis pursued by, among others, Giorgio Vasari, who, arriving in Rome sometime during the winter of 1541–2 from Venice, where he was making fanciful designs (remarkable for all the different Roman buildings and styles shown together on stage) for Aretino's scabrous play *Talanta*, featuring a Roman courtesan, and dedicated to the duke of Florence, had the impression that the whole of Rome was just as astonished and overwhelmed as he was. Vasari sent three large drawings of the fresco to Giulio Romano in Mantua. Very soon great numbers of copies and prints of the *Last Judgement* were in circulation. The painting became a 'school' for artists and students, and was eagerly copied and revered, just as the cartoon for the *Battle of Cascina* had once been.

Aretino had asked Michelangelo for some drawings, and was waiting impatiently for them. To ingratiate himself with the pope and the Curial cardinals, he wanted signs of Michelangelo's respect. Michelangelo's reserve was unbearable. After the completion of *The Last Judgement*, Aretino saw the chance to strike using his poisoned pen. The scourge of princes could shame the prince of painters and ingratiate himself with the influential cardinals at the court of Rome, and even with the pope.

Michelangelo's powerful interpretation of the Day of Judgement and the resurrection of the dead attested to his belief in the importance of faith and the power of the divine will. These were key elements in the thought of the reform movements within the Catholic Church in Rome, which were distancing themselves in varying degrees from the Lutheran revolt against papal authority as the chances of Christian reconciliation in Europe receded beyond recall.

In 1542 Vittoria Colonna's early mentor Fra Bernardino Ochino, rather than face an examination of his teaching by the Inquisition in Rome, fled to Calvin's Geneva (and subsequently to England). The same year, the conciliatory Cardinal Contarini died and the more rigid Cardinal Caraffa found his powers and credibility in Rome strengthened. Inevitably its location and its content put Michelangelo's disturbing and ambivalent Last Judgement under intense suspicious scrutiny.

What was immediately shocking to many pious eyes was the glaring

nudity of some of the fresco's totally self-absorbed figures. The religious messages of the fresco were rich and diverse, and open to varying interpretations – not so much obscure as omnifarious. It was a monumental declaration of the independence of the artist. But the *Last Judgement* contained more poetry than theology; the insights of Dante rather than Savonarola. Michelangelo had expressed his ideas through pictures as concrete as the verbal images of his poetry. Apart from the teeming bodies – human, angelic, demonic and divine – he painted symbolic objects: dry bones, the rocky cave directly above the altar, Charon's boat, the insignia of the saints and of the Passion.

From the beginning, the enemies of Michelangelo's fresco attacked the impropriety of painting several flagrantly nude figures (especially of holy men and women) in a sacred place; and from the beginning the painting was vulnerable to suspicions of heresy. At that time observance of so-called 'decorum' in both art and life was widely regarded by educated people as aesthetically and morally essential. Alberti and, following him, Leonardo, mindful of ancient precedents and modern tendencies, had laid the foundations for a theory of decorum, and by the time Michelangelo painted the *Last Judgement* the decorum of nudity in particular was being discussed.

Among the early adverse critics were priests Michelangelo had come to know through his friendship with Vittoria Colonna and encounters in San Silvestro. Ambrogio Politi (Caterino) linked the 'shameful' nudities of the *Last Judgement* with those of the heretics; in debate, he also ominously defended Pope Gregory the Great's destruction in the thirteenth century of ancient pagan statues. Another priest from the same circle, Bernardino Cirillo, damned Michelangelo's fresco with the praise that it was a miracle of nature, but suitable for a loggia not a church. Writing about the relationship between music and painting, Cirillo compared the decline of music in the Sistine Chapel with the licentiousness of the *Last Judgement*.

The really cutting, cunning censure, however, came from Pietro Aretino, provoked, when he saw a copy of the *Last Judgement*, to write a letter of arrogant reproach. He was exasperated by Michelangelo's unfeigned aloofness towards him, by his obvious indifference to his advice, and by his flouting of the rules whose observance for decorum's sake justified Aretino's own tacitly licensed indecencies.

Aretino's letter was addressed to Michelangelo and dated November 1545. Registering, like a rejected suitor, all kinds of emotions, knowing cleverly where he might embarrass or hurt the most, Aretino began by saying that, having seen the sketch of the *Last Judgement* in all its detail, he realized how graceful and inventive Raphael had been. As a baptized

Christian, he blushed at the licence Michelangelo had used in expressing ideas related to the most exalted aspirations and ends of their faith. Michelangelo's stupendous fame, his renowned prudence and the universal admiration he had won made it hard to believe that he had displayed to the whole world a painting whose perfection was matched by its impiety. How could Michelangelo, who scorned to consort with human beings since he was divine, have done this in the greatest temple built to God, over the highest altar raised to Christ, in the most sacred chapel on earth?

After comparing his own discretion when he wrote *La Nanna*, in which he used decorous language for immodest themes, with the way Michelangelo had presented indecent-looking saints and unheavenly angels, Aretino added that even the pagans' naked statue of Venus covered with her hand the parts not to be seen. Yet Michelangelo the Christian, esteeming art higher than religion, made a grand spectacle of martyrs and virgins in improper attitudes, men dragged downwards by their testicles, things from which brothels would want to avert their eyes.

Michelangelo's art would be at home in a voluptuous *bagnio*, Aretino continued. Its very excellence meant the death of the artist's good name. But he could restore it by covering the indecent parts of the damned with flames and those of the blessed with rays from the sun, or he could imitate the modesty shown in Florence, where his David's shame was hidden under gilded leaves, though it was on a piazza, not in a consecrated chapel. He wished God to pardon Michelangelo, and he was not arguing because of being denied the things he had wanted. If Michelangelo had sent what he had promised him, he would only have been doing what he should have done keenly in his own interest, as this act of courtesy would have silenced the tongues saying that such things were available only 'to certain Gerards and Thomases'. Michelangelo's ingratitude, not his meanness, was the cause of Aretino's anger.

Having dragged in Gherardo Perini and Tommaso de' Cavalieri, Aretino delivered a stronger, less veiled, threat, praying God, he said, that he would inspire Pope Paul as he had inspired Pope Gregory, who had rid Rome of idolatrous statues.

Aretino was expressing what many others were feeling and writing, but probably circumspectly, given Michelangelo's standing with the pope and the far-reaching implications of the accusations, including the innuendo about Michelangelo's feelings for Gherardo and Tommaso. This was not just Aretino's jaundiced, jealous eye. Michelangelo had shown he was aware of the gossip when he wrote for Tommaso (about the mid-1530s) the sonnet '*Veggio nel tuo bel viso, signor mio*', charged with Platonic fervour and Dantesque disdain for the common herd.

My Lord, in your most gracious face I see
what here on earth may never be portrayed:
my soul, which mortal flesh and blood pervade,
climbs Godward with it to eternity.
And should the mob with its stupidity
foist on to others feelings which degrade,
no less intense is my sweet longing made,
my love, my trust, my honest amity.
So from the sacred fount whence all men come
each earthly beauty takes its attributes
and we are told that these from God are sent;
And for its image there's no other home,
for heaven on earth, or for our worldly fruits.
Thus loving you makes death beneficent.

Shamelessly, Aretino wrote again to Michelangelo in April 1546, saying that he adored him and asking for some drawing from the prodigious number Michelangelo was known to throw into the fire.

The attitudes of the pope towards the *Last Judgement* were what mattered, and Paul did nothing. But the murmuring went on, in Rome and beyond. In the spring of 1549 there was an outburst in Florence linking Michelangelo's fresco over the altar in the Sistine with Baccio Bandinelli's marble statues of Adam and Eve for Santa Maria del Fiore. Denouncing Bandinelli's figures as filthy and obscene, the unknown critic added that all the city blamed the duke for having put them before the altar of the Duomo. 'Modern painters and sculptors were copying suchlike Lutheran fancies throughout the blessed churches to bury faith and piety, but it was to be hoped that one day God would send his saints to hurl down idolatries such as these.'

62 Cosimo de' Medici in power

Florence, before Bandinelli began his statues of Adam and Eve, had once more become an attractive city for artists, less dominated than Rome by Michelangelo's towering presence, and once again held firmly by a formidable Medici with grandiose ideas.

After Michelangelo had left the city in 1534, Alessandro de' Medici, ever more violent and hated, ruled for another three years before being murdered by his freakish companion and relation Lorenzino and a

hired assassin. Ippolito de' Medici had been poisoned in 1535, when on his way to bring the emperor in Tunis a petition from the swollen number of Florentines in exile condemning Alessandro's rule. (His killer, Giovanni Andrea, was stoned to death by indignant fellow citizens in Borgo San Sepolcro.)

The most formidable opponents of the Medicean regime were in banishment or voluntary exile. The Fortezza da Basso, the emperor's guarantee of Florence's obeisance, was unfinished but garrisoned. After intense debates, Francesco Guicciardini and Francesco Vettori, fearful of the exiles trying to return and seize power, decided to send for Cosimo de' Medici, the eighteen-year-old son of the legendary Giovanni dalle Bande Nere. At first he was to be 'capo e primario' of the city of Florence, but almost immediately the balance tilted further towards Imperial domination through controlled autocracy when Alessandro Vitelli, the dead duke's commander, seized the Fortezza and declared he held it for Charles though not against Cosimo.

Cosimo de' Medici, scarcely known in Florence, was the beneficiary of his father's reputation and his descent from Lorenzo de' Medici – brother of Cosimo, Pater Patriae – and of his mother, Maria Salviati, the grandchild of Lorenzo the Magnificent. Cosimo at eighteen was a good-looking, deep-thinking, cold and calculating young man with Medicean traits of cunning and avarice and the ferocious instincts of the Sforzas. (His paternal grandmother was a Sforza.) Maria Salviati had made sure that he became known in important political circles – by the pope, the doge and the emperor – and he had been unsuspectingly taken up as a companion by Alessandro. As a child, he had been well looked after (for safety's sake) in Venice, which had hired his father as condottiere, and well tutored, especially in Roman history, by Pietro Francesco Riccio.

When the news came of Alessandro's murder, Cosimo, leaving a hunting-party at his castle in Trebbio, rode immediately to Florence, where the streets had suddenly filled with armed men shouting for the Medici. After agreement that he should be head of the Republic – provided the salary were limited to 12,000 ducats and other conditions were met – he sent messengers to implore the sanction of the emperor, mindful that Pope Paul, who had dispatched three cardinals to Florence, was ready to assert his own right to supremacy, to the advantage (some suspected) of his son Pier Luigi Farnese.

In January 1537 Cosimo was publicly proclaimed as head of state by the Council of the Forty. The Roman cardinals, who included Cosimo's uncle, Cardinal Salviati, agreed to accept Cosimo's appointment under the emperor's protection, but asked that the exiles should be allowed to

return; they then left for Bologna for discussions with some of the exiles – important men, many of them, frustrated at their enforced absence from Florence at this opportune time. On 21 June, with the emperor's approval, Cosimo assumed the title of duke of the Republic.

Financed and organized by Filippo Strozzi, erstwhile near friend of the Buonarroti, subsidized by the French, encouraged by discontent in several Tuscan towns, still hopeful of a rising in Florence against the Medici, the exiles moved their forces into the fortress of Montemurlo on a spur of the Apennines above the road from Pistoia to Florence. Well informed about what was happening, in August 1537 Cosimo and Alessandro Vitelli moved against them with Spanish and Italian troops, fired the gates, crushed a brave resistance, and took the leaders captive. After rapid trials, most of the captured exiles were publicly executed. Cosimo was believed to have insisted on the death sentence.

The victory of Montemurlo finally broke the back of Florentine resistance to Medici rule. The emperor refused Cosimo's deferential request to let him marry Alessandro's widow, the emperor's daughter Margaret of Austria; she was too valuable a property in the emperor's dealings with the pope, and would eventually marry the pope's grandson, Ottavio Farnese. Nor would the emperor immediately hand over the citadels of Pisa, Leghorn and Florence itself to Cosimo. Charles did, however, approve of Cosimo's marriage in 1539 to Eleonora, daughter of the viceroy of Naples, Don Pietro of Toledo; the position of the Imperial arbiter of Italy (now aged thirty-eight) was not so secure that he could, even if he wanted to, ride roughshod over Cosimo. The new Medicean prince (a headstrong young man on his own horse in a beautiful meadow, as Cellini told his friends in Rome at the time) did things like a Florentine, his way – *al suo modo* – from the start.

By 1544, Cosimo, paying enormously for the agreement, had secured the withdrawal of the emperor's garrisons from the Fortezza da Basso and the stronghold at Livorno.

63 Artists in chains

When Cosimo's first son, Francesco, was born in 1541, Aretino wrote to the duke directly to say that on the news his heart had leapt:

> because the birth of a son to you means for Caesar [the emperor] the birth of loyalty, for Italy adornment, for Tuscany glory, for

Florence unity, for the Medici stability, for their subjects an idol, for their adversaries a bridle, for the humble forgiveness, for the just a refuge, for the poor abundance, for the virtuous support, for praise breath, for honour dignity, for fame a subject and for the pen a theme.

Always uniquely brash, Aretino spoke for thousands who saw Cosimo, their new prince, primarily as patron, the grandest of the *gran maestri*, to whom they wanted to bind themselves through flattery, friendship, subservience or honest service, in return for security and status. Pressing forward as hungrily as any were the artists, and Cosimo was soon employing the best of the available talent, primarily for the construction and embellishment of all kinds of buildings to magnify the Medici and the state.

The best sculptor eager and available to serve Duke Cosimo – he came back to Florence in 1540 – was Baccio Bandinelli. After the siege of Florence he had been given, in place of Michelangelo, and to Michelangelo's disgust, the commission to match the statue of David on the piazza with a free-standing group of Hercules slaying Cacus, which he finished in 1534. Bandinelli soon became intimate with Duke Cosimo, who agreed that he should be commissioned, instead of Tribolo, to do the tomb for Giovanni dalle Bande Nere and, in 1540, with Baccio d'Agnolo, a huge stone and marble dais with a set of statues of the Medici family for the Palazzo Vecchio's audience chamber. Before this misconceived project was half completed, Bandinelli was cajoling the duke to let him work on the octagonal choir of the Duomo and on an ambitious programme of sculptural embellishment of the main parts of the cathedral. Bandinelli's megalomania was fed by a wild, imaginative eclecticism which sometimes yielded interesting, but more often incongruous, results.

Among the painters, Francesco Salviati, following an amazingly productive two years in Rome, was attracted back to Florence in 1543 and was soon employed to adorn the Palazzo Vecchio – Cosimo's preferred seat of government – with allegorical scenes from the life of the Roman tyrant Camillus. Bronzino, faithful to Florence during the 1530s, in 1540–41 began to decorate the chapel of the duchess Eleonora, also in the Palazzo Vecchio, with frescoes. Pontormo, in his forties, ever more escaping into himself, painted frescoes for the Medici in their villa at Castello till 1543 and then, about 1545, with Bronzino and Salviati, began to draw cartoons for state tapestries for Cosimo.

* * *

Michelangelo's magnificent repertory of forms in the *Last Judgement* influenced Florentine design – as well as painting in Rome – just as the new Medici régime increased demand for public works and adornment of all kinds. Visiting artists familiar with the twisting movements and lengthened proportions of Michelangelo's figures were arrested and challenged by the hundreds of solid, sculptural forms. As with the main works of Leonardo, Raphael and Michelangelo completed by the 1520s, awestruck artists knew that they could not ignore but dare not compete with what they were seeing, and knew they might feel but could not begin to articulate or express its profound, disturbing and disturbed religious sentiment. Vasari, seeking to describe a painter's reaction, came to say that all those who had thought they had mastered the art of painting followed behind the *Last Judgement* in chains.

64 Vasari and the cardinal

Giorgio Vasari was being drawn to Rome more and more – not by Michelangelo, with whom his relationship so far had been tenuous, but by Bindo Altoviti, the banker head of a family of Florentine exiles, and his influential circle. In his early thirties, fully recovered from a nervous breakdown after the assassination of Lorenzino, the murderer of Alessandro de' Medici who was slain in Venice in February 1548 in an act of revenge, Vasari was introduced by Altoviti and Paolo Giovio to Cardinal Alessandro Farnese, son of Pier Luigi and grandson of Pope Paul, on the strength, apparently, of his idiosyncratic painting of a Deposition from the Cross. This showed, as well as the Virgin and the dead Christ, the pagan god Phoebus obscuring the sun and the goddess Diana the moon, craggy mountains being destroyed by an earthquake, and dead saints rising from their graves.

Vasari assiduously pursued his relationship with Michelangelo. He made sure to ask Michelangelo's advice, and was told by him – heaven knows in what tone of voice – that he should study architecture more carefully. He was always attentive to Michelangelo, and during his Roman visits in 1543 and 1544 he became sure that a good friendship had been established. Who knew where it might lead?

The scholarly and conscientious Cardinal Farnese was also himself now close to Michelangelo, though not through any devouring interest in

Michelangelo's work. (Like his father, he preferred collecting miniatures, gems, and bookbindings: the Croatian miniaturist Giulio Clovio entered his service in about 1538.) The cardinal's dealings with Michelangelo sprang from his involvement in the last sad act of the drama of the tomb of Pope Julius, which once again in the mid-1540s had Michelangelo writhing like Laocoön.

Duke Cosimo, meanwhile, had been thinking about Michelangelo: about the work he had left unfinished and, doubtless, the work he might do in his own city of Florence. In October 1546 Bishop Tornabuoni in Florence wrote to Francesco Lottino, Cosimo's secretary, about the steps taken and to be taken for Michelangelo to return.

65 The ill-fated tomb

Michelangelo's third contract for the tomb of Pope Julius expired in 1535, but scant progress had been made on the project since the contract was signed in 1532. Pope Paul, having made him chief architect, painter and sculptor to the Vatican in 1535, a year later exempted Michelangelo from any legal penalties due to his non-fulfilment of the contract. The new young duke of Urbino, Guidobaldo della Rovere, a cultivated *condottiere*, agreed in September 1539 that Michelangelo, who was now tied into the Sistine programme, should finish the tomb when he could. This did not greatly relieve Michelangelo's anxiety, which redoubled when Pope Paul pressed him to paint the new Pauline Chapel. (Ghosts of unfinished work from the distant past also materialized in 1537 in the guise of a decision by the heir of Pope Pius III, Anton Maria Piccolomini, to cede to Paolo di Oliviero de' Panciatichi all his claims on Michelangelo, who was stated still to owe 100 crowns, as he had not executed the fifteen statues allocated to him for the Piccolomini Chapel in Siena Cathedral, for which he had been paid 300 crowns.)

Pope Paul then told the duke of Urbino that other artists should now finish the tomb, working under Michelangelo. So, of the six statues promised, three were allocated to Raffaello da Montelupo in February 1542. Later that year Michelangelo first agreed with Giovanni de' Marchesi and his own Urbino that they should complete the frame of the tomb and then asked the pope to be relieved of all responsibility for the tomb, proposing to deliver just the statue of Moses by his own hand.

The tomb's progress was ill-fated to the last. Giovanni de' Marchesi and Urbino fell out with each other, and already that May Michelangelo was writing to his comparatively new, increasingly close friend Luigi del Riccio that, because one of them was mean beyond words and the other mad, their estrangement could lead to violence or even murder. He was thinking of sending them both packing, and in any case would have to take the work back to do himself.

The fourth and last contract for the tomb of Pope Julius was settled on 20 August 1542. Michelangelo was to deposit 1,400 scudi to pay for the tomb's completion, and he was confirmed as the owner of the house in Macello de' Corvi. After yet more arguments, vexations and delays, the work was completed at the beginning of 1545. In a furious letter sent in October or November 1542, Michelangelo confirmed how cruelly he was still tormented by the disputes over the tomb, and not least by the opprobrium he felt coming from the duke of Urbino. The letter was addressed to a *Monsignor*, probably Cardinal Alessandro Farnese.

> Monsignor. – Your Lordship sends me word that I should paint and not worry about anything else. I reply that one paints with the head and not with the hands; and if he can't keep a clear head a man is lost. So until this business of the tomb is settled I shan't do any good work. I have not had the ratification of the last contract; and on the strength of the other contract, drawn up in Pope Clement's presence, people stone me every day just as if I had crucified Christ.
>
> I say that to my knowledge the contract was not read over in the presence of Pope Clement as the copy I received later said it was. What happened was that Clement sent me to Florence the same day, and then the ambassador Gianmaria da Modena [Giovan Maria della Porta] who was with the notary had him add to it in the way he wanted. Through this, when I returned and inspected it, I found that it specified 1,000 ducats more than had been fixed for me to pay; that the house I live in was included in the contract; and there were several other traps to destroy me, which Pope Clement would never have allowed . . . I swear that I know nothing of having had the money the contract mentions and as alleged by Gianmaria. But let us agree that I did have the money, since I've acknowledged receipt and I cannot withdraw from the contract; and let's add more money besides, if more is

claimed; and heap it all together. And then look at what I've done for Pope Julius at Bologna, Florence and at Rome, in bronze, marble and painting, and all the time I stayed with him, which was as long as he was pope; and judge what I deserve. I say in good conscience, with reference to the salary that Pope Paul gives me, that I am owed 5,000 crowns by the heirs of Pope Julius . . .

Gianmaria, who was ambassador at the time of the old duke, in Clement's presence, after the contract was made and I had returned from Florence and was starting to work on Julius's tomb, said to me that if I wanted to do the duke a great favour I should clear off altogether, for he didn't care about tombs but he couldn't stand the idea of my working for Pope Paul. Then I realized why he had brought my house into the contract: to get shot of me and grab possession on the authority of that document . . .

The fellow who came to see me just now wanted to know all about what I had in Florence; that was his first question, before he asked to see what stage the work for the tomb had reached. And so I find that I have lost all my youth tied to this tomb, defending it as best I could against the demands of Pope Leo and Clement. And my too trusting nature has gone unrewarded and been my ruin . . .

But to return to the painting: I can deny nothing to Pope Paul. And I shall paint miserably and make miserable things . . .

Your Lordship's servant, Michelangelo.

I should also tell you the following: that this ambassador says I lent Pope Julius's money at interest, and that I made myself rich on it, as if Pope Julius had counted me out 8,000 ducats in advance. The money I had for the tomb was meant for the expenses incurred for it at the time, and it will appear to be about the sum that the contract made in Clement's time should state. For in the first year of Julius, when he commissioned the tomb from me, I stayed for eight months in Carrara to quarry marble and transport it to the piazza of St Peter, where I had my workrooms behind Santa Caterina; then Pope Julius decided not to have the tomb made during his lifetime, and he put me on to painting instead . . . Then, after the death of Julius, Aginense wanted to continue with the tomb, but to have it bigger; and so I brought the marble to Macello de' Corvi, where I finished the part which was put up in San Pietro in Vincoli and made the figure I have at home.

At this time Pope Leo, who did not want me to do the tomb, made out that he wished to do the façade of San Lorenzo in Florence, and he asked Aginense for me; so the latter had perforce to give me leave, but on condition that I should make Pope Julius's tomb while in Florence.

When I was in Florence for the façade of San Lorenzo, as I had no marble there for the tomb of Julius, I returned to Carrara and stayed there thirteen months, and I brought all the marble for the tomb to Florence, where I built for it a shop in which I started work . . .

Seeing this, namely that I was doing work for the tomb, Medici, who was in Florence, and later became Pope Clement, would not let me continue; and so I was left frustrated till the Medici was transformed into Pope Clement: whereupon the last contract for the tomb up to this present one was drawn up in front of him, and in it was stated that I had received the 8,000 ducats which they say I lent at interest. And now I want to confess to Your Lordship the sin that, being at Carrara, when I stayed thirteen months because of the tomb, and lacking money, I spent on marble for that work 1,000 crowns that Pope Leo had sent to me for the façade of San Lorenzo, or to keep me occupied. And I sent him a word or two putting forward difficulties; and this I did out of my love and enthusiasm for the job, for which I am paid by being called a thief and usurer by ignorant people who hadn't even been born at that time.

I am writing this account for your Lordship because I dearly wish to justify myself to you . . . and if I fly into a passion it's sometimes necessary, as you know, when defending yourself against evil people.

Following on further about the tomb of Pope Julius, I recall that after he changed his ideas, as I said, about making it during his lifetime, there arrived at Ripa some boatloads of marble which I had ordered at Carrara some time before. And being unable to get money from the pope, as he had changed his mind about the work, I had to pay freight charges on the marble of 150, or rather 200, ducats, with a loan from Baldassare Balducci (namely the bank of Jacopo Galli). And as also at that time some stonecutters whom I had sent for to work on the tomb, some of whom are still living, arrived from Florence, and as I had furnished the house behind Santa Caterina, given me by Julius, with beds and other fittings for the blockcutters and other things for the tomb, I found

myself very frustrated by lack of money. And I pressed the pope to push things forward as much as I could, and one morning when I was about to talk to him about this matter he had me turned away by a groom. Then a bishop from Lucca who witnessed this said to the groom, 'Don't you know who it is?' And the groom said to me, 'Forgive me, sir, but I have been ordered to do this.' I went home and I wrote to the pope as follows: 'Most Holy Father: I have this very morning been driven from the palace at the behest of Your Holiness; so I am giving you to understand that from now on, if you want me, you will look for me elsewhere than in Rome.' . . . Then I went, mounted one of the post horses, and took myself off towards Florence . . .

. . . this business lost me over 1,000 ducats, because after I had left Rome a great fuss was made about it, to the shame of the pope; and almost all the marble that I had on the piazza of St Peter was looted, especially the small pieces; and I had to do them once more. In such wise I say and affirm that either for damages or interest I am owed 5,000 ducats by the heirs of Pope Julius. And those who have robbed me of my youth, my honour and my property call me thief! . . .

All the occasions for discord arising between Pope Julius and me, all of them resulted from the envy of Bramante and Raphael of Urbino: and this was the cause of his not continuing his tomb while he was still living, and was meant to ruin me. Raphael had good reason for this, for all his art he had from me.

This, for Michelangelo, exceptionally long letter (here cut by more than a third), with its furious recall of the injustices and slights of present and past, sounds the depths of his depression in the winter of 1542–3. He was overwhelmed. Other, briefer, letters at this time register the same despair. The delay of the duke of Urbino in ratifying the new agreement for the tomb worried him more than the dampness of the first coat of plaster (arricciato) for the fresco painting he was beginning in the Pauline Chapel of the Vatican in November 1542, and was stopping him not only painting but living life at all, he told Luigi del Riccio.

His anger and pride sustained him. In April 1543 he was writing to his nephew Lionardo in Florence to say how busy he was and to make the point that when he wrote to him Lionardo should not put 'Michelangelo Simoni' or 'sculptor' on the outside. 'It suffices to say "Michelangelo Buonarroti", as this is how I am known here.'

66 'do not wake me, do not weep'

The monument to Pope Julius II, the former Cardinal San Pietro in Vincoli, was erected in the transept of his titular church. Over thirty years after the first contract, which envisaged forty figures on a free-standing tomb, the completed wall monument in San Pietro in Vincoli (St Peter Chained, because housed there were the chains said to have bound St Peter when in prison) was dominated by the Moses which had been originally one of the subsidiary figures: an immensely strong male figure, the torso and limbs either bare or clearly outlined through the draperies, full of energy, passion and spiritual power.

The glaring face of this statue of Moses, begun in the summer of 1515, had finally been touched up by Michelangelo in the winter of 1544–5, as stipulated in an agreement between Raffaello da Montelupo, Urbino and the duke of Urbino. The duke had insisted that Michelangelo should himself finish the Old Testament figures of Leah and Rachel on the ivory-toned lower stage of the monument; the upper part contains the Madonna and Child, with a half-reclining figure of a weary-looking Pope Julius at her feet.

The allegories now offered by the monument to Julius were no simpler than in the original design. The statue of Moses might stand for Pope Julius; the figures of the gentle Leah and the ardent Rachel for the Active Life and the Contemplative Life and/or, in the context of the religious debates of the time, for Good Works and Faith.

The tomb was erected as part of the architecture of the church of San Pietro in Vincoli, perfectly accommodated to the membering of its wall, grandiloquent and cold. But the body of the della Rovere pope was to remain with that of his uncle, Pope Sixtus, in St Peter's, and so the tomb was not in the end a tomb at all.

Not long after the completion of the monument, Michelangelo wrote an epigram in response to a quatrain written by the Florentine academician Giovanni di Carlo Strozzi praising his statue of Night in the Medici Chapel as having been sculpted by an angel and so alive that she would speak if woken. Michelangelo's reponse to this was sonorously gloomy and politically scathing if read in the context of the new Medici government in Florence, where his figure of Night rested.

> Dear to me is sleep; still more to sleep
> in stone while harm and shame persist;

not to see, not to feel, is bliss;
speak softly, do not wake me, do not weep.

Caro m'è 'l sonno, e più l'esser di sasso,
mentre che 'l danno e la vergogna dura;
non veder, non sentir m'è gran ventura;
però non mi destar, deh, parla basso.

After his involvement in the defence of Florence during the siege, Michelangelo's cautious political attitudes were expressed through silence and absence. Now and then in his verse he expressed where his sympathies lay, noting in his poem of country life, for example, that 'he who rules the world and is so great' can never be satisfied and never know peace.

67 Giannotti and the exiles

Dante placed Brutus, the friend and assassin of Caesar, in the ninth circle of hell. In Michelangelo's time, Brutus's role as tyrannicide came to be intensely debated among Florentine exiles after the assassination of Duke Alessandro in 1537 by Lorenzino; the murder of Lorenzino in Venice in 1548 revived memories of his claim to have killed Alessandro for noble political ends.

The idea of a bust of Brutus came to Michelangelo from Donato Giannotti, the charming, erudite Florentine scholar and political theorist who had thought of writing a tragedy about Brutus. Torn between political action and contemplation, Giannotti had been secretary of war in Florence in succession to Machiavelli. Since 1539, after several years of confinement followed by voluntary exile, he had been serving as secretary to Cardinal Niccolò Ridolfi, a nephew of Leo X.

Favoured by Pope Paul III, Cardinal Ridolfi worked as a diplomat and as prefect of the papal chancellery and was prominent among the reforming cardinals. Archbishop in Florence, after Pope Clement died he had stood at the front of the opponents of the Medici régime: he wanted a republic based on the old Great Council of Florence, sustaining the interests and influence of his own sort of people and the great families.

This is the context for Michelangelo's decision, which he seems later to have regretted because of its political implications, to sculpt a bust of

Brutus for the friend of artists, Cardinal Ridolfi.* In the minds of such
republicans, the Brutus of the modern world was arguably Lorenzino –
the destroyer of the tyrant of Florence, praised in verse, commemorated
in a medal (which he commissioned himself) showing a portrait in
Roman dress with the Phrygian cap of liberty and two daggers on the
reverse: otherwise, a replica of one of the Roman coins of Brutus.

Giannotti's *Dialoghi de' giorni che Dante consumò nel cercare l'Inferno e 'l
Purgatorio* provides another glimpse of Michelangelo in conversation.

One day, Giannotti recalled, when Luigi del Riccio was approaching
the Lateran with Antonio Petreo, the two friends began discussing
Dante. They were joined by Michelangelo and Giannotti, also out
walking, and Giannotti challenged Michelangelo's high opinion of
Dante on the grounds that Dante had made an error in placing Brutus
and Cassius in the two mouths of Satan, in the eternal cold of the
lowest part of hell. Michelangelo retorted that Dante knew that Caesar
was a tyrant and so that Brutus and Cassius were justified. But he was
right, none the less, to put them in the final reaches of hell, since Brutus
and Cassius had betrayed the majesty of the Roman Empire, signified
by Caesar.

The now perplexed Giannotti asked whether Dante had then put
Caesar in limbo as Caesar or as 'the imperial majesty', and
Michelangelo began rather sharply to question whether it had indeed
been right to kill Caesar. Perhaps Caesar would have restored Rome's
liberties? Times and people changed, and there was always the hope
that good might come.

The Brutus carved by Michelangelo has the looks of a man of great
firmness of character, integrity and intellect in a mood of noble, defiant
heroism. The Latin verse inscription on the pedestal of the bust –
doubtfully attributed – reads that while the sculptor was carving the
likeness of Brutus his crime came to mind and he abandoned it. In fact
Michelangelo later gave the marble for finishing to a new pupil of his
called Tiberio Calcagni, a gentle-mannered Florentine in his teens who
was studying architecture.

In the second of Giannotti's *Dialoghi* Michelangelo was again at centre
stage. The conversations took place among friends, again including
Antonio Petreo. From the Piazza del Popolo, they walked along the

* The bust of Brutus, 29½ inches high, is in the Bargello, Florence.

ancient Via Flaminia towards the Ponte Molle, two miles distant. Michelangelo was affable. His friends pressed him to accept del Riccio's invitation to have a little meal with them. Michelangelo resisted. He said, in effect, that he was so fond of company that he had to be a recluse. This was a world for weeping rather than for merriment.

According to Giannotti, Michelangelo then exclaimed that of all men ever born he was the most inclined to like people:

> Whenever I see someone who may have talent [*qualche virtù*], who may show some liveliness of mind [*destrezza d'ingegno*], who may know how to do or say something better presented than by the others, I am bound to fall in love with him, and I fall prey to him in such a manner that I am no longer my own: I am all his. So if I were to have dinner with you, as you are all so well endowed with talent and kindness, beyond that each one of you three has already robbed me of something, each one of those dining with me would take a part of me.

The way to rediscover and enjoy oneself, Michelangelo reflected, is not through so many pleasures and delights but by thinking of death. This thought alone keeps us at one with ourselves: safe against ambition, avarice and all the other vices and sins, and also against relations, friends and rulers – the 'great masters'.

Giannotti's idealistic and Michelangelo's tempered Florentine republicanism came together in civilized discourse in Rome at the time when, in Florence, Duke Cosimo had secured the recall of the emperor's representatives, taken over the Fortezza da Basso, established an understanding with Pope Paul III, and thrown himself into the task of making Tuscany a well-armed, independent autocracy. Another kind of new order was also being created in Italy in the 1540s by the surge of Catholic reform, flanked by the *spirituali* on one side, and by the Index and the Inquisition on the other.

68 St Paul and the grace of God

After he had finished the fresco of the *Last Judgement*, Michelangelo, between his sixty-seventh and seventy-fifth birthday, from November 1542 till the end of 1550, worked intermittently on two great lateral fresco paintings for the Pauline Chapel. The picture he painted first,

judging by its greater continuity of style with the *Last Judgement*, shows the conversion of St Paul – the Jewish-Roman Saul – and was completed in July 1545.

The biblical starting-point was the passage in the Acts of the Apostles describing how Saul, the Roman citizen and Jewish zealot, on the road to Damascus, was hurled to the ground as a light flashed from the sky all around him, and heard a voice proclaiming, 'Saul, Saul, why do you persecute me?'

Michelangelo illustrated the overwhelming force of the grace of God in the shaft of light falling from the abruptly foreshortened aerial figure of God towards the powerful but now blinded and prostrate figure of Saul, shimmering through his alarmed companions and radiating round the head of his bolting horse. Sprawling helplessly, Saul is being held up with tender concern by the only person not attending to the bolt from heaven. The band of suddenly scattered travellers below is paralleled above by an orderly tier of mostly naked angels and saints expressing reverence and awe. The two worlds of time and eternity are connected by the beam of light from God and also by many correspondences of grouping and form. The bleak background consists of barren earth, rocklike hills and sky.

Michelangelo's own features have been seen in the dazed, expectant face of Saul, to which the viewer's eyes are drawn.

In the sonnet '*Vorrei voler, Signor, quel ch'io non voglio*', quoted on p. 258 and written perhaps several years before he painted this very theatrical scene of God shafting his way with lightning into the awareness of the persecuting, hard-hearted Saul, Michelangelo had lamented his own icy resistance to God's grace and had pleaded for him to pierce the barrier and bring his light as to a bride.

69 Luigi's friendship: poetry and music

Bartolommeo Angiolini died in December 1540, and Michelangelo turned to Luigi del Riccio during the painful years when his work in the Pauline Chapel was often interrupted by illness. The friends of del Riccio formed a group distinctively apart from Michelangelo's several other familiar, often jealous, contiguous little worlds, and the bonds between Michelangelo and del Riccio grew steadily warmer and stronger.

Early on in their friendship Michelangelo asked del Riccio to revise his poetry, and specifically, in 1542, two madrigals about the peril he was in, so close to death, from a friend's heavenly face, the shame of loving intensely in old age, and the impossibility of losing the habit of years in an hour or a day.

Michelangelo subsequently sent del Riccio drafts of many other poems for comment and correction as he cooperated with a plan to publish his selected verse, 105 poems in all. Among the first chosen was a poem probably written for Tommaso de' Cavalieri about ten years earlier, even then referring to imminent death, and opening with an echo of Michelangelo's view of the process of artistic creation: 'The smith when forging iron uses fire/ to match the beauty shaped within his mind . . .'

The dispatch of poems to del Riccio, and occasionally to Donato Giannotti, developed into a teasing ritual: Michelangelo adopted the pretence that he was sending scraps of verse to pay for supplies of fruit and wine. Both del Riccio and Giannotti tried to Latinize Michelangelo's spelling, but his grammar and spelling stayed idiosyncratic, the latter showing his lasting loyalty to Tuscan pronunciation.

Two of Michelangelo's madrigals were set to music by Jacques Arcadelt through del Riccio's agency, and appeared in May 1539 in the first extant edition of Arcadelt's *First Book of Madrigals* (*Primo libro de' madrigali a quattro voci*). In successive letters to del Riccio, Michelangelo showed his appreciation and some concern about this.

One brief letter mentioned some poetry sent to Florence a while before and now being sent to del Riccio revised for a special occasion, to consign to the flames if del Riccio wished – that is, 'to the one that burns me'. Michelangelo mentioned his previous night's dream in which their shared idol ('*idolo nostro*'), del Riccio's young relation Francesco (Cecchino) de' Bracci, had smiled at him yet menaced him ('*ridendo mi minacciassi*'). Would del Riccio find out from Cecchino what he should think, and resolve the matter? In a postscript, Michelangelo asked del Riccio to make a clean copy of the madrigal and have it given to 'those *corde* that bind men without distinction, and remember me to messer Donato [Giannotti]'.

Composed by Michelangelo for Tommaso de' Cavalieri, set to music by Arcadelt, now the revised verses would do for Cecchino.

But what sort of thanks should Michelangelo make to the composer of the music which was making him known as a poet? In another brief letter to del Riccio, Michelangelo remarked that he did not want to seem ungrateful and would return to del Riccio whatever he felt it

suitable to give. Meanwhile, he had at home a piece of satin for a doublet which might do.

Michelangelo's next letter on the subject, sent to del Riccio at his bank, began by remarking that Arcadelt's *canto* – or air – was held to be very beautiful. It had given no less pleasure to Michelangelo than to del Riccio, who had commissioned it. He wanted to show the composer his appreciation, so would del Riccio think of some present to give him, either silks or money, and let him know, and he would do as told. Michelangelo ended by sending his regards to Riccio, to Giannotti and 'to heaven and earth'.

70 'Alas . . . Cecchino has died'

Del Riccio's noble family background helped account for his hold on Michelangelo's affection. So did his social skills. When he received a present from a cardinal, Michelangelo asked del Riccio to make his thanks for him in the way that was alien to him but second nature to del Riccio, as 'a master of ceremony'. Another bond between them was their extravagant affection for del Riccio's first cousin once removed; intense on Riccio's part, bemused and vicarious on Michelangelo's.

Francesco de' Bracci – Cecchino – born in April 1528, was the son of Florentine *fuorusciti*, Medici-haters who had settled in Rome in 1534. Del Riccio, married but childless, adopted him and took him into his apartment in the Strozzi Palace. In May 1542 Francesco was one of the witnesses to the contract for the frame of the tomb of Julius II between Michelangelo and Giovanni de' Marchesi and Urbino. He was well known – at least in del Riccio's circle of *fuorusciti* – for his stunning charm and good looks, which were making him some sort of patriotic mascot.

On 8 January 1543 Cecchino died, and del Riccio was plunged into misery and grief. To Giannotti in Vicenza he wrote, 'Alas, my dear messer Donato! Our Cecchino has died! All Rome mourns for him. Messer Michelangelo is designing a decent marble sepulchre for me and you will please do the epitaph. I die a thousand times every hour.' Giannotti wrote three sonnets one after the other, the second of which was shown to Michelangelo, who pronounced it as beautiful as any of their time. More verse, in Latin as well as in the vernacular, flowed in from Tuscan writers. Michelangelo, however, deeply and willingly in

del Riccio's debt, wrote more than any of them: a sonnet, a madrigal
and forty-eight short poems or epitaphs during 1544.

As the months passed, Michelangelo began to betray some exaspera-
tion at having to respond (as he thought often ineptly) to the pressures
from del Riccio on him to write more – pressures which took the
usually very acceptable form of food and drink. 'I do not want to send
this one to you, as it is very awkward, but the trout and the truffles
would force heaven itself,' he wrote. At other times Michelangelo
scribbled that the verses were for the salted mushrooms, or the fennel,
or the melons. After one epitaph he remarked that his well was
running dry and they must wait for rain; del Riccio was in too much of
a hurry.

The verses for Cecchino were full of puns and Petrarchan themes,
becoming strained and repetitive as the months passed, but now and
then moving.

> *La carne terra . . .*
>
> Flesh turned to clay, mere bone preserved (both stripped
> of my commanding eyes and handsome face)
> attest to him who earned my love and grace
> what prison is the body, what soul's crypt.
>
> *Qui serro il Braccio . . .*
>
> Here Braccio and his beauty shall I keep in trust
> and just as flesh to soul true life and substance brings,
> so does my shape reflect such noble pleasing things:
> the plain sheath still shows how the splendid dagger thrust.

In the sonnet in memory of Cecchino – '*A pena prima aperti gli vidd'io*'
– a clever, gracious apology to Luigi del Riccio for not wanting to
carve the likeness of Cecchino for his tomb – Michelangelo produced a
beautiful, affectionate lyric, ending with the comment that, as a lover
was transformed into the one he loved, to make Cecchino he should
portray Luigi: '*convien che per far lui ritragga voi*'.

In the verses cajoled from him by del Riccio for Cecchino,
Michelangelo was playing variations on the theme of untimely death,
in a generally detached mood, and achieving wonders in the felicitous
compression of thought and phrase.

His pen moved as swiftly as if he were drawing. So did his thoughts,
which in one instance raced to change direction dramatically. Having
written the four-line epitaph beginning '*La carne terra*', Michelangelo
added an alternative couplet for the last two lines, introduced by the

remark 'Take these two lines below, which are quite moral' (*'cosa morale'*). For the lines:

> *fan fede a quel ch'i'fu' grazia e diletto*
> *in che carcer quaggiù l'anima vive*

Michelangelo suggested:

> *fan fede a quel ch'i'fui grazia nel letto,*
> *che abbracciava e'n che l'anima vive*

or

> attest to him whose grace I was in bed,
> who embraced me and in whom [my] soul still lives.

Michelangelo fell seriously ill twice during his friendship with del Riccio, and each time he readily accepted an invitation to convalesce in the Palazzo Strozzi.

At the end of July 1544 del Riccio wrote to Roberto Strozzi in Lyons and reported that a grateful Michelangelo was no longer feverish but still weak. Soon after, from the Strozzi villa in the Roman Campagna, del Riccio sent Michelangelo two melons and a flask of wine (called *greco*) from San Gimignano. Michelangelo also heard from Giovan Francesco Rustici, now in the king's pay in Paris, congratulating him on his return to health and mentioning the cartoons by Michelangelo he had had from Antonio Mini.

Towards the end of 1545, Michelangelo again stayed in the Palazzo Strozzi. Del Riccio wrote to Michelangelo's nephew Lionardo in January 1546 to say that his uncle had been badly ill but was now cured: he had confessed and been to communion and made his will. In gratitude, Michelangelo gave Luigi the breathtaking present of two statues (the captives or prisoners) originally meant for the tomb of Pope Julius.

Inevitably, del Riccio on one occasion gave Michelangelo cause for grievance. In a terse, ill-tempered letter of January 1545, apparently prompted by some impressions or figures produced by a plate or mould (*stampa*) which he wanted destroyed, Michelangelo remarked that even someone who had saved him from death could insult him, and he did not know whether death or this insult were heavier. 'So I beg and adjure you, through what I thought the true friendship between us, that you have the plate destroyed and burn the impressions that have been made; and if you are making use of me for trade, do not let others do so as well; but if you tear me into pieces, I shall do just the same, not to you, but to your things.' This was signed 'Michelangelo Buonarroti,

neither painter nor sculptor nor architect, but whatever you wish, but not a drunkard, as I said to you at [your] home.'

Marking the end of the last phase of the tragedy of the tomb of Pope Julius, and perhaps the subsidence of his anger with Luigi del Riccio, was the letter Michelangelo sent to Luigi at the beginning of 1545 to say that he would be arranging for the statues by Raffaello da Montelupo and others to be moved to San Pietro in Vincoli.

71 Lionardo looking for a wife

No more now than in the past did Michelangelo readily forgive members of his own family for slights or backslidings. Not the least of Luigi del Riccio's services to Michelangelo was his continuing effort to teach Lionardo how not to enrage his uncle.

When Michelangelo first fell seriously ill in Rome in the summer of 1544, Lionardo, now in his mid-twenties, had tried but failed to see him. He then received a letter from Michelangelo of cutting sarcasm. Lionardo had come to kill him off and see what he had been left, Michelangelo wrote. Lionardo was like his father, Buonarroto, who, Michelangelo said, had turned Michelangelo out of his own house in Florence. He should know that Michelangelo had made his will in such a way that Lionardo need not worry any more about what he had in Rome. 'So go with God, and never write to me again, and do as the priest tells you.' Lionardo's reception was no friendlier the next time he hurried to Rome on hearing again how unwell his uncle was, during the early weeks of 1546. Again Michelangelo did not see him, and again an angry letter pursued Lionardo to Florence, where there had been rumours of Michelangelo's death.

Michelangelo (through letters largely penned for him by del Riccio) had been instructing Lionardo how to handle the money he would send his brothers Giovansimone and Gismondo and Lionardo himself (1,000 gold crowns each) to invest in property or in some other way to provide a long-term income for the family. He had heard about the sale of some properties belonging to a Francesco Corboli who had gone bankrupt while living in Venice: an old house in the Santo Spirito quarter of Florence and some possessions at Monte Spertoli, including six yoke of oxen and a big house suitable for an inn. He had given detailed

instructions to Lionardo to enquire about the state of the properties, their estimated worth, the revenue they yielded and the tax position. On 6 February 1546 he wrote:

Lionardo. – You have been very quick in giving me advice about the Corboli properties: I didn't think you were yet back in Florence. Were you frightened I might change my mind, as someone perhaps soft-soaped you into thinking? I tell you that I want to go gently, because the money needed I have earned here with exertions such as are unknown to someone born clothed and clad like you.

As for your coming to Rome so furiously, I don't know whether you'd have come so quickly if I had been in poverty and need of bread: it is enough that you throw away money you haven't earned. So jealous are you of not losing this inheritance! And then you say you were bound to come because of your love for me: cupboard love! If you loved me, you would now have written to me: Michelangelo, spend the 3,000 crowns there on yourself, because you have given us more than enough: we hold your life dearer than your possessions.

You have lived off me now for forty years, and I have never had from you even so much as a kind word.

It is true that last year you were so exhorted and admonished that from shame you sent me a packload of Trebbiano [a white wine]; I would rather you had not!

I am not writing this to you because I do not want to buy; I do indeed want to buy in order to provide an income for myself, because I cannot work any longer; I want to go gently, so as not to buy trouble: so don't rush.

In March, now well over his illness, Michelangelo wrote in weary tones ('today there are only frauds and no one's to be trusted') to tell Lionardo to be wary over opening a shop ('it's pointless to think it could succeed nowadays') and not to pursue the idea of buying the Corboli assets, as he had received conflicting reports on them, was suspicious, and did not want to store up trouble for himself or for Lionardo after him.

He continued to write regularly to Lionardo as his main channel for communication with the rest of the family in Florence and as a trustworthy business agent, and as the male heir of the Buonarroti. In 1546, as he was working on the initial stages of his second big fresco in the Pauline Chapel, he sent Lionardo several notes successively acknowl-

edging the receipt of some shirts, giving him powers of attorney, complaining about his bad handwriting ('don't write any more, it makes me feverish'), acknowledging the arrival in Rome of sixteen *marzolini* – cheeses made near Florence – and mentioning letters which he had not had time to answer from his niece Francesca and the husband she had married in 1537, Michele Guicciardini.

Michele and Francesca were soon producing children: between 1538 and 1545, a daughter and three sons, one of whom died in infancy. Lionardo, aged twenty-seven in 1546, was still single, but as well as being chivvied and scolded by Michelangelo was constantly reminded of the past and present pride and importance of the family. The letters bearing instructions about money and business also brought Michelangelo's wishes for Lionardo to buy a *casa onorevole*, an imposing house, in Florence; for Gismondo to be asked to return to live in Florence so that Michelangelo would be no longer shamed by hearing he had a brother in Settignano who trudged after the oxen; for Lionardo to be told one day, when there was time, 'about our origins and whence and when we came to Florence'.

Scathing as he often was towards Lionardo, with whom he was no more able to share his artistic and intellectual life than he had been with his brothers, Michelangelo never failed to help him materially in the interests of the betterment of the family. Lionardo shared his uncle's financial caution, keeping from the age of eighteen a record of debtors and creditors and his dealing with Michelangelo, who helped him and Gismondo in their business plans with up to 1,200 scudi between 1542 and 1546. He kept the money intact till he was ready to start a wool company, in partnership with Matteo Quercetani, in 1548. Michelangelo also encouraged him and provided funds to buy a lordly house, but Lionardo preferred to stay put in Via Ghibellina. Further to raise his nephew's standing in Florence, Michelangelo bought four farms in Chianti, for 2,300 florins, in 1549.

In November 1546, when suggesting that Lionardo buy a bigger house, Michelangelo gave as the reasons that his nephew must take a wife and also that, as an old man, he himself wanted a good haven for his money. From now on, Michelangelo's pressure on Lionardo to buy a big house and marry was constant and controlling – increasingly so as he came to toy with the idea of returning to Florence himself.

72 Del Riccio's death

Giannotti took del Riccio's place as Michelangelo's helper when del Riccio was away from Rome. Most of the time del Riccio was the mainstay, and never more effectively and discreetly so than with regard to Michelangelo's tetchy dealings with Lionardo. After Michelangelo's illness early in 1546, for instance, del Riccio wrote several times to Lionardo to explain Michelangelo's feelings about buying the possessions of the bankrupt Corboli and, before this, to advise him precisely how best to approach Michelangelo concerning a projected partnership with Luigi's relation, Francesco Salvetti, without breathing a word to Michelangelo about his involvement.

Luigi del Riccio returned to Rome from journeying on business during the summer of 1546, and then he died. With him went the chance of an edition of Michelangelo's poetry in the author's lifetime. When Luigi and Michelangelo last met, the date of his death and where he was buried are all unrecorded; but not the depths of Michelangelo's sorrow.

In 1545 Pope Paul had made his son Pier Luigi duke of Parma and Piacenza, now newly independent. In November 1546 Bernardino della Croce, bishop of Casale, writing from Rome to Pier Luigi Farnese in Piacenza about Michelangelo's right to revenues from the Po ferry, reported that now Luigi del Riccio, who had managed all his affairs, was dead, Michelangelo appeared so bogged down as to be utterly desperate. A few days later, when Pier Luigi's ambassador in Rome, Fabio Cappalati, wrote to the duke about the same matter of the Po ferry, he put Michelangelo's grief over the death of del Riccio in the grand context of the designs of Pope Paul. For Antonio da Sangallo, ten years younger than Michelangelo, had also recently died, leaving the pope's massive building projects uncompleted.

The pope had spoken at length, Cappalati wrote to the duke, saying that if ever he had need of Michelangelo it was now – especially for the construction of St Peter's and his palace – and that if ever it had been difficult to appease Michelangelo and persuade him to do anything it was still more so now, because Luigi del Riccio, who used to manage him, had died.

When he wrote to Lionardo on the last day of 1546, Michelangelo was as usual anxious mostly to deal with practical matters – on this

occasion, buying a house in Florence at the best price. He made no mention of grief over the death of del Riccio; he did not share deep feelings of this sort with many people, least of all with his nephew. Shoring him up against the shocks of so many deaths was Michelangelo's own Roman *famiglia*, run by the indispensable Urbino. At the beginning of 1547, they were joined by a new maidservant, Caterina di Giuliano, with her little girl.

In January 1548 Michelangelo suffered the pain of yet another death – that of his brother Giovansimone, with whom he had long since been reconciled after their violent rows, and who had been living modestly in his own house in Florence. Michelangelo was hurt that Lionardo sent him so little news about how Giovansimone had died, or what he had left, and that Gismondo had not written at all. 'I remind you', he wrote to Lionardo, 'that he was my brother, for what he was, and I cannot but grieve for him, and wish that something be done for the welfare of his soul, as I have done for the soul of your father.'

Michelangelo was relieved to get all the details he wanted a little later on, and to hear that Giovansimone had died with an act of perfect contrition (*buona contritione*) 'which is enough for salvation'. All that Giovansimone left, after Michelangelo had renounced his rights as heir, went to Gismondo, now his only living brother.

73 'divine things in a blue field'

During 1546–7 Michelangelo was painting in the Pauline Chapel, fretting over the litigation prompted by conflicting claims to the revenues from the Po ferry, keeping his hand in as a sculptor (sometimes working at night by the light of a candle stuck in his paper hat), and hugging to himself his grief over the loss of Luigi del Riccio. His lifelong anxiety over family affairs took a new direction as his intimations of death began to trouble him more. His concern that Lionardo should marry became obsessive but ambivalent, as he came to brood more and more on the transience of life.

Michelangelo's attachment to the now forty-year-old Tommaso de' Cavalieri remained loving and firm, but was altogether calmer. The flow of love poetry for Tommaso had ebbed following over a decade of effusive outpourings, and after mingling with his more devout and emotionally more passive madrigals and sonnets for Vittoria Colonna.

It seems to have been a backward look and summation when about 1546–7 he wrote in the sonnet '*Non è sempre di colpa aspra e mortale*' that fierce ardour for immense beauty is not always a mortal sin if it so melts the heart that it can be penetrated by a divine dart and love unsated can rise to heaven:

> The love I speak of aspires to the heights;
> woman is too dissimilar, and it ill becomes
> a wise and manly heart to burn for her.
> One draws up heaven, and the other to earth;
> in the soul the one, in the senses the other lives,
> and draws its bow at base and vile things.

In 1545 Tommaso had married Lavinia della Valle, related to Cardinal Andrea della Valle who had died during a fetid Roman summer ten years previously. In 1548 he was elected one of the deputies for the restoration of the ancient Capitol after plans drawn up by Michelangelo, and his association with Michelangelo continued on its now more placid course.

Vittoria Colonna, from 1545, was living in the convent Sant'Anna de' Funeri (St Anne of the Ropemakers) in the quarter of Sant'Eustachio. She too was losing friends and relations, and was hurt especially by the deaths of Gian Matteo Giberti and, on 31 March 1546, of the cousin (by marriage) whom she had brought up, Alfonso d'Avalos, the marquis of Vasto. Alfonso, like Vittoria, had been moved and changed by the preaching of Bernardino Ochino. His pious death amidst the nuns as he prayed for eternal life through Christ's sacrifice on the Cross was a sign of the times. Titian had immortalized Alfonso differently in a powerful dramatic portrait of 1539–41, showing him in the mode of a Roman general in modern armour, Imperial baton in hand.*

Vittoria, like Tommaso de' Cavalieri, influenced the tone and content of Michelangelo's literary expression. Michelangelo's letter of thanks to Vittoria Colonna written about 1541 for the gift of a book of her sonnets in sheepskin was accompanied by a poem of his own, and he sent both to Giannotti to ensure their correctness. At the end of a madrigal for Vittoria written on blue-grey paper, he wrote fancifully, '*Delle cose divine se ne parla in campo azzurro*' – 'Of divine things one speaks in a blue field [i.e. the heavens].' Michelangelo called Vittoria

* The Louvre, Paris.

beautiful. Her beautiful face, her *bel volto*, spurred him to rise above vain desire, he wrote. What portraits survive show Vittoria looking plain and intelligent with long, straight nose, full pouting lips and soulful, almond-shaped eyes.

Michelangelo's deep feelings for her caused him confusion, drawing from him poetry which dealt with the nature of his art as well as his feelings about human and divine love. In a madrigal written about 1545, he paid her the compliment of having the qualities of a man – or a god – in being able to take him out of himself. The most profound record of their relationship Michelangelo left in the large presentation drawings he did for her: the sacred *storia* in black chalk of Christ and the woman of Samaria, of which there are surviving exploratory sketches and an engraving done in 1542; the *Pietà*, with the inscription on the stem of the Cross 'They do not realize how great the cost in blood' (a quotation from Dante's *Paradiso* about the spread of the Gospel); and the crucified 'sweet' Christ to whom, Vittoria wrote to Michelangelo, she would make her prayers, and who is shown startlingly alive with uplifted head between desolate angels, as he dies naked on the Cross, demanding why God has forsaken him.

Vittoria Colonna's already bad health had steadily worsened after her return to Rome from Viterbo at the end of 1544. She died on 25 February 1547. Michelangelo visited her as she was dying. He was distraught after her death. He grieved especially, he said, because when she was passing from this life he did not kiss her brow or her face but simply her hand. He wrote to Fattucci in Florence a few weeks later ('after a long time, and to prove to you that I am still living') and uncovered the edge of his sorrow with the remark that in his recent mood of great unhappiness he had found a few scraps of verse to send his friend as he used to do. No doubt Fattucci would think him old and mad, but it was only by a little madness that he could keep calm and collected, he said.

Michelangelo's last tribute to Vittoria Colonna came in two madrigals inspired by her death: '*Per non s'avere a ripigliar da tanti*' and '*Qual maraviglia è, se prossim'al foco*'. The latter, borrowing from Petrarch's poem on his lamented Laura, compared Vittoria to an external fire that used to burn him and had left him as an ember turning into ashes.

Sebastiano del Piombo died in his house in Campo Marzo in June 1547, unforgiven for his presumption by Michelangelo, chided for his indolence and self-indulgent style of life by Giorgio Vasari. Vasari himself, as well as painting on a grand scale, was finishing the book he

had been writing on the lives of famous artists from Cimabue to his own times.

74 The 'Florentine' *Pietà*

King Francis died in March 1547. He left as his heir a son, Henri, married to a Medici, Catherine, daughter of Lorenzo, duke of Urbino. The artistic culture of the French court had been transformed by the sculpture of Benvenuto Cellini, the painting of Rosso and Primaticcio, the architectural practice and theory of Sebastiano Serlio. Francis left the state more centralized than he had found it, but it was challenged by aggressive Protestantism at home and the Habsburgs' advancing power in Italy and the world at large. Francis's death was a great blow to artists and a great relief to Charles V, whose hopes of pacifying and consolidating his disparate dominions had been continually frustrated by the French king's intrigues and intrusions. This negative success in European dynastic conflict was secured at a tremendously high cost to the French crown: the war of the mid-1540s had been financed heavily by loans.

Benvenuto Cellini had special cause to remember the king who had heaped commissions on him and elevated his status. When he was making the fabled royal salt-cellar, Francis had told him that he did not know what was greater: the pleasure of a prince finding a man after his own heart or the pleasure of an artist finding a prince to provide all that his creativity needed.

For Michelangelo, the death of Francis (to whom he had written only a year previously wishing him a long and happy life) wiped out a promise to do 'something in marble, something in bronze, something in painting'. More upsetting was the death of Pope Paul's son Pier Luigi, duke of Parma and Piacenza, in September 1547.

Immediately after Pier Luigi's assassination – planned by the Imperial viceroy, Ferrante Gonzaga; effected by the dagger of a discontented noble – Piacenza was occupied in the name of the emperor (but Parma was saved for the pope by the quick action of Pier Luigi's son, Ottavio). These violent events brought shock and sorrow to the pope and forced him, uselessly, to look again to France for support against the Empire. They also ended Michelangelo's erratic income from the Po ferry. (The pope replaced it with the paid office of civil notary to the Romagna,

but this was worth only about half as much. Overall, by 1550, Michelangelo reckoned that 2,000 crowns were owed him by Pope Paul.)

In 1547 Michelangelo began carving a marble group showing the broken body of the dead Christ held up by Nicodemus, Mary Magdalene and the Virgin Mary. He told friends that using the hammer kept his body healthy. After the two serious illnesses when he had lived with Luigi del Riccio, he had begun to suffer from kidney stones. How he used the hammer was recorded about then by a French visitor to Rome, Blaise de Vigenère, who recalled that, though Michelangelo was over sixty (in fact well over seventy) and not so strong:

> in a quarter of an hour he caused more splinters to fall from a very hard block of marble than three or four masons in three or four times as long . . . he attacked the work with such energy and fire that I thought it would fly into pieces . . .
>
> With one blow he brought down fragments three or four fingers in breadth, and so exactly at the point marked that if only a little more marble had fallen he would have risked spoiling the whole work.

Michelangelo intended the *Pietà** for his own tomb; and once again, as he had done in the flayed skin painted in the *Last Judgement*, he was portraying his own features, soon faintly emerging from the section of the block showing a hooded, bearded, sweetly resigned Nicodemus at the back of Christ.

Michelangelo's letters to Lionardo meanwhile were registering his feelings about his nephew's thoughts about marriage, and growing more intimate and trusting, though still liable to be the vehicle for sharp rebuke. In October 1547 his response to a warning from Lionardo about the impending proclamation in Florence against the exiles (forbidding dealings with them either within or beyond the state) was chiefly meant to reassure and protect Lionardo and the rest of the family. He would, Michelangelo wrote, be even more on his guard against speaking with or frequenting the exiles:

> As for my staying when I was ill in the house belonging to the Strozzi, the important thing is not that I was in their house but

* The so-called 'Florentine' *Pietà*, 92 inches high, Duomo, Florence

that I was in the room of Messer Luigi del Riccio, who was my close friend; and since Bartolommeo Angiolini died I have not found any man to look after my affairs better than him, or more faithfully. But since he died I have no longer frequented that house, as all Rome can bear witness, as it can to the sort of life I lead, since I always live alone, and I go out little and speak to no one, least of all to Florentines. But if I am greeted as I go my way I can only answer politely, and continue on my way; though if I knew exactly who were the exiles I wouldn't reply for anything. As I said, from now on I'll be especially on my guard, above all since I've so much else to worry about that my life is a burden to me.

75 Marriage advice

Early in 1549 Michelangelo gave Lionardo his considered advice about the sort of woman he should marry. He noted that in Florence there were many poor and noble families with whom it would be an act of charity to seek a relationship, and that, if there were no dowry, there would then be less conceit:

> Lionardo, you need a woman who will stay with you and whom you are able to command, and who will not want to put on airs and spend every day going to feasts and gadding about; for parties can easily turn women into prostitutes, especially a woman with no relations at home. And pay no heed to anyone saying you seem to want to ennoble yourself, because it is well known that we are as ancient and noble citizens of Florence as any other family.

A little later, Michelangelo directed his nephew's attention ('as I have been begged to do so') to one of the daughters of Lionardo Ginori, whose mother was a Soderini, he pointed out. In August 1550 he was telling Lionardo rather peevishly that, though he had no knowledge of contemporary Florentines, everyone was telling him to find Lionardo a wife – 'as if I had a thousand women in my pocket'. There were other approaches: one of them, specified in a letter otherwise about buying a farm next to the Buonarroti family holding at Settignano, mentioned the orphaned daughter of Alto Altoviti – 'I do not know her and do not know what to say.'

Lionardo began to say that he wanted to see his uncle in Rome, to

discuss his marriage. Michelangelo said scathingly that he had come to know what these visits were really all about, but if this one were for the reason Lionardo was giving then he should come before the rains started in Florence.

In October 1550 Lionardo made his way to Rome and, as instructed, to his uncle's house in Macello de' Corvi. By mid-November 1550 he was back in Florence, where he received a note from Michelangelo thanking him for sending some ravioli, which had arrived spoilt and stuck together – perhaps because it had been packed too fresh and water had got to it on the way – but was otherwise fine. On his visit, Lionardo had presented Michelangelo with a length of cloth, worth about twenty to twenty-five crowns – a sum which Michelangelo thought of giving to charity in Florence but then decided to use to buy bread, a scarce item in Rome because of the hordes of pilgrims who had arrived for Holy Year.

Just before Christmas 1550 Michelangelo wrote to thank Lionardo for twelve cheeses (some of which he would give to friends) but telling him not to send things that cost money. The short letter inevitably raised the question of Lionardo's taking a wife – 'as is necessary' – though Michelangelo remarked he had nothing to say about it. Except, he went on, that Lionardo should not worry about the dowry, as people mattered more than possessions: he should have an eye only to nobility, health and, most of all, goodness. As for good looks, Lionardo was not the best-looking young man in Florence, so he did not have to bother too much, provided any bride-to-be was not crippled or loathsome. 'I have no more to say on this,' Michelangelo repeated. Apart from being temperamentally an unlikely marriage-broker, Michelangelo this winter felt occupied enough – overwhelmed by a load of work on his shoulders and the animosities and hatreds accompanying it.

76 The Pauline frescoes

In the autumn of 1542, as he prepared to begin work in the Pauline Chapel, Michelangelo had told Luigi del Riccio that painting and sculpture, hard work and honest behaviour had ruined him and he would better have been put in his youth to making sulphur matches.

In July 1545 Pope Paul inspected the first of the two Pauline frescoes, showing the conversion of St Paul. Four years later, on 13 October

1549, he very carefully climbed a ladder to where Michelangelo was completing the painting of the crucifixion of St Peter. There he had the satisfaction of seeing nearly finished the third great fresco done for him by the artist whose services he had wanted for thirty years and then enjoyed for fifteen. The two old Italian Catholics – the artist seventy-five, the pope eighty-two – stared together at St Peter, and St Peter, upside down, lifted his head by superhuman effort from the wood and stared at them. The eyes of the prince of the Apostles and the first of the popes as Michelangelo depicted them in his second fresco on the wall of the Pauline Chapel seemed to follow them as they moved around on the marbled floor.

The stare was indignant and angry, like the glances of the martyrs in the *Last Judgement*, which painting's features of boundless space, altering perspectives and multiple viewpoints were here replicated and simplified. With a stroke of brilliant inventiveness, Michelangelo had shown the slanting cross and the living, nearly naked, aged saint being raised and rotated by the executioners towards the vertical position for the cross to be dropped into the hole that has just been dug. The closed, circular rhythms of the suspended drama in which soldiers, executioners and followers concentrate on the crucifix are broken by St Peter's arresting stare at the spectator and the outwardly and inwardly directed eyes of a small group on the edge of the foreground. Towering over them, standing apart, a tall, bearded, hooded man meditates. The colours and forms, which pivot on the lifted head of St Peter, are strong and austere: for the bands of cloudy sky, desert hills, gesticulating bodies and barren rock, Michelangelo used rich blues, reds, greens and yellows; the lightly draped torsos and limbs he created with ceaselessly varying contours, creating realistically fleshy, thickened bodies.

As a complement to the conversion of St Paul, the painting of the crucifixion of St Peter may have been Michelangelo's preferred alternative to the more logical subject of St Peter receiving the keys of authority from Christ. Its source was the Church's tradition that, when condemned to death, the Apostle Peter had from humility asked to be crucified differently from Christ, his Lord.

These private paintings combined the expression of the mature Michelangelo's own technical facility and spiritual development with the translation into acceptable iconography of the theological preconceptions of the reigning pope, the successor to St Peter, at a time of crisis for the Church's doctrines and survival.

The Pauline frescoes were painted during 1542–50, the crucial, exploratory early years of the Council of Trent, when Michelangelo's

artistic aims and techniques were changing in response to his profound religious development. The frescoes of St Paul's conversion and St Peter's crucifixion proclaim mankind's dependence for salvation on faith in Christ's power and grace.

The pope's bull convoking the General Council of the Church had been issued in 1536, but the bishops did not assemble at Trent, an Imperial city on Italian territory, until December 1545. The choir of the beautiful Romanesque cathedral was adapted for the council hall. The Council was hardly ecumenical, representative of the whole world: most of the bishops came from southern Europe, chiefly Italy. For fear of the fever, the council moved to Bologna near the time of its seventh session in 1547. After the turn of the year, following ten sessions, the Council was suspended.

Despite its inevitable failure to reconcile the Lutherans, who refused to acknowledge its authority, the Council had pushed the Catholic Church further on the long path of serious, far-reaching reform, and was preparing to strengthen it to meet the onslaught of Protestantism. Urgently – anxious to refute Lutheran denials of free will – the Council dealt with the problem of original sin and, impelled by the demands of its own internal confusions, with the meaning of 'justification', theology's running battle of the age.

Justification, the Council decided, was both 'the transition from the state (of sin) in which man, son of the first Adam, is born to the state of grace and the "spirit of sonship" [Romans 8:15] of God through the second Adam, Jesus Christ our Saviour' and 'the sanctification of the inner man by the voluntary acceptance of the grace and gifts whereby the unjust man becomes just'. The Council rejected the doctrine of predestination: 'If anyone says that man's free will, moved and stimulated by God, cannot cooperate at all by giving its assent to God when he stimulates and calls him . . . and that he cannot dissent, if he so wills, but like an inanimate creature is utterly inert and passive, let him be anathema.'

Man's good deeds, not faith alone, counted for salvation; faith was a necessary but not a sufficient condition, decreed the Council after its seven months' wrestling with justification, before moving on to debate and pronounce on the seven sacraments.

77 Saving grace

Michelangelo had been close to Catholic reformers in Italy through Vittoria Colonna. But he was no more an expert on the theology of justification than were most of the bishops who went to Trent and were baffled by the arguments. His Catholic belief, as borne out by letters to his family and his own pious practice, was strong and simple assent to the importance of faith and good works. Michelangelo's spiritual torment was over whether his own sinfulness stood in the way of his salvation; over how far Christ's sacrifice would, as it must, outweigh transgressions.

During the 1540s Michelangelo grew steadily more disturbed by ageing and illness, which exacerbated his old disgruntlement with his own body and looks. His despondency seeped into his painting and erupted in his unconstrained poetry in grim and grotesque images and words, whose self-mockery and humour proved a kind of secular saving grace.

Written probably between 1546 and 1550, the *capitolo* '*I'sto rinchiuso come la midolla*' rattled like a skeleton. Ruptured, racked, bruised and broken by his labours, he was eating on credit at the inn of death. No love was left in his heart; there was a hornet in his jug of a head; there were bones and string inside his leather sack of a body, and three pills of pitch rattling in his gut; in one ear was a spider's web, in the other a cricket sang all night, and his panting killed off sleep. His scribblings on love, the muses and flowery grottoes, all were good just for tambourine covers and wrapping-paper, for cleaning latrines, brothels and beer halls. What had been the good of his making so many childish things, if finally he ended like the man who crossed the sea and drowned in snot? The so highly prized art for which he was once so esteemed had brought him to this: he was poor, old and at the service of others, and so he was done for, if he did not die soon.

The harsh language was the Florentine of the streets and carnivals of Michelangelo's youth, but the burden of physical self-loathing and macabre melancholy was the product of lassitude and longevity and the dismal times.

78 The charge of St Peter's

When in October Pope Paul went to examine Michelangelo's painting of the crucifixion of St Peter he was eighty-two and had been pope fifteen years to the day. On his mind were the preparations being made for the Holy Year of 1550, and the tremendous changes he had wrought in the Vatican and the city since the entry of the emperor into Rome in April 1536, eighteen months after he had been elected pope.

The emperor's visit had reflected the dominance of Spanish military and political power in Italy, but also the new pope's determination to restore the grandeur of Rome itself. By the late 1540s spiritual reformation and reaction at the heart of the Church had radically changed the Vatican's cultural and spiritual programme, but Pope Paul's vision of a new Rome had largely been realized. In the process he had bound Michelangelo to the architectural programme of the city as tightly as Julius II had tied him to the della Rovere monument. As Michelangelo's old age now made it physically impossible to continue the exhausting, monumental work of a fresco-painter, his intellectual and creative energies were redirected into architectural design and management.

Michelangelo's architectural talent was, of course, well known to the popes, but while Bramante and members of his circle survived he was cold-shouldered in Rome. Leo X preferred to use him as an architect in Florence, partly because of his personality and partly because of his disturbing innovations. When Pope Paul decided to seize the chance of employing him at St Peter's, Giulio Romano, the last of the 'school' of Bramante and Raphael, had just died; even so, the pope took a while to confirm the appointment.

Michelangelo's work as sculptor of the huge projected tomb for Pope Julius had influenced the very first plan for a new basilica. A letter of his concerning St Peter's, written in January 1547, stands out from his other writing of the time for its ringing affirmations and decisive tone, its idiosyncratic but sane observations. He was about to succeed Sangallo at St Peter's and take up the office of superintendent of the building work. He wanted it to be known that he was doing so against his will, and only at the pope's insistence. Architecture was not his profession. But he wrote decisively to a friend (probably Bishop Bartolommeo Ferratino, canon of St Peter's and prefect of the fabric) as follows:

It cannot be denied that Bramante was as skilled in architecture as anyone else from the time of the ancients till now. It was he who drew up the first plan for St Peter's, not full of confusion, but clear and uncluttered, luminous and free on all sides so that it did not detract at all from the palace. It was regarded as a beautiful achievement, as is still manifest; and thus anyone who has distanced himself from Bramante's arrangements, as Sangallo did, has distanced himself from the truth. And that this is so anyone whose sight isn't clouded can see from his model. For, with his ambulatory, Sangallo immediately took away all and every light from Bramante's plan; and moreover it [the outer ambulatory] does so when it has no light itself whatsoever. And there are so many hiding-places above and below, all dark, that they provide great opportunities for no end of vile misdemeanours; such as the concealment of outlaws, the counterfeiting of money, getting nuns pregnant, and other sordid misbehaviour; and so in the evening, after the church closes, you would need twenty-five men to seek out those who are hidden there. Even then it would be very difficult, the way things are. Also there would be this other inconvenience: that, in adding to Bramante's composition the additional building shown in the model, you would be forced to tear down the Pauline Chapel, the apartments of the Piombo, the Rota, and more besides; nor, I believe, would even the Sistine Chapel survive intact.

If Sangallo's model (an enormous construction by his pupil Antonio Labacco) were followed, Michelangelo added in a postscript, everything done in his time – the buildings to the north of St Peter's – would have to be destroyed, and this would be a great loss. In wanting to go back to Bramante's original plan, ignore Sangallo's scheme for ambulatories, and demolish the now half-built ambulatory to the south, Michelangelo aroused the anger of Sangallo's old team, who grew increasingly infuriated by his threat not to employ any of them.

In presenting his case to the pontiff, Michelangelo appealed to Paul's sense of value for money: his simpler, more convenient and more graceful plan for St Peter's would save fifty years of time and over 300 crowns. He would himself take no salary. As if to prove this, Michelangelo made a clay model of his design in a fortnight at a cost of twenty-five crowns (compared with the 4,000 crowns incurred for Sangallo's, which took years to finish) while his wooden scale model was being built in his own house. All this while, work was going on at

St Peter's on the walls of the southern and northern arms and prepara-
tions were under way to build a cornice at the base of the drum.

On 11 October 1549 a fresh papal brief granted Michelangelo
extraordinary and unprecedented powers as prefect, operations man-
ager (*operarius*) and architect of the basilica on behalf of the pope and
the Apostolic See for as long as he should live. Never had a patron
granted such liberty in such a vast undertaking to the artist concerned.
In the plenitude of his apostolic power, the pope approved the new
design and all the demolition and building work that Michelangelo
might order to be done, no matter what. These conditions and the plan
submitted by Michelangelo were guaranteed in perpetuity. Neither
Michelangelo nor all those connected with him (his master craftsmen
and their heirs) could be held responsible on account of damages or
expenses caused by these matters. Michelangelo could at any time
change the model and plan and construction of the building as seemed
best to him. He could employ and dismiss and pay all those he needed
for work on the fabric entirely at his own discretion. The deputies of the
fabric were to have no authority over him.

This last provision was very emphatic. Michelangelo's lifelong strug-
gle to be free of constraint had never been so scrupulously and liberally
acknowledged and facilitated.

Pope Paul's intentions immediately met resistance. The lesser artists
and craftsmen who had become Sangallo's assistants as he secured
increasing Farnese patronage in Rome did not disperse. The deputies of
the fabric who had been aligned with Sangallo (corruptly, Michelangelo
had alleged) still kept influential friends in the higher reaches of the
Curia, including Cardinal Giovanni Salviati. Among the artists, especi-
ally resentful was the versatile architect Nanni di Baccio Bigio, who had
set out to be a sculptor under Raffaello da Montelupo in Florence, and
after arriving in Rome had made a fine copy of Michelangelo's *Pietà*.

After Michelangelo had made his clay and wooden models (both
now lost), he completed a large-scale model of the cornice of the
interior drum. The pope's insistence that Michelangelo's model be
respected did not silence the complaints that Michelangelo was keeping
the deputies in the dark, but it ensured that the new surge forward in
the building of the basilica, whose course had been set when Bramante
raised the crossing piers, was determined by Michelangelo's unifying
instincts.

Michelangelo took out all the perimeter of Sangallo's design and
restored the basilica's central-plan scheme, removing Sangallo's utili-
tarian porch and forenave. These vital changes saved time and money,

preserved important existing buildings, and brought direct light into the interior of St Peter's. He made a simple, coherent church out of Sangallo's plan with a few boldly drawn lines, walling off the entrances to the previously disconnected spaces. Then, as the work progressed, his ideas were constantly modified in response to the emerging structures as he saw and judged them.

79 Defences for Rome

Pope Paul gave Michelangelo the stupendous task of command at St Peter's because of his practical approach and his purposiveness, as well as his art. Michelangelo, at seventy-four, accepted the post both to show how successfully he could do it and for the sake of his soul: a mixture of pride and piety.

Throughout most of his pontificate, Paul had feared waking up to hear news of an attack on Rome by the Turks or an assault by the Imperialists. Christian and pagan armies had sacked Rome with equal fervour in the past. In 1537 Pope Paul had looked to Antonio da Sangallo to carry through a costly programme to strengthen and extend the defences on the Tiber's left bank and then those of the Borgo safeguarding the Vatican itself. By the end of 1542 Sangallo's first big scheme for extensive walls with as many as eighteen bastions had proved impracticable, and it was decided to concentrate resources on the Borgo itself. The main point at issue became whether the Vatican's defences should be shortened or extended along the ridges of the hills.

Pope Paul had wanted as much advice as he could get, and Michelangelo, not at all shy about his military service on behalf of Florence, was invited to contribute to the discussions. He clarified some of his views in a letter dated 26 February 1544 to Tiberio Crispi, castellan of the fortress of Sant'Angelo, expressing his hope that the existing management would be removed.

At one of the pope's meetings of military and civil advisers, the mutual dislike of Michelangelo and Sangallo had erupted unpleasantly. Characteristically, Michelangelo had been holding his tongue, letting others talk. Then Pope Paul asked for his opinion. He gave it eloquently, criticizing Sangallo's position so scathingly that Antonio expostulated that sculpture and painting were Michelangelo's arts, not fortification. The quarrel grew so bitter that the pope had to impose silence.

Sangallo had remained in charge of the defences and his architectural legacy included three finished bastions, part of the gateway of Santo Spirito, and his huge wooden model of St Peter's.

Soon after Sangallo's death in 1546, Jacopo Meleghino of Ferrara was given the post of director of fortifications, but was told that he must defer to Michelangelo, and the Belvedere bastion was finished under Michelangelo's supervision. Meanwhile Michelangelo had the extra satisfaction not only of cutting Sangallo's design for St Peter's down to size but also of taking over completely work on the Farnese Palace.

80 Palace and Capitol

After his years of rivalry with Sangallo, in the autumn of 1546 Michelangelo could now enjoy the sweet sense of justification, if not revenge. Although, as with nearly all his architectural commissions, there was a daunting restricting condition (in this instance, extensive building by Sangallo), Michelangelo's powerfully original designs for the Farnese Palace transformed its appearance, with assertive magnificence deliberately employed to impress and amaze the pope.

Michelangelo's three bold changes to Sangallo's plans to fashion a new cornice, heighten the third storey and reshape the central window, emerged after he had built a wooden model of the cornice about twelve feet long, and had it placed at one of the corners of the palace to show the effect. The cornice was at least partly completed in July 1547; by that time it had provoked an angry rumbling dispute between Sangallo's followers and Michelangelo's. The former asserted that the cornice was so heavy it was causing cracks in the façade; Michelangelo's supporters retorted that the cracks were caused by the poor foundations built on ancient walls. Nanni di Baccio Bigio alleged that Michelangelo wanted to ruin the palace.

Michelangelo's decision to raise the height of the third storey to counterbalance the enormous cornice defied Sangallo's traditional Florentine expedient of a progressive diminishing of the heights of the three storeys. In changing the form of the central window above the entablature, Michelangelo provided a declamatory climax in the form of a huge marble coat of arms of Pope Paul covered with fleurs-de-lis. Here, as with the ornamentation of the cornice and the window-frames,

with pediments teasingly free of their supports, he set out to puzzle and surprise the eye.

These elements were only a part of the transformation of Sangallo's palace project envisaged by Michelangelo. His imagination was kindled by the discovery (in 1546) at the Baths of Antoninus (or Caracalla) of a block of marble about fourteen feet square carved with a figure of Hercules seizing a bull by its horns, with surrounding figures of shepherds, nymphs and animals, probably meant for a fountain. Michelangelo suggested that it should be placed in the second courtyard of the Farnese Palace and put in working order. He made designs for a bridge over the Tiber to the Villa Farnesina and its gardens, transforming a massive closed structure into a negotiable urban landscape of ornate buildings, statues, water and plants.

In December 1537 Michelangelo had been honoured with Roman citizenship in a ceremony at the Capitol, Rome's historic civic centre: in 1539 Pope Paul had asked his advice on placing the bronze equestrian statue – identified by scholars as of Marcus Aurelius – which had been brought from the Lateran to the Capitoline Hill to improve its shabby appearance. Pope Paul further pressed Michelangelo to submit proposals to restore and adorn the whole site, a plateau under the northern peak occupied by the church of Santa Maria in Aracoeli, with the old Senators' Palace to its east and the more recently built Conservators' Palace on the south. The plateau was to be converted into a level paved area with an entrance from the city up the existing muddy slope.

Michelangelo's proposals for the Capitoline Hill were grandly theatrical: the pope wanted a superb stage for ceremony, and Michelangelo's design was both innovative and economical. It imposed harmonious grandeur and order on the old jumble of miscellaneous elements: a new palace along the open side to create a pleasing symmetry and a campanile to draw attention to the axis of the square. To complement the irregularity of the boundary, Michelangelo devised a patterned, shield-like oval set in the paving, surrounded by three steps and rising slightly towards the middle with, in the centre, on a matching oval base, the statue of Marcus Aurelius.

Michelangelo's plan reinforced the Capitol's association with the glory of ancient Rome, now reclaimed by the papacy for the greater glory of God.

Rome was transformed by Pope Paul's development and building initiatives. From Ponte Sant'Angelo, the Via Paolina went through the

commercial districts to the church of the Florentine *nazione*, San Giovanni, and the new Via del Panico was built through the banking quarter. Michelangelo's contribution to the communications of Rome was the strengthening of the Ponte Santa Maria, threatened by the strong flow of the Tiber. Before 1549, he had begun the work by buttressing the piers and building caissons, using wood and travertine.

The price of Pope Paul's programmes, especially for the works of St Peter's, was the disappearance of ancient marbles, most of all around the ancient Forum, for new construction or to make lime. But the pope's thirst for renovation turned Rome into a more beautiful, somewhat better defended and potentially far healthier city than the dirty, devastated capital he had inherited from Clement.

In 1549, however, work to implement the new architectural schemes to which Michelangelo was committed − for St Peter's, the walls and bastions for the Borgo, the Farnese Palace and the Capitol − was scarcely started. Michelangelo, in his mid-seventies, obviously knew that he would never see the completion of more than a fraction of what he had undertaken to design and supervise, so many decades after his true contemporaries in the art had died.

What he could try to do (as Bramante had done with the core of St Peter's) was to ensure sufficient progress to tie his successors' hands. His pride and assurance kept him in Rome.

While Michelangelo was working hard for Pope Paul, Duke Cosimo sent Tribolo from Florence to try to persuade him to finish the sacristy of San Lorenzo. Michelangelo's response was that he was too old and could not support the burden of the work, and had commitments to honour in Rome.

81 Michelangelo and Titian: storming giants

In a letter of 1542 to Cardinal Alessandro Farnese from the Aretine bronze sculptor and engraver Leone Leoni, Titian was described as 'mild, tractable and easy to deal with, which is worthy of note in respect of such exceptional men'. The contrast with Michelangelo, to whose Sistine frescoes his own paintings had often paid homage, could hardly have been greater.

Academic commentators and artists themselves saw Michelangelo

and Titian as giants storming not only the palaces of the rich but also the mansions of the learned and the liberal arts. On the tide of their success, the entire profession of painters, sculptors and architects might secure ever higher social and intellectual status.

During 1543–5, Pope Paul was preoccupied with preparations for the Council of Trent. At the same time he was grappling with the problems of the French incursion into Italy, the Imperial invasion of France, and the shortlived Peace of Crépy between king and emperor. When the pope came to feel less harassed, at the end of 1545, Titian was invited to Rome from Venice. He was welcomed by his fellow Venetian Pietro Bembo, a cardinal of six years' standing, and received by Pope Paul and Cardinal Farnese, who allocated him rooms in the Belvedere. Giorgio Vasari was deputed to show him the sights and, naturally, was there to observe his first meeting with Michelangelo.

Accompanying Vasari on a visit to Titian in his temporary workshop in the Belvedere, Michelangelo had found himself staring at a painting of a nude Danaë and, as Vasari recalled, praised the work most warmly. Afterwards, Michelangelo had said in commendation that Titian's colour and style pleased him very much. In the same breath, however, Michelangelo had added that it was a shame that in Venice they did not learn to draw well from the beginning, and a pity that Venetian painters did not pursue their study with better method (*miglior modo*). The truth was, Michelangelo believed, that if Titian had practised drawing from living models then, being so greatly gifted, no one could have achieved more or done better, for he had a very fine spirit and a lively and entrancing style.

Vasari had listened very carefully to all this. Vasari was Michelangelo's man in Florence, and his eyes and ears in different parts of Italy, as he travelled to paint, or to study the works of others.

Towards the end of his fruitful year in Rome, Titian executed a portentous portrait of the pope with his grandsons, Alessandro Cardinal Farnese and Ottavio.* The nearly eighty-year-old pontiff, with foxy face and cotton-wool beard, shrunken and bent in his robes and his armchair, eyes the young Ottavio, his 'idol', with affectionate misgiving. The cardinal's stillness, the pope's sudden turn of the head at Ottavio's dancing approach, create a study in suspense making the breathing of the Farnese almost audible. Titian also painted several other portraits

* Capodimonte, Naples.

for the Farnese family, as well as a Danaë, a Magdalen, and an *Ecce Homo*. When he left he was loaded with gifts and had been promised a benefice for one of his sons, Pomponio.

Because of his visit to Rome, Titian came to believe, his work improved greatly. Mature as he was, the effect of the works of the ancient world and of the modern works of Michelangelo (not least the statue of the Risen Christ) was to strengthen his assurance in painting pictures of heroic grandeur, such as, almost immediately, four mythological stories from Ovid's *Metamorphoses*. In particular, when in Rome – after being advised by Aretino not to spend too long looking at *The Last Judgement* – Titian's painting of the rape of a receptive Danaë had shown that he could emulate Michelangelo's painting of a reluctant Leda (taken to France by Antonio Mini, but known in Venice from a copy).

Vasari felt he had become a warm friend of Titian and was flattered by the mutual familiarity. But he also felt relieved when this formidable competitor for patronage prepared to leave Rome for Venice and home. Perino del Vaga most certainly did, having deliberately avoided Titian during his stay. (At this time Perino was frantically busy in the Sala Regis in Castel Sant'Angelo, painting heavy Michelangelesque forms for sheer ornamentation.)

Daniele da Volterra (Daniele Ricciarelli), about ten years younger than Perino del Vaga, and in his late thirties when Titian visited Rome, had by then come to play in Michelangelo's emotions something of the role taken by Sebastiano del Piombo through the 1520s. He had learned from Sodoma, in Siena, when young, and then from Baldassare Peruzzi. In Rome in the late 1530s and 1540s he had first carried out many of Perino's designs, and then painted, independently, scenes from the life of St Helena in Santissima Trinita. In the winter of 1547, when Perino died, Daniele da Volterra, chiefly it was believed through Michelangelo's influence, was engaged by Pope Paul to continue the painting in the Sala Regia. The new office of guardian and cleaner of the frescoes in the Sistine and Pauline Chapels went to Michelangelo's assistant Urbino. The responsibilities were 'to clean well and keep clean the pictures of the vault from dust and other defilements and to preserve them from the smoke of the lights which ascend in both chapels during the performance of the divine offices'.

82 Pope Paul's legacy

Michelangelo's late flowering as architect, in Florence thanks to Pope Clement, in Rome thanks to Pope Paul, distanced him both from his long-dead contemporary rivals, Bramante and Raphael, and from the younger artists including Sansovino and Giulio Romano whom they had influenced and who had migrated to the north. In his own way, Michelangelo drew with dispassionate eye and perfect memory on the continuum of the work of all the known past, including his own. The tremendous cornice and the exuberant window-frames he designed for the Farnese Palace showed what original and, to the academic mind, shocking art this generated.

How reluctant Michelangelo had been to accept architectural commissions is difficult to assess: probably not as much as he made out. Towards the pope who loaded him with such burdens, and also with welcome honours, he felt gratitude and warmth.

Busily preparing among other things to celebrate the Holy Year of 1550, Pope Paul fell ill with a raging fever in the winter of 1549.

The outrage of his idolized grandson Ottavio's seizure of power in Parma with the help of his father's killer, and the brutal effect of his other grandson's apparent connivance when Cardinal Farnese met the infuriated pope in the Villa Carafa on 6 November 1549, surely precipitated Paul III's death four days later. Ironically, the nepotistic pope died for family reasons.

Michelangelo wrote to Lionardo that the pope in November, aged eighty-two, had died a beautiful death, conscious to the last. 'As to my own well-being, I am putting up with my illness as best I can, and compared with other old men I have no cause to complain, thank God. Here from hour to hour we are awaiting the new pope.'

83 Vasari's lesson: design and intellect • Varchi and the *paragone*

Following his breakdown after the death of Duke Alessandro, Giorgio Vasari had recuperated and won influential friends working in a monastery at Camaldoli, where he caught the eye of the visiting

Bindo Altoviti, and then, in the early 1540s, he had found his way to the court of Cardinal Alessandro Farnese. During the 1540s, he had worked in Venice, Naples (to which he claimed to have brought the '*maniera moderna*') and then Rome, where, as Michelangelo was attending to the architecture of St Peter's and the Farnese Palace, he was commissioned to fresco the great hall in the Palazzo della Cancelleria, Cardinal Farnese's chief residence, with scenes from the life of Pope Paul.

Vasari worked hard on devising the work and preparing the cartoons, but delegated much of the painting to apprentices. Cardinal Farnese had wanted the scenes done quickly, and one of the inscriptions by Paolo Giovio said that the work had been completed in a hundred days. Michelangelo was heard to say that this was evident. Vasari did not take Michelangelo's sarcasm too much to heart, but he never forgot it, coming to tell the story as if it were about another hurried painter. On matters of art he was hanging on Michelangelo's every word. In this regard, Michelangelo's reaction to Titian's manner of painting and lack of *disegno* was important.

Michelangelo had practised drawing incessantly since boyhood, and vehemently urged young men to master it as the basis of the arts: a concept going back to Ghiberti and Alberti, and so general as to be asserted in Castiglione's *The Book of the Courtier*, where it was especially recommended to courtiers as very useful for planning war and designing fortifications. *Disegno* was rooted in Italian and especially Florentine practice. Also fundamental to Michelangelo's practice and understanding of the nature of art was *intelletto*: the God-given, mental faculty of discerning beauty. The motto accompanying his symbol of three linked circles (for painting, sculpture and architecture) was '*Levan al cielo nostro intelletto*' – 'They raise our intellect to heaven.' In verse written for Vittoria Colonna, he said he was given beauty at his birth and it was beauty that raised every pure intellect to heaven.

In a poem for Vittoria written about 1544, Michelangelo gave a fresh insight into his idea of art when he described the sculptor's intellect guiding his hand to reveal the form he imagined within the stone:

> No block of marble but it does not hide
> the concept living in the artist's mind –
> pursuing it inside that form, he'll guide
> his hand to shape what reason [*intelletto*] has defined . . .

This sonnet – '*Non ha l'ottimo artista alcun concetto*' – delighted Benedetto Varchi, the much-liked versifier and author of a dry, revealing history

of Florence ('the Florentines, even if they do not excel all other nations, are at least inferior to none in those things to which they give their minds ... besides trade, it is clear that the three most noble arts of painting, sculpture and architecture have reached that degree of supreme excellence in which we find them now').

Varchi was a member of the Florentine Academy, founded in 1540 and dedicated to the study of Italian literature and the safeguarding of linguistic correctness. Michelangelo was elected a member when Varchi gave two discourses on Michelangelo's poetry on 6 March 1547.

Varchi analysed the influence of Petrarch and Dante on Michelangelo's sonnet '*Non ha l'ottimo artista alcun concetto*' and the classical or Tuscan base of its wording. (Varchi as a boy had been forbidden to read anything in the 'barbarous' vernacular, and was threatened with punishment for furtively reading Petrarch.) On the following Sunday, 13 March, Varchi lectured on the popular topic of the rival merits of painting and sculpture: Michelangelo, Varchi had assumed from his metaphor of the form concealed in the stone, would put sculpture first.

Varchi was a complex, sensual and scholarly man. (Titian's portrait* shows him black-robed, black-bearded, in his early forties, holding a book casually and staring guardedly into the distance.) His first discourse on Michelangelo's poetry almost buried the sonnet under a mountain of erudition. He fleshed out Michelangelo's beautifully phrased and essentially intuitive summary of the creative act with Aristotelean commentary and quotation, arguing that Michelangelo's stirring metaphor had 'no more to do with Plato's ideas than with the demons of Avicenna' but was an illustration of Aristotle's notion of potentiality. Michelangelo's prudent response was not to pursue scholastic analyses of his art, which explained itself, but mainly to express his pleasure at the compliment.

Varchi was one of Michelangelo's important links with the socially elevated but still aspiring world of Florentine academia. Commenting on Michelangelo's love poetry in his first lecture, Varchi cited especially the sonnet '*Non vider gli occhi miei cosa mortale*' written for Tommaso de' Cavalieri (and now known only from Varchi's *Due lezzioni*). The poem, using Platonic concepts, as Varchi remarked, expressed love for the spiritual and universal form underlying physical beauty and rejected

* Kunsthistorisches Museum, Vienna.

the unbridled desire which, through the senses, killed love, in favour of Michelangelo's and Tommaso's true friendship, perfect on earth, even more so in heaven after death.

> *Voglia sfrenata el senso è, non amore,*
> *che l'alma uccide; e'l nostro fa perfetti*
> *gli amici qui, ma più per morte in cielo.*

See, exclaimed Varchi, how Michelangelo, more archangel than angel, had surpassed the ancients and the modern in poetry as well as in architecture, sculpture and painting.

The bound manuscript of the two lectures was sent to Michelangelo on Varchi's behalf through Luca Martini, a wealthy functionary and friend of Duke Cosimo, a member of the Academy, buyer of paintings and occasional poet. Martini's letter to Michelangelo has not survived; Michelangelo's response was rapturous. After thanking him for his letter and for Varchi's divine commentary (which he had shown to Donato Giannotti, who could not put it down), he characteristically demurred over the praise for his sonnet and said he would not want to seem what he was not. His letter was written in March 1547, not long after the deaths of Luigi del Riccio and Vittoria Colonna. He ended, 'I am old, and death has taken from me the ideas [*pensieri*] of youth; and may those who do not know what old age is bear it patiently when it comes, for they cannot understand it beforehand. Commend me, as I said, to Varchi, as being most warmly devoted to his talents, and to his service wherever I am.'

Michelangelo took up Varchi's challenge to discuss the *paragone* – specifically in this context the comparison between sculpture and painting – in a rather more revealing letter. (Varchi had circulated his challenge to seven artists, including Vasari and Cellini.)

I say that painting seems to me the better regarded the more it approaches relief, and relief the worse regarded the more it approaches painting; thus I used to think that sculpture acted as painting's lantern and that between the one and the other was the same difference as between the sun and the moon. Now, as I have read in your script where you say that, speaking philosophically, those things which have the same end are one and the same, I have changed my opinion and I say that if greater judgement and difficulty, impediment and labour do not make for greater nobility, painting and sculpture are the same thing; and, this being held to be so, no painter should make less of painting than of sculpture:

nor likewise the sculptor of painting than of sculpture. I mean by sculpture what is made by force of taking away [*per forza di levare*]; what is made by means of shaping [*per via di porre*] is similar to painting. Enough that as both of them, sculpture and painting, derive from the same intelligence, we can bring them to a good accord and eschew these disputes, for they take up more time than making figures. If he who wrote that painting was more noble than sculpture understood as well the other things he wrote about, my maidservant would have written them better. There are endless things, not yet said, that are to be said about such scholarly matters; but, as I have said, they would want too much time, and I have little, for I am not only old but almost numbered among the dead. So I beg you to hold me excused. And I commend myself to you and thank you all I know how and can for the too great honour you do me, which is not fitting for me.

Varchi's very influential *Due Lezzioni* was published in 1550. He had just been asked by Tommaso de' Cavalieri, Michelangelo wrote to Fattucci in February 1550, to thank Varchi on his behalf 'for a splendid little book of his that has been printed, in which he [Tommaso] says Varchi speaks very honourably of him, and no less of me.' Michelangelo enclosed a sonnet he had once written for Tommaso, who now wanted it to go to Varchi for him to expound. 'So please give it to him, or else put it in the fire, and reflect that I am fighting with death and have other matters in mind: though now and then one must do such things as this.'

Despite his reluctance to be drawn into debate about the comparative merits of sculpture and painting, his touch of exasperation and the irony of his reponse, Michelangelo was with good reason immensely gratified by Varchi's disquisition, which would now enjoy a large readership outside their own literate Florentine circles. In the lecture, Varchi had analysed Michelangelo's own reference to '*L'ottimo artista*' so as to raise him to the plane of the canonized saints of Tuscan letters, Dante and Petrarch. As a poet and historian, he could make no greater contribution than this to the apotheosis of Michelangelo.

For the mostly literary members of the Florentine Academy the tribute was very satisfactory. Artists, however, required something more to reap full advantage from the supremely exalted position which Michelangelo had reached. They needed him to be set firmly in the context of the historical ascent of the arts of design to the level of the classical arts and sciences; they needed acknowledgement of his high

social standing; and, in the reformist moral and religious climate of the mid-century, they needed him to be accepted into the ranks of the orthodox.

84 Giorgio Vasari's *Lives*

By 1550, when Varchi's exaltation of Michelangelo as poet was published, Giorgio Vasari was putting the last touches to his two great volumes of art history. His grand design, recounting the rebirth and progress of the arts, made the living Michelangelo its culmination and its glory. Vasari had been living in Rome when the idea took shape, probably in 1543. He had then been staying with Bindo Altoviti, beginning to paint for Cardinal Alessandro Farnese, and assiduously cultivating Michelangelo. In 1547 Vasari was having a fair copy of what he had compiled made by a skilled penman.

Before mid-1550, the book had appeared from the press of Duke Cosimo's printer. The title page, with caryatids and putti, Medici *palle*, clusters of fruits and flowers, and a little panorama of Florence, announced *The Lives of the Most Excellent Italian Architects, Painters, and Sculptors, from Cimabue up to our own times: described in the Tuscan language, by Giorgio Vasari, Aretine Painter, with his useful & necessary introduction to their arts.*

Michelangelo was moved enough by Vasari's book to write a sonnet to him, since, as he said (in a letter to him in August 1550), he had brought the dead back to life and so, not surprisingly, prolonged the life of the living or the half-living like himself, as he hurried to the grave. Meanwhile the notably alliterative, strongly crafted sonnet – '*Se con lo stile o coi colori avete*' – incisively and musically expressed strong sentiments of gratitude and hope. Vasari with his stylus (the tool for transferring outlines from cartoons on to plaster) and his colours had already made art the equal of nature; now, by rekindling memories of others, long extinguished, Vasari made them and himself live eternally.

> *Or le memorie altrui, già spente, accese*
> *tornando, fate or che fien quelle e voi,*
> *malgrado d'esse, eternalmente vive.*

Vasari's *Lives* in its first edition (dedicated to Duke Cosimo de' Medici, to whom he was *Giorgio charissimo*) put the story of the living

Michelangelo Buonarroti of Florence, painter, sculptor and architect, into the context of the divine plan.

> While all artists of energy and distinction enlightened by the renowned Giotto and his followers were striving to give the world proof of the talent with which the benign disposition of the stars and balanced composition of their humours had endowed them, and while, being desirous of imitating the greatness of nature through the excellence of art to come as close as they could to that full understanding which many call intelligence, they were everywhere applying themselves strenuously, but in vain, the most benign ruler of heaven in his clemency looked down to earth and, having seen the infinite vanity of all these efforts, the fruitlessness of the most ardent studies and the presumptuous opinion of men as far from the truth as shadows are from the light, he disposed himself to send to earth the spirit of one who should be able in any single art and every profession, working on his own, to resolve all the problems of delineation, of painting, of judgement in sculpture, of invention in truly elegant architecture. And he wished moreover for him to be accompanied by true moral philosophy and the ornamentation of sweet poetry. This was so the whole world should choose and admire him as a most singular mirror for life, for their works, and for sound example in every human deed and act, and so that he should be acknowledged by us all as celestial rather than earthly. And since he saw that in the performance of these exercises and in these most singular arts, namely in painting, in sculpture and in architecture, Tuscan minds [*ingegni*] have always been truly the greatest and most elevated of all, being most observant in their work and studies in every faculty, above whatsoever other people of Italy, he wished to give him Florence, worthiest of all cities, as his native land [*patria*], in order to raise there worthily to the height of perfection all the talents [*virtù*] by means of one of its citizens; having already made a great and marvellous beginning with Cimabue, Giotto, Donatello, Filippo [Lippi], Brunelleschi and Leonardo da Vinci.

Vasari wrote that 'Michele Agnolo' was called so by his father at baptism to point to a celestial and divine phenomenon; that he was of most noble birth; that as a child he was always drawing on paper or on walls; that he was apprenticed to Domenico Ghirlandaio for three years; that Lorenzo de' Medici took him into the garden-school of excellent sculptors and painters run by the elderly Bertoldo, Donatello's

one-time pupil. He then listed Michelangelo's works, with precise technical and aesthetic comments, from Michelangelo's marble copy of an antique head and the marble boy (also in imitation of the antique) brought to Rome, buried in a vineyard and sold fraudulently, to the fresco painting of the Sistine Chapel, in which all the power of art was displayed in the awesomeness, or *terribilità*, of the last of the figures, the prophet Jonas.

Vasari then apostrophized those readers he chiefly had in mind – his fellow artists:

> Oh what a truly happy age is ours! O blessed artists [*artefici*]! You must truly be called so since in your time you have been able, at the fount of such shining brightness, to let the scales drop from your eyes and see made plain all that was difficult, by such a marvellous and singular artist! The glory of his labours has surely brought you recognition and honour, since he has stripped away the bandage from your previously clouded perception, and has uncovered the veil of falsity, which darkened the finest rooms of intellect. So thank heaven for this, and force yourself to imitate Michelangelo in everything you do.

In his praise for Michelangelo's pictures, Vasari gave a creatively fresh guide to the aesthetic and theoretical values held by Vasari himself and his professional friends in mid-century Florence. As he wrote his first series of *Lives*, he had been developing a lexicon with contemporary theological and social undertones (*virtù, grazia, miracolo*) but chiefly technical and aesthetic connotations. The theology, in his rapturous disquisition on the Sistine ceiling, he took for granted: Michelangelo's embodiment of the divine in the human; the history of man's dealings with God. The artistic triumph he saw chiefly in terms of the creation of innumerable beautiful figures, nude or lightly draped; the solving of problems in perspective and foreshortening; the conveying of all varieties of profound human emotion; the brilliance of successful illusionism; the surpassing of nature.

Commenting on the architecture of the new sacristy at San Lorenzo and its tombs, Vasari seized on the novelty of Michelangelo's designs: he had made beautiful cornices, capitals, bases, doors, tabernacles and tombs, utterly different from those regulated by proportion, order and rule (*misura, ordine e regola*). Others had followed Michelangelo in departing from convention and ambiguity, but their new kinds of fantastic ornamentation (*nuove fantasie a' loro ornamenti*) had more of the grotesque than of reason or rule.

Continuing his critical, comprehensive listing of Michelangelo's artistic achievements following the first climactic adornment of the Sistine, Vasari recorded his heroic efforts to fuse sculpture with architecture in the library of San Lorenzo; the naked Christ; the seven statues for the new sacristy; the Leda in tempera painted after his flight to Venice and return to Florence; and his accomplishment of the *Judgement*, a work executed so cohesively that it seemed to have taken just a day, and whose indescribable multitude of figures, *terribilità* and *grandezza* meant that all who thought they had mastered the art of painting must follow it in chains.

After ecstatically congratulating Paul III for the good fortune he had enjoyed as patron of Michelangelo, Vasari complimented the artists of his time on having seen their own merits enhanced by someone who had solved all the problems raised by paintings, sculptures and works of architecture. Michelangelo's intelligence had been infused with the ability not only to solve the problems of art but also to compose great songs and sonnets put to music, commented on and read aloud in Italy's most celebrated academies.

Of the four figures roughed out in a single block of marble in Michelangelo's own house, Vasari wrote that if the sculptor finished it it would surpass all his other works, given the difficulty of carving so many perfect things from the stone. This work made him reflect on the religious element Michelangelo had shown in all his actions, and in his shunning as far as possible the traffic of the court, to keep company only with those who had need of him for his work or whom he was constrained to love for the virtue he saw in them.

Excusing Michelangelo's aloofness, which some attributed to eccentricity and quirkiness, Vasari said that his profession demanded this for the sake of perfection: talent sought thoughtful solitude. Michelangelo, whose labours had benefited all artists, lived honourably, Vasari added. He delighted in very fine horses, and, being born of very noble citizens, he had maintained the rank and demonstrated the wisdom of a marvellous artist.

Anxious to forestall any other criticisms he might have heard or be hearing, after mentioning that Michelangelo was now seventy-three (verging on seventy-five when the *Lives* was published) Vasari wrote that his wise and beautiful discourse had always made him known as a man of prudence. Among Michelangelo's 'most beautiful and wise' responses, Vasari included his remarking, to a friend of his who was religious and appeared in Rome in extraordinary finery, after pretending not to recognize him, 'Oh, you're beautiful; and if you looked on the inside as you do on the outside it would be good for your soul.'

After several disjointed but moving and revealing passages, Vasari brought his life of Michelangelo and the first version of his great book to a moving close:

> Let no one marvel that I have told the life story of Michelangelo, though he is still living. This is because, without waiting till he must die, I have thought it right and proper to do him this small honour so that when, like all others, he leaves his body behind, he will never experience the death of his utterly immortal works. So long as the world endures, their fame will live most gloriously for ever through the mouths of men and the pens of writers, notwithstanding envy and in despite of death.

85 Ascanio Condivi: authorized biography

In Varchi's lectures and Vasari's *Lives* we have a new Michelangelo, true to life but with some roughnesses smoothed away, set up as the exemplar of the cinquecento vision of the artist as genius.

The real-life Michelangelo acknowledged that Varchi had done him and Tommaso de' Cavalieri great honour, and that Vasari, now his special friend, had given lasting life to artists through his painting and his writing. In his preface to the third part of the *Lives*, Vasari trailed the section on Michelangelo by announcing that the divine Michelangelo was supreme in all three of the arts and had triumphed over nature, over the artists of the ancient world, and over later artists, among whom he specifically cited Leonardo da Vinci, Giorgione, Fra Bartolommeo, Raphael, Andrea del Sarto, Correggio, Parmigianino, Polidoro, Maturino, Rosso, Sebastiano, Giulio Romano and Perino del Vaga among the lately dead. Michelangelo's inspiring labours had spread their branches so wide that the world had been filled with an abundance of delectable fruits. This sort of praise may have seemed embarrassingly lavish to Michelangelo, despite his own occasionally used skills in high-flown language. But there was something else.

Vasari's biography, admiring as it was, to Michelangelo's keenly interested eye lamentably failed to emphasize how little as an artist he owed to others; it failed to put the record straight on the great matter of the time and money he had spent on the monument of Pope Julius II; it failed to highlight how long and faithfully he had served the popes. It

was only eight years since, in his long, angry letter about the protracted dealings over the tomb, Michelangelo had expostulated that he had been called a thief by those who had robbed him of his youth, his honour and his property, and that discord between him and Pope Julius had been caused by the envy of Bramante and of Raphael, who had received all his art from him.

Just over three years after Vasari published his *Lives*, a short (30,000 words or so) biography of Michelangelo appeared, in two printings. Michelangelo with satisfaction, Vasari with chagrin, read the following author's letter to readers:

> From the hour when the Lord God, by his outstanding kindness, made me worthy not just of the presence (which I could scarcely have hoped to enter) but of the love, of the conversation and of the close intimacy of Michelangelo Buonarroti, the unique sculptor and painter, from then on, conscious of such favour, and being a lover of his profession and admirer of his merit, I gave myself with all possible attention and study to observing and assembling not only the precepts he taught me about the art of design, but also his sayings, deeds and habits, with everything in his whole life that seemed to me to merit wonder, imitation or praise; and I also intended to write about it at some future time. This was as much to show him some gratitude for my infinite obligations towards him as to give others the benefit of the advice and example of this great man ... I find then that I have made two collections relating to him: one concerning his art and the other his life. And while both of these are still in part being added to and in part still being digested, circumstances have arisen that for two reasons force me to hurry forward, indeed to rush out with this material on the· life itself. First, because there have been some who in writing about this rare man, since (I believe) they have not been as familiar as I have with him, on the one hand have said things about him that never happened, and on the other have left out many of those most worthy of being recorded; and next, because some other people, to whom I handed over and entrusted these endeavours of mine, had appropriated them in a way that suggests they designed to win credit for them as their own. Hence to make up for the shortcomings of the former, and to forestall the injury by the others, I have resolved to publish my notes on his life in their present imperfect form ... I have drawn them deftly and most patiently from the living oracle himself, and finally [I affirm]

that I have checked and confirmed them with the testimony of writings and men worthy of belief.

The writer was Ascanio Condivi, a young Italian in his twenties, from Ripatransone near the Adriatic coast, north of Pescara. He had started to study in Rome, living in Michelangelo's house, during the late 1540s. After publishing his book *Vita di Michelagnolo Buonarroti raccolta per Ascanio Condivi da la Ripa Transone*, he returned home to paint an altarpiece of the *Mysteries of the Virgin* for the church of San Domenico. In 1556 he married Porzia, the daughter of Michelangelo's friend Annibale Caro. Judging by his unfinished painting of the Madonna from a cartoon by Michelangelo, Condivi had painfully little talent as a painter; but he clearly attracted, and was trusted by, Michelangelo.

There is no trace of Condivi in Michelangelo's surviving letters or written records but, though here and there inaccurate, the young apprentice painter's choice of material and tone of voice reveal warmth of feeling between them.

Unlike Vasari, Condivi referred at some length to Michelangelo's well-known love of the beauty of the human body, and the gossip about his feelings for good-looking young men, perhaps because he was one such himself. In the last few pages of his *Life*, where he reports on Michelangelo's literary talents (his reading of prose and poetry, especially Dante, and his study of the Bible and of Savonarola; his composition of sonnets), before expounding other aspects of his character and mind (frugality, generosity, memory, imagination, patience, wit), Condivi recorded that Michelangelo loved the beauty of the human body as someone who knew it thoroughly and well. 'And he loved it in such a fashion that among certain lewd men, who do not know how to understand the love of Beauty unless it is lascivious and impure, there has been occasion to think and talk evil of him: as if Alcibiades, a most handsome young man, had not been loved most chastely by Socrates.'

He had often heard Michelangelo talk about love, Condivi added protectively:

and I have heard later from those who were present that he did not speak otherwise of love than is to be found written in the works of Plato. For myself, I do not know what Plato said on the subject: I well know, having been close to him for so long and so intimately, that I have never heard his mouth utter other than the purest words, which had the power to extinguish in youth every indecent

and unbridled desire that could come along. And that he conceives no filthy thoughts can also be recognized from the fact that he has loved not only human beauty but universally every beautiful thing, a beautiful horse, a beautiful dog, a beautiful landscape, a beautiful plant, a beautiful mountain, a beautiful wood, and every place and thing beautiful and rare after its own kind, looking at them all with marvellous feeling and admiration and so selecting what is beautiful from nature, as bees gather honey from the flowers to make use of it later in their works, and as do all those who have made some name for themselves in painting.

The protective strain in Condivi's *Life* (protection against calumny and detraction, against suspicions of his sexual behaviour) also seems to have been in evidence in his omission of any mention of Michelangelo's erotic and pagan presentation drawings for Tommaso de' Cavalieri. He listed only the religious drawings done for Vittoria Colonia.

Condivi was told that, when he had been more robust, Michelangelo, who never needed much sleep, would lie down in his clothes and the boots he wore because of cramp. Sometimes when he took off his boots he had sloughed off his skin, like a snake's. Condivi described the seventy-eight-year-old Michelangelo as a sinewy, lean, old man – healthy by nature and physical exercise, as well as from his continence with regard to sexual intercourse. He found it painful to urinate, but was saved from more serious illness through the good care of his doctor.

His face has always had a good complexion; and his stature is as follows: his body is of medium height, broad across the shoulders, the rest of the body in proportion and more slender than not. The shape of the front part of his skull is rounded so that over the ears it forms a half-circle and a sixth. So his temples project somewhat beyond his ears, and his ears beyond his cheek-bones, and these beyond the rest. All this means that his head must be deemed large in proportion to the face. The forehead seen from the front is square; the nose is rather squashed, not naturally but because when he was a boy someone called Torrigiano de' Torrigiani, an arrogant bestial man, with a blow of the fist almost tore off the cartilage of his nose, and so he was carried home as if dead . . .

The lips are thin, but the lower one is somewhat thicker, and seen in profile it juts out a little bit. His chin is well matched to the features already mentioned. In profile the forehead projects beyond the nose, which is almost completely flattened save for a little bump in the middle. The eyebrows are sparse, the eyes can rather

be called small than otherwise, the colour of horn, but changeable and flecked with tiny sparks of yellow and blue; the ears are the right size; the hair is black, as is the beard, save that now that he is in his seventy-ninth year the hair is copiously flecked with grey. And the beard is forked, between four and five fingers long, and not very thick, as can in part be seen in his portrait.

The chief aim of Condivi's book, as a corrective to Vasari, was demonstrated at its very beginning. Michelangelo had been born of a noble and illustrious family. His horoscope had been splendid (Mercury with Venus having propitiously entered the house of Jupiter). He had (as he told Condivi) sucked from the breasts of a wet-nurse married to, and the daughter of, a stonemason, and so had had his constitution and disposition changed to those of a sculptor. When at grammar school he had been encouraged in his strong will and inclination towards the art of design by Francesco Granacci, who was studying with Domenico Ghirlandaio. Rather than help, Ghirlandaio had grown envious of him. 'I wanted to make mention of this, because I have been told that the son of Domenico used to attribute the divine excellence of Michelangelo in great part to the teaching of his father, who in reality gave him no assistance at all; and yet, rather than complaining about that, Michelangelo praises Domenico both for his art and his behaviour.'

Lorenzo de' Medici, Condivi explained, had been the first adult to recognize and foster Michelangelo's exceptional talent and his simplicity and goodness. After recounting the *Magnifico*'s virtual adoption of Michelangelo (taking him into his house, seating him at table above his own sons), Condivi put securely in place Michelangelo's lifelong conviction that he had been destined for sculpture:

Michelangelo set himself to do it [the *Battle of the Centaurs*] in marble, in half-relief, and the result of the enterprise was such that I remember hearing him say that, when he set eyes on it again, he realized how much wrong he had done to nature in not readily pursuing the art of sculpture, being able to judge from that work how well he could have succeeded. He did not say this to boast, being a most modest man, but because really and truly he grieved at having had the misfortune, through the fault of others, to have done nothing in that line, sometimes for ten or twelve years at a stretch, as we shall see later.

This work of his is still to be seen in his house in Florence, and the figures in it are about two palms high. Scarcely had he finished it when Lorenzo the Magnificent passed from this life.

Michelangelo returned to his father's house; and he was so grief-stricken by Lorenzo's death that for many days he could do simply nothing. But then, when he recovered himself, he bought a large piece of marble, which for many years had been lying in the wind and rain, and from this he carved a Hercules, eight feet high, which was then sent to France.

Michelangelo's gently ironic, ribbing tone of voice can often be heard informing Condivi's biography, as it did Francisco de Holanda's reports. In direct speech, he tells Condivi about the beautiful *Pietà* in Rome, of which some people had remarked reproachfully that the mother looked too young in relation to her son:

Don't you know that chaste women remain far fresher than those who are not chaste? So much more the Virgin, in whom never has the least lascivious desire ever arisen that might alter her body . . . This was not necessary in the Son; rather completely the opposite; because to show that, as he did, the Son of God took a completely human body . . . there was no need for the divine to hold back the human.

Condivi also captured Michelangelo's fury of expression in his version of the story of the tomb of Julius II. Vasari wrote that the reason for the flight from Rome in 1506 had been that one of Michelangelo's assistants had disobediently let the impatient pope come into the chapel while the work was in progress, only for him to be greeted, as he poked his head in, by Michelangelo hurling planks from the scaffolding. Condivi does not go into the actual financial reasons for the quarrel (explained by Michelangelo in the letters written in 1506 and 1542), but he gives a detailed, sustained account of what he called 'the tragedy' of the tomb. This had its genesis in the dispute of 1506, when Michelangelo had come to think his own tomb might be finished and ready before the pope's were he to stay in Rome.

Like a fugue, the theme of the tragedy of the tomb thereafter was threaded by Condivi (or Michelangelo metaphorically at his shoulder) through the rest of the story. The tragedy in retrospective was irreversible, inexhaustible. But it had not been inevitable, Condivi implied. If the tomb had been built according to the first design, this would 'have enabled Michelangelo to have taken the honours in his art (be it said without envy) above anyone ever esteemed as an artist, since he would have had such a broad field in which to show his worth'. The tomb would have been housed in the huge choir designed for Pope Nicholas

V by Bernardo Rossellino, begun, and then abandoned, as a vast extension to the old basilica of St Peter's.

Condivi's account of Michelangelo's second great expenditure of wasted time and energy on the tomb mentioned that Julius's heirs thought the first project had been too big. (In fact the new design was in important respects still more ambitious than the first.) Sharing out the desire for the tomb between Julius and Michelangelo, Condivi wrote that the pope had wished to continue to enjoy Michelangelo's services even after his death:

> So Michelangelo embarked once more on the tragedy of the tomb, and progress for him was no easier than the first time, rather far worse, for it brought him infinite troubles, sorrows and vexations. And worse, through the malice of certain men, it even brought him disgrace; and scarcely after many years did he purge himself of this.

When he came to the time when Michelangelo was offering to do both the tomb and the façade for San Lorenzo, to satisfy both a dead and a living pope, Condivi wrote innocently about the loving way Michelangelo had been working on the tomb, the resistance he had made to taking on the work at San Lorenzo, the abandonment of the tomb 'in tears'.

The 1516 contract for the tomb reflected Michelangelo's disillusionment: the number of statues was cut to twenty, for a single-bay projection from the wall. Passing this over in silence, Condivi picked up the thread again, a decade later, with comments echoing Michelangelo's bitterness and inner despair. After being called to Rome by Pope Clement:

> he started to be harassed by the agents of the duke of Urbino with regard to the tomb of Julius . . . he tried his best to stay in Rome, and to keep himself busy on the work of the tomb; and all the more because everyone alleged that he had received from Pope Julius, as was said, a good 16,000 crowns for the purpose and had lived well on that money without doing what he was under obligation to do. And being unable to bear this reproach, as a man who was tender of his honour, he would not refuse, old as he now was, the very heavy task of finishing what he had begun.

Condivi's last words on the tomb had a dying fall. When, under the final contract, the agents of the duke of Urbino had given statues out to others to be done, 'the tragedy of the tomb and the tomb itself came to

completion'. But the tomb 'just as it is, botched and rebuilt, is perhaps the most impressive to be found in Rome and perhaps anywhere else ... The whole of the tomb is altogether beautiful, and especially the way its parts are bound together by the great cornice, which cannot be faulted.'

Condivi then apologized for having perhaps written too much about the tomb. 'None the less I thought it was necessary to write it in order to extirpate the false and unfortunate opinion which had taken root in men's minds, namely that Michelangelo had received 16,000 crowns and did not wish to do what he was under obligation to do.'

Then came the reminder of Michelangelo's once greatest ambition and most intense relationship: 'never was a man more eager to apply himself to any work than he was to this; partly because he knew how much it would increase his reputation, partly because of the remembrance in which he always held the blessed soul of Pope Julius'.

Vasari wrote for the Medici and for his fellow artists; Condivi, in supplementing and correcting parts of Vasari's text, wrote to justify Michelangelo to himself and his world. Condivi, like Vasari, exalted Michelangelo's artistic genius and revealed also, from a simpler view-point, something of his techniques and theories. Michelangelo, he said, had carved 'the Giant in Florence so exactly from the block that the old rough surface of the marble still appeared on the crown of the head and the base; he had praised Donatello except that he did not have the patience to polish his works, which were successful only seen from afar; all painters had drawn enlightenment from Michelangelo's marvellous cartoon for the Hall of the Great Council in Florence; the Sistine ceiling frescoes were the wonder and admiration of the world, placing his reputation beyond envy with the loveliness of the different compart-ments, the diversity of the different attitudes and the contrasts of the different planes; his fortifications had saved Florence; his statues of Night and Day (signifying Time, which consumed everything) and of the Madonna, for San Lorenzo, were divine rather than human; his Moses for the tomb was a marvellous work, full of art, and especially since under beautiful garments he seemed completely nude and so, as was universal in his painting and sculpture, clothing did not destroy the sight of the beauty of the body; in the Last Judgement he expressed all that the art of painting could make of the human body, leaving out not one single attitude or movement; and in the Pauline Chapel, the paintings of the conversion of St Paul and the crucifixion of St Peter

were both stupendous, whether for the whole in general or for each particular figure.'

86 Friends in high places

Every so often in the text of his *Life*, Condivi makes Michelangelo himself visible and palpable to the reader: early on, when we are asked to see him, after he had been painting the Sistine ceiling for a long time with his eyes raised towards the vault, having to read a letter or look at other small things with outstretched arms above his head; many years later, when we watch him bending to kiss the hand of the dead Vittoria Colonna; or when he is with the young Condivi himself, in Sant'Agata where Condivi lived, teaching him anatomy through the dissection of the corpse of a handsome young Moor, sent by the surgeon Realdo Colombo.

Condivi testified to Michelangelo's range of friends in Rome, where he had often when young come close to cutting himself off from the fellowship of men for the sake of work and meditation. In the circle of the Curia, and ranked by Condivi among his master's friends, Annibale Caro was a man Michelangelo would like to have known earlier in life, as he was 'much to his taste'. Caro enjoyed writing facetious, vulgar verse and satire as well as elevated poetry: on the one hand a *Diceria de' nasi*, or discourse on noses; on the other a magnificent blank-verse translation of Virgil's *Aeneid*.

Other ecclesiastics listed as friends of Michelangelo were Cardinal Reginald Pole (whom Michelangelo revered for 'his rare talents and singular goodness', Condivi wrote) and Claudio Tolomei, the learned bishop of Corsola, founder of an Academy of Vitruvius, and close to the establishment of Cardinal Farnese.

Of the Florentines exiled in Rome, Condivi mentioned Cardinal Niccolò Ridolfi and Donato Giannotti. The 'open and generous nature' of Cristoforo Spiriti, patriarch of Jerusalem since 1550, as well as his services as the guardian of Michelangelo's interests at St Peter's had won him Michelangelo's affection. And naturally among the other 'esteemed gentlemen' whom Condivi named without comment, so as not to be too prolix, was Tommaso de' Cavalieri.

Condivi, like Vasari in his 1550 *Lives*, made no mention of Luigi del

Riccio among Michelangelo's friends; and in several instances the names he did produce were surely chosen for reasons of prudence as well as for their social importance. In 1551–2 the surge of reform within the Catholic Church was strengthening throughout Italy as sessions of the reconvened Council were held in Trent. Among the cardinals and influential members of the Curia mentioned by Condivi, Cardinal Pole and the erudite, austere and very influential Marcello Cervini, cardinal of Santa Croce, both served on the Roman Inquisition. Cardinal Bernardino Maffei (who died in 1553), as well as serving Cardinal Alessandro Farnese, had been active on reform commissions for the Roman University and the Council.

In the concluding pages of the *Life* Condivi made a special mention of Raphael as someone who, 'however much he wished to compete with Michelangelo, many times had to confess that he thanked God he was born in his time; for he had derived from him a style different from the one he had learned from his father, who was a painter, and from his master, Perugino.' Scarcely any other artists were mentioned by name (none in the list of eminent friends).

Despite Condivi's disparaging allusion to him, Michelangelo's relations with Vasari remained amicable and fruitful. In 1550 he and Michelangelo made the round of the seven churches of Rome to gain the Holy Year's special indulgence, a remission of the punishment due for sin. Because of Michelangelo's age, the new pope (Julius III, elected in February 1550, of the del Monte family) graciously let them ride on horseback instead of walking.

Just before their visit to the churches, Vasari later remembered, Michelangelo had been mollified by him about the behaviour years before of Bartolommeo Ammanati and Nanni di Baccio Bigio, who had filched some of Michelangelo's drawings from Antonio Mini and then been let off lightly by the magistrates in Florence after returning them. Vasari turned the matter into a jest, and Michelangelo gave approval to Ammanati's working with Vasari for the new pope (on tombs in the family chapel in San Pietro in Montorio). Vasari's attitude towards Michelangelo grew more relaxed, but was always mixed with awe; Michelangelo's towards Vasari was always tinged with amusement.

Condivi seems to have dropped out of Michelangelo's life soon after his biography was published, as if he had served his purpose. Of his work, in which he strove scrupulously to copy Michelangelo's secrets, as he saw them, the only two known items, apart from the altarpiece at Ripatransone, were the painting of the Madonna after Michelangelo's design

and a bronze bust of Sulla, commissioned by Niccolò Ridolfi, which has now disappeared.

87 The glory of St Peter's •
Pope Julius, the Council, the dome

Michelangelo had served Pope Paul III during the whole of his fifteen-year pontificate. The pontificates of the following four popes, including one twenty-two-day reign, lasted another fifteen years, and Michelangelo nearly outlived them too.

Michelangelo's mind was absorbed increasingly by architectural problems relating to St Peter's, which had become for him the symbol of his preoccupation with approaching death and the tension between his art and his redemption. Contemplation and action were reconciled in the creation of designs for the great basilica. The likely timetable stretched over centuries rather than decades, and the imperative for Michelangelo was to make enough progress to block changes after his death. The frame for the crowning glory of this work, the cupola, was boundless – the sky itself. Michelangelo's unrivalled artistic eminence and spiritual hunger, rather than any material need or particular affection, kept him in the service of the popes. He was constantly troubled by pressure to return to Florence and by apprehension of physical danger.

Other worries continued to plague Michelangelo as he was moving into his eighties. As late as 1553, after Condivi's *Life* had been published, Annibale Caro was writing to the duke of Urbino's secretary to say that Michelangelo was so anguished at being in disfavour with His Excellency that this alone might cause him to be buried before his time. If the duke pardoned him, it would prolong the life of this 'singular man' and make him the duke's for ever. Nearer to home, the hostile group at St Peter's had never been routed; they continued to work together, sharing economic aims and artistic values. They also had the backing of influential people in Rome, such as Cardinal Salviati, Bishop Baldo Ferratini (who had been appointed as one of Michelangelo's protectors), the architect Pirro Ligorio (who started a rumour that Michelangelo was in his second childhood), and the irritating Nanni di Baccio Bigio.

Michelangelo and, in some respects, the Catholic Church were fortunate

with the first of the popes following Paul III. Giovanni Maria del Monte, Julius III, born in 1487, chose his new name in gratitude to Pope Julius II, who had honoured his family. Del Monte had studied law and was made a cardinal by Paul III (among the impressive batch including Gianpietro Caraffa and Reginald Pole) as part of the programme to weaken Medicean influence and reform the Church.

The papal election took an exceptionally long time. The struggle was intense between the Imperial and the French factions among the cardinals, lodged for over two months in 1549–50 behind ceremoniously bolted doors in six great halls of the Vatican, including the Sistine and Pauline Chapels, now both transformed by Michelangelo's hand. The Englishman Cardinal Pole was nearly elected. At one stage of the conclave he fell short of success by only one vote. He was too foreign, too young (at forty-nine), too soft on Protestantism, suggested the Italian cardinals. Del Monte was put forward as a compromise candidate to end the deadlock.

Pope Julius was a big, ugly, greedy man, inordinately fond of onions and prone to moodiness. He liked hunting and gambling and spectacles, and Plautus's gamy plays. Unlike Pope Paul, he had risen from the ranks, and he liked to be liked. His devotion to Michelangelo was demonstrated immediately after his election, before all the cardinals still in Rome, when he defended him and offered to protect him against his enemies, the overseers of the fabric of St Peter's. Michelangelo wrote to Fattucci that the whole of Rome had rejoiced at the result of the election, and nothing but the greatest good was expected to come of it – 'especially for the poor, because of his liberality'.

The pope had no sons or daughters of his own to care for, but he did have one notorious male favourite whom he had picked up when he was legate in Piacenza. Del Monte had been impressed by his brave attitude when the legate's pet monkey seized hold of the boy, and he was taken on as the animal's keeper. Del Monte grew to love him, and persuaded his brother to adopt him, with the name of Innocenzo del Monte. After becoming pope, the infatuated del Monte made Innocenzo a cardinal (at a secret consistory of 30 May 1550). Innocenzo's hold on Julius was interpreted as showing that he was really the pope's son or, less charitably, the pope's *pivo* or boy-lover.

In one of the poems he wrote in Rome during the 1550s, while he was in the household of Cardinal Jean du Bellay, the French poet Joachim du Bellay said that the true miracles of Rome were to see a child, a dolt, a braggart, a coward and a flunky made a cardinal for having groomed a monkey; to see this Ganymede given a red hat; and

to hear called 'Holy Father' someone who'd once been displayed high on a scaffold, with a halter round his neck, by a Spanish soldier.

Assisted by competent secretaries, Julius began his pontificate with vigorous involvement in the business of the day. His aims, stated at his first consistory in February 1550, were to strive for the reform of the Church and the peace of Christendom. In almost every area of policy he only too soon ran out of will-power and money, and he increasingly often retreated to his villa outside the Porta del Popolo.

Julius's first important policy decision was to surrender Parma to Ottavio Farnese, on whose behalf the emperor had claimed Parma and Piacenza from Pope Paul III. By the summer of 1551 papal and Imperial troops were fighting against the forces of Farnese and France inside the Papal States.

The Peace of Crépy between the Empire and France was thus effectively broken, and French forces moved against Milan from Piedmont. Once again, as Machiavelli had written in the *Discorsi*, the Church could neither dominate Italy nor allow any other power to do so; and therefore Italy, disunited, was the prey of anyone who attacked it. Julius made peace with the French, and the emperor (distracted by revolt in Germany) followed on. Thereafter, Pope Julius determined to stay neutral between the Imperialists and the French, and to prove himself a peacemaker. But the French, having been conspiring with the Turks against the emperor, aggressively supported the Sienese in their revolt against a Spanish garrison. In August 1552 Rome was full of rumours of an imminent attack by Spanish troops and another sack. 'Peace and good times reign here no more,' du Bellay was soon writing in one of his sonnets. 'Only soldiers are to be seen, and helmets; and Rome waits daily only for another sack.'

Early the following year, Spanish troops moved north from Naples through the Papal States, and Spanish galleys sailed to Livorno. Julius's efforts to make peace continued to be frustrated partly by the mutual hatred of Henri II and Charles V, and by the sapping of his own energies through gout.

In January 1551 the pope's printed bull reconvening the Council of Trent had been sent to all Catholic bishops throughout the world. On 1 May 1551 the eleventh session of the Council was held for the bull to be read and for other formalities.

The German elector Maurice of Saxony, whose representatives were in Trent and whose theologians were thought to be on the way,

suddenly – with other rebel rulers – began to fight against the emperor in Germany, in collaboration with the French. With all Germany reported to be in turmoil and all Rome terrified, the Council was suspended at its sixteenth session on 12 April 1552.

The Council had thus far failed to reconcile Lutherans to the Catholic Church or to persuade Catholic rulers to unite against the Turk as envisaged in its original bull of convocation. But, despite its dismal interruption and flawed composition, by the end of the 1551–2 sessions it had moved far to stamp a new certitude and uniformity on Roman Catholic beliefs, had issued guidelines for reforming bishops and priests, and had begun to energize the Italian churches with a sense of common mission and to make their territories dangerous for recalcitrant Catholics as well as heretical Protestants. At the centre of the Church, the pope had within two years prepared a comprehensive bull of reform covering his own office and the role of the cardinals, the bishops and the clergy, the teaching of the Bible, and the nature of indulgences.

The Council, when dispersed, had not yet turned its attention to the subject of the cult of the saints, of relics and images, but its calls for reform were already being heeded in this context, in great part in response to Protestant iconoclasm, to which the Roman reaction was the affirmation of art, the avoidance of scandal.

In the war against Protestantism, Julius's other momentous decision was to open the way in the Church for Jesuits. In July 1550 he confirmed the constitution of the new order of the Society of Jesus; the Counter-Reformation now had its intellectual shock troops, its crack regiment, its intelligence corps in place.

Pope Julius pursued his policies by fits and starts. Pope Paul's schemes for roads and fortifications were only desultorily continued. Rome under Julius presented an image of broken-down antiquity, modern opulence and repressed energy.

Pope Julius's Rome was described by du Bellay, pining for the air of Anjou, as a city of marble and of idleness, a messy heap of all the world's good and evil, like Chaos. If he goes to the Vatican, he finds pride, hidden vice and ceremony – the noise of drums, a strange harmony, a show of scarlet apparel. If he goes to the district of the banks, he finds the latest news and infinite usury, lamenting Sienese, and rich exiled Florentines. Everywhere he finds prostitutes. Entering old Rome from new Rome, he finds just a great heap of stones. Rome is packed with priests, prelates, and monks, with bankers and artisans, he

exclaims; but one does not see, as in Paris, any honest women strolling about, so here it seems as if God has created only half of humanity.

Du Bellay's picture was one-sided, however: in Holy Year the poor and the sick among the many thousands of pilgrims to Rome were looked after by the Confraternity of the Most Holy Trinity recently founded by the Florentine layman Philip Neri. Encouraged by Pope Julius, members of the new orders and societies worked in scores of little churches in Rome to help the poor practically as well as to preach to them. Julius's Rome was a spiritual watershed.

For his costly construction programme, Julius employed chiefly Giacomo Barozzi da Vignola, much favoured by the Farnese family, an industrious, systematic, if not very imaginative architect who had studied the ancient buildings of Rome and had worked in France, where his ideas were influenced by his fellow Bolognese, Sebastiano Serlio. Vasari, Ammanati, the visiting Andrea Palladio and Michelangelo played varying parts in the conception and building of the pope's villa, the Villa Guilia, in emulation of Julius's II's Belvedere. Vasari found working with the pope (through one of Michelangelo's *bêtes noires*, the busybody Bishop Pier Giovanni Alliotti) exhausting and frustrating. For some reason, Julius preferred Vignola's approach. Vasari preferred to carry on doing work for Bindo Altoviti in Rome and to accept painting commissions in Florence.

Pope Julius's greatest service to music was through his special patronage of Giovanni Pierluigi from Palestrina. The pope had been bishop of Palestrina, a lovely town in the Sabine Hills, and in 1551 he called the choirmaster of the cathedral there to Rome. Though Palestrina was married, and should not have been eligible, Julius made him director of the Cappella Giulia of St Peter's when he was still under thirty.

In Michelangelo's dealings with Julius immediately after the papal election, the atmosphere of mutual easy-going familiarity suited them both. Having asked Michelangelo's advice about the tombs he wanted for his uncle and grandfather at San Pietro in Montorio, and having had all the designs allocated to Vasari and Ammanati, Julius started to modify his plans. After discussion, the pope said he was thinking of putting the tombs in the church of the Florentines, San Giovanni dei Fiorentini in Via Giulia. Michelangelo encouraged the pope to do this, he wrote to Vasari: it would mean the church had to be finished. (It had been begun by Rome's Florentine community during Leo X's reign, but financial problems and political changes hindered its completion.)

In October 1550 Michelangelo had some more news for Vasari about the tombs. Michelangelo had been told by the pope that he wanted to have the tombs' foundation laid at Montorio after all, and so had supplied a mason from St Peter's:

> *Tantecose* [Busybody – Bishop Alliotti] heard this, and wanted to send his own choice. So, not wanting to fight against someone who sets the winds in motion, I backed away, for as I'm a lightweight man I would not want to be transported to some thicket. Enough that it seems to me there's no need to consider the church of the Florentines any further.

The tone of these letters (counterpointed by letters to his nephew in Florence about property, money and marriage, and gifts of wine, shirts and cheeses) marks a sudden transition in the pitch of Michelangelo's emotions, from the tormented desperation of the last few years of Paul III to the more serene mood engendered by the affectionate attitude and more lightly imposed demands of Julius III. Michelangelo had painted prodigiously for Pope Paul. Julius, out of consideration and common sense, gave him supervisory tasks, commensurate with his status, experience and resources of energy. Less burdensome, all the same these brought their own enormous intellectual and emotional challenges.

Julius's fondness for painting, sculpture and architecture, Condivi wrote, could be clearly recognized from the works he had commissioned for the palace and the Belvedere and was presently having made for the Villa Giulia, a marvellous monument.

> The pope has not pressed Michelangelo to work for him on this, out of respect for the age he has reached. He well recognizes and relishes his greatness, but he refrains from burdening him with more than he wishes to do. And this respect, in my judgement, enhances Michelangelo's reputation more than any of the work all the other pontiffs employed him to do. But certainly, as regards the works of painting and sculpture that His Holiness commissions, he almost always seeks Michelangelo's opinion and judgement, very often sending the masters of these crafts to find him in his own home.

Condivi mentioned that Michelangelo had made for the pope the design for an unidentified palace in Rome, and he designed a new stairway for the Belvedere to replace Bramante's. Where Julius was absolutely insistent on the involvement of Michelangelo was in supervis-

ing the work at the new St Peter's. This was ordered against continuing opposition from all those clerics, craftsmen and contractors with vested interests in the fabric likely to be disregarded by Michelangelo, or who really did think he was too old: all those of the Sangallo faction.

When he had taken on the supervision of the work at St Peter's, Michelangelo resolved to refuse payment. The gesture – a substantial one – was doubly meaningful: it demonstrated his distance from the Sangallo faction in terms of incorruptibility and independence; it was a fitting outward sign of his own inner spiritual resolution to move closer in faith and love to God. It was renunciation and dedication. It paradoxically kept him bound to and burdened by art just as he was coming broodingly to confide in his poetry that all his art was straw.

Michelangelo kept his distance from the site itself, but never from the work in its every detail. Soon after his appointment he was writing to the overseers to complain about the poor quality of a delivery of lime and warning about collusion between suppliers and people taking delivery – an offence that could implicate him.

Pope Julius moved abruptly to protect Michelangelo against the murmurings and abuse which erupted at a meeting early in 1551. The critics had found Michelangelo's vulnerable point, they thought. The hemicycle at the end of the southern arm of the new basilica, called the Cappella del Re di Francia (Chapel of the King of France), would not have enough light if Michelangelo's ideas were followed. Cardinals Salviati and Cervini came to share these doubts. As Vasari recalled the information he was given, presumably by Michelangelo, the essential elements of Michelangelo's new position at the papal court were encapsulated in the dramatic confrontation when Michelangelo proclaimed that the vault would have three windows more than his enemies said.

Michelangelo had never mentioned the other three windows, Cardinal Cervini complained:

Then Michelangelo declared, 'I'm not and I don't intend to be obliged to discuss with Your Eminence or anyone else what I ought or intend to do. Your duty is to collect the money and guard it against thieves, and you must leave the task of designing the building to me.'

Then he turned to the pope and added, 'Holy Father, you know what my earnings are from their enterprise, and you know that unless my labours bring me spiritual satisfaction I am wasting all my time and work.'

The pope, who loved him, put his hand on Michelangelo's

shoulder and said, 'Both your body and your soul will profit, never fear.'

The deputies Michelangelo had annoyed wrote to Pope Julius elaborating their misgivings about his wilfulness and his secrecy, but the protests succeeded in augmenting rather than diminishing his authority.

On 23 January 1552 Pope Julius issued a brief which authenticated the content of Pope Paul's brief of 1547. Michelangelo's design (a wooden scale model, following the first quickly finished clay model) must be respected. By now, one arm of St Peter's had been completed and another partly finished. Thereafter, Michelangelo's ideas for St Peter's were constantly modified but as the building slowly, fitfully proceeded, Michelangelo imposed his own vision on the plans by drastically reducing and simplifying Sangallo's design.

Michelangelo's changes to the existing plan for St Peter's, like Bramante's original design, left successors limited room for alteration. His greatest contributions to the final form of the basilica were his conception of a unified, cross-and-square interior and, in contrast to Bramante's design for a stepped hemispherical dome, a slowly realized plan for a dome with strongly accented ribs.

From the beginning of his official involvement, Michelangelo had pondered the crowning structure, the dome of the basilica. In a letter to Lionardo in the summer of 1547 otherwise about property, he wrote a postscript asking his nephew to find out through Giovan Francesco Fattucci the height of the cupola of Santa Maria del Fiore from the bottom of the lantern to the ground, and also the overall height of the lantern. One of the main intended gains of his modification of Bramante's squared central plan – the reduction in size of the main façade and a portico at a corner of the square – was greater stability and support for a tremendous dome. Early in 1552 a special celebration marked the completion of the cornice as the base for the drum and the cupola of St Peter's.

As always, Michelangelo kept his own secret, creative self apart and unknown. Intensely personal things to do with his art – such as his preparatory sketches and cartoons, which he almost invariably destroyed – he jealously shielded from family and friends.

Vasari remembered vividly the time he intruded by accident into Michelangelo's secret world, early one night in Rome during the reign of Julius III. The pope had sent Vasari to Michelangelo's house to fetch a design and, recognizing his knock, Michelangelo came to the

door with a lamp in his hand. While Urbino was upstairs looking for the drawing, Vasari caught sight of the leg of Christ of the *Pietà* on which Michelangelo was then working, and started to look more closely. Immediately, Michelangelo let the lamp drop from his hand and they were left in darkness. Calling Urbino to fetch a light, Michelangelo came out from the enclosure where he had been working and said, 'I am so old that death often tugs my cloak for me to go with him. One day my body will fall just like that lamp, and my light will be put out.'

Spending on the building of St Peter's in 1552 stopped for a while before being resumed only meanly, because of the expenses of the war over Parma. Michelangelo was absorbed by his ever-intense family concerns and by his brooding on death and the quickening of time. But nothing diverted him from St Peter's. In the autumn of 1554 he sent a letter to Vasari, accompanied by a beautiful sad sonnet (*'Giunto è già 'l corso della vita mia'*), explaining that he could not return to Florence as this would mean the ruin of the fabric of St Peter's and be a great disgrace and even a great sin; that things would be different when the structure had completely taken shape, so that it could not be changed.

Partial construction of the drum for St Peter's began in 1555. In March, Pope Julius III died. The new pope, Marcellus II, was Marcello Cervini – bishop of Nicastro, Reggio Emilia and Gubbio, cardinal priest of Santa Croce, Roman inquisitor, co-president of the Council of Trent, reorganizer of the Vatican library, half-heeded conscience of the del Monte pontiff. He was fifty-four and no friend of Michelangelo, who let it be known that, as he was being harassed again over St Peter's, he would, after all, leave Rome.

As recently as the winter of 1552, Michelangelo had told Lionardo that he should look for an impressive house in a good position, because if he happened to return to Florence he would want somewhere to live, and also he wanted to find somewhere to put the little capital he had and live unburdened with it in Rome.

88 A wife for Lionardo •
New life and death in Florence and Rome

Not long before Pope Julius died, Duke Cosimo had sent Tribolo to persuade Michelangelo to return at last to Florence and finish the sacristy of San Lorenzo. Michelangelo had said the work would be too much for him and he was too old. Nor, when entreated, could he remember the details of the stairway as he had envisaged it for the San Lorenzo library.

Commanded by Cosimo, Vasari also wrote about the stairway. Michelangelo replied:

Giorgio, my dear friend,

Concerning the stairway for the library that I've been asked about so much, believe me if I could remember how I planned it I would not need to be asked. A certain staircase comes to my mind just like a dream, but I don't think it can be the same as the one I had in mind originally since it seems so awkward. However, I'll describe it for you: first, it is as if you took a number of oval boxes, each about a span deep but not of the same length or width, and placed the largest down on the paving further from or nearer to the wall with the door, depending on the gradient wanted for the stairs. Then it is as if you placed another box on top of the first, smaller than the first and leaving all round enough space for the foot to ascend; and so on, diminishing and drawing back the steps towards the door, always with enough space to climb; and the last step should be the same size as the opening of the door. And this oval stairway should have two wings, one on either side, following the centre steps but straight instead of oval. The central flight from the beginning of the stairs to halfway up should be reserved for the master. The ends of the two wings should face the walls and, with the entire staircase, come about three spans from the wall, leaving the lower part of each wall of the anteroom completely unobstructed. I am writing nonsense, but I know you will find something here to your purpose.

The death of Pope Julius gave Cosimo another opportunity to put the greatest star back in the Tuscan firmament of painters, sculptors and architects, Vasari, Pontormo, Pierino da Vinci, Bronzino, Band-

inelli and Cellini among them. All he would want from Michelangelo, the duke explained, would be occasional advice and plans for his buildings; Michelangelo would receive all he wanted, without needing to do any work himself.

Towards his own family in Florence – and this meant primarily Lionardo – Michelangelo was now feeling more benign. Aged almost thirty-three when Pope Julius died, Lionardo was living comfortably and cautiously the life of a devout Florentine, a sensible citizen, and now a family man.

In 1548, after careful consideration, Lionardo had formed a company in the wool trade with Matteo Quercetani, and had sent the articles to Michelangelo, who wrote that he need not have bothered, as they meant nothing to him. Increasingly, Michelangelo had come to encourage Lionardo to pursue financial dealings, telling him after Giovansimone's death in 1548 to do as he thought best with various properties, including a house Michelangelo had helped him buy.

Michelangelo had been able to confide in Lionardo during his terrifying painful attack of the stone in 1549, when he had been unable to urinate and could not sleep day or night. He had a good doctor (Realdo Colombo), Michelangelo told Lionardo, but he believed in prayer more than medicine. All the same, water from the springs of Viterbo was what he now used for drinking and cooking.

In letter after letter Michelangelo gave Lionardo genial avuncular, or rather paternal, advice that often illuminated in a colloquial phrase the essence of his own independent disposition; never dance to anyone else's tune unless you really want to, he wrote at the end of a letter about finding a wife.

Michelangelo kept insisting that Lionardo should marry someone of good family – not necessarily a rich girl and not a girl with airs and graces. In case Lionardo himself might take on airs and graces, he felt the need to remind him every so often of the wretched state the family had been in before he began to help them. In February 1552 Michelangelo warned his nephew that he was thinking of making a will leaving his all to him and Gismondo, and if Lionardo had no legitimate heir everything would then go to St Martin's, a charitable organization for the poor who were ashamed to beg.

At last, after several false starts, Lionardo (who, unlike his uncle, had been on the lookout for a good dowry), with the help of his brother-in-law Michele Guicciardini, began marriage negotiations with the Ridolfi family, and after a hiccup (probably over the dowry) and another snort

of exasperation from Rome ('this matter has gone on so long, that it's tired me out . . . I've attended to the affairs of all of you for sixty years; now I'm old and must think of my own concerns') Lionardo married the well-born Cassandra Ridolfi.

Michelangelo behaved dutifully and charmingly. Lionardo received the dowry of 1,500 ducats in May, and wrote to tell Michelangelo he had taken his bride home. Michelangelo had offered to have the dowry secured on his property. In October 1553, the year of Condivi's book, Michelangelo learned that Cassandra was pregnant. Surviving letters from the period October 1553 to April 1554 are brief and rather tongue-tied, as all Michelangelo's intense family feelings were aroused in this fresh dimension of pregnancy and childbirth.

> [March 1554] I had one of your letters last week in which you write of your continuing happiness with Cassandra: for which we have to thank God, especially as this is rare. Thank her and remember me to her; and if anything here should please her at all, let me know. As for giving a name to the child you expect, it seems to me you should call him after your father, and if it is female our mother, that's to say Buonarroto or Francesca.
>
> [21 April 1554] I learn from your letter that Cassandra has given birth to a fine son and that she is well, and that you are naming him Buonarroto. All this has given me the greatest joy. God be thanked; and may He make him good, so that he may honour and maintain our family.

Buonarroto was born to Lionardo and Cassandra on 14 April 1554. Vasari wrote to Michelangelo soon after. Michelangelo, in a sombre response to Vasari's letter, said Lionardo's celebrations over the birth of 'another Buonarroto' – including the feasting – displeased him, because man should not laugh when all the world was weeping. '. . . it seems to me that Lionardo does not have much judgement and especially in celebrating so much the birth of someone with the joy that should be reserved for the death of someone who had lived well.'

One reason for the world to weep, to Michelangelo's mind, was the appalling ferocity of the fighting that had broken out again at the beginning of 1554 between Florence and Siena.

Early in 1555 Michelangelo was happy to hear that the new baby expected by Cassandra would be called Michelangelo, if a boy. But the baby Michelangelo died. Michelangelo wrote tersely that as much as he had rejoiced he now suffered, but much more. (And this suffering was repeated as successive children were born and, mostly, failed to survive.)

There was worse to come. Julius III died on 23 March 1555; at the other end of the year, on 13 November, Michelangelo's brother Gismondo died at Settignano after a few months' illness. Michelangelo wrote to Lionardo about his great sorrow, but said they must be resigned and thank God, since Gismondo had died fully conscious and with all the ordained sacraments of the Church. He was more disturbed by Urbino's continuing illness, which had begun several months earlier. He confessed to Lionardo that he was as upset as he would be if Urbino were his son, because he had been with him very loyally for twenty-five years 'and because I am old, I do not have time to make another to suit me'. Urbino, of all Michelangelo's many simple friends providing loyal, uncompetitive company, had grown by far the closest to him.

Urbino died on 3 December 1555, leaving Michelangelo, as Lionardo was told, 'so afflicted and distressed that it would have been sweeter for me to have died with him, for the love I bore him: he deserved no less; for he was a splendid man, full of faith and loyalty; and thus I feel I have been left lifeless through his death, and I cannot find peace'. The hurt was still raw a month or so later. He informed Vasari on 23 February 1556 that he felt scarcely able to write, but would try to answer his letter.

You know that Urbino has died: through whom God has granted me that greatest favour, but now grave loss and infinite grief. The favour has been that, whereas in living he kept me alive, in dying he has taught me how to die, not unhappily but with a desire for death. I had him with me for twenty-six years, and I found him most loyal and faithful; and now, after I have made him rich and expected him to be the support and comfort of my old age, he has been taken from me; and I have no hope left other than to see him in paradise. And of this God has given me a sign through the very cheerful death that he made; indeed far more than from dying his grief sprang from leaving me still living in this treacherous world; although the greater part of me has gone with him, and I am left with just unending wretchedness.

Michelangelo had nursed Urbino during his illness. He continued to care for his family, whose financial security was guaranteed. Urbino's will made Michelangelo his executor. Urbino's spirited widow, Cornelia – they had married in 1551 – returned to her family in Castel Durante, with her two sons, the first of whom, called Michelangelo, had been held by Michelangelo at his baptism. Michelangelo, after the terms of

Urbino's will, invested 660 crowns in the Monte of Florence on behalf of the heirs. He continued to be involved in the management of Urbino's estate, even after Cornelia's second marriage in 1559, and to feel concern for her and the 'poor little orphans'.

Michelangelo kept in touch with his niece Francesca through Lionardo. He once called her a companion in tribulation, and another time a companion in affliction; better people suffered more, he said, echoing a line from one of his own poems on Dante. Francesca, a sad woman, often ill, more genuinely fond of Michelangelo than was Lionardo, had four children between 1538 and 1545; the last, the second son, died in infancy. Michelangelo developed a high regard and liking for Francesca's husband, Michele Guicciardini.

After the death of Julius III in 1555, not just immediately but for many years, Michelangelo's relations in Florence lived in the expectation that he would one day return. Michelangelo drew gradually closer to Lionardo and to Vasari for practical business and emotional support respectively. Following the death of Urbino his health faltered again, and the old age about which he had been talking and writing for decades year by year now threatened to wear down his independence.

Lionardo never failed to send his uncle food to eat and wine to drink, or sometimes clothes to wear; Michelangelo kept him busy on their shared financial concerns. As well as the regular pack-loads of Trebbiano, Lionardo sent his uncle all kinds of provisions, and at one time offered to find him servants. (Refusing these, Michelangelo said in 1557 that he had two good *garzoni*, who served him well enough.) The gifts included sausages and cheeses, different varieties of peas and beans (for Lent, from whose fasting and abstinence Michelangelo, however, could excuse himself in old age), shirts and cloth.

Michelangelo relied on Lionardo to carry on the male line (tenuously secure after Buonarroto's birth in 1554), and to look after investments and transact other business important to him in Florence. The batch of contracts (with a treasured letter from Count Alessandro da Canossa) which Michelangelo sent to Florence in 1548 were kept safe and accessible. Lionardo passed on some of his uncle's letters to people in Florence, and did some of his frequent alms-giving for him (and earned a rebuke for sending receipts in 1556, which upset Michelangelo 'as it seems you think I do not trust you').

Over several years from 1550, Lionardo wanted to buy a farm adjoining the Buonarroto land at Settignano, owned by Giannozzo di Gherardo da Cepperello, and encumbered with a woman as life-tenant.

Cepperello urged the purchase on Michelangelo in Rome. In the spring of 1555 Michelangelo wrote telling Lionardo that the woman with a life interest in the farm had died. 'If he wants to let it go at a fair price with good security, take it and let me know, and I shall send the money.' Michelangelo told Lionardo he could spend money on the farm, and more besides on other property.

But some time later, instead of taking Michelangelo's advice and pretending that his uncle did not want the farm (so that they should be begged to buy it), Lionardo rushed to the brokers in Florence and promised to pay at least fifty gold crowns more than Michelangelo thought it was worth, and arranged for the contract. Michelangelo found himself hassled by Lionardo into sending 650 gold crowns to Florence, and he did this angrily as soon as he could. Then he tore into Lionardo for acting so rashly and wasting money: 'Remember your father, and the death he made.'

In that summer of 1556, Michelangelo was under great strain, but his irritability with Lionardo was habitual: on the one hand, he had intense family feeling but no great respect for his nephew; on the other, he sensed and resented the growth of his own dependency. The fury these conflicting emotions provoked became liable to erupt at any time. During a bitter dispute with Lionardo when he was eighty-eight, he told his nephew to get on with his own life and not worry about his, Michelangelo's, business, because he knew how to look after himself in need, and he was not a child: '*e non sono un putto*'.

89 Archbishop Beccadelli and the sonnets of renunciation

From 1550 Michelangelo was adjusting to the different tempo of his professional life under Pope Julius III and living with the continuing hostility of the Sangallo faction to his supervision at St Peter's. He was working on his own *Pietà* at home.

In September 1554 Michelangelo sent the final version of his sonnet of resignation and renunciation (first drafted in 1552) to Giorgio Vasari in Florence. The sonnet's first quatrain introduced the image of a frail boat reaching harbour from a stormy sea:

Giunto è già 'l corso della vita mia,
con tempestoso mar, per fragil barca
al commun porto, ov'a render si varca
conto e ragion d'ogni opra trista e pia.

The voyage of my life at last has reached,
across tempestuous sea, in fragile boat
the common port all must pass through to give
cause and account of every evil, every pious deed.

'I now well know', the poem went on, 'how laden with error was the impassioned fantasy that made [my] art both idol and monarch, like the things every man desires despite himself. Now what will become of my thoughts of love, once so vain and gladsome, if I am nearing two kinds of death? One is sure, and the other threatens me. Neither painting nor sculpture any more can quieten my soul, turned to the divine love that, taking hold of us, opened his arms on the Cross.'

The poem put in a fresh theological context Michelangelo's long-established fascination with death. It marked a new stage in his spiritual life with the acknowledgement that, as he approached certain bodily death and the threat of the death of the spirit, his two forms of love, for men and for his art, must be displaced by love received from an active Christ on the Cross.

Another sad but serene sonnet of renunciation was inspired by interests and experiences Michelangelo had come to share with a clever, cultivated and enormously experienced cleric, twenty-five years younger than himself. Ludovico Beccadelli had studied in Bologna and then – veering in his interests from law to literature and the classical world – in Florence and Padua. He had moved in the erudite circles of Giovanni della Casa and Bembo, served Cardinal Contarini and Cardinal Pole as secretary, been sympathetic to Vittoria Colonna and her friends, and recently represented Julius III as nuncio in Venice (from 1550–54) and then as vicar-general and a prefect of the office of works of St Peter's. For love of Petrarch, Beccadelli had made a pilgrimage to the Vaucluse and had written Petrarch's life. But the determining influence in his life had come from contacts with reformist Catholics in the Veneto, in the early 1530s. Following the brief pontificate of Marcellus II and the election of Paul IV, no friend now of him or his friends, Beccadelli began to exchange sonnets with Michelangelo.

Michelangelo's austere sonnet beginning '*Le favole del mondo m'hanno tolto/il tempo dato a contemplare Iddio*' went first to Beccadelli, then (with another sonnet) to Vasari, to pass on to Fattucci. In it Michelangelo

asked God's help to make him hate what the world values, with all the beautiful things he had honoured and adored, so that he can secure immortal life before death.

Michelangelo's late religious poems, which he was so anxious to put in the hands of close and learned friends such as Vasari, Fattucci and Beccadelli, were intensely confessional and uninhibitedly autobiographical. They elicited responses in kind from his correspondents, creating a poetic counterpart to the spiritual conversations that had centred a decade previously on Vittoria Colonna, whose verse they sometimes echoed, as well as the phraseology and images of Petrarch and Dante. The fabric of Michelangelo's lifelong Catholic piety – frequent prayer, devotion to the Virgin Mary, prayers for the souls of the faithful departed, good works through alms-giving (to friars, orphans and priests, for example, when he buried Urbino), and membership of the confraternity of San Giovanni Decollato, comforters of the condemned – was completed with meditation on the mysteries of salvation: the saving grace of the crucified Christ, the sinner's justification through faith, the collaborative role of the believer's own suffering. The late religious poems of Michelangelo broke new ground, but this was the same Michelangelo who (as Condivi carefully reminded people) had carried through life into old age his memory since boyhood of the voice of Savonarola.

In his early eighties Michelangelo sent an 'occasional' sonnet to Archbishop Beccadelli in response to his friend's verses of regret that they were being kept apart (as Beccadelli was to go to Dalmatia). '*Per croce e per grazia e per diverse pene,*' the poem begins:

> Through the Cross and through grace and through diverse
> sufferings
> I am sure, monsignor, we shall meet in heaven
> but before our last breath in extremity
> it will be good to enjoy each other on earth . . .

Michelangelo ended this sonnet with a lament for his dead Urbino, who might have visited Beccadelli with him, he sighed. But now Urbino's death was hurrying Michelangelo along another road 'where he waits for me to lodge with him'. Human love, then, for all Michelangelo's renunciation of art and the world's beauty, he expects to find in paradise.

Duke Cosimo never ceased asking Michelangelo to return to Florence; Michelangelo kept answering in a manner to suggest that he would

obey only if his conscience over his responsibility for St Peter's would let him.

In 1557, when he heard that the work on St Peter's had been suspended, Cosimo tried again to persuade Michelangelo to come back to Florence. The pace of work at St Peter's had been slackening since the autumn of 1556. Writing to Lionardo in February 1557, Michelangelo said that, since he received so many offers from the duke two years previously, he had been begged by 'all Rome, and especially by the Most Reverend Cardinal di Carpi' to make a large wooden model including the cupola and the lantern for St Peter's so that his design could not be changed. So he believed he needed to stay in Rome not less than a year.

In March, Michelangelo was informing Urbino's widow, Cornelia, that he would leave Rome for good the coming winter. In May he was asking Lionardo to be ready to come to Rome in September to settle their affairs. But he was soon experiencing more trial and tribulation than ever over the fabric of St Peter's. A mistake had arisen over the vaulting of the Chapel of the King of France, the southern dome of the transept – because of his age and his not being able to go there often enough, Michelangelo explained. This meant that much of what had been done must be taken down.

In his letters to Vasari and Duke Cosimo, Michelangelo was always making excuses, asking for more time, pleading (to Vasari on 22 May 1557) that the work on St Peter's was now being held back just when it had reached the most difficult point and if he were to abandon it he would be disgraced and lose the fruits of ten years' labour for the love of God. The only people to be gratified would be the thieves, who might ruin it all and close it down for ever. Moreover, he had obligations in Rome, including his house and possessions worth some thousands of crowns; and, as his doctor, master Realdo Colombo, who had saved his life, could testify, he, like all old men, was in poor shape, with kidney problems, the stone and colic.

Michelangelo, Vasari came to say (having seen from the sonnet 'Giunto è già 'l corso' that he was drawing away from the world towards God and, because of persecution, casting away the cares of art), would gladly have left Rome but had grown so old and feeble that his flesh betrayed his spirit.

In one mood, in his poetry, Michelangelo cried out against the vanity of all his art, lamenting, like St Thomas Aquinas, that all his works had been waste. In another, he wrote eagerly and fully to Vasari with

drawings and explanations of what had gone wrong in the construction of the vault of the chapel. Michelangelo's first note about the faulty construction was written under two drawings, filling over half the page, of the curves of the vault with their centring as it should have been and also as it had wrongly been erected. Sebastiano Malenotti, overseer at St Peter's, had failed to realize there must be separate vaults over each of three windows. 'They had the model (which I always make),' Michelangelo had written to Vasari in the letter of 17 August 1557, 'and they ought not to have committed so gross an error as to try to make one single curve of vaulting do for all three vault shells.'

After being dismantled, the vault, in travertine, was rebuilt at great cost in 1558.

When Michelangelo had said that all Rome had wanted him to make a model of the cupola for St Peter's, he meant above all – by Vasari's account – not only Cardinal Ridolfi Pio di Carpi but also Donato Giannotti, Francesco Bandini, Tommaso de' Cavalieri, and Giovan Francesco Lottino. Bandini had not taken the place of the dead Luigi del Riccio, but he was often very helpful to Michelangelo in his business dealings. He was a Florentine banker, well trusted by the leaders of the Florentine community in Rome. Lottino was Cosimo de' Medici's agent in Rome.

After some reflection, Michelangelo began working on a study in clay for a large-scale wooden model of the dome. By setting his hand to its detailed design, Michelangelo again in a most critical area ensured his continuing influence on the appearance of the great basilica. The work he now started also ensured that he had more good excuses for not returning to Florence. It was also, amazingly, part of a fresh burst of activity, some of which was, ironically, specifically to do with Florentines, if not Florence.

In July 1557 Lottino wrote to tell Duke Cosimo that Michelangelo, who now rarely went to St Peter's because his old age made it difficult for him to stir far, would take months and months to complete the model he was obliged and anxious to finish. Michelangelo had been moved to tears, Lottino added, when told of the duke's latest offers.

A year or two later, with Duke Cosimo's support, the Florentines in Rome persuaded Michelangelo to submit designs to continue the building of their own church, San Giovanni dei Fiorentini. The decision to build such a church had been made in 1518. Scant progress had been made when Michelangelo was asked for designs in 1550 by Julius III, who briefly considered using it to house his family tombs. Now, at the age of eighty-four, Michelangelo was being asked to finish what Jacopo

Sansovino (now working as a sculptor of a series of beautiful tombs in Venice) had begun with his design about forty years before.

Michelangelo did leave Rome in the late 1550s, but only briefly, and not for Florence. He fled as he had done before when he grew convinced that impending violence threatened his safety and security and even his life.

This time the danger came from the army of Spain's viceroy in Naples, Ferdinando Alvarez de Toledo, the duke of Alba, which, in the wake of an upsurge of Imperial fury against the papacy, on 25 September 1556 crossed the border of the Papal States in the Campagna. Rome was cut off from the sea when Ostia was seized on 18 November. After an armistice which ended in January 1557, the viceroy's soldiers moved against the city. But eventually Alba withdrew and peace negotiations began. The duke of Alba moved into Rome to offer his submission to the pope as a good Catholic.

In a letter to Lionardo of 31 October 1556, which mentioned that work on the fabric of St Peter's had been falling off, Michelangelo said that the pause had given him the chance to go to Loreto (well to the north-east of Rome) to make his devotions, and that on the way, being tired, he had stayed in Spoleto for a while. But then his purpose in making the journey had been frustrated, 'for a man was sent to me expressly to tell me I must return to Rome: whereupon, not to disobey, I set out'.

To Vasari, in December, in a brief note of thanks, Michelangelo made another reference to his having left Rome: 'In recent days with great discomfort and expense I found great pleasure in visiting those hermits in the mountains of Spoleto, and as a result I have returned only half-heartedly to Rome; for indeed peace is not to be found elsewhere than in the woods. This is all I have to tell you.'

And this is all we know about Michelangelo's flight to Spoleto and rare – or rarely expressed – enjoyment of the countryside.

90 Duke Cosimo's court: Vasari, Cellini, Pontormo, Bronzino

In the autumn of 1557 there were devastating floods in Florence. The Arno had burst its banks, wrecking the Ponte a Santa Trinita.*

*Later beautifully rebuilt by Bartolommeo Ammanati.

Michelangelo was informed by Lionardo about the loss of life as well as of bridges, monasteries and houses in Florence, about which he already knew, and he wrote saying that doubtless Lionardo had heard about the comparable flood damage in Rome. He prayed God to save them from worse, which, he said, 'I fear because of our sins.' He added a complaint about the overseers of St Peter's and their damaging ignorance or malice, and said he was pining over his sufferings. As for his other woes, Lionardo could imagine what they were, given his uncle's age.

It clearly seemed quite possible to Duke Cosimo, at least till the end of 1557, that Michelangelo would indeed return to serve him in Florence, where his friend Vasari was being employed at court as painter and adviser on the arts (at a monthly salary of twenty-five florins). Vasari had brought his household to Florence; Michelangelo could surely join his family there.

In 1539, by marrying Eleonora, the daughter of Don Pedro of Toledo, the viceroy of Naples, Cosimo had secured strong politically important connections and, through her personal fortune, the resource for active policies of aggrandizement. By 1557 Cosimo's strategic aims were well on their way to realization. This hard-headed, hard-hearted, hard-working and now very experienced politician and ruler was rising forty, physically big, energetic and agile.

One of his aims especially relevant to the arts was the glorification of the Medici family, never so blatantly pursued as now. Others were to free Florence from the emperor's control, the integration of Florence with its dependent territories, and the loosening of the control of government by the traditional ruling class.

In 1537 the battle of Montemurlo had finally tilted the balance of power in Florence in favour of Cosimo; the republican opposition in Florence was thrown into full retreat. By 1554 he had consolidated his power within Florence's existing territories and had tested his strength against Siena. When in 1552 the Sienese expelled the Imperial garrison, maintained there to protect communications between Naples and Milan, this had given Cosimo the excuse he needed. After a campaign of cunning misinformation and double-dealing, he had launched his attack, ostensibly to support Imperial authority, against Florence's centuries-old rival.

In July 1557 Duke Cosimo was at last invested with the city and dominions of Siena, to be held in fief from the king of Spain. Spanish garrisons were to stay in the south of Sienese territory. None the less, for the Medici family and for Cosimo – newly styled *Dux senarum* – the

triumph was substantial, enhancing prestige and power, not least through extended control of the main routes from north Italy to the Papal States and Naples. (By the Treaty of Câteau–Cambrésis, 1559, the French again, and finally, renounced their interest in Italian territory. This brought the Franco-Imperial conflict in Italy to an end at last.)

Cosimo's genius for government provided the sinews for war, and then for art. He decentralized but regulated trade and industry; controls and huge purchases of reclaimable lands gave him rising tax revenues and a large personal income. He carefully and intelligently fostered the administrative unity of all Tuscany. He acted subtly to create a network for personal ducal power and the promotion of new men under the cover of the old forms of the 1532 constitution of Florence.

Cosimo's private pleasures included hunting almost whatever moved and was feathered or furred, and collecting jewels, medals and antique statues, as well as books and manuscripts. His patronage of the arts of design was linked to his urge to project himself, his family and the state, and to fulfil military needs. He set in train an immense programme of architecture, sculpture and painting, of controlled academic expansion, and of well-paid literary exercises.

Vasari, already the duke's court painter, was chosen to succeed the much favoured Battista del Tasso as architect to the Palazzo Vecchio (the Palazzo della Signoria) in May 1555. He almost entirely remod-elled the palace, and he decorated the Quartiere degli Elementi with frescoes illustrating the benefits of Medici rule. He also began decorating the Quartiere di Leone X with stories from the history of Cosimo's family (Leo X). Rivalling the huge, triumphalist wall paintings of Rome and Venice, the series was a triumph of propaganda and patron-age. (Michelangelo is depicted, along with Leonardo, in the scene where Pope Leo creates thirty-one cardinals.)

For Vasari's purposes, publicizing the generosity of patrons towards artists helped the great cause of status, and created a virtuous circle of recognition and reward. Vasari boasted about the rich rewards of Medicean employment: from Duke Cosimo he received houses in Flor-ence and the country, paid offices in Arezzo for himself and in Florence for his brother Piero, and many favours for other members of his family. The contrast with Michelangelo's pleadings of poverty and his methodical recording of his patrons' disbursements to him could not have been sharper. None the less, the works and spirit of Michelangelo pervaded the artistic atmosphere of the court of Duke Cosimo.

At the Medici court, so different from Rome's, a woman, the duchess, wielded influence over the patronage. About ten years after their

marriage, Duke Cosimo began to build to Ammanati's plans a massive new palace on the southern side of the Arno, taking in the remnant of the palace grandly designed by Brunelleschi, but left unfinished by the Pitti family for lack of money.

Cellini was a vital link between Michelangelo and the development of sculpture in Florence. In 1547 he took part in the exchanges launched by Varchi on the rival merits of painting and sculpture, and contributed the thought that sculpture was seven times greater than painting since a statue must have eight views all of equal quality (that is, four main views of the main axes and four of the diagonal axes).

This new concept of 'multi-faciality' did not apparently fit well with Michelangelo's relief-like method of attacking the stone with hammer and claw chisel to create one principal view. But it pointed to the trend of sculpture – through greater use of the plastic sketch and the manoeuvrable small wax or clay model introduced by Michelangelo – away from Michelangelo's method, *per forza di levare*. (Simultaneously, and paradoxically, because of Michelangelo's immense prestige and the rising social ambition of sculptors, the hard physical labour of sculpting began to be regarded as demeaning compared with the processes of modelling.)

Cellini's liberating intellectual ingenuity was transmuted into genius when he applied his abstract thinking to casting bronzes. Walking round his startlingly elegant statue of *Perseus and Medusa** reveals not only a multiplicity of views of the composite group but also the variety and strength of its detail, from the stern mask at the back of the winged helmet of Perseus to the agonized face of Medusa with parted lips and writhing snakes. When he was fashioning and casting the Perseus, Cellini was pitting himself against Donatello, whose statue of Judith also represented the idea of liberation, and against Michelangelo, whose *David*, standing for the independence of Florence, was nearby.

As Michelangelo's art in Rome grew increasingly otherworldly and austere, Ammanati, winning first place in the favour of Duke Cosimo in Florence, constantly revealed his knowledge of Michelangelo's work in the detail of his own.

Bandinelli had seen his territory in Florence invaded by sharp-elbowed rivals, including Cellini, Vasari and Ammanati, his pupil. He emulated Michelangelo in several of his works – including the last, a *Pietà* – but he was quite unable to achieve Michelangelo's purity of form.

* * *

*In the Loggia dei Lanzi, Piazza della Signoria, Florence.

Of the artists in Florence, Jacopo Pontormo was the most original, the most disturbed, the most scorched by his encounter with the art of Michelangelo. Vasari knew him very well. To Vasari's bemusement, Pontormo tended to work only when he wished to, and when asked to paint something by a nobleman would deliberately start something else for a commoner, at a low price. He did stunning work for the Medici after 1527, including a posthumous portrait of a pensive Cosimo il Vecchio garbed in rich red gown and hat, and a portrait of the young Cosimo about the time he came to power, with jutting staff and sword, sportive, virile, posed with hand on hip in potent adolescence.

Pontormo was another of the painters and sculptors who took part in Benedetto Varchi's debate on the arts of painting and of sculpture. He suggested that every other consideration paled in significance with the certainty that design – *disegno* – was the fundamental element, and that anyone competent in design also had the two arts in question. He described the glories of sculpture through its materials and of painting chiefly through its subject-matter (the 'fires and other brightnesses of night, clouds, landscapes far and near, buildings with so many varied perspective viewpoints, animals of all kinds and so many varied colours'). How arrogant the painter was, he thought, in wanting to vanquish nature by breathing life into a figure and making it appear alive, albeit in one plane.

Then Pontormo struggled to say some of the things he felt about Michelangelo. Michelangelo's profound design and awesome grandeur of intelligence (*ingegno*) had been seen more in his miraculous paintings, which showed so many varied figures and beautiful gestures and fore-shortenings, than in his tremendous statues. He had always loved painting as something more difficult and more suited to his supernatural intelligence, although he had also recognized that his greatness and eternity sprang from sculpture, which was itself eternal and wholly excellent; but the marble quarries of Carrara had shared in this eternity more than the skill of the artists. The point was, Pontormo sought to explain, that the sculptor's raw material was superior in this context to the painter's, and when it was used by a great master led to great prizes, fame and other honours in recognition of meritorious ability. 'I think therefore there is an analogy with clothes: this [sculpture] is like a fine cloth because it lasts longer and costs more; while painting is [like] a fleecy cloth, which does not last long and is cheaper, since once the nap has gone it becomes worthless; but since everything must come to an end, neither painting nor sculpture is eternal.'

In 1546, with his own pupil Agnolo Bronzino, Pontormo had begun work for the Medici family on the fresco decoration (now gone) of their church of San Lorenzo. His memories of Michelangelo's *Last Judgement* in Rome, seen perhaps just three years before, of Michelangelo's myriad floating forms, impelled him to devise quasi-abstract figural shapes for the stories from Genesis and the combined Resurrection and Last Judgement. The surviving drawings show swirling, dancing figures like watery eddies of airy arabesques, palpable but wraithlike, with the inconsequentiality of images in dreams.

Vasari noted in bewilderment the dire result – as he saw it – for the final years of Pontormo's life and work of his agonizing obsession with the *terribilità* of Michelangelo. At San Lorenzo, Pontormo closed off the chapel with hoardings and curtains and worked in total solitude. Just once, some youngsters drawing in the new sacristy found their way to the roof of the church, removed some tiles, and saw everything. Jacopo, it was said, chased after them, and then he barricaded himself in more carefully than before.

Giorgio Vasari thought he would go mad if he brooded too long on Pontormo's new style.

> Imagining that he must surpass all the other painters, and, it was said, even Michelangelo, in this work, Jacopo painted in the upper part several scenes . . .
>
> . . . it does not seem to me that in any place at all did he pay heed to any order of composition, or measurement, or time, or variety in the faces, or changes in the flesh colours, or, in brief, to any rule, proportion or law of perspective; and instead the work is full of nude figures with an order, design, invention, composition, colouring and painting done in his own personal way, with so much melancholy and so little pleasure for the beholder that I am resolved, since even I do not understand it though I am a painter myself, to let those who see it judge for themselves.

While he was working in the choir of San Lorenzo, Pontormo kept a diary, with sketches in the margin, in which he briefly recorded some of the progress of his work but chiefly jotted down minute details about changes in the weather, his state of health, just what he was eating, who called, and the occasions when he did not open the door. In November 1555 he wrote that on the first of the month, Friday morning, he had his midday meal of eel and fishes from the Arno, and that on Saturday, Sunday and Monday he was cold. On 9 November, he wrote, he had drawn the head which was below the figure he was

showing now. The diary's pages are brittle and obsessive, with details about the slices of bread he consumed, the times he did not answer the door, the shape and colour of his turds, the wine he put into cask. They are also alive with the presence of Pontormo's friends and patrons. Most of all Bronzino's name occurs: once bringing Pontormo some beef not fit for dogs, and eating the best cut himself, Pontormo wrote down, but mostly just visiting, drawing and going out with Pontormo.

Pontormo died in 1556. His lifelong friend Bronzino, about ten years younger, painted subtle, elaborate portraits of the duke and his family, ambivalent allegories, big religious paintings of increasing intensity. Bronzino was a friendly rival for court patronage with Vasari, who was also ten years younger than him. Like Vasari and Pontormo, though with less dramatic consequences than Pontormo, Bronzino responded to what he saw during his visits to Rome (in the late 1540s) and especially to Michelangelo's frescoes, and produced mannered, ingenious anatomical exercises of a beautiful kind.

Bronzino helped keep open the channels of professional painting between the Florentines and Michelangelo in Rome. His nephew and pupil Alessandro di Cristofano Allori went to Rome in his mid-twenties to study the *Last Judgement*. Soon after Alessandro's return to Florence, Varchi was writing to Michelangelo to send Allori's regards, thank him for the courtesy he had shown the young man, and press him to return to Florence, where he would be able to live in peace, honour and liberty under a benign prince.

Neither Duke Cosimo nor Vasari ever gave up hope that Michelangelo would return to Florence. Their motives were mixed. Both in different ways were moved by admiration and affection. The duke also saw in Michelangelo's possible presence in Florence a glittering prize for the prestige of the Medici family and their state. Vasari saw the boost Michelangelo's home-coming would give to the cause of the artists working in and from the city.

Vasari and his mentor Vincenzo Borghini were prime movers in the campaign to give those who practised the arts of design better recognition and status. The final emancipation of artists from the guilds and acceptance of their social and creative superiority to other craftsmen were encouraged by the mutually advantageous collaboration of the artists and the Medicean government. Vasari cited the precedent of the by then moribund artists' confraternity the Compagnia di San Luca when he persuaded Cosimo to found the Accademia del Disegno, whose regulations were approved by Cosimo in January 1563. A key difference

from the old guilds was that membership, initially for thirty-six artists, was an honour to be conferred on independent – and now often quite rich – creators of the fine arts. Establishing the Academy also led to the development of new canons of excellence and, paradoxically, the return of authoritarian structures.

The first statutes of the Academy were approved by Cosimo in January 1563. Michelangelo was nearly eighty-eight, still in Rome, and writing tersely that same month to tell Lionardo not to visit him as it would only add to his vexations. If Vasari and the duke could still not force him back to Florence, however, they could at any rate use the lustre of his name for their new Academy. From Vasari in March, Michelangelo received a significant letter.

As Michelangelo knew, Vasari wrote, Duke Cosimo had brought together all the practitioners of the art of design, the architects, sculptors and painters, and had most generously given them the beautiful church Santa Maria degli Angeli to be a university of studies. The duke had provided in the Academy's statutes for mutual assistance for the artists, for proper obsequies, and for devotions to help their souls after death. The academicians were to come from the best of the artists, and foreigners in Florence, of no matter what nation, should enjoy the same privileges as those of the city and the duke's most happy state. Membership was to be through the votes of the academicians confirmed by His Excellency, and so open to talented people from everywhere.

As Michelangelo would have been expecting, this was followed by some not so subtle reminders of the duke's wishes as regards the absent greatest artist of all. As Michelangelo knew, Vasari said again, the duke had for a long while tried in various ways to have him return to Florence, not only to advise on and execute the so many great enterprises undertaken in his dominion but also to finish his planned work for the sacristy of San Lorenzo.

Duke Cosimo had decided that all the statues missing from the niches over the tombs and the tabernacles over the doors should be made by the excellent sculptors of the Academy, in competition with each other. The painters should do likewise for the pictures, the arches and walls, as Michelangelo had decided on them; and the same went for the stuccoes, ornaments and paving. This was the right occasion for all the brilliant artists of the Academy to act so as not to leave imperfect 'the most rare work that has ever been made among mortals'.

So, at the duke's command, Vasari was writing to Michelangelo to beg him to tell His Excellency or himself what had been his intentions. Would Michelangelo also send all relevant sketches and drawings for

the work, which would be honoured. If old age hindered Michelangelo, would he impart to others what he knew and let them write it?

Michelangelo excused himself for his ensuing silence to the duke's ambassador, Averardo Serristori, and to Vasari. To the clamorous requests of Cosimo de' Medici he sent no response.

91 Pope Marcellus · Pope Paul IV · Pope Pius IV · Old age and new friends

In the 1550s Michelangelo had continued to show Duke Cosimo a natural deference, partly to keep open his Florentine option in case any new pope should come to persecute him. He thought to leave for Florence in April 1555, when the prominent reforming cardinal Marcello Cervini was chosen to succeed Julius III. Cervini, who took the title of Marcellus II, was just reaching fifty-four, a quarter of a century younger than Michelangelo, who had known his friendship but was fearful of what he might do.

Pope Marcellus engaged sternly with the work of reform, with all the energy he had shown as a pastoral bishop, legate at the Council of Trent and director of the Vatican library. He was poised to revive and expand Pope Paul III's reforming programme and to begin a régime of austerity within the Vatican itself. He was an unsmiling man. In front of Pope Paul III, Michelangelo had made the new pope look foolish about the lighting in the apse of the new St Peter's. Most disturbing for Michelangelo, however, must have been the memory of Marcello Cervini's disapproval of the young, beardless Christ and the nudity of some of the figures in the fresco of the *Last Judgement*.

Duke Cosimo redoubled his appeals to Michelangelo to leave Rome, but Marcellus died from a stroke after a pontificate of only three weeks. The noble Neapolitan Gianpietro Caraffa, elected Pope Paul IV, was almost the same age as Michelangelo; he was a tall, energetic man, bounding with life, impulsive and peremptory. He condemned the Peace of Augsburg of 1555, which envisaged Roman Catholic and Protestant coexistence, as conducive to heresy. He hated the emperor and the Spaniards, and the Germans, and immediately on his accession he joined the French in war against them.

Michelangelo went to kiss Pope Paul's feet as soon as he was elected, and received effusive promises. Soon after, he made his journey to the woods of Spoleto as a result of the invasion of the Papal States from Naples.

The clever, cruel pope wanted Michelangelo as architect and military engineer. But he had not been ruling long when Michelangelo was told 'by certain people' that he was minded to alter the *Last Judgement* because the figures revealed their nakedness too shamelessly. 'Tell the pope this is a trivial matter and can easily be arranged,' Michelangelo said. 'Let him set about putting the world to rights, for pictures are soon put to rights.'

The aims nearest Paul's heart were the pursuance of Catholic reform, the heightened effectiveness of the Inquisition in fighting heresy, and the continuation of the work on St Peter's, to the greater glory of God and the Church. The last imperative made him keep a close eye on Michelangelo throughout his pontificate, and kept their understanding from collapse.

Pope Paul's reign was turbulent and terroristic. The Inquisition was urged to investigate simony and sodomy as well as heresy. The property of Jews was confiscated and their movements were restricted. After Rome's flood and famine of 1557, the pope sanctioned the forcible return of workers to the countryside.

Lists of forbidden books already existed locally in Europe before the late 1540s; then under Julius III an Index had appeared in Rome banning the entire works of many Protestant authors, and even ten of Erasmus's books. The censorship was only moderately pursued till, under Paul IV, a new fiercer Index was promulgated in 1559. This condemned the entire work of about five hundred authors, now on grounds of lasciviousness and immorality as well as heresy, including the works of Aretino, Machiavelli, Boccaccio and Rabelais, the poems of Berni and della Casa, all of Erasmus's works and many of Savonarola's. The Talmud was also banned. This was a new kind of censorship covering an unprecedented stretch of literature.

Pope Paul died in August 1559. Romans rioted, mutilated his statue on the Capitol, freed the prisoners, and wrecked the offices of the Inquisition.

In the new Pope, Pius IV, formerly Cardinal Gian Angelo de' Medici of Milan, Michelangelo found another pontiff ready to renew the *motu proprio* proclaiming his authority over the work at St Peter's, as well as to restore some of the allowances cut by Paul IV. Pius had been born in Milan, the son of a notary, and was related very distantly if at

all to the Medici family of Florence. But he shared the Medicean fondness for the fine arts and for building. He was energetic but greedy, and victim to corpulence and gout; curious and kindly; commonsensical and vain.

Pius promised the Church and the Romans that he would protect religion, peace and justice, intending to do so by avoiding the extreme politics of Caraffa – by friendliness rather than force. He left the city more prosperous and more beautiful than he found it, though his broadening of the revenue basis provoked fury in the Papal States. He asserted religious discipline through the Inquisition and a modified Index, but less harshly, and – his decisive act as supreme pontiff – he reconvened and brought to a resounding conclusion the Council of Trent after its ten years of suspension.

Through sense and necessity Pius reconciled the Holy See with Philip II of Spain and the emperor Ferdinand. (Charles V had abdicated in 1556.) He held back from the excommunication of the successor to Mary Tudor as queen of England, Elizabeth I, trusting that her ambivalence pointed in the direction of reconciliation.

Pius IV was worldly and nepotistic, with three natural children of his own, but intelligently open to good advice, especially from the good-living Carlo Borromeo, who pursued close to the pope the reforming mission of the Catholic Church in its burgeoning twofold aspect of personal sanctification and institutional cleansing.

During Michelangelo's years in Rome, from his sixties to his eighties, the papacy experienced two decades of transition, reaching the climax of its spiritual reorientation under Pope Pius IV. The survival of the European base of the Catholic Church as an international force was now secure, not least through Jesuit initiative and Protestant fragmentation.

Machiavelli, when he wrote his *Discorsi* during the reign of Pope Leo X, had accused the Church not only of being the main cause of the disunity and weakness of Italy but also of causing its irreligion. No country was ever united and happy unless ruled by one republic or prince, he wrote. The Church had its centre in Italy and enjoyed temporal power, but it had never been able to rule Italy, though it had always been able to prevent any other Italian power doing so. Italians had the Church to thank for Italy's victimization by the barbarians. To see how the religious spirit of Italy had declined, Machiavelli argued, one needed to look no further than those who lived near Rome. There was less religion there than anywhere, and Italians had grown irreligious and wicked through the Church and the priests.

In 1493 Pope Alexander VI had drawn the line of demarcation between the Spanish and Portuguese zones of exploration in the New World and had given the monarchs control of the Church in the lands they colonized. In 1564, through imposing the profession of the Tridentine Faith on the bishops, superiors of religious orders and theologians at the Council, Pius IV made sure that in the now worldwide 'holy, Catholic and Apostolic' Church the papacy would maintain its headship and power.

Scourged by the sack of Rome and the shock of the Reformation, but also reinvigorated by Catholic reformers acting at different levels of ecclesiastical life, and through the decrees of the Council of Trent, the Catholic Church reformed itself.

And what the papacy wanted from the arts changed as decisively as did its spiritual priorities. The spiritual triumphalism instinctive to Rome sought new forms of expression. It could no longer countenance the emphasis on the adaptation of pagan subject-matter and critical aspects of the antique, including nudity, to set the fashion for Roman and Catholic art.

From the mid-1550s, now into his eighties, Michelangelo, like the reformers among his friends, was reacting against clerical abuses, indifference and superstitions, but was primarily seeking renewal at a personal level. The seeds of his spirituality went back to the regular Catholic practices of his upbringing and the powerful twin influences of Dante and Savonarola, but he also responded to the surge of reform in the institutional Church, and the new stresses in its developing theology. The poetry he wrote in his old age, the *Pietàs* he drew and carved, the great frescoes in the Sistine and Pauline Chapels and his last masterpieces of architectural design demonstrated this will to respond – albeit, as ever, in his own way. But his emotions were still strained and his work tense through his fascination with the form and carnality of the human body – specifically the potent expressiveness of the male nude – and through his sense of guilt over past sins, of hunger for future grace.

The surviving letters addressed to Michelangelo during his old age bear witness to the continuing creative stimulus of friendship in his life. Michelangelo's own letters in his eighties went mostly to his nephew Lionardo and to his long-term friend Giorgio Vasari; there are also a few to the duke of Florence, to Ammanati and to Urbino's widow, Cornelia. They testify to his sustained alertness, awareness and wit, and to his continuingly extreme emotional range.

The bronze bust of Michelangelo attributed to Daniele da Volterra shows his features as they were in old age, with open eyes, curled beard

390 MICHELANGELO: A BIOGRAPHY

and full head of hair, prominent forehead, squashed nose, wrinkled brow, an expression of strength, repose, intelligence.*

Daniele da Volterra had prospered almost effortlessly since he first came to Rome after studying Sodoma's painting in Siena. He had assisted and then succeeded Perino del Vaga in numerous projects for great family chapels. Daniele emulated the power and energy of Michelangelo's figures in the Sistine, adapted them with his own preciousness and grace, and became one of Michelangelo's close younger professional friends.

After a burst of painting under Julius III, chiefly for the cultivated archbishop Giovanni della Casa, and largely based on sketches from Michelangelo, Daniele shifted direction to develop his new obsession with sculpture. He began, through the offices of Vasari (to whom Michelangelo had commended him), to work for Duke Cosimo. He made plaster casts of Michelangelo's figures in the new sacristy of San Lorenzo. Daniele was adaptable, energetic, enthusiastic and religious. Michelangelo trusted and often relied on him.

Michelangelo's closest, most tranquil, friendships in his old age were with men whose scholarship he admired, whose religious piety he shared, and whose liking for literature and poetry reflected his own. Ludovico Beccadelli was the most congenial among them, and the least demanding of Michelangelo's correspondents. He was imbued with the attitudes and outlook of the Reformist cardinals; he shared Michelangelo's devotion to the memory of Vittoria Colonna, describing her on her death as another Sappho in poetry, another St Elizabeth in charity and good works; his diplomatic career had been marked by competence and discretion; he had written accounts of the lives of the worldly Bembo and the reformists Contarini and Pole, and had been painted by Titian.

Beccadelli's warmly reciprocated friendship with Michelangelo was well established by the time Pope Paul IV 'exiled' him to Dalmatia as archbishop of Ragusa. Their exchange of sonnets in 1556 included Michelangelo's renunciatory invocation of his sainted Urbino in the loving '*Per croce e per grazia e per diverse pene*'.

In March 1557, having heard that Michelangelo had left Rome, Beccadelli wrote to him affectionately from Ragusa, asking nothing, praising his friend's prudence and piety, sharing the thought of resignation to the will of God. Wherever he was, he said, Michelangelo had a loving son and servant. He prayed God that he would see him

* In the Galleria Buonarroti, Florence.

again and enjoy him sometime in this world and then eternally in the next.

That same spring, a letter to Michelangelo from Amilcare Anguissola in Cremona thanked him for the goodness he had shown in helping his daughter Sofonisba in her ambition to paint, and moreover in sending her a drawing to paint in oils, on condition that she returned it faithfully finished by her own hand. Anguissola wrote of Michelangelo's innate courtesy, his talents and goodness given by God.

A more weighty request than one for a drawing to colour came in a letter sent to Michelangelo, dated 14 November 1559, by Catherine de' Medici, queen of France, writing from Blois. Michelangelo's pensive effigy of her father Lorenzo waited in San Lorenzo for the new sacristy to be finished; her husband Henri II had in July been accidently killed in a tournament. She planned to put in the middle of the courtyard of one of her palaces – the château at Blois – a bronze statue of her lord on horseback, of a size appropriate to the court. It was agreed between Michelangelo and Roberto Strozzi, Catherine's cousin, that Michelangelo would provide the design and Daniele da Volterra would execute the statue. About a year later, Strozzi wrote from Paris, pleading with Michelangelo to have the work hurried along. Michelangelo may have balked at the detailed brief he was being given: Queen Catherine sent a picture of her 'legittimo e unico amore' and had her agent, Bartolommeo del Bene, add to her letter of October 1560 a note saying that Michelangelo must do the king's head without curls and as much to his likeness as possible, and do the armour and the horse's trappings in the beautiful modern fashion. The result of Michelangelo's most perfect judgement and loving kindness would then amaze and stupefy the present age and the age to come, del Bene hastily added.

On 14 October 1560 Leone Leoni wrote a vivid letter telling Michelangelo how matters stood with regard to the competition for the Neptune fountain for the Piazza della Signoria in Florence.

> models have been made by four persons: Ammanati, Benvenuto Cellini, a Perugino [Vincenzo Dante] and a Fleming called Giambologna. Ammanati says he has done best, but I have not seen it, as it's been wrapped up to wait for the marble to arrive. Benvenuto has shown me his, and because of it I feel pity that in his old age he has been so badly obeyed by the clay and the clippings. The Perugino has done well enough, for a young man,

but has no standing. The Fleming must pay his expenses, but he has fashioned his clay very neatly. So much, Your Lordship, for the competition.

As well as having eyes and ears in Florence, Michelangelo had, from 1556, in the Florentine Tiberio Calcagni, secured the services of a devoted, responsible, young sculptor who combined the roles of pupil, assistant and secretary and who could go there on his behalf. Calcagni had been born in 1532, had studied architecture in Rome, and was in his mid-twenties when he became one of Michelangelo's regular visitors – accorded the same kind of professional respect as Daniele da Volterra, and often supplementing the help given Michelangelo by his living-in assistant, Pierluigi Gaeta. Vasari remarked Michelangelo's fondness for Calcagni, and Calcagni's discretion, and that Michelangelo gave him the marble bust of Brutus to finish, after he had carved the features himself using the claw-chisel.

From Urbino's executors and family, and especially from Cornelia herself, Michelangelo, as one of the executors and guardian to the children, received scores of animated letters. These plotted the financial affairs of the estate and the emotions of those involved; Cornelia's plans and problems of remarriage; and squabbles between the new husband and Cornelia's brother, Il Fattorino, and between the heirs and the managers of the estate, one of whom renounced the trust.

Cornelia's letters were among the longest Michelangelo ever received, and written with brio and intelligence, full of life and detail, signed for Michelangelo as from a loving daughter. Notable communications were her powerful outburst in October 1558 expostulating about her parents' efforts to make her marry a penniless and dissolute young man who, she had heard, was riddled with the French disease; her gifts of sweet hay and ham; and her message, just before Michelangelo's eighty-seventh birthday, that she had just given birth to a baby boy, a brother for her Michelangelo and Francesco.

Several of Michelangelo's Florentine friends and assistants were sent for urgently by his servant when he had a seizure during August 1561. He had been working in the fierce heat on designs for an imposing new gate, to be called the Porta Pia, to commemorate the reigning pope, Pius IV. Those who hurried to the house in Macello de' Corvi were Daniele da Volterra, Tiberio Calcagni, Francesco Bandini (the banker concerned with the fabric of San Giovanni dei Fiorentini) and Tommaso de' Cavalieri.

Michelangelo's fond friendship with Tommaso had continued. Tommaso, a widower since 1553, played a subdued but influential part in the public life of Rome, chiefly as one of the deputies for the fabric of the Capitol and, from 1563, as a special deputy for the Senate. He built up a rich collection of antiques and drawings (with some of Michelangelo's designs as the nucleus) in the family *palazzo* in the district of Sant'Eustachio near the Torre Argentina. His rapport with Michelangelo was well understood by others, and his influence was often sought.

One of the last poems Michelangelo seems to have meant for Tommaso – '*Ben può talor col mio 'rdente desio*' – survives in four versions. The poem asks whether there could not be times when hope could rise with desire and not prove false, for, if all our emotions displeased heaven, why would God have created the world? The reason for love was to glorify the eternal peace which descended into the loved one and made every gentle heart chaste and holy.

On 15 November 1561, very unusually, Cavalieri wrote Michelangelo from his own home a hurt and angry letter asking why Michelangelo had developed some grievance against him; we do not know the cause. This occurred at a time when Michelangelo was still involved in the legal and emotional problems of the management of Urbino's estate; his grandniece, Alessandra, had died in infancy and left Lionardo with just one child again; after over fifty years, demands by the heirs of Pius III for the unearned balance of payments of the Piccolomini statues had resurfaced; and he was being vexed by an eruption of labour problems at St Peter's, to whose progress he had committed himself in defiance of sustained emotional blackmail and manoeuvring by Duke Cosimo to win him back for the Medici.

92 Masks and medals •
The *Last Judgement* assailed

Michelangelo's imagination spilled over from his paintings and drawings, sculpture and architecture into the creation of many different kinds of mask. Their faces showed the features of monsters, satyrs, lions, grimacing and shouting men. He did friezes of masks, paired masks, unique masks; masks to frame the Doni Madonna, to adorn the tomb of Julius II and the statues of the Medici princes. The masks, like his

prolific carvings of animals and birds, filled in the empty spaces he dreaded, worked as symbols of night or lechery, gave warning of danger, but as well as and above all else suggested mocking, ironic deceit and satisfied Michelangelo's love of hidden meanings.

Michelangelo often masked his true feelings, as well as his meanings, in irony. What they really were when, after nearly thirty years, he encountered Medici princes again in the flesh, in 1560 and 1561, it is hard to tell from the little he said about the meetings, or that Vasari noted down.

In the spring of 1560 Cosimo and Michelangelo were corresponding directly in tones of mutual respect about plans for San Giovanni dei Fiorentini and about alterations to the Palazzo Vecchio. Vasari discussed this immense programme with Michelangelo when he accompanied Cosimo's seventeen-year-old second son, Giovanni, on his triumphal journey to Rome to receive his cardinal's hat from Pope Pius. They arrived late in March 1560, and to fulfil his own mission Vasari visited Michelangelo to show him the wooden model and discuss the paintings for the Sala Grande in the Palazzo Vecchio.

Michelangelo's letter to Cosimo, written on 25 April, elegant, formal, and circumspect, was not in his own handwriting, though he signed it himself. He had seen Messer Giorgio's designs and model and the design of Messer Bartolommeo (Ammanati) for the Neptune fountain. All seemed wonderful to him, though as so much was being spent on the hall he thought it should be raised at least twelve braccia (about twenty-four feet). The fountain also appeared to be a beautiful idea that would succeed marvellously. For all these things to be done, he prayed God to grant Cosimo a long life.

As for the church of the Florentines, Michelangelo wrote, 'it grieves me that being so old and near to death I cannot satisfy your desire in everything; but, while alive, I will do what I can'.

A year later, in November 1561, Cosimo's first son and heir, Francesco, a moody, inward-looking twenty-year-old, informed Michelangelo through a letter from Vasari that, knowing how much his father loved and admired him, he would like to see him. Michelangelo's letter to Vasari about his encounter with Francesco de' Medici is lost. According to Vasari, Michelangelo had been delighted with the young prince, who treated him reverently and always held his cap in his hand when they conversed.

Michelangelo's idea of himself as old and frail and submissive to the will of God was realized by Leone Leoni in a medal struck in his honour: Michelangelo's profile is on the obverse; his likeness as a blind

pilgrim with a staff, led by a dog, on the reverse. On 14 March 1561 Leone Leoni sent four copies of the medal he had made as Michelangelo wanted: two in silver and two in bronze. The inscription round the reverse of the medal came from the Old Testament, the fourth penitential psalm (Psalms 51:13) and read: '*Docebo iniquos vias tuas et impii ad te convertentur*' ('Then will I teach transgressors thy ways; and sinners shall be converted unto thee'). The psalm chosen by Michelangelo is a prayer of sorrowful confession asking God to cleanse the sinner and blot out his guilt, to purify his heart and to renew his spirit; and then he could do God's work.

The medal was copied in great numbers in Italy and abroad; Michelangelo responded generously by presenting Leoni with several drawings and a wax model of Hercules crushing Antaeus.

Michelangelo's pre-eminence also, inevitably, attracted hostile criticism. The articulator of the artistic case against Michelangelo was Pietro Aretino, first-rate critic, opportunistic but not unprincipled, whose first murmurings had been heard soon after Michelangelo, in the autumn of 1537, had quite courteously said it was too late for him to use Aretino's suggestions for the painting of the Day of Judgement. Aretino was further upset by Michelangelo's failure to send him a drawing he had sought.

In 1557 a blast against Michelangelo was published in Venice, a manifesto expressing the views of writers and artists in Aretino's circle. It was produced under the name of Aretino's sympathetic collaborator Lodovico Dolce, as *Dialogo della pittura intitolato l'Aretino* (*Dialogue on Painting after Aretino*).

Aretino himself had died, aged sixty-four, in the autumn of 1556, before the *Dialogue* was published. It may be that his death cleared the way for publication, since his longing for Michelangelo's acknowledgement had always hitherto restrained his fury. His death was said to have been caused by a fall in a tavern, when he tilted back his chair to roar with laughter at an obscene joke. Aretino (recently addressed by the writer Anton Doni as a drunkard and glutton – 'his Divine Hogsheadedness, Divine Wine-jug', 'the tiltyard dummy of all worthless rascals', 'that wild boar') now talked coolly and calmly from beyond the grave through the pages of the *Dialogue*.

The fictional discourse takes place between the Florentine grammarian Giovan Francesco Fabrini, cast as an apologist for Michelangelo, and Aretino himself, cast as the perceptive critic, the friend of Titian. Fabrini argued that whoever had seen the pictures of the divine

Michelangelo need never look at paintings by anyone else, but Aretino objected that stupendous works had been created by Raphael, Correggio, Parmigianino, Giulio Romano, Polidoro and Titian, and that he could also mention Andrea del Sarto, Perino del Vaga, and Pordenone. Michelangelo was miraculous in bringing together nature and art, but there was no reason to praise him alone. In some respects other painters were greater than Michelangelo. Raphael, while he had been living, had been preferred as a painter by artists and experts in Rome, Michelangelo as a sculptor.

Aretino then brought in the importance in painting of invention, design and colouring. In invention, it was essential to observe order and propriety (*convenevolezza*). In design, the painter must produce easy and graceful attitudes, and accurate and precise outlines of the body and all its parts, giving them strength, energy and force, and correcting nature's defects. Proportion was the principal foundation of design. Propriety must be preserved in painting the nude; draperies must be appropriate to times and nations. In colouring, the chief factor was the contrast between light and shade, and the middle tint uniting and blending the extremes.

After recommending works by Alberti (as translated by Domenichino) and Vasari, Aretino then argued that, on considering all the parts needed for a good painting, we would find that Michelangelo possessed one alone, which was design, whereas Raphael possessed them all, or the greater part of them all.

To the proof! exclaimed Fabrini. So Aretino, counterpointing Michelangelo and Raphael, pointed out how Raphael's children were soft and tender, his men robust, and his women painted with the delicacy belonging to their sex; but Michelangelo did not show the general distinctions of age and sex in the distribution of the muscles. Moreover, was it proper for a painter, in order to show the difficulties of his art, to exhibit what shame and modesty concealed, disregarding the sanctity of the persons he was representing or the place where they were painted?

Obsessed by the painting of the *Last Judgement*, Aretino refused to concede that problematic elements in it could be explained as profound allegories. There were too many ridiculous things in it, he said – as, for example, the representation, among the multitude of the blessed, of souls tenderly kissing each other, when they ought to have been contemplating the divinity of God and their own destiny. What was the mystical sense of a beardless Christ or a Devil pulling down by his genitals some huge figure gnawing its fingers in pain? Nor was

Michelangelo's invention very proper in letting children, matrons and virgins openly see the immodest parts, whose allegorical meanings only the learned could discern.

Here was another cause for Aretino's resentment, and he switched his attack to his grievance over Michelangelo's frequent, sometimes teasing, opacity. Michelangelo did not want his inventions to be understood by any except a few learned people, Aretino said, and so, 'as I am not among them, I shall leave him to his own thoughts'.

Fabrini continued that, excellent as Raphael's paintings were in invention, he still did not see how Raphael could be compared with Michelangelo for design. But even here Aretino conceded little. Michelangelo was stupendous, truly miraculous, in depicting nude muscular bodies in action, strongly marked with violent foreshortenings and showing every difficulty of the art. But in every other kind of nude he was inferior, since he did not know or would not observe the differences in age and sex in which Raphael was so admirable. 'Whoever sees one figure of Michelangelo sees them all.'

Such discussion of the limitations of Michelangelo's design of figures can be traced back to the criticism by Leonardo, in 1502, of those 'who to appear great designers make their nudes woody and graceless so that they appear to see them as bags of nuts and bunches of radishes rather than muscular nudes'.

Some people, Aretino added, after observing Michelangelo's violence and Raphael's pleasing grace, had compared Michelangelo to Dante and Raphael to Petrarch.

Aretino casually brushed aside, as if it were obvious, Michelangelo's 'little care' over colouring. Clearly, to many, Michelangelo's flesh tints and luminous colours in the Sistine lacked the fresh appeal of rich Venetian oils. (There was at this time a burgeoning argument, stimulated by Vasari's prejudices, over the comparative virtues of Venetian and Tuscan painters.)

The *Dialogue* also carried forward the standard comparison of painting with poetry. More dramatically, it was the most thorough discussion ever of a living painter judged by comparison with a contemporary.

Whether Michelangelo read Dolce's *Dialogue* after it was published in 1557 is unknown; it seems improbable. But the onslaught on Michelangelo's transgressions against modesty, against appropriateness, against decorum, appeared at an exceptionally dangerous time, not for Michelangelo's person but for the great *Last Judgement* itself.

As the laws prohibited the printing of immodest books, said Aretino through the pen of Dolce, how much more should they prohibit such

pictures! Pope Paul IV had used the Index of Forbidden Books with great determination against both heretical and indecent works. Pius IV modified Paul's repressive policies, but by reconvening and energizing the Council of Trent he ensured, among other things, that the Church's new attitude to art was codified and applied.

In an age of mounting claims to authority and power by the papacy, the Council prudently refrained from formal discussion of the primacy of Rome. In 1562–3, largely through the diplomatic skills of the reforming Cardinal Giovanni Morone, presiding papal legate, it approved several important reform decrees dealing mainly with the responsibilities and powers of the bishops. A decree approved in December 1563 dealt with the invocation, veneration and relics of saints, and with sacred images. It was one of several decrees accepted almost unanimously by 255 Church fathers as the Council was being rushed to its close.

Against the iconoclasts, who had destroyed countless works of art in the Protestant regions of Europe, the Council taught that images of Christ, the Mother of God and the saints were to be given due honour and veneration for what they represented. In the use of images for edification and instruction, there must be no representation of false doctrine, no superstition, no quest for gain and no lasciviousness: 'images shall not be painted and adorned with a seductive charm, or the celebration of saints and the visitation of relics be perverted by the people into boisterous festivities and drunkenness'.

With these admonitions, the fathers of the Council were following rather than leading a shift in the attitudes of pope and bishops. They would no longer tolerate the indecorousness of the work of even the greatest of artists, including Michelangelo; he alone, admittedly, could have been allowed to paint a work with features as lewd and questionably orthodox as his Day of Judgement. Art – cleansed, but by no manner of means condemned – was to be a weapon at the service of the reformed Church, designed and directed with the guidance of the theologians.

Before the last session of the Council of Trent, about the time that Dolce's *Dialogue* reached Rome, Pope Paul IV had already been considering the destruction of Michelangelo's *Last Judgement*. His drive to impose good behaviour and order on the churches of Rome included the removal of works of art deemed improper. Michelangelo's reported jibe about putting the world rather than pictures to rights, when he heard Paul's wish to have him alter his fresco, was bitter rather than

fearful; but the pope's outrage over the nakedness of the saints, especially of the kneeling St Catherine, was ominous. Just after the end of the Council, censorship of the fresco was called for; the decision to have the nude figures retouched was reached on 21 January 1564, by a commission under the presidency of Cardinal Giovanni Morone, a friend of Michelangelo (as he had been of Vittoria Colonna). Michelangelo had enjoyed the friendship and favour of numerous Curial officials and cardinals. These men were not his personal enemies. To veil the offensive parts of the fresco, they turned to Michelangelo's friend and follower Daniele da Volterra, perhaps to soften the affront.

What Michelangelo knew about the decision to censor him, what he felt about it, we do not know. Soon after he completed the *Last Judgement*, in the winter of 1541, he had seen it start to deteriorate. (Paolo Giovio reported to Michelangelo that it was being destroyed 'through saltpetre and cracking' a few years after Urbino had been made its caretaker.) During the years when the suggestion was being bruited that some of the nude figures in the painting should be changed, even that the entire fresco be destroyed, Michelangelo's emotions were engaged far elsewhere.

PART FIVE

La Notte 1560–1564

93 The last *Pietàs*

In 1553 Michelangelo was still working on the *Pietà* showing a near-naked Christ with the Virgin, the Magdalene and Nicodemus. Vasari recorded that he was probably still carving this ('Florentine') *Pietà* in 1556, the year that ended with his flight to Spoleto and recall to Rome. When Michelangelo smashed the statue this time, Vasari was not too shocked. He thought Michelangelo had become exasperated either because the marble was hard and full of emery (so that his chisel struck sparks from it) or because he was being too severe with himself. Vasari also heard that Urbino had nagged Michelangelo every day to finish it. Very few statues, Vasari reflected, had been finished by Michelangelo since in his youth he perfected the Bacchus, the *Pietà* in St Peter's, the giant David and the Risen Christ in the Minerva. Apart from the statues of Duke Giuliano and Duke Lorenzo, of Night, Dawn, Day and Dusk, and of Moses, all the others – of which there were many – had been abandoned as soon as Michelangelo saw the tiniest flaw. This was why he had finished so few statues or pictures, Michelangelo had explained to Vasari.

After Francesco Bandini had been told he could take the broken *Pietà* away, his friend (and now Michelangelo's) the young Tiberio Calcagni persuaded Michelangelo to let him use the existing models and finish the statue for Bandini.

The *Pietà* as Calcagni left it was partly polished (the Magdalene, Christ's trunk, the folds in the shroud). The figure of Nicodemus, Vasari believed, represented Michelangelo himself. The left leg of Christ is missing, and probably it was because it would have been against his principles to add this on that Michelangelo despaired of the group he had meant for his own tomb. Unfinished, like so much of the work of Michelangelo's maturity, this broken *Pietà* mixing resignation, suffering and lamentation in the almost fused figures of Nicodemus, Christ and Mary and the Magdalene, is a powerful combination of abstraction and powerful representation.

Partly for his health's sake, Michelangelo started work on another, much smaller, *Pietà*, using a block probably already roughed out. And he was still working on a *Pietà* – a marble group, over six feet high – at the beginning of 1564, as he was approaching his eighty-ninth birthday. He would spend all day long standing before it, stopping for Sundays.

This ('Rondanini') *Pietà** he made with just the two figures of Christ and Mary: the son slumped but nearly upright, the mother behind him in the same passively supporting stance as Nicodemus in the 'Florentine' *Pietà*. The figures, seeming to support each other in their frailty, almost merge into one, however; and the sense of struggle is faint. By the thin, limp figures of Mary and Christ hangs a free-floating right arm from Michelangelo's first version.

Through the *Pietàs* of his old age, the drawings and the sculptures, Michelangelo struggled to reconcile his art with his renunciation of art, as he did in the poems he wrote after 1555.

The architectural designs and tasks of Michelangelo's old age, done without thought of gain, in the spirit of the Jesuits' motto *ad majorem Dei gloriam*, offered another way to reconciliation. They, like the Sistine paintings, brought him suffering, strife and what he perceived as outrageous betrayal.

Although Pope Pius IV reassured Michelangelo about his position as supreme director of the works of St Peter's, he could not protect him from abuse. Pope Paul IV had involved the bumptious Neapolitan Pirro Ligorio in the work at St Peter's, where Michelangelo's enemies were now saying that the old man was in his second childhood. Michelangelo's friend and supporter Cardinal Ridolfo Pio da Carpi seemed to be acquiescing in the murmurs of complaint. Michelangelo, apparently chastened, undoubtedly irate, wrote to ask to be relieved of the task.

The pope ignored Michelangelo's request if he ever received it. Michelangelo continued to keep as close an eye on the progress of the work as before, asking the deputies in the winter of 1561, for example, to appoint the young Pierluigi Gaeta as a colleague to his superintendent of the fabric, Cesare da Castel Durante. Pierluigi (a successor to Urbino) lived in Michelangelo's house and could explain to him every evening what was to be done the next day, Michelangelo said. He would pay him from his own pocket, if need be.

Michelangelo's adversaries struck again, more successfully, in 1563, after the death of Cesare da Castel Durante. The deputies refused to agree to Michelangelo's appointment of Pierluigi as Cesare's successor, and when he threatened to retire from the building work they claimed

* Milan, Castello Sforzesco, 75⅝ inches high.

that he was clearly too old and unfit and that Nanni di Baccio Bigio should now take over. Bishop Ferratini, one of the two deputies put in place by Julius III to protect Michelangelo's position, said when Michelangelo sent Daniele da Volterra to him to explain everything that he would willingly accept Daniele as a replacement. But then Ferratini himself had Baccio Bigio installed by the deputies, without consulting Michelangelo.

Nanni di Baccio Bigio overhauled the way materials were being taken to the site (a great waste of ropes, he alleged); stung by this, Michelangelo straight away hurried to find the pope and told him that the commissioners had found someone he knew nothing about to replace him, but if they and His Holiness had decided he was no longer capable he would withdraw to Florence. He would stay near Duke Cosimo and end his life in his own house.

The pope summoned a special conference of the deputies, dismissed Baccio Bigio on generous terms, and appointed the architect Francesco da Cortona to deputize for Michelangelo. Michelangelo's feelings were spared; he was further mollified when Pius, following precedent, commanded that there should be not the slightest deviation from his plans.

Every one of Michelangelo's brief and infrequent letters to Lionardo now carried, not surprisingly, the refrain that he was an old man. His vigorous emotional ploys and use of resource in defending his position at St Peter's showed that he kept all his old fiery temper.

But Michelangelo was vulnerable to exploitation, as Lionardo and the ever-observant, jealous Vasari knew only too well. The big house in Rome was stuffed with valuables of all kinds, odd amounts of money in considerable quantities (such as 200 gold crowns that Pius IV sent as a gift in 1562), works of sculpture allocated to different projects both in Rome and Florence, numerous drawings and records. Michelangelo needed more than just his servant Antonio del Francese to keep house for him, Vasari reported to Duke Cosimo, asking him to advise the pope secretly through his ambassador in Rome that a careful watch should be kept on those who were looking after Michelangelo, and an inventory be made of everything in the house, in case he had an accident.

In his letter to Lionardo written on 21 August 1563, Michelangelo spluttered with rage:

I see that you are lending credence to certain envious villains, who write to you with no end of lies, because they cannot manage me or rob me. They are all greedy sharks; and you are stupid to lend

credence to them about my affairs, as if I were a child. Clear them out of your way as the scandalous, envious, evil-living lot they are. As for the being looked after that you write to me about, and the other matter, well, as to being looked after, I could not be better off, I could not be better looked after and treated in everything more loyally; as for being robbed, which I think you mean, I tell you I have people in the house in whom I can repose trust and reliance.

Vasari was satisfied that a better watch was being kept on Michelangelo. Antonio stayed with him, and whatever surveillance was made was discreet, judging by the calm tone of Michelangelo's letter to his nephew just after Christmas 1563.

Michelangelo's calm clarity of insight can be seen from his spontaneous comments on certain passages in Condivi's *Life*, noted down by a friend. In their freshness and simplicity, these annotations seem to bring Michelangelo back in the flesh, speaking *viva voce* as he reflects on crucial events in his career, some of them well over half a century earlier.

By a passage where Condivi records Michelangelo's resolve, in the face of the anger of Pope Julius II, to leave Florence for the East, where he would build a bridge from Constantinople to Pera, the annotator wrote, 'It is true that he had already made a model, he told me.' At about twenty other critical points, Condivi's account of Michelangelo's life was extended or modified as Michelangelo reminisced in tranquillity on his turbulent past.

Early on, Condivi reported how Poliziano had given Michelangelo the story for his marble relief (the *Battle of the Centaurs*) and recalled Michelangelo's saying that he had done wrong not to give all his time to sculpture. 'Indeed he said that his art is sculpture; and he pursued the other arts to please the rulers.' The suggestion that Michelangelo thought this early work had achieved the perfection for which he would ever afterwards be striving was confirmed further on by the annotation 'This work at home seems perfect to me.'

The notes also suggest that Michelangelo had fled from Piero de' Medici's Florence not only because of the dire prediction of Cardiere's vision, but also because of the growing unpopularity of Piero; that the behaviour of Cardinal San Giorgio in returning Michelangelo's statue of Cupid because it was not an antique still rankled; that Michelangelo had once said that Donatello's Judith and Holofernes (not his bronze

David) had not been polished, and that this did not matter so much if the work was good.

Other notes show Michelangelo's wish in his vigorous age to quash the idea that he had been particularly hostile to Bramante, and to refute Condivi's statements that, after he had abandoned sculpture for fifteen years, he had started work again on the Medici tombs for Pope Clement (after the return of the Medici to Florence in 1530) driven more by fear than by love: 'All nonsense,' he commented.

Where Condivi wrote of the tragedy of the tomb that at least it had yielded three great statues, though the final monument was botched and bungled, Michelangelo reflected, 'If only all botched things were so . . .' Yet another note confirms it was for his friend Cardinal Niccolò Ridolfi that Michelangelo began his bust of Brutus – a fact strangely ignored by Condivi.

The notes reveal significant details about still more intimate aspects of Michelangelo's life. On the passage where Condivi had written of the mutual love of Michelangelo and Vittoria Colonna, the annotation stated that, because of this, Michelangelo had always kept her portrait at his home. Where Condivi described Michelangelo in his late seventies as eating frugally, sometimes content with just a piece of bread when working, sleeping little, ever acting generously and charitably, and keeping healthy through physical exercise and sexual continence, the note read, 'as for coitus: I have always observed this [continence] and if you wish to prolong your life indulge in it as little as possible'.

A skeleton with a coffin drawn over the stairs of the house in Macello de' Corvi reflected Michelangelo's sometimes grim sense of humour. In his serious, solitary struggle with guilt and faith, so his friend Ludovico Beccadelli implied, Michelangelo reached some kind of mystical resolution through his readiness for death as the supreme experience for the comprehension of life. The archbishop wrote on 27 June 1556 that through Urbino's death Michelangelo had gained courage to die willingly; such was God's grace for those he loved, for whom he made all things well. Wise men, Beccadelli had said, quoting from the Psalms (116: 16–17), would sing with the Prophet, 'Lord, thou has undone the bonds that bound me, and to thee will I bring a thank-offering.' He knew that Michelangelo did not need to be told this consolation.

Vasari once heard Michelangelo say to a friend who suggested that it must sadden him to think of death, since he had devoted all his time ceaselessly to art, that this was not so, for if life were found to be

agreeable then so should be death as coming from the hands of the same master.

In the *Trionfi*, Petrarch's poems written in his old age on the transitory phases of human life, Love, Chastity, Death, Fame and Time conquer and are conquered in turn by each other until the final triumph of God's Eternity, *la Divinità*. The last of the verses of the *Trionfi* describe Petrarch's horror, in old age, at the flux of the world, his turning to faith and trust in God's grace, and his vision of his beloved Laura, her soul reunited with her resurrected and glorified body in heaven.

Many of Michelangelo's themes and images stemmed from the three fatalities of Love, Death and Time; but he was denied the consolation of Petrarch's resolution of life's impermanence through revivified human love. The goal of Platonic ascent to the skies on paired wings with his *signore* Tommaso de' Cavalieri ('*S'un casto amor* . . .') had been succeeded by the hope of unimaginable bliss in the arms of the *Signore* Christ. In his advanced old age, Michelangelo, attuned to the transitoriness of human art and love, sought peace in God's will and defeated despair by transmuting his art into architecture and reconciling it with the Eternal Divine.

94 Architecture and divinity

Michelangelo had received no professional training in architecture, but he displayed stupendous originality and competence, and had a seemingly instinctive grasp of its mathematical content. The 'architects' of Michelangelo's time included the *capomaestro*, who supervised the execution of the designer's plan; the adviser, who judged its suitability; and also the engineer.

The Florence of Michelangelo's boyhood and the Rome of his maturity instructed his intellect and eye through the works of Brunelleschi and Alberti, Michelozzo, Bramante, Raphael and Antonio da Sangallo. (Sangallo, exceptionally among the great artists, had been prepared for the career.) In Rome, he was also familiar with the classical ruins and the almost intact Pantheon.

Vasari, in the second edition of his *Lives*, described architecture as the most universal, necessary and useful of the arts, served and adorned by sculpture and painting. The excellence of modern architecture,

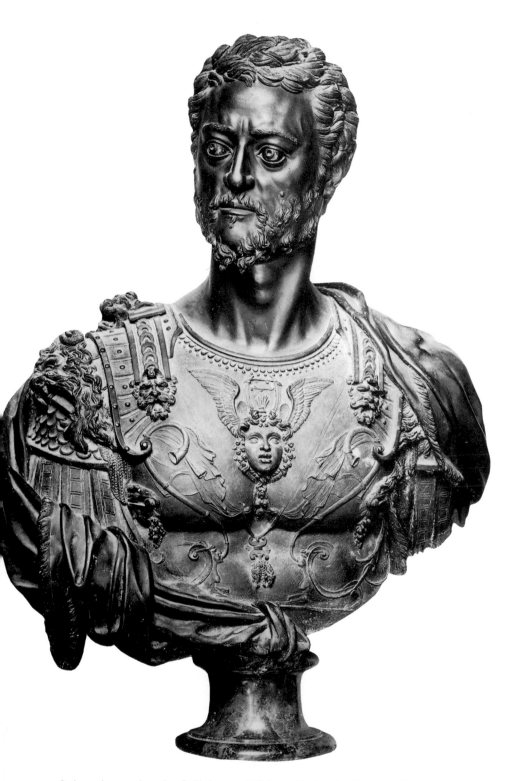

49. *Cosimo I*, bronze bust by Cellini, 1545–8 (Museo Nazionale, Bargello, Florence)

50. *The Seven Churches of Rome*, published by Antoine Lafréry, 1575.
The new St Peter's is shown rising behind the old

51. *Allegorical Scene (Nations Paying Homage) from the Life of Pope Paul III*, fresco by
Giorgio Vasari, 1546 (Palazzo della Cancelleria, Rome)

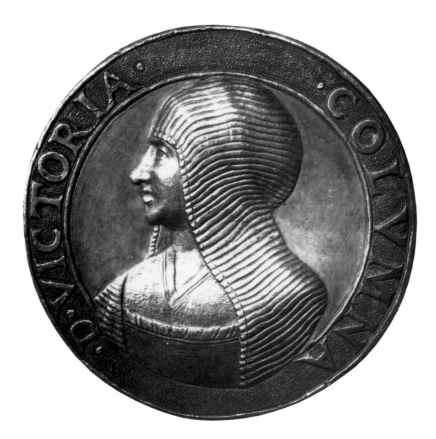

52. *Vittoria Colonna, Marchioness of Pescara*, bronze portrait medal, Italian school
(Bibliothèque Nationale, Paris)

53. *Pietro Aretino*, portrait medal *c.*1553 by
essandro Vittoria (1525–1608) (British Museum)

STEMMA BUONARROTI

54. The coat of arms of the Buonarroti family

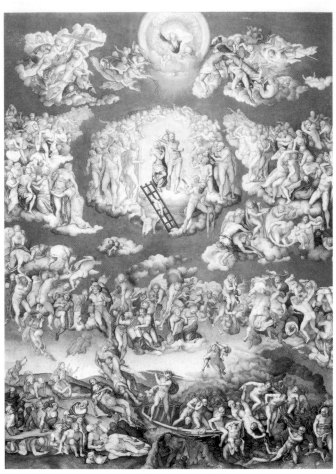

55. *Last Judgement after Michelangelo*, parchment, by circle of Giulio Clovio, *c.*1570 (Casa Buonarroti, Florence)

56. *The Risen Christ*, or *Christ Descending to Limbo*, black chalk, by Michelangelo (British Museum)

57. The *Last Judgement*, detail showing a presumed self-portrait of Michelangelo as the skin of St Bartholomew, fresco (Sistine Chapel)

58. Sketch for a (pointed) dome of St Peter's, black chalk and pen attributed to Michelangelo, 1546 (Musée des Beaux-Arts, Lille)

59. Plan for the drum of the cupola St Peter's, drawing by Michelangelo (Uffizi, Florence)

60. Wooden model for the dome of St Peter's by Michelangelo and Giacomo Della Porta, begun c.1558 (Museum of St Peter's, Rome)

. *The Capitoline Hill, Rome*, drawing by Italian school, *c.*1554–60, showing the look of the site when Michelangelo`s designs were beginning to be implemented (Louvre, Paris)

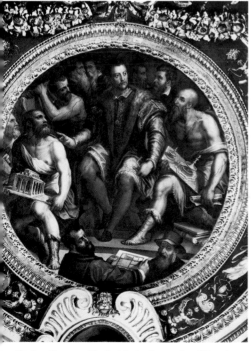

2. *Cosimo I among his Architects*, fresco by Giorgio Vasari, 1562–72 (Palazzo Vecchio, Florence)

63. Study for the central portal of the Porta Pia, Rome, black chalk, pen, wash and white pigment drawing by Michelangelo, 1561 (Casa Buonarroti, Florence)

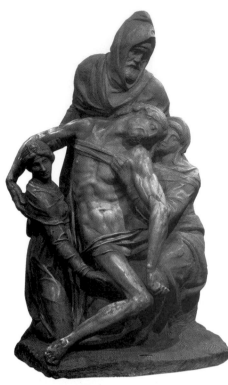

64. *Pietà*, with self-portrait, marble by Michelangelo
and Tiberio Calcagni, *c.*1547–55 (Museo dell'Opera
del Duomo, Florence)

65. *Varchi's Oration at the Funeral
of Michelangelo in San Lorenzo*,
oil on canvas, by Agostino
Ciampelli, before 1620
(Casa Buonarroti, Florence)

Vasari taught, sprang from its perfection of good rule, order, proportion, design and style: *regola, ordine, misura, disegno, maniera*. The values of the architect (especially of Vasari's master, Michelangelo) were practical as well as aethestic.

The Composite order, Vasari said, though not much mentioned by Vitruvius, had been used by the Romans and perfected by the moderns, who used it more effectively than any of the ancients did. For the truth of this, he pointed to the work of Michelangelo in the sacristy and library of San Lorenzo in Florence, and in the second storey and cornice of the Casa Farnese.

> He who wishes to see in this manner of work the proof of this man's excellence – of truly celestial origin – in art and design of various kinds, let him consider that which he has accomplished in the fabric of St Peter's in compacting together the body of that edifice and in making so many sorts of various and novel ornaments, such beautiful profiles of mouldings, so many different niches and numerous other things, all invented by him and treated differently from the custom of the ancients. Therefore no one can deny that this new Composite order, which through Michelangelo has attained to such perfection, may be worthily compared with the others.

Michelangelo had done several designs for the church of the Florentines in Rome, San Giovanni, when he wrote to Cosimo at the end of 1559 to say that he would have the best of them copied for him and would be working as best he could from his own house. Michelangelo gladly entrusted the execution of measured drawings and a clay model to Tiberio Calcagni, who also supervised the building of a wooden model. However, after Calcagni's visit to the duke in 1560, and more discussions in Rome, Tiberio was replaced and the project again went into limbo, presumably for lack of financial support.

The studies Michelangelo left for San Giovanni showed his concern with the flow of axes rather than the stability of shapes, with an open area of convergence rather than a central point, and (in the last drawing) with the masses needed to support a heavy dome. In Michelangelo's final model for San Giovanni he created a novel plan reconciling the church's circularity with its monumental entrance façade. In the stages from first study to final model, Michelangelo's design moved towards simplicity and repose. The domed roof of the church pressed down massively on the developing plasticity of the base;

great windows round the drum would drench the central flooring of the church with broad shafts of falling light.

Michelangelo also about 1560 entrusted Tiberio Calcagni with his yet more novel design for a chapel begun at the church of Santa Maria Maggiore for Cardinal Guido Ascanio Sforza.

Pope Pius's exuberant Medicean-style building programme was expanded at the beginning of the 1560s (partly from fear of surprise attack by the Turks) to embrace a big new scheme of fortification. But the papacy's new sense of triumphal certitude was nowhere more clearly demonstrated than in the programme to reconstruct the Baths of Diocletian, consecrated in 1561 as the church and monastery of Santa Maria degli Angeli. The project had been promoted for about twenty years, by a Sicilian priest inspired by a vision of angels. Michelangelo produced a simple, bold design making as few changes as possible to the surviving structures but well suited to the hermetic needs of the Carthusians and using a Greek-cross plan like that for San Giovanni dei Fiorentini.

In March 1561 work began on a new entrance to the city, the Porta Pia, between the ancient Porta Nomentana and the Porta Salaria, with Michelangelo as director. He produced, Vasari noted, three lavish and beautiful designs, of which Pius chose the least costly. Michelangelo, again breaking with tradition, designed an inward-facing gate – a thin brick screen through which the wide new street would run from the Quirinal hill to the church of Sant'Agnese, outside the walls.

Michelangelo's surviving chalk drawings for the Porta Pia show the portal and the central panels. Deliberately, it seems, he eschewed the obvious Roman precedents and created a theatrical fantasy. A shocking feature of the Porta Pia was the savagery of a grotesque mask carved over the keystone, a salutary reminder for people leaving Rome of what they might encounter outside the safety of the walls.

For the work on the Porta Pia, during 1563–4 Michelangelo received 'on account of Pierluigi Gaeta his agent' the sum of fifty crowns a month. For his work at St Peter's, Michelangelo reiterated that he had wanted no payment: he would do the work for the good of his own soul and the glory of the Church. He and his friends knew they had little time left to settle the essential features of the basilica and make it impossible for his intentions to be frustrated; and to keep the great project, so Vasari planned, in the right hands.

From 1557, when the drum was almost finished, Michelangelo's designs for St Peter's were mostly concentrated on the dome. He intended his dome to emulate the breath-taking grandeur of Brunelle-

schi's at Santa Maria del Fiore in Florence, and he took from this the double-shell and rib construction (though with sixteen ribs rather than eight) and the raised profile, octagonal lantern and round openings of the drum.*

As the builders climbed ever higher, Michelangelo continued to modify his existing ideas and designs. In particular, he progressively lowered the profile of the dome from an elevated curve to a hemisphere. This affected the key design of the lantern, which continued and completed the dynamics of the paired columns in the drum and the ribs of the dome. Michelangelo's drum, dome and lantern rising over the massive basilica against the Roman sky and hills were meant to be enriched with an attic and a series of colossal statues. Among Michelangelo's last decisions was the device of bringing diffused light into the dome through hidden sources.

95 Lionardo summoned to Rome • Michelangelo's last illness and death

When, just after Christmas 1563, Michelangelo wrote to thank Lionardo for some cheeses, he mentioned that in future he would get others to write his letters and he would only sign them. It was just over two years since a bad illness in the summer of 1561, when 'being an old man', he was arranging to have alms given in Florence for the good of his soul. A few months after this, he had appointed Pierluigi Gaeta to report regularly to him at home in Macello de' Corvi on the daily progress of the work at St Peter's. He stayed physically active and seemed mentally as quick and creative as ever. The powerful guardian figures in his last years of life, Pope Pius and Duke Cosimo, watched over him.

In Rome, the pope rejoiced over the resoundingly successful conclusion of the Council of Trent; in March 1564 he received the first printed edition of the Tridentine decrees, officially announcing the Counter-Reformation.

In Florence, as a loyal Catholic prince, Duke Cosimo promoted the

* The dome model, as altered by Giacomo della Porta, is in St Peter's, Rome.

reform of religion through measures which included restoring churches and making monasteries with cure of souls subject to the bishops. He also, at the urging of Vincenzo Borghini, forbade the priests in San Lorenzo to light the stoves whose smoke had been blackening Michelangelo's crowd-drawing statues. In 1563 Cosimo accepted the presidency of the Accademia del Disegno; Michelangelo had been nominated 'head, father and master' of all the other thirty-six distinguished academicians of the city and the dominion.

In very shaky writing, Michelangelo added his signature to a letter from Daniele da Volterra to Lionardo in Florence, dated 14 February 1564, containing the summons Michelangelo's nephew had sometimes anticipated. Michelangelo was of sound constitution, Daniele wrote, though sometimes he experienced stomach and other kinds of upset, as happened with everyone born into this world. Then yesterday, the letter continued, as Michelangelo was breathing rather heavily and sunk deep in sleep, Antonio, Michelangelo's servant, had sent for Daniele and had said that Michelangelo would like Lionardo to be sent for. It was mentioned that Lionardo had expressed the wish to spend some days in Rome during Lent to see Michelangelo and make his devotions. Three or four times, Michelangelo had prayed Daniele for this. 'So it would seem to me', Daniele wrote, 'that you should not delay in coming here; and when you are here you will be able to arrange things for the future as will seem best to him and you.'

Tiberio Calcagni wrote to Lionardo from Rome on the same day as Daniele. Many people had just told him that Michelangelo was ill, he said. He had at once gone to see him, and, though it was raining, had found him up and about. He had told Michelangelo that it did not seem right for him to be out of doors in such weather. 'What do you want me to do?' he had been asked. 'I am ill and I cannot find peace anywhere.' From what he saw and heard, Calcagni thought perhaps through divine grace he might be with them a little longer.

Covering the letter from Daniele, and dated 15 February, was a note to Lionardo from the Sienese Diomede Leoni:

> I have taken care to direct to you the enclosed letter, written by messer Daniele Ricciarelli da Volterra and subscribed by messer Michelangelo your uncle, by which you are informed of his indisposition, which started yesterday morning, and of his wish that you come to Rome. I urge you to come immediately, but with sufficient care not to risk riding post by the bad roads in a manner to which you are not accustomed, for indeed to someone not used to it this

kind of travelling is dangerous as well as violent. And you can all the more endeavour to betake yourself here in good time and safely, as you can be certain that messer Tommaso de' Cavalieri, messer Daniele and I will not fail in your absence in every possible duty for your honour and advantage. Besides, Antonio, his old and faithful servant, is bound to give a good account of himself in whatever circumstances God wills. Antonio himself wished to send the letter post-haste by courier; but, as this seemed to me likely to cause you more alarm than otherwise, I have advised and persuaded him to send it this way, which I consider as quick and safe as the other . . . But to give you some account of his state up to the present hour, I tell you that I left him on his feet clear-headed and in good spirit, but heavily weighed down by unending somnolence; and to rid himself of this, today between 22 and 23 hours he wished to make the effort to ride, following his custom every evening in good weather; but the coldness of the season and the weakness in his head and legs prevented him, and so he went back to his fireside, to sit down in a chair, where he stays more willingly than in bed. We are all praying God to preserve him yet for some years, and to bring you safely to Rome.

On Saturday 12 February, Michelangelo had been working on the block for his 'Rondanini' *Pietà*. During the feverish illness which started almost immediately afterwards, he was looked after by Antonio del Francese and two medical attendants, Federigo Donato and Gherardo Fidelissimi, who treated him with herbal medicines: concoctions of honey, vinegar and seawater, and crushed almonds in water. He burned or caused to be burned in two lots a large number of his drawings, sketches and cartoons, no doubt with some of his verses. He made a simple declaratory will (leaving his soul to God, his body to the earth, and his possessions to his nearest relations) in three sentences.

Michelangelo asked his friends to recall to him, as he died, the suffering of Christ. The friends gathered around him during these few days were Daniele da Volterra, Tommaso de' Cavalieri, Diomede Leoni and Tiberio Calcagni. Michelangelo died in the late afternoon of 18 February 1564. That evening, Gherardo Fidelissimi wrote to Duke Cosimo to inform him of Michelangelo's death and the wish he had voiced to be buried in Florence.

Even before Lionardo reached Rome, an inventory had been taken by

the governor of the city of everything in the house in Macello de' Corvi, at the insistence of Duke Cosimo's ambassador Averardo Serristori. Cosimo learned to his chagrin that there were left in the house 'few things and still fewer drawings'. Itemized as being in Michelangelo's own room were ten cartoons, some in pieces; the plan of the fabric of St Peter's; a small palace façade; a window of St Peter's; the old plan of St Peter's, said to be after Sangallo's model; three sketches of figures; drawings of a window and other things; a big *Pietà* with nine unfinished figures; sketches of three large figures and two putti; a single large figure; and sketches of Christ and the Virgin. There was also a walnut chest that had been locked and then secured with the seals of Cavalieri and Leoni, against the arrival of Michelangelo's nephew, in whose presence it was later opened and the monies it contained in a variety of receptacles from handkerchiefs to copper pots were written down.

Among the works of art downstairs were an unfinished statue of St Peter; an unfinished figure of Christ with another figure attached to it above; and a very small unfinished statue, a Christ with the Cross. In the stable they found a little chestnut horse, with saddle and bridle.

When Lionardo arrived he found that Michelangelo's corpse had been taken by fellow members of the confraternity of San Giovanni Decollato to the church of the Santi Apostoli, honoured by a huge concourse including friends, Florentines and artists. Pope Pius IV, so the story went round, had promised that he would erect a memorial and sepulchre for Michelangelo in St Peter's itself. Michelangelo, however, as on 17 March Daniele da Volterra confirmed in a letter to Vasari, had wanted at least his bones to be interred in Florence.

Daniele's letter also contained some moving references to the last days of Michelangelo, who, after he had sent for Daniele on the Monday, had exclaimed, 'O Daniele, I am done for, I am in your keeping, do not abandon me.' He had spent two days during his last illness by the fire, three days in his bed.

The leading artists and *cognoscenti* of Florence had no doubt where Michelangelo's body rightly belonged; they were also well aware that his final homecoming would present a unique opportunity for promoting the arts. Scarcely had Michelangelo died than Vincenzo Borghini was writing to Vasari with the suggestion that the Academy should mark the occasion with some special event, with a funeral service where he could be praised, the arts honoured, and the younger men inspired. Vasari responded, of course, with enthusiasm and swung into action.

First he must mollify Duke Cosimo, who was deeply vexed when he heard that Michelangelo had put so many drawings and papers in the

fire, including, he presumed, the designs for the façade of San Lorenzo, the Medici family church. This seemed an act unworthy of Michelangelo, the duke wrote in a letter to Serristori.

Vasari wrote to Lionardo in Rome, telling him how to help appease Cosimo (for example, by assuring him that the few pieces of sculpture left in Michelangelo's workshop in Via Mozza should be his, if he pleased). Vasari then wrote a supporting letter to the duke. On 2 March Borghini sent the petition of the academicians to hold an ambitious memorial service in San Lorenzo itself. Duke Cosimo wrote to Borghini on 8 March that he wanted the Academy to celebrate 'in every way possible the genius of this great man'. He even promised financial support, though in the event this was meagre.

On 9 March the customs office in Florence informed Vasari of the arrival from Rome of the coffin with the body of Michelangelo, a consignment addressed to Vasari. There was an upsurge of mass enthusiasm – part genuinely affectionate and patriotic, part engendered by the (chiefly moral) pressure exerted by the officials of the Academy on its members to turn out and take part. The ambiguous myth of Michelangelo as a reluctant exile was refurbished; his absence so long from Florence, it was explained, had been because of the quality of the air, sharp and keen, unlike Roman air, which was sweeter and more temperate and had kept him in the best of health. Never before had an artist living or dead been so honoured as was Michelangelo in March 1564.

On 11 March Michelangelo's corpse was placed in the vault of the Confraternity of the Assumption, in San Piero Maggiore. The next day, the second Sunday in Lent, scores of artists flocked to the church, where they draped a velvet pall embroidered with gold on the bier and the coffin, with a crucifix on top. At nightfall, among those now gathered round the coffin, the oldest and best known each took hold of a flaming torch and simultaneously the young men raised the bier. The noise and movement around San Piero Maggiore had attracted more and more people, and the crowd grew enormous when it was learned that Michelangelo's body was there and about to be carried to Santa Croce. Precautions had been taken to keep the proceedings secret, for fear of turmoil and because the academicians wanted the impact of a tremendous public display to come later. However the news passed from mouth to mouth, and almost instantly, it seemed, Santa Croce was so crowded that it was a struggle to bear Michelangelo's corpse to the sacristy, where it was freed from its wrapping and laid to rest. The funeral procession – a sea of wax-lights, with mourners in black, priests

and acolytes, artists – stood still as the monks prayed for the soul of the dead man.

Vincenzo Borghini, there as the representative of the duke, had the coffin opened, apparently on impulse (to please the people and to see for himself in death the great artist he had never seen alive, he explained later). They were all astonished to find Michelangelo's body still perfect in every part, free of any evil odour, as if he were sunk in a sweet sleep. Though his features were touched with the pallor of death, his limbs were clean and intact, and his face and cheeks felt as if he had only a short while before been alive.

The great crush of people subsided, and the body was moved to a tomb near the altar of the Cavalcanti family. The following morning, verses in praise of Michelangelo, written in Latin and Florentine, were being attached to the tomb.

For weeks, the organizing committee of the Accademia del Disegno worked on the decorations and the programme for the obsequies. After cantankerous exchanges, the arrangements were put in the hands of Vasari and Bronzino, for the painters, and Ammanati and Cellini for the sculptors, with Zanobi Lastricati in the hard seat of *provveditore*. Cellini arrogantly submitted his own modest proposals, saw them rejected in favour of the grandiose ideas of Vasari and Borghini, and went into an angry sulk.

On 14 July 1564 Michelangelo's obsequies, beginning with the singing of a solemn mass for the dead and ending with Varchi's funeral oration, were solemnized in the crowded church of San Lorenzo with an enormous catafalque in the nave, which was all draped in black cloth, symbolic statues and large paintings, showing significant scenes from Michelangelo's life, and ingenious figures of Death along the walls, alternating with representations of Michelangelo's emblem of the three crowns: circles that were equally intertwined, taken by the academicians to mean that Michelangelo had been perfect in each of the three arts of design and that each had furthered and embellished the other.

Europe was now divided between Roman Catholicism and Protestantism, but the artists had profited from the continuing prosperity in Italy throughout the long phase of dynamic change. Even the wars, whose demands had so often diverted funds from artistic projects during Michelangelo's lifetime, brought enormous amounts of money into the peninsula. Michelangelo himself was the prime example of the new wealth and status of the artist.

The decorations in San Lorenzo stayed up till August 1564, exalting

Michelangelo but also proclaiming the sublime virtuosity of the artist and so the importance of the profession, and the apotheosis of the Medici, autocratic rulers of Florence and its *dominio*, in a spirit totally alien to that of Michelangelo's life and work.

Notes on the text

xvi *painters and sculptors flourished*: Writers and artists of the 600 'creative élite' active during the period are discussed in Peter Burke's methodologically controversial and fascinating book *The Italian Renaissance: Culture and Society in Italy* (Cambridge, 1986).

xvii *as a colourist*: From the ever-rising pile of articles and books on the cleaning of Michelangelo's frescoes in the Sistine Chapel I recommend reading to start with the enthusiastic articles by Kathleen Weil-Garris Brandt, David Ekserdjian and Ezio Buzzegoli in *Apollo*, December 1987, pp. 392–408. They were written before the cleaned *Last Judgement* was officially revealed in the spring of 1994, the culmination of a controversial cleaning programme by the Vatican Museums' Conservation Laboratory that started in June 1980.

4 *from motives of propaganda*: In his revised 'Life of Michelangelo' for the second edition of *Lives of the Artists*, Vasari used an engraved portrait showing Michelangelo (alone of all the artists) wearing a brocaded, fur-lined coat – a splendid illustration of his transformation into a Medicean courtier as well as a genius.

4 *the decorations*: See *The Divine Michelangelo: The Florentine Academy's Homage on his Death in 1564*, a facsimile edition of *Esequie del Divino Michelangelo Buonarroti Florence 1564*, introduced, translated and annotated by Rudolf and Margot Wittkower (London, 1964). The *Esequie*, published as a novel style of commemorative pamphlet by the printing house of Jacopo Giunti, provided Giorgio Vasari with most of the material for his description of the obsequies of Michelangelo which ended his biography of Michelangelo in the second (1568) edition of *Lives of the Most Excellent Painters, Sculptors and Architects*. Rudolf and Margot Wittkower argue convincingly for assigning 'the spiritual authorship [of the little booklet] as well as substantial contributions' to Vincenzo Borghini.

7 *I record that*: Cf. Karl von Frey, *Michelagniolo Buonarroti Quellen und Forschungen zu Seiner Geschichte und Kunst* (Berlin, 1907), vol. 1, p. 3, and Aurelio Gotti, *Michelangelo Buonarroti* vol. 1, p. 3.

8 *Rucellai descent*: For a family tree of the Rucellai family see *La Famiglia Rucellai*, Luigi Passerini (Florence, 1861). I am grateful to John Bury for this information and for his 'discovery' of the relationship of Giovanni Rucellai to Michelangelo Buonarroti.

8 *416 florins*: Coinages varied from one Italian state to another in Michelangelo's time. In commerce, prices were still often quoted in ancient *lire*, *soldi* and *denari*. A new gold standard had appeared in 1252 with the first minting of Florence's gold florin (*fiorino d'oro*), later supplemented by the florins circulated in sealed leather bags (*fiorino di suggello*) and then superseded by the broader gold florin (*fiorino largo d'oro*) of 24 carats, defended by Florence as the most

important trading currency. Venice issued gold ducats from 1284; these too went into general circulation and also came to be minted in Rome. About 1540 both the florin and the ducat were officially replaced by another, rather higher-value, gold coin, the *scudo*. Cf. *The Letters of Michelangelo*, trans. and ed. E. H. Ramsden (2 vols., London, 1963), vol. 1, app. 3, and the illustrated book *Monete Fiorentine dalla Repubblica ai Medici* edited by Beatrice Strozzi (Florence, 1984). On relative rewards for artists see D. S. Chambers, *Patrons and Artists in the Italian Renaissance* (London, 1971).

11 *scolded*: In his revised 'Life of Michelangelo', published in 1568, Vasari wrote that, because of his drawing, Michelangelo was sometimes beaten by his father and older members of the family; Condivi's earlier published *Life* records that Michelangelo was scolded by his father and uncles and often outrageously beaten after Granacci had begun to encourage Michelangelo to draw. The story seems no less likely for becoming a commonplace theme in lives of artists.

For the difference in age and the relationship between Michelangelo and Granacci, see especially Giuseppe Fiocco, '*La data di nascita di Francesco Granacci e un'ipotesi michelangiolesca*', in *Rivista d'Arte*, April–June 1930, and Herbert Einem, *Michelangelo* (English edn trans. Ronald Taylor, London, 1973), p. 272.

12 *Michelangelo came to his workshop*: In accord with Vasari it has been generally accepted that on 1 April 1488 Michelangelo's father contracted with Domenico and Davide Ghirlandaio to take him as an apprentice for three years. But there is documentary evidence for payment by Domenico to Michelangelo being debited on 28 June 1487, suggesting an earlier association when Ghirlandaio was painting an altarpiece for the Ospedale degli Innocenti. If Vasari's date of 1 April 1488 for the start of the apprenticeship was based on a misreading or mistranscription, for 1 April 1487, soon after Michelangelo's twelfth birthday, Michelangelo could have seen Ghirlandaio working on a panel painting as well as in fresco, and have spent a year or more with him as well as several years subsequently in the home of Lorenzo de' Medici before the latter's death on 8 April 1492. Cf. Jean K. Cadogan, 'Michelangelo in the workshop of Domenico Ghirlandaio', *Burlington Magazine*, January 1993.

13 *trained on the job*: Chambers, *Patrons and Artists in the Italian Renaissance*, pp. 172–5.

13 *that the said Michelangelo*: Giorgio Vasari, *Lives of the Artists*, trans. George Bull (2 vols., Harmondsworth, 1987), vol. 1, p. 327.

14 *Masterpieces in Santa Maria Novella*: And in Florence's many other churches, not least Santa Maria del Carmine, where the recent cleaning of the frescoes in the Brancacci Chapel reveals the power and humanity of Masaccio's figures, and command of space and perspective, along with Masolino's skilful use of light and shadows and loving familiarity with the detail of daily life in early fifteenth-century Florence.

Details revealed more clearly through the earlier completion of the restoration

of Ghirlandaio's frescoes in the choir of Santa Maria Novella, pointing to the many different hands at work, also prompted speculation that several figures in the scenes of the Death of the Virgin and the Baptism of Christ betray the hand of the young Michelangelo about 'to turn his back on a world which was not for him . . .' (cf. Giuseppe Marchini, 'The Frescoes in the Choir of Santa Maria Novella', *Burlington Magazine*, xcv, 1953, pp. 320–31).

15 *Bertoldo*: See James David Draper, *Bertoldo di Giovanni: Sculptor of the Medici Household* (Columbia and London, 1992). This critical reappraisal and *catalogue raisonné* of Bertoldo's work makes a spirited defence of the overall truth of Vasari's account of the Medici garden and collections in Via Larga, under the supervision of Bertoldo and functioning as a meeting-place, an academy, for students.

16 *You'll always be poor*: Cf. *Michelangelo: Life, Letters and Poetry*, trans. George Bull and Peter Porter (Oxford, 1987), p. 14.

17 *Lorenzo remarked*: E. Bigi (ed.), *Commento ad alcuni sonetti d'amore* in *Lorenzo de' Medici: Scritti Scelti* (Turin, 1965), p. 133.

19 *The soul, consumed: The Letters of Marsilio Ficino*, vol. i (London, 1975), p. 85.

19 *from the material*: Ibid., vol. ii, p. 35.

19 *something of a model*: Ibid., vol. iii, p. 144

19 *influence of Ficino*: Charles Trinkaus, 'Marsilio Ficino and the Ideal of Human Autonomy', in Eisenbichler and Pugliese (eds.), *Ficino and Renaissance NeoPlatonism* (Toronto, 1986).

21 *The struggling male nudes*: In his *Life of Michelangelo*, Condivi reported that the subject for the marble relief was suggested to Michelangelo by Poliziano. It is impossible to relate Michelangelo's nude male figures in detail to the classical legend of the battle between Lapiths and Centaurs, and in the contemporary Italian way he veils the realism of the horrors of war (Ovid's cracked skulls, gouged out eyeballs, vomited blood and splattered brains in *Metamorphoses* Book xii), following rather Imperial Roman sarcophagus fronts. Cf. Charles de Tolnay's *Michelangelo Sculptor, Painter, Architect*, trans. Gaynor Woodhouse (Princeton, 1985), where the relief, which Michelangelo loved, is classified as a 'personal interpretation' of antiquity (p. 5). For specifically Bertoldo's influence on the battle scene – including nudity, figural proportions and vertical descents – see Draper (*Bertoldo di Giovanni*, p. 40), who also notes Michelangelo's 'far grander assimilation of antique forms'.

22 *Giovanni was admonished*: Cf. Judith Hook, *Lorenzo de' Medici* (London, 1984), p. 185.

22 *gently criticized*: Roberto Ridolfi, *The Life of Girolamo Savonarola*, trans. Cecil Grayson (London, 1959), p. 34.

25 *flayed many corpses*: Kenneth Clark, *The Nude* (Harmondsworth, 1985), pp. 183–95.

26 *The wooden crucifix*: The crucifix for Santo Spirito has been identified with the crucifix found in Santo Spirito and placed in the Casa Buonarroti and also

NOTES ON THE TEXT

NOTES ON THE TEXT 421

with the crucifix of San Rocco in Massa Carrara, for which see especially *'Michelangelo Crocefisso, 1493'* in Alessandro Parronchi (ed.), *Capolavori di scultura fiorentina dal XIV al XVII secolo* (Florence, 1986).

27 *And behold*: Genesis 6:17.

29 *The statues demonstrated*: James Beck (*Jacopo della Quercia* (2 vols., New York, 1991) *passim*) in treating della Quercia as the proto-Michelangelesque artist *per eccellenza* reflects that, after his youthful encounter with della Quercia in the early 1490s, Michelangelo had the chance to examine his work carefully at first hand when in 1508 his statue of Julius II was placed on the portal of San Petronio above the lunette containing della Quercia's Madonna. 'Time and time again Michelangelo's solutions are predicted by Jacopo's art: the prophets and sybils on the Sistine ceiling are one body of examples, but the Bruges Madonna provides another' (op. cit., p. 120).

Johannes Wilde, *Michelangelo: Six Lectures* (Oxford, 1978) notes Michelangelo's 'more modern style' and 'multitude and faultlessness of details' after his stay in Bologna.

29 *alleged that the commission*: Giovanni Papini, *Vita di Michelangiolo nella vita del suo tempo* (Milan, 1951), pp. 68–70.

30 *Francesco Gonzaga*: Michael Mallett, *Mercenaries and their Masters* (London, 1974), pp. 245–8.

31 *austerity and exaltation*: Richard Trexler, *Public Life in Renaissance Florence* (London, 1987), pp. 474–90.

31 *Morganti*: Luca Landucci, *A Florentine Diary 1450–1516*, trans. Alice de Rosen (New York, 1969), p. 130, refers to Pulci's mocking and irreverent poem on an unruly giant: *Il Morgante Maggiore*.

32 *syphilis*: See Girolamo Fracastoro, *Syphilis or the French Disease*, trans. Heneage Wynne-Finch (London, 1935). The historical origin of syphilis in Europe is still in dispute.

32 *inspired by Savonarola's religious teaching*: For Savonarola's disputed artistic influence, see Ronald M. Steinberg, *Fra Girolamo Savonarola, Florentine Art and Renaissance Historiography* (Athens, Ohio, 1977).

33 *mysterious* Primavera: 'Mysterious' partly because commentators have made it so, but 'one thing can be said of this picture without fear of contradiction: the imagery is of Spring . . . love, too, is part of the Spring' (L. D. and Helen S. Ettlinger, *Botticelli* (London, 1976), pp. 128–30).

34 *Then on Sunday*: Gaetano Milanesi, *Le lettere di Michelangelo Buonarroti pubblicate coi ricordi ed i contratti artistici* (Florence, 1875; Osnabrück, 1976), CCXLII; Giovanni Poggi, Paola Barocchi and Renzo Ristori, *Il carteggio di Michelangelo* (5 vols., Florence, 1956–83), vol. I, I. For this and quotations from other letters of Michelangelo, I have followed usually E. H. Ramsden's dating, using my own translations.

For some reason, perhaps the suspect position of the Medici in Florence, the letter to Lorenzo di Pierfrancesco was sent addressed to Sandro di Botticelli in Florence, but the extant copy is not in Michelangelo's handwriting and may have been a copy made specifically for Botticelli.

36 *The circular composition*: Maurice Bowra, 'Songs of Carnival and Dance', in
E. F. Jacob (ed.), *Italian Renaissance Studies*, pp. 349–50.

37 *satisfied and rewarded*: *Lettere/contratti*, i; *Carteggio*, vol. i, ii.

37 *I undertook*: *Lettere/contratti*, ii; *Carteggio*, vol. i, iii.

38 *there has been*: Paola Barocchi and Bramanti and Renzo Ristori (eds.), *Il
carteggio di Michelangelo: Carteggio indiretto*, vol. i (Florence, 1988), i.

38 *a contract*: *Lettere/contratti*, pp. 613–14.

39 *We have recently*: Ibid., p. 613.

40 *the drill*: The hand-drill, used by Michelangelo to fashion the hair of Christ
from the marble, was customarily used by sculptors in Florence for speed.
Michelangelo came to discard it, making more painstaking use of the claw-
chisel, on works rarely finished. (Cf. Rudolf Wittkower, *Sculpture* (London,
1977), pp. 102–14.)

40 *On Christmas Eve*: Johann Burchard, *At the Court of the Borgia*, ed. and trans.
Geoffrey Parker (London, 1963), pp. 175–7.

41 *The oil-painting*: The altarpiece may have been begun during the winter of
1500–1501 and is arguably the panel in the National Gallery, London, of the
unfinished Entombment, or Christ carried to the tomb, narrative painting – as
I describe – continuing Michelangelo's innovative essays in portrayal of the
dead Christ. Dr Nicholas Penny has drawn attention to the similarity between
the face and posture of Christ on the cross found in Santo Spirito and those of
Christ in this panel.

For analysis of Michelangelo's work as a painter in Rome in his early years
and for the argument that the *Entombment* and the so-called *Manchester Madonna*
(both in the National Gallery, London) are demonstrably by Michelangelo,
see Michael Hirst and Jill Dunkerton, *The Young Michelangelo* (London, 1994).

43 *Lodovico complained*: *Carteggio*, vol. i, v.

44 *Buonarroto tells me*: Ibid., vol. i, vi.

44 *a hundred grooms*: Burchard, *At the Court of the Borgia*, p. 180.

45 *the man who had ordered*: Ibid., p. 183.

45 *Here they make:* This sonnet was written after early 1497, possibly during the
pontificate · of Julius II, but, argues Lucilla Bardeschi Ciulich (*Costanza ed
evoluzione nella scrittura di Michelangelo* (Florence, 1989), p. 17), probably during
the reign of Alexander VI and just after the excommunication of Savonarola.
In the final verses of the poem Michelangelo complains that there is no work
for him in Rome and the man in the cope could do what Medusa did when
Perseus used her head to turn the Titan Atlas into stone, creating Mount Atlas
in the Romans' Mauretania.

47 *a chance meeting*: Variously told anecdote, quoted in Aurelio Gotti, *Vita di
Michelangelo*, vol. i, p. 48, from *Archivio storico italiano*, serie terza, vol. xvi, p. 226.

48 *a grandiose new chamber*: See Vasari's accounts in his lives of Michelangelo,
Leonardo and Cronaca, and his own autobiography, where he describes the
metamorphosis of the republican great hall into the ducal *salone*.

50 *which seem to compare*: Cf. the Introduction in Charles Seymour Jr,
Michelangelo's David: A Search for Identity (New York, 1967).

50 *During the night*: Landucci, *A Florentine Diary*, pp. 213–14.

54 *In its agreement*: *Lettere/contratti*, pp. 625–6.

57 *Payments*: For the allocation of the statue of David and the opinion of the artists see *Lettere/contratti*, pp. 620–23. See also ibid., pp. 625–6, for the contract for the twelve Apostles.

58 *St Anne and the Holy Family*: For discussion of the only surviving cartoon by Leonardo da Vinci (Madonna, Child, St Anne, and St John: London, National Gallery) and its relationship with the cartoon described by Vasari, see Martin Kemp, *Leonardo da Vinci: The Marvellous Works of Nature and Man* (London, 1981), pp. 223–4.

59 *Christ as Saviour*: Chambers, *Patrons and Artists in the Italian Renaissance*, pp. 85–6.

59 *employ Michelangelo*: Michael Hirst, *Michelangelo and his Drawings* (New Haven and London, 1988), pp. 43–4.

60 *Leonardo judiciously used*: See Kemp, *Leonardo da Vinci*, pp. 238–40, for details of Leonardo's technique and a reconstruction of his vanished painting.

60 *Michelangelo's cartoon*: Reconstruction is helped by surviving studies of figures and Aristotile da Sangallo's small-scale study of Michelangelo's bathing soldiers painted in oil in 1542, and now at Holkham Hall, England. The latter may understate the compact flow of movement in the original 'forest of statues'. Cf. Wilde, *Michelangelo: Six Lectures*, p. 43.

61 *There was a muster*: Landucci, *A Florentine Diary*, p. 218.

62 *Julius II*: For Julius's successive attempts to win the papacy and for a well-considered assessment of the circumstances of his election in 1503 (to which he came prepared with his own 'fisherman's ring'), see especially Christine Shaw, *Julius II: The Warrior Pope* (Oxford, 1993), pp. 123–5.

62 *the Pontiff's symbol*: Cf. L. Partridge and R. Starn, *A Renaissance Likeness: Art and Culture in Raphael's 'Julius II'* (Berkeley, 1980), pp. 50, 56–8.

63 *People here expect*: L. Pastor, *The History of the Popes from the Close of the Middle Ages* (40 vols., London, 1906–7, 1950), vol. VI, p. 211.

64 *the strength of the city*: Ibid., vol. VI, p. 276.

64 *to preserve ancient sculptures*: Cf. Roberto Weiss, *The Renaissance Discovery of Classical Antiquity* (Oxford, 1969), p. 192.

65 *As conceived in 1505*: Charles de Tolnay, in *Michelangelo Sculptor, Painter, Architect*, pp. 77–8, sees the iconographic programme of the tomb in terms of the 'fundamentally simple idea' of 'a triumphant monument to the very principle of Christianity', a 'representation of the victory and diffusion of the Christian faith'. Instead of Vasari's and Condivi's (contradictory) interpretations, he offers a lower level with slaves and victories (the Apostolic Church vanquishing the pagans); an upper level with large seated figures symbolizing the true faith (based on the Bible and its signposting of the Active and Contemplative ways of life); and a top 'empyrean' level where the apostle-pope personifies the Holy Church in its apotheosis.

65 *tombs within churches*: Cf. R. W. Lightbrown, *Donatello and Michelozzo* (2 vols., London, 1980), vol. I, pp. 24–6.

67 *I talk with the pope*: Lettere/contratti, III; *Carteggio*, vol. I, VII.

68 *a miracle of sculpture*: P. P. Bober and R. O. Rubinstein, *Renaissance Artists and Antique Sculpture* (Oxford, 1986), p. 153.

68 *encumbrance and failing struggle*: Adrian Stokes, *Michelangelo: A Study in the Nature of Art* (London, 1955), p. 85.

68 *on Holy Saturday*: Lettere/contratti, CCCXLIII; *Carteggio*, vol. I, VIII.

70 *he regarded painting*: Cf. Kemp, *Leonardo da Vinci*, p. 211.

71 *supremacy as a draughtman*: Cf. Hirst, *Michelangelo and his Drawings*, p. 66, on Michelangelo's 'decisive development' as a draughtsman at this stage, at the age of nearly thirty.

71 *I must inform you*: *Carteggio*, vol. I, X.

73 *The bearer is*: Gotti, *Michelangelo Buonarroti*, vol. I, p. 54.

74 *Falling to his knees*: Cf. accounts by Vasari (*Lives of the Artists*, trans. Bull, pp. 347–8) and Condivi (Bull and Porter, *Michelangelo: Life, Letters and Poetry*, p. 31).

74 *what this would cost*: Condivi reported that for the bronze statue of himself Pope Julius left 1,000 ducats banked in Bologna. In his letter of December 1523 to Fattucci (*Lettere/contratti*, CCCLXXXIII and Condivi in Bull and Porter, *Michelangelo: Life, Letters and Poetry*, p. 102) Michelangelo recalled having had 3,000 ducats for the commission for the Hall of the Great Council in Florence, and being paid 1,000 ducats in stages for the bronze statue.

75 *having shown himself content*: Lettere/contratti, L; *Carteggio*, vol. I, XX.

75 *But their deepest anguish*: Lettere/contratti, IV; *Carteggio*, vol. I, XVI.

76 *Michelangelo confided*: Lettere/contratti, LV, LVI, LVII, CXXV, LX, LXI, LXII; *Carteggio*, vol. I, XX, XXI, XXII, XXVIII, XXIX, XXX, XXXI.

76 *Bernardino*: Lettere/contratti, LXIII; *Carteggio*, vol. I, XXXI.

77 *to Michelangelo's surprise*: Lettere/contratti, LXIV, LXVI, LXXII; *Carteggio*, vol. I, XXXI, XXXIV, XL. The prayers for Michelangelo's success were probably said by a friend in Bologna, Fra Lorenzo Viviani, a fellow Florentine and a sententious Dominican preacher who wrote very admiringly and affectionately soon after Michelangelo had left for Florence, mentioning the little carnival that had been held in his honour in '*Bologna la grassa*' and the prayers and fastings that had secured his well-being through so many perils (*Carteggio*, vol. I, XLV, p. 62). Cf. Charles de Tolnay, *Michelangelo I: The Youth of Michelangelo* (Princeton, 1943), pp. 39–40.

Michelangelo's bronze statue of Julius was a dead end for him and for this branch of sculpture, which, following the stupendous achievements of Donatello, had to wait for its great revival till the maturity of Benvenuto Cellini.

78 *Today I've received*: Lettere/contratti, LXVIII; *Carteggio*, vol. I, XXXVI.

79 *an elegant and curious sonnet*: See James M. Saslow, *The Poetry of Michelangelo* (New Haven and London, 1991), p. 69, and Robert J. Clements, *The Poetry of Michelangelo* (London, 1965), p. 204.

83 *The property*: See Ugo Procacci, *La Casa Buonarroti a Firenze* (Milan, 1967) in the series *Gallerie e musei minori de Firenze*.

84 *Giovansimone was thinking*: *Carteggio indiretto*, vol. 1, 15.

84 *hammered his family*: *Lettere/contratti*, LXXIX; *Carteggio*, vol. 1, V.

84 *I have had*: *Lettere/contratti*, VII; *Carteggio*, vol. 1, LXXI; Condivi in Bull and Porter, *Michelangelo: Life, Letters and Poetry*, pp. 80–81.

85 *Giovansimone –They say*: *Lettere/contratti*, CXXVII; *Carteggio*, vol. 1, LXVII; Condivi in Bull and Porter, *Michelangelo: Life, Letters and Poetry*, pp. 82–3.

86 *Giovansimone is beginning*: *Lettere/contratti*, LXXX; *Carteggio*, vol. 1, LXX.

87 *I, Michelangelo*: Lucilla Bardeschi Ciulich and Paola Barocchi (eds.), *I ricordi di Michelangelo* (Florence, 1970), pp. 1–2.

Before Michelangelo started work on the ceiling he may well have discussed its design with Bramante, who was skilled in perspective and foreshortening and whose architecture Michelangelo certainly admired and praised even after their relationship soured. For this and the use of the vernacular Malermi Bible (first published with illustrations in 1490 and again in 1493), see C. Robertson, 'Bramante, Michelangelo and the Sistine Ceiling', in *Journal of the Warburg and Courtauld Institutes*, vol. 49 (1986), pp. 91–105.

89 *an accompanying letter*: *Carteggio*, vol. 1, XLVII.

90 *a young Spanish painter*: This was without doubt Alonso Berruguete. At first he was refused permission to see Michelangelo's battle cartoon, and at the end of July 1508 Michelangelo writing to his brother Buonarroto added a line of subdued sarcasm saying that, as the herald and the commissary had refused the keys of the Hall of the Pope to the Spaniard, he thanked them and they should remember to treat others the same way (*Carteggio*, vol. 1, LIII). Berruguete stayed in Florence several years studying Michelangelo's work. He returned to Spain to become an important sculptor.

90 *Turn a deaf ear*: *Lettere/contratti*, X; *Carteggio*, vol. 1, LXII. Vasari named the friends and skilled painters who came from Florence as Granacci, Giuliano Bugiardini, Jacopo di Sandro, the elder Indaco, Angelo di Donnini and Aristotile. Michelangelo refused to see them even when he was at home, Vasari commented, and 'when they thought the joke was wearing thin, they accepted their dismissal and went back ashamed to Florence' (Vasari, *Lives of the Artists*, trans. Bull, vol. 1, p. 351).

91 *I learn*: *Lettere/contratti*, V; *Carteggio*, vol. 1, LXIV.

94 *spirit of Castiglione*: Julia Cartwright, *Baldassare Castiglione* (2 vols., London, 1908), vol. 1, p. 273.

94 *Raphael spellbound*: Cf. Roger Jones and Nicholas Penny, *Raphael* (New Haven and London, 1983), p. 129.

94 *'the hangman'*: Reported by Giovan Paolo Lomazzo (1538–1600) and cited in, for example, Robert J. Clements, *Michelangelo's Theory of Art* (London, 1963), p. 203.

94 *I have no friends*: *Lettere/contratti*, LXXX; *Carteggio*, vol. 1, LXX.

95 *his own universe*: Recent reconstruction of the scaffolding adopted shows that Michelangelo could have painted the histories, beginning at the entrance wall end, the triangular spandrels with the prophets and sibyls, and (single-handed, without cartoons, following long months of hard work, and a short

learning-curve on the ceiling proper) the lunettes, all from the same structure and in the same phase of the work. '. . . we may deduce from the sequence of day's works or *giornate* that the painting was executed in this way throughout the entire Chapel, that is, proceeding from zone to zone, and from the centre of the ceiling to the lunettes, towards the altar wall' (Fabrizio Mancinelli, 'The Painting of the Lunettes: Michelangelo at Work', in Massimo Giacometti (ed.), *The Sistine Chapel: Michelangelo Rediscovered* (London, 1986), p. 241.

On Michelangelo's responsibility for choosing his own texts see especially Richard Cocke's *From Magic to High Fashion* (Norwich, 1993) and 'The Sibyls in the Sistine Chapel' (*Bulletin of the Society for Renaissance Studies*, vol. XI, no. 1, October 1993, pp. 14–18), where he concludes that 'Michelangelo himself was responsible for the choice of subject . . . The narrative scenes are drawn from Genesis, the roundels from the Malermi Bible, and the sibyls from the texts studied in this article,' namely prophetic texts associated with sibyls, circulating in the quattrocento.

For artistic and literary traditions influencing Michelangelo's choice of sibyls, his use of paired putti of both sexes, and his creation of scenes and images strongly suggestive of the equality of men and women, see 'The Proportion of Women', in Creighton Gilbert's *Michelangelo On and Off the Sistine Ceiling* (New York, 1994), pp. 59–113.

95 *Julius's impatience*: In Vasari's confused account of the painting of the Sistine ceiling, he writes that, when the work was half finished, Julius, who had gone to inspect it close to several times, wanted it to be thrown open to the public, and 'the whole of Rome flocked to see it; and the pope was the first, not having the patience to wait till the dust had settled after the dismantling of the scaffolds'. This follows Condivi's statement that Julius was often given a helping hand by Michelangelo on to the platform while the work was in progress and that 'once half was done, namely from the door to the middle of the vault, he wished it to be revealed, even though it was imperfect and lacked the finishing touches. Michelangelo's reputation and the expectations that he aroused drew all Rome to view it, along with the pope, even before dust that had been raised from taking down the scaffolding had settled.' This is usually taken to have been after Julius's return to Rome in the summer of 1511, and not before he left in 1510. (Vasari, *Lives of the Artists*, trans. Bull, vol. I, p. 352; Bull and Porter, *Michelangelo: Life, Letters and Poetry*, p. 37.)

Attempts to settle what parts of the ceiling were painted when are unending. For a useful summary of many of them, see Michael Hirst, '*Il modo delle attitudini*', in Giacometti, *The Sistine Chapel: Michelangelo Rediscovered*, p. 208. I have followed Hirst's own suggested chronology in which the (generally accepted) certain points are that preparing the surface of the vault began in May 1508; painting was being done during the winter of 1508–9, the first phase ending in the summer of 1510; after his return to Rome in June 1511 the pope saw the recently uncovered ceiling frescoes on 14 and 15 August; lastly, the completed work was seen by Pope Julius and sixteen cardinals on the eve of the Feast of All Saints, 31 October 1512.

During the enforced interruption from the summer of 1510, Michelangelo decided on important changes, probably after being able to view all the first half of the vault from below after its uncovering. In particular, the incised tablets of the lunettes, a unifying element for the whole chapel, with identifying inscriptions, changed their shape, as did the figures of the ancestors of Christ and, growing larger to a dramatically greater extent, the ceiling figures. (Cf. Fabrizio Mancinelli, 'The Painting of the Lunettes: Michelangelo at Work', in Giacometti, op. cit., pp. 218–59.)

95 *because the 500 ducats*: *Lettere/contratti*, xx; *Carteggio*, vol. i, Lxxv.

96 *for this chapel*: Paris de Grassis, *Diary*, cited in Charles Seymour Jr, *Michelangelo: The Sistine Chapel Ceiling* (New York, 1972), p. 108.

96 *recorded a fifth payment*: Cf. *The Letters of Michelangelo*, ed. Ramsden, vol. i, app. 9. Ramsden argues 'categorically' that, with further payments in June and October 1512, Michelangelo received 3,000 ducats for painting the vault.

96 *join the papal army*: Pastor, *History of the Popes*, vol. iii, p. 341.

97 *to liberate Italy*: Francesco Guicciardini, *Storia d'Italia*, Book x, ed. Alessandro Gherardi (Florence, 1919).

98 *The portrait*: Partridge and Starn, *A Renaissance Likeness*, pp. 2–3.

98 *This comes of dangling*: *I'ho già fatto un gozzo in questo stento*. Translation by Peter Porter in Bull and Porter, *Michelangelo: Life, Letters and Poetry*, p. 139.

99 *directly from life*: Cf. Michael Hirst, '*Il modo delle attitudini*', in Giacometti (ed.), *The Sistine Chapel: Michelangelo Rediscovered*, pp. 208–17.

99 *The story goes*: The anecdote is in Condivi's *Life*.

100 *the lunettes*: Cf. Fabrizio Mancinelli, 'The Painting of the Lunettes', in Giacometti (ed.), *The Sistine Chapel: Michelangelo Rediscovered*, pp. 241–3.

101 *cushioned by cherubim*: There have been endless attempts to identify the young female and other figures accompanying the Almighty as he charges Adam with life. For lengthy, beguiling disputation, see especially Leo Steinberg's exuberently imaginative 'Who's Who in Michelangelo's Creation of Adam: A Chronology of the Picture's Reluctant Self-Revelation', *Art Bulletin*, vol. Lxxiv, no. 4 (1992), pp. 522–66, and subsequent correspondence.

For identification of the biblical subject-matter of the medallions, see Charles Hope, 'The Medallions on the Sistine Ceiling', *Journal of the Warburg and Courtauld Institutes*, vol. 50 (1987), pp. 200–294.

102 *The Platonists*: Cf. Tolnay, *Michelangelo Sculptor, Painter, Architect*, p. 27: 'Michelangelo seems to have added a new significance to the biblical content of his work. He has deepened the original iconographic program with a philosophic conception of human existence taken from Platonism and Neoplatonism.'

102 *transform the course of the arts*: Cf. Arnold Hauser, *Mannerism: The Crisis of the Renaissance and the Origin of Modern Art* (Cambridge, Mass., 1986), p. 169, where the ceiling of the Sistine is characterized as 'so full of mannerist elements and [with] anti-classical stylistic features so unmistakable that they could serve to illustrate the disintegration of the Renaissance just as well as its fruition'. For

other assessments of the general impact of Michelangelo's Sistine ceiling frescoes on contemporary artists and the drift or direction of the arts, see especially Sir Kenneth Clark's *A Failure of Nerve* (H. R. Bickley Memorial Lecture: Oxford, 1967) and John Shearman's *Mannerism* (Harmondsworth, 1967), in which subtle attention is drawn to 'qualities of grace, elegance and poise [which] are so intense that the beauty of the work of art becomes more nearly its subject than ever before. At this point perhaps, we should judge that the quality *maniera* begins to characterize a style.'

103 *To stimulate his imagination*: Cf. Edgar Wind, 'Maccabean Histories in the Sistine Ceiling', in E. F. Jacob (ed.), *Italian Renaissance Studies*: 'In order to understand Michelangelo's method of invention, it is of inestimable value to know that he consulted the Malermi Bible.'

104 *the new basilica*: 'Vita di Bramante', in Giorgio Vasari, *Le vite dei più eccellenti pittori, scultori e architetti*, ed. Carlo L. Ragghianti (4 vols., Milan and Rome, 1942–3), vol. II, p. 6; Pastor, *History of the Popes*, vol. VI, pp. 469–82.

104 *I toil harder*: *Lettere/contratti*, LXXVII; *Carteggio*, vol. I, C; *Lettere*, LXXXIX, *Carteggio*, vol. I, CI.

104 *Julius had remarked*: Herman Grimm, *Life of Michelangelo*, trans. Fanny Bunnett (2 vols., Boston, 1896), vol. I, p. 415.

105 *I have finished*: *Lettere/contratti*, XV; *Carteggio*, vol. I, CIV.

106 *Every day came stories*: Landucci, *A Florentine Diary*, p. 251.

106 *single for each individual*: Philip Hughes, *The Church in Crisis: The Twenty Great Councils* (London, 1960), p. 259.

107 *as timid as mice*: Landucci, *A Florentine Diary*, p. 257.

107 *Soderini's deposition*: Cf. H. C. Butters, *Governors and Government in Early Sixteenth Century Florence 1502–1519* (Oxford, 1985), p. 172.

107 *They made a proclamation*: Landucci, *A Florentine Diary*, p. 260.

107 *Hall of the Great Council*: Butters, *Governors and Government in Early Sixteenth Century Florence 1502–1519*, p. 187.

108 *Niccolò Machiavelli*: Cf. Roberto Ridolfi, *Vita di Niccolò Machiavelli* (Rome, 1954), pp. 202–3.

108 *Michelangelo wrote*: *Lettere/contratti*, XC; *Carteggio*, vol. I, CII. *Lettere/contratti*, XCI; *Carteggio*, vol. I, CIII.

108 *I have never*: *Lettere/contratti*, XXXVI; *Carteggio*, vol. I, CVI.

110 *The 'little turd'*: *Lettere/contratti*, XVIII; *Carteggio*, vol. I, CXV (there dated October 1514, but dated to February 1513 by Ramsden).

110 *a contract*: *Lettere/contratti*, pp. 635–7.

110 *Papal Choir Chapel*: Cf. Iain Fenlon (ed.), *The Renaissance* (London, 1989), p. 68.

111 *a short letter*: *Carteggio indiretto*, vol. I, 24.

112 *the carnival of 1513*: Cf. Vasari's 'Life of Pontormo' (*Lives of the Artists*, vol. II, trans. Bull, pp. 239–44). For the rich musical content of Florence's three days of *feste* and the ceremonies in Rome, see Anthony M. Cummings, *The Politicized Muse: Music for Medici Festivals 1512–1537* (Princeton, 1992), pp. 42–8, 52. Two societies for exuberant young men cannily inspired by the Medici

after their reinstatement were named the *Diamante* and the *Broncone* (the diamond and the laurel branch being Medici emblems) and they performed for the carnival of February 1513. Vasari in his account confused this with the celebrations for the election of Pope Leo X in March 1513. For the impressive contributions made by young artists and especially Jacopo Pontormo to the floats, see John Shearman, 'Pontormo and Andrea del Sarto, 1513', *Burlington Magazine*, CIV, 1962, pp. 478–83.

115 *who would have made a better general*: Shaw, *Julius II: The Warrior Pope*, p. 315.

116 *has provided me*: Chambers, *Patrons and Artists in the Italian Renaissance*, p. 30.

118 *I did indeed kiss*: Quoted from Ariosto's *Satires* (III) in William Roscoe, *The Life and Pontificate of Leo X*, (4 vols., London, 1805), vol. III, pp. 207–9.

118 *a Medicean hegemony*: Peter Partner, *The Pope's Men* (Oxford, 1990), pp. 209–13.

118 *He loved musical performances*: Cf. Cummings, *The Politicized Muse*, pp. 12–14.

119 *Knowledge of so many*: G. Holt (ed.), *A Documentary History of Art* (New York, 1957), pp. 289–96.

120 *pillage the ancient ruins*: Jones and Penny, *Raphael*, pp. 315, 205.

121 *Chigi's villa*: Cf. *Carteggio*, vol. II, CCCLXXXIX, dated 1 January 1519. In his 'Life of Giovanni da Udine', Vasari wrote that Giovanni had painted every kind of regional fruit and vegetable produced by nature. 'And over the figure of Mercury in flight, he has simulated for Priapus a gourd, thrusting through its tendrils, with two melons for testicles, and near its flower he has simulated a cluster of heavy autumn figs, entering into one of which, shown as ripe and bursting, he has depicted the tip of the gourd with its flower; and this fanciful idea is expressed more gracefully than anyone can imagine' (*Le vite*, ed. Ragghianti, vol. III, p. 222). In his 'Life of Raphael', Vasari commented that when 'his close friend Agostino Chigi commissioned him to decorate the first loggia in his palace, Raphael could not give his mind to his work because of his infatuation for his mistress. Agostino was almost in despair when with great difficulty he managed with the help of others to arrange for the woman to go and live with Raphael in the part of the house where he was working; and that was how the painting was finished' (*Lives of the Artists*, trans. Bull, vol. I, p. 312).

121 *Francesco Berni*: For a very readable background to Berni's career, see J. A. Symonds, *The Renaissance in Italy* (7 vols., London, 1897–8), vol. V, p. 320: for comparison between Berni's burlesque verse and Michelangelo's, see Glauco Cambon, *Michelangelo's Poetry: Fury of Form* (Princeton, 1985), pp. 13–18.

122 *Michelangelo's house*: For the house as it once stood, see Luigi Rossini, *I monumenti più interessanti di Roma* (Rome, 1818), where the vestibule and staircase are illustrated (referred to in Linda Murray, *Michelangelo: His Life, Work and Times* (London, 1984), pp. 116, 236).

122 *rent free*: *Lettere/contratti*, p. 651.

122 *Have no doubt*: *Lettere/contratti*, CCCLIX; *Carteggio*, vol. II, CCLXXXV.

122 *for he is truly*: *Lettere/contratti*, CIX; *Carteggio*, vol. I, CXLII.

123 *Silvio Falcone*: Symonds, *The Renaissance in Italy*, vol. II, p. 341.

123 *Pietro, or Piero, Urbano*: *Lettere/contratti*, CCCLXVIII; *Carteggio*, vol. II, CDXLIII.

124 *Luigi Pulci*: For the wild life and death of the handsome, promiscuous Luigi Pulci (grandson of Luigi Pulci who wrote the *Morgante Maggiore*) and Michelangelo's interest in his singing, see Benvenuto Cellini, *Autobiography*, trans. George Bull (Harmondsworth, 1956), pp. 64-9.

124 *in this vast Babylonia*: *Carteggio*, vol. I, CXXIV.

125 *since he is well versed*: Quoted in *The Letters of Michelangelo*, ed. Ramsden, pp. xxxvii and xxxviii.

125 *I do not want*: *Lettere/contratti*, XCII; *Carteggio*, vol. I, CVIII.

126 *Pietrasanta*: For a 'clear, coherent and unequivocal account' of Michelangelo and the quarries of Pietrasanta see *The Letters of Michelangelo*, ed. Ramsden, vol. I, app. 13.

126 *The contract*: *Lettere/contratti*, pp. 635-7.

127 *Moses seems portrayed*: Cf. Exodus 32:18 and 34:30. Among innumerable psychological interpretations of the 'meaning' of the Moses, those of Freud, Liebert and Stokes stress its demonstration of tremendous tensions mastered by iron will and, of course, the statue's memorialization of the pope, Michelangelo's fatherly, fearsome master.

128 *Michelangelo wrote*: *Lettere/contratti*, XCVII, CIII; *Carteggio*, vol. I, CXXVIII, CXXXIV.

128 *because I have never*: *Lettere/contratti*, CXII; *Carteggio*, vol. I, CLXXV.

128 *the largest possible frame*: Discussing the 'menu' written and drawn by Michelangelo on the back of a letter he received from Bernardo Niccolini (dated 18 March 1518), Steinberg notes even here his 'compulsion to take possession of the entire field'.

129 *like so many knife-thrusts*: *Lettere/contratti*, CCCLIX; *Carteggio*, vol. II, CCCLXXXII.

130 *our Holy Father*: *Carteggio*, vol. I, CXLIV.

131 *told to involve himself*: Writing many years later, in 1542, Michelangelo recorded in a letter, 'At this time, Pope Leo, who did not want me to do the tomb, made out [*finse*] that he wished to do the façade of San Lorenzo; and he asked Aginense to give me leave, but on condition that I should make Pope Julius's tomb while in Florence' (*Lettere/contratti*, CDXXXV; *Carteggio*, vol. IV, MI).

131 *And now*: *Carteggio*, vol. I, CLXXIII.

132 *a totally different approach*: 'This solved most of the problems that bedevilled earlier architects ... Furthermore, the design was ideally suited to the sculptural programme.' Cf. James S. Ackerman, *The Architecture of Michelangelo* (2 vols., London, 1961), text & plates vol., p. 17.

133 *execute this work*: *Lettere/contratti*, CCCXLVIII; *Carteggio*, vol. I, CCXXI.

133 *the detailed agreement*: *Lettere/contratti*, p. 671.

134 *the marbles should*: *Carteggio*, vol. I, CXCIV.

135 *The loosely worded agreement*: *Lettere/contratti*, p. 661.

135 *Gismondo reported*: *Carteggio indiretto*, vol. I, 88.

135 *Michelangelo sought authority*: *Lettere/contratti*, CCL; *Carteggio,* vol. II, CCLXXXVI; *Lettere/contratti*, CXIV; *Carteggio*, vol. I, CCLXVIII.

136 *The quarry site*: *Lettere/contratti*, CCCL; *Carteggio*, vol. I, II, CCLXXXVI. *Lettere/contratti*, CXIV; *Carteggio*, vol. I, CCLXVIII; *Lettere/contratti*, CCCLVI; *Carteggio*, vol. II, CCCLXXXIII.

136 *I am more discontented*: *Lettere/contratti*, CCCLIX; *Carteggio*, vol. II, CCCLXXXII.

136 *I have already*: *Lettere/contratti*. CCCLXIII; *Carteggio*, vol. II, CCCLXXXVI.

137 *Again, Michelangelo noted*: *Lettere/contratti*, CCCLI; *Carteggio*, vol. II, CDXXIII.

137 *writing . . . his records*: *Lettere/contratti*, p. 578; *Ricordi*, pp. 90–100.

138 *Not having been able*: *Carteggio*, vol. I, CCXXXI.

138 *Pope Leo, perhaps*: *Ricordi*, pp. 101–2.

139 *When I was in Carrara*: *Lettere/contratti*, CCCLXXIV; *Carteggio*, vol. II, CDLVIII (where various possible recipients are cited).

141 *Leo's expenses*: John F. D'Amico, *Renaissance Humanism in Papal Rome* (Baltimore and London, 1983), p. 43.

142 *swarm of parasites*: Euan Cameron, *The European Reformation* (Oxford, 1991), p. 31.

142 *measureless grief*: Jones and Penny, *Raphael*, p. 246.

142 *Leo's goodwill*: *Carteggio*, vol. II, CDLXII; Ibid., vol. II, CDLXXIV; Ibid., vol. II, CDLXXVII.

144 *hearsay*: According to Vasari, Domenico Buoninsegni, being in charge of the accounts for the marble for the tombs, 'tempted Michelangelo to join in with him secretly in arranging the work for the façade of San Lorenzo; but when Michelangelo refused, disliking the idea of using his talent to defraud the pope, Domenico came to hate him so much that he was always opposing his efforts so as to diminish and upset him; but he did so covertly' (Vasari, *Le vite*, ed. Ragghianti, vol. II, p. 761: 'Vita di Baccio Bandinelli').

145 *speak neither good*: *Lettere/contratti*, XCI; *Carteggio*, vol. I, CIII.

145 *Buonarroto told*: *Lettere/contratti*, CVII; *Carteggio*, vol. I, CXXXVIII. *Lettere/contratti*, CIX; *Carteggio*, vol. I, CXLII.

145 *Buonarroto wrote*: *Carteggio*, vol. I, CCIII; *Carteggio indiretto*, vol. I, 37.

146 *I'll be as patient*: *Carteggio indiretto*, vol. I, 55.

146 *learn to write*: Ibid., vol. I, 57.

147 *growing so fat*: Ibid., vol. I, 61.

147 *Did she want*: Ibid., vol. I, 75.

147 *these outlaws*: Ibid., vol. I, 76.

147–8 *Buonarroto intended*: Ibid., vol. I, 80.

148 *told Gismondo*: Ibid., vol. I, 82.

148 *Buonarroto to Bartolommea*: Ibid., vol. I, 89, 90.

148 *although she may*: Ibid., vol. I, 96.

149 *the mood in Florence*: Cf. J. N. Stephens, *The Fall of the Florentine Republic 1512–30* (Oxford), p. 163.

149–50 *huge building project*: Cf. Alessandro Parronchi, '*Michelangelo al tempo dei lavori di San Loranzo in Una "ricordanza" del Figiovanni*', in *Paragone*, CLXXV (1964).

151 *The agreement*: *Lettere/contratti*, pp. 694, 696.

151 *Castel Sant'Angelo*: Cf. John Shearman, *Mannerism* (Harmondsworth, 1967), p. 71: 'No single form is markedly irregular in relation to the antique, and no contemporary connoisseur could doubt that Michelangelo knew the anatomy of antique architecture as well as he did that of the human body. It is the incipiently wilful composition that is distinctive . . .'

152 *would also do*: *Lettere/contratti*, CCCLXXIX; *Carteggio*, vol. II, DLXXI.

153 *the contract*: *Lettere/contratti*, p. 641.

153 *it's not my business*: *Carteggio*, vol. II, DXXVII.

154 *Michelangelo offered*: Ibid., vol. II, DXXVI, DXL.

154 *Michelangelo had carved*: Cf. Umberto Baldini, 'Sculpture', in *The Complete Work of Michelangelo* (New York, n.d.), p. 120.

155 *I was amazed*: *Lettere/contratti*, XXXIX; *Carteggio*, vol. II, CDXCIV.

155 *respectable citizen class*: See Machiavelli's comedy *Clizia* for a splendid description of a middle-class Florentine (Niccolò), though one by Lodovico's standards perhaps too much in business.

155 *la vostra casa*: Gotti, *Michelangelo Buonarroti*, vol. I, p. 4. The castle of Canossa, in Reggio Emilia, was best known as the place where the emperor Henry IV submitted to Pope Gregory VII in 1077.

156 *save to remind you*: Cf. *The Letters of Michelangelo*, ed. Ramsden, vol. I, XLVIII; *Carteggio*, vol. II, DXLV, DXLVII. The implications of Sellaio's advice to Michelangelo not to go out at night and to abandon harmful practices – '*nonne a[n]dare di notte e lasc[i]are le pratiche nocive all'animo e al chorpo*' – have been much discussed and remain obscure. Michelangelo himself, giving advice to Pietro Urbano in Florence in the winter of 1517, said he should not go about much: '*e va pocho actor[no]*' (*Carteggio*, vol. II, p. 175). Ramsden discusses the view (of Giovanni Papini) that the *malattia* of which Michelangelo was cured was the *mal francese*, or venereal disease, only to dismiss it; and she wonders tentatively whether it may have been to do with an 'intimate' relationship, perhaps as evidenced by the passionate sonnets addressed to him by Giovanni da Pistoia (Giovanni de Benedetto, with whom he later fell out and who became secretary of the Florentine Academy). To him Michelangelo addressed the sour verses on painting the Sistine, '*I'ho già fatto un gozzo in questo stento*'. Leonardo's admonition to Michelangelo not to go out at night (for practices harmful to mind and body) suggests perhaps that Michelangelo was drinking too much (rather more rare and shameful in Italy than the north) and maybe looking for congenial, risky company. This last supposition is supported by the apparently 'coded' use in the Tuscan burlesque tradition of the word 'night' for sodomy, which had been (till 1502) the special concern of the magistracy called the Office of the Night. (Cf Michael Rocke, *Forbidden Friendships*, OUP 1996, p. 152, referring to J. Toscan, *Le Carnival du Langage; Le Lexique érotique des pòetes de l'équivoque de Burchiello à Marino*, Lille, 1981.)

157 *had made a pact*: Pastor, *History of the Popes*, vol. VIII, p. 36.

158 *Luther's message*: Cameron, *The European Reformation*, p. 191.

159 *patron of music*: Cf. Fenlon, *The Renaissance*, especially 'Rome: A City of Rich Contrasts' by Christopher Reynolds.

159 *remembered Leo gratefully*: For recent judgements tending to be favourable, see John Shearman, *Andrea del Sarto* (Oxford, 1965) and S. J. Freedberg, *Painting in Italy 1500–1600* (Harmondsworth, 1971).

159 *the new writing*: For a lively, censorious overview of the 'subversive' friends and followers of Berni and imitators of his *capitoli*, see Symonds, *The Renaissance in Italy*, vol. V, pp. 319–24.

159–60 capitoli . . . terza rima: 'Contro Papa Adriano VI', Francesco Berni, *I Capitoli*, ed. Riccardo Dusi (Turin, 1926), pp. 32–9.

160 *the Holy Spirit*: Cartwright, *Baldassare Castilione*, vol. II, p. 138.

161 *described vividly*: Cartwright, *Baldassare Castiglione*, vol. II, p. 175.

162 *Archbishop Antonino*: Lorenzo Polizzotto, 'The Medici and the Savonaroleans', in F. W. Kent and Patricia Simons (eds.), *Patronage, Art and Society in Renaissance Italy* (Oxford, 1987), p. 148.

163 *black chalk drawings*: Noting the three periods, in the 1520s, early 1530s and briefly in the 1540s, when Michelangelo produced carefully worked presentation drawings, Hirst (*Michelangelo and his Drawings*, p. 107) comments that they are explained by the workings of profound personal attachment: 'The real parallel for these drawings of Michelangelo is love poetry.'

163 *Writing from Venice*: *Carteggio*, vol. II, DLV.

164 *Relations*: Ibid., vol. II, DLXXXVIII, DLXXXI, CDLXVIII. For Matteo Buonarroti, see Frey, *Michelagniolo Buonarroti*, vol. I, p. 12.

164 *Angiolini . . . Frizzi*: *Carteggio*, vol. II, DXXIX, DXLVI.

164 *Gherardo Perini*: Ibid., vol. II, DLIX, DLX.

165 ricordi *show*: *Ricordi*, p. 109.

165 *I am not replying*: *Lettere/contratti*, XLIV; *Carteggio*, vol. II, DLXXVII.

166 *I have a great obligation*: *Carteggio*, vol. II, DLXXXVI.

167 *so-called* prigioni: The dating and the intended purpose of these statues, known as the Boboli slaves, from the garden where they were first put by Duke Cosimo, are both controversial. For detailed discussion, see Charles de Tolnay, *Michelangelo IV: The Tomb of Julius II* (Princeton, 1943–60); also Wilde, *Michelangelo: Six Lectures* and (on Michelangelo's sculptural technique) Clements (*Michelangelo's Theory of Art*, p. 24) and Wittkower (*Sculpture*, p. 188).

169 *the king spoke*: *Carteggio*, vol. II, p. 151.

170 *Both in painting*: Cf. Giovio as translated and with comments by Peter Murray in *Michelangelo* (Selwyn Brinton Lecture: London, 1975). Also Paolo Giovio, *Opere*, ed. R. Meregazzi (Rome, 1972).

172 *The pope has not failed*: Cartwright, *Baldassare Castiglione*, vol. II, p. 202.

172 *large extra payments*: Guicciardini, *Selected Writings: Ricordanze*, ed. Cecil Grayson (London, 1965), p. 165.

173 *To Pope Clement VII*: Randolph Starn, *Donato Giannotti and His Epistolae*, trans. Brook (Geneva, 1968), pp. 156–7.

174 *Fattucci in a letter*: *Carteggio*, vol. III, DCIV.

175 *The bearer*: *Lettere/contratti*, CDXCV; *Carteggio*, vol. III, DCI.

175 *In your letter*: From Florence, December 1523: *Lettere/contratti*, CCCLXXXIII; *Carteggio*, vol. III, DXCIV; Bull and Porter, *Michelangelo:Life, Letters and Poetry*, pp. 99–102.

177 *As soon as*: *Lettere/contratti*, CCCXCIV; *Carteggio*, vol. III, DCXCVII.

178 *Michelangelo recorded*: Letter to Giovan Francesco Fattucci: *Lettere/contratti*, CCCXCV; *Carteggio*, vol. III, DCCCLXXV (but dated 1532).

178 *full of pathos*: *Lettere/contratti*, CD; *Carteggio*, vol. III, DCCXIX.

178 *bizarre stanzas*: Saslow, *The Poetry of Michelangelo*, 20, pp. 90–92.

178 *frottola*: Saslow, *The Poetry of Michelangelo*, 21, pp. 93–4.

178 *although it is not*: *Lettere/contratti*, CCCLXXXV; Carteggio, vol. III, DCII.

180 *financial records*: *Ricordi*, pp. 119–27; also Paul James Le Brooy, *Michelangelo Models* (Vancouver, 1972).

180 *up to now*: *Lettere/contratti*, CCCLXXXVII; *Carteggio*, vol. III, DCVIII.

181 *will see what I shall do*: *Lettere/contratti*, CCCLXXXI; *Carteggio*, vol. III, DCLXXXVIII.

181 *I said to him*: *Carteggio*, vol. III, DXCIX.

182 *This colossus*: *Lettere/contratti*, CCCXCIX; *Carteggio*, vol. III, DCCXXX.

183 *Next week*: *Lettere/contratti*, CDII; *Carteggio*, vol. III, DCCLII.

183 *drawings and clay models*: Hirst, *Michelangelo and his Drawings*, p. 62.

184 *Clement was saying*: *Carteggio*, vol. III, DCXXVIII.

185 *the pope was again in touch*: Ibid., vol. III, DCCXXVII, DCCXXVIII, DCCXXXII.

186 *promise Fattucci*: *Lettere/contratti*, CDII; *Carteggio*, vol. III, DCCLII.

For Michelangelo's day-to-day management of flexible teams of suppliers, craftsmen and labourers, see especially William E. Wallace, *Michelangelo at San Lorenzo: The Genius as Entrepreneur* (Cambridge, 1994). Making good use of the *ricordi* and their weekly listings of supplies, payments and disbursements, Wallace illuminates Michelangelo's teeming world of work, his tremendous organizational flair and energy, and his care and concern for scores of helpers, carpenters, stonecutters, many of whom he had known since boyhood, many by their nicknames – such as Bel[l]o, Berto, and Gatta, Mosca, Turco and Anti Cristo: the Cat, the Fly, the Turk, the Antichrist (a stonecutter who worked in the Laurenziana).

187 *Michelangelo's vision*: 'Everywhere in the vestibule Michelangelo's licentious use of classical vocabulary, obscuring the actual relationships of load and support, created paradoxes for his academic contemporaries,' comments Ackerman, to whom I am indebted for my explanation of architectural designs and procedures. 'We can gain from the history of the Laurentian library a singular insight into the relative significance of "commodity, firmness, and delight" in Renaissance architectural design,' he adds (*The Architecture of Michelangelo*, text & plates vol., ch. 4, p. 44). Compare the harsh judgement of Michelangelo's biographer Charles Heath Wilson: 'The architecture of the Laurentian is the beginning of the style which, borrowing an Italian expression, is termed the Baroque, of which no doubt Michelangelo was the founder. The task of building this library was forced upon him . . . It was undertaken without heart for

the work, with a modest deprecation of being thus employed; in estimating its obvious defects these circumstances are not to be forgotten' (*Life and Works of Michelangelo Buonarroti* (London, 1876), p. 310).

187 *Giovanni could come*: Lettere/contratti, CDII; Carteggio, vol. III, DCCLII.

187 *Michelangelo was thanked*: Carteggio, vol. III, DCCLVI, DCCLIX.

188 *If I hardly know*: Ibid., vol. III, DCCLX.

188 *acknowledging Raphael*: Cf. Michael Hirst, *Sebastiano del Piombo* (Oxford, 1982), where it is suggested that the Prague panel was one of two works completed for Pope Clement, paying overt tribute to Raphael, though traditional in motive, and that Parmigianino's example may have led Sebastiano to Raphael.

189 *collaboration with Sebastiano*: Hirst, *Sebastiano del Piombo*, pp. 32–89.

189 *Sebastiano's portrait*: Freedberg (*Painting in Italy 1500–1600*, p. 226) puts the portrait of Pope Clement in the context of an 'afterlife of classical style'. See also Hirst, *Sebastiano del Piombo*, pp. 102–8.

190 *Sansovino*: For discussion of Michelangelo's influence on Sansovino at this stage, see Bruce Boucher, *The Sculpture of Jacopo Sansovino* (New Haven and London, 1991), ch. 11.

191 *I took a fancy*: Pietro Aretino, *Selected Letters*, trans. George Bull (Harmondsworth, 1976), p. 156.

192 *an embarrassed letter*: Carteggio, vol. III, DCCLVIII.

193 *from the plague in Rome*: In his 'Life of Perino del Vaga', Vasari is not very clear about whether Perino and Piloto left Rome because of the plague – always a plausible excuse to depart – or on impulse, or about the sequence of events. One morning, he recorded, the two artists set off for Florence, where Perino was delighted to see the works of the great painters he had studied in his youth and where, after discussing the differences between Rome and Florence, he obtained work through friends in order to show the Roman style – *questa maniera di Roma*. Again because of plague, according to Vasari, Perino went from place to place before returning to Rome (*Le vite*, ed. Ragghianti, vol. II, pp. 630–32).

194 *like magic*: In his 'Life of Giovanfrancesco Rustici' Vasari recorded that this sculptor and architect studied necromancy, and associated with conjuring up spirits as a Sicilian priest and necromancer once did for Benvenuto Cellini on a famous, fearsome and farcical occasion in the Roman Colosseum. This kind of 'black' magic, as well as natural or scientific magic – exploring invisible and intangible forces – flourished during the lifetime of Michelangelo, who was immune to both of them.

195 *an extraordinary to-do*: '. . . era uno fanc[i]ulo e fu fotuto da quatro, e fugli roto el chulo in quatro. Pure, el p[a]dre se n'a[n]do algl'Oto e fue preso uno e ando a pa[r]tito per ese[r]gli tagliato la testa. Ebe 5 fave nere.' Carteggio indiretto, vol. I, 131.

196 *and I have been*: Ibid., vol. I, 146.

196 *Andrea del Sarto*: '. . . in his later years [Andrea del Sarto] tended to sink comfortably into routine,' according to Heinrich Wölfflin (*Classic Art: An*

Introduction to the Italian Renaissance, trans. Peter and Linda Murray (London, 1952), p. 155). But Shearman's vigorous and balanced appraisal leaves him 'one of the great artists of the Renaissance', with 'cool and fastidious self-discipline' and 'sheer beauty of performance' (*Andrea del Sarto*, p. 178).

196 *painting of the dead Christ*: But Vasari was appalled by Rosso's frescoes in Rome. He commented that perhaps their badness was because by changing home Rosso had changed his nature and was left dazed and stupefied. 'And this is what could have happened to Rosso in the air of Rome, on account of both the stupendous things he saw, in architecture and sculpture, and also the pictures and statues of Michelangelo which perhaps unbalanced him, and which also made Fra Bartolommeo of San Marco and Andrea del Sarto take to flight from Rome' (*Lives of the Artists*, trans. Bull, vol. ii, p. 175).

198 *It was here*: The dating of many of Michelangelo's poems is conjectural, and the person to whom they are addressed may sometimes be as plausibly Christ or God as a close friend. Thus Clements (*The Poetry of Michelangelo*, p. 194) dates the poem beginning 'It was here that my love . . .' to *c.* 1524–34, following E. N. Girardi (*Rime di Michelangelo Buonarroti* (Bari, 1960)) and Ettore Barelli (*Michelangelo Rime* ((Bari, 1967)).

198 *This is as follows*: *Lettere/contratti*, CCCLXXXII; *Carteggio*, vol. iii, DCCLXIX.

199 *scurrilous story*: Quoted by Ridolfi (*Vita di Niccolò Machiavelli*, pp. 345–6) from Bandello *Novelle* 1, 46.

201 *financial entanglements*: *Carteggio indiretto*, vol. i, 156.

202 *Lodovico had commented*: Ibid., vol. i, 150.

203 *Cisti, wrote*: Ibid., vol. i, 156.

204 *bloodless, aborted coup*: Cf. Guicciardini's *Storia d'Italia*, Book XVIII, where he records that he had been accused by the crowd of persuading them to surrender too easily.

205 *Charles V . . . smiled*: To do Charles V justice, he did show appropriate grief when he received the appalling details of the humiliation and terrorizing of the pope (Cartwright, *Baldassare Castiglione*, vol. ii, pp. 338–40).

205 *massive looting*: Pastor, *History of the Popes*, vol. i, ch. XI.

206 *Jacopo Sansovino*: Cf. Boucher, *The Sculpture of Jacopo Sansovino*, pp. 32–3.

207 *Polidoro and Maturino*: Vasari's account of these two painters (*Le vite*, ed. Ragghianti, vol. ii, pp. 355–65) adds that Polidoro, eventually about to tear himself away from the woman he came to love and return to Rome, was strangled by his boy assistant for the money he had drawn from the bank. The boy was tortured with red-hot pincers, hanged and quartered.

207 *the artistic colony*: Vasari collected first-hand stories about the experiences of artists during the sack when he went to Rome in 1540, and scattered through his *Lives* are accounts of the varied and memorable experiences of sixteen artists. 'It is a chapter out of a thriller,' André Chastel comments (*The Sack of Rome, 1527*, trans. Beth Archer (Princeton, 1983), p. 170).

208 *The awfulness of the sack*: Guicciardini (*Storia d'Italia*, Book XVIII) estimated that about 4,000 men perished in the battle and the sack and had heard that, counting money, gold, silver and jewels, the sack amounted to over 1 million

ducats, with an even greater sum being extracted through ransoms. The fate of the tapestries is outlined in Chastel, *The Sack of Rome, 1527*.

209 *Guicciardini reflected*: Guicciardini, *Storia d'Italia*, Book XVIII.

210 *Policies of revenge*: For detailed elaboration of the elements of 'revenge' in Florentine popular government from 1527, cf. Stephens, *The Fall of the Florentine Republic 1512–30*, pp. 220–55.

211 *Charles was crowned*: Guicciardini, *Storia d'Italia*, Book XX.

211 *surreptitiously modelled*: Cf. J. A. Crowe and G. B. Cavalcaselle, *Titian: His Life and Times* (2 vols., London, 1877), vol. I, pp. 366–7. Lombardi's portrait was made first in relief on a tablet of wax and then carved in marble. The Titian portrait has vanished.

213 *appointment was confirmed*: Cf. Gotti, *Michelangelo Buonarroti*, vol. II, app. 16.

The project for a colossal statue to match his David on the Piazza della Signoria inspired Michelangelo between 1525 and 1533 with ideas for at least two groups – neither fully realized, as the marble went to Bandinelli. The first took shape as an unfinished clay model of two struggling figures (now in the Casa Buonarroti). The second, also not finished, as the bronze statuette of Samson and the Philistine (Bargello, Florence, perhaps a copy). A heroic group partly inspired by the antique *Laocoön*, this prompted numerous bronze copies and was especially acknowledged in Giambologna's marble group of Samson slaying a Philistine. The *contrapposto* stance and strong detail of the figure of Laocoön – thighs, right arm, torso, chest, left hand – haunted Michelangelo's imagination, and was most powerfully expressed in the Christ of *The Last Judgement*. (Cf. Angela Hass, 'Michelangelo's Samson and the Philistine', *Apollo*, December 1993, pp. 383–7).

214 *the fortifications*: For a full and fascinating detail of defence planning and implementation in Florence under Clement and the new Republic, and especially Michelangelo's role, see Renzo Manetti, *Michelangiolo: le fortificazioni per l'assedio di Firenze* (Florence, 1980). The automatic response of lopping a city's old towers when danger threatened from armies with artillery sprang from fear that material from the bombarded tower would fall into the defensive ditches and destroy their usefulness in preventing the scaling of the walls.

214 *Michelangelo's drawings*: Cf. Ackerman, *The Architecture of Michelangelo*, text & plates vol., p. 52, on Michelangelo's fortification drawings (Casa Buonarroti) which 'are stroked with a vigour that evokes their spread and power; the structures themselves take shape around them'. Michelangelo's drawings appear to show the development and adjustment of his ideas to structural and functional conditions and even to anticipate forms used much later.

215 *Michelangelo suspected*: Cited from a letter of Busini in Manetti, *Michelangiolo: le fortificazioni per l'assedio di Firenze* from *Le opere di Giorgio Vasari*, ed. Gaetano Milanesi (9 vols., Florence, 1973), vol. VII, p. 369.

215 *I give notice*: Cf. Wilson, *Life and Works of Michelangelo Buonarroti*, p. 320.

217 *increasingly fearful*: Cf. Wilson, *Life and Works of Michelangelo Buonarroti*, pp. 326–30, for references to the tenth book of Varchi's *Storie fiorentine*, where Varchi narrates that when Michelangelo was questioned in his name by Giovanbattista Busini he replied that:

Signor Mario Orsini had said to him one day in conversation that he
feared greatly that Malatesta had come to terms with the pope, and
would prove a traitor. Which thing he, as a loyal citizen and zealous for
the well-being of his country, immediately referred to the Signory. The
gonfaloniere Carduccio in reply took him to task as somewhat suspicious
and timid and attached little importance to his revelation. Whence he,
moved by this fear, or because Rinaldo Corsini did not cease to molest
him, to induce him to fly with him, as the city in a few hours, not days,
would be in the power of the Medici, he had 12,000 golden florins sewn
into part of his dress, and with the said Rinaldo and with Antonio Mini,
his pupil, left Florence, not without difficulty, although he was of the
Council of Nine for the army, passing through the gate 'alla Giustizia' as
likely to be least suspicious and as being least guarded.

Busini gives another account of the cause of this flight of Michelangelo in his
letter to Varchi of 31 January 1549:

I asked Michelangelo what was the cause of his departure. He answered,
that being one of the Nine, and the Florentine people being gathered
within the walls and Malatesta and Signor Mario Orsini and other
leaders, he then distributed the soldiers on the fortifications and assigned
each captain his place, providing victuals, ammunition and eight pieces of
artillery to Malatesta, who was to set a guard over them and to defend a
portion of the bastion del Monte; he placed them [the guns] outside
under the bastions without any guard. Mario did the contrary with that
under his charge. Michelangelo, who as magistrate and engineer superin-
tended that part of the defences of the Monte, asked Signor Mario how it
happened that Malatesta kept his artillery unguarded, to which Signor
Mario replied, 'You know that he is of a family who have all been
traitors, and he also will betray this city.' This caused such apprehension
to Michelangelo that he felt constrained to depart.

For a heartfelt explanation and defence of Michelangelo's flight from Flor-
ence see also the 'Ragionamento' by Melchior Missirini, Difesa di Michelangelo
Buonarroti per la sua partenza da Firenze (Florence, 1840).

217 a little inventory: Lettere/contratti, p. 602.

217 Dearest Father: Carteggio indiretto, vol. 1, 207–12.

219 ingenious decision: The story is told by both Vasari and Condivi in their
lives of Michelangelo, but this clashes with the records for this work.

221 kept by Michelangelo: Michelangelo had the Victory locked away in his
studio before he left Florence for Rome in 1534. The name 'Victory' was first
given to this group by Vasari in a letter after Michelangelo's death to his
nephew Lionardo, who wanted to make it the centre of a tomb for
Michelangelo in Santa Croce, and who then handed it over to the Medici.
Dates for its creation range from 1515 to 1534, but most scholars associate it
with the tomb of Pope Julius. I have followed the mind of Johannes Wilde,

who, in a Charlton Lecture (*Michelangelo's 'Victory'* (Oxford, 1954)), puts it in the context of Michelangelo's new, later modified, plan for the Julius monument which he brought to Florence in 1516. He sees the statue as meant for this plan's magnificent, unified two-level structure, for which some figures (e.g. the two *prigioni* or allegories of the arts, now in the Louvre) were ready or, like the figure of Moses, on their way.

After years quarrying and preparing the façade for San Lorenzo, and intermittently working on the Risen Christ, Michelangelo paused only to start again on Medici work with the tombs for the New Sacristy. Then, after the death of Leo X (pressed all the while by the heirs of Julius II), he worked till at least the end of 1523 on the four unfinished *prigioni* now in the Accademia at Florence. In the 'break' between 1527 and 1530 Michelangelo worked on a small model (for a second statue to go with his figure of David on the piazza), on the city's defences, on painting a picture of Leda (between January and October 1530) and – during the same four years – on statues for the Julius monument including and perhaps especially the 'Victory'. For dating the Accademia captives to the early and the 'Victory' to the late 1520s, Wilde advises stylistic evidence including studies preparatory to the 'Victory' which 'seem to represent a further stage in the development of the method of drawing that characterizes Michelangelo's studies for the Giorno [the Day]' begun late in 1524.

221 *for seven months*: Cf. Roberto Ridolfi, *The Life of Francesco Guicciardini*, trans. Cecil Grayson (London, 1967), pp. 208–9.

223 *every reason to fear*: Vasari's first version of his 'Life of Michelangelo' (1550) stressed Michelangelo's ingratitude to the Medici and alleged willingness to offend them. Condivi in his *Life* mentioned Alessandro's 'old ill will' (*vecchia malevolenza*) towards Michelangelo.

223 *saved him from death*: For all these remarkable details, see the papers '*Michelangelo al tempo dei lavori di San Lorenzo in una "ricordanza" del Figiovanni*' by Alessandro Parronchi and '*Una ricordanza di Giovan Battista Figiovanni*' by Gino Corti (*Paragone*, CLXXV (1964)). The *ricordanza* of Figiovanni in his own hand was discovered in the Conti Capponi archives in Florence and was apparently written by Figiovanni a few years after the death of Pope Clement. Figiovanni died in 1544.

While the siege was still on, Michelangelo had written from the Santa Croce quarter, gonfalone of the Black Lion, as if furnishing an official declaration: 'I, Michelagniolo Buonarroti, have at home eight barrels of wine, and about two barrels of beans and one half-barrel of vinegar, and four mouths to feed.' This was dated 16 April, with no year given, and seems to have been a copy by Michelangelo of one of the declarations of goods that citizens had to make to the government during the siege. The context suggests it was made in 1530. For details and discussion of the document, see William Wallace, 'An unpublished Michelangelo Document', *Burlington Magazine*, March 1987, pp. 181–4. The 'four mouths' were almost certainly Michelangelo's nephew Lionardo, Antonio Mini, the family servant Mona Margherita and Michelangelo himself.

224 *for he works much*: *Carteggio*, vol. III, DCCCXXVII.

224 *a mass of drawings*: For discussion of the figural drawings uncovered in the altar chapel and the crypt of the New Sacristy (Catalogue by Paolo dal Poggetto: *I disegni murali di Michelangelo e della sua scuola nella Sagrestia Nuova di San Lorenzo* (Florence, 1979)), see the assessment by Caroline Elam in 'The Mural Drawings in Michelangelo's New Sacristy', in *Burlington Magazine*, October 1981, pp. 592–602. Elam argues that most of the studies on the side walls of the altar chapel are by Michelangelo but not so the drawings in the crypt.

225 *a flea in his ear*: So the story is told in the lives of Michelangelo by both Vasari and Condivi. One imagines that the duke of Ferrara, who was a greedy collector and domineering, would have pursued the matter vigorously, but what happened when his painting did not come is unknown, and he died in October 1534.

225 *He is a worthy man*: *Carteggio*, vol. III, DCCCXIII.

226 *The Piombo*: Bulls issued from the chancery of the Roman Curia, after being composed and executed, went to the *frates barbati* or *bullatores* 'usually two illiterate Cistercians (illiterate so they could not tamper with the text)' (cf. D'Amico, *Renaissance Humanism in Papal Rome*, p. 26). Julius II started to include laymen among the *bullatores* – notably Bramante.

226 *he would spend all his time*: Cellini's outrageous account in his *Autobiography* (trans. Bull, pp. 106–7) adds:

> My answer to this was that the purest-bred cats made better mousers when they were fat than when they were starving; and in the same way honest craftsmen did much better work when they had plenty to live on ... As a parting shot I told him to follow the example of his worthy predecessor Pope Julius, who gave such a post to the wonderful architect Bramante. Then I bowed abruptly and left in a rage. When I had gone Bastiano Veneziano, the painter, came forward and said to the pope, 'Holy Father, why don't you give the post to someone who devotes all his time to his art? I give myself wholeheartedly to my work, and I beg you to consider whether I am worthy of the position.'

227 *On 16 June 1531*: *Carteggio*, vol. III, DCCCXV, DCCCXX.

227 *still developing brilliantly*: For discussion of Sebastiano's experimentation of new ways of painting (on marble and slate) and the implications of his requests for drawings to Michelangelo in 1532, see Hirst, *Sebastiano del Piombo*, pp. 124–8.

227 *A long, newsy latter*: *Carteggio*, vol. III, DCCCXXXIII.

227 *Bear with me*: *Lettere/contratti*, CDVII; *Carteggio*, vol. III, DCCCXXIV.

228 *My very dear friend*: *Carteggio*, vol. III, DCCCLVII.

230 *in a hurry*: Ibid., vol. III, DCCCLIX.

231 *the contract*: Ramsden (*The Letters of Michelangelo*, vol. I, pp. 258) emphasizes that Michelangelo was himself present when the contract was witnessed on 29 April as stated in the document itself – *Michael Angelum ibidem presentem* – and as confirmed in a letter to the duke of Urbino from della Porta.

232 *inasmuch as*: Cf. Gotti, *Michelangelo Buonarroti*, vol. ii, p. 79.

232 *trusted helpers*: Michelangelo thus overcame both his dislike of close collaboration and his tendency to select mediocre albeit loyal and loving assistants such as Mini. For Michelangelo's use of the *compagni* or joint Florentine workforce with the ability 'to subordinate themselves stylistically to a prescribed mode', see Kent and Simons, *Patronage, Art and Society in Renaissance Italy*, pp. 288–90.

234 *never sit for anyone else*: In his play *The Stablemaster*, set at the court of Mantua and published in 1533, Aretino includes praise of Titian, 'the rival or rather master of nature'; Sebastiano, 'the inspired painter of Venice'; Sansovino, 'the mirror of Florence'; and Michelangelo, who was worth twice as much as each of them. Cf. translation by George Bull in *Five Renaissance Comedies*, ed. Bruce Penman (Harmondsworth, 1978), p. 177.

236 *knew the ill will*: Cf. Vasari's 'Life of Michelangelo' (*Lives of the Artists*, trans. Bull, vol. i, pp. 369–73) and Condivi (Bull and Porter, *Michelangelo: Life, Letters and Poetry*, pp. 43–5).

236 *build the citadel*: See J. R. Hale, 'The End of Florentine Liberty: the Fortezza da Basso', in Nicolai Rubinstein (ed.), *Florentine Studies* (London, 1968). At several stages of construction, following tradition, astrologers were consulted.

236 *Lodovico died*: The reasons for putting Lodovico Buonarroti's death probably in the spring or early summer of 1531 are convincingly given in *The Letters of Michelangelo*, ed. Ramsden, vol. i, pp. 295–7.

237 *If you know him*: Lettere/contratti, cxxx; *Carteggio*, vol. iv, cmxxxix.

237 *As I have to pay*: *Carteggio*, vol. iii, dcccLxxvi.

237 *when he looked back*: Michelangelo's own potted history of the financial dealings concerning the tragedy of the tomb was given in an angry letter to (probably) Cardinal Alessandro Farnese in October/November 1542; see below, note to p. 340.

237 *Apparently seething*: Gotti, *Michelangelo Buonarroti*, vol. i, p. 226.

238 *and I shall donate*: Lettere/contratti, cdxix; *Carteggio*, vol. iv, cmxxxvi.

241 *Silvio Cosini*: *Carteggio*, vol. iii, dccclxi.

242 *I could not answer*: Addressed to 'Niccolò', the letter (*Lettere/contratti*, ccclIII) is assumed to be to Niccolò di Raffaello de' Pericoli, nicknamed Tribolo, though this and its date are uncertain. Cf. *The Letters of Michelangelo*, ed. Ramsden, vol. i, app. 24, p. 186.

242 *and it seems*: *Carteggio*, vol. iii, dcccxcvi.

243 *Febo – Although*: Lettere/contratti, cdxx; *Carteggio*, vol. iv, cmxli.

243 *Febo replied*: J. A. Symonds, *The Life of Michelangelo* (2 vols., London, 1893), vol. ii, p. 403. Symonds suggests that M. Vincenzo is Vincenzo Perini, later treasurer of the Romagna, and comments on the 'bad orthography' of the letter to Michelangelo from Febo, which he gives in modernized Italian. For the dating of Michelangelo's dealings with Febo and his departure from Florence, see *The Letters of Michelangelo*, ed. Ramsden, vol. i, app. 25. Febo seems to have dropped out of Michelangelo's life after 1535.

Robert S. Liebert, in *Michelangelo: A Psychoanalytic Study of his Life and Images* (New Haven and London, 1983), comments on the element of 'soft' blackmail in Febo's letters to Michelangelo.

244 *your dear Simon*: *Carteggio*, vol. IV, CMXL.

244 *so near to death*: Saslow, *The Poetry of Michelangelo*, 66, p. 162.

244 *seven offspring*: For Dante in the *Purgatorio* (Canto II) seven horned heads were used to represent the seven deadly sins in the scene of the harlot and the giant. The seven offspring of Michelangelo's giant and the giantess may have been meant for the seven sins, the children of Fury and Pride. Michelangelo may also or alternatively have meant the giant to stand for tyranny. Cf. Saslow, *The Poetry of Michelangelo*, pp. 173–4.

245 *For them*: Saslow, *The Poetry of Michelangelo*, 67, pp. 163–6. (Trans. George Bull.)

245 *three times*: *Carteggio*, vol. IV, CMXIII, pp. 22–3.

245 *You have given*: *Lettere/contratti*, CDXV; *Carteggio*, vol. IV, CMXXIII.

246 *Mini wrote*: *Carteggio*, vol. III, DCCCXLI.

247 *another Leda*: Ibid., vol. III, DCCCLI.

247 *constantly asked*: Ibid., vol. III, DCCCLII.

247 *Oh just think*: Ibid., vol. III, DCCCLIII.

247 *Rustici acknowledged*: Ibid., vol. IV, CMIV.

247 *Mini died*: An account of what happened to Mini in Paris and of his own financial and legal involvement in the *Leda* was set down by Tedaldi on 1 July 1540 in Lyons. As his books would show, Tedaldi recorded, his half of the *Leda* had cost him 140 gold ducats, borrowed from his brother Papi Tedaldi. In Lyons he and Mini had been able to obtain on its security 500 ducats from Spina and 500 from Tommasino Guadagni. See Gotti, *Vita di Michelangelo Buonarroti*, vol. I, p. 201, and Symonds, *Life of Michelangelo*, vol. I, pp. 440–43. Vasari's statement that Michelangelo simply gave the original *Leda* to Mini and· kept no financial interest in it has been questioned by Wilson (*Life and Works of Michelangelo Buonarroti*, pp. 346–7), who suggests that Mini may have bought the picture on an advance in order to sell it in France, more or less acting as part of a syndicate. The *Leda* remained at Fontainebleau till the reign of Louis XIII, when it was burnt (or severely damaged) by the then superintendant of the royal palaces, perhaps on account of its lascivious nature. See also Tolnay, *Michelangelo* III: The Medici Chapel, p. 191.

248 *portrait*: The story of Bugiardini's painting of Michelangelo is told in Vasari's 'Life of Bugiardini' (*Le vite*, ed. Ragghianti, vol. II, pp. 803–9). It did not appear in the first edition but in the second, after Michelangelo's death, and has been seen by some as an example of Vasari's disparaging attacks on Michelangelo's early friends and associates. A portrait of Michelangelo in the Louvre, attributed to Bugiardini, formerly to Sebastiano del Piombo, was supposedly painted in 1522, showing him aged forty-seven. Another portrait of Michelangelo, wearing a turban, in the Casa Buonarroti, is attributed to Bugiardini, and also said to be from 1522. For possible identification of the portrait with a painting of Michelangelo aged about fifty-seven in 1532 in the

now disappeared gallery of Torre al Gallo at Arcetri near Florence, see Gaetano Guasti, *Il ritratto migliore e autentico di M. Buonarroti* (Florence, 1893). Vasari mentions four contemporary portraits of Michelangelo in all: Giuliano Bugiardini's, commissioned by Ottaviano de' Medici; Jacopo del Conte's (Palazzo Strozzi, Florence); the bust by Daniele Ricciarelli da Volterra, four copies of which were cast altogether; the medal by Leone Leoni.

250 *Inconsiderately*: *Lettere/contratti*, CDXI.

251 *a third draft*: *Lettere/contratti*, CDXII; *Carteggio*, vol. IV, CM.

251 *physical beauty*: Alexander Perrig (*Michelangelo's Drawings: The Science of Attribution*, trans. Michael Joyce (New Haven and London, 1991)) imaginatively suggests that with his youthful softness of features and good looks Tommaso must have looked like the 'ideal figures' Michelangelo had drawn in his youth – e.g. Bacchus, the *Pietà* in St Peter's, David, the Apollo, the Dying Slave, the Sistine *ignudi* and so forth – and that Tommaso was most likely to have been the model for the drawn faces Michelangelo did at this time.

251 *I do truly*: Symonds, *Life of Michelangelo*, vol. II, p. 400 (Italian text).

252 *I could now*: *Lettere/contratti*, CDXVII; *Carteggio*, vol. IV, CMXVIII.

252 *indeed I am sure*: Symonds, *Life of Michelangelo*, vol. II, p. 401.

252 *Michelangelo brought virtù*: Both men used words with care, and would do so especially when writing to each other at the initial, possibly fragile, stage of the friendship. Cavalieri said that Michelangelo was '*virtuosissimo*' or '*essa virtù*'; writing to Cavalieri simultaneously, Michelangelo had referred to his '*valoroso ingegnio*' (*Carteggio*, vol. III, DCCCXCVII). *Virtù* still bore the Latin sense of the sum of the highest qualities of a man, and *ingegno* the Latin sense of creativity, as well as in the context of the arts of painting and sculpture, respectively, virtuosity – even genius – and applied intelligence – even ingenuity.

253 *He loves you no less*: *Carteggio*, vol. IV, CMXV.

253 *had no other desire*: Ibid., vol. IV, CMXXI.

253 *Messer Tommaso*: Ibid., vol. III, CMXXV, CMXXXIII.

253 *Among the drawings*. For the argument that the drawings of the head of a youth wearing a cap in black chalk (Windsor) and the bust of a youth in fantastic dress in red chalk (Oxford, Ashmolean) were by Cavalieri in free exploration of Michelangelo's Cleopatra (Casa Buonarroti), see Perrig, *Michelangelo's Drawings*, pp. 77–8.

254 *powerful drawings*: In his letter to Michelangelo of 6 September, Cavalieri mentioned all these drawings except the Phaeton and its children's bacchanal, which Vasari said was done for Cavalieri. See Perrig, *Michelangelo's Drawings*, pp. 451–67.

254 *purpose-made drawings*: Hirst, in *Michelangelo and his Drawings* (p. 107), accepts that three drawings now in the Uffizi are those made for Gherardo Perini by Michelangelo; they are known as the *Fury*, the *Three Heads* and *Venus, Mars and Cupid* (also known as the *Zenobia*). Creighton Gilbert, in a paper reprinted in *Michelangelo On and Off the Sistine Chapel: Selected Essays* (New York, 1994), pp. 253–69, glosses Vasari's two important passages on Michelangelo's gifts to those he loved of *teste divine* (concerning the Cleopatra for Tommaso

and the three sheets for Perini), suggests that they may well all be dated in the 1520s, and suggestively finds an analogue for the *Fury* in a 1524 engraving (by Caraglio) after Rosso. But Perrig (*Michelangelo's Drawings*, p. 127, note 93) argues that the *teste divine* in the Uffizi were the products of the labours of Antonio Mini, probably the original recipient. Perini, alleges Perrig, seems to have tried to convince his contemporaries that they were original drawings and personal gifts from Michelangelo.

254 *sarcophagus*: Cf. Bober and Rubinstein, *Renaissance Artists and Antique Sculpture*, p. 70, where two relevant sarcophagi are discussed.

255 *uninhibitedly opened*: Commenting on the drawings of the bacchanal, among the rest, Liebert, in *Michelangelo: A Psychoanalytic Study* (p. 291) rightly says that 'In regarding [the drawing] as a communication piece to Tommaso, one finds oneself on highly speculative ground. My impression is that it expresses Michelangelo's wish that he could retreat with Tommaso into this all-male world, where time has no forward movement and ageing is unknown.'

255 *drawings for Cavalieri*: Locations of originals and/or copies of the drawings Michelangelo presented to Cavalieri as indicated by Perrig (*Michelangelo's Drawings*, pp. 42–6) include: The Archers – Windsor Castle, Royal Library, no. 12778r and 0442r; Ganymede – Fogg Art Museum, Cambridge, Mass., no. 1955.750; Tityus – Windsor, no. 12771r and 0472r; Cleopatra – Florence, Casa Buonarroti, no. 2F, and British Museum, no. 1887–5–2–120; the Risen Christ – Windsor, no. 12768; Fall of Phaeton – Windsor, no. 12766r, and British Museum, no. 1895–9–15–517; Children's Bacchanal – Windsor, no. 12777.

Perrig includes the so-called Dream of Human Life (Courtauld, London) among the drawings made for Cavalieri. Perrig and Michael Hirst (*Michelangelo and his Drawings*) between them provide ample fare for anyone hungry to know more about modern-day differences over specific attributions, as well as Michelangelo's art of drawing.

255 *l'onesto desio*: Saslow, *The Poetry of Michelangelo*, 83, p. 195.

256 *it was a strange place*: Baldassare Castiglione, *The Book of the Courtier*, trans. George Bull (Harmondsworth, 1976), p. 248.

256 *a most happy end*: Ibid., pp. 340–42.

256 *cruelly severe*: In 1508, the 'Eight' (the magistracy in charge of criminal justice), according to a note by Landucci (*A Florentine Diary*, p. 218), proclaimed that those guilty of 'a certain villainy' should be beheaded if they did not appear: 'they had dared to threaten a father if he did not give them his son'. But the accused were (apparently all four) absolved from the condemnation. In Italian cities generally throughout at least the first half of the cinquecento the harsh penalties seem to have been only rarely carried out. Cf. Rudolf and Margot Wittkower, *Born under Saturn* (London, 1963), pp. 169–70, and Saslow: 'Homosexuality in the Renaissance: Behaviour, Identity, and Artistic Expression', in Martha Bauml Duberman, Martha Vicinus and George Chauncey Jr (eds.), *Hidden from History: Reclaiming the Gay and Lesbian Past* (Harmondsworth, 1991). Ariosto accused writers and academics rather than artists of Landucci's 'certain villainy'.

257 *If one chaste love*: Bull and Porter, *Michelangelo: Life, Letters and Poetry*, p. 140.

257 *Why should I still*: Ibid., p. 149.

258 *I wish to want*: Ibid., p. 146.

258 *This time the signor*: For a compelling discussion of the language and significance of the madrigal '*Come può esser . . .*' as well as the sonnet '*Vorrei voler, Signor . . .*' – the enduring 'troubling ambiguity' of Michelangelo's new life after 1532 – see Cambon, *Michelangelo's Poetry*, pp. 41–57. The generally accepted dating for the deeply religious sonnet ('*Vorrei voler, Signor . . .*') of 1534 (by Girardi, instead of the late 1550s, earlier, by Frey) justified the attention given to its astonishing correspondence with the erotically charged poems for Cavalieri. For the change in Michelangelo's handwriting, see Ciulich, *Costanza ed evoluzione nella scrittura di Michelangelo*, p. 48.

259 *make a contract*: *Carteggio*, vol. IV, CMX.

260 *and His Holiness*: Ibid., vol. IV, CMXX, CMXXI.

260 *respectful dispatch*: Ibid., vol. IV, CMXXII. Gian Francesco Bini was respected enough by Michelangelo to be among the few people he asked to improve his verse. Cf. Symonds, *Life of Michelangelo*, vol. II, p. 168, note 2.

260 *He reported*: *Carteggio*, vol. IV, CMXXXIII.

260 *Pope Clement*: See Pastor, *History of the Popes*, vol. X, pp. 222–37, where the suggestion that Clement agreed to Francis's deal with the Turks and Protestants is dismissed as pernicious.

261 *I am sending you a mount*: *Carteggio*, vol. IV, CMXXX.

261 '*disposed*' *Michelangelo*: Pastor, *History of the Popes*, vol. X, p. 363.

262 *Compositional sketches*: Florence, Casa Buonarroti, no. 65F-r, Last Judgement, black chalk; London, British Museum, no. 1895-9-15-518r, partial sketch with subsidiary sketches, figure studies, black chalk; Windsor Castle, Royal Library, no. 12776r, partial sketch with subsidiary sketches, black chalk.

262 *After brooding*: Cf. Condivi (Bull and Porter, *Michelangelo: Life, Letters and Poetry*, p. 51): Pope Clement, 'being a person of great discernment, who had brooded on this project time and time again, [he] finally resolved to have Michelangelo depict the day of the Last Judgement . . . Michelangelo, knowing the obligation he was under to the duke of Urbino, resisted the demand as much as he could. But, since he was unable to free himself, he delayed things from day to day, pretending to be occupied on the cartoon, as he was in part, while secretly working on the statues destined for the tomb.'

For discussion of Michelangelo's compositional drawings and their relationship to the fresco, see Perrig, *Michelangelo's Drawings*, pp. 52–4.

262 *he complained*: *Lettere/contratti*, CXXIX; *Carteggio*, vol. IV, CMXXXVIII (dated 1534).

263 *living model*: The possibility that Michelangelo consciously or subconsciously portrayed Cavalieri in the statue in San Lorenzo is argued cogently by Perrig (*Michelangelo's Drawings*, p. 79). 'The Giuliano has the same physiognomic characteristics as the Windsor and Oxford drawings . . . the deep eyes with

the heavy lower lids, the girl-like fine mouth with the dimples, the small energetic chin . . .' The profile of the statue of Giuliano is 'idealized' none the less, and is also not unlike that of Michelangelo's marble giant statue of David, done so long before.

264 *magnificent library*: Cf. Ackerman, *The Architecture of Michelangelo*, text & plates vol., pp. 33-4.

Renaissance architecture, like that of any other period, was a product of social and technological forces as well as of ideas. Michelangelo, when asked about it, justified the fantastic design of his stairway by explaining – how seriously? – that the central flight was for the ruler and those on the side for retainers.

265 *French disease*: The disease Cellini believed he had caught from a young servant girl, and that he cured with lignum vitae, was known to him and other Italians as *morbo gallico*. Nearly all the Italian names for syphilis were then associated with France, though the rampant disease, first evident in Europe when the army of King Charles VIII of France captured Naples in 1495, seemed to have arrived with the return of Colombus's men from Haiti in 1493. Girolamo Fracastoro coined the name Syphilis for a Greek shepherd who, he explained in his poem of the same name (*Syphilis sive Morbus Gallicus* (Verona, 1530)), first incurred the disease as a punishment from Apollo.

Some commentators have thought that the dangerous illness from which Michelangelo's recovery was hailed by his friend Lionardo di Compagno in 1522 was syphilis: this is discussed and rejected by Ramsden (*The Letters of Michelangelo*, vol. i, pp. xlviii–xlix). The medical and historical context of Fracastoro's poem is outlined in an edition of the Latin hexameters and a translation (*Syphilis or the French Disease*) by Heneage Wynne-Finch (London, 1935).

267 Un papato: In *The Renaissance in Italy*, vol. v, pp. 323-4, Symonds starts his translation of the sonnet with:

A papacy composed of compliment,
Debate, consideration, complaisance,
Of furthermore, then, but, yes, well, perchance,
Haply, and suchlike terms inconsequent . . .

268 *imprisoned*: Cellini's *Autobiography* recalls that Paul III came to tell the castellan of Sant'Angelo that he was once imprisoned in the castle and had himself made his escape, as Cellini did in 1538. Cellini adds that the pope, when young, had been imprisoned by Pope Alexander VI for forging a brief. In fact the pope who imprisoned the young Farnese was Innocent VIII. Cf. also Pastor, *History of the Popes*, vol. ii, pp. 16–17, where it states that Farnese was imprisoned on account of his behaviour 'in some family quarrel'.

270 *To remunerate him*: *Lettere/contratti*, p. 708. As with Julius II and during the siege of Florence and on other occasions, Michelangelo's flight or threatened flight ensured that he secured, if not exactly what he listed, at least some relief from pressure and the assurance that he was wanted and valued. My account

of the 'negotiation' that took place with Pope Paul III over the commission of the *Last Judgement* is based on Condivi (Bull and Porter, *Michelangelo: Life, Letters and Poetry*, pp. 54–5) and secondly Vasari (*Lives of the Artists*, trans. Bull, vol. I, pp. 378–9), who both in this instance wrote what Michelangelo wished to recall for the record. We need not doubt his genuine anguish over the tomb, but he was surely not so unwilling a victim of Pope Clement and Pope Paul, whose commissions he interpreted to suit his own style and vision.

270 *to quarrel angrily*: For the alleged quarrel, see Sebastiano's life by Vasari (*Le Vite*, ed. Ragghianti, vol. II, pp. 613–14) who claims that Michelangelo never forgave the injury he thought had been done to him. His account is accepted by Hirst (*Sebastiano del Piombo*, pp. 122–5).

271 *stock of images*: Filippo Signorelli's *Last Judgement* in Orvieto Cathedral (painted in 1499) as Vasari described it showed all the scenes of the end of the world, with angels, demons, ruins, earthquakes and the miracles of Antichrist, using nudes and foreshortenings, and brought in portraits of his friends. Dante in the *Inferno* (Canto III) described Charon, with eyes of glowing coal, ferrying the blaspheming damned across Acheron to hell and beating the laggards with his oar. In the Bible, Ezekiel (38: 1ff.) tells how he was transported to the valley of dry bones, brought together, given sinews and flesh and skin, and breathed into life by the Lord God.

271 *Tommaso de' Cavalieri*: Perrig (*Michelangelo's Drawings*, pp. 79–82), discussing Michelangelo's early relationship with Tommaso, gives the latter an important role in the development and execution of the *Last Judgement*, which he comments therefore looks 'more earthly and human than the myth of a lonely brooding titan would have it'. He believes that at least ten of the fresco figures 'appear to be Cavalieri's ideas that Michelangelo thought through to their final form'.

271 *Now who would not*: See Aretino, *Selected Letters*, trans. Bull, p. 97. In the letter to the printer Francesco Marcolini on the honourable way for a writer to live, Aretino added that 'those who sell their own writings become wheelers and dealers in their own infamy. So print my letters carefully, on good parchment, and that's the only recompense I want.'

272 *In receiving your letter*: *Carteggio*, vol. IV, CMLV.

274 *circle of . . . friends*: Cf. M. F. Jerrold, *Vittoria Colonna* (1906, reprinted New York, 1969), where the chapter on 'A Chronicle of Friendships' lists Sannazzaro, the poet Girolamo Britonio, the recluse Galeazzo di Tarsia (who praised her white, soft hands and golden hair), Giberti, Sadoleto, Bembo, Castiglione, Marcantonio Flaminio, Paolo Giovio, the secretary and poet Giovanni Guidiccioni, Molza, Claudio Tolomei (founder of the Accademia Romana), the (her) secretaries Carlo Gualteruzzi and Giuseppe Jova, the duchessa Elisabetta of Castiglione's *The Book of The Courtier* (her aunt), Giulia and Eleonora of the house of Gonzaga, the poetess Veronica Gambara, and the cardinals Contarini, Morone and Pole; and Michelangelo.

274 *has so rare*: Quoted in Robert de la Sizeranne, *Celebrities of the Renaissance* (London, 1926), pp. 336–7.

274 *Vittoria's poems*: For a sympathetic critique of Vittoria Colonna's poetry, see Dennis J. McAuliffe, 'NeoPlatonism in Vittoria Colonna's Poetry', in Eisenbichler and Pugliese, *Ficino and Renaissance NeoPlatonism*. McAuliffe considers that Vittoria's 'NeoPlatonism' changed from the earlier to the later *canzoniere* as a result of a personal spiritual conversion about the time Juãn de Valdes established himself in Naples in 1534. Her ascent became one to Jesus – the flight to the Cross – and she abandoned her contemplation of Ferrante, her 'Bel Sole', and also the perception of the good through the beautiful.

275 *personal attraction*: Many of the poems seemingly written for the cruel woman could as well have been for Vittoria Colonna; some few of Michelangelo's poems during this period could have even been addressed alternatively to Colonna or Cavalieri. Cambon comments in his rewarding discussion of the poems for Colonna (*Michelangelo's Poetry*, pp. 66–111) on their key biographical importance in that 'As Vittoria, the Eternal Feminine would for ever draw him on high, beyond himself; as fair and cruel lady that same hypostatized force would tease him out of countenance and threaten him with moral destruction.' Cambon inserts the idiosyncratic Michelangelo at this point into the old literary tradition of the poetic articulation of feelings of rejection and despair, inspired by desired women, from the Provençal troubadours to Cavalcanti, Dante and Petrarch.

281 *Castilian soldiers*: At this point, quite ferociously, Michelangelo, according to Francisco's report of his oration in direct speech, claimed to have covered the towers with sacks filled with wool and others with gunpowder and to have burned the blood of the Castilians. He remained extremely sensitive about every aspect of his role during the siege, where his talent as a military engineer had been in dispute from the start. When Pope Paul sought his advice on the defences of Rome, Antonio da Sangallo, already employed on studies for this purpose, said that Michelangelo's arts were sculpture and painting and not fortification. Michelangelo (wrote Vasari later) responded meiotically that he knew only a little about sculpture and painting, but, given all the thought he had devoted to it and his practical experience of it, considered he knew more about fortification than Sangallo or any of his people (*Lives of the Artists*, trans. Bull, vol. 1, p. 384).

284 *Francisco had been privileged*: This account of the meetings of Francisco de Holanda, Michelangelo, Vittoria Colonna, Lattanzio Tolomei and Giulio Clovio is based on the dialogue by Francisco completed in October 1548 and incorporated as vol. II of Holanda's *Da Pintura Antigua*. An English translation was published in Charles Holroyd's *Michael Angelo Buonarroti* (London, 1903) and Francisco de Hollanda [*sic*], *Four Dialogues on Painting*, trans. Aubrey F. G. Bell (Oxford, 1928; Westport, Conn., 1979). For a detailed discussion of the authenticity of the four dialogues, known as the Roman Dialogues, see J. B. Bury, *Two Notes on Francisco de Holanda*, The Warburg Institute (London, 1981). Bury examines the three dialogues in which de Holanda presents Michelangelo's views (the fourth involves the artists Valerio Belli and Giulio Clovio) and concludes that the Roman Dialogues are unique in sixteenth-

century dialogues in the degree of their verisimilitude. One of the main difficulties in the internal evidence for the authenticity of the dialogues – the discourse in which Michelangelo is reported as naming twenty-one towns in Italy containing notable works of art, though as far as is known he had personal acquaintance of only six of them – Bury explains by supposing that Francisco put into Michelangelo's mouth his own travel observations and appreciations of the works of art he saw. In making use of Francisco's fresh and, to me, most convincing narrative, I have therefore followed him in nearly everything but this. Also convinced of the authenticity of the Roman Dialogues, Clements comments, 'One begins to understand why Michelangelo was willing about this time (1538–42) to discard the title of sculptor in signing letters and to assume that of painting, in the broad and individual sense that he attributed to the term' (*Michelangelo's Theory of Art*, p. 311).

285 *O dark yet lovely*: See Bull and Porter, *Michelangelo: Life, Letters and Poetry*, p. 150.

286 *Further letters*: For translations of some of Vittoria's sonnets and letters to Michelangelo at this time, see Jerrold, *Vittoria Colonna*, pp. 127–38. Between Ramsden (*The Letters of Michelangelo*, vol. II, app. 26) and Perrig (*Michelangelo's Drawings*, pp. 47–9 and notes) there is serious disagreement about the dating and order of the letters exchanged between Michelangelo and Vittoria and the drawings he did for her. The gist of Perrig's argument is that the initiative came from Colonna, who wanted Michelangelo to design a crucifix for a painting, and asked first for a sketch; that the earliest engraving of the Crucifixion published in 1546 gives a *terminus ante quem* for the drawing and painting (and was meant for a small circle of the marchesa's pious friends); that the drawing, painting and related correspondence from the engraving cannot be chronologically separated; and therefore the documents should be dated around 1545 and not 1538–42. This would mean that the 'great task' mentioned by Michelangelo to Vittoria was the painting of the conversion of St Paul rather than the *Last Judgement*.

286 *To your resplendent beauty*: Bull and Porter, *Michelangelo: Life, Letters and Poetry*, p. 154.

288 *You have taken*: Pastor, *History of the Popes*, vol. II, ch. III. The report of the reform commission – the *Consilium de emenanda ecclesia* – was formally presented to the pope in March 1537. The English text can be conveniently found in John Olin, *Catholic Reform: From Cardinal Ximenes to the Council of Trent* (New York, 1990), p. 65.

Addressing the pope as bishop of Rome (having admonished him as pontiff of the Universal Church) the nine cardinals reported on contemporary Roman society that:

> This city and church of Rome is the mother and teacher of the other churches. Therefore in her especially divine worship and integrity of morals ought to flourish. Accordingly, most blessed Father, all strangers are scandalized when they enter the basilica of St Peter where priests,

some of whom are vile, ignorant, and clothed in robes and vestments which they cannot decently wear in poor churches, celebrate mass. This is a great scandal to everyone. Therefore the most reverend archpriest or the most reverend penitentiary must be ordered to attend to this matter and remove this scandal. And the same must be done in other churches.

Also in this city harlots walk about like matrons or ride on mules, attended in broad daylight by noble members of the cardinals' households and by clerics. In no city do we see this corruption except in this model for all cities. Indeed they even dwell in fine houses. This foul abuse must also be corrected.

There are in this city hospitals, orphans, widows. Their care especially is the concern of the bishop and the prince. Therefore Your Holiness could properly take care of all of these through cardinals who are upright men . . .

289 *Michelangelo now drew a cave:* For argument that the central 'hell-cave' in the *Last Judgement*, (to be distinguished from the entrance of hell to the viewer's right of the fresco – denoted by the figure of Minos) is part of a sun-deity theme in the fresco and refers to the famous cave of Plato, where men see only shadows of reality, see Valerie Shrimplin-Evangelidis, 'Hell in Michelangelo's Last Judgement', *Artibus et Historiae* (Vienna), no. 27, 1994. Michelangelo's sharp-witted fellow-Florentine Cellini warns in his autobiography that commentators made Dante, for example, say things 'of which he never even thought'. However, the cleaning of the fresco has revealed fully an imposing standard figure, a male nude with arms raised high and a back displaying powerful muscle-architecture, who seems to be fending off the heat of the infernal flames. This adds some credence to the suggestion that Michelangelo was here depicting the visit of Christ to set up his Cross in Hell as liberator, described in various versions of the apocryphal so-called *Gospel of Nicodemus (Acts of Pilate)*.

289 *the main design*: Michelangelo probably made early on a *modello*, doubtless a large drawing, of the projected fresco of the Last Judgement for Pope Clement, which Condivi reported that Pope Paul saw when he visited Michelangelo's studio. Cf. Hirst, *Michelangelo and his Drawings*, p. 80.

Perrig (*Michelangelo's Drawings*, pp. 52–5) comments that the three compositional sketches by Michelangelo for the *Last Judgement*, in the Casa Buonarroti, Florence, the Royal Library, Windsor, and the British Museum, London, 'allow a unique view not only into the genesis of this gigantic fresco, but also into Michelangelo's way of conceiving scenes with masses of figures'.

For the innumerable interpretations of the bewildering iconography of the *Last Judgement*, see Valerie Shrimplin-Evangelidis, 'Sun-Symbolism and Cosmology in Michelangelo's Last Judgement', *The Sixteenth-Century Journal*, vol. XXI, no. 4 (winter 1990), pp. 607–43, which itself argues challengingly for the ordering of Michelangelo's complex scene by relating it to a heliocentric

concept of the universe which placed a spherical earth in a circular sun-centred system.

292 *perilous company*: Michelangelo's angry joke at the expense of Biagio – recorded by Vasari – his experiments with dissections and flayings in his youth, and other kinds of boldness came to earn him a reputation for evil which found full expression in the *Itinerary* of the great English Elizabethan traveller Fynes Moryson (a graduate of Peterhouse in Cambridge), first written in Latin and then published in English in 1617. He wrote of his discoveries in 1594 – thirty years after Michelangelo's death:

> that he being to paint a crucifix for the Pope, when he came to expresse the lively actions of the passion, hired a Porter to be fastned upon a Crosse, and at that very time stabbed him with a penknife, and while he was dying, made a rare peece of worke for the Art, but infamous for the murther: and that hereupon he was banished Rome, and went to the Court of the Duke of Urbino, where he was entertained with much honour.
>
> (Fynes Moryson, *An Itinerary: Containing his Ten Yeeres Travell* . . . (4 vols., Glasgow, 1908), vol. I, p. 236).

295 *copies and prints*: A large painting of Michelangelo's *Last Judgement* by Marcello Venusti, executed in 1549 for Cardinal Farnese and preserved in the Capodimonte Museum, Naples, was till the recent cleaning of *The Last Judgement* in the Sistine the best guide to the original fresco as it left Michelangelo's hand.

296 *rather than Savonarola*: It is hard to see Savonarola's influence in the details of a work vehemently protesting that profound religious feelings can be expressed through all kinds of moving figures, from a powerful heavily breasted crouching St Catherine to a wingless angel sprawling on his back, legs raised, as he takes in his arms the weight of a massive, swinging stone column. Noting that Michelangelo was exceptional for the creatively synthesizing abilities of his art and intellect, Leo Steinberg (*Michelangelo's Last Paintings* (London, 1975), p. 39) sees parallels – as in the case of Michelangelo's statue of David – between the ideas and imagery of Savonarola and Michelangelo, rather than influences of the former on the latter.

296 *decorum*: In the 1530s Pietro Andrea Mattioli attempted in his verses, concerning the palace of the Cardinal of Trent, to discuss intelligently the topic of decorum, locations and nudity. The debate was explosively intensified when Michelangelo's *Last Judgement* was finished and opened to view. For background, see Francis Ames-Lewis and Anka Bednarek (eds.), *Decorum in Renaissance Narrative Art* (London, 1992).

296 *'shameful' nudities*: Cf. Romeo De Maio, *Michelangelo e la Controriforma* (Rome, 1981), pp. 19–23. Published in Venice in 1551, the relevant commentary – in Latin – included the following:

> There is an outstanding contemporary painter and sculptor named

Michelangelo, who is wonderful at portraying naked and shameful human bodies. I commend his skill as far as its execution is concerned; but I passionately upbraid and abhor the execution itself . . . However, for my present purposes [the lesson] I wanted to draw from the foregoing is that the disgraceful and offensive naked bodies (which when all is said and done nature herself wanted us to cover) are not painted by that outstanding painter Michelangelo with the absolute perfection with which our Apostle [or Apostolus] has portrayed and put in view with the living brush of the spirit every nude and shameful [body] of the heretics . . .
(*Commentoria in omnes divi Pauli et alias septem canonicas epistolas* (Venice, 1551).)

297 *gilded leaves*: Aretino's reference to the gilded leaves covering the 'shame' of the giant statue of David in Florence seems to confirm that from the beginning Florentines disagreed about the acceptability of its nudity. David has shed and regained his fig-leaves on and off over the years, depending on the sexual mores of the time. When first placed on the piazza, the statue was adorned with gilt accessories: a '*ghirlanda*' and a '*cigna*' or belt of copper leaves.

Aretino made a fresh version of his 1545 letter to Michelangelo and addressed it to Alessandro Corvini, one of the secretaries to Duke Ottavio Farnese in Rome; dated July 1547, it was published in Aretino's fourth book of letters in 1550, the year Julius III became pope, and Julius must have been the new pope referred to, making the dating inconsistent. The letter (Aretino, *Selected Letters*, trans. Bull, pp. 226–8) was more or less as before and included the following:

how can a Michelangelo of such stupendous fame, a Michelangelo of outstanding wisdom, a Michelangelo of exemplary goodness, have allowed envy the chance to say that in this work he shows no less religious impiety than artistic perfection? Is it possible for a man who is more divine than human to have done this in the foremost church of God, above the main altar of Jesus, in the most excellent chapel in the world, where the cardinals of the Church, where the reverend priests, where the vicar of Christ, in Catholic devotions, with sacred rites and holy prayers, bear witness to, contemplate and adore His body, His blood and His flesh? . . .
Even the fine points of these extravagant marvels may not remain unpunished, since their very brilliance (with regard to the sinfulness ascribed to them by the faithful) means the death of all praise. But the great master can restore their good name by feigning the manhood of the blessed with the rays of the sun, and that of the damned with flames of fire: for he well knows that Florentine virtue hides beneath some leaves of gold the shame of the giant figure standing on the public square, and not placed in an open and sacred place.
It could be that the new pontiff, with deferrence to Paul, will imitate Gregory, who wished rather to strip Rome of its adornment of the proud statues of the idols than to hinder, because of them, the reverence due to

the humble images of the saints. For our souls are more in need of the feeling of devotion than of the pleasure that accompanies vitality of design . . .

298 *My Lord*: Bull and Porter, *Michelangelo: Life, Letters and Poetry*, p. 144.

298 *Modern painters*: Quoted from De Maio, *Michelangelo e la Controriforma*, p. 49, note 23. From Florence Bibl. Nazionale, ms magliah ii.iv. 19, pp. 138–9.

298 *Lorenzino*: Lorenzino came to be called Lorenzaccio by his detractors, who accused him of sharing Alessandro's vices. His apologia stated that he had acted to save Florence from tyranny. He has inspired novels and plays, e.g. *Lorenzino* by Alvin Upton and notably Alfred de Musset's *Lorenzaccio*.

300 *Medici rule*: Cf. Kent and Simons, *Patronage, Art and Society in Renaissance Italy*: 'Political survival [in Florence] now [after 1532] depended entirely on the will of the Dukes; and prominent Savonarolans, like the other Florentines of the same class, were forced to come to terms with the Medici. A radicalized Savonarolan ideology now became almost exclusively the preserve of the socially humble and of the politically disenfranchised.'

300 *as Cellini told*: Cellini, *Autobiography*, trans. Bull, p. 166.

301 *Baccio Bandinelli*: After Duke Cosimo had approved his model for filling in the cathedral, Bandinelli, following several attempts (his first bungled Adam he converted into a Bacchus and his first Eve into a Ceres), in 1549 unveiled an Adam and an Eve which inspired numerous sarcastic poems in Tuscan and Latin. It was then that an anonymous Florentine associated the nakedness of Bandinelli's figures with the alleged indecencies of the *Last Judgement*.

303 *exempted Michelangelo*: This was one of several steps taken to tie Michelangelo more closely to the service of the pope in Rome, and to enhance his status during the pontificate of Paul III. In 1540, for example, the pope officially emancipated Michelangelo, along with Pierantonio Cecchini, from their guild, the Ars Scalpellinorum. (In Rome the trade guilds were mostly small and weak in contrast with the 'national' associations and sodalities and the loan societies. Cf. Peter Partner, *Renaissance Rome 1550–1559* (Berkeley, 1976), pp. 102–96.) In March 1546, after deliberation by the municipal council of Rome, Michelangelo was made a Roman citizen.

304 *probably Cardinal . . . Farnese*: Cf. *The Letters of Michelangelo*, ed. Ramsden, vol. II, app. 31.

304 *Monsignor*: From Rome, October/November 1542: *Lettere/contratti*, CDXXV; *Carteggio*, vol. IV, MI.

308 *Dear to me*: Saslow, *The Poetry of Michelangelo*, 247 (1545–46), p. 419.

309 *he who rules*: Ibid., p. 164.

309 *Florentine exiles*: Exiles during the half-century of foreign invasion and political upheaval in Italy after 1494 'rarely expressed their grievances in poetry, but the more articulate of them did produce a great outpouring of political speculation, proposals for constitutional reform, and historical writing' (Randolph Starn, *Contrary Commonwealth* (Berkeley, 1982)).

Michelangelo's poems on Dante, and the tone of much of his poetry after he left Florence, could also surely be regarded as part of the poetry of exile.

309 *from Donato Giannotti*: For Michelangelo's involvement with Giannotti, see Starn, *Donato Giannotti and His Epistolae*.

Vasari in his 'Life of Michelangelo' relates that he had executed just the head of the bust of Brutus, copied for Ridolfi at Giannotti's request from an antique cornelian, using light chisels, before giving it to Tiberio Calcagni to finish. Cf. *Lives of the Artists*, trans. Bull, vol. I, p. 413.

310 *Giannotti recalled*: D. J. Gordon, in 'Michelangelo and the Cult of Brutus' (*Fritz Saxl 1890–1948: A Volume of Memorial Essays from His Friends in England*, ed. D. J. Gordon (London, 1957)), accepts the view of Deoclecio Redig De Campos in his edition of the *Dialoghi di Donato Giannotti* (Florence, 1939) that, as Giannotti makes Michelangelo declare that he is in his seventieth year, and from other evidence, the conversations must have taken place between the last days of January and 6 March 1546. He does not think that De Campos allowed enough for the way the conventions of the literary form used by Giannotti allowed variations and degrees in its presentation of 'what actually happened'. But he does not dispute that 'words and phrases are put into the mouth of Michelangelo which are so idiosyncratic that they cannot have been invented'.

312 *Luigi del Riccio*: Neither Vasari nor Condivi mentioned Luigi del Riccio in their biographies of Michelangelo, when they listed his illustrious friends. Vasari mentioned Luigi del Riccio in the first edition of the *Lives* (referring to the drawing Michelangelo did for his 'domestic' friend del Riccio for the tomb of Cecchino Bracci) but left him out in the second edition. Amends were made in Ernst Steinmann's *Michelangelo e Luigi del Riccio* (Florence, 1932).

313 *idiosyncratic*: Clements, *The Poetry of Michelangelo*, p. 30, where Michelangelo's softened palatal forms – e.g. *chome*, *locho*, *pechato* – are especially noted, with the rider that after 1527–8 the *ch* became *c*.

313 *One brief letter*: *Lettere/contratti*, CDXXIII; *Carteggio*, vol. IV, CMLXIII.

313 *another brief letter*: *Lettere/contratti*, CDXXVIII; *Carteggio*, vol. IV, CMLXIV.

For discussion of Arcadelt's career in Rome and Florence and the critical dating of his settings for Michelangelo's madrigals, see Iain Fenlon and James Haar, *The Italian Madrigal in the Sixteenth Century* (Cambridge, 1988), pp. 60–63. Their identification of del Riccio as an intermediary, with the fact that the only copy of '*Io dico che fra voi*' and '*Deh dimmi, Amor*' is in his hand, 'is suggestive'. Several of Arcadelt's settings of Michelangelo's poems have been recorded and are available on compact discs as part of selections of sixteenth-century madrigals.

314 *Alas*: Quoted in Steinmann, *Michelangelo e Luigi del Riccio*, p. 13.

314 *as beautiful*: In his comment on the excellence of Giannotti's sonnet, Michelangelo also said that, being so often with del Riccio, he would feel shame if he did not sometimes speak Latin, even if bad Latin; but being of poor taste that he could not judge good cloth even if it were Romagnol (i.e.

Giannotti's verse in the vernacular) any more than worn brocades (i.e. Latin) which would make a tailor's dummy look beautiful.

315 *verses for Cecchino*: Saslow, *The Poetry of Michelangelo*, pp. 339–90.

315 *felicitous compression*: Cf. Cambon, *Michelangelo's Poetry*, p. 157: 'Michelangelo often experiments with elliptical phrasing as if he is transferring to verbal language the foreshortening effects that mark his painting.'

316 *quite moral*: Though asserting that his dream about Cecchino confirmed Michelangelo's 'emotional and erotic attachment to youths of exceptional beauty and gifts', and subsequent feelings of extreme vulnerability, Liebert argues that taking the poems and the postscript as evidence of Michelangelo's sexual relationship with Cecchino is based on a 'gross misreading' of the poems in terms of who the surviving lover was (*Michelangelo: A Psychoanalytic Study*, pp. 302–5). Ramsden (*The Letters of Michelangelo*, vol. II, pp. xxxiv–xxxvi) also robustly eschews the very idea of a sexual relationship between Michelangelo (aged sixty-nine in 1544) and Cecchino de' Bracci, and, moreover, insists that Michelangelo was 'not himself emotionally involved' in the relationship between del Riccio and Cecchino, 'who was as dear to the childless del Riccio as a son'. Ramsden dismisses the notorious two lines about going to bed as springing from Michelangelo's 'typically Renaissance penchant for a pun'. Comment 'from America' on this subject, Ramsden dismisses as 'pompous rot'.

What is abundantly clear is that Michelangelo wrote the verses about Cecchino de' Bracci because of his affection for and obligation to Luigi del Riccio. When Cecchino is made to say that his soul lives on in the person whom he pleased in bed ('*a quel ch'i'fui grazia nel letto*'), it seems most likely that this person was del Riccio, addressed (as we have seen) by Cecchino in another epitaph, composed by Michelangelo, as the lover in whom he survived. Saslow (*The Poetry of Michelangelo*, p. 359) sensibly adds to all this the reflection that 'Renaissance language regarding love is ambiguous, and many people shared beds without having intercourse'.

The monument for Cecchino was executed by Urbino and put in Santa Maria in Aracoeli.

316 *breathtaking present*: Ramsden (*The Letters of Michelangelo*, vol. II, app. 27, p. 257) argues plausibly that the statues were probably presented first to Luigi del Riccio and, after his death, then offered to Roberto Strozzi; Michelangelo had been a guest in his house (but in Luigi's apartment).

316 *So I beg*: *Lettere/contratti*, p. 521. Also cf. *Carteggio*, vol. IV, MLVI, and *The Letters of Michelangelo*, ed. Ramsden, vol. II, app. 27. The date of the letter is uncertain, but Ramsden assigns it to January 1545 and is certain that the quarrel was over an engraved portrait of Michelangelo; one such, by Bonasone, bore the title 'Michel Angelus Buonarrotus, Patricius Florentinus, Sculptor, Pictor, Architectus Unicus' – words reflected in the way Michelangelo signed his letter. Ramsden's belief is that del Riccio had shown Michelangelo a proof of one of Bonasone's two engravings, which made him look like a drunkard, and then made the terrible mistake of resubmitting it. To show how hurt he had been, Ramsden also suggests, Michelangelo added that he would have to smash the statues he was giving to Luigi, as he could not do otherwise.

317 *sent to Luigi*: *Lettere/contratti*, CDLI; *Carteggio*, vol. IV, MXXXII.

318 *Lionardo. – You have*: *Lettere/contratti*, CLXII; *Carteggio*, vol. IV, MLIII.

318 *today there are only frauds*: *Carteggio*, vol. IV, MLIX.

319 *constantly reminded*: *Lettere/contratti*, CLX–CLXXI; *Carteggio*, vol. IV, MLI– MLIII.

320 *an edition*: By early 1546 fair copies had been made of 105 poems for the proposed publication, but the first printed edition of Michelangelo's poems did not appear till 1623 and was edited by his grand-nephew, Michelangelo, from manuscripts, including the fair copies mentioned. Michelangelo the Younger, notoriously, made additions and changes both (as he saw it) to improve his uncle's language and to safeguard his reputation against allegations of scandalous sexual behaviour and impropriety. For discussion of this and the subsequent critical editions of Michelangelo's poetry by Carl Frey (1897) and Enzo Girardi (1960) – and translations into English – see Saslow, *The Poetry of Michelangelo*, pp. 53–61.

320 *Po ferry*: Cf. Steinmann, *Michelangelo e Luigi del Riccio*, pp. 27–8, and *The Letters of Michelangelo*, ed. Ramsden, vol. II, app. 23. A papal brief had conceded revenues from the Po ferry above Piacenza to Michelangelo in September 1535. After the concession became his officially in 1538 (being entered into the books of the Apostolic Camera), first a rival ferry was set up and then the municipality of Piacenza challenged Michelangelo's right to the revenues, which in any case never reached the annual sum he had expected. After Pier Luigi Farnese became duke of Parma and Piacenza in 1545, his agents seized the ferry and the pope intervened again, but payments to Michelangelo were suspended till early 1546. Michelangelo complained to del Riccio (in Lyons) that he could not stay in Rome without an income (and remarked in his letter to Lionardo thanking him for the shirts that his nephew's idea of investing in a water-mill did not appeal to him, as he had no confidence in 'income based on water'). Then members of the Pusterli family claimed the revenues of the Po ferry by right of inheritance, and Michelangelo was appalled to be summoned to appear before a tribunal. The pope had the matter settled in Michelangelo's favour, but not for long.

321 *I remind you*: *Lettere/contratti*, CXCII; *Carteggio*, vol. IV, MCII.

322 *The love I speak of*: Saslow, *The Poetry of Michelangelo*, 260, p. 440.

322 *their correctness*: Giannotti brought precision and consistency to bear on Michelangelo's effective spontaneity, and altered spellings, e.g. *indegniamente* became *indegnamente*, Michelagniolo/Michelagnolo, *pechato/peccato*. Cf. Ciulich, *Costanza ed evoluzione nella scrittura di Michelangelo*, p. 501.

322 *blue-grey paper*: Michelangelo used for letters the same kind of paper as he used for his drawings. For a pioneering study of the extremely diverse range of watermarks in the paper he used, including the 'old-fashioned' single ladder, pair of shears and bell-flower type, see Jane Roberts, *A Dictionary of Michelangelo's Watermarks* (Milan, 1988).

323 *plain and intelligent*: The most reliable sources for Vittoria's appearance include an anonymous portrait in oils in the Casa Buonarroti in Florence

(damaged in the 1966 flood and restored) and the portraits on medals (referred to enthusiastically by Hirst in *Sebastiano del Piombo*, p. 117, and reproduced in detail in Ludwig Goldscheider's *Unknown Renaissance Portraits* (London, 1952)). The medal now in the Kunsthistorisches Museum in Vienna shows Vittoria in her widow's veil and was probably made in 1533 when she was created a princess by Charles V. She is shown in rather plump profile, with a straight, long, flattish nose and full lips.

323 *caused him confusion*: Clements (*The Poetry of Michelangelo*, pp. 201, 369) suggests that a drawing of a bearded old man in a bear's coif staring at a frumpish-looking woman with exposed sagging breasts next to a hand making the obscene *fico* gesture showed Michelangelo's disturbed feelings about the enforced chastity between him and Vittoria, 'like that troublesome negativity of Tommaso Cavalieri'. The sonnet on the verso of the same folio – '*Quand'el ministro de' sospir mie tanti*' – he dates to 1547. But the strong sad poem seems to have been about a man and is dated 'from the late 1520s' by Saslow (*The Poetry of Michelangelo*, p. 130), who ascribes it 'by a student' to 1506–12. Frey, however, also saw the drawings as sketches of Vittoria and Michelangelo, and there are certainly resemblances (*Die Dichtungen des Michelangiolo Buonarroti*, 1879). Yet again, it has been suggested that, with its reference to the sun, the sonnet may have commemorated Febo di Poggio (Barelli, *Michelangelo Rime*, p. 91).

323 *presentation drawings*: Cf. Hirst, *Michelangelo and his Drawings*, p. 53, where attention is drawn to the 'new manner' of Michelangelo's drawing reached by the repetition of soft lines rather than cross-hatching and pressure of chalk, and (p. 118) the importance (perhaps with Vittoria Colonna's counsel) of the adoption of a dramatized Cristo Vivo for future work by Giambologna, El Greco, Barocci, Reni and Rubens. See also Condivi's *Life* (in Bull and Porter, *Michelangelo: Life, Letters and Poetry*, pp. 67–8), where Michelangelo's Christ on the Cross, calling out to God, is described as 'a living being, wracked and contorted by a bitter torment'. Six large drawings by Michelangelo of Christ on the Cross are believed to survive; the *Crucifixion* drawing made for Vittoria Colonna almost certainly corresponds to the drawing in the British Museum no. 1895–9–15–504.

323 *after a long time*: Lettere/contratti, CDLXV and drafts; *The Letters of Michelangelo*, ed. Ramsden, vol. II, p. 76.

323 *Sebastiano . . . died*: Perhaps in tune with the reforming spirit of the time, Sebastiano in his will wrote that he was to have an unceremonious funeral at night, in Santa Maria Maggiore, accompanied by one or two priests and lights and the cross, and that the money saved be put aside for the dowry of a poor, good-living orphan and used at the discretion of his son and heir Giulio dei Luciani. Cf. Hirst, *Sebastiano del Piombo*, app. B.

324 *heaped commissions*: Cellini describes how in his own life, seemingly often modelled on Michelangelo's, he replied from Florence to a demand from one of the king's treasurers with a detailed – nine sheets of paper – account of what he had done for the king, how much he had received and what he had spent:

he had not put a single quattrino into his own purse and received nothing for his finished works.

325 *in a quarter of an hour*: Quoted in Ludwig Goldscheider, *Michelangelo: Paintings, Sculptures, Architecture* (London, 1953), p. 22.

325 *As for my staying*: From Rome, 22 October 1547: *Lettere/contratti*, CXCV; *Carteggio*, vol. IV, MXCII.

326 *Lionardo, you need*: *Lettere/contratti*, CCX; *Carteggio*, vol. IV, MCXIX.

327 *had ruined him*: *Lettere/contratti*, CDXXXIX; *Carteggio*, vol. IV, M.

328 *thickened bodies*: One of the two surviving cartoons by Michelangelo, now in the Capodimonte Museum, Naples, shows a group of three soldiers as they appear in the mural of the crucifixion of St Peter. Their backs seem both realistically human and abstractly geological: 'muscle-architecture', one of the most stirring examples of which, the Day of the new sacristy, Kenneth Clark described as being developed like a theme of Beethoven, a 'majestic landscape of hill and hollow' (*The Nude*, ch. VI, pp. 240–41). This cartoon was never applied physically to the damp plaster of the chapel wall, being made so that its design could be transferred to smaller, more manageable cartoons and as part of a huge master cartoon; it thus may also reflect Michelangelo's long-standing practice (cf. Hirst, *Michelangelo and his Drawings*, p. 76).

In the fresco of the conversion of Saul, motifs inspired by Michelangelo's predecessors included the soldier ducking under his shield, as from Signorelli's Conversion at Loreto; the paired fugitives, as in Ghirlandaio's predella at Lucca; the truant charger, as in Raphael's tapestry. These instances are cited by Leo Steinberg in *Michelangelo's Last Paintings*, p. 25. Michelangelo took copiously from others, drawing on his extraordinarily retentive memory. What he took he transformed.

329 *Justification*: Cf. Jean Delumeau, *Catholicism between Luther and Voltaire* (London, 1977), pp. 9–12. The quotation from St Paul's letter to the Romans continues, 'We are God's heirs and Christ's fellow-heirs, if we share his suffering now in order to share his splendour hereafter.'

330 I'sto rinchiuso: Saslow, *The Poetry of Michelangelo*, 267, p. 451.

332 *It cannot be denied*: *Lettere/contratti*, CDLXXIV; *Carteggio*, vol. IV, MLXXI.

333 *papal brief*: For the full translated text of the *motu proprio* of Paul II, see *The Letters of Michelangelo*, ed. Ramsden, vol. II, app. 44, p. 308. It was given in Rome in the church of St Mark's 'on the Ides of October and in the fifteenth year of our reign'.

334 *constantly modified*: Ackerman refers to 'the peculiar chronology for Michelangelo's studies for the construction; the design was not wholly fixed at the start, but grew as the builders advanced upwards from the foundations' (*Architecture of Michelangelo*, text & plates vol., p. 97).

Sangallo's forenave or concourse included a loggia from which the pope would give his traditional annual blessing to the City and the World (*Urbi et Orbi*), now delivered from a window in the papal apartments. The exterior of St Peter's on completion looks very different from Michelangelo's plan, but the central features are as he wanted them to be.

'Saint Peter's, as Michelangelo conceived it, was the image of the threatened and defended unity of the Christian world': cf. Giulio Carlo Argan and Bruno Contardi, *Michelangelo: Architect* (London, 1993), p. 29, whose preface satisfyingly relates Michelangelo's influential and controversial originality as architect to, *inter alia*, his techniques as a life-long poet, rejection of the classical distinction between construction and decoration, and strong, defensive political emotions both in Florence and in Rome. A 'profoundly distressed artist', with his architecture Michelangelo 'posed the question not of perfection in art but of its intrinsic, irreducible problematicity. This may be his legacy to the modern world.'

334 *erupted unpleasantly*: I have dated the meeting at which Michelangelo and Sangallo railed at each other in front of the pope as 25 February 1544, following Gotti and Ramsden, though others put it in October 1545. Discussing the progress of the Belvedere fortifications after Sangallo's death, Ackerman (*The Architecture of Michelangelo*, catalogue vol., p. 114) comments that 'The vigorous and monumental style of the defences distinguishes them from Sangallo's and suggests Michelangelo's influence but does not serve . . . as proof of his authorship.'

336 *envisaged by Michelangelo*: Cf. Ackerman, *The Architecture of Michelangelo*, text & plates vol., p. 86, for the scheme by Michelangelo (which Vasari described in his 'Life of Michelangelo' and which was rejected as too ambitious) and its 'dramatic axis of vision and communication'. (Cf. *Lives of the Artists*, trans. Bull, vol. I, p. 413.)

336 *Michelangelo's proposals*: Michelangelo's intentions were made clear by a series of engravings done soon after his death. The project was implemented at a snail's pace, and many changes were made by Giacomo della Porta.

336 *Via Paolina*: Cf. Peter Partner, *Renaissance Rome 1550–1559*, p. 174: 'The "trifaria", or three-pronged road development, was one of the most important planning concepts to take hold in Renaissance and Baroque Rome.'

337 *Ponte Santa Maria*: The work on the Ponte Santa Maria was later taken from Michelangelo and given to Nanni di Baccio Bigio, on the excuse that Michelangelo was so old and uninterested that it would never be finished. After Nanni had done the work, when Vasari one day was riding with Michelangelo over the bridge on horseback, Michelangelo remarked that the bridge was shaking, so they had better ride faster in case it crashed down. This it actually did in 1557, pointing to the truth of the accusations that Nanni had stolen the travertine and substituted gravel and had so disguised the exterior that the bridge looked as if it had been rebuilt. Cf. Vasari's 'Life of Michelangelo', in *Lives of the Artists*, trans. Bull, p. 398.

337 *mild, tractable*: Quoted in Crowe and Cavalcaselle, *Titian: His Life and Times*, vol. II, p. 82. For Leone Leoni, whose travels and criminal career, like Cellini's, were very colourful, see Wittkower, *Born Under Saturn*, pp. 190–92.

338 *a shame that in Venice*: Cf. Vasari's 'Life of Titian' (*Lives of the Artists*, trans. Bull, vol. I, p. 455). Vasari added that Titian's son Orazio painted the excellent violin-player Battista Ceciliano before they left for Florence, where

Duke Cosimo showed no interest in having his portrait painted by Titian – 'perhaps because he was anxious to avoid slighting the distinguished artists to be found in his city and dominion'.

338 *study in suspense*: Discussing the classical influences on Titian's triple portrait, and the novelty of its composition, Erwin Panofsky notes how Titian's experienced mind 'seems to have registered the subterranean disturbances within the Farnese family' (*Problems in Titian: Mostly Iconographical* (New York, 1969), pp. 78–9).

339 *advised by Aretino*: *Il terzo libro delle lettere di M. Pietro Aretino* (Paris, 1609), p. 236.

Titian's Danaë is in the Capodimonte, Naples. A later version of the Danaë (in the Prado, Madrid), with a distraught woman attendant replacing the boy, is more erotic and menacing and, Panofsky says, 'de-heroized . . . de-Michelangelized' (*Problems in Titian*, p. 150).

339 *Perino died*: Vasari, who knew Perino well, reported that he died from apoplexy brought on by work, love affairs and intemperance after he had been worn out (*Le vite*, ed. Ragghianti, vol. II, p. 654). He was buried in the Rotonda (the Pantheon) by his physician, his son-in-law and his wife, Catherine Perino.

340 *the work of all the known past*: Ackerman, *The Architecture of Michelangelo*, text & plates vol., pp. 139–40.

340 *As to my own*: *Lettere/contratti*, CCXXXI; *Carteggio*, vol. IV, MCXLI.

341 *Michelangelo's practice*: See especially Clements, *Michelangelo's Theory of Art*, chs. I, V.

341 *Benedetto Varchi*: For extensive references to Varchi in the context of other Florentine historians of the cinquecento and for extracts from his *Storia fiorentina* see Symonds, *The Renaissance in Italy*, vol. I.

342 *sculpture first*: Cf. Symonds, *The Renaissance in Italy*, vol. IV, p. 205.

342 *potentiality*: Summers, *Michelangelo and the Language of Art*, pp. 206–12. Summers stresses the importance of the contemporary idea that 'the point and sum of the activities of both art and nature was to give form to matter. Both art and nature proceeded in an orderly fashion to the fulfillment of their purpose, the realization of the *composto*.'

343 Voglia sfrenata: Saslow, *The Poetry of Michelangelo*, 105, p. 236.

Varchi's lecture on Michelangelo's sonnet was published in the *Due lezzioni di M. Benedetto Varchi* by Lorenzo Torrentino in March 1550, with 'a letter of Michelangelo [to Varchi] and other excellent Painters and Sculptors on the question'.

343 *I am old*: *Lettere/contratti*, CDLXIII; *Carteggio*, vol. IV, MLXXVI.

343 *I say that*: *Lettere/contratti*, CDLXII; *Carteggio*, vol. IV, MLXXXII.

In Castiglione's *The Book of the Courtier*, see the discussion in Book II on whether sculpture or painting required more effort and skill and possessed more dignity (trans. Bull, pp. 98–9). Count Lodovico da Canossa says in his defence of the superiority of painting to the sculptor Giovan Cristoforo Romano, 'I am not arguing for the sake of Raphael, nor should you think

me so ignorant as not to recognize the excellence shown by Michelangelo and yourself and other painters. But I am speaking of the art and not the artists.' Vittoria Colonna had arranged to have copied some of the manuscript lent her by Castiglione, even before it was first published in 1528. Michelangelo would not have overlooked its references to himself and Raphael.

For a summary of differing views on Michelangelo's reflections as reported by de Holanda and comments to Varchi on the rival merits of painting and sculpture – from Cellini to Croce – see Clements, *Michelangelo's Theory of Art*, pp. 308–18.

344 *for a splendid little book*: *Lettere/contratti*, CDLXVI; *Carteggio*, vol. IV, MCXLIII.

345 *the dead back to life*: *Lettere/contratti*, CDLXVIII; *Carteggio*, vol. IV, MCXLVIII.

345 Or le memorie: Saslow, *The Poetry of Michelangelo*, 277, p. 467.

347 *aesthetic . . . values*: Exploring the importance to Vasari of the meaning of the words in his critical lexicon, Roland Le Mollé in *Georges Vasari et le vocabulaire de la critique d'art dans les 'Vite'* (Grenoble, 1988) concentrates on ten terms abundant in the *Lives* and their subtleties as used singly or in significant combination: *unione, chiaro, scuro, luce* and *lume, tavola, quadro, morbido, bizzarro, capriccio, imitazione*. Clements (*Michelangelo's Theory of Art*, p. xxi) reminds us that Michelangelo was 'extremely reluctant to talk shop, as his contemporaries testify'; disliking *abboccamenti*, or verbal rambling, he never wrote his treatise or treatises on painting or art that he sometimes said he would.

348 *man of prudence*: None the less, allegations of Michelangelo's readiness to indulge in anti-Medicean propaganda – he had promised to make hostile drawings and statues during the siege of Florence, Vasari reported – appeared in the *Lives*, to be dropped in the second edition.

350 *From the hour*: The letter to readers is translated in Bull and Porter, *Michelangelo: Life, Letters and Poetry*, pp. 5–6.

In his second edition of the *Lives*, in the extended and revised 'Life of Michelangelo', Vasari took his revenge for Condivi's references to those who had said things about Michelangelo that had never happened and left out important matters. Having said how much Michelangelo enjoyed the company of fellow craftsmen, and was willing to teach people, Vasari added, 'To be sure, he was unlucky with those who went to live in his house . . .' These included Pietro Urbino, Antonio Mini and Ascanio, 'who worked very hard indeed, but never produced results, either in the form of designs or finished works. Ascanio spent years on a picture for which Michelangelo provided the cartoon, and all in all the high expectations he aroused have gone up in smoke' (*Lives of the Artists*, trans. Bull, vol. I, pp. 421–2).

351 *as if Alcibiades*: The unconscious irony of Condivi's reference to Alcibiades rising chastely from the side of Socrates would not have been lost on those (such as Aretino) familiar with Castiglione's *The Book of the Courtier* (published in 1528), in which Cesare Gonzaga remarks that 'indeed it was a strange place

and time – in bed and by night – to contemplate that beauty which Socrates is said to have loved without any improper desire' (trans. Bull, p. 248).

353 *a corrective to Vasari*: In the second edition of his *Lives* (which included the lives of more living artists as well as Michelangelo's life, and which incorporated a fair amount of Condivi's material) Vasari stuck to his earlier version of Michelangelo's training as an artist.

> Incidentally [he wrote], the author of a biography of Michelangelo which was written after 1550 (which was when I wrote these *Lives* the first time) says that some people, because they did not know Michelangelo personally, have said things about him that were never true and have left out others that deserved to be mentioned. For instance, he himself taxes Domenico with envy and alleges that he never gave any help to Michelangelo. But this accusation is plainly false, as can be judged from something written by Michelangelo's father Lodovico, in one of Domenico's record books, which is now in the possession of his heirs. The entry read as follows:
>
>> 1488. This first day of April I record that I, Lodovico di Leonardo Buonarroti, do apprentice my son Michelangelo to Domenico and David di Tommaso di Currado for the next three years, under the following conditions: that the said Michelangelo must stay for the stipulated time with the above-named to learn and practise the art of painting, and that he should obey their orders, and that the same Domenico and David should pay him in those three years twenty-four florins of full weight; six in the first year, eight in the second year and ten in the third year, to a total of ninety-six lire.
>
> And below this, also in Lodovico's handwriting, is the following entry or record:
>
>> The above-named Michelangelo received this sixteenth day of April two gold florins, and I, Lodovico di Leonardo, his father, received twelve lire and twelve soldi on his account.
>
> (Vasari, *Lives of the Artists*, trans. Bull, vol. 1, pp. 327–8.) See also note to p. 12.

356 *Vasari wrote for*: Comparing Vasari's biography of 1550 with Condivi's of 1553, H. Wohl (Ascanio Condivi, *The Life of Michelangelo*, trans. Alice Sedgewick Wohl (Baton Rouge, 1976), Introduction) contrasts the former's 'didactic and propagandist' aims with the latter's intention to describe what Michelangelo thought 'most noteworthy' in his career and, on another level, its unconscious provision of vital keys to Michelangelo's personality, such as his speculation on the origin of his inclination for sculpture.

357 *dissection*: Condivi's *Life* shed some more light on Michelangelo's thoughts about human anatomy with the comment that he gave up dissecting corpses because his long practice in this had begun to upset his stomach so much that

he could not eat or drink beneficially. '. . . but truly when he parted from this branch of study his knowledge was so rich that he very often had in mind, as a service to those wanting to make works of sculpture and painting, to produce a treatise of his own on different kinds of human movement and appearance, and on the bone structure, with an ingenious theory which he had elaborated after long experience.' Dürer's ideas in this field, Condivi added, Michelangelo had found when he read them to be very weak. 'Albrecht [Dürer] treats only of the proportions and varieties of human bodies, for which no fixed rule can be given, making his figures as straight as posts; and even more important, he says not a word about human actions and gestures' (Bull and Porter, *Michelangelo: Life, Letters and Poetry*, pp. 63–4).

358 *painting of the Madonna*: Condivi's unfinished painting, the Epiphany (tempera on wood), is in the Casa Buonarroti, Florence. Perrig (*Michelangelo's Drawings*, pp. 86–90) attributes the cartoon at the British Museum to Condivi, not to Michelangelo as generally stated by, for example, Hirst (*Michelangelo and his Drawings*, p. 75), who stresses its importance as one of only two surviving large cartoons of Michelangelo.

360 *especially for the poor*: *Carteggio*, vol. IV, MCXLIII.

360 *Joachim du Bellay*: Du Bellay went to Rome in 1553 and published the sequence of sonnets *Les Regrets et autres œuvres poétiques* in 1558. The poem devoted to Pope Julius and the ape-boy, written just after Julius's death, includes the 'miracle' that the '*belistre*', the rogue, became the equal of princes in three days, and in three days fell back to where he was. For a splendid translation (with French text) of *Les Regrets*, see *The Regrets* by C. H. Sisson (Manchester, 1984). For source references to Innocenzo, see vol. XIII of *The History of the Popes* by Pastor, who comments that the accusation of the 'gravest immorality' against Julius has never been proved.

362 *Society of Jesus*: Cf. John W. O'Malley, *The First Jesuits* (Cambridge, Mass., 1993), p. 358: 'Jesuit sources say not a word about the painting [the *Last Judgement*, completed in 1541] or the controversy, or about any other artistic or architectural monument of the day. For all the Jesuits' cultivation of the imagination, their culture was directly a culture of the book and the word.'

364 *palace in Rome*: Condivi refers baldly to the design for a new palace in Rome. Vasari in his second edition of the *Lives* wrote that Michelangelo made a model for the façade of a palace to be built alongside the church of San Rocco which would use the mausoleum of Augustus for the remainder of the walls. 'So Michelangelo produced a design of incomparable richness, variety, and originality, for in everything he did he was in no need of architectural rules, either ancient or modern, being an artist with the power to invent varied and original things as beautiful as those of the past.' Vasari added that Pope Pius IV had given the model to Cosimo de' Medici when he visited Rome. It has disappeared. (Condivi's *Life* in Bull and Porter, *Michelangelo: Life, Letters and Poetry*, p. 63; Vasari, *Lives of the Artists*, trans. Bull, vol. I, p. 397.)

365 *writing to the overseers*: *Lettere/contratti*, CDXCI; *Carteggio*, vol. IV, MCLIX.

365 *Then Michelangelo declared*: For these exchanges over Michelangelo's role at

St Peter's, see Vasari's *Lives of the Artists*, trans. Bull, vol. I, p. 397. Vasari's chronology is often confusing. But in this instance, he continued, 'the pope ordered both Michelangelo and Vasari to go the following day to the Villa Giulia, where they held many discussions'.

366 *The deputies . . . wrote*: The deputies' protest is quoted in Latin by Gotti (*Michelangelo Buonarroti*, vol. I, p. 311) and in translation from Italian by Ramsden (*The Letters of Michelangelo*, vol. II, p. 310), who suggests a dating of the end of 1551 or early 1552.

366 *Michelangelo's changes*: When Michelangelo prepared his first model for St Peter's, in clay, the work had proceeded since the foundation was laid in 1506 as follows: the construction of Bramante's four huge piers and their connecting arches at the crossing, creating the fixed central space; completion, by Bramante, of Rossellini's choir to the west; Sangallo's creation of pendentives for the base of the drum round the central space, and his completion of the eastern hemicycle and raising of the vault towards the entrance to the basilica (the liturgical 'east' of St Peter's is in fact the west end of the building); Sangallo's raising of the vault of the south transept and beginning of its terminal (later demolished) and outer hemicycle.

366 *Vasari remembered*: Vasari, *Lives of the Artists*, trans. Bull, vol. I, p. 428.

367 *letter to Vasari*: *Lettere/contratti*, CDLXXIII; *Carteggio*, vol. V, MCXCVII.

367 *construction of the drum*: For discussion of the hotly disputed status of the sheet of drawings for the cupola of St Peter's (Musée des Beaux-Arts, Lille) and a description, which I have followed, of its contents and their sequence, see Hirst, *Michelangelo and his Drawings*, pp. 101–2.

368 *Giorgio, my dear friend*: Cf. Vasari, *Lives of the Artists*, trans. Bull, vol. I, p. 400.

369 *never dance*: *Lettere/contratti*, CCXX; *Carteggio*, vol. IV, MCXXX.

369 *warned his nephew*: *Lettere/contratti*, CCL; *Carteggio*, vol. IV, MCLXIX.

370 *this matter has gone on*: *Carteggio*, vol. V, MCLXXXII.

370 *Surviving letters*: *Lettere/contratti*, CCLXVIII; *Carteggio*, vol. V, MCXCI. *Lettere/contratti*, CCLXX; *Carteggio*, vol. V, MCXCIV. *Lettere/contratti*, CDLXXII; *Carteggio*, vol. V, MCXCV.

370 *wrote tersely*: *Lettere/contratti*, CCLXXV; *Carteggio*, vol. V, MCCII.

371 *and because I am old*: *Lettere/contratti*, CCLXXXIII; *Carteggio*, vol. V, MCCXVI.

371 *so afflicted*: *Lettere/contratti*, CLXXXIV; *Carteggio*, vol. V, MCCXVII.

371 *You know that*: *Lettere/contratti*, CDLXXX; *Carteggio*, vol. V, MCCXIX.

372 *four children*: The three surviving children of Francesco and Michele were Gabriele, Niccolò and Elizabetta. Successive surviving daughters born to Lionardo and Cassandra were given the names of Alessandra (but she died aged four months), Bartolommea (who became a nun called Sister Deodata), Lucrezia and Caterina (both of whom married).

Directly descended from Lionardo's first son, Buonarroto, and Alessandra di Andrea Macinghi, Cosimo Buonarroti in the nineteenth century bequeathed the Casa Buonarroti and its contents to the city of Florence.

372 *as it seems*: *Carteggio*, vol. V, MCCXXIII.

373 *if he wants to*: Lettere/contratti, CCLXXV; *Carteggio*, vol. V, MCCII.

373 *Remember your father*: Lettere/contratti, CCXCVI; *Carteggio*, vol. V, MCCXXXIII. Lettere/contratti, CCXCVII; *Carteggio*, vol. V, MCCXXXIV.

373 *final version*: For variant readings of key phrases and the detailed changes made by Michelangelo in the style (affecting meaning, rhythm and expressiveness) of this sonnet in its successive drafts, see Cambon, *Michelangelo's Poetry*, pp. 128–36. Cambon also discusses in detail alternative readings of the last two lines of this renowned, austere sonnet (e.g. 'to take us' as well as 'opening us' in place of 'taking hold of us') to demonstrate Michelangelo's extreme care, his poetic 'fury of form'.

374 *Ludovico Beccadelli*: Beccadelli played an active role in 1561 in preparation for the Council of Trent and spent his last years (relieved of his archiepiscopal duties in Ragusa) in Prato, where he died in 1572, leaving a mountain of literary work.

375 per croce e per grazia: Saslow, *The Poetry of Michelangelo*, 300, p. 498.

375 *renunciation*: A discussion of the predominantly religious tone and Petrarchan cast of Michelangelo's poetry after the death of Vittoria Colonna in 1547, with its chronological problems, by Joseph Farrell (*Renaissance and Other Studies*, University of Glasgow, 1988) argues persuasively that the same fears, obsessions, dreads and torments appear at all stages of Michelangelo's development; that hope and optimism permeate his late poetry despite its renunciations; and that this poetry stands comparison with the work of St John of the Cross.

376 *all Rome, and especially*: Carteggio, vol. V, MCCXLIV.

376 *In March*: Ibid., vol. V, MCCXLVI.

376 *In May*: Ibid., vol. V, MCCLVI.

376 *if he were to abandon it*: Ibid., vol. V, MCCLVII.

377 *gone wrong*: For details of the mistakes and Michelangelo's intentions for the Cappella del Re, see Ackerman, *The Architecture of Michelangelo*, catalogue vol., p. 94.

377 *Lottino wrote*: Quoted in *The Letters of Michelangelo*, ed. Ramsden, vol. II, p. li, from Gaye, *Carteggio inedito d'artisti dei secoli XIV, XV, XVI* (3 vols., Florence, 1839–40), vol. III, p. 14.

378 *for a man*: Lettere/contratti, CCXCIX; *Carteggio*, vol. V, MCCXXXVI.

378 *In recent days*: Carteggio, vol. V, MCCXXXVII.

378 *flight to Spoleto*: Vasari's account of the flight of Michelangelo to Spoleto talks of French rather than Spanish arms threatening Rome, and in amplifying Michelangelo's account produces some fascinating echoes of the flight from Florence to Ferrara and Venice, with Antonio Mini and Piloto.

In the time of Paul IV Michelangelo was employed on many parts of the fortifications of Rome; in this connection he also served Salvestro Peruzzi, whom, as said elsewhere, the pope had commissioned to make the great gate of Castel Sant'Angelo, which is today half-ruined. At that time the French army approached Rome, leading Michelangelo to fear

that he would come to a violent end along with the city. Antonio Franzese of Casteldurante, whom Urbino had left to serve him after he died, determined to flee from Rome, and Michelangelo himself went secretly to the mountains of Spoleto, where he stayed in various hermitages.

(Vasari, *Lives of the Artists*, trans. Bull, vol. 1, p. 403.)

Michelangelo condenses that wooded beauty surrounding Umbrian Spoleto in the phrases that he had taken great pleasure '*nelle montagne di Spuleti a visitare que' romiti*' and that '*e non si trova pace se non ne' boschi*'. For what was going on by contrast in Rome, to which he was ordered to return, he uses the word (in the letter to Lionardo) '*frangenti*' – literally the surgings or billowings of the sea: miseries or crises.

In his *Itinerary* (vol. 1, p. 219) having thrown up his hands at the superstitions of Loreto, with its 'incredible concourse' from all parts of Europe, including repentant bandits, Fynes Moryson, visiting Spoleto nearly forty years after Michelangelo, described the still recognizable approach to the city 'through a firtile plaine, but stony, yeelding together in the same field, vines, corne, Almond and Olive trees'. He quoted Martial in praise of the wine of Spoleto.

379 *I fear because of our sins*: Carteggio, vol. v, MCCLXIV.

379 *his aims*: Cf. J. R. Hale, *Florence and the Medici: The Pattern of Control* (London, 1977), p. 128.

380 *Palazzo Vecchio*: The exuberant and lavish paintings in the Palazzo Vecchio demanded, Vasari felt, not only elaborate verbal interpretation to yield their rich, clever – mythological, historical and religious – significances but a book to explain these to the eager viewer. Hence he wrote the *Ragionamenti* in the form of his own guide for his interlocutor (Cosimo's son, the regent Francesco) which in catechetical fashion provides a none the less fascinating commentary on the pictures and insight into the mind of their creator(s). Dedicated to Cardinal Ferdinando Medici, grand duke of Tuscany, in 1588 but written in 1557 and (concerning the Sala Grande) 1567, the *Ragionamenti* yoked Michelangelo to the cause of the Medici with the reminder that he had been one of the young men working under Donatello's pupil Bertoldo in Lorenzo de' Medici's garden-school at San Marco. (Vasari, *Le vite*, ed. Ragghianti, vol. 1, p. 130.)

382 *Pontormo . . . suggested*: 'Lettera del Pontormo a Benedetto Varchi', in Pontormo's *Diario* (Rome, 1988).

383 *Vasari noted*: Vasari, *Lives of the Artists*, trans. Bull, vol. 11, pp. 269–70.

383 *Pontormo kept a diary*: Jacopo Pontormo, *Il libro mio*, ed. Salvatore S. Nigro (Genoa, 1984).

385 *the Academy*: For the cultural and social context of the development of the academies, see Arnold Hauser, *The Social History of Art* (London, 1962), vol. 11, ch. 3, which in particular assesses the role of 'humanists' and patrons in creating a new self-consciousness among artists and changed attitudes to their own work. Vasari gives a lively account in his life of the sculptor and friar

Montorsoli of the revival of the company of design (founded in the period of Giotto) at the instigation of Montorsoli, Bronzino, Francesco Sangallo, Ammanati, Vincenzo de' Rossi, Michele di Ridolfo and others to the number of forty-eight: the academy was to teach those who wished to learn and to enhance the skills of established masters through honourable competition.

386 *excused himself*: Carteggio, vol. V, MCCLXXXVI.

387 *Tell the pope*: Vasari, *Lives of the Artists*, trans. Bull, vol. I, p. 402.

387 *censorship*: Paul F. Grendler, *The Roman Inquisition and the Venetian Press* (Princeton, 1977), pp. 115–17.

388 *Jesuit initiative*: The early Jesuits quickly assumed importance as preachers and educationalists and were the first Catholic religious order to undertake formal education as a main ministry. When it became hopeless for them to spend time in Jerusalem, they enlisted in the battle against Protestantism, seeing the Reformation as a prime pastoral problem. Cf. O'Malley, *The First Jesuits*, pp. 15–17.

389 *what the papacy wanted*: For a stimulating overview of the long cycle of Roman patronage from the twelfth-century rediscovery of Rome to the decisive 'change of taste' under Pius IV, see Richard Cocke, *From Magic to High Fashion* (Norwich, 1993).

389 *his work tense*: Steinberg pulls together the frescoes of the Last Judgement and the conversion of St Paul as confessional and rhetorical works which synthesized Michelangelo's 'private penance, apostolic fervour and art'. Speculating that, among the fifty or so heads depicted in the crucifixion of St Peter, the old man in the Phyrygian cap, with folded arms (lower right), and the younger bearded man, on horseback behind and paired with the handsome commanding officer (upper left), may be self-portraits, he concludes that the whole fresco may then be read as 'a chart of the artist's personal trial; like the *Last Judgement* . . . The work's ultimate meaning flows in the geometry of its structure' (*Michelangelo's Last Paintings*, p. 55).

391 *Anguissola wrote*: Carteggio, vol. V, MCCXLIX. The drawing sent to Sofonisba Anguissola is unknown, and there are no other references.

In his account of Lombard painters, Vasari mentions several of Sofonisba's paintings, including the novel picture he had seen in her father's house in Cremona of her three sisters (who also painted) playing chess.

391 *a bronze statue*: Ibid., vol. V, MCCCVI, MCCCXLI, MCCCXLII. The memorial equestrian statue ordered from Michelangelo and Daniele was never finished, and it is not certain whether the bronze horse that Daniele eventually completed after a first unsuccessful casting was to Michelangelo's design.

391 *models have been made*: Ibid., vol. V, MCCCXXXIX.

392 *Cornelia's letters*: Ibid., vol. V, MCCLXXVII (October 1558), MCCLXXXIII (January 1559), MCCCXXXI (April 1560), MCCCXLIII (7 January 1561), MCCCLXI (September 1561).

392 *his influence*: Cf. De Maio, *Michelangelo e la Controriforma*, p. 358. Cardinal Ridolfo Pio da Carpi used Tommaso to convey the first payment of a salary of 100 gold crowns a month, charged to the fabric of St Peter's. Michelangelo refused, saying that if he had needed it he would have asked for it.

393 Ben può: Saslow, *The Poetry of Michelangelo*, 259, p. 438.

393 *Cavalieri wrote*: *Carteggio*, vol. V, MCCCLXVIII.

393 *masks*: Goldscheider, in a brief note on his thirteen illustrations of Michelangelo's masks, remarks that it would be possible to collect illustrations of 100 of them, including the many fine masks used as minor symbols on the lateral parts of architectural capitals (*Michelangelo: Paintings, Sculptures, Architecture* (London, 1953, pp. 243–4). Some apparently hidden meanings may of course simply be lost meanings.

394 *letter to Cosimo*: *Lettere/contratti*, CDLXXXIX; *Carteggio*, vol. V, MCCCXXX.

395 *The inscription*: Steinberg sees the motto on the Leone Leoni medal as a petition whose context in the Psalm 'may help to illuminate the spirit that would have allowed the painter of the Conversion [of Saul, in the Pauline Chapel] to identify himself with the saint . . . The artist is like the protagonist of his picture in past pride and selfhood, and in longing to undergo the Apostolic ordeal – wanting only the assurance of grace' (*Michelangelo's Last Paintings*, p. 41).

Referring to the vast number of copies, Vasari stated that the only other portraits of Michelangelo were two paintings, one by Bugiardini and one by Jacopo del Conte, and the bronze relief by Daniele Ricciarello (Daniele da Volterra). The *Portrait of Michelangelo in a Turban* in the Casa Buonarroti, Florence, is one of several versions attributed to Bugiardini, and which is the original is disputed. Versions of a portrait attributed to Jacopo de Conte include the painting in the Palazzo Strozzi, Florence. (Vasari, *Lives of the Artists*, trans. Bull, vol. I, p. 410.)

395 *whose first murmurings*: The first condemnatory letter addressed to Michelangelo is generally accepted as having been written in November 1545 and probably never sent to Michelangelo. The second, milder, letter was probably sent in or after 1550. To give it currency before it was published as part of Aretino's series of books of letters, it went to Corvino, a friend of Aretino's in Rome, a well-connected man about town, likely to give Aretino's views on the *Last Judgement* the 'semi-public' manifestation he wanted. Aretino's letters, partly the product of hurt pride, were literary forms aimed at stirring up the chiefly Venetian-based reaction against the shockingness of Michelangelo's *Last Judgement*. Passages in Vasari's second edition of the *Lives* were modified to meet Aretino's strictures on indecorous nudity, and the spirit of the times. Cf. Erica Tietze-Conrat, 'Neglected Contemporary Sources Relating to Michelangelo and Titian', *Art Bulletin*, vol. XXV, June 1943, pp. 154–9.

395 Dialogo della pittura: Lodovico Dolce, *Aretin: A Dialogue on Painting*, trans. W. Brown (Scolar Press, 1970). See also Mark Roskill, *Dolce's 'Aretino' and Venetian Art Theory of the Cinquecento* (New York, 1968).

397 *who to appear*: The quotation from Leonardo (Leonardo Cod. dell'Institut de France f. 79r) is used by Alessandro Parronchi (*Capolavori di scultura fiorentina dal XIV al XVII secolo*) to strengthen his argument identifying the wooden (poplar) crucifix at Massa Carrara, San Rocco, with the wooden crucifix sculpted by Michelangelo in 1493.

Dolce's (Aretino's) criteria for rating Raphael as a painter superior to Michelangelo and for rating Titian as unequalled in invention, design and colour were a mixture of contemporary Venetian preferences and 'classical' attitudes of which, early on, Michelangelo's practice was subversive. Kemp (*Leonardo da Vinci*, pp. 336–8) comments, 'there is one artist who could be seen to embody, almost without exception, all the faults upon which Leonardo dwelt in his late writings. That artist was his unfriendly rival, Michelangelo. The figures on the Sistine ceiling, to which Leonardo cannot but have reacted when he moved to Rome in 1513–14, all tended to come from the same Herculean mould ... Furthermore, Michelangelo's concentration on the human figure negated the "universality" upon which Leonardo set such store.'

397 *said Aretino*: For differences between Dolce's Venetian ideas about decorum and those of Aretino, whose views he purported to be conveying in the *Dialogue* (and on the whole did convey), see Mary Rogers, 'Decorum in Lodovico Dolce and Titian's *poesie*', in Ames-Lewis and Bednarek, *Decorum in Renaissance Narrative Art*, pp. 111–20.

398 *images shall not*: Canons and Decrees of the Council of Trent, trans. H. J. Schroeder (St Louis and London, 1941).

399 *by a commission*: Cf. De Maio, *Michelangelo e la Controriforma*, pp. 40–44.

399 *These men were not his personal enemies*: De Maio (*Michelangelo e la Controriforma*, pp. 374–5) cites as an example of Curial attitudes towards Michelangelo the praise of Pietro Bembo, once Leo X's secretary, for both Michelangelo and Raphael, who were so superb and excellent that it was easier to say how near they were to the artists of antiquity than which of them was better and greater than the other.

399 *Michelangelo's emotions*: Michelangelo's struggle was not over reconciling certain essential elements of his art, such as nudity, with the teachings of the Church, which crystallized only after the Council of Trent, but over reconciling all his art with abandonment to God. Among his critics, Giovanni Andrea Gilio of Fabriano was the most discerning. In *A Dialogue on the Abuse of History by Painters* (dedicated to Cardinal Alessandro Farnese and published in 1564), Gilio attacked Michelangelo's excessive use of nudity, violent postures, wingless angels and, above all, mixture of the true with the fictitious and fabulous (i.e. an improper confusion of the modes, each with its own decorum). He censured Michelangelo for returning to the ancients to adopt their style which intermingled history with poetic fictions and for depicting inventions such as Charon's barque and the seven deadly sins personified.

> The conclusions that Gilio draws from this is a very serious one ... Michelangelo has fallen into the sin of error in his presentation of sacred history, and ... his error was not made out of ignorance but made from wilful choice. His wilfulness appears in the priority he gave his own conception and his own conceits over the demands of sacred history and

the truth, and it stems from Michelangelo's desire to vaunt his own art, considering this more important than its subject.
(Charles Dempsey, 'Mythic Inventions in Counter-Reformation Painting', in P. A. Ramsey (ed.), *Rome and the Renaissance: The City and the Myth* (New York, 1982).)

403 *Vasari recorded*: After these details, Vasari added that the statue was immediately carried off 'and subsequently put together by Tiberio who added God knows how many new pieces. All the same, it stayed unfinished because of the death of Bandini, of Michelangelo, and of Tiberio' (*Lives of the Artists*, trans. Bull, vol. I, p. 405).

404 ('*Rondanini*') Pietà: Making the two figures of the 'Rondanini' *Pietà* merge to become one was 'a unique conception in Michelangelo's work and in sixteenth-century art' (Wilde, *Michelangelo: Six Lectures*, pp. 184–5). Wilde also discusses sketches in black chalk among those on a sheet at Oxford (Ashmolean Museum, Parker no. 339) as being connected with the 'Rondanini' *Pietà* and showing with their *pentimenti* Michelangelo's development of the two-figure group to the last stage. Wilde accepts the attribution to Michelangelo of another unfinished *Pietà* (the 'Palestrina', now in the Accademia, Florence): a squat, flattened, three-figure group of interlocking figures, like a circle, with Christ's torso at the centre.

404 *suffering, strife*: Saslow, *The Poetry of Michelangelo*, 298, p. 494.

405 *dismissed Baccio Bigio*: For Vasari's biased account of the intrigues of Nanni di Baccio Bigio, see Vasari, *Lives of the Artists*, trans. Bull, vol. II, pp. 414–15, and Pastor, *History of the Popes*, vol. XVI, pp. 450–52.

405 *an inventory*: In the 'Life of Michelangelo', Vasari wrote that the precautions he took, chiefly the inventory of works concerning St Peter's and San Lorenzo, 'proved well worth while' (*Lives of the Artists*, trans. Bull, vol. I, p. 417).

405 *I see that*: Lettere/contratti, CCCXL; *Carteggio*, vol. V, MCCCXC.

406 *letter to his nephew*: Lettere/contratti, CCCXLI; *Carteggio*, vol. V, MCCCXCI.

406 *these annotations*: See Ugo Procacci's '*Postille contemporanee in un esemplare della vita di Michelangiolo del Condivi*' in *Atti del Convegno di Studi Michelangioleschi, Firenze-Roma, 1964* (Rome, 1966). Procacci conjectures that the person annotating his copy of Condivi's *Life* was still asking for clarification of certain points up to the time of Michelangelo's death.

407 *The archbishop wrote*: *Carteggio*, vol. V, MCCXXIX. For a stimulating discussion of the development of Michelangelo's attitude to his own death and his lifelong meditation on the death of Christ, see De Maio, *Michelangelo e la Controriforma*, pp. 428–32.

408 *the three fatalities*: Saslow (*The Poetry of Michelangelo*, pp. 24–5) suggests that the *Trionfi* may have helped Michelangelo express his large-scale human conflict, between his sense of man's fallen state and struggle for God's saving grace. But whereas Michelangelo 'remained concerned with the same issues for most of his life, his convictions about those issues are dynamic, not static'.

408 *Florence*: For an appreciative view of Lorenzo de' Medici as architect, see

Beverley Louise Brown, 'An Enthusiastic Amateur: Lorenzo de' Medici as Architect', in *Renaissance Quarterly*, vol. XLVI (spring 1993), pp. 1–22.

409 *He who wishes*: Careful not to say that Michelangelo himself had gone over the top, but nervous about Michelangelo's expressiveness and its influence, Vasari added the caveat 'In our day certain vulgar architects, not considering these things judiciously and not imitating them, have worked presumptuously and without design almost as if by chance, without observing ornaments, art, or any order. All their things are monstrous and worse than the German.' (The translation of these passages comes from Louisa S. Maclehose and G. Baldwin Brown, *Vasari on Technique* (Dover edition, New York, 1960).)

An instinct for architectonic values and a compulsion to innovate in the process of drawing architectural lines was present in Michelangelo's earliest work and a dominant element during his old age. The bold perspective of young Michelangelo's *Madonna della Scala* announced 'new demands of taste, going beyond the spirit of Renaissance experience and foreshadowing new researches'. In Michelangelo's last architecture – the Porta Pia – 'a new personal language interprets and dominates the formal contingencies of the architectural order . . . generously open to new architectural worlds' ('Architecture', by Guglielmo De Angelis d'Ossat, in *The Complete Work of Michelangelo*, pp. 273, 375).

410 *shafts of falling light*: Ackerman (*The Architecture of Michelangelo*, text & plates vol., pp. 103–9) comments finally, 'Nothing in Michelangelo's previous architecture prepares for what might be called the resignation of this late project [San Giovanni dei Fiorentini]. It is surely another manifestation of the profound religious experience of his last years, an architectural version of the *Pietàs* and Passion drawings of the 1550s, where again the forms sink gravely earthwards.'

San Giovanni dei Fiorentini, in the end, was redesigned and completed by Carlo Maderno. Had the church been built under Michelangelo's supervision, Ackerman considers, with its neoclassic repose, simplicity, and unity, 'the future history of architecture would have been different'.

410 *design for a chapel*: For the changing 'moods' of Michelangelo's studies for the Sforza chapel – with its equal but differentiated arms and dynamic forms 'one of the most influential of Michelangelo's inventions' – see Ackerman, pp. 109–11.

410 *make it impossible*: Cf. Vasari's 'Life of Michelangelo' (*Lives of the Artists*, trans. Bull pp. 416–17): 'for seventeen years Michelangelo had devoted himself entirely to settling the essential features of the building so as to frustrate those whose envious hostility made him think they would make changes after his death . . . Pius V was as zealous for the glory of St Peter's as for the Christian religion: so much so that in 1565, when Vasari went to kiss his feet, and again when he was summoned in 1566, he talked only of how to make sure that Michelangelo's plans were followed.'

In 1565, after a year as chief architect, Pirro Ligorio was dismissed for suggesting alterations to Michelangelo's plan. In 1588 the building of the

cupola began. In 1607 the last remains of old St Peter's were cleared away, and then the decision to add a long nave and a huge narthex and façade, returning to a Latin from a Greek cross, wrecked the coherence of the design and robbed posterity of the clear view of the great cupola from the piazza as conceived by Michelangelo. To appreciate the impact of the size of the dome, one must visit the Vatican gardens and look at it from there.

The majestic church of St Peter's including the portico has an exterior length of 694 feet, and the height to the top of the dome is 435 feet. The diameter of the dome is 138 feet.

411 *the dome*: For discussion of Michelangelo's design of the central dome of St Peter's and the minor domes he is assumed to have envisaged, see especially Ackerman, *The Architecture of Michelangelo*, catalogue vol., pp. 103–12. This notes, *inter alia*, that Michelangelo's chief concern from the start had been the relationship between the dome and the lantern, as indicated by della Porta's decision to elevate the dome and lower the lantern. For further illustration and discussion, see Henry A. Millon and Craig Hugh Smyth, *Michelangelo architetto: La facciata di San Lorenzo e la cupola di San Pietro* (Milan, 1988), pp. 93–184.

412 *letter from Daniele*: *Carteggio*, vol. V, MCCCXCI, MCCCXCII.

413 *burned . . . drawings*: Vasari explained the reasons for Michelangelo's destruction of his drawings as being 'so that no one should see the labours he endured and the ways he tested his genius, and lest he should appear less than perfect'. After mentioning that he had some of Michelangelo's drawings in his own book of drawings, Vasari commented that Michelangelo 'strove only to achieve a certain overall harmony of grace, which nature does not present; and he said that one should have compasses in one's eyes, not in one's hands, because the hands execute but it is the eye which judges. He also used this method [making his figures the sum of nine, ten and even twelve 'heads'] in architecture.' (Vasari, *Lives of the Artists*, trans. Bull, vol. I, p. 419.)

Of the 'many stupendous sheets of divine heads, executed in black and red chalk' (as recorded by Vasari), the one we know by name, the Cleopatra, Tommaso had given to Duke Cosimo in 1562, and this, he wrote, was like losing a child of his own. Perrig (*Michelangelo's Drawings*, pp. 44–5) argues that the version in the Casa Buonarroti was indeed one of Tommaso's children – a copy of the original by Michelangelo. The recently uncovered verso of the drawing (resolutely attributed to Michelangelo at the Casa Buonarroti) shows a drawing of a screaming Cleopatra, after the sting. Michelangelo's destruction of his own drawings (notably the two lots burned just before he died, and the cartoons mentioned by Leonardo Sellaio writing from Rome in 1518), and his care not to give drawings to other than very talented or close friends, are cited by Perrig to strengthen his argument that far fewer of Michelangelo's drawings survive than has generally been supposed by other scholars, including Tolnay, who in this context speculated that the cartoons destroyed in 1518 were lascivious drawings of which Michelangelo grew ashamed. (Cf. Charles de Tolnay, *I disegni di Michelangelo nelle collezioni italiane* (Florence, 1975); and Perrig, *Michelangelo's Drawings*, Introduction, pp. 1–11.)

415 *Arrival from Rome*: Vasari wrote in his 'Life of Michelangelo' that the body was smuggled out 'secretly' from Rome (*Lives of the Artists*, trans. Bull, vol. 1, p. 436); but, as Rudolf and Margot Wittkower argue convincingly in *The Divine Michelangelo* (p. 17), there was no sinister need for this.

416 *obsequies*: For the details of the memorial service and decorations in San Lorenzo, see Wittkower, *The Divine Michelangelo*, extensively, with the eyewitness account which it contains (and which the Wittkowers attribute to the prior of the Innocenti, Vincenzo Borghini). Michelangelo's blessings, according to Borghini, included his great fortune in not having died before the foundation of the Academy and his additional fortune in passing to eternal life before Varchi, who was therefore able to make his funeral oration.

In Santa Croce, Michelangelo's tomb, designed by Vasari, with statues by Bandini, Simone, Cioli and Battista di Lorenzi, was completed in 1575.

416 *money into the peninsula*: Cf. Richard Goldthwaite, *Wealth and the Demand for Art in Italy 1300–1600* (Baltimore and London, 1993), pp. 30–31. Goldthwaite's enquiry into the new habits of consumption developed by Italians of Michelangelo's time and the opening up of 'an expansive world of goods in which people came to have a new kind of relation to their possessions' adds 'the discovery of things' to Jacob Burckhardt's classic view of the Renaissance as the discovery by the Italians of antiquity, nature and man. Continuing the Burckhardtian tradition, in his overarching *The Civilization of Europe in the Renaissance* (London, 1993) John Hale explores the circumstances in which the concepts and words 'Europe' and 'European' came to be meaningful throughout the Continent, which 'was given a securely map-based frame of reference, a set of images that established its identity in pictorial terms, and a triumphal ideology that overrode its internal contradictions'.

Further reading

For the complete bibliography of Michelangelo, see Ernst Steinmann and Rudolf Wittkower (eds.), *Michelangelo Bibliographie, 1510–1926* (Leipzig, 1927); Hans Werner Schmidt, '*Nachtag und Fortsetzung der Michelangelo Bibliographie von Steinmann-Wittkower bis 1930*' in Ernst Steinmann, *Michelangelo im Spiegel seiner Zeit* (Leipzig, 1930); Luitpold Dussler (ed.), *Michelangelo Bibliographie, 1926–70* (Wiesbaden, 1974); P. Cherubelli, '*Supplemento alla bibliografia michelangiolesca 1931–1942*', in *Centenario del Giudizio* (1942); and, for previous omissions and a post-1961 supplement, Peter Meller's Bibliography in *The Complete Work of Michelangelo* (New York, n.d.)

In addition to the essential works cited in my Select Bibliography, the following books have provided varied insights and information for successive phases of this life of Michelangelo.

From 1475

Acton, Harold, *The Pazzi Conspiracy* (London, 1979)

Ady, Cecilia M., *The Bentivoglio of Bologna* (Oxford, 1969)

Alberti, Leon Battista, *On Painting*, trans. Cecil Grayson, intro. Martin Kemp (London, 1991)

Ames-Lewis, Francis (ed.), *Cosimo 'Il Vecchio' de' Medici 1389–1464* (Oxford, 1992)

Avery, Charles, *Florentine Renaissance Sculpture* (London, 1970)

Baldini, Umberto and Casazza, Ornella, *The Brancacci Chapel Frescoes: Masaccio, Masolini, Filippino Lipi*, trans. Lysa Hochroth with Marion L. Grayson (London, 1992)

Barash, Moshe, *Giotto and the Language of Gesture* (Cambridge, 1987)

Baxandall, Michael, *Painting and Experience in Fifteenth-Century Italy* (Oxford, 1972)

Beck, James, *Jacopo della Quercia* (2 vols., New York, 1991)

Burckhardt, Jacob, *The Civilization of the Renaissance in Italy* (successive editions)

Burke, P., *Culture and Society in Renaissance Italy 1420–1540* (New York, 1972)

Butters, H. C., *Governors and Government in Early Sixteenth-Century Florence 1502–1519* (Oxford, 1985)

Chambers, D. S. (ed.), *Patrons and Artists in the Italian Renaissance* (Columbia, S. C., and London, 1971)

Clark, Kenneth, *The Nude* (Harmondsworth, 1960, 1985)

Cocke, Richard, *From Magic to High Fashion* (Norwich, 1993)

Denis, Anne, *Charles VIII et les Italiens* (Geneva, 1979)

Draper, James David, *Bertoldo di Giovanni; Sculptor of the Medici Household* (Columbia and London, 1992)

Edgerton, Samuel Y. Jr, *The Renaissance Rediscovery of Linear Perspective* (New York, 1975)

Einem, Herbert von, *Michelangelo* (Stuttgart, 1959; revised English edition, trans. Ronald Taylor, London, 1973)

Eisenbichler and Pugliese (eds.), *Ficino and Renaissance NeoPlatonism* (Toronto, 1986)

Ficino, Marsilio, *The Letters of Marsilio Ficino*, trans. by the Latin Language Department of the School of Economic Science (4 vols., London, 1975–88)

Field, Arthur, *Origins of the Platonic Academy of Florence* (Princeton, 1988)

Freedberg, S. J., *Painting in Italy 1500–1600* (Harmondsworth, successive editions)

Gage, John, *Colour and Culture* (London, 1993)

Gilmore, M., *The World of Humanism 1453–1517* (New York, 1952)

Goldthwaite, Richard A., *Wealth and the Demand for Art in Italy 1300–1600* (Baltimore and London, 1993)

Hauser, Arnold, *The Social History of Art, Volume 2: Renaissance, Mannerism, Baroque* (London, 1962)

Hibbard, Howard, *Michael Angelo* (Harmondsworth, successive editions)

Hibbert, Charles, *The Rise and Fall of the House of Medici* (London, 1974)

Hollingsworth, Mary, *Patronage in Renaissance Italy* (London, 1994)

Holroyd, Charles, *Michelangelo Buonarroti* (London, 1903)

Hook, Judith, *Lorenzo de' Medici* (London, 1984)

Jacob, E. F. (ed.), *Italian Renaissance Studies* (London, 1960)

Kemp, Martin, *Leonardo da Vinci: The Marvellous Works of Nature and Man* (London, 1981)

Kerrigan, William, and Braden, Gordon, *The Idea of Renaissance* (Baltimore, 1989)

Kristeller, Paul Oskar, *Eight Philosophers of the Italian Renaissance* (Columbia, 1964)

Kristeller, Paul Oskar, *Renaissance Concepts of Man* (New York, 1972)

Kristeller, Paul Oskar, *Renaissance Thought and the Arts* (Oxford, 1990)

Landucci, Luca, *A Florentine Diary 1450–1516*, trans. Alice de Rosen (New York, 1969)

Le Brooy, Paul James, *Michelangelo Models* (Vancouver, 1972)

Levey, Michael, *Early Renaissance* (Harmondsworth, 1967)

Lowe, K. J. P., *Church and Politics in Renaissance Italy: The Life and Career of Cardinal Francesco Soderini 1453–1524* (Cambridge, 1993)

Mallett, Michael, *Mercenaries and their Masters: Warfare in Renaissance Italy* (London, 1974)

Murray, Linda, *Michelangelo: His Life, Work and Times* (London, 1984)

Panofsky, Erwin, *Renaissance and Renascences in Western Art* (Stockholm, 1960)

Pastor, L., *The History of the Popes from the Close of the Middle Ages* (40 vols., London, 1906–7, 1950)

Pater, Walter, *The Renaissance* (New York, 1871, 1961)

Porter, Roy, and Teich, Mikuláš (eds.), *The Renaissance in National Context* (Cambridge, 1992)

Ridolfo, Roberto, *The Life of Girolamo Savonarola*, trans. Cecil Grayson (London, 1959)

Rubinstein, Nicolai, *The Government of Florence under the Medici 1434–1494* (Oxford, 1966)

Schevill, F., *History of Florence from the Founding of the City through the Renaissance* (New York, 1936)

Seymour, Charles Jr, *Michelangelo's David: A Search for Identity* (New York, 1967)

Shaw, Christine, *Julius II: The Warrior Pope* (Oxford, 1993)

Shearman, John, *Only Connect . . . Art and the Spectator in the Italian Renaissance* (Princeton, 1992)

Steinberg, Ronald M., *Fra Girolamo Savonarola, Florentine Art and Renaissance Historiography* (Athens, Ohio, 1977)

Symonds, John Addington, *The Life of Michelangelo* (2 vols., London, 1893)

Trexler, Richard, *Public Life in Renaissance Florence* (London, 1987)

Valentier, W. R., *Studies of Italian Renaissance Sculpture* (London, 1950)

Wackernagel, Martin, *The World of the Florentine Renaissance Artist*, trans. Alison Luchs (Princeton, 1981)

Weinberger, Martin, *Michelangelo the Sculptor* (2 vols., London and New York, 1967)

Weinstein, Donald, *Savonarola and Florence* (Princeton, 1970)

Wilde, Johannes, *Michelangelo: Six Lectures* (Oxford, 1978)

Wilson, Charles Heath, *Life and Works of Michelangelo Buonarroti* (London, 1876)

Wind, E., *Pagan Mysteries in the Renaissance*, Norton (New York, 1958)

Wittkower, Rudolf and Margot, *Born under Saturn* (London, 1963)

From 1508

Ames-Lewis, Francis, and Wright, Joanne, *Drawing in the Italian Renaissance Workshop* (London, 1983)

Bailey, C. C., *War and Society in Renaissance Florence* (Toronto, 1961)

Boase, T. S. R., *Giorgio Vasari: The Man and the Book* (Princeton, 1979)

Boucher, Bruce, *The Sculpture of Jacopo Sansovino* (New Haven and London, 1991)

Braudel, F., *The Mediterranean and the Mediterranean World in the Age of Philip II* (2 vols., New York, 1973)

Brown, Peter M., and Miller, Eileen (eds.), *Renaissance and Other Studies* (Glasgow, 1988)

Chastel, André, *The Sack of Rome*, trans. Beth Archer (Princeton, 1983)

Creighton, Gilbert, *Michelangelo On and Off the Sistine Ceiling* (New York, 1994)

Cummings, Anthony M., *The Politicized Muse: Music for Medici Festivals 1512–1537* (Princeton, 1992)

D'Amico, John F., *Renaissance Humanism in Papal Rome: Humanists and Churchmen on the Eve of the Reformation* (Baltimore and London, 1983)

Fracastoro, Girolamo, *Syphilis or the French Disease*, trans. Heneage Wynne-Finch (London, 1935)

Franklin, David, *Rosso in Italy* (New Haven and London, 1994)

Gilbert, Felix, *The Pope, his Banker and Venice* (Cambridge, Mass., and London, 1980)

Hale, J. R., *Florence and the Medici: The Pattern of Control* (London, 1977)

Jacks, Philip, *The Antiquarian and the Myth of Antiquity: The Origins of Rome in Renaissance Thought* (Cambridge, 1993)

Jacob, E. F. (ed.), *Italian Renaissance Studies* (London, 1960)

Machiavelli, Niccolò, *Tutte le Opere*, ed. Mario Martelli (Florence, 1971)

Mallett, Michael, *The Rise and Fall of the Renaissance Dynasty* (London, 1969)

Oremland, Jerome, *Michelangelo's Sistine Ceiling: A Psychoanalytic Study of Creativity* (Madison, Conn., 1989)

Panofksy, Erwin, *Studies in Iconology* (Oxford, 1939)

Partridge, L., and Starn, R., *A Renaissance Likeness: Art and Culture in Raphael's 'Julius II'* (Berkeley, 1980)

Rubin, Patricia Lee, *Giorgio Vasari, Art and History* (New Haven and London, 1995)

Seymour, Charles Jr, *Michelangelo: The Sistine Chapel Ceiling* (New York, 1972)

Trexler, Richard, *Public Life in Renaissance Florence* (London, 1987)

Wallace, William E., *Michelangelo at San Lorenzo: The Genius as Entrepreneur* (Cambridge, 1994)

From 1534

Argan, Giulio Carlo, and Contardi, Bruno, *Michelangelo: Architect* (London, 1993)

Cambon, Glauco, *Michelangelo's Poetry: Fury of Form* (Princeton, 1985)

Clements, Robert J., *Michelangelo's Theory of Art* (London, 1963)

Clements, Robert J., *The Poetry of Michelangelo* (London, 1965)

Clovio, Giorgio Giulio, *Miniaturist of the Renaissance* (London, 1993)

Cohen, Thomas V., and Cohen, Elizabeth S., *Words and Deeds in Renaissance Rome: Trials before the Papal Magistrates* (Toronto, 1993)

Cox-Rearick, Janet, *Bronzino's Chapel of Eleonara in the Palazzo Vecchio* (Berkeley, 1993)

Friedlander, Walter, *Mannerism and Anti-Mannerism in Italian Painting* (New York, 1965)

Hauser, Arnold, *Mannerism: The Crisis of the Renaissance and the Origin of Modern Art* (Cambridge, Mass., 1986)

Heydenreich, Ludwig, and Lotz, Wolfgang, *Architecture in Italy: 1400 to 1600*, trans. Mary Hottinger (Harmondsworth, 1974)

Hirst, Michael, *Sebastiano del Piombo* (Oxford, 1982)

Levey, Michael, *High Renaissance* (London, 1975)

Liebert, Robert S., *Michelangelo: A Psychological Study of his Life and Images* (New Haven and London, 1983)

Mancinelli, F., Colalucci, G., and Gabrielli, N., *Rapporto sul 'Giudizio', Estrato da Bollettino*, XI, 1991 (Vatican)

Partner, Peter, *The Pope's Men: The Papal Civil Service in the Renaissance* (Oxford, 1990)

Partner, Peter, *Renaissance Rome* (Berkeley, 1976)

Penny, Nicholas, *The Materials of Sculpture* (New Haven and London, 1993)

Perlingieri, Ilya Sandra, *Sofonisba Anguissola: The First Great Woman Artist of the Renaissance* (New York, 1992)

Pope-Hennessy, J., 'The Palestrina Pietà', in *Essays on Italian Sculpture* (London, 1968)

Ramsey, P. A. (ed.), *Rome in the Renaissance: The City and the Myth* (New York, 1982)

Shearman, John, *Mannerism* (Harmondsworth, 1967)

Smart, Alastair, *The Renaissance and Mannerism in Italy* (London, 1971)

Steinmann, Ernst, *Michelangelo e Luigi del Riccio* (Florence, 1932)

Summers, David, *Michelangelo and the Language of Art* (Princeton, 1981)

From 1560

Delumeau, Jean, *Catholicism between Luther and Voltaire*, trans. Jeremy Moiser (London, 1977)

Giannotti, Donato, *Dialogi di Donato Giannotti de' giorni che Dante consumò nel cercare l'Inferno e 'l Purgatorio*, ed. Deoclecio Redig De Campos (Florence, 1939)

Hudon, William V., *Marcello Cervini and Ecclesiastical Government in Tridentine Italy* (De Kalb, 1992)

Millon, Henry A., and Smyth, Craig Hugh, *Michelangelo architetto: La facciata di San Lorenzo e la cupola di San Pietro* (Milan, 1988)

O'Malley, John W., *The First Jesuits* (Harvard, 1993)

Steinberg, Leo, *Michelangelo's Last Paintings* (London, 1975)

Trevor, Meriol, *Apostle of Rome: St Philip Neri 1515–1595* (London, 1966)

Index

Other than in the entry under his name,
Michelangelo is referred to as M.